Changing Contexts—Shifting Meanings

Changing Contexts, Shifting Meanings

Transformations of Cultural Traditions in Oceania

EDITED BY
ELFRIEDE HERMANN

UNIVERSITY OF HAWAI‘I PRESS
IN ASSOCIATION WITH THE HONOLULU ACADEMY OF ARTS

HONOLULU

This publication is partly funded by the
Doris Duke Foundation Endowment Fund
at the Honolulu Academy of Arts.

© 2011 University of Hawai'i Press
All rights reserved
Printed in the United States of America
16 15 14 13 12 11 6 5 4 3 2 1

Library of Congress Cataloging-in-Publication Data

Changing contexts, shifting meanings : transformations of cultural traditions in Oceania / edited by Elfriede Hermann.

 p. cm.

Papers from a symposium sponsored by the Honolulu Academy of Arts, held Feb. 23–26, 2006, in conjunction with the exhibition Life in the Pacific of the 1700s.

 Includes bibliographical references and index.

 ISBN 978-0-8248-3366-4 (hardcover : alk. paper)

 1. Oceania—Civilization—Congresses. 2. Social change—Oceania—Congresses. 3. Pacific Islanders—Congresses. I. Hermann, Elfriede.

 DU28.C47 2011

 995—dc22

 2011005312

University of Hawai'i Press books are printed on acid-free paper and meet the guidelines for permanence and durability of the Council on Library Resources.

Designed by Josie Herr

Printed by Sheridan Books, Inc.

Contents

Foreword
 Stephen Little vii
Acknowledgments xi

Introduction ~ Engaging with Interactions: Traditions as Context-Bound Articulations
 Elfriede Hermann 1

Changing Contexts, Shifting Meanings: The Cook/Forster Collection, For Example
 Brigitta Hauser-Schäublin 20

Part I: Early Encounters

Histories of the Before: Lelu, Nan Madol, and Deep Time
 David Hanlon 41

Beyond the Beach? Re-articulating the Limen in Oceanic Pasts, Presents, and Futures
 Margaret Jolly 56

Encountering Agency: Islanders, European Voyagers, and the Production of Race in Oceania
 Bronwen Douglas 74

Aphrodite's Island: Sexual Mythologies in Early Contact Tahiti
 Anne Salmond 93

An Encounter with Violence in Paradise: Georg Forster's Reflections on War in Aotearoa, Tahiti, and Tonga (1772–1775)
 Gundolf Krüger 107

Inventing Polynesia
 Serge Tcherkézoff 123

Part II: Memories

Naming and Memory on Tanna, Vanuatu
 Lamont Lindstrom 141

Inventing Traditions and Remembering the Past in Manus
 Ton Otto 157

Social Mimesis, Commemoration, and Ethnic Performance:
Fiji Banaban Representations of the Past
 Wolfgang Kempf 174

Part III: Global and (Trans)local Processes

Moving onto the Stage: Tourism and the Transformation of Tahitian Dance
 Miriam Kahn 195

Producing Inalienable Objects in a Global Market: The Solien Besena
in Contemporary Australia
 Jacquelyn A. Lewis-Harris 209

Alienation and Appropriation: Fijian Water and the Pacific Romance
in Fiji and New York
 Martha Kaplan 221

Shanti and *Mana:* The Loss and Recovery of Culture under Postcolonial
Conditions in Fiji
 John D. Kelly 235

Justice in Wallis-'Uvea: Customary Rights and Republican Law
in a French Overseas Territory
 Françoise Douaire-Marsaudon 250

Part IV: Cultural Exchange and Identities

Maori Traditions in Analogy with the Past
 Toon van Meijl 263

Contemporary Tongan Artists and the Reshaping of Oceanic Identity
 Paul van der Grijp 277

A Tale of Three Time Travelers: Maintaining Relationships,
Exploring Visual Technologies
 Karen L. Nero 296

* * *

Cultural Change in Oceania: Remembering the Historical Questions
 Peter Hempenstall 313

Epilogue
 Aletta Biersack 323

Contributors 351
Index 357

Foreword

The symposium "Changing Contexts—Shifting Meanings: Transformations of Cultural Traditions in Oceania" was sponsored by the Honolulu Academy of Arts between February 23 and 26, 2006, in conjunction with the exhibition Life in the Pacific of the 1700s. This extraordinary gathering presented several hundred artifacts collected during the second and third Pacific voyages of Captain James Cook (1728–1779), generously loaned to the academy by the Institute of Cultural and Social Anthropology at the Georg August University of Göttingen, Lower Saxony, Germany, and the Lower Saxon State Museum in Hanover.

The majority of these artifacts originated in Aotearoa (New Zealand), Tonga, and Tahiti and were given to Göttingen University in 1782 (three years after Cook's death) by King George III of England. Some thirty-five of the works came from Hawai'i, while other works came from the northwest coast of America. A number of works came to Göttingen from the collection of Johann Reinhold Forster, a natural scientist who accompanied Cook on his second voyage. These combined gifts are known today as the Cook/Forster Collection. These beautiful and rare artifacts at the exhibition's core, which included objects for both daily use and ritual, were largely made prior to Cook's contact with the indigenous cultures of the Pacific. They are extraordinary for their beauty, craftsmanship, and unique mana (spiritual power). They are significant as well because they were given as gifts to or traded with Cook from the peoples he encountered.

The purpose of the Life in the Pacific of the 1700s exhibition was to celebrate the brilliant cultural and spiritual lives of these indigenous peoples as they existed before the first contact with Westerners. The exhibition explored the connections between these cultures within the broader geographical context of the Pacific of the 1700s. These rare and beautiful artifacts also posed the question: What is the role and relevance of the indigenous cultures of the Pacific today? These and other lines of inquiry formed the foundation of this international scholarly symposium, the idea for which was first proposed to me by Professor Dr. Brigitta Hauser-Schäublin of Göttingen's Institute of Cultural and Social Anthropology. The symposium was organized by her colleague, Dr. Elfriede Hermann, and I am deeply grateful to both scholars for their focus, perseverance, and enthusiasm. The symposium allowed for greater study and analysis of the questions embodied in and activated by the exhibition's remarkable artifacts.

The Honolulu Academy of Arts is deeply grateful to the many experts and scholars who participated in the symposium and to Elfriede Hermann for her hard work

After blessing the Cook/Forster Collection, La'akea Suganuma and the other members of the Hawaiian delegation pay their respects to the feathered image of the god Kūkā'ilimoku from Hawai'i. The objects selected for display at the Honolulu Academy of Arts were blessed on the premises of the University of Göttingen's Institute of Cultural and Social Anthropology prior to setting off on their long journey.
Photo: Wolfgang Kempf, January 23, 2006.

Maori club in the context of contemporary dance: from a performance put on by a Maori dance group during the opening of the exhibition Life in the Pacific of the 1700s at the Honolulu Academy of Arts.

Photo: Shuzo Uemoto, February 22, 2006.

Copyright: Honolulu Academy of Arts.

Ancient Maori club (Inv. Oz 282) from the Cook/Forster Collection: in a showcase at the exhibition Life in the Pacific of the 1700s.

Photo: Steffen Herrmann, February 22, 2006.

Ancient Maori club from the Cook/Forster Collection (housed at the Ethnographic Collection of the University of Göttingen's Institute of Cultural and Social Anthropology): full view / detail.

Inv. Oz 282 L. 195.5 cm, blade W 10.1 cm.

Photo: Harry Haase, October 2008.

Copyright: Institute of Cultural and Social Anthropology, University of Göttingen.

in bringing the symposium papers to publication. We are delighted that this volume of symposium transactions has been published in cooperation with the University of Hawai'i Press, and we are grateful to the academy's Doris Duke Foundation Endowment Fund for making its publication possible.

On behalf of the Honolulu Academy of Arts, I would also like to express my gratitude to the many indigenous cultural experts throughout the Pacific who advised the museum in the preparations for the Life in the Pacific of the 1700s exhibition, especially regarding the observation of indigenous protocols for the treatment of sacred and ritual objects. These amazing artifacts, which are windows into the past, present, and future, lie at the heart of both the exhibition and the symposium.

August 2009
Dr. Stephen Little
Director
Honolulu Academy of Arts

Acknowledgments

First of all, sincerest thanks to those cultural communities throughout Oceania who generously welcomed us into their midst. To all who aided our research and granted access to their lives and knowledge, we are greatly indebted. Given that in the process of writing culture we constantly interact with their representations and praxis, it is not surprising that their voices and actions are always present in our research findings.

The idea for a symposium with the title "Changing Contexts—Shifting Meanings" originated with Brigitta Hauser-Schäublin. This topic, which she had treated already in earlier publications as well as in the article heading the present volume, was a fortuitous one, as it allowed a dependable roof to be built that enclosed many different research interests. I wish to expressly thank her for support rendered in the run-up to the symposium. In dialogue with her I developed a specific focus within the overall architecture, inviting an exchange of novel research on "Changing Contexts—Shifting Meanings: Transformations of Cultural Traditions in Oceania."

For affording us the opportunity to present our research results—first at the symposium, now within the pages of this volume—we are especially indebted to Stephen Little, director of the Honolulu Academy of Arts. In the planning phase for the exhibition Life in the Pacific of the 1700s: The Cook/Forster Collection of the Georg August University of Göttingen, Stephen immediately picked up on the importance of a symposium connected with the exhibition. He got the meeting off to a splendid start with an inspirational walk through the rooms housing the exhibitions at the academy. On this tour he was concerned to place the art objects within their respective contexts—cultural origin, time and place of acquisition, and museological classification—stressing that the artifacts represent highly variegated interactions with their contexts. And in the symposium's aftermath, he enthusiastically supported the idea of bringing its papers to a wider audience of readers. On a personal note, I wish to thank Stephen for encouraging me to organize the symposium as a research fellow with the Honolulu Academy of Arts, and also for inspiring conversation and unstinting support in preparing this volume for publication. I would also like to record my gratitude to the Honolulu Academy of Arts itself for the above research fellowship and for generously cofinancing with the Doris Duke Foundation Endowment Fund both the symposium and the present publication. For agreeing to subsidize the printing costs I am greatly indebted to the academy's Board of Trustees and especially to Lynne Johnson, the chairman and interim director. In connection with the task of planning the symposium, I am indebted to suggestions made, from time to time, by a special committee consisting of Stephen Little, Brigitta

Hauser-Schäublin, Adrienne Kaeppler, and Deborah Waite. To all coworkers and volunteers at the Honolulu Academy of Arts who helped out in the symposium's organizing phase or in preparing this volume for print, I owe a debt of gratitude. Thus my thanks go to Lori Admiral for her demonstrated expertise and organizational skills and for the harmonious way we interacted throughout; to Cathy Ng, who was always on hand to smooth the logistics; to Chris Scrofani and Aaron Hara, who competently assisted with the IT; to Kathee Hoover, who supplied expert advice; to Milt Chun for his typeface concept for the book cover; and to Shuzo Uemoto, who let me use his brilliant photographs of the opening of the Life in the Pacific of the 1700s exhibition. Harry Haase from the University of Göttingen added his own masterly photographs of objects, for which I am grateful too. My sincere thanks to Ulrich Menter for his tireless commitment to seeing the symposium through and for laying out the present manuscript, a process in which he brought to bear the same formidable know-how and experience displayed in his own publications. In the context of the Life in the Pacific of the 1700s exhibition, he and conservator Gerry Barton honed my eye for the fascinating complexity of the objects on display. I would also like to warmly thank Steffen Herrmann for helping with bibliographic research, preparing the photos for the manuscript and offering to include one of his own, and giving valuable advice and expert assistance when pursuing the copyedited manuscript. He is also to be complimented for drafting a cover design that is at once striking and masterfully executed.

Indigenous scholars have, through their studies of Oceania, exerted great influence on our own research. Extending thanks to them, as I now do, is but modest tribute for invaluable windows opened onto cultural processes past and present. To the late Epeli Hau'ofa I wish to record my gratitude for many an impulse in reflecting on anthropological perspectives of indigenous traditions. What left a lasting impression on me was an impromptu artistic presentation he put on at the Oceania Centre for Arts and Culture (based on the campus of the University of the South Pacific) when we came to invite him to the symposium. Equally valuable have been research links forged with Ropate Qalo, who has deepened my insight into Fiji's cultures, into their transformations and into ongoing intercultural exchange in that island nation. Let me also thank Ralph Regenvanu for the interesting discussions on historical awareness among the Ni-Vanuatu. Of my colleagues from Papua New Guinea I will single out Jacob Simet, in view of a dialogue we have been waging periodically since the 1980s on cultural heritage. That these scholars were prevented at the last moment, for weighty reasons, from speaking at the symposium is much to be regretted. Timing clashes and pressures from work or social life also intervened to stop other colleagues from various Pacific Islands, who had been invited to attend, from finally being able to do so. Much as we missed their personal voices, we did not omit their arguments from our debates. Their insights and understandings, to which we have referred copiously in our texts, were invaluable for this anthropological project.

I would also like to expressly thank La'akea Suganuma, Len Kelemoana Barrow, and Jackie Kaho'okele Burke for acquainting me with Hawaiian culture. Right from the outset, as when they held a ceremony in Göttingen before the Oceanic objects set

off for Honolulu, they insisted on including us German scholars in their rituals. And during my stay in Hawai'i, their comments and explanations helped me to grasp deeper connectivities.

At the University of Hawai'i in Mānoa, Alan Howard, Jan Rensel, David Hanlon, and Geoffrey White offered valuable suggestions and engaged me in a fruitful exchange of ideas. I would also like to acknowledge help received from staff at the University of Hawai'i Press, without which this book could not have appeared; in this connection, I am particularly grateful to Masako Ikeda and Cheri Dunn. Let me add my many thanks to Drew Bryan for doing an excellent job with copyediting the manuscript.

My express thanks also go to the anonymous reviewers for engaging with the key findings in these collected studies and for offering exacting evaluations and valuable suggestions on possible improvements. Nor may I neglect to mention the efforts made by archivists and librarians to track down written and pictorial materials. In addition, I wish to thank Bruce Allen for his professional translations and proofreading and for his unstinting support as I set about organizing the symposium and seeing this work into print.

Immeasurably valuable during this time of research have been my motivating social relations, which invariably had the effect of returning me, refreshed, to the work in hand. I mean Wolfgang Kempf and my family and friends in Europe, but not less my Papua New Guinean and Banaban families and friends.

Finally, a word of thanks to Hawai'i itself, for hospitality graciously extended to all who contributed to this volume.

<div align="right">Elfriede Hermann</div>

Introduction
Engaging with Interactions: Traditions as Context-Bound Articulations

Elfriede Hermann

Interactions, Changing Contexts, Shifting Meanings

The meanings ascribed to cultural traditions constantly shift in the course of interactions between people and their ideas, actions, and objects. They are always articulated from specific perspectives that social actors have staked out within historically developed interconnectivities and multifaceted power relations. Being formed and expressed in relation to particular circumstances, they can be said to articulate the specific contexts in which interactions take place. Thus, cultural traditions can be seen as context-bound articulations.

The chapters in this volume examine various interactions within various changing contexts. We scrutinize social interactions to imagine how these played out in the past and still do so today, turning our attention to the specific meanings that social actors give under certain circumstances to their own actions, objects, and ideas and to the material and immaterial manifestations of others. We also look at structural interactions of cultural orders, with a view to the context-sensitive meanings resulting from these. Focusing on these multivalent interactions, we gain far-reaching insight into how cultural traditions change through time. It is via interactions between social actors that new ideas, practices, and materials are adopted from others and reconceptualized from within the cultural repertoire of one's own group. And it is via interactions with the products of social activities that these products change—and their meanings along with them. Brigitta Hauser-Schäublin has drawn attention to this dynamic when speaking of how we see objects acquired during James Cook's voyages that are now part of the Cook/Forster Collection at the Georg August University of Göttingen:

> [O]ur point of view changes with every new epoch, and the significance of the objects has also changed for the members of the cultures from which they originated. The objects as such are therefore not merely objects in themselves as we perceive them, because perception is dependent not only on the individual, but also on the particular time and culture in which the individual lives. In this way, the objects continuously "change" as well. (Hauser-Schäublin 1998: 11)

And if we adopt a perspective that allows us to explore objects, culturally specific concepts, and actions as interacting with changing contexts, it becomes clear that such interactions can cause structural formations to shift in a variety of ways.

But to contemplate the shaping and reshaping of meaning from a scientific distance is not to obscure the fact that the meanings transmitted to us by members of cultural communities are a product of how they have interacted with us. Often enough, social actors from the contemporary cultures we have been studying have exerted influence and power over us. And not infrequently, historical personalities also make a lasting impression on us. We recognize their agency every time we try to render at least some of them visible as persons, audible as voices, understandable as actors. These are the contexts of encounters in which we analytically interact with sociocultural and structural relationships alike. The research results presented in these pages are, therefore, to be seen as products of our attempting to engage with interactions.

Interaction and Cultural Transformation

To talk of interaction and cultural transformation is to evoke, in the field of anthropological debate, the name of Marshall Sahlins. His book *Historical Metaphors and Mythical Realities* (1981) is for the present volume a key benchmark, for two reasons. First, he delivered an explanatory model for how Hawaiians reacted to the appearance of Captain Cook, a model referred to by many of the present essays about early encounters between Pacific Islanders and European voyagers. Second, through his model of the "structure of the conjuncture" he developed a theoretical approach to analyzing transformation, one which we frequently refer to and reflect upon. Within his model, Sahlins focuses explicitly on how the contexts of praxis relate to the meanings of cultural categories, as when he writes: "contextual values, if unlike the definitions culturally presupposed, have the capacity then of working back on the conventional values" (Sahlins 1981: 35). New meanings are created and integrated into the already existing cultural structure (Sahlins 1981: 68). This process leads to the structure being transformed even as it is being reproduced.

As Aletta Biersack (1989: 73) has noted, Sahlins' theoretical arguments point clearly to a paradigm shift in anthropology—the transition from a structural anthropology that was not concerned with history to a historical anthropology. Studies on transformations of culture that appeared soon after Sahlins' first publications on structural history and were informed by his insights, such as those assembled by Hooper and Huntsman (1985), testify to this shift. Indeed, Sahlins' anthropological approach to structural history has yielded wide-ranging insight into processes of cultural transformation. Emphasizing this fact, Joel Robbins (2005) observed that while Sahlins, in his major work, masterfully found cultural continuity in change, he also, in a less-known essay on "develop-man" (reprinted 2005), considered the possibility that humiliation and related emotions may lead to cultural discontinuity. Importantly, Sahlins paved the way for theorization of cultural transformation within the context of interactions taking place not only within a culture, but also—and especially—between cultures. Yet it is precisely when analyzing intercultural processes that a structural theory runs up against

its limits. Thus Francesca Merlan (2005: 173) has noted that such a theory makes the boundedness of a system of meanings into a central issue in that it views the (re)ordering of cultural categories as proceeding within that system. Whether in the course of intercultural interactions systems of meanings will remain bounded is open, however, to doubt. Thus Jean Comaroff (1985), Aletta Biersack (1995), and Martha Kaplan (1995) suggested that when considering such contexts, one should pay attention to how sociocultural systems articulate with each other. Looking at articulated conceptions and actions may be particularly promising, if, following Kaplan and Kelly (1994, Kelly and Kaplan 2001, Kelly this volume) and Merlan (2005), we apply a theoretical perspective that permits us to recognize dialogical relationships between cultures.

The advantage of analyzing the transformation of interrelating cultures in terms of articulation was shown especially by Jean Comaroff (1985) for the case of anthropological research. The concept of articulation she uses gathers together the dual meanings of "join together" and "give expression to" (cf. Hall 1986: 53; Clifford 2001: 477–478). According to Comaroff (1985: 153), what the concept of articulation lets us do is see that specific systems of praxis and meaning combine into a unitary formation, a novel product of specific historical circumstances. Based on this theoretical perspective, my own suggestion is that we conceptualize tradition as context-bound articulation. But before presenting what I mean by this, let me take a closer look at popular and academic ways of understanding tradition.

Popular and Academic Conceptions of Tradition

If, then, this volume is about exchanging ideas on the importance of contexts, it is only right that I exemplify this by contextualizing my arguments. This will involve touching on two discursive fields that constitute contexts—in the sense of "connecting texts" or "con-texts"—for our discussions on transformations of cultural traditions in Oceania. These are the popular-indigenous and the academic conceptions of tradition.

The popular concepts developed by the indigenous inhabitants of Oceania are for anthropologists—and also, to an extent, for other scholars of Pacific societies—the most immediate and important points of reference. Now by "indigenous inhabitants of Oceania" I mean not only those autochthonous to the region, but also the many other groups who have long made Oceania their home (see Clifford 1994: 308–309; Robertson 1998: 205ff.). All have specific concepts to describe the cultural practices they attribute to their own group, and all have self-consciously reflected on how these practices have changed through time. They have evolved their definition of tradition out of their own, culturally specific historicity. "Historicity," as Michel-Rolph Trouillot (1995: 22–29) reminds us, is simultaneously a "sociohistorical process" and the "narrative constructions about that process" that members of a society have produced as subjects who articulate their thoughts and emotions with their stories about the past. Thus a society's specific historicity is a context that should not be allowed to escape analysis (cf. Hermann 1995, 2005).

An analysis sensitive to historicity allows us to see that Oceania's inhabitants have fashioned their ideas of cultural traditions from interacting with persons or groups of

different cultural backgrounds. These interactions were not always peaceful: In pre- and postcolonial times to an extent but in colonial times especially, these interactions were linked to the exercise of power, coercion, or violence. During such interactions, members of Oceanian societies have, at times, adopted concepts of "culture," "custom," and "tradition" from the discourses of other societies. They have "transcultured" these concepts, that is, they have, in the process of adoption, recontextualized and reconceptualized them to fit the needs of their own culture (Hermann 2007). Excellent examples of the products of such transculturation processes are indigenous conceptualizations of "*kastom*" in Vanuatu (Jolly 1982, 1992a, 1992b; Lindstrom 1982; Tonkinson 1982b), in the Solomon Islands (Keesing 1982b; White 1991); and in Papua New Guinea (Otto 1991, 1992) to name but a few of the early studies.

A case study may help to elucidate what I mean by the indigenous conceptualization of tradition, so I will briefly consider the "*kastom*" discourse as developed by the Ngaing of northeast Papua New Guinea during the transition from colonial to postcolonial times. The Ngaing from a village I will call Yasaburing refer to their traditional culture as *ununung nining doung* ("everything that belongs to us"), adding that all this comes "from before," *saguing yerak* (Hermann 1997: 94). Several decades ago they transcultured the term "custom," talking ever since of "*kastom*" to communicate their concerns more effectively to missionaries and colonial officers (later national officers) as well as others. After some of the cultural practices from their ancestral religion were attacked by representatives of Christian missions and the colonial administration, they partly modified what they had inherited, now designating as *kastom* only those aspects not negatively valued by the colonial authorities and, in turn, by themselves. In modifying traits from their cultural repertoire, they combined these in part with new elements adopted from hegemonic discourses of Western provenance. Aware of these changes, they note that though much of their traditional culture was handed down, not everything in it was. There is, however, one context where they insist they are exclusively practicing their own *kastom*, free of any add-ons: Recalling that they were accused in the mid-twentieth century, by missionaries and the then colonial administration, of colluding with the Yali Movement (tantamount to charging them with involvement in a so-called "cargo cult"), they strongly insist that what they were following at the time was not "*kago kalt*," as they call it in Tok Pisin, but their own *kastom* (Hermann 1992, 1995, 1997). Listen to what Marka, a woman from the Dasit-Halaloang clan, told me (on October 10, 1990): "We really did nothing like that [*kago kalt*]; all we thought of was our work. And Yali, the poor man, he had thought of the work of *kastom*. That was all he did, the work of *kastom!*"[1] Now, one needs to know that "'cargo cult' has become a term of disparagement," as Peter Hempenstall (1981; cf. Hempenstall and Rutherford 1984: 120) pointed out. Therefore, the Ngaing talk of being ashamed, weary, and angry in the face of *kago kalt* insinuations, to the point where they now distance themselves from such ascriptions by referring to their own positively connoted tradition. In their counterhegemonic move, they articulate representations of their traditional culture with an anti-"cargo cult" discourse. What this case teaches us is that two basic principles are at work in the indigenous conceptu-

alization of tradition: tradition is represented from within a specific historicity—linked as this is to emotions—but it is also articulated with and through specific discourses on other themes.

Now it so happens that in interaction with indigenous discourses and academic debate, anthropologists have themselves devised a series of definitions of tradition. This brings me to the second of my contextualizations: I need to briefly review the genealogy of anthropological concepts of tradition if I am to argue, in dialogue with these, that it is time to take a fresh look at how traditions are transformed.

Together with the neighboring discipline of history, anthropology has witnessed, since the early 1980s, a radical transformation of how it conceives tradition. The previous approach had seen tradition as having "a core of traits" handed down internally in unbroken continuity (Handler and Linnekin 1984: 274).[2] Studies using this earlier concept were frequently based on a series of dichotomies: tradition versus modernity; continuity versus discontinuity; genuine versus spurious tradition; internal culture versus external cultures (cf. Handler and Linnekin 1984: 273–274; White 1993: 476–477, 492; Otto and Pedersen 2005: 12; Sahlins 2005: 34). What was problematic, apart from these binary assumptions, was the widespread absence of any attempt to theorize the power relationships involved in matters of tradition.

By revising assumptions of this kind and by developing new conceptions, the study of tradition took a giant step forward. One of these new conceptions, steering research into fertile fields, was to see tradition as a political symbol. Studies of indigenous representations of traditions on the Solomon Islands and on Vanuatu have shown that, in contexts of anticolonial resentment and moves toward independence, tradition can become a symbol for political interests and action—and so, in the final analysis, for the identities that are linked to these (e.g., Keesing 1982a, 1982b; Tonkinson 1982a; Lindstrom 1982: 317–318).

Similarly trailblazing has been to see tradition as invented. This conception was first floated in *The Invention of Tradition* (Hobsbawm and Ranger 1983). There the historian Hobsbawm defined "invented tradition" as an ensemble of "practices (. . .) of a ritual or symbolic nature, which seek to inculcate certain values and norms of behaviour by repetition, which automatically implies continuity with the past" (Hobsbawm 1983: 1), adding that this continuity is "largely factitious" (1983: 2). Soon after this conception saw the light of day, a violent controversy arose over its viability and range of application. On one side, the conception was positively received by many anthropological studies that understood it in terms of Roy Wagner's theory of *The Invention of Culture* (1981) as an ongoing process of cultural creativity (Jolly and Thomas 1992a: 242). But there were plenty of authors ready to oppose the notion of "invented tradition." It was charged that the conception seemed to imply that such tradition sprang from a vacuum, devoid of any cultural antecedents or constraints, or even that it was fabricated. For instance, the Hawaiian political scientist and professor of Hawaiian studies Haunani-Kay Trask (1991) accused the anthropologist Roger Keesing of "academic colonialism," since the latter had intimated in an essay (1989) that, as a concomitant to postcolonial nationalism in Oceania, "ideologies" of the past had been

constructed for political ends. In her critique of this analysis, Trask (1991: 159) charged that Keesing was using his position as a white man to deny to Oceania's peoples a knowledge of history and to dismiss indigenous representations of the past as just so many idealizations for purposes of creating political myths. Mindful that the notion of invention might include unintended meanings, anthropological conceptions of tradition were careful to stress, from that point on, that what was meant thereby was a symbolic construction of cultural continuity (e.g., Linnekin 1992).[3]

Influenced by the intensity of the debate over tradition, anthropologists then argued that instead of describing tradition as "invented," it would be better to talk of it being "constructed" (e.g., Jolly and Thomas 1992a: 243; Linnekin 1992). At the same time, they took to focusing on the "politics of tradition" (see the essays in Jolly and Thomas 1992b; van Meijl 1990; Otto 1991). This switch of focus had the advantage of enabling indigenous depictions of cultural continuity to be analyzed in light of related political strategies pursued by actors on the local and national levels. Coming from a similar direction, Lamont Lindstrom and Geoffrey White explored the potential of viewing tradition as discourse. These authors stressed that this meant highlighting the historical constituting of tradition within systems of power (Lindstrom and White 1993: 469). In view of the scholarly critique of "invention," Terence Ranger also revised the concept. The new conception he had in mind was "imagined tradition" (Ranger 1993: 81–82; 1999: 142; 2005). By shifting the focus, attention could now be steered more to the ideas, concepts, and symbols than was the case with "invention." Alive to the criticisms voiced by Pacific Islanders, Robert Tonkinson made another innovative suggestion: tradition should be conceptualized heuristically as a resource that is strategically (and politically) deployed by specific members of a community (Tonkinson 1993: 599; 1999, 2000).

Now the conceiving of tradition in terms of its political use, such as has been done in a plethora of studies (and to great benefit too, as measured by the insights yielded), has not gone uncritiqued within the anthropological fold. Thus, for example, Sahlins (1999: 402–404) has charged those so persuaded with having adopted a functional (if not functionalist) approach by focusing one-sidedly on the practical and political utility of traditions. The responses elicited by Sahlins' critique stress yet again the need to analyze the links existing between tradition and power. Thus Ton Otto and Poul Pedersen (2005) make the important point that there is no alternative to seeing tradition as a resource for the exercise of power. Therefore they consider it necessary to analytically include strategies followed by indigenous actors, and particularly their agency in dealing with tradition (Otto and Pedersen 2005; cf. Otto and Pedersen 2000).

Nor is it the case that these hefty debates and controversies have gone away (cf. Biersack 1991: 15; Hanlon and White 2000: 13; Hauʻofa 2000: 454ff.; Babadzan 2000; Inoue 2000). In view of their ongoing nature (see, e.g., Rogister and Vergati 2004; Weiner and Glaskin 2006; Bräuchler and Widlok 2007), it is not a bad idea to add my own suggestion to the pile. Let us think tradition in such a way as to avoid one-sided prioritizations (and the misunderstandings these invariably cause). In the next section, I will argue that tradition may be profitably understood as context-sensitive articulation.

Tradition as Context-Bound Articulation

In dialogue with studies of tradition pointing to the importance of contexts and/or the usefulness of the idea of articulation, I suggest that conceptualizing tradition as context-bound articulation has much to offer. Just how important it is to include contexts in the study of culturally specific ways of relating to tradition is something anthropologists have repeatedly noted (e.g., Jolly 1992a: 344). Thus Geoffrey White (1993) wrote with great clarity: "Getting a better fix on the multivocal and multivalent inflections of custom requires attending to the range of contexts in which ideas about tradition are put to use" (White 1993: 475). The necessity of allowing for contexts is grounded in the insight that what people make of the past is always a function of present needs and intentions (e.g., Lindstrom 1982: 317). The Tongan anthropologist and author Epeli Hau'ofa expressed this insight clearly when talking of the cultures of Oceania: "Versions of truth may be accepted for particular purposes and moments, only to be reversed when circumstances demand other versions" (Hau'ofa 2000: 454).

So there is a consensus that contexts strongly determine the meanings social actors ascribe to certain statements, objects, and actions associated with tradition. From this we may conclude that traditions are invariably context-bound. If traditions—or, more precisely, the meanings associated with and expressed by these—are context-bound, it is because they result from the connection between these meanings and ambient discourses. This property of "being-expressed" and "being-connected" can be subsumed under the concept of articulation, which I have already discussed earlier. Jean Comaroff (1985) and Stuart Hall (1980, 1986: 53–55) pointed out that cultural orders can be viewed as articulations (i.e., clearly expressed connectivities) of such distinguishable configurations as relationships, discourses, practices, and systems. Martha Kaplan (1995: 15–16) has gone still further in studying the routinization of articulating systems. Important too is the theoretical perspective developed by Hall (1986: 53), for whom connectivities also exist between discourses and human subjects.

Turning now to the literature on tradition, we find various approaches as to how the concept of articulation can usefully be deployed. Margaret Jolly (1992a: 330) suggested, for instance, that the concept of tradition, as encountered in Vanuatu and Fiji, was best seen as consisting of divergent articulations of past and present. White noted that the indigenous concept of *kastom* can hold many meanings, since it "may be used in multiple ways in diverse contexts, each of which may articulate with specific, well-formed local practices" (White 1993: 477–478). James Clifford (2003: 89) opined, referring to the controversy over the academic conceptualization of tradition, that much of what had been designated as invented was ripe for rethinking in terms of Stuart Hall's notion of a "politics of articulation." Based on these insights, Wolfgang Kempf and I proposed, with a view to Fiji, that the articulation of relations between past and present should be conceptualized as an integral part of a dynamic that includes transformation and positioning (Hermann and Kempf 2005).

Now it is in this context that I suggest traditions be seen as context-bound articulations. This novel approach to the concept I would explain thus: Tradition involves

processes of articulation in a double sense. Practices and discourses referring to relationships between cultural past and present are linked with, even as they are expressed by, contexts and identities. In this process of such context-bound expressivity, tradition is endowed with the meaning it finally carries.

Since it is the case that political contexts and interests flow into multiple connections, any attempt to analyze tradition as context-bound articulation must include power relationships that have arisen historically. Given that articulation presupposes human action, the focus of study must be placed on the agency of individual and collective actors.[4]

Interactions and the Transformation of Cultural Traditions in Oceania

Transcultural interactions, such as have taken place ever since the Pacific was first peopled, provided fertile ground for old meanings to be articulated within, and to articulate with, new contexts, thus encouraging the transformation of traditions. Following from the Pacific Islanders' own intercultural encounters, contacts between Oceania's people and Europe's travelers prompted all parties to change their ideas and practices, at least to a degree. The encounters between the Pacific Islanders and James Cook and his fellow travelers are but one (albeit prominent) example of such momentous interactions, as has been demonstrated by Anne Salmond (e.g., 2003) and Nicholas Thomas (2003) and represented by Paul Turnbull (see, e.g., 2002) and colleagues in the South Seas Project, an innovative online resource devoted to Cook's first Pacific voyage.[5]

So the contributions to this volume show how social and structural interactions in Oceania yield articulations of cultural traditions and their meanings. They focus on reciprocities between these meanings and their respective contexts, past and present. With an eye set firmly on objects, cultural practices, and ideas, they trace continuities and transformations alike. The shaping and reshaping of meanings via a multiplicity of interactions is analyzed in four sections under the following headings: (1) early encounters, (2) memories, (3) ongoing global and (trans)local processes, and (4) cultural exchange and identities.

The lead essay by Brigitta Hauser-Schäublin introduces our theme, namely changing contexts—shifting meanings, by examining a celebrated case: the Cook/Forster Collection. Housed permanently at the Institute of Cultural and Social Anthropology of the Georg August University of Göttingen, in early 2006 the collection journeyed to the Honolulu Academy of Arts, then on to the National Museum of Australia—attracting, in each case, an admiring public. In her essay, Hauser-Schäublin argues that not only these fascinating objects from the Pacific cultures of the mid-eighteenth century but their attendant meanings as well have been exposed to a continuous process of change. Since the material forms accreted specific meanings depending on the exact historical, political, social, and economic circumstances, they could not evade change—their seemingly unchanging materiality notwithstanding. As Hauser-Schäublin points out, these changes were wrought by the social actors then and now. Indeed, it is the diverse perspectives of the beholders that causes these objects always to appear in a different light, just as it is the motivations of these same beholders that put the objects to diverse uses.

Accordingly, the meanings of the artifacts foregrounded here are to be seen as products of social interactions between the Pacific Islanders themselves, between the latter and European voyagers (see also Hauser-Schäublin 2006), and between voyagers, traders, collectors, and scientists. Such interactions—especially those between the above on the one hand and the objects on the other—resulted in their meanings being specifically transformed from case to case.

Early Encounters

The essays in this first part look at early encounters, first among the actual inhabitants of Oceania and then between the Pacific Islanders and the European voyagers. They investigate the archaeological record, local histories, travel logs, and journals, drawing a picture of the social relationships accompanying contacts that proceeded at times peacefully, at times violently. The essays also treat the exchange of material and immaterial products, the better to address the issue of transculturation between the participating parties. Studying encounters and thus the crossing of cultural boundaries, which Dening (1980: 3, 20) poetically calls "beaches," requires a close look at the shifting of meanings. "To know cultures in contact is to know the misreadings of meanings, the transformation of meanings, the recognition of meanings" (Dening 1980: 6). Hence, whenever sources permit, the essays inquire into the culturally specific meanings of what happened between the Pacific Islanders and what sense, or senses, the Europeans were able to read into their own and others' actions. With a fine eye for the contextual specifics, the essays treat the transformations in such meanings as grew out of these relationships. So what we have here is a collection of historical and historical-anthropological studies—all of them "stories," if by that is meant context-sensitive descriptions of past "encounters between human beings and their situations" (Hempenstall 2000: 46).

David Hanlon tells the story of historical links between indigenous societies on two islands: Kosrae and Pohnpei. He examines certain similarities between two historical sites (Lelu on Kosrae and Nan Madol on Pohnpei) as well as between their respective oral histories in order to uncover past interactions. The resultant cultural transformations in the two societies he views as heralding later changes in the region now known as Micronesia (Hanlon 1994). As in Micronesia so also in Polynesia, contacts between Pacific Islanders long antedated the coming of the Europeans. As a result of these indigenous links, Polynesia too was for centuries the scene of cultural transformation, but without non-Polynesians ever becoming a major influence—so is the argument of Steven Hooper (2006: 16). Furthermore, even as the European voyages got underway, these indigenous encounters continued—in parallel. Margaret Jolly tells the story of Tupaia and Mai, two men from the Tahitian group who boarded Cook's ships and were able to contact other inhabitants of Oceania and (in Mai's case) learn a thing or two about British society. In Jolly's narrative, Tupaia and Mai are shown as travelers between cultural worlds, who, with no small show of ingenuity, articulate the dual perspectives of the Oceanian and European cultures. Ever alert to processes of transculturation, she illustrates the potential there was for reciprocal transformation. Bronwen Douglas has

focused on contacts, from the time of Duperrey's expedition of 1823, between French seamen and the Pacific Islanders of Tahiti and New Ireland. She sees these encounters as points where indigenous and French agencies intersect. In her eyes, behavioral changes among the Pacific Islanders resulted from old codes and norms having to come to terms with new possibilities arising in a context of change. Anne Salmond investigates changing cultural practices on Tahiti, focusing on sexual encounters, among others, between Tahitians and (a) British seamen in 1767, (b) Bougainville's French crew in 1768, and (c) sailors with the Spanish expeditions of 1772 and 1774. She notes that sex was associated with mythology—not just for the indigenes but for the Europeans too. These mythologies underwent, in turn, articulation, thus imprinting themselves on new apprehensions of events; at the same time, the meanings and experiences of sex were transformed for all concerned.

The shaping of meanings, such as occurred on the European side as a result of these Pacific encounters, is the subject of two other chapters. Gundolf Krüger relates the story of the young Georg Forster, who sailed with Cook on his second voyage between 1772 and 1775. He describes how Georg Forster sought to extract meaning from the material manifestations of violence on Tahiti, Aotearoa, and Tonga; in an age of enlightenment, this meant contextualizing these in the light of culture and political history. Serge Tcherkézoff studies the various meanings the idea of "Polynesia" has acquired in changing scientific contexts. As he shows, significant differences existed between late eighteenth-century definitions and those dating from the first half of the nineteenth century, when scientists like Dumont d'Urville unmistakably pegged to a racial agenda the mapping of this part of the world. Clearly, therefore, "Polynesia" acquired its various meanings by dint of its definition becoming articulated with the dominant scientific discourse of the age.

Memories

The cultural specifics of how members of Oceanian cultures recall past interactions in combination with the shaping of traditions is the subject of the essays in the second part. Memories in these cultures are retained not only in stories or in oral and written histories. As Vilsoni Hereniko (2000: 79–80) has noted, Pacific Islanders also express what they know of the past through the media of dance, song, and theater. Such performative practices operate on many levels, but chiefly through communication, recollection, and commemoration, as Amy Kuʻuleialoha Stillman (2001: 187) argues in her study of the history of the Hawaiian hula. As practices primarily consecrated to intragroup memory, they create meaning (Mageo 2001: 13). The essays collected here treat memories with just such a creative outlet—embodied in places and persons, in social and artistic activities. What they show is that memories contain reflections about meanings undergoing transformation, that is, memories can be said to represent specific historicities.

Lamont Lindstrom sheds light on how memory is constituted by naming practices on Tanna, an island in today's Vanuatu. Analyzed is how the Tannese confer meaningful names on places and persons—whether old names evoking unchanging structures

or new names recalling transformation and events like the first contacts the Islanders had with Cook and his party in 1774. By encoding memories into landscapes and socioscapes, historicity expresses itself in the interweaving of continuity and transformation. Ton Otto discusses historicity in another context, that of the Baluan Islanders on Papua New Guinea's Manus Island, but in similar terms of cultural continuity and transformation. Taking indigenous agency as his cue, he shows how the people of Baluan crafted their idea of tradition, *kastam,* along with its concomitant activities, by consciously pegging it to contexts undergoing constant change. Against the background of the Paliau movement pressing for social change, the people of Baluan created *kastam* as a context-bound tradition, one stressing the undiminished need to remain mindful of the ancestors and their past deeds. Wolfgang Kempf, for his part, explores how memory is created by social mimesis. He looks at mimetic practices among the Banabans, a people originally from the island of Banaba in the central Pacific but relocated to Fiji in 1945. How social mimesis plays out is exemplified by ethnic performances, in which the actors embody memories. Kempf illustrates his thesis in terms of the dance theater, specifically a play enacting the Banabans' own conversion to Christianity; in it, the memory of this event, the island of origin, and the ancestral goddess—all three—are kept alive. In reflecting on the transformation of religion, we find a historicity being manifested that articulates, at once, sharp rupture and powerful continuity.

Global and (Trans)local Processes

The third section of this volume focuses on interactions between global and local processes. As Aletta Biersack states in her epilogue, such interactions can be observed already in early intercultural exchanges between European voyagers and Pacific Islanders in Oceania—or, for that matter, between the Pacific voyagers and the people in Europe's metropolitan cities. These interactions intensify with the onset of the transpacific labor trade and colonialism, and they have been gathering momentum ever since (see Lockwood 2004: 10–16). In Oceania, as in other parts of the world, local and global systems articulate with each other, therefore, in multiple ways characterized by symbiosis and conflict (Comaroff 1985: 3). When global and local processes intersect, power differentials kick in from the start. Peter Hempenstall advances a similar argument in his epilogue when he refers to "the political economy of cultural transformation." Between the conflicting priorities of these processes, Oceanians formed their cultural practices in their efforts at cultural preservation as well as in transformation and transculturation. Fijians, for example, are quite willing to adopt traditions from other cultures in order to enrich their own, as Ropate Qalo (1997: 132) points out. Ulrich Menter (2003: 23) illustrates with regard to cultural transfers during early contacts that transcultured objects such as European weapons did indeed serve as instruments of power for Pacific Islanders. As the essays in this volume clearly demonstrate, cultural traditions in Oceania arose as articulations within, but also with, contexts of historically evolved power relationships.

Miriam Kahn has turned her attention to transformations in the dance traditions of

Tahitians after their encounters with Cook and other early voyagers. She charts the run-up to the circumstance that in today's context of mass tourism, Tahitian dancing is seen as emblematic of Tahitian culture and, against a backdrop of nuclear testing in French Polynesia, as the icon of "paradise." For the Tahitian actors who creatively choreographed their presentations when interacting with the visitors, their dancing now carries a different meaning than it once did. Jacquelyn Lewis-Harris also focuses on aspects of dance and discusses its shifting meanings and values, albeit against the backdrop of migration. She tells how, after migrating to Australia, the Solien Besena, a people originally from Papua New Guinea, still consider their costume, choreography, and lyrics as inalienable wealth in exchange situations. It emerges, however, that present-day aspects of the dance traditions of the Solien Besena are the product of their interactions within, and also with, the global market. Martha Kaplan considers the global market as a context for transforming yet another product: water, sourced in Fiji and consumed in faraway New York. She traces how ethnic Fijians transform their cultural perceptions of water (and also of land and landowning) through their interactions with the Fiji Water bottling company. She goes on to study U.S. American perceptions of the consumption of Fiji Water. Her analysis makes clear that cultural traditions result on both sides from context-bound articulations of meanings—and the politics thus spawned. John Kelly studies other forms of politics of cultural transformations in Fiji, contextualizing these within the postcolonial manifestations of global and local processes. His focus is on concepts of great relevance for political interactions between ethnic Fijians and Indo-Fijians: the Fijian "*mana*," glossed as "power," and the Hindu concept of "*shanti*," "peace." In his opinion, these concepts have been developed in a gendered political dialogue into polarities, manifested today in male power demonstrations by ethnonationalist Fijians met by androgynous quietism on the Indo-Fijian side. Françoise Douaire-Marsaudon also looks at cultural transformations, this time with clear references to colonialism; she focuses on a different area with a different political status: the French Overseas Territory of Wallis-and-Futuna. She demonstrates how interactions between French law and the legal system of Wallis-'Uvea, which is deemed traditional, have wrought transformations in the latter. Taking an actual case, she shows how much the specific meaning of justice depends on its associated context.

Cultural Exchange and Identities

Essays in the fourth section chiefly interlink themes resonant in many of the earlier contributions: intercultural exchanges and their role in the formation of collective and personal identities. Intercultural traditions in Oceania were already in place by precolonial times, becoming increasingly prominent in the colonial and postcolonial eras (e.g., Biersack 1995: 44; this volume; Merlan 2005). "The authenticity of the inside—the reputed source and fundament of 'tradition' as well as its continuities—invariably and everywhere results from historical struggles and manifestations of power: it is not the point from which these start," states Wolfgang Kempf (1996: 13; translation W. K.; see Kempf 2002). In this context it is important to recognize that intercultural communication has long been accompanied by an awareness of cultural differences between

one's own way of life and the ways of others (Jolly 1992b: 57–59). Such a recognition may be found in stories about culture and history—and not least about cultural traditions—which are, in turn, constitutive of identities (White 1991). Recognition of cultural difference does not necessarily preclude cultural exchanges. Interestingly, aspects of tradition that members of a cultural community regard as important for their collective identity may sometimes be the product of transculturation, as in the case of the *maneapa*-style meeting house in Tuvalu, which, in the convincing analysis of Michael Goldsmith (1985), displays clear traces of having been a cultural borrowing from Kiribati that was subsequently integrated into Tuvaluan society as a national symbol. Still, irrespective of what past interactions the cultural practices of the present may be traced to, once they become part of a community's tradition they may play an important role in processes of identification. Here identification is taken to mean what Toon van Meijl (2004: 4) called "a shifting image of identity." When members of a cultural community identify with their traditions, according to Hall (1986: 53), this can be understood as an articulation in the sense of subjects connecting with, and expressing themselves through, specific tradition discourses. This means that traditions as context-bound articulations also integrate identifications.

In his essay, Toon van Meijl proposes a new analytical concept for studying indigenous discourses on tradition: traditions as reconstructions of cultural practices analogous to similar actions performed in the past. His concept allows us to see just how much indigenous descriptions themselves use analogies in order to emphasize continuity. His studies of the Maori concepts of "*iwi*" (frequently glossed as "tribe") and "*aroha*" ("love" in a broad sense) demonstrate that similarities between earlier meanings of these terms and today's meanings are accentuated via analogies. Though the analogies do presuppose cultural transformations, the latter have been attenuated by the Maori politics of identity. This shows that analogies are deciding cofactors in constituting the traditions that acquire specific meaning as context-bound articulations. Paul van der Grijp is concerned with Tongan artists and the shifting meanings of their works of art, especially in contexts of an increasingly monetarized economy and the increased mobility of people, ideas, and finances. On the basis of artists' biographies, he recounts how they—as a result of social interactions in different locations in Oceania and intercultural communications—came to re-introduce traditionally shaped art objects and to transform conventional forms so as to create new works of art. In this creative process, they exercised their agency to form for themselves individual and collective identities. Karen Nero also traces the meaning of material culture, focusing on treasures from eighteenth-century Palau that are now kept in the British Museum. She shows that these objects, for the Palauans, refer to exchange relationships between their ancestors and British voyagers of the time; moreover, they are still used today to maintain interchanges between the Belau National Museum and the British Museum. At the same time, the treasures also represent ancestral knowledge, which may well serve as a reference for fashioning present-day Palauan identities. This again demonstrates that it is social interactions then and now, as well as imaginative interactions between past and present, that lead to the creative arrangement of shifting meanings in changing contexts.

Acknowledgments

Warmest thanks to all who gave papers at the symposium, acted as discussants or chairs, or contributed comments from the floor. A number of colleagues who were invited to contribute to this volume were unfortunately unable to submit final texts. Since their oral presentations enlivened our discussions, it is only right to record their names: Adrienne Kaeppler spoke on "Objects or Collections? Collections in Search of a Subject, Objects in Search of their Histories"; Jacob Simet had scheduled a lecture on "Pacific Cultures as Heritage"; Amy Kuʻuleialoha Stillman discussed the topic "Modern Hula: A Crucible of Hawaiian Tradition"; Carol S. Ivory addressed us on "Reconfigurations/Recontextualizations of Art and Identity in the Marquesas Islands (Te Henua Enana/Te Fenua Enata)"; and Deborah Waite weighed in with "The Imaging and Virtual Repatriation of ʻAʻa (Rurutu Island, Austral Islands)." I additionally owe much to Anne D'Alleva, Jerome Feldman, Christian Feest, Paul van der Grijp, David Hanlon, Alan Howard, and Jacquelyn Lewis-Harris, all of whom chaired one or another of the panels at the symposium and who enthusiastically discussed the papers presented there. For carefully reading and commenting on this introduction, I wish to thank Aletta Biersack, Peter Hempenstall, David Hanlon, Margaret Jolly, Wolfgang Kempf, Bruce Allen, and two anonymous readers, who provided me with very valuable suggestions. As always, my deepest gratitude is with the Ngaing of Papua New Guinea and the Banabans in Fiji (also on Banaba in Kiribati), who welcomed me in their midst, thus creating the most important context of all for understanding their traditions.

Notes

1. Sincerest thanks to Marka and all other Ngaing interlocutors for their kind explanations.
2. Handler and Linnekin (1984: 274) cite as an example the classical definition of A. L. Kroeber (1948: 411): "tradition is the 'internal handing on through time' of culture traits."
3. Jocelyn Linnekin and Richard Handler had earlier, in their respective studies on Hawaiʻi and on Canada's Quebec, presented tradition as a symbolic process. Reflected in their conception is the fact that traditions arise as a result of symbolic ascriptions (Handler and Linnekin 1984).
4. Agency means the ability human actors have to bring influence and power to bear on others, while being themselves exposed to the power of these same others and also to that of the cultural systems involved (Ortner 1984: 144–145; 1999: 146–147; Strathern 1987: 22–23).
5. The South Seas online resource can be found at http://southseas.nla.gov.au.

References

Babadzan, Alain. 2000. "Anthropology, Nationalism and 'The Invention of Tradition.'" *Anthropological Forum* 10 (2): 131–155.
Biersack, Aletta. 1989. "Local Knowledge, Local History: Geertz and Beyond." In *The New Cultural History,* edited by Lynn Hunt, 72–96. Berkeley: University of California Press.
———. 1991. "Introduction: History and Theory in Anthropology." In *Clio in Oceania: Toward a Historical Anthropology,* edited by Aletta Biersack, 1–36. Washington and London: Smithsonian Institution Press.
———. 1995. "Introduction: The Huli, Duna, and Ipili Peoples Yesterday and Today." In *Papuan Borderlands: Huli, Duna, and Ipili Perspectives on the Papua New Guinea Highlands,* edited by Aletta Biersack, 1–54. Ann Arbor: The University of Michigan Press.

Bräuchler, Birgit, and Thomas Widlok. 2007. "Die Revitalisierung von Tradition: Im (Ver-)Handlungsfeld zwischen staatlichem und lokalem Recht." In *Die Revitalisierung von Tradition/ The Revitalisation of Tradition,* edited by Birgit Bräuchler and Thomas Widlok. Thematic Issue of *Zeitschrift für Ethnologie* 132 (1): 5–14.

Clifford, James. 1994. "Diasporas." *Cultural Anthropology* 9 (3): 302–338.

———. 2001. "Indigenous Articulations." *The Contemporary Pacific* 13 (2): 468–490.

———. 2003. *On The Edges of Anthropology (Interviews).* Chicago: Prickly Paradigm Press.

Comaroff, Jean. 1985. *Body of Power, Spirit of Resistance: The Culture and History of a South African People.* Chicago: The University of Chicago Press.

Dening, Greg. 1980. *Islands and Beaches: Discourse on a Silent Land: Marquesas 1774–1880.* Chicago: The Dorsey Press.

Goldsmith, Michael. 1985. "Transformations of the Meeting-House in Tuvalu." In *Transformations of Polynesian Culture,* edited by Antony Hooper and Judith Huntsman, 151–175. Auckland: The Polynesian Society.

Hall, Stuart. 1980. "Race, Articulation and Societies Structured in Dominance." In *Sociological Theories: Race and Colonialism,* edited by UNESCO, 305–345. Paris: UNESCO Press.

———. 1986. "On Postmodernism and Articulation. An Interview with Stuart Hall." Edited by Lawrence Grossberg. *Journal of Communication Inquiry* 10 (2): 45–60.

Handler, Richard, and Jocelyn Linnekin. 1984. "Tradition, Genuine or Spurious." *Journal of American Folklore* 97 (385): 273–290.

Hanlon, David. 1994. "Patterns of Colonial Rule in Micronesia." In *Tides of History: The Pacific Islands in the Twentieth Century,* edited by K. R. Howe, Robert C. Kiste, and Brij V. Lal, 93–118. Honolulu: University of Hawai'i Press.

Hanlon, David, and Geoffrey M. White. 2000. "Introduction." In *Voyaging through the Contemporary Pacific,* edited by David Hanlon and Geoffrey M. White, 1–21. Lanham, Md.: Rowman and Littlefield Publishers.

Hauʻofa, Epeli. 2000. "Epilogue: Pasts to Remember." In *Remembrance of Pacific Pasts: An Invitation to Remake History,* edited by Robert Borofsky, 453–471. Honolulu: University of Hawai'i Press.

Hauser-Schäublin, Brigitta. 1998. "Exchanged Value—The Winding Paths of the Objects." In *James Cook: Gifts and Treasures from the South Seas; The Cook/Forster Collection, Göttingen. Gaben und Schätze aus der Südsee; Die Göttinger Sammlung Cook/Forster* (English-German edition), edited by Brigitta Hauser-Schäublin and Gundolf Krüger, 11–29. Munich: Prestel.

———. 2006. "Witnesses of Encounters and Interactions. In *Life in the Pacific of the 1700s— The Cook/Forster Collection of the Georg August University of Göttingen.* Vol. II, edited by Stephen Little, Peter Ruthenberg, Brigitta Hauser-Schäublin, and Gundolf Krüger, 20–35. Honolulu: Honolulu Academy of Arts.

Hempenstall, Peter. 1981. "Protest or Experiment? Theories of 'Cargo Cults.'" Occasional Paper No. 2:1–10. Research Centre for Southwest Pacific Studies. La Trobe University.

———. 2000. "Releasing the Voices: Historicizing Colonial Encounters in the Pacific." In *Remembrance of Pacific Pasts: An Invitation to Remake History,* edited by Robert Borofsky, 43–61. Honolulu: University of Hawai'i Press.

Hempenstall, Peter, and Noel Rutherford. 1984. *Protest and Dissent in the Colonial Pacific.* Suva: The Institute of Pacific Studies of the University of the South Pacific.

Hereniko, Vilsoni. 2000. "Indigenous Knowledge and Academic Imperialism." In *Remembrance of Pacific Pasts: An Invitation to Remake History,* edited by Robert Borofsky, 78–91. Honolulu: University of Hawai'i Press.

Hermann, Elfriede. 1992. "The Yali Movement in Retrospect: Rewriting History, Redefining

'Cargo Cult.'" In *Alienating Mirrors: Christianity, Cargo Cults and Colonialism in Melanesia*, edited by Andrew Lattas. Special Issue of *Oceania* 63 (1): 55–71.

———. 1995. *Emotionen und Historizität: Der emotionale Diskurs über die Yali-Bewegung in einer Dorfgemeinschaft der Ngaing, Papua New Guinea*. Berlin: Reimer.

———. 1997. "Kastom Versus 'Cargo Cult': Emotional Discourse on the Yali Movement in Madang Province, Papua New Guinea." In *Cultural Dynamics of Religious Change in Oceania*, edited by Ton Otto and Ad Borsboom, 87–102. Leiden: KITLV.

———. 2005. "Emotions and the Relevance of the Past: Historicity and Ethnicity Among the Banabans of Fiji." In *Ethnographies of Historicity*, edited by Eric Hirsch and Charles Stewart. Special Issue of *History and Anthropology* 16 (3): 275–291.

———. 2007. "Communicating with Transculturation." In *Pacific Challenges: Questioning Concepts, Rethinking Conflicts*, edited by Françoise Douaire-Marsaudon. Special Issue of *Le Journal de la Société des Océanistes* 125 (2): 257–260.

Hermann, Elfriede, and Wolfgang Kempf. 2005. "Introduction to Relations in Multicultural Fiji: The Dynamics of Articulations, Transformations and Positionings." In *Relations in Multicultural Fiji: Transformations, Positionings and Articulations*, edited by Elfriede Hermann and Wolfgang Kempf. Special Issue of *Oceania* 75 (4): 309–324.

Hobsbawm, Eric. 1983. "Introduction: Inventing Traditions." In *The Invention of Tradition*, edited by Eric Hobsbawm and Terence Ranger, 1–14. Cambridge: Cambridge University Press.

Hobsbawm, Eric, and Terence Ranger, eds. 1983. *The Invention of Tradition*. Cambridge: Cambridge University Press.

Hooper, Antony, and Judith Huntsman, eds. 1985. *Transformations of Polynesian Culture*. Auckland: The Polynesian Society.

Hooper, Steven. 2006. *Pacific Encounters: Art and Divinity in Polynesia 1760–1860*. London: The British Museum Press.

Inoue, Akihiro. 2000. "Academism and the Politics of Culture in the Pacific." *Anthropological Forum* 10 (2): 157–177.

Jolly, Margaret. 1982. "Birds and Banyans of South Pentecost: Kastom in Anti-Colonial Struggle." In *Reinventing Traditional Culture: The Politics of Kastom in Island Melanesia*, edited by Roger M. Keesing and Robert Tonkinson. Special Issue of *Mankind* 13 (4): 338–356.

———. 1992a. "Custom and the Way of the Land: Past and Present in Vanuatu and Fiji." In *The Politics of Tradition in the Pacific*, edited by Margaret Jolly and Nicholas Thomas. Special Issue of *Oceania* 62 (4): 330–354.

———. 1992b. "Specters of Inauthenticity." *The Contemporary Pacific* 4 (1): 49–72.

Jolly, Margaret, and Nicholas Thomas. 1992a. "Introduction." In *The Politics of Tradition in the Pacific*, edited by Margaret Jolly and Nicholas Thomas. Special Issue of *Oceania* 62 (4): 241–248.

———, eds. 1992b. *The Politics of Tradition in the Pacific*. Special Issue of *Oceania* 62 (4).

Kaplan, Martha. 1995. *Neither Cargo Nor Cult: Ritual Politics and the Colonial Imagination in Fiji*. Durham, N.C.: Duke University Press.

Kaplan, Martha, and John D. Kelly. 1994. "Rethinking Resistance: Dialogics of 'Disaffection' in Colonial Fiji." *American Ethnologist* 21 (1): 123–151.

Keesing, Roger M. 1982a. "Kastom in Melanesia: An Overview." In *Reinventing Traditional Culture: The Politics of Kastom in Island Melanesia*, edited by Roger M. Keesing and Robert Tonkinson. Special Issue of *Mankind* 13 (4): 297–301.

———. 1982b. "Kastom and Anticolonialism on Malaita: 'Culture' as Political Symbol." In *Reinventing Traditional Culture: The Politics of Kastom in Island Melanesia*, edited by Roger M. Keesing and Robert Tonkinson. Special Issue of *Mankind* 13 (4): 357–373.

———. 1989. "Creating the Past: Custom and Identity in the Contemporary Pacific." *The Contemporary Pacific* 1 (1, 2): 19–42.

Kelly, John D., and Martha Kaplan. 2001. *Represented Communities: Fiji and World Decolonization*. Chicago: The University of Chicago Press.

Kempf, Wolfgang. 1996. *Das Innere des Äusseren: Ritual, Macht und Historische Praxis bei den Ngaing in Papua Neuguinea*. Berlin: Reimer.

———. 2002. "The Politics of Incorporation: Masculinity, Spatiality and Modernity among the Ngaing of Papua New Guinea." *Oceania* 73 (1): 56–77.

Kroeber, Alfred Louis. 1948. *Anthropology*. New York: Harcourt, Brace and Co.

Lindstrom, Lamont. 1982. "Leftamap Kastom: The Political History of Tradition on Tanna, Vanuatu." In *Reinventing Traditional Culture: The Politics of Kastom in Island Melanesia*, edited by Roger M. Keesing and Robert Tonkinson. Special Issue of *Mankind* 13 (4): 316–329.

Lindstrom, Lamont, and Geoffrey M. White. 1993. "Introduction: Custom Today." In *Custom Today*, edited by Geoffrey M. White and Lamont Lindstrom. Special Issue of *Anthropological Forum* 6 (4): 467–473.

Linnekin, Jocelyn. 1992. "On the Theory and Politics of Cultural Construction in the Pacific." In *The Politics of Tradition in the Pacific*, edited by Margaret Jolly and Nicholas Thomas. Special Issue of *Oceania* 62 (4): 249–263.

Lockwood, Victoria S. 2004. "The Global Imperative and Pacific Island Societies." In *Globalization and Culture Change in the Pacific Islands*, edited by Victoria S. Lockwood, 1–39. Upper Saddle River, N.J.: Pearson Prentice Hall.

Mageo, Jeannette Marie. 2001. "On Memory Genres: Tendencies in Cultural Remembering." In *Cultural Memory: Reconfiguring History and Identity in the Postcolonial Pacific*, edited by Jeannette Marie Mageo, 11–33. Honolulu: University of Hawai'i Press.

Menter, Ulrich. 2003. *Ozeanien—Kult und Visionen: Verborgene Schätze aus deutschen Völkerkundemuseen*. Munich: Prestel.

Merlan, Francesca. 2005. "Explorations towards Intercultural Accounts of Socio-Cultural Reproduction and Change." *Oceania* 75: 167–182.

Ortner, Sherry B. 1984. "Theory in Anthropology since the Sixties." *Comparative Studies in Society and History* 26 (1): 126–166.

———. 1999. "Thick Resistance: Death and the Cultural Construction of Agency in Himalayan Mountaineering." In *The Fate of "Culture": Geertz and Beyond*, edited by Sherry B. Ortner, 136–163. Berkeley: University of California Press.

Otto, Ton. 1991. *The Politics of Tradition in Baluan: Social Change and the Construction of the Past in a Manus Society*. Nijmegen: Centre for Pacific Studies.

———. 1992. "The Ways of Kastam: Tradition as Category and Practice in a Manus Village." In *The Politics of Tradition in the Pacific*, edited by Margaret Jolly and Nicholas Thomas. Special Issue of *Oceania* 62 (4): 264–283.

Otto, Ton, and Poul Pedersen. 2000. "Tradition Between Continuity and Invention: An Introduction." In *Anthropology and the Revival of Tradition: Between Cultural Continuity and Invention*, edited by Ton Otto and Poul Pedersen. Special Issue of *FOLK: Journal of the Danish Ethnographic Society* 42: 3–17.

———. 2005. "Disentangling Traditions: Culture, Agency and Power." In *Tradition and Agency: Tracing Cultural Continuity and Invention*, edited by Ton Otto and Poul Pedersen, 11–49. Aarhus: Aarhus University Press.

Qalo, Ropate Rakuita. 1997. *Small Business: A Study of a Fijian Family. The Mucunabitu Iron Works Contractor Cooperative Society Limited*. Suva, Fiji: Mucunabitu Education Trust.

Ranger, Terence. 1993. "The Invention of Tradition Revisited: The Case of Colonial Africa." In *Legitimacy and the State in Twentieth-Century Africa. Essays in Honour of A. H. M. Kirk-Greene*, edited by Terence Ranger and Olufemi Vaughan, 62–111. Basingstoke: St. Antony's/Macmillan.

———. 1999. "Concluding Comments." In *Ethnicity and Nationalism in Africa: Constructivist Reflections and Contemporary Politics,* edited by Paris Yeros, 133–144. London: Macmillan.

———. 2005. "Postscript." In *Tradition and Agency: Tracing Cultural Continuity and Invention,* edited by Ton Otto and Poul Pedersen, 327–338. Aarhus: Aarhus University Press.

Robbins, Joel. 2005. "Introduction—Humiliation and Transformation: Marshall Sahlins and the Study of Cultural Change in Melanesia." In *The Making of Global and Local Modernities in Melanesia: Humiliation, Transformation and the Nature of Cultural Change,* edited by Joel Robbins and Holly Wardlow, 3–21. Burlington: Ashgate Publishing Company.

Robertson, Robert. 1998. *Multiculturalism and Reconciliation in an Indulgent Republic: Fiji after the Coups 1987–1998.* Suva: Fiji Institute of Applied Studies.

Rogister, John, and Anne Vergati. 2004. "Introduction: Tradition Revisited." Special Issue of *History and Anthropology* 15 (3): 201–205.

Sahlins, Marshall. 1981. *Historical Metaphors and Mythical Realities: Structure in the Early History of the Sandwich Islands Kingdom.* Ann Arbor: The University of Michigan Press.

———. 1999. "Two or Three Things that I Know About Culture." *Journal of the Royal Anthropological Institute* 5 (N.S.): 399–421.

———. 2005. "The Economics of Develop-man in the Pacific." In *The Making of Global and Local Modernities in Melanesia. Humiliation, Transformation and the Nature of Cultural Change,* edited by Joel Robbins and Holly Wardlow, 23–42. Burlington: Ashgate Publishing Company.

Salmond, Anne. 2003. *The Trial of the Cannibal Dog: The Remarkable Story of Captain Cook's Encounters in the South Seas.* New Haven, Conn.: Yale University Press.

Stillman, Amy Kuʻuleialoha. 2001. "Re-Membering the History of the Hawaiian Hula." In *Cultural Memory: Reconfiguring History and Identity in the Postcolonial Pacific,* edited by Jeannette Marie Mageo, 187–204. Honolulu: University of Hawaiʻi Press.

Strathern, Marilyn. 1987. "Introduction." In *Dealing With Inequality: Analysing Gender Relations in Melanesia and Beyond,* edited by Marilyn Strathern, 1–32. Cambridge: Cambridge University Press.

Thomas, Nicholas. 2003. *Discoveries: The Voyages of Captain Cook.* London: Allen Lane.

Tonkinson, Robert. 1982a. "Kastom in Melanesia: Introduction." In *Reinventing Traditional Culture: The Politics of Kastom in Island Melanesia,* edited by Roger M. Keesing and Robert Tonkinson. Special Issue of *Mankind* 13 (4): 302–305.

———. 1982b. "National Identity and the Problem of Kastom in Vanuatu." In *Reinventing Traditional Culture: The Politics of Kastom in Island Melanesia,* edited by Roger M. Keesing and Robert Tonkinson. Special Issue of *Mankind* 13 (4): 306–315.

———. 1993. "Understanding 'Tradition'–Ten Years On." In *Custom Today,* edited by Geoffrey M. White and Lamont Lindstrom. Special Issue of *Anthropological Forum* 6 (4): 597–606.

———. 1999. "The Pragmatics and Politics of Aboriginal Tradition and Identity in Australia." *Le Journal de la Société des Océanistes* 109 (2): 133–147.

———. 2000. "'Tradition' in Oceania, and Its Relevance in a Fourth World Context (Australia)." In *Anthropology and the Revival of Tradition: Between Cultural Continuity and Invention,* edited by Ton Otto and Poul Pedersen. Special Issue of *FOLK: Journal of the Danish Ethnographic Society* 42: 169–195.

Trask, Haunani-Kay. 1991. "Natives and Anthropologists: The Colonial Struggle." *The Contemporary Pacific* 3 (1): 159–167.

Trouillot, Michel-Rolph. 1995. *Silencing the Past: Power and the Production of History.* Boston: Beacon Press.

Turnbull, Paul. 2002. "Engaging with History Complexity in the Virtual Environment: The South Seas Project." *Archives and Manuscripts* 30 (1): 66–81.

van Meijl, Toon. 1990. *Political Paradoxes and Timeless Traditions: Ideology and Development Among the Tainui Maori, New Zealand*. Nijmegen: Centre for Pacific Studies.

———. 2004. "Introduction." In *Shifting Images of Identity in the Pacific*, edited by Toon van Meijl and Jelle Miedema, 1–20. Leiden: KITLV Press.

Wagner, Roy. 1981. *The Invention of Culture*. Rev. and exp. ed. Chicago: The University of Chicago Press.

Weiner, James F., and Katie Glaskin. 2006. "Introduction: The (Re-)Invention of Indigenous Laws and Customs." In *Custom: Indigenous Tradition and Law in the Twenty-first Century*, edited by James F. Weiner and Katie Glaskin. Special Issue of *The Asia Pacific Journal of Anthropology* 7 (1): 1–13.

White, Geoffrey M. 1991. *Identity through History: Living Stories in a Solomon Islands Society*. Cambridge: Cambridge University Press.

———. 1993. "Three Discourses of Custom." In *Custom Today*, edited by Geoffrey M. White and Lamont Lindstrom. Special Issue of *Anthropological Forum* 6 (4): 475–494.

Changing Contexts, Shifting Meanings
The Cook/Forster Collection, for Example

Brigitta Hauser-Schäublin

The artifacts of the Göttingen–Cook/Forster Collection originate mainly from different islands and cultures from the South Seas; they were collected during the three voyages James Cook undertook between 1768 and 1780 on behalf of the British Crown. Shortly after the return of the ships from the first voyage, some items came into the possession of the Academic Museum of Göttingen University. They formed the basis of what became the world's largest collection of artifacts from the Pacific assembled during the voyages by scientists and crew members under varying circumstances. This collection—the Cook/Forster Collection of the Institute of Cultural and Social Anthropology (Hauser-Schäublin and Krüger 1998; Little, Ruthenberg, Hauser-Schäublin, and Krüger 2006)—contains almost five hundred items (for an overview of the whole collection and the individual artifacts see http://nma.gov.au/exhibitions/past_exhibitions/cooks_pacific_encounters). For 230 years this collection has remained physically separated by thousands of miles from its place of origin: Polynesia, Melanesia, and the Americas. The invitation of the Honolulu Academy of Arts to have this unique collection displayed in a superb exhibition, Life in the Pacific of the 1700s, in early 2006 brought the artifacts back for the first time to their original setting, a return phrased as "coming home" by the *Honolulu Advertiser*. Indeed, the way the native Hawaiians and other Pacific Islanders reacted to them showed that the materiality and cultural value of these artifacts still serve as a means to compress time and seamlessly to connect periods that have almost nothing in common from either the cultural or the political perspective.

The artifacts have changed very little physically over the past 230 years. The color of the delicate feathers, for example, the brightness of the shells, and the warmth of the turtle shells are as fresh and shining as if the artists had made them only yesterday. It is tempting to assume that they offer us an immediate window into the past, a time when most of them were made before any contact with Europeans; as the exhibits show, most of them are free of any imported material from Europe. They convey authenticity—proof of a time that was much better than that which followed in the wake of these first contacts, followed by oppression and colonialism.

In fact, these wonderful artifacts provide us, like a kaleidoscope, with a variety of perspectives and ever-changing patterns. Every new view establishes a specific relation-

ship between the artifact and the onlooker. Nevertheless, we may fall into a trap—the illusion that we are experiencing a reality that is in fact no longer accessible to us. For our perception is filtered through the multilayered system of knowledge and expectations that each particular onlooker has. And this applies to the reconstruction of the original context and its representation as well. René Magritte's famous painting of a pipe (1928–1929) with the title *The Treachery of Images*—on the painting he wrote the comment *Ceci n'est pas une pipe* ("This is not a pipe")—illustrates what I mean. His statement would certainly have puzzled many of his contemporaries in the 1920s. With this comment, the French surrealist wanted to point out that the painting of a pipe is not the same as the pipe you can hold in your hand and smoke (Magritte explained this painting as follows: "*La fameuse pipe, me l'a-t-on assez reprochée! Et pourtant, pouvez-vous la bourrer ma pipe? Non, n'est-ce pas, elle n'est qu'une représentation. Donc si j'avais écrit sous mon tableau 'ceci est une pipe', j'aurais menti!*" "The famous pipe. How people reproached me for it! And yet, could you stuff my pipe? No, it's just a representation, is it not? So if I had written on my picture 'This is a pipe,' I'd have been lying"). It is the topic of representation that this surrealist raised (cf. Foucault 1983), a question that began to bother anthropologists only many decades later: the object of the study we describe is not the object of study itself but a description of it, with all the implication this has (Wagner 1979; for an overview over the whole debate in anthropol-

Her Royal Highness, Abigail Kekaulike Kinoiki Kawananakoa, Hawai'i, and Her Royal Highness, Princess Pilolevu of Tonga, discussing plaited mats from different Polynesian islands of the Cook/Forster Collection during the opening of the exhibition Life in the Pacific of the 1700s, Honolulu. Photo: Shuzo Uemoto, February 22, 2006. Copyright: Honolulu Academy of Arts.

ogy see Berg and Fuchs 1993). In this sense what we see as a photograph or transparency is an electronic or printed representation of the artifact and not the object itself; it is a simulation of what we conceive to be its main characteristics from the perspective of visualization. An implicit part of this form of representation is that we only imagine we can see the artifact, although the artifact in its materiality is actually somewhere else. In fact, it is our imagination or our interpretation shaped by previous knowledge that allows us to understand the digitalized pictures to subsume the material dimension of the artifact too.

The same applies to the original contexts in which the artifacts were once embedded. We can try to imagine or reconstruct them with the help of reports, drawings, and paintings made on the voyages or shortly after. But the contexts as such, the actual behavior of the actors, are no longer observable. It is the temporal and cultural lag that our imagination attempts to bridge.

Therefore, in spite of their seemingly unchanged materiality, artifacts are not immutable but are in a continuous process of change, because every new age raises new questions and transforms the artifacts according to the changing perspectives of the observer and the acts of seeing and the object seen.

In this way the artifacts give us ever-changing answers, and new meanings become apparent against the background of shifting standpoints and questions. The view we get indeed resembles a kaleidoscope—there is no one single, true picture, but several, existing side by side. These pictures are always composed of the same basic elements but are put together in new constellations or arrangements with new messages. This means that we, from our side, can expect, every time we look at them, a fresh dialogue with artifacts made by indigenous people who did not shy away from contact with the captain and crew of the English ships (see also Salmond 2004; Thomas 2004).

The Eighteenth Century and the Awakening of Science

In this chapter I would like to show that the Göttingen collection was not a discrete entity handed by James Cook to Göttingen. Instead, it is a collection that came into being through the actions of a great number of people with different backgrounds, motivations, and goals. This applies to those who came into direct contact with the inhabitants of the islands in the South Pacific, the Admiralty representatives on the ships, the scientists, and the numerous crew members, who in turn came from a variety of cultural and social backgrounds. It applies, too, to art dealers and collectors who bought objects singly or in bulk upon the return of the ships to London. It applies as well to those people who were responsible for the transfer of the "natural and artificial curiosities," as they were called, to Göttingen University, where they served as objects of scholarly research. Depending on the actors and the contexts, the artifacts conveyed different meanings and served different purposes. In order to understand them and to answer the question of why they have been preserved in spite of the easily perishable material they are made of, it is necessary to outline the motivations of the major actors through whose hands they passed.

The social and cultural context in which collectors lived—whether in the South

Pacific, in London, or in Göttingen—needs now to be briefly reconsidered. The mid-eighteenth century was the dawn of modern times. At universities such as Halle and Göttingen, distinguished scholars broke new ground in the natural sciences as well as in the humanities. Göttingen University was the center of international networks of scholars and institutions, especially those working in Russia (e.g., the Russian Academy of Sciences and the Kunstkamera in St. Petersburg) and England.

These emerging modern sciences proposed and developed a methodology based on rationality and empirical investigation. Scholars no longer wished to base their research on theological dogmas and on fantasies and miraculous stories handed down from one generation to the next. During the Enlightenment, science was not yet split into a number of subdisciplines; it was encyclopedic in outline. In those days, the interest of researchers encompassed subjects that are fragmented today. The study of mankind in all its facets, for example, was prevalent among scholars of the Enlightenment. One of the questions hotly debated was whether humans were a separate species or belonged to the apes—a discussion that heavily influenced the perception and classification of peoples beyond Europe. The Swedish natural scientist Carl von Linné (1707–1778)—and in a different context the French natural historian Buffon (1707–1788), but not, e.g., Blumenbach (see below)—suggested that the most primitive people had tails like apes. By contrast, Georg Forster, relying on his firsthand experience and research carried out during Cook's second voyage, was able to refute this assumption. Instead, he developed the theory of the seven *exempla* of mankind (see Uhlig n.d.). The scientists on all three voyages saw their mission as one involving the investigation of the world humans lived in from a truly holistic perspective, including the properties of natural conditions—geology, climate, flora, fauna, the physical appearance of humans, their social life, and their culture. The collections they created, therefore, contained all sorts of material that from our present perspective may look like an arbitrary assemblage of disparate specimens. They constituted, however, the basis from which later a number of specialized university museums, following the systematization and delineation of the individual disciplines, took their identity.

The ethnographic collection presented here is, in fact, only one part of a more comprehensive compilation of all sorts of objects, among the most prominent of which is the herbarium, a systematic collection of six to seven hundred rare botanic species put together by the natural historians Johann Reinhold Forster and his son Georg on the second voyage. Göttingen University still houses 327 specimens (http://www.sysbot.uni-goettingen.de); an even larger botanic collection is kept in the London Natural History Museum.

It is obvious that the world view of all those actors to whom Göttingen owes this singular ethnographic collection substantially differed from our own today, and we have to acknowledge this difference in knowledge and orientation; it would be too easy to sit in judgment on the time and its actors—even though we now know that one of the consequences of European "discoveries" was conquest and colonialism, which caused the suffering and death of countless people. Although the Enlightenment may be the overarching framework within which we can explore the meanings that such collections

Johann Reinhold and Georg Forster (graphic representation after an oil painting by Francis Rigaud, London 1780).

had in the eighteenth century, we have to carefully distinguish between the individual actors and their respective backgrounds. Let us first turn to the different ways and the varying contexts in which these items were acquired.

How the Collection Came into Being: Trade, Barter, and Gifts

As briefly mentioned, apart from Captain Cook and the high-ranking officers who as representatives of the Admiralty were responsible for the voyages in general, the groups traveling on the large ships included scholars and their assistants, medical doctors, artists (mainly painters and draftsmen), craftsmen specializing in different crafts, cooks, navy soldiers, workmen, and crew members of various nationalities. Most of these men

were in one way or another engaged in collecting natural and artificial curiosities. On the second voyage (1772–1775), the German natural historian Johann Reinhold Forster was commissioned as the leading natural historian on board. Johann Reinhold Forster was accompanied by his then seventeen-year-old, multitalented son Georg; Georg had already accompanied his father on an earlier expedition to the lower Volga in Russia when he was only eleven years old (cf. Uhlig 2004). The Forsters were among the very few men who apparently collected systematically, though these were mostly pieces related to their main interest, natural history (cf. Reichardt 1994a). Both were keen observers interested also in social and cultural questions and therefore also in artifacts to which they often gave detailed descriptions in situ (G. Forster 1989; J. Forster 1996). Johann Reinhold Forster established a comprehensive comparative word list (partly based on words compiled by Banks, Parkinson, and others; see Gascoigne 1994: 161–162); with this list he was able to document and prove the striking similarities between many of the languages in the Pacific and Southeast Asia (Hoare 1982, vol. I: fig. 5).

The contexts in which the collecting activities were carried out by the people of unequal standing and with various functions on board differed considerably (see also Hauser-Schäublin 1998). First of all, it is important to note that *collecting* was not the main emphasis of the mission and of their interactions with the local people that they met on various islands. Rather, it was the *distribution* of small gifts, already seen as trumpery and tinsel from the perspective of critical European contemporaries such as the French philosopher Diderot, namely glass beads, buttons, mirrors, nails, and pins, items that were of little worth in European culture. It was the first goal of the ships' captains to establish a friendly relationship with the inhabitants of the Pacific islands by distributing such objects. The giving of such items also served a further purpose, one vital for the survival of the travelers: to replenish the ship's supplies, drinking water, fresh food (living animals, fruits, unprocessed staple food), and firewood. Cook and his companions soon noticed that most of the local people with whom they tried to set up a supply barter system unfortunately preferred to give handicrafts instead of food. Whether goods such as mirrors, nails, or beads were, according to local understanding, to be reciprocated primarily by handicrafts too, or whether the production of food was a matter of self-sufficiency or allowed to be given away only within restricted social contexts, is difficult to say.

Beside the priority of securing the ship crew's provisions, Cook and his natural historians had received instructions from the Admiralty and the Royal Society as to the scope of their tasks and their behavior toward the natives. Both institutions emphasized that the inhabitants of the islands they were going to meet had to be treated with respect, and undesirable incidents had to be avoided. They were to investigate the fauna and flora of the islands and collect samples of minerals or precious stones, seeds of trees, fruits, and grains (Urban 1998a: 33–36). Apart from these scientific goals, the three voyages must of course be seen first and foremost within the context of Britain's endeavors to secure a major share for themselves in the European expansion and to explore the possibilities of establishing colonies.

The seamen apparently were soon attracted by the opportunity to get hold of arti-

Replenishment of provisions in the Tongan Islands during James Cook's third voyage (engraving by William Byrne after John Webber; Niedersächsische Staats- und Universitätsbibliothek, Göttingen).

facts of all kinds—for themselves they immediately started a private barter system, noted by Cook and others as a "collecting mania." Some gave their personal shirts in exchange for any item that seemed worthwhile. Others started to give away parts of the ships' equipment and stock without authorization. The seamen knew that such curiosities (natural as well as artificial) were highly valued commodities much desired by European dealers and collectors and could be easily sold upon their return. In consequence, the seamen were not only eager to barter with the natives but to trade their acquisitions off to others, mostly the natural historians on board, as a note in Johann Reinhold Forster's diary reveals (July 14, 1774):

> Today a Saylor offered me 6 Shells to sale, all of which were not quite compleat, & he asked half a Gallon brandy for them, which is now worth more than half a Guinea. This shews however what these people think to get for their Curiosities when they come home, & how difficult it must be for a Man like me, sent out on purpose by Government to collect Natural Curiosities, to get these things from the Natives in the Isles, as every Sailor whatsoever buys vast Quantities of Shells, birds, Fish etc. so that the things are dearer & scarcer than one would believe, & often they go to such people, who have made vast Collections, especially of Shells viz. the Gunner & Carpenter, who have several 1000 Shells: some of these Curiosities are neglected, broke, thrown over board, or lost. (Hoare 1982, vol. IV: 555–556)

The individual and unregulated barter hampered the captain's efforts, as a priority, to secure the ships' supplies in an ordered and systematic way. On his very first voyage Cook was forced to draw up a regulation (on April 13, 1769) in which he appointed a specific small group of staff members to trade on behalf of the captain in procuring provisions. All others were excluded. Nevertheless, individual barter soon started

again, though perhaps in a more restricted way. In various parts of the Pacific where the ships docked, similar processes related to the barter activities took place; they give insight into what constituted value—and inflation. As a rule, the first iron objects Cook offered were highly prized, and he was able to receive a living pig for a single pike. But it took people only a little while to realize that the ship was in vital need of fresh food. As a consequence, within a few hours the established exchange rate crashed; the value of a pig sometimes rose to such heights that the ship was unable to satisfy its need.

The potentially communicative dimension of objects (Kohl 2003: 130) did not always develop in the ways Cook and his people had anticipated. As is documented in one case, Cook had laid out objects on the shore in the hope of engaging the islanders in positive communication with him. However, after some time, a woman got up, picked up the items piece by piece, and threw them back into Cook's boat that was waiting nearby. In some parts of the Pacific, people were not so much interested in the European goods. Instead they showed a keen interest either in red feathers or in barkcloth that Cook had collected on other islands. The local people were prepared to enter into barter only when these objects were offered. This forced the Europeans to become intermediaries in a kind of interisland trade.

Apart from bartering and trading that turned the artifacts into commodities, there existed other interactions through which artifacts from the South Seas could be brought to Europe. For example, the inhabitants of the various islands soon became aware that the foreigners were not all equal. Cook was always identified as the head or chief of the whole crew. The interactions between the crew members and the local people clearly followed lines of social distinction: Cook invited the nobility, mostly chiefs or kings with their entourages or families, on board. Conversely, it was he that was invited by the local chiefs. Displays of respect and esteem usually characterized both sides. The exchange of gifts along these lines of distinction differed from the usual barter or trading (Kohl 2003: 130–133). This can be gathered from the categories of objects that were exchanged. Both sides attributed special value to them; they were much more than just ordinary artifacts or tools used in everyday life. Instead, Cook and his officers were given artifacts that, according to local custom, were regarded as appropriate for an exchange of gifts between high-ranking personages. Cook, too, selected prestigious gifts for his honorable guests; he even had dresses or tools made by craftsmen on the ship for special occasions. Some of the artifacts Cook was given were even sacred, such as the feathered head, representing the Hawaiian god Kūkāʻilimoku.

There must have been times when the ships were filled with thousands of natural and cultural curiosities. The Forsters once complained that water leaked into their cabin and their mattress was soaked with seawater while they tried to keep the artifacts dry. Cook mentioned (as did Forster) that the seamen sometimes got tired of all the things they had indiscriminately collected and threw many of them overboard. There was no system of registration for the artifacts on board. The precise origin of most of the objects collected and the circumstances of their acquisition were therefore undocumented when the artifacts were sold upon the ships' return to England. It is only thanks to the careful entries that Johann Reinhold Forster and, sometimes, Cook's companions

Feathered image, *ki'i hulu manu*, representing the Hawaiian war god Kūkā'ilimoku (Cook/Forster Collection Inv. Oz 254, Institute of Cultural and Social Anthropology, University of Göttingen). Photo: Harry Haase.

made in their journals that we are able to do some reconstruction. But on most of the items we have no information whatever. What we have in Göttingen is therefore a more or less arbitrary "collection" in terms of how it came into being and who got hold of the artifacts and sold them in London to dealers and collectors.

Scholars of the Enlightenment and Artifacts as Objects of Knowledge

Göttingen University was founded in 1734. It was one of the earliest reformist universities, explicitly committed to the ideas of the Enlightenment, that is, above all, rationalism and empiricism and the rejection of dogmatism of all kind. Who were the scholars

who initiated the acquisition of "natural and artificial curiosities"? Only a few years after the university was founded, the idea of establishing a university collection used for research and teaching arose. Before, there existed the private collection of the natural historian Christian Wilhelm Büttner, who had been Johann Friedrich Blumenbach's (1752–1840) teacher and mentor. Blumenbach was a most influential and enterprising scholar and succeeded in his efforts to found the Academic Museum; this took place in 1773. Blumenbach was interested in comparative anatomy as well as in anthropology, which was to become the focus of a circle of scholars, among them the historian A. L. Schlözer, the orientalists David Johann Michaelis and Christian Gottlob Heyne (who was also the head of the university library), and the geographer J. C. Gatterer. Blumenbach initiated far-reaching contacts for the benefit of the university and the Academic Museum; it was through him that the earliest known ethnographic collection from Siberia and Russian America (Alaska) came to Göttingen. Blumenbach also knew the natural scientist Joseph Banks, a renowned member of the London Royal Society (see Gascoigne 1994) who accompanied James Cook on his first voyage (1768–1771). Blumenbach expressed his obligation and gratitude to "the famous Joseph Banks" in a letter he published as a foreword to the third printed edition (1795) of his dissertation *De generis humani varietate nativa* (On the original varieties of mankind) (completed in 1775, first printed in 1776). Banks was, according to Kaeppler, probably the greatest collector of "artificial curiosities" on Cook's first voyage (1978: 40). It is possible that the first artifacts from the South Seas that reached Göttingen may go back to him and the personal friendship between the two scientists.

In this dissertation, Blumenbach, who only a year later became professor of medicine and "Sub-inspector of the University Cabinet" (see Urban 1998b: 56–57), analyzed the varieties of mankind (*Menschenvarietäten*), all of which he traced back in equal measure to one and the same species. Unlike many of his contemporaries, he insisted that "Europeans, Negroes and others" are all "true humans" and "mere varieties [*Spielarten*] of one and the same species" (Blumenbach 1806: 50). He disagreed with those who maintained that humans can be ordered into lower and higher races, emphasizing the arbitrariness of any attempt to draw boundaries between races. As a medical doctor and natural historian he made use of the newly established science of anatomy and its methodology of dissection by pointing out that the analysis of human skulls from different parts of the world proved "the unbounded transition" between species considered by others to represent incompatible opposites (1806: 68–69). Blumenbach was the founder of physical anthropology; it was he who coined the term "Caucasian," a term nowadays widely used as a name for white people; this term goes back to a skull of a Georgian (*Georgische*) female who he fancied must have been a most beautiful woman—according to European taste (1806: 70), as he conceded. Blumenbach therefore resisted the growing temptation to classify non-European humans as primitive or more animal-like. He was eager to learn about nature, about stones, plants, animals, and, among his most prominent endeavors, about mankind.

There existed a whole circle of open-minded scholars at Göttingen University; they were all interested in learning about the world beyond Europe. During their meet-

ings, they eagerly read and discussed travel literature. It is therefore not surprising that it was during that period in Göttingen where the terms *Völkerkunde* (ethnology, or anthropology) and *Ethnographie* (ethnography) were coined. The method and practice of ethnography, however, had been developed earlier by the German scholars who participated in expeditions initiated by Peter the Great to explore Siberia and Russian America. The most prominent among them in this respect was Gerhard Friedrich Müller (1705–1783), who in 1740 published an outline for the "Description of Customs and Mores of the Peoples" (*Von der Beschreibung der Sitten und Gebräuche der Völker*). It was through his work that the Göttingen historian A. L. Schlözer in 1771 and almost simultaneously his colleague J. Chr. Gatterer coined the terms *Ethnographie* (ethnography) and *Völkerkunde;* the Slovakian historian Adam Frantisek Kollár, then librarian at the court in Vienna, finally introduced the term *ethnologica* in 1783 (Vermeulen 2008); these terms as names for an awakening discipline subsequently spread around the world.

The Göttingen circle had excellent international connections with other scholars. The political situation favored such contacts: Since 1714, Hanoverians (descendants of the noble house of Hanover) had ascended to the British throne. Therefore, the electorate (*Kurfürstentum*) of Hanover, to which Göttingen belonged, was united with the island realm through personal union; King George II was also the founder of Göttingen University. Hanover is today the capital of Lower Saxony, about seventy miles north of Göttingen. It was these royal connections between Hanover and the British Crown—mainly King George III—that Blumenbach made use of in 1781 to receive a

Johann Friedrich Blumenbach (engraving by Casselis, 1793, Institute of Cultural and Social Anthropology, University of Göttingen).

share of what he called "the surplus of foreign natural curiosities, which in particular have been collected in larger quantities on the recently completed voyages around the world on Your Majesty's command" (Urban 1998b: 58). George III ordered that 349 (Nawa 2005) artifacts from the Cook voyages should be sent to the Academic Museum.

In this transfer, several prominent people were involved. An important intermediary function was played by the king's secret counsel, Christian Heinrich von Hinüber, a German and one of the first alumni of Göttingen University (Nawa 2005: 64), who had been in the service of the court in London for more than twenty years (Urban 1998b: 59). He seems to have assembled the collection for the Göttingen Academic Museum from a variety of sources, including a number of art dealers. A considerable amount apparently originated from the sale (forced by his creditors) of the private collection of George Humphrey, an art dealer who, as Kaeppler wrote, "simply went to the Resolution [the ship of the second voyage] when it docked and bought whatever he could from whomever he could" (1978: 44); he did the same after the third voyage (Kaeppler 1978: 47). Humphrey was not primarily interested in ethnographic artifacts but in seashells. Apart from direct purchases from the ships, Humphrey subsequently also bought artifacts that had already been in the possession of collectors and probably dealers as well. The artifacts von Hinüber obtained from Humphrey were carefully listed in a catalogue that accompanied the collection. Von Hinüber's efforts to satisfy Blumenbach's request seem to have been not solely determined by his attempts to carry out the orders of King George III (Nawa 2005: 64). It happened that von Hinüber's son was a student at Göttingen University at that time. In a letter to Blumenbach in which he described the progress he made in assembling the collection destined for Göttingen, he also recommended his son to Blumenbach's protection (Nawa 2005: 64); later, von Hinüber assisted Blumenbach once more in obtaining ethnographic items, and again his motivation for stocking the collection with additional artifacts went beyond the artifacts themselves.

The other substantial contribution from the Cook voyages to the Göttingen collection goes back to the Forsters, with whom Blumenbach and other scholars interested in travel literature and reports about the world outside Europe maintained close contact. The largest Forster collection (about 220 pieces) is housed today in the Pitt Rivers Museum in Oxford (Kaeppler 1998; Coote 1999; Coote, Gathercole, and Meister 2000); Johann Reinhold Forster had donated it to the Ashmolean Museum after receiving an honorary degree, doctor of civil laws, in November 1775 (Kaeppler 1998: 87). A few years later, in 1778, Georg Forster had been made a professor at Kassel, a city about forty miles south of Göttingen. He was made a corresponding member of the Königliche Societät der Wissenschaft (Royal Society of Science) in Göttingen when he visited Göttingen for the first time. He maintained a friendly relationship with many of his Göttingen colleagues, among them the philosopher Lichtenberg, and with C. G. Heine, the classical philologist and scholar of the ancient world who also was the director of the University Library. On his visits to Göttingen, Georg Forster now and then brought an artifact as a gift to the households of his colleagues. The daughter of one of his colleagues (Michaelis) received a bale of white Tahitian barkcloth, *tapa,* from him.

She had a shepherdess's costume made out of it and wore it to a ball. He also gave a *tapa* ball to Therese Heine (Urban 1998a: 55–56). Once again, the artifacts from the South Seas served as highly treasured gifts to establish and maintain social relations; the Forsters, both father and son, seem to have frequently used artifacts as gifts to express appreciation, affection, and, in the case of influential personalities, respect. Forster later married Therese, strengthening the relationship between colleagues by a family tie.

The greatest donation Forster made to the university was the herbarium, the outstanding collection of botanic material from the second voyage, unique in the whole world (Forster and Forster 1776). Later, the Forsters tried to sell parts of their ethnographic collection, probably for financial reasons; they did not succeed in this, even though they seem to have been prepared to sell at modest prices (Urban 1998b: 69). Georg Forster was not only a gifted scientist but also an ardent fighter for social justice. A social revolutionary, he died impoverished and in obscurity in 1794 as an emigré in Paris (Reichardt 1994b). His father, Johann Reinhold, at that time professor of natural history in Halle, survived his son by five years. He left his estate to his wife. Blumenbach once again became active and managed to have the ethnographic legacy, containing 160 artifacts, bought from Johann Reinhold's widow. The royal donation of 1782 and the Forster legacy of 1799 are the two major sources of the Göttingen ethnographic collection from the South Seas; other pieces acquired over several decades have added to the collection.

The World View of Cabinets of Curiosities and the Museum Turn

What were these artifacts, called "artificial curiosities," used for? First of all it is necessary to understand the fundamental shift in meaning that has taken place with the term "curiosities" and its German equivalent "*Merkwürdigkeiten*." In the seventeenth century the meaning of these terms was much closer to that of the original Latin words *curiosus* and *curiositas,* that is, "careful," "interested," "eager for knowledge," or "thirst of knowledge." *Curiositas*—and curiosity—was closely related to *cura,* that is "care," "cultivation," "inspection," and "curator." The slightly derisive connotations of the words today were absent at that time. And "artificial"—to mention another key expression—mostly had the meaning of "artistically or skillfully made, fabricated"; it was understood as the converse of "natural," that is, produced by nature without human interference. During the Enlightenment—and especially during Blumenbach's lifetime—the meaning of "curiosity" acquired an increasingly ironic connotation that implied a lack of system and scholarship. The same happened with the term "cabinet," which goes back to the context of private collections mostly owned by intellectuals and wealthy individuals during the late Renaissance. Such Renaissance cabinets were definitely inspired by the collections of relics and other treasures kept in churches. The churches were the first institutions that collected and displayed artifacts of foreign origin, often brought back by pilgrims to the Holy Land; they were pieces of collective memory and representation of almost magical power (Schlosser 1908).

The older cabinets contained natural and artificial curiosities (cf. Mauriès 2002). One of the most beautiful, the Francke collection, still exists in Halle, the old reformist

Most of the academic museums and collections had their origin in cabinets housing natural and artificial curiosities that were also used for teaching purposes like the one in the Franckesche Stiftungen in Halle/Saale. Photo: Klaus E. Göltz, Halle, 1998. Credit: Franckesche Stiftungen, Halle: AFSt/BM0489.

university city in Sachsen Anhalt, where Johann Reinhold Forster had been professor. The Francke collection was a cabinet (*Naturalienkammer*) established in 1698 in an orphanage that soon became a renowned educational institution. As this cabinet shows, the guiding principle was encyclopedic, an attempt to mirror the whole world. It was a great *theatrum mundi,* a world theater, that this sort of cabinet sought to represent (Bredekamp, Brüning, and Weber 2000). An attempt to convey to visitors the totality of the cosmos, with the world's and man's place in it, can be seen in the two astronomical models, each three and a half meters high, one representing the geocentric concept of

the universe according to Tycho Brahe and the other the heliocentric concept according to the theory of Copernicus. These models could be moved by cranks (Müller-Bahlke 1998: 118–119). Francke's goal was to convey his pupils into an almost infinite world of the sort that the awakening disciplines were beginning to explore. The cabinet was intended to facilitate theoretical explanations to contemporary fundamental questions about the cosmos, the complex world, and the place of all beings in it. This was achieved by presenting mathematical, mechanical, and astronomical models—analytical instruments as a means to understanding the guiding principles of the organization of the cosmos and the world—as well as natural and artificial curiosities; the exhibition was further supplemented by an impressive library of books and texts as well as pictures. The cabinet with its sixteen showcases reflected the order assumed to underlie the whole world. The showcases were beautifully decorated by the painter Gottfried August Gründler in 1741. Each showcase has a distinct subject such as inanimate nature (stones and minerals), plants from land and sea, animals (including specimens in formalin), and conchylia. A further showcase contained various astronomical measuring instruments, with mathematical and mechanical models. Six showcases displayed artifacts arranged under the headings of religion, everyday culture, clothing, pictures and portraits, the art of writing, as well as one regional section, India (from where missionaries had sent ethnographic objects to Halle). Outside the showcases were many additional exhibits, such as a huge crocodile, whale bones, and landscape models representing the holy land, Jerusalem, and the tabernacle (*Stiftshütte*) of Solomon's temple. Each item had its own number that was registered in a catalogue. Gründler was later dismissed for spending too much time decorating the cabinet; for this reason, some showcases have remained plain (Müller-Bahlke 1998).

The beautiful Kunstkamera und Naturalienkammer of Halle cannot be compared with the Academic Museum in Göttingen, which seems to have been much more sober in its academic view of the world. The shifting meaning of both "curiosities" and "cabinet" are reflected in the fact that the collection at Göttingen University was originally called "Naturalien-Kabinett" and only later "Academisches Museum" (Academic Museum), a title first mentioned in an article written by the German philosopher Georg Christoph Lichtenberg in 1779 (Nawa 2005: 58). Nevertheless, the Göttingen Academic Museum (sometimes called the Royal Academic Museum) was also rooted in a private collection, the Büttner collection. Christian Wilhelm Büttner, a natural historian and philologist at Göttingen University, was one of Blumenbach's most influential teachers. In his teaching, which was greatly inspired by travel literature, he focused on mankind and on man's activities and achievements by using artifacts from the cabinet he had initially inherited from his father (Plischke 1937: 2–3).

The layout of the Academic Museum and its exhibitions apparently did not substantially differ from the older private "cabinets." Today, the Institute of Cultural and Social Anthropology still owns some showcases that Blumenbach commissioned. The Academic Museum had no building of its own. The collections were first housed in the main university building (*Altes Kollegienhaus*) in a hall that had formerly been used as a medical auditorium; next to it were the library and the auditorium. So far no docu-

ments have been found to tell us in detail how the collection was arranged and how the artifacts were displayed. We only know that the museum was divided into four parts, one dealing with the history of mankind, including everything that belonged to the way of life and customs of remote people (*alles, was die Lebensart, eigenthümlichen Sitten und fremde Völkerschaften betrifft*). The second part contained "the rest of animal's world," the third plants, and the fourth minerals and stones. Only a few years later, however, the ethnographic collection was separated from the others and became a collection in its own right; the Academic Museum was moved in 1793 to another building where the ethnographic collection received two halls (Nawa 2005: 78–80).

The Academic Museum, the most prominent collection of which was that from Cook's voyages, primarily served teaching purposes. It is well known that Blumenbach often presented the artifacts as a source of knowledge and understanding to his students (Plischke 1937: 6). At that time, when no worldwide communication and transportation systems existed, they were used as a unique window to a world that was so far away. Blumenbach served the Academic Museum for sixty-seven years until his death in 1840; he taught several generations of academics about the varieties of mankind by using these artifacts (Urban 1998b: 84). Blumenbach's enthusiasm and deep knowledge attracted many students, some of whom became famous scholars, such as Alexander von Humboldt, Prince Max von Neuwied, Ludwig Burckhardt, and others.

As the conditions of the artifacts prove, Blumenbach treated these cultural documents with respect and care. None of them suffered any damage. He and his successors up to the present did their best to preserve them even in times of dramatic change and social turmoil, such as the Industrial Revolution and the two World Wars. Apart from being a teaching institution for students of various disciplines, the Academic Museum also became an attraction for visitors and scholars as well as for members of the educated elite from throughout Europe and beyond, a function it still has today.

New means of transportation and communication introduced in the twentieth and twenty-first centuries enabled the Cook/Forster Collection to be displayed in new settings and to achieve new significance. This became evident when the Göttingen collection traveled to Honolulu and subsequently to Canberra. In the first place, the objects were displayed and also perceived by the visitors as authentic documents of Pacific cultures that had been manufactured during a still precolonial era. They represented the life and beliefs of the ancestors before Christianization. In Canberra, the exhibition focused mainly on Cook and his achievements (Cook's Pacific Encounters 2006). In both exhibitions the same artifacts were endowed with different meanings depending on the setting and location of their display and the corresponding attitudes of the onlookers. Most of the Pacific Islanders visiting in Honolulu felt, as the visitors' book testifies, that the collection constituted a shared cultural heritage to be preserved for generations to come. The temporary "coming home" of the Göttingen collection to the Pacific became, however, involved in new, unanticipated contexts, those of local cultural politics with different camps and conflicting interests, and this unique return trip after more than two hundred years was unfortunately not able to bridge these difficulties (see Jolly 2008).

References

Berg, Eberhard, and Martin Fuchs, eds. 1993. *Kultur, soziale Praxis, Text. Die Krise der ethnographischen Repräsentation.* Frankfurt a.M.: Suhrkamp Wissenschaft.
Blumenbach, Johann Friedrich. (1775) 1795. *De generis humani varietate nativa. Praemissa est Epistola ad Josephvm Banks.* Gottingae: Vandenhoek & Ruprecht.
———. 1806. *Beyträge zur Naturgeschichte.* Göttingen: Heinrich Dieterich.
Bredekamp, Horst, Jochen Brüning, and Cornelia Weber, eds. 2000. *Theater der Natur und Kunst. Theatrum Naturae et Artis.* Berlin: Henschel.
Cook's Pacific Encounters. 2006. *The Cook-Forster Collection of the Georg-August University Göttingen.* Canberra: The National Museum of Australia.
Coote, Jeremy. 1999. "Computerizing the Forster ('Cook'), Arawe, and Founding Collections at the Pitt Rivers Museum." *Pacific Arts: The Journal of the Pacific Arts Association* 19: 48–80.
Coote, Jeremy, Peter Gathercole, and Nicolette Meister. 2000. "Curiosities Sent to Oxford. The Original Documentation of the Forster Collection at the Pitt Rivers Museum." *Journal of the History of Collections* 12 (2): 177–192.
Forster, Georg. 1989. *Reise um die Welt.* Vol. 1, 2. Berlin: Akademie-Verlag.
Forster, Johann Reinhold. 1996. *Observations Made During a Voyage round the World.* Edited by Nicholas Thomas. Honolulu: University of Hawai'i Press.
Forster, Johann Reinhold, and Georg Forster. 1776. *Characteres generum plantarum. Quas In Itinere Ad Insulas Maris Australis, Collegerunt, Descripserunt, Delinearunt, Annis MDCCLXXII–MDCCLXXV.* London: B. White, T. Cadell, & P. Elmsly.
Foucault, Michel. 1983. *This Is Not a Pipe.* Berkeley: University of California Press.
Gascoigne, John. 1994. *Joseph Banks and the English Enlightenment: Useful Knowledge and Polite Culture.* Cambridge: Cambridge University Press.
Hauser-Schäublin, Brigitta. 1998. "Exchanged Value—the Winding Paths of the Objects/Getauschter Wert—Die verschlungenen Wege der Objekte." In *James Cook: Gifts and Treasures from the South Seas/Gaben und Schätze aus der Südsee. The Cook/Forster Collection, Göttingen,* edited by Brigitta Hauser-Schäublin and Gundolf Krüger, 11–29. Munich, New York: Prestel.
Hauser-Schäublin, Brigitta, and Gundolf Krüger, eds. 1998. *James Cook: Gifts and Treasures from the South Seas/Gaben und Schätze aus der Südsee. The Cook/Forster Collection, Göttingen.* Munich, New York: Prestel.
Hoare, Michael E., ed. 1982. *The Resolution Journal of Johann Reinhold Forster 1772–1775.* Vol. I–IV. London: The Hakluyt Society.
Jolly, Margaret. 2008. *Moving Objects: Reflections on Oceanic Collections.* Keynote speech delivered at the Esfo conference in Verona (July 10, 2008).
Kaeppler, Adrienne. 1978. *"Artificial Curiosities." An Exposition of Native Manufactures Collected on the Three Pacific Voyages of Captain James Cook.* Bernice P. Bishop Museum Special Publication 65. Honolulu: Bishop Museum Press.
———. 1998. "The Göttingen Collection in an International Context/Die Göttinger Sammlung im internationalen Kontext." In *James Cook: Gifts and Treasures from the South Seas/Gaben und Schätze aus der Südsee. The Cook/Forster Collection, Göttingen,* edited by Brigitta Hauser-Schäublin and Gundolf Krüger, 86–93. Munich, New York: Prestel.
Kohl, Karl-Heinz. 2003. *Die Macht der Dinge: Geschichte und Theorie sakraler Objekte.* Munich: Beck.
Little, Stephen, Peter Ruthenberg, Brigitta Hauser-Schäublin, and Gundolf Krüger, eds. 2006. *Life in the Pacific of the 1700s,* vols. 1 and 2. Honolulu: Honolulu Academy of Arts.
Mauriès, Patrick. 2002. *Das Kuriositätenkabinett.* Köln: DuMont.

Müller-Bahlke, Thomas. 1998. *Die Wunderkammer. Die Kunst- und Naturalienkammer der Franckeschen Stiftungen zu Halle (Saale)*. Halle: Franckesche Stiftung Halle/Saale.

Nawa, Christine. 2005. "Sammeln für die Wissenschaft? Das Academische Museum Göttingen (1773–1840)." MA thesis, Georg August University Göttingen.

Plischke, Hans. 1937. *Johann Friedrich Blumenbachs Einfluß auf die Entdeckungsreisenden seiner Zeit*. Göttingen: Vandenhoeck & Ruprecht.

Reichardt, Rolf, ed. 1994a. *Weltbürger—Europäer—Deutscher—Franke: Georg Forster zum 200. Todestag*. Exhibition catalogue: Universitätsbibliothek Mainz, 10. Januar—27. Februar 1994, Niedersächsische Staats- und Universitätsbibliothek Göttingen, 7. April—6. Juni 1994. Mainz: Universitätsbibliothek.

Reichardt, Rolf. 1994b. "Zwischen Deutschland und Frankreich: Georg Forster als Mittler der französischen Aufklärungs- und Revolutionskultur." In *Weltbürger—Europäer—Deutscher—Franke: Georg Forster zum 200. Todestag*. Exhibition catalogue: Universitätsbibliothek Mainz, 10. Januar—27 Februar 1994, Niedersächsische Staats- und Universitätsbibliothek Göttingen, 7. April—6. Juni 1994, edited by Rolf Reichardt, 225–245. Mainz: Universitätsbibliothek.

Salmond, Anne. 2004. *The Trial of the Cannibal Dog. Captain Cook in the South Seas*. London: Penguin.

Schlosser, Julius von. 1908. *Die Kunst- und Wunderkammern der Spätrenaissance: ein Beitrag zur Geschichte des Sammelwesens*. Leipzig: Klinkhardt & Biermann.

Thomas, Nicholas. 2004. *Discoveries: The Voyages of Captain Cook*. London: Penguin.

Uhlig, Ludwig. 2004. *Georg Forster: Lebensabenteuer eines gelehrten Weltbürgers (1754–1794)*. Göttingen: Vandenhoeck & Ruprecht.

———. N.d. *Hominis historia naturalis. Georg Forsters Vorlesung von 1786/87 im Zusammenhang mit seiner Anthropologie*. Unpublished manuscript.

Urban, Manfred. 1998a. "Cook's Voyages and the European Discovery of the South Seas/Cooks Reisen und die europäische Entdeckung der Südsee." In *James Cook: Gifts and Treasures from the South Seas/Gaben und Schätze aus der Südsee. The Cook/Forster Collection, Göttingen*, edited by Brigitta Hauser-Schäublin and Gundolf Krüger, 30–56. Munich, New York: Prestel.

———. 1998b. "The Acquisition History of the Göttingen Collection/Die Erwerbungsgeschichte der Göttinger Sammlung." In *James Cook: Gifts and Treasures from the South Seas/Gaben und Schätze aus der Südsee. The Cook/Forster Collection, Göttingen*, edited by Brigitta Hauser-Schäublin and Gundolf Krüger, 56–86. Munich, New York: Prestel.

Vermeulen, Han F. 2008: "Göttingen und die Völkerkunde. Ethnologie und Ethnographie in der deutschen Aufklärung, 1710–1815." In *Die Wissenschaft vom Menschen in Göttingen um 1800*, edited by H. E. Bödeker, P. Büttgen, and M. Espagne, 199–230. Göttingen: Vandenhoeck & Ruprecht.

Wagner, Roy. 1979. *The Invention of Culture*. Chicago: Chicago University Press.

PART I

Early Encounters

Histories of the Before
Lelu, Nan Madol, and Deep Time

David Hanlon

From the "Sea of Little Lands" to "Our Sea of Islands"

During his end-of-century tour through what he called the "sea of little lands," the British anthropologist F. W. Christian (1899a) visited Nan Madol on the island of Pohnpei in the Eastern Caroline group of the larger Micronesian geographical area. In three separate visits to the ruins in March of 1895, Christian surveyed the entire site, made maps, and took photographs of the larger, more prominent islets of Nan Dauwas and Pahn Kadira; he also conducted excavations of several tombs on Nan Dauwas, from which he took a substantial collection of beads and shell burial goods. Christian supplemented his description of Nan Madol with selective, self-serving, and liberally interpretive accounts of Pohnpeian traditions concerning the site.

Despite an avowedly scientific posture, Christian's ideas reflected the late nineteenth century's essentially racialist—often racist—approach to issues involving the origins and migrations of Pacific peoples. Christian held Pohnpei's settlement to be the result of separate waves of migration, most of which had moved eastward from the Malay archipelago beginning some one thousand years ago. He described Pohnpeians as a branch of a widely dispersed Malay family that linked the inhabitants of the Caroline Islands with the people of Formosa, Borneo, the Philippines, and the Marianas. According to Christian, a later party of Japanese migrants sweeping down upon the island from the northwest proved the most prominent and influential of the island's settler groups. It was they, argued Christian, who were most responsible for the building of Nan Madol. The upward sweep of the junction of the northern and western walls of Nan Dauwas provided concrete testament, believed Christian, to this Japanese influence.

Christian saw only degeneration and decline in the history that followed Nan Madol's construction. A centuries-old pattern of racial mixing had diluted the ingenuity and talents of Nan Madol's builders. Christian held contemporary Pohnpeians and indeed all Caroline Islanders to be a "strange apathetic folk, with all of the Malay naivete, and alas! some of the Malay treachery—in a word endowed with all of the strange power and strength and equally strange weaknesses and limitations of the Malay" (Christian 1899b: 288). Christian read a similar history into the ruins of Lelu (also spelled Leluh) on Kosrae, which he visited the following year.

The similarity between the two sites struck Christian. While not as elaborately constructed as Nan Madol, Lelu, wrote Christian, possessed a "rude and massive grandeur" of its own (Christian 1899a: 157). He drew a partial map of the ruins that centered on the compound of Kinyeir Fulat, but he carried out no excavations. He did, however, develop a theory on the identity of the builders of Lelu that mirrored his explanation of Nan Madol's origins. Lelu, he argued, was settled by Japanese from either a wrecked junk or from one of the early trading vessels that plied the Pacific from the port of Nagasaki before the Tokugawa interdicted such voyaging in 1640. Christian supported his theory with reference to more contemporary drift voyages and shipwrecks from Japan, alleged Kosraean legends that spoke of a foreign race of builders who came on ships from the northwest, and parallel accounts from Pohnpei that spoke of contact between the two islands.

Christian's writings represent an older, decidedly colonial archaeology that sought to make evolutionary sense of Lelu and Nan Madol. Like those before him and after him, he read his times, his prejudices, his politics, and his moral values into the ruins. In so doing, he appropriated science to the cause of colonialism. There was imperial opportunity in the gap between the magnificence of the ruins and the allegedly demoralized, impoverished, racially diluted descendants of those who built them. Science would close this gap by replacing the silences with explanations, while colonialism arrested the social decline with development programs and civilizing projects. Lelu, Nan Madol, and sites like them were manipulated to serve as powerful symbols that justified the colonization of the Pacific and its people.

I use Christian's accounts as a vehicle for the reconsideration of the historical relationship or links between Lelu and Nan Madol. Borrowing from Greg Dening's (2004) concept of deep time, I write of the ways in which archaeology might again be history, and in support of the project that would relax if not eliminate the distinction between history and prehistory. In so doing, I argue for a reconceptualization of the practice of history in this "sea of little lands," and in a way that escapes colonial notions of time, event, sequence, and space in favor of an understanding of history that is at once more locally grounded and expansive. Put another way, I argue for an approach to the past that facilitates the transformation of Christian's "sea of little lands" into what the Tongan writer Epeli Hau'ofa (1994) has called "our sea of islands." At the same time, I see the cultural transformation that resulted from the voyaging contact between Kosrae and Pohnpei as precedent for the changes brought to the two islands by later contact with the Euro-American world. The contexts of these later encounters differed as did the nature of the social interaction between natives and strangers. There was continuity, nonetheless, in the historically specific, culturally informed transformation of traditions and their meanings.

As preface to these arguments, I offer a summary description and comparison of Lelu and Nan Madol borrowed from more recent archaeological investigations. I rely primarily on the works of Athens (1980, 1981, 1990, 1995), Ayres (1990), Ayres and Haun (1985), Ayres, Haun, and Mauricio (1983), Bryson (1989), Cordy (1993), Hambruch (1932–1936), Kirch (2000), and Rainbird (2004) for this overview. In referenc-

ing this work, I do not mean to elide archaeology's entanglement with colonial and colonizing projects. I choose, though, to emphasize its more collaborative and affirming features and the ways in which it might be refashioned to serve more local and indigenous purposes.

Revisiting Lelu and Nan Madol

Both Lelu and Nan Madol are stunning in their dimensions and in the general features of their architecture. The Japanese archaeologist Iwakichi Muranushi captured a sense of the awe the two sites continue to inspire. Muranushi wrote that the megalithic ruins at Lelu, "like the magnificent megalithic structures at Nan Madol, are massive unworked natural rocks used in their original state, and even in the context of the structures of ancient megalithic cultures they can be said to be ruins which cannot be compared to any others in the world" (Cordy 1993: 1). William Morgan, a noted architect, claims that "no site in Oceania surpasses the dramatic beauty of Nan Madol" (Morgan 1988: 68). Its artificial islets linked by canals have caused Morgan and others to describe Nan Madol as the "Venice of the Pacific."

Both Kosrae and Pohnpei are high volcanic islands separated by 550 kilometers of ocean. Linguistic and archaeological evidence indicates that eastern Micronesia, of which Kosrae and Pohnpei are a part, was settled during the late phase of Lapita expansion, and from an area between the Bismarck archipelago and the Southeast Solomons–Vanuatu region (Kirch 2000). Both Kosraean and Pohnpeian are classified as nuclear Micronesian languages within the Oceanic subgroup of the Austronesian language family. Easterly trade winds and an accompanying easterly swell dominate the seas around the two islands for most of the year. There is seasonal variation characterized by a diminution of the trades during the middle months of the calendar. Kosrae's location on the boundary between the west-flowing north equatorial current and the east-flowing north equatorial countercurrent would have complicated but not prohibited voyaging contact with Pohnpei. While both islands eventually lost the navigational skills that allowed for their respective settlements, local histories, linguistic evidence, and archaeological data all indicate contact between Kosrae and Pohnpei.

Kosrae lies east-southeast of Pohnpei and covers a total land area of 109 square kilometers. Its highest peak rises 629 meters above sea level. Lelu Island sits on a flat reef just off the northeast side of the main island; the megalithic complex, which was built over time as an extension of its western shore, covers twenty-seven hectares and consists of walled compounds, most of which functioned as residences and a few as tombs (Cordy 1993). Paved paths connected the compounds and a canal traversed the center of the site, providing maritime access for its inhabitants. While the dating of early pottery points to the first century AD as the start of human habitation, megalithic construction at Lelu began in the period from 1250 to 1400 AD. The archaeological record suggests an intensification of construction from 1400 to 1600 AD and in what became the core of Lelu. Residential compounds such as Kinyeir Fulat and Lurun are distinguished by stacked prismatic basalt walls six meters high. A third construction phase occurred from 1600 to 1650 AD; walls made of rounded basalt boulders that

Map of Lelu (Cordy 1993: 319; used with permission).

averaged four to five meters in height are said to be characteristic of this period. A final building period took place from 1650 to 1800 AD and is marked by more modestly built walls of mixed coral stones that vary in height from 1 to 1.4 meters.

The theories used to explain the appearance and expansion of Lelu focus on the development of political stratification resulting in a complex chiefly polity. Cordy (1993) posits an early Kosraean society divided between chiefs and commoners that witnessed the emergence of a second but lower chiefly strata as a consequence of social unification on the main island. The imposition of a fourth and paramount chiefly tier resulted from island-wide consolidation and took place during the time of intensified construction at Lelu, the period from 1400 to 1600 AD. These sociopolitical changes were driven by population growth that led to imbalance and competition over land and sea resources among local polities. Cordy's theory is seconded by Athens (1995) whose excavations of 109 different sites on the main island indicate the start of significant population growth at about 500 AD with an intensification in 800 AD that continued for another four hundred years. The emergence of a chiefly hierarchy has also been the focus of much archaeological research on Pohnpei.

Larger than Kosrae, Pohnpei possesses a total land area of 334 square kilometers. Eleven mountainous peaks dominate the interior, all of which stand at least 600 meters high and with the largest being 729 meters. A fringing reef, which includes small coral and volcanic islands, encompasses a lagoon that covers 178 square kilometers. Nan

Nan Madol, by the German anthropologist Hambruch (1936: 20).

Madol abuts Temwen Island, which lies just off the southeastern coast of the main island of Pohnpei in the modern-day municipality or chiefdom of Madolenihmw. There is the immediate complex of ruins at Nan Madol and the larger area of Deleur of which Nan Madol was a part. Deleur, an older name for the core area of what became Madolenihmw, covers 47 square kilometers, with Nan Madol as its southern boundary.

The main complex of Nan Madol consists of ninety-three artificial islets and linking channels built on the reef adjoining Temwen Island (Bryson 1989). A combination of seawalls and constructed islets border Nan Madol on the northeast, southeast, and southwest sides, with Temwen Island to the northwest. Immense columns of prismatic basalt rock, quarried from various locations on the island, provide the foundations and walls for Nan Madol's islets. The individual islets vary in size, internal structural complexity, and architectural style. Archaeologists explain the construction of the massive walls with reference to the principles of the wedge, the inclined plane, and the greased pulley and to a systematic stacking technique that alternated headers with cross columns to form rectangular structures. Nan Madol's builders used smaller boulders, boulder fragments, and coral rubble as fill for the islets' floors.

The name Nan Madol translates as "in the space between things" and refers most immediately to the intricate network of tidal channels and waterways that border the inner islets and provided a means of communication and travel for their occupants. Lelu was an active, inhabited site when the French explorer Louis Isadore Duperrey stopped at Kosrae in 1824 (Cordy 1993); early written accounts of contact with Pohnpei indicate that Nan Madol had been largely abandoned before 1836 (Campbell 1836).

Whereas much of what is known about Lelu derives from the accounts of early nineteenth century French and Russian voyagers, Nan Madol's histories are more locally generated and exist significantly apart from contact or encounter literature, travel writing, missionary reports, and, even later, more professional ethnographies (Bernart 1977; Hadley 1981a). These local histories suggest that Nan Madol was divided into two separate sections: Madol Powe and Madol Pah.

Madol Powe or "Upper Madol" covers the northeast half of the complex and includes the remains of priestly residences and sites associated with ritual activity (Bryson 1989). Nan Dauwas is the best known of Madol Powe's islets because of its prominent location, its impressive size, and its multiple construction features. At eight meters, the walls of Nan Dauwas are the highest in the entire complex and utilize columns nearly a meter in diameter and several meters in length. Madol Pah or "Lower Madol" is made up of islets in the southwestern half of the complex that served more secular purposes. Of these, Pahn Kadira is perhaps the most notable. L-shaped, it covers an area of 12,770 square meters, has thirty-nine significant features and ninety-eight subfeatures, and is recorded in various histories of Nan Madol as the residence of the Saudeleur, the ruler of Nan Madol. Pahn Kadira is similar in construction style to Nan Dauwas but smaller in scale. Archaeologists speculate that the variation in layout and architectural complexity of the islets, which includes the quantity and size of basalt prisms, may represent differences in functions, construction periods, or the status of their occupants (Athens 1980, Ayres, Haun, and Mauricio 1983, Bath 1984a).

Earliest human habitation of the Nan Madol area dates to about 1 AD. Drawing from ceramic-bearing deposits taken from the tidal zone under the fill of Nan Madol's artificial islets, archaeologists believe the first occupation of Nan Madol consisted of stilt-houses of the Lapita type situated over the flat reef (Kirch 2000). The construction of elevated, artificial islets had commenced by 900 to 1200 AD. A phase of truly megalithic building occurred in the period from 1200 to 1600 AD. Unlike Lelu, where the megalithic construction appears to have been locally motivated, the building of megalithic structures at Nan Madol is associated in the island's histories with the arrival of a foreign party from Katau Peidi or "downwind Katau" led by two men, Ohlosihpa and Ohlosopha (Bernart 1977; Hadley 1981a). Nan Madol, then, contrasts with Lelu in that it is a site created by people from elsewhere whose presence and ambitions elicited from the inhabitants of Pohnpei initially enormous, possibly cooperative labor, later tribute, and ultimately resistance. Archaeological surveys in other parts of the island have uncovered similar megalithic architecture that points to Nan Madol's architectural and political influence over Pohnpei proper (Bath 1984b).

As with Kosrae, theories or models have been advanced for the evolution and transformation of Pohnpeian society over the last two millennia. The development of a chiefly hierarchy is clear, although the role of religious motivation as opposed to coercion is less so. In reference to both Kosrae and Pohnpei, Peoples (1990) favors a coercive rather than functionalist model to explain the increase in chiefly power through administrative control. Bath and Athens (1990) argue for a period of centralized power located at Nan Madol and around the title of the Saudeleur; this foreign hierarchy failed to sustain

An aerial photograph providing a partial view of Nan Madol. Temwen Island, Madolenihmw Harbor, the precipice Takaiuh, and the mainland of Pohnpei can all be seen in the background. The large, high-walled structure in the right foreground is the islet of Nan Dauwas, marked as item 113 on Hambruch's map of Pohnpei (courtesy of J. Stephen Athens, International Archaeological Research Institute, Inc.).

itself and gave way to a more local and diffused system of chiefly rule. Others have pointed to the intensification of agriculture as a significant aspect of the Pohnpeian economy that made possible social stratification, the evolution of a chiefly system, and the construction of Nan Madol (Ayres and Haun 1985).

Archaeological Comparisons

Comparisons between Lelu and Nan Madol are certainly not new (Hale 1846, Hambruch 1932–1936, Cordy 1993). A range of observers from casual visitors to professional archaeologists have noted the similarities between the two sites. But there are differences as well. Cordy (1993) notes that Nan Madol is characterized by a complex of small islets scattered between Temwen and the site's outer seawalls and islets. Numerous canals traverse the watery space between these islets. Lelu, on the other hand, is a contiguous site crossed by a single canal system. Architectural variations between the two sites include foundations and funerary structures. Nan Madol's roofed structures sat atop raised platforms whereas Lelu's rested on paved surfaces. Nan Madol's tombs are rectangular in shape and covered with pieces of prismatic basalt; some are rectangular crypts sunk into islet foundations and covered again with the same prismatic basalt pieces. All but one are found on the seaward side of the site. Lelu's tombs have been described as rectangular truncated pyramids; they are located at the center of the complex amidst chiefly residential complexes.

The restored path between Kinyeir Fulat and Pensa. Kinyeir Fulat is to the left (courtesy of Ross Cordy).

There are also differences in wall construction between the two sites (Cordy 1993). Nan Madol's walls are built of stacked, intersecting columnar basalt boulders, with only minor variation in this general style. Lelu shares Nan Madol's predominant form of wall construction but includes other and simpler walls as well. In general, Nan Madol's walls are well made and have survived nicely. The facings are vertical and the fittings tight; gaps are filled with smaller rocks. The quality of Lelu's surviving walls varies considerably, with more recent construction being modest in form, fitting, and durability. Both sites evidence variation in the height of their walls and the function of the enclosed sites. Nan Madol's highest walls are those that surround burial compounds, while the surrounding walls for ceremonial sites and dwelling compounds are in general smaller. At Lelu, this pattern is reversed.

There is a difference too in the profile of the sites' residents (Cordy 1993). Most archaeological and oral historical evidence for Nan Madol indicates occupation by a privileged, initially foreign class of people. At Lelu, physical remains and early European accounts indicate that common people resided on the outskirts of the site, with lesser chiefs occupying dwelling compounds on the main island. Archaeological findings also point to a variation in mortuary practices. Nan Madol's tombs were actual burial sites. Lelu's tombs appear to have been temporary repositories with cleansed remains later placed in recessed areas on the surrounding reef. Both sites also included a number of nearby, built-upon islands where associated activities or functions took place.

This litany of differences, however, should not obscure the similarities of the two sites. As Cordy (1993) notes, both Lelu and Nan Madol are extended from small, coastal islands and incorporate canals into their layout. Both contain walls made of stacked prismatic basalt columns that surround tombs, residential compounds, and sites for sacred or ceremonial activities. Lelu and Nan Madol share a similar inventory of artifacts that include necklaces, arm rings, "trolling lure" ornaments, lancet and disc-

A corner wall of the residential compound at Lurun (courtesy of Ross Cordy).

shaped bead necklaces, and large kava pounding stones. A major similarity is clearly the concept of a walled compound built on artificially extended land. While Cordy sees this artificial extension as being locally generated, the construction of a major and separated governing center is a concept of a different order. "The coincidence," he writes, "is a bit too great to consider independent development" (Cordy 1993: 270). Drawing from the extant architectural record, Cordy concludes that contact between Kosrae and Pohnpei occurred, though the differences between the two sites suggest this contact was sporadic and limited. Rainbird (2004) agrees with Cordy, though he sees the similarities between the two sites as speaking not to the development of sociopolitical organization but to the importance of genealogy and place in negotiations over power.

Histories

The oral histories from these two islands add further evidence to the case for contact and exchange. There is a substantial body of transcribed and translated oral histories of Nan Madol that describe its construction, development, and decline. These, as Glenn Petersen (1990) notes, are partial, often ambiguous, and conflicting histories that are difficult to date or sequence and that are referenced to individuals, places, practices, and events not easily aligned with cultural memories and current language usage. Care needs to be taken in assessing this evidence, but they are nonetheless histories. A place called Katau figures prominently in the accounts of Nan Madol's decline as a site of governance and power. Several of these accounts indicate Katau to be the island where the Pohnpeian thunder god, Nahn Sapwe, fled after his escape from Nan Madol and the wrath of the Saudeleur (Hambruch 1936; Hanlon 1988). It is on Katau that Nahn Sapwe joins with a local woman to produce a son, Isohkelekel, who later returns to Pohnpei to restore his father's honor and to end the rule of the Saudeleurs at Nan Madol. The identification of Katau figures prominently in the question of contact between Kosrae and Pohnpei. Ward Goodenough (1986) argues that Katau or Kachaw is a generic, pan-Micronesian term that refers to the other or sky world and is not the name of any specific place or island. Twentieth-century Pohnpeian historians Luelen Bernart (1977) and Masao Hadley (1981b) do not explicitly identify Katau with Kosrae; their editors and translators do, however (Fisher, Riesenberg, and Whiting 1977; Hadley 1981a).

The accounts of the fall of Nan Madol have a rough, Kosraean counterpart in the story of Selbasr who leaves Kosrae for Pohnpei to defeat the Saudeleurs and establish a whole new order of governance there. According to the Kosraean account as recorded by the German anthropologist Ernst Sarfert (1920), there is a war between the Kiti and Madolenihmw sections of Pohnpei. Kiti sends messengers to the paramount chief of Kosrae, the Tokosra, asking for assistance. The message is contained in a coconut brought by the messengers, who promptly hide themselves upon arrival at Kosrae. An old woman finds and eats the coconut, becomes pregnant, and later gives birth to Selbasr. Selbasr grows up to be a young man who possesses exceptional abilities. Accompanied by 333 Kosraean warriors, Selbasr sails to Pohnpei, where his party twice fights to a draw with forces from Kiti. The stalemates end when Selbasr defeats Kiti's premier warrior in a duel. The Kosraean forces, continues this history, go on to conquer

the entire island, killing all its inhabitants and leaving behind a couple to restore the population. Before the departure of the Kosraean forces, Selbasr ends his life and commemorates his conquest of Pohnpei by turning himself into a rock on the Kiti coast that comes to be called Neparak.

The differences between the Kosraean account of Selbasr and the Pohnpeian histories of Isohkelekel are many and considerable. In a composite account drawn from several sources (Hanlon 1988), Isohkelekel is hospitably received upon his arrival at And off the western coast of Pohnpei and eventually makes his way to the eastern side of the island, where he is hosted and fed, albeit suspiciously, by the Saudeleur. A fight breaks out between Isohkelekel's men and the Saudeleur's Pohnpeian allies. The battle is joined and the forces of Nan Madol and their local allies appear poised to carry the day when one of Isohkelekel's lieutenants, Nahnesen, described as the fiercest and most capable of Katauan fighters, thrusts a spear into his foot and declares that there will be no further retreat from where he stands. This act of bravery stems the tide of battle and allows Isohkelekel's men and his Pohnpeian allies to carry the day. Nan Madol falls and the Saudeleur flees to a pond in the north where he transforms himself into a small red fish. Isohkelekel then establishes a new, more localized form of chiefly government that spreads to other areas of the island. Isohkelekel later tires of life and kills himself in dramatic fashion, but not before leaving behind an heir to govern an expanded Deleur, later to be called Madolenihmw.

The discrepancies between these two histories are also significant. The names Kiti and Madolenihmw in the Kosraean account, for example, are actually terms referring to more recent political entities that postdate the decline of Nan Madol. We cannot dismiss the possibility of some revision, adjustment, error, or editorial conflation that affects this particular history. We need then to caution ourselves against assuming that Selbasr is Isohkelekel and that the two accounts are about the same event, the fall of the Saudeleurs. Still, the similarities are striking and the accounts independent enough of one another to further substantiate the connection and contact between Nan Madol and Lelu.

There is other research that might further elucidate these connections, including greater paleobotanical analysis and a more rigorous comparison of recovered artifacts. Multiple citations in local histories and the ethnohistorical and anthropological literature invite more comparative investigations. An examination of Lelu's core ceremony of renewal, the *epang,* with Nan Madol's *pwung en sapw* could establish the existence of shared rituals and beliefs. There are also names and descriptions of local deities whose attributes and domains are similar and whose identities and histories might be linked. There is Lelu's Sitel Nosounsap, a spirit associated with thunder, lightning, and the turtle, whose own genealogy might draw from Nan Madol's principal deity Nahnisohnsapw, Pohnpei's thunder god Nahn Sapwe, and other remarkable beings including the eel god Nahn Samwohl and the turtle woman Liahnensokole.

The exact initiation, direction, dimensions, and sequencing of contact between Lelu and Nan Madol remain uncertain. Some scholars have posited a connection between the builders of Lelu and those who commanded the construction of Nan Madol. Kosraean

histories indicate that Isohkelekel was Kosraean and that the impetus for contact and conquest are found in Kosrae. Pohnpeian accounts identify Isohkelekel as the son of the thunder god Nahn Sapwe and a Katauan woman whom he slept with while in exile. The earlier dates for the building of Nan Madol persuade still others that Pohnpei inaugurated contact with Kosrae, resulting in the construction of Lelu and the political stratification of Kosraean society.

Imagining Deep Time

What is known about Lelu, Nan Madol, and the nature and extent of the contact between them is not enough to escape the bonds of prehistory, a designation based on the division of indigenous pasts into the before and after periods of contact with the Western world. With reference to the antihistorical prejudice of British functionalism, Greg Dening (2004) writes of the dividing moment or zero point between a *Before* time, when indigenous cultures were presumed to have been pure, and an *After* encounter time with the Euro-American world, when they were assumed to have become adulterated or corrupted. The intimate ongoing relationship between past and present leads Dening to see this distinction between history and prehistory as false. "The disappearance of the zero point," he writes, "involves the blurring of the division between a *Before* and *After*, when apparent discontinuities and separations or distinctions are

The exterior west wall of Nan Dauwas (courtesy of J. Stephen Athens, International Archaeological Research Institute, Inc.).

transformed in the continuities of living" (Dening 2004: 51, emphasis added). It is this blurring of divisions, this recognition of the continuity of living, that recognizes Lelu and Nan Madol as having linked histories, not prehistories.

This recognition of prehistory as actually history is slow in coming for the islands of the area called Micronesia. Much of the history of this region is rendered through a litany of periods that begins with first encounters and then moves on to the Spanish, German, Japanese, British, Australian, and American colonial periods. The deeper, pre-contact pasts receive only prefatory comment if they receive any acknowledgment at all. The dilemma is evident in the title of Francis X. Hezel's oft-cited history, *The First Taint of Civilization: A History of the Caroline and Marshall Islands in Pre-Colonial Days, 1521–1885* (1983). The temporal markers of this history are Magellan's landing at Guam and the establishment of formal colonial rule over the Caroline Islands by Spain in 1885. Hezel describes the histories of these islands prior to contact with the West as irrevocably lost, buried under sand and sea, and forgotten. For Hezel, Europeans and Americans are the catalysts of change and the most appropriate subjects around which to organize the more recent, accessible, and documented past of the islands.

If the Micronesian past is accessible only through its engagement with colonialism and external accounts of that engagement, then it will remain elusive and largely unknown. Dening's solution for transcending the limitations of this approach is a recognition of deep time. Lelu and Nan Madol are part of that deep time. To know deep time requires an entrance into the ways earlier people knew themselves and understood their world. In the case of Lelu and Nan Madol, we need to wonder imaginatively and marvel responsibly about the building of the two sites; about the beliefs, aspirations, and ambitions that motivated their construction; about the seasons, rituals, protocol, and daily practices that informed life in these special places and over centuries; and about the contact and exchange between them.

Dening's words second those of Epeli Hauʻofa (1994), who has written about the need for Pacific peoples to do their own histories, and in ways that reflect the distinctive relationships that Pacific peoples have had with their land, the surrounding sea, their gods, ancestors, and each other. Hauʻofa argues for a focus that privileges not colonial time, but concurrent and previous relationships between or among Oceanic peoples. Pan-Pacific voyaging, Melanesian and Micronesian trade networks, the worship of ʻOro, the prominence of Rarotonga in the development of Polynesian religions, and the contact, interaction, and movement among western Polynesia are more meaningful and appropriate topics through which to write, speak, or think of history in the Pacific.

I return to the name Nan Madol, which translates into English as "in the space between things." It refers most immediately to the channels or canals that separate the ninety-three human-made islets that make up the site. I see here a metaphor that invites us to do histories that do not privilege Euro-American understandings of the past but focus instead on historical relationships between or among Pacific peoples and across the spaces they traveled. This chapter is about imagining those earlier times and the different, re-emergent histories made possible as a result of this employment of imagination. If we can escape the strictly empirical or positivist schools of thought

in which many of us were trained, we might be able then to develop a more expansive understanding of the past that challenges the still-held distinction between history and prehistory. We might be able to better marvel at the contact, encounters, engagement, exchange, appropriation, and adaptation among different peoples in the Micronesian geographical area, contact that at once predates interaction with European and American worlds and also provides pattern and precedent for the later, equally transforming encounters with these other worlds.

References

Athens, J. Stephen. 1980. *Archaeological Investigations at Nan Madol: Islet Maps and Artifacts.* Guam: Pacific Studies Institute.

———. 1981. *The Discovery and Archaeological Investigations of Nan Madol, Ponape, Eastern Caroline Islands: An Annotated Bibliography.* Rev. ed. Micronesian Archaeological Survey Report 3. Trust Territory Historic Preservation Office, Saipan.

———. 1990. "Nan Madol Pottery." In *Recent Advances in Micronesian Archaeology,* edited by Rosalind L. Hunter-Anderson. A Special Issue of *Micronesica.* Supplement No. 2: 17–32. Mangilao: University of Guam Press.

———. 1995. *Landscape Archaeology: Prehistoric Settlement, Subsistence, and Environment of Kosrae, Eastern Caroline Islands, Micronesia.* Archaeological Data Recovery Investigations for the Kosrae Wastewater Project. Honolulu: International Archaeological Research Institute.

Ayres, William S. 1990. "Pohnpei's Position in Eastern Micronesian Prehistory." In *Recent Advances in Micronesian Archaeology,* edited by Rosalind L. Hunter-Anderson. A Special Issue of *Micronesica.* Supplement No. 2: 187–212. Mangilao: University of Guam Press.

Ayres, William S., and Alan E. Haun. 1985. "Archaeological Perspectives on Food Production in Eastern Micronesia." In *Prehistoric Intensive Agriculture in the Tropics,* edited by I. S. Farrington, 455–473. B.A.R. International Series 232. Oxford: British Archaeological Reports.

Ayres, William S., Alan E. Haun, and Rufino Mauricio. 1983. "Nan Madol Archaeology: 1981 Survey and Excavations." Submitted to the Pacific Studies Institute, Guam, to the Historic Preservation Committee, Ponape State, Federated States of Micronesia, and the Historic Preservation Program, Trust Territory of the Pacific Islands, Saipan.

Bath, Joyce E. 1984a. "Sahpwtakai: Archaeological Survey and Testing. Micronesian Archaeology Survey Report 14." Trust Territory Historic Preservation Committee, Saipan.

———. 1984b. "A Tale of Two Cities: An Evaluation of Political Evolution in the Eastern Caroline Islands of Micronesia Since A.D. 1000." PhD dissertation, University of Hawai'i at Mānoa.

Bath, Joyce E., and J. Stephen Athens. 1990. "Prehistoric Social Complexity on Pohnpei: The *Saudeleur* to *Nahnmwarki* Transformation." In *Recent Advances in Micronesian Archaeology,* edited by Rosalind L. Hunter-Anderson. A Special Issue of *Micronesica.* Supplement No. 2: 275–290. Mangilao: University of Guam Press.

Bernart, Luelen. 1977. *The Book of Luelen.* Translated and edited by John L. Fischer, Saul H. Riesenberg, and Margaret G. Whiting. Pacific History Series 8. Honolulu: University Press of Hawai'i.

Bryson, Robert Usher. 1989. "Ceramics and Spatial Archaeology at Nan Madol, Pohnpei." PhD diss., University of Oregon.

Campbell, Dr. 1836. "Island of Ascension." *The Colonist, New South Wales* 2 (78) (22 June). Reprinted in R. G. Ward, ed., *American Activities in the Central Pacific, 1790–1870,* vol. 6, 126–139. Ridgewood, N.J.: The Gregg Press, 1967.

Christian, F. W. 1899a. *The Caroline Islands: Travel in the Sea of Little Lands.* London: Methuen.
———. 1899b. "On Micronesian Weapons, Dress, Implements, etc. . . ." *The Journal of the Anthropological Institute of Great Britain and Ireland* 1: 288–306.
Cordy, Ross. 1993. "The Lelu Stone Ruins (Kosrae, Micronesia): 1978–1981 Historical and Archaeological Research." Asian and Pacific Archaeology Series No. 10. Social Science Research Institute, University of Hawai'i at Mānoa, Honolulu.
Dening, Greg. 2004. *Beach Crossings: Voyaging Across Times, Cultures, and Self.* Philadelphia: University of Pennsylvania Press.
Fischer, John L., Saul H. Riesenberg, and Marjorie G. Whiting, trans. and eds. 1977. *Annotations to the Book of Luelen.* Pacific History Series 9. Honolulu: University Press of Hawai'i.
Goodenough, Ward H. 1986. "Sky World and This World: The Place of Kachaw in Micronesian Cosmology." *American Anthropologist* 88: 551–568.
Hadley, Masao. 1981a. "A History of Nan Madol." Manuscript translated and edited by Paul M. Ehrlich. Copy in author's possession.
———. 1981b. "Koasoi en Kanihmw en Nan Madol." Manuscript edited by Paul M. Ehrlich. Copy in author's possession.
Hale, Horatio. 1846. *Ethnology and Philology.* Vol. 6 of *A Narrative of the United States Exploring Expedition During the Years 1838, 1839, 1840, and 1841.* Philadelphia: C. Sherman, Philadelphia; Reprint 1967. Ridgewood, N.J.: Gregg Press.
Hambruch, Paul. 1932–1936. *Ponape.* 3 vols. Ergebnisse der Südsee Expedition, 1908–1910. G. Thilenius, ed., II, Ethnographie, B, Mikronesien, Bd. 7. Hamburg: Friederichsen, DeGruyter und Co.
Hanlon, David. 1988. *Upon a Stone Altar: A History of the Island of Pohnpei to 1890.* Pacific Islands Monograph Series 5. Honolulu: University of Hawai'i Press.
Hau'ofa, Epeli. 1994. "Our Sea of Islands." *The Contemporary Pacific* 6 (1): 147–161.
Hezel, Francis X. 1983. *The First Taint of Civilization: A History of the Caroline and Marshall Islands in Pre-Colonial Days, 1521–1885.* Pacific Islands Monograph Series 1. Honolulu: University of Hawai'i Press.
Kirch, Patrick Vinton. 2000. *On the Road of the Winds: An Archaeological History of the Pacific Islands before European Contact.* Berkeley: University of California Press.
Morgan, William N. 1988. *Prehistoric Architecture in Micronesia.* Austin: University of Texas Press.
Peoples, James G. 1990. "The Evolution of Complex Stratification in Eastern Micronesia." In *Recent Advances in Micronesian Archaeology,* edited by Rosalind L. Hunter-Anderson. A Special Issue of *Micronesica.* Supplement No. 2: 291–302. Mangilao: University of Guam Press.
Petersen, Glenn. 1990. "Lost in the Weeds: Theme and Variation in Pohnpei Political Mythology." Occasional Paper 35. Center for Pacific Islands Studies. University of Hawai'i at Mānoa, Honolulu.
Rainbird, Paul. 2004. *The Archaeology of Micronesia.* Cambridge World Archaeology Series. Cambridge: Cambridge University Press.
Sarfert, Ernst. 1920. *Kusae.* Vol. 2. Geistige Kultur. G. Thilenius, ed., II, Ethnographie, B, Mikronesien, Bd. 4. Hamburg: Friederichsen, DeGruyter und Co.

Beyond the Beach?

Re-articulating the Limen in Oceanic Pasts, Presents, and Futures

Margaret Jolly

Greg Dening on the Beach

Moruya Heads, New South Wales January 1999. I am reading Greg Dening's *Readings/Writings* tucked up against the sand dunes, pondering the relation between his writing and the materiality of the beach: its scorching sands, its vast white expanse, the turbulent palette of the ocean as the weather changes and the tide rises and ebbs, and how in the heat of an Australian summer mirages are created, confounding quotidian vision and creating a dreamy haze in which pasts, presents, and futures seem to fold into and embrace each other. Suddenly a southerly breeze picks up and scatters fine grains of sand into my book, dusting the words on its pages and insinuating themselves into its spine. I am aghast but also strangely delighted: Just as I am struggling to understand Dening's concept of the beach, the mental and metaphysical value he imputes to that liminal space, the raw materiality of *this* beach has fought back. Back in Canberra I confessed what had happened to Greg. He seemed a little disturbed by my propensity for sun bathing and my penchant for taking valuable hardbacks to the beach, but he was, I think, also rather chuffed.

 I retell this silly story of my summer holidays not just to pay homage to Greg Dening, who is no longer with us,[1] and his apical importance in the genealogy of those of us who have been exploring similar questions in Oceania, but to pose the problem of the *relation* between embodied experiences and encounters on the many beaches of Oceania and the central values that suffuse Dening's concept of "the beach," a limen where everyday understandings are displaced, where crossings occur, cross-cultural even transcultural encounters, where the exchange of bodies and meanings subverts taken-for-granted understandings and creates the potential for profound and mutual transformation. I ponder how Dening's beach images portray the relations of Europeans and Islanders and the relations of Islanders to each other, and how it articulates the crossings between pasts, presents, and futures in Oceania.

"On the beach edginess rules": Dening's Beach from 1974 to 2004

The idea and the value of the beach can be discerned from Dening's earliest works, his edition of *The Marquesan Journal of Edwards Robarts* (1974) and his "double-visioned" history of Fenua'enata/The Marquesas in *Islands and Beaches* (1980). But I start from *Readings/Writings* (1998), where the concept of the beach is clearly articulated as a theme across several essays,[2] as ambivalent space, as marginal time, as metaphor for cross-cultural encounters, and, in the creative process of reading and writing, as "beaches of the mind." "The Beach has long been a metaphor of my understanding, not just for Oceania, the Sea of Islands, but for life itself" (Dening 1998: 85).[3] He acknowledges a debt to both Victor Turner and Richard White in exploring these spaces-in-between, "neither one thing nor another," "spaces of defining rather than definition," "ordinary moments of living" interrupted by abnormal moments when identities are suspended and novel meanings emergent, as in liminal states of ritual or the "as if" of theater (1998: 86). The beach is also that place where "the thoughts of a writer encounter the thoughts of a reader" (1998: 86), where "everything is in translation," "where we see ourselves reflected in somebody else's otherness" (1998: 87); "where minds meet is a beach of sorts" (1998: 87).

Dening thus evokes the beach as the shifting sands of unending conversations and mutually transforming dialogues between self and other, writer and reader. And, as such, beaches are destinations in his navigation of the historical anthropology of Oceania. He juxtaposes crossings by both Europeans and Islanders, re-membered[4] in the present, for example, in the twin passages of the replica of Cook's ship, *Endeavour*, and the Hawaiian canoe *Hōkūle'a*. On the European side, Dening evinces a particular empathy not so much with those men who were confident captains or heroic "discoverers," like Cook, but those who were mutinous and "on the edge," like Bligh, or those who deserted and even threatened the fragile ships of civilization, "beachcombers" like Edward Robarts.

Dening constantly distinguishes his writing from Eurocentric, imperially minded histories of the Pacific. From the outset he aspired to tell the story from *both* sides of the beach. This is how he expresses it in his book, *Beach Crossings* (2004):

> Fifty years ago I made a discovery that changed my life. I discovered that I wanted to write the history of the other side of the beach, of indigenous island peoples with whom I had no cultural bond, of Natives. And on 'this side of the beach', my side as an outsider, as Stranger, I wanted to write the history of people whom the world would esteem as little. . . . Not of kings and queens, not of heroes. Little people. . . . These people on both sides of the beach were to be my Natives, my Strangers. (2004: 12)

The text of *Beach Crossings* is full of such stories: of men beached in the Marquesas and Tahiti, like Edward Robarts "the beachcomber"; William Pascoe Crook of the London Missionary Society; and Joseph Kabris, whaler and runaway from Bordeaux (who in his full body armour of Marquesan body tattoos made an uncertain living at fairs

back in France as the Tatoué, alongside the fat lady and the three-headed cow). And the stories of more famous beach crossers like Herbert Melville or Paul Gauguin, inspired by the texts and images they bequeathed: letters, journals, ethnographic accounts, novels, and Gauguin's extraordinary artistic corpus. Such stories of past beach crossings are punctuated with Dening's own accounts of "being there," of his own journeys to the Marquesas in 1974 and thereafter. He traveled to those beaches whose silence muted the clamor of past horrors, the tsunami of colonial conquest and decimating diseases, the bloody wake of indigenous wars, the "fishing" of people, and the sacrifice of victims to hungry gods. Dening's ethnographic crossings are saturated with the malaise of the past and the stench of his own seasickness, induced by voyages on small, pitching boats like *Kaoha Nui*. "I have to confess that I retreated to the mission archives in some relief. Archives are my life. I love their cool quiet. Meeting the dead in archives is less traumatic than meeting the living on the beach" (2004: 89).

Dening's paths of entrance and exit to the beach are typically retraced through linking his own life passages with the stories of early and later European visitors in the Pacific or early Pacific visitors in Europe, like Mai (2004). In this later work, Dening dives more deeply into the deep time of ecological and indigenous history, plotted in the superb endpapers. Still, for Dening, as for many of us, the privileged crossings have been those canonical encounters between Europeans and Islanders, as they moved from "two worlds" to "between worlds" (Salmond 1991: 1998), and, prospectively perhaps, one shared world. As Salmond avers, such crossings entailed profound mutual transformations (2003: 10). But how might such an emphasis on crossing the limen between Europeans and Islanders suppress parallel histories, other beach crossings, encounters *between* Islanders? And how does a stress on encounters between Europeans and Islanders, as dialogical exchanges, bleach the blood of conquest from the beach, as it reinscribes these past beach crossings from the expanded horizons of an optimistic postcolonialism, the promise of living together in a new Oceanic millennium of equality and reconciliation?

We might more critically consider how our own stories of "beach crossings" have become sedimented memories rather than evanescent footprints, as they cross the limen between pasts, presents, and futures. Sedimentations of memory are differently layered in different parts of Oceania, in the different locales of Australia and Aotearoa New Zealand, Hawai'i, and Vanuatu, for instance. The differences in part are the differences between the privileged narratives of settler colonies and of nominally independent Pacific states and in how the sediments of European voyages perdure or vaporize in present negotiations about land and ocean. I have explored these issues elsewhere in the commemorations of "beach crossers" like Quirós and Cook between Vanuatu and Australia in 2006, for instance (Jolly 2007a, 2007b, 2008b, 2009; Jolly and Tcherkézoff 2009). I suggest that in such commemorations there is often an undue focus on the benign mutuality of past meetings, on exchanges of words and things but not blows, and a scrupulous avoidance of undue reference to the blood on the beach, either at those privileged moments of "first contacts" or later histories of violent colonial occupation and settlement. The re-membering of European beach crossers like Quirós or

Cook in contemporary acts of commemoration combines recollection and forgetting in divergent imperial and national acts of memory (2007a). But in many locales, shared destinies are envisaged through the trope of open and Oceanic exchange, appropriate to our epoch of globalization.

Here I rather consider two indigenous beach crossers, privileged in most retellings of cross-cultural encounters in the Pacific, Mai and Tupaia. These two Polynesian men are not only central to Dening's narratives in *Beach Crossings*, they have become icons in their crossing of that space between the Oceanic and the European worlds of the late 1700s. I first consider how Omai (Mai) has been represented in a recent book and exhibition (i.e., Hetherington et al. 2001) and then how his "beach crossings" compare with representations of an earlier figure from Cook's first voyage, Tupaia, the "proud priest" of 'Oro, the consummate "wayfinder," mediator of the limen not just between the two worlds of Europeans and Islanders, but between the peoples of Oceania.

(O)Mai and Tupaia: Translation and Transculturation in the Late 1700s and Today

Omai, or rather Mai (for O signifies "it is") was the first Pacific person to cross the beach of British shores. He was listed as a supernumerary on the HMS *Adventure* on Cook's second voyage and sailed under the English alias of Tetuby Homey, or, as the sailors preferred, Jack. Mai came from a landowning but not a noble family (or *ari'i*) from the island of Ra'iatea, but around 1763 fled with his family to Tahiti when men from Bora Bora invaded and his father was, probably, killed in battle. He was witness to Captain Wallis' "discovery" of Tahiti in 1767, Tobias Furneaux' claiming of it as "King Georges Island," and the spiraling violence unleashed by the British as canoes were destroyed and about eighty people were killed and many wounded by cannon shot. He was among those women and children gathered on "One Tree Hill" when the beaches of early contact were soaked with blood. He lived through the rival Act of Possession by Bougainville in 1768 (who claimed Tahiti as Nouvelle Cythère), and the return of the British, led by Cook on his first voyage in 1769 on the *Endeavour*. Like Bougainville, Sir Joseph Banks, naturalist on Cook's first voyage, decided to carry back a human "curiosity," and chose his intimate friend Tupaia, the priest. But unlike Ahutoru with Bougainville, Tupaia never made it to Europe; he died in Batavia en route. Undeterred, it seems, by news of Tupaia's early death and the increasing internecine wars, famine, and venereal disease unleashed by these first acts of "discovery," Mai chose to accompany the British (with Tobias Furneaux on the *Adventure* rather than Cook, who opposed the plan). Mai was not a captive; he went to Britain knowingly, perhaps for his own "curiosity," but certainly to elevate his status and power and to get guns to avenge the men of Bora Bora and reclaim his lost land.

Both in the late eighteenth century and since, Mai has become an iconic figure in debates about the rise and fall of the "noble savage" and about the prospective progress or regress of civilization (see Smith 1985 [1960]). He has become a "lightning rod" for "the expression of sentiments and anxieties regarding imperialism, civilization and human nature" (Cook 2001: 37). He is imaged in a series of famous por-

traits: Caldwall's engraving after William Hodges (1777), Bartolozzi's engraving after Nathaniel Dance and Tobias Furneaux (1774) (see figure below), and oil paintings by Sir Joshua Reynolds (*Omai*, 1775–1776) (see figure on top of page 61), and William Parry (*Sir Joseph Banks with Omai, the Otaheitan Chief and Doctor Daniel Solander,* 1775–1776)[5] (see figure on the bottom of page 61). He was also the subject of a famous pantomime, produced a decade later in the Theatre Royal in Covent Garden (*OMAI: Or, A Trip Round the World,* 1785). These British representations all cross the limen between fact and fiction. There are some gestures toward cultural and historical veracity—Dance envisions Mai with a head rest and a fly whisk and, like most other portraits, in the flowing white tapa robes and waist wrappings that were a sign of high rank in Tahiti (though Mai usually wore Western clothes while in Britain). Reynolds represents Mai in his tapa robes, with a patrician poise akin to his usual British subjects, the noble and the famous. But the tapa cloth is chronically represented like Roman togas or Middle Eastern turbans, even if the delicate traces of tattoo on Mai's hands articulate a distinctively Oceanic otherness.[6]

The pantomime *OMAI* of 1785 was a concoction of the ethnographic and of magic, a "blockbuster" masquerade in which stage designer De Loutherberg transmuted John Webber's paintings from Cook's third voyage through the theatrics of

Francesco Bartolozzi (1727–1815) after Nathaniel Dance (1735–1811), *Omai, a Native of Ulaietea, Brought into England in the Year 1774 by Tobias Furneaux,* London: Published according to Act of Parlt., 25 October 1774, engraving, plate mark 54.5 x 33 cm, reprinted in *Cook and Omai: The Cult of the South Seas,* National Library of Australia, Canberra, 2001, p. 27.

Sir Joshua Reynolds (1723–1792), *Omai*, 1775–1776, oil on canvas; 236 x 146 cm, from the Howard Castle Collection, reprinted in *Cook and Omai: The Cult of the South Seas*, National Library of Australia, Canberra, 2001, p. 22. Reproduced courtesy of the National Library of Australia.

(Below)

William Parry (1742–1791), *Sir Joseph Banks with Omai, the Otaheitan Chief, and Doctor Daniel Solander*, 1775–1776, oil on canvas; 147.5 x 147.5 cm, private collection, by kind permission of Nevill Keating Pictures Ltd, as reprinted in *Cook and Omai: The Cult of the South Seas*, National Library of Australia, Canberra, 2001, p. 25.

illusion to create "reality effects" (McCalman 2001: 13).[7] The narrative surely "disregards all historical facts" (Knellwolf 2001: 17): Omai comes to London not to get guns but to woo a British maid, Londina. Omai mimics the Harlequin figure of his servant, whose untamed sexuality and cavalier behavior spoofs the follies of European courtly rituals, wealth, and power. Omai and Harlequin are twinned, both are "blacked up" with masks and makeup; Omai pursues Londina as Harlequin pursues Columbine. Omai is chased all around the world by his rival Don Struttolando but succeeds in winning Londina and eventually is invested on the throne as rightful ruler of Tahiti. The play concludes with Oberea (based on Purea, the so called "Queen of Tahiti") relinquishing her role as protectress of Struttolando and bowing before Captain Cook, in welcome of the British presence. Finally, that grand image of Cook's apotheosis was lowered to the theme:

> *Mourne Owhyhee's fatal shore*
> *For Cook, our great Orono is no more!*

As Knellwolf (2001: 17) cogently observes, the "posthumous blemish" of Cook's violent death was here erased in eulogistic incantation, as the "our" aspired to embrace both British and Islanders, in worship of Lono. But despite this optimistic finale, a subversive potential remained: *OMAI* proffered a satiric challenge to the celebration of Cook and the British Empire (if with less bite than David Garrick had originally intended). At least some contemporaries acknowledged that "Owhyhee's fatal shore" was bloodied not just by the death of Cook but by the deaths of many indigenous Hawaiians and other Islanders, equally a part of "the wake" of Cook's three voyages.[8]

During his real life in London, Mai was perceived as a curiosity, sometimes as an exemplar of the natural good manners of the native and a favorite of the ladies, sometimes as symptomatic of the corrupting influences of materialism and civilization. When Mai returned to Tahiti, he took back not just the guns he desired but several other "things" others deemed appropriate: seeds, iron tools, cutlery and furniture, portraits of the king and queen and perhaps Cook himself, an illustrated Bible, miniature figures, fireworks, a jack-in-a-box, handkerchiefs printed with the map of England and Wales, two drums, and a suit of armor. Guest plays with "Omai's things" with caustic irony (Guest 2001: 31–32).[9] Bligh of the *Bounty* later proclaimed that these possessions only briefly enhanced his power and status. Yet the site of Mai's house on Huahine was long known as Beritani and some of these British "things" were kept by later chiefs, perhaps as "curiosities," more likely as icons and instruments of the power of the strangers.

Mai has thus been seen both in the Britain of his time and by subsequent writers as an iconic Islander engaged in a "beach crossing" between the Pacific and Europe. As a figure of European vision he has been abundantly endowed with both the positive and the negative marks of that crossing. Alexander Cook presents Mai as at best a ventriloquist, at worst a mute, since the British "bubble of gossip" was blown up in the "absence of Omai's own voice" (2001: 40). By contrast, Turnbull offers the most ethnographic and historically sensitive account of Mai, arguing that he was not cap-

tive to European visions but "had his own dreams" (2001: 43). He situates him as the proud eldest son of a *manahune* or "landowning dynasty" and compares the dynamism of late eighteenth-century politics in Ra'iatea and the violent politics of the expanding cult of the war god 'Oro with the dynamism of British politics and imperial expansion. Although Mai fed the British taste for the exotic, he was, according to Turnbull, also an "embittered refugee" who "knowingly" went to Britain to raise his status and power back home. Greg Dening (2001: 51–56) replays Mai's real life as "a masque of a sort," a tragic pantomime told from Mai's viewpoint in which the British are made strange, as Cook is refigured as Toote.

Less well known in the late eighteenth century, but perhaps more celebrated in our new millennium, is Tupaia, who preceded Mai, joining Cook on his first voyage. As earlier noted, he never made it to London, as his life was tragically cut short by disease in Batavia (where he and his servant Taiato and half of those on board the *Endeavour* died of the combined effects of scurvy, malaria, tuberculosis, and "the flux"). Whereas attention on Mai has focused on the spectacle of his life in London rather than back home, Tupaia has been celebrated of late in beach crossings where translation and transculturation are seen to have made deeper furrows. Here, rather than celebrations of European visions, the interpretive agency and creativity of Islanders is vaunted, especially in his learning of European forms of representation. Reanalyses by Greg Dening (2004), Anne Salmond (2003), and Nicholas Thomas (1997, 2003) have focused on two things—Tupaia's "map" and, more recently, Tupaia's paintings. Based on a note in Joseph Banks' letters, recently discovered by Banks' biographer Harold Carter, Tupaia, not Banks, has been revealed as the creator of several drawings and watercolors, of *arioi* musicians with their drums, of indigenous Australian men in canoes in Botany Bay, and a sketch of an exchange between a Māori man and Banks of a large crayfish for white tapa, a delightful, iconic image Anne Salmond used on the cover of *Between Worlds*. Salmond has offered the best appraisal of Tupaia and his world to date, consummately evoking the complicated indigenous politics of rank, rivalry, and religion in which he was enmeshed and his central role as navigator and interpreter on Cook's first voyage (2003: 34ff). I offer a telegraphic version here.

Like Mai, Tupaia came from the island of Ra'iatea in the Tahitian group (the "Society Islands" of Cook). He was a priest of 'Oro, the war god, whose worship was being carried from island to island in a violent politics of conversion.[10] I quote Salmond: "'Oro demanded human sacrifices and his marae were dark, awesome places, associated with Te Po [the space of cosmic darkness inhabited by gods and ancestors] and regarded with dread and terror" (Salmond 2003: 35). 'Oro was seen to have come to that sacred island on a rainbow-canoe and to have traveled around the islands in the form of a feathered basket or *tiki*. 'Oro's temple on Ra'iatea was Taputapuatea, "Sacrifices from Abroad." Here human victims to be sacrificed to 'Oro were transported on canoes, slung between poles or used as rollers for canoes to beach. Standing on a sacred stone on the limen between land and sea, the high chief or *ari'i nui* would eat their eyes. He was wrapped in the feather girdle of 'Oro's power and authority, but then covered with shit and semen to signal the ultimate abjection of all humans before their gods.[11]

Tupaia was a high-ranking member of the *arioi*, the traveling missionary society of 'Oro, composed of priests, navigators, orators, artists, warriors, and lovers. Their dramatic performances celebrated the bloody arts of war and the delights of sexual pleasure (although they were forbidden to have children). Tupaia wore the red tapa and the black tattooed legs of the highest *arioi* grade. On a voyage dedicated to spreading 'Oro's influence, he brought a foundation stone from Ra'iatea to Tahiti for 'Oro's temple there. He was a confidant of and advisor to those of high rank, including Purea, who became his lover after she had separated from her husband Amo (after they had given birth to a child against the rules of the *arioi*). From Wallis' visit on the *Dolphin* in 1767, the British had taken Purea to be the queen of Tahiti, "Oberea" (as we saw in the pantomime *OMAI*). But as Salmond (2003: 35–107) shows, Tupaia, Amo, and Purea were involved in a complex and bloody internecine politics of succession struggles and invasive wars, in which their successive friendships (as *taio* or ceremonial friends), alliances, and conflicts with Wallis, Bougainville, and Cook became an integral part. After all, Cook's arrival had been prophesied and the power of the strangers became creolized with the power of indigenous gods like 'Oro; the red pennants of British possession were woven into the red girdle of the god.[12]

Tupaia joined the *Endeavour* when Cook left Tahiti in July 1769. Cook found him immensely intelligent and knowledgeable about "the Geography of the Islands," and he guided Cook on the next phase of the voyage, not west as he desired (and where he knew there were many islands) but south, as Cook determined, to discover Terra Australis. Tupaia and Banks conversed in a mixture of Tahitian and English, and Tupaia offered an ethnographic account of Tahiti (plotting not just the esoteric details of social hierarchies and religion but the demography and military capacity of districts). He also learned the strangers' graphic language, sketching first the more familiar islands of Ra'iatea, Tahaa, Borabora, and Maurua, and then his detailed knowledge of his "Sea of Islands," in a map called "Tupaia's Chart." Although centered on Otaheite, this traverses several thousand kilometers of the central Pacific, from the Marquesas in the east to the Fiji group in the west; he named 130 islands, many of which he had visited (including those to the west, in ten days of sailing and thirty days to return, against the prevailing winds). It included islands as far as New Zealand (Pounamu and Teatea), Tonga, Samoa and Rotuma, the Tuamotus, the Marquesas, the southern Cooks, and Australs. Tupaia's original drawing is lost, but several copies were made, including a chart with the notation "Drawn by Lieut James Cook" and one by Georg Forster that was the basis of an engraving published in Johann Reinhold Forster's magnum opus, *Observations Made During a Voyage round the World* (Forster 1996 [1778]).[13] Forster and his son Georg were the naturalists on Cook's second voyage, a voyage which generated a different cartography of the Pacific (see Jolly 2007b).

Though he is the original author, this map is *not* Tupaia's indigenous view. We will never know the details of that, but his vision was likely a differently "situated knowledge."[14] I suspect it located the observer not so much soaring high above the islands, riding on the coordinates of longitude and latitude, plotting a changing global position relative to east and west, north and south, but lying low in a canoe, looking up at the

heavens for the star paths, scanning the horizon for signs of land in changing clouds and the movement of birds, watching for reflections and deflections, seaweed and debris on the surface of the ocean, navigating the powerful seas with the embodied visual, aural, olfactory, and kinesthetic knowledge passed down through generations of Pacific wayfinders and assisted by the persuasive guidance of ancestors and gods in dreams (see Finney 1994; and the film *Sacred Vessels,* Diaz 1997). Tupaia's full-bodied knowledge was etiolated and converted through the agency of a quill and a piece of parchment into a "map." Moreover, his Tahitian names and dispositions of islands are not just written down and graphed as a "map," but situated in and saturated by the discursive frame of "discovery" of Enlightenment voyaging.

But some have talked about the relation between Tupaia's map and Cook's chart not so much as a creative translation between Oceanic wayfinding and European navigation but as an encounter framed by "cartographic *méconnaissance*" (Turnbull 1998, Di Piazza and Pearthree 2007). Neither Cook nor Banks recorded Tupaia's descriptions of islands or sailing directions, nor the stories of settlement. Although Tupaia told Cook about returning home with the summer westerlies and Banks how to predict winds from "the shifting curve of the Milky Way" (Salmond 2003: 110), their fractured conversations were likely insufficient to learn about the complex arts of Polynesian wayfinding. So Dening stresses English *mis*interpretations of "Tupaia's map" (2004). Half the islands of Tupaia's original were omitted; Cook seems to have misunderstood his plotting of directions, and many of the words transcribed as island names are actually the chiefly titles of persons of those places.[15]

Di Piazza and Pearthree (2007) have an even more radical reading, suggesting that despite its appearance as a map, Tupaia's chart is in fact a "mosaic of sailing directions or plotting diagrams drawn on paper, similar to those of [Polynesian] master navigators tracing lines in the sand or arranging pebbles on a mat to instruct their pupils" (2007: 321). They see Tupaia's earlier sketches as "practice exercises" in which islands are out of scale and lack a cartographic grid. Although they suggest that in learning from the Europeans Tupaia started to plot distance as well as bearings, they see his chart primarily as *his* attempt to teach Cook and his officers the directions to surrounding islands. Traditional wayfinding concepts in Oceania were not based on absolute global references in Cartesian space but on subject-centered sailing directions or bearings to distant islands. Drawing on Gell's previous observations (1985), Di Piazza and Pearthree suggest that the navigator places himself in the center at the point of departure (as at Otaheite) and plots a series of bearings radiating out to other islands on the perimeter (2007: 326). Star compasses consisted of "bearings radiating from a centre to points on the horizon marked by the rising and setting of key stars" (2007: 326). Navigators often memorized lists of islands in pairs and plotted star compasses between these islands (2007). Di Piazza and Pearthree conclude

> This unravelling of the Chart also highlights the difficulties of understanding or sharing knowledge on both sides. . . . Cook clearly remained fixed in his Cartesian world, adding cardinal points to Tupai's Chart. But both could look at the

manuscript and see their own system represented: Cook reading islands on a grid and Tupaia reading islands radiating out from different centres. (Di Piazza and Pearthree 2007: 336)

Despite this "cartographic *méconnaissance*," on his voyages with Cook, Tupaia piloted the *Endeavour* through open sea to islands to the south with great accuracy, but everywhere he insisted on transposing his own protocols of respect and obeisance to the high-ranking peoples and sacred spaces of new places. However, his cultural and linguistic translations were far more compelling within what later became called the "Polynesian triangle," places like Aotearoa New Zealand, where he sustained long and detailed conversations and explored shared genealogies of voyaging and settlement, though it must be admitted that he was also a part of the violence of these visits, shooting some Māori in the legs with small shot. Still, Māori revered and long remembered him, naming the cave where he slept, the well he dug, and their own children Tupaia (Dening 2004; Salmond 2003: 116–134, 141–145, Tapsell 2009: 92–110).[16] In other landfalls, like Cook's New Hebrides (Vanuatu) or New South Wales (on the eastern coast of Australia), few shared words reverberated across the beaches of cross-cultural conversation (Salmond 2003: 153–158). Moreover, Tupaia's priestly pride and cultural hubris seem here to have been an impediment to mutual understanding,[17] and his sense of superiority seems to have been reinforced by views of "naked savages" and "primitive" bark canoes in Botany Bay (which he sketched, see Salmond 2003: 153), too flimsy to attempt the ocean crossings of his own experience. Further north near the present Bustard Bay, Tupaia described indigenous Australians, as '*ta'ata ino*,' bad people. It is perhaps unsurprising, then, that some days before his death in Batavia, Tupaia threw away his European clothes and wrapped himself again in red tapa, remembering his status as priest of 'Oro and *arioi*.

But what of the other artifacts, the drawings we now know were painted by Tupaia (see, for instance, the one on page **67**)? Nicholas Thomas (1997) celebrates how adept Tupaia was at learning the visual vocabulary of Europeans, although his maps and paintings in European styles may have rearticulated some of the meaning and force of indigenous arts, which were embodiments rather than representations of divine ancestral powers (Thomas 1995). Tupaia's visual "beach crossing" has become a celebrated act of wonder and mystery. Anne Salmond talks of sharing the "thrill" of Carter's discovery of Banks' note (2003: xv), revealing several images as from "Tupaia's paintbox" (2003: 56ff). Greg Dening similarly proclaims Tupaia's triumph and "brilliant heritage" (2004: 172).

> In the great cabin of the *Endeavour*, Tupaia saw James Cook bending over his chart table. He saw Sydney Parkinson, the painter, at his easel working his oils and watercolours. So Tupaia makes a map of his ocean world. And he starts painting. In his map and paintings, Tupaia equips himself with new skills to represent something old within him. They are Pacific representations of extraordinary brilliance. They are translations of culture. Tupaia translates his metaphors into somebody else's. (Dening 2004: 173)

Dening considers him a "most remarkable man. . . . He is a hero of mine" (2004: 170). So the dubious heroics of Cook have been eclipsed by Tupaia. I share that sense of wonder about Tupaia's maps and drawings but I also wonder about our sense of wonder. I want to ponder why crossing *that* beach between Europeans and Islanders matters so much more than the other beaches Tupaia crossed, in the several parts of Oceania, including those far beyond his own linguistic and geographical origins. Tupaia not only translated between English and Tahitian, he also attempted to translate the languages and customs of others in his "Sea of Islands" to the British. Such translations were, as noted above, far easier in those places where languages of the Polynesian family prevailed and far harder in the islands of the New Hebrides and New Caledonia, where people spoke very different Austronesian languages (see Jolly 1992), or in Australia, where linguistic and cultural differences seemed like a chasm rather than a beach. Like Mai, Tupaia brought a Polynesian perspective to his encounters with the indigenous peoples of Oceania. And as *the* valued guide and translator for Europeans on Cook's first voyage, his perspective was privileged over those whose languages and cultures seemed simultaneously more distant from both Tahiti and Europe. His consternation in the face of more intractable differences was likely compounded by his priestly pride and cultural hubris in ways similar to those Europeans, sailors and scholars alike, for whom their civilized superiority was a given. Not all of Tupaia's beach crossings gener-

Artist of the Chief Mourner, *Drawings illustrative of Captain Cook's First Voyage, 1768–1770 (A Maori bartering a crayfish with an English naval officer)* [Drawing no. 12], 1769. © The British Library Board, Add. 15508, f.11.

ated mutually transforming dialogues. His translations between other Oceanic peoples and the British were both mediations of, and proud meditations on, his own beach crossings.

With the exception of Salmond, too little analytic effort has focused on how Tupaia crossed the beaches of his own "Sea of Islands." These other beach crossings are blurred by the privileged limen between Europeans and Islanders. Moreover, I sense a breathlessness in our celebrations of Tupaia that owes as much to the limen of the future, to the optimistic allure of a time beyond colonialism (a postcolonialism?) as it does to any beach crossings of the past. In postcolonial visions, the relations of European settlers and indigenous people are again perforce privileged, albeit in the politics of a faltering reconciliation in Australia or of bicultural celebration in Aotearoa New Zealand.

This tendency to see the relations *between* Islanders through the lens of their differential relation *to* Europeans is patently rearticulated in the present. This tendency has been criticized in how European labels of Melanesia, Polynesia, and Micronesia are used by Islanders to identify themselves and each other (see Jolly 2007b). Similar problems have been perceived in how the contemporary geopolitics of nation-states privileges not the deep Oceanic connections of Islanders but their different relations to place as "natives" or "migrants" (as between Māori and other Islanders in Aotearoa New Zealand for instance, see Jolly 2001 and Teaiwa and Mallon 2006).

Crossing the Limen of Pasts, Presents, and Futures

"Our Sea of Islands" may be full of beaches, but the beaches of the mind and of memory are differently configured, between Australia and Aotearoa New Zealand, between Hawai'i and Vanuatu. I have argued elsewhere (Jolly 2007a, 2009; Jolly and Tcherkézoff 2009) that contemporary commemorations of Quirós and Cook in both Australia and Vanuatu remember their beach crossings through selective, amnesiac histories that bleach the blood of the beach of violent first contacts and of subsequent European occupation and settlement. The stress is rather on the mutuality of exchange and the parity of European and Islander agency. By contrast, Dening's histories display a full-blooded acknowledgment of the violence engendered by beach crossings, between Europeans and Islanders and between Islanders.

But how might we acknowledge and redress the violence of past beach crossings in the present without again unduly privileging the encounter between Europeans and Islanders as the only encounter that matters? Let me bring this conundrum to the context of the exhibition at the Honolulu Academy of Arts, where this essay was first presented. This was a powerful example of how shifting contexts transform the meanings of objects. There we had the privilege of seeing an array of stunning Pacific objects that were collected, traded, or "gifted," primarily on the Cook voyages. Those objects surely crossed the beach, between the 1700s and the present, between Germany and Hawai'i. Indeed, in her article on the exhibition "Coming Home" (Morse 2006), Maria Morse quotes Honolulu Academy of Arts director Stephen Little's portrayal of the objects as "ancestors," communicating between past and present. As well as powerfully speaking across that limen, these objects were also potentially speaking across

the beaches *between* Islanders. In the way the objects were displayed, the spiritual unity and aesthetic coherence of Oceanic cultures was evoked, rather than their provenance in terms of contemporary nation-states. In this mounting of the exhibition, the mediating frame of European collection and museology was muted, in comparison to Canberra.[18]

But neither the politics of eighteenth-century voyaging nor that of contemporary Oceanic politics can be dissociated from the exhibition, the conference, and this volume, which re-articulates those embodied experiences for readers who were not present. We are perforce exploring the life of the 1700s in the Pacific from the beach of our different presents and framed by our different horizons for the future. We need to acknowledge that moral and political concerns pervade not just the contemporary oral histories of Pacific Islanders but our contemporary textual and visual constructions as scholars, regardless of whether we are Islanders or Outlanders. Stories of past Oceanic encounters are remembered in the moral and political relations we construct between those pasts, our presents, and our prospective futures, suffused by the rainbow of postcolonial prospects or shadowed by darker clouds on our shared horizons as human beings.

Notes

1. Greg Dening passed away in March 2008 between the first writing of this essay in 2006 and its eventual publication, and I regret that I never had the chance to discuss the final version with him. I am indebted to him as a person and a scholar. I was fortunate to be present at his funeral in Melbourne, in the superb surroundings of the Newman College chapel on the campus of the University of Melbourne. The mellifluous light created by the translucent white and honey-colored stained glass, the soaring melodies of St Hilda's choir, and the character of a formal but intimate Catholic mass softened the loss for many of us. It seemed fitting that Greg passed just before the Christian celebration of Easter, with its hopes of resurrection in death. I dedicate this essay to his continuing spirit and to his beloved partner in life and work, Donna Merwick.

2. Especially in "Beaches of the Mind" (Dening 1998: 85–87, 170–172, and 195–196); compare Dening 1996.

3. He later elaborates: "From a beach, things loom in the glim of the horizon and in the shimmer of the mind's eye. . . . Beaches breed expansiveness. Beaches are *limen*, thresholds to some other place, some other time, some other condition" (Dening 2004: 31). His phrase "The Sea of Islands" is indebted to Hauʻofa's revolutionary reconception of Oceania (Hauʻofa 1994).

4. I hyphenate this as re-membered to stress the active, embodied agency and materiality in the process of memory. See also Jolly 2008a, 2009.

5. Caroline Turner offers a succinct appraisal of these images of Mai and how they combine ethnographic veracity with European conventions in portraiture. She considers that Reynolds' pencil drawing of 1774 (inaccurately titled "Omai of the Friendly Isles") best captures Omai's physical likeness and thinks his "open and even ingenuous gaze reflects something of the calm demeanour and good nature he showed to his hosts" (Turner 2001: 23). She compares this with Reynolds' full portrait, where Omai is represented far more in the style of noble portraiture. The painting by Reynolds' student Parry, which presents Omai between Solander and Banks with the latter pointing to his arm as if he was both specimen and protégé, is more curious. He is pointing to Omai's hand but the tattoos are absent, perhaps inadvertently brushed off or painted over in later restorations (Turner 2001: 26).

6. Bernard Smith (1985 [1960], 1992) and many since have written eloquently about how

Polynesians in particular were compared to the ancients of Greece and Rome, with constant textual allusions to classical figures such as Venus, Flavius, and Hector. Compare my analysis of images of ni-Vanuatu (Jolly 1992).

7. McCalman (2001) notes De Loutherberg's equal interest in voyage narratives and images and necromancy and magic, highlighting how late eighteenth-century science was still saturated by magical and metaphysical concerns. De Loutherberg employed John Webber to advise on "native" costumes and to paint some scenes, but he also deployed *trompe l'oeil* to image whirlpools, waterfalls, shipwrecks, and storms at sea (2001: 11–12). McCalman compares his art of illusion with both twentieth-century ethnographic film and the special effects of blockbuster cinema.

8. Many authors since Smith (1992) have written "in the wake" of Cook's voyages in both senses. I can here only allude to the huge debates between Sahlins (1985, 1995) and Obeyesekere (1992) about how Hawaiians saw Cook and to the scale and significance of the violence unleashed by Cook's voyages. Smith, like Dening, always acknowledges the violence inherent in European voyages.

9. Guest (2001) offers the most negative view of Omai's return, focused on the British toys and the conjunction of Omai's body armor with guns, which he shot wildly. See her elaborated discussion in her book (Guest 2007: 157–163).

10. Turnbull (2001) highlights how the prophecies of the 'Oro cult fertilized the ground for the reception of the strangers in Tahiti as much as Hawai'i (see Sahlins 1985, 1995).

11. Dening elaborates on his position as a priest, as a guardian of tradition, rather than a prophet (2004: 170).

12. Wallis' British flag with which he took possession was woven into the sacred red feather girdle of 'Oro on Matavai (Dening 2004: 172). Dening also points out how 'Oro's temples were treasure houses of memorabilia: at Matavai for instance, a portrait of Cook by Webber, some red hair from the barber of the *Bounty*, and the skulls of two mutineers (2004: 171).

13. Di Piazza and Pearthree (2007) note that Banks' copy drawn by Cook was not published till 1955 in Beaglehole's first volume of Cook's journals, while that which was long known as "Tupaia's Chart" was rather based on a hand-drawn sketch by Georg Forster that was published with his own journal in 1777 and as an engraving with his father's *Observations* in 1778. Banks' copy lists only seventy-four islands (which corresponds with Cook's description of Tupaia's naming of islands) while the Forsters' versions added more islands, identified by Europeans, misplaced some of Tupaia's islands, and added a "latitude-longitude grid" (2007: 324).

14. I here echo the phrase so associated with Donna Haraway's writing (1991). She insists that all knowledge is situated and partial, and she criticizes those who too readily associate vision with hegemonic power. Haraway insists on the embodied nature of *all* vision so that we can "reclaim the sensory system that has been used to signify a leap out of the marked body and into a conquering gaze from nowhere" (1991: 188). So I do not imply that the European experience of navigation was not also full-bodied knowledge. The visual technologies of cartography, of longitude and latitude, were novel and far less certain than they seem at present, and they were surely complemented by other senses. Moreover, Cook and his sailors learned from Tupaia and other Islanders to discern signs of land in the appearance of land birds and changes in the patterns of seaweed and fish (see Dening 1998).

15. Salmond concurs: "In Pacific oral histories, island place-names are often linked with voyaging narratives; and Tupaia's chart is relatively mute without these stories. . . . In many ways Tupaia and Cook and Banks were on diverging trajectories. The sky and the seas that they traversed were the same, and yet quite different" (Salmond 2003: 111).

16. Tapsell (2009) offers important insights on "Tupaea" for Māori today. Māori converted his name to Tupaea, which means "to stand and cast ashore." Although he records how a "deep genealogical current of Pacific interconnectivity shiver[s] up my spine" (2009: 110) as he meets

his son's friend so named, he laments that Tupaia's footprints on the sand of the beaches of Oceania remain far less retraced and celebrated in academic and museological history than those of Cook and Banks.

17. As Salmond notes, Tupaia's pride did not endear him to Cook and the crew of the *Endeavour,* because he expected homage from the sailors, who "thought themselves degraded by bending to an Indian" (Marra, quoted in Salmond 2003: 112). He even showed contempt for King George, because he had many children, whereas he, as a noble *arioi,* prided himself on having none.

18. In both "Unsettling Memories: Commemorating 'Discoverers' in Australia and Vanuatu in 2006" (Jolly 2007a) and in detail in "Moving Objects: Reflections on Oceanic Collections" (Jolly 2008b), I compare the exhibitions as they were mounted in Honolulu and Canberra. The differences were distilled in the contrasting titles: Life in the Pacific of the 1700s from February to May 2006 in Honolulu, and Cook's Pacific Encounters in Canberra from June to September 2006. The first emphasized and celebrated the mana of the Oceanic objects and their pristine character, showing few signs of contact. In the exhibition, but not in the accompanying catalogue and guide, the context of European collecting and the name of Cook was not highlighted. By contrast, in Canberra Cook was celebrated as an icon of the British exploration and settlement of Australia, and the presentation of the objects was framed both in the exhibition and the catalogue by the context of European collecting and the mutuality of material exchanges between the Europeans and Islanders.

Filmography

Sacred Vessels. 1997. Directed by Vicente Diaz. Moving Island Productions.

References

Cook, Alexander. 2001. "The Art of Ventriloquism: European Imagination and the Pacific." In *Cook and Omai: The Cult of the South Seas,* curated by Michelle Hetherington et al., 37–41. Canberra: National Library of Australia, in association with the Humanities Research Centre, ANU.

Dening, Greg, ed. 1974. *The Marquesan Journal of Edward Robarts, 1797–1824.* Canberra: The Australian National University Press.

———. 1980. *Islands and Beaches: Discourse on a Silent Land, Marquesas 1774–1880.* Carlton, Vic.: Melbourne University Press.

———. 1996. "Voices from the Beach." In *Exchanges: Cross Cultural Encounters in Australia and the Pacific,* edited by Ross Gibson, 165–184. Sydney: Museum of Sydney/Historic Houses Trust of New South Wales.

———. 1998. *Readings/Writings.* Melbourne: Melbourne University Press.

———. 2001. "Ó Mai! This is Mai: A Masque of a Sort." In *Cook and Omai: The Cult of the South Seas,* curated by Michelle Hetherington et al., 51–56. Canberra: National Library of Australia, in association with the Humanities Research Centre, ANU.

———. 2004. *Beach Crossings: Voyaging across Times, Cultures and Self.* Melbourne: Miegunyah Press.

Di Piazza, Anne, and Erik Pearthree. 2007. "A New Reading of Tupaia's Chart." *Journal of the Polynesian Society* 116 (3): 321–340.

Finney, Ben (with Marlene Among et al.). 1994. *Voyage of Rediscovery: A Cultural Odyssey through Polynesia.* Berkeley: University of California Press.

Forster, Johann Reinhold. 1996 [1778]. *Observations Made During a Voyage Round the World.* Edited by Nicholas Thomas, Harriet Guest, and Michael Dettelbach. Honolulu: University of Hawai'i Press.

Gell, Alfred. 1985. "How to Read a Map: Remarks on the Practical Logic of Navigation." *Man* 20 (2): 271–286.

Guest, Harriet. 2001. "Omai's Things." In *Cook and Omai: The Cult of the South Seas*, curated by Michelle Hetherington et al., 31–35. Canberra: National Library of Australia, in association with the Humanities Research Centre, ANU.

———. 2007. *Empire, Barbarism and Civilisation: Captain Cook, William Hodges and the Return to the Pacific.* Cambridge: Cambridge University Press.

Haraway, Donna. 1991. "Situated Knowledges: The Science Question in Feminism and the Privilege of Partial Perspective." In *Simians, Cyborgs and Women: The Reinvention of Nature*, 183–201. London: Routledge.

Hau'ofa, Epeli. 1994. "Our Sea of Islands." *The Contemporary Pacific* 6 (1): 148–161.

Hetherington, Michelle, et al., eds., 2001. *Cook and Omai: The Cult of the South Seas.* Canberra: National Library of Australia, in association with the Humanities Research Centre, ANU.

Jolly, Margaret. 1992. "'Ill-Natured Comparisons'?: Racism and Relativism in European Representations of ni-Vanuatu from Cook's Second Voyage." In *Colonialism and Culture*, edited by Nicholas Thomas. *History and Anthropology*, Special Issue 5 (3–4): 331–364.

———. 2001. "On the Edge: Deserts, Oceans, Islands." In *Native Cultural Studies in the Pacific*, edited by Vicente Diaz and J. Kehaulani Kauanui. *The Contemporary Pacific*, Special Issue 13 (2): 417–466.

———. 2007a. "Unsettling Memories: Commemorating 'Discoverers' in Australia and Vanuatu in 2006." In *Pedro Fernández de Quirós et le Vanuatu: Découverte mutuella et historiographie d'un acte foundateur 1606*, edited by Frédéric Angleviel, 197–219. Nouméa and Port Vila: GROCH Nouméa with assistance of the European Union, République Française, Vanuatu Government and Vanuatu National Cultural Council, Sun Productions.

———. 2007b. "Imagining the Pacific: Indigenous and Foreign Representations of a Sea of Islands." *The Contemporary Pacific*, 19 (2): 508–545.

———. 2008a. "Introduction. Moving Masculinities: Memories and Bodies Across Oceania." In *Re-membering Oceanic Masculinities*, edited by Margaret Jolly. Special Issue of *The Contemporary Pacific* 20 (1): 1–24.

———. 2008b. "Moving Objects: Reflections on Oceanic Collections." Keynote Distinguished Lecture at the European Society for Oceanists Conference, University of Verona, July 10–12, 2008. To appear as "Oggetti in movimento: riflessioni sulle collezioni d'Oceania," in Anna Paini and Elisabetta Gnecchi Ruscone, eds., *Putting People First / Prima vengono le persone. Dialogo interculturale immaginando il futuro in Oceania.* Special Issue of *La Ricerca Folklorica*, 63. English and Italian versions.

———. 2009. "The Sediment of Voyages: Re-membering Quirós, Bougainville and Cook in Vanuatu." In *Oceanic Encounters: Exchange, Desire, Violence*, edited by Margaret Jolly, Serge Tcherkézoff, and Darrell Tryon, 57–111. Canberra: ANU E Press.

Jolly, Margaret, and Serge Tcherkézoff. 2009. "Oceanic Encounters: A Prelude." In *Oceanic Encounters: Exchange, Desire, Violence*, edited by Margaret Jolly, Serge Tcherkézoff, and Darrell Tryon, 1–36. Canberra: ANU E Press.

Knellwolf, Christa. 2001. "Comedy in the OMAI Performance." In *Cook and Omai: The Cult of the South Seas*, curated by Michelle Hetherington et al., 17–21. Canberra: National Library of Australia, in association with the Humanities Research Centre, ANU.

McCalman, Iain. 2001. "Spectacles of Knowledge: OMAI as Ethnographic Travelogue." In *Cook and Omai: The Cult of the South Seas*, curated by Michelle Hetherington et al., 9–15. Canberra: National Library of Australia, in association with the Humanities Research Centre, ANU.

Morse, Maria. 2006. "Coming Home." *Honolulu Weekly*, February 22–28: 7–8.

Obeyesekere, Gananath. 1992. *The Apotheosis of Captain Cook: European Mythmaking in the Pacific*. Princeton, N.J.: Princeton University Press.
Sahlins, Marshall. 1985. *Islands of History*. Chicago: University of Chicago Press.
———. 1995. *How "Natives" Think. About Captain Cook, For Example*. Chicago and London: University of Chicago Press.
Salmond, Anne. 1991. *Two Worlds: First Meetings between Maori and Europeans 1642–1772*. Honolulu: University of Hawai'i Press.
———. 1998. *Between Worlds*. Auckland: Viking Press.
———. 2003. *The Trial of the Cannibal Dog: Captain Cook in the South Seas*. London: Allen Lane, Penguin Books.
Smith, Bernard. 1985 [1960]. *European Vision and the South Pacific, 1768–1850*. 2nd ed. Sydney: Harper and Rowe.
———. 1992. *Imagining the Pacific: In the Wake of the Cook Voyages*. Carlton, Vic.: Melbourne University Press at the Miegunyah Press.
Tapsell, Paul. 2009. "Footprints in the Sand: Banks' Maori Collection, Cook's First Voyage 1768–1771." In *Discovering Cook's Collection*, edited by Michelle Hetherington and Howard Morphy, 92–111. Canberra: National Museum of Australia Press.
Teaiwa, Teresia, and Sean Mallon. 2006. "Ambivalent Kinships? Pacific People in New Zealand." In *New Zealand Identities, Departures and Destinations*, edited by James Liu, Tim McCreanor, Tracey McIntosh, and Teresia Teaiwa, 207–229. Wellington: Victoria University Press.
Thomas, Nicholas. 1995. *Oceanic Art*. London and New York: Thames and Hudson.
———. 1997. *In Oceania: Visions, Artifacts, Histories*. Durham, N.C., and London: Duke University Press.
———. 2003. *Discoveries: The Voyages of Captain Cook*. London: Allen Lane, Penguin Books.
Turnbull, David. 1998. "Cook and Tupaia, a Tale of Cartographic *Méconnaisance*." In *Science and Exploration in the Pacific; European Voyages in the Southern Oceans in the Eighteenth Century*, edited by Margarette Lincoln, 117–131. Woodridge, Suffolk: National Maritime Museum.
Turnbull, Paul. 2001. "Mai, the Other Beyond the Exotic Stranger." In *Cook and Omai: The Cult of the South Seas*, curated by Michelle Hetherington et al., 43–49. Canberra: National Library of Australia, in association with the Humanities Research Centre, ANU.
Turner, Caroline. 2001. "Images of Mai." In *Cook and Omai: The Cult of the South Seas*, curated by Michelle Hetherington et al., 23–29. Canberra: National Library of Australia, in association with the Humanities Research Centre, ANU.

Encountering Agency

Islanders, European Voyagers, and the Production of Race in Oceania

Bronwen Douglas

This chapter combines an ethnohistory of encounters between Pacific Islanders and European voyagers with the history of the unstable idea of "race" by correlating voyagers' racial terminology with their experience of particular indigenous people. I take seriously local initiatives, actions, and demeanors—condensed as agency—as refracted through varied genres, modes, or media of travelers' representations. I interpret encounters situationally, not as a general clash of reified cultures but as ambiguous intersections of multiple indigenous and foreign agencies that were usually at cross-purposes but not necessarily opposed. Theoretically, this approach postulates an oblique liaison between indigenous actions and their representation by foreign observers—between referents and signifiers.[1] Such representations should be read not merely as involuntary expressions of dominant metropolitan discourses and conventions but also as personal productions generated in the flux, excitement, stress, and ambiguity of encounters. The demeanor or lifestyle of particular indigenous people attracted, intimidated, or repelled observers, affected their perceptions, challenged or confirmed their predispositions, and left distorted countersigns in what they wrote and drew.[2] Indigenous countersigns often permeate voyagers' representations but are never transparent, given European ignorance and ethnocentric processes of perception and enunciation. They can be identified through systematic critical comparison of different media, genres, and modes of representation and the language and tone of their utterance.

Oceania and "Race"

From the late eighteenth century, with Europe convulsed by revolution, war, and reaction, an uneven but pervasive ideological shift saw the holistic, "environmentalist" humanism of the natural history of man retreat before the differentiating, innatist physicalism of the new sciences of biology and physical anthropology. In the process, conceptions of human difference were transformed as inchoate Enlightenment ideas about unstable varieties within a common humanity metamorphosed into the nineteenth-century science of race, which normalized races as tangible markers of permanent somatic differences between bounded human groups.[3] Eighteenth-century discourses on man

were often scurrilous about non-Christians, "Negroes," and other nonwhites, and yet racial taxonomy was still embryonic, while most savants allowed all human beings the innate capacity to become "civilized." Nineteenth-century racial discourses varied widely but were often obsessively taxonomic and doubted the potential of so-called "savages" to progress unaided, if at all.

In 1804, the French geographer Malte-Brun coined the term Océanique, "Oceanica," to name the "fifth part of the globe" and suggested a racial terminology for its people. He located the "very beautiful," "copper-colored," "Polynesian race" in what are now Polynesia and Micronesia and assigned it "common origin" with "the Malays." He differentiated Malays and Polynesians from the "savage," "black race" of "Oceanic Negroes" who inhabited modern Melanesia (Mentelle and Malte-Brun 1804: 361–363, 474, 573). Malte-Brun (1803: 548) clearly believed in the biological reality of races, rejecting climatic explanations for their "formation."[4] His reasoning contrasted sharply with the fluid, circumstantial classifications of Oceanian people proposed by a few eighteenth-century writers, notably the German naturalist Johann Reinhold Forster (1778: 228), who accompanied Cook's second circumnavigation of the globe in 1772–1775 and subsequently divided South Sea Islanders into "more fair" and "blacker" varieties (see also Douglas 1999: 167–175; 2006: 5–6).

This chapter is set in the hardening racial climate of reactionary Restoration France, which resumed scientific voyaging to Oceania after 1817 (Staum 2003). I focus on Duperrey's expedition on *la Coquille* in 1822–1825 and on representations by Duperrey himself, the first officer Dumont d'Urville, the sublieutenant Blosseville, the master gunner Rolland, the artist Le Jeune, and the surgeon-naturalists Garnot and Lesson. The media of their expression are written and visual, published and unpublished. The genres range from contemporary journals and reports to formal voyage narratives, from sketches to watercolors to engravings. The modes are anecdote, history, and ethnography. The encounters occurred in Tahiti and New Ireland in 1823.

"All power is with the missionaries": Tahiti, May 1823

On May 3, 1823, *la Coquille* became the first French vessel to anchor at Tahiti since Bougainville's stay in 1768. The published reports of his, Cook's, and Bligh's visits had produced a potent myth of a place endowed by nature with "rich and enticing productions" and beautiful, seductive women (Duperrey 1823a; Le Jeune 1822–1823: 20). According to Rolland's journal (1993: 66, 70), the French were "much surprised" when no canoes came out to greet them. The reason soon emerged: "it was their Sunday and devoted to church services." The next day, to Duperrey's relief (1823a; 1823b: 1–5), great crowds "brought all kinds of provisions" to the vessel. A flourishing market continued throughout the French stay, ratified by formal exchanges of visits and gifts between Duperrey and members of the Tahitian royal family, some of whom are portrayed in Le Jeune's sketch.[5] The middle-aged Rolland (1993: 68) noted with surprise that the women were "no longer" eager to "lavish their favors on the kind voyagers" and opined that "[a]ll power is with the missionaries." Le Jeune (1822–1823: 21v), young in years as well as name, rued the disparity between expectation and experience

in unpublished notes on the voyage: "in the districts where there are missionaries, the women are extremely reserved" and "no longer indulge in the indecent scenes that occurred during Bougainville's passage." The reason was not "lack of desire but too much surveillance." Lesson's published narrative (1839, vol. 1: 250) retrospectively confirmed the "cruel disappointment" of crew members whose "sensual images" and "tender expectations" had been stirred by "Bougainville's stories."

In French eyes, the spoilsports were the English Protestant missionaries of the London Missionary Society (LMS), who labored unavailingly in Tahiti for more than fifteen years before Pomare II endorsed their faith, consolidated his rule as the island's Christian king, and oversaw the installation of Evangelical Christianity as the new state religion (Davies 1961: passim). Now, nearly eighteen months after Pomare's death, the missionaries seemed to the French to be the "real sovereigns of these islands," the "absolute masters" of a "sad," subdued populace (Duperrey 1823b: 6, 9; Le Jeune 1822–1823: 21v), epitomized in the elegiac pose of the man in Le Jeune's drawing. Dumont d'Urville (1825: 124) regretted that "the real good" the missionaries had done had turned into a "kind of inquisition" over "the timorous consciences of these feeble humans." They "control everything," said Rolland (1993: 68, 70), "tyrannize" the people, and banned the much valued practices of tattooing, dance, and song. The captain's official reports were ambivalent (Duperrey 1823a, 1823b: 6, 8, 12). He admired the "happy changes" inspired in Tahitian "mind and morals" by "the word of god"—the end of "idolatry," "bloody wars," "human sacrifices," sexual license, and the taboo on women's eating with their husbands, along with the general introduction of literacy and European-style marriage. But in "commerce," he claimed, the missionaries did not act "in the interests of the people they admit to their Communion."[6] Duperrey's shipmates were more forthright. Le Jeune (1822–1823: 21v, 22v) protested that the missionaries "mislead the public" by making "ideas of religion and humanity" their "pretext" for a "commercial system" that extorted an annual "tribute" in kind from every Tahitian for the benefit of the Missionary Society. Lesson's journal (1823–1824, vol. 1: 459, 464–465, 470) and especially his narrative (1839, vol. 1: 239–240, 419–446) seethe with "regret" for the vanished primitive and disdain for missionaries who were "without talent or greatness of soul," who behaved like "madmen," and whose "works" were only "ramifications of a vast commercial enterprise." He deplored their "narrow, bigoted ideas," "fanaticism," and "rigorism" which had caused the "naïve physiognomy" of these "big children" to be "disfigured" as their natural "penchant for love" vanished beneath a "veneer of deceit." He and Garnot (1827: 279) both accused the missionaries of using "corporal punishment" to deter Tahitian women from "the pleasures of love."

From "Caricature" to Agency

This dismal catalogue of peculation, loss, and thwarted desire is profoundly Eurocentric and shot through with sexual, gender, religious, national, class, and racial biases. As such, it might seem an unlikely vehicle for a serious discussion of local agency. Yet French representations of the visit of *la Coquille* to Tahiti are suffused with more or less obscure traces of the actions and demeanors of indigenous women and men

Jules-Louis Le Jeune, "Taïti" [portraits of members of the Tahitian royal family] [May 1823], pen and wash drawings. Jules-Louis Le Jeune, "Voyage autour du monde sur la Corvette La Coquille," folio album of drawings (Vincennes, France: Service historique de la Défense, Archives centrales de la Marine, SH 356), folio 44.

Le Jeune, "Taïtien" [May 1823], pen and wash drawing. Le Jeune, "Voyage," folio 38.

who were engaged in multiple strategic negotiations, with each other, with foreigners, with a new god, and with aspects of modernity. Some Tahitian tactics were acknowledged by the visitors and reported even-handedly; others were noticed but belittled or satirized; many were unconsciously embedded in the very fabric of the representations themselves, including in blatant expressions of prejudice. This section of the chapter samples a range of such signs and countersigns clustered loosely under the rubrics of encounter, dress, tattoo, and sex. The following section on New Ireland focuses on exchange.

In Le Jeune's disarming account of his first sightings of Tahitians (1822–1823: 22), the crew were "alarmed" by the vast number of people onshore, "especially as some had guns and spears." Though quickly rendered implausible by the warm Tahitian welcome, this fleeting admission of apprehension is a reminder of the perennial insecurity of Oceanic voyaging and the vulnerability of sailors to unpredictable local behavior (see Douglas 2003). Lesson (1823–1824, vol. 1: 454; vol. 2: 5, 48) reported that Tahitians were "abundantly supplied" with guns and powder, which they traded from visiting

Le Jeune, "Le mot d'ordre. Garde Royale de Taïti" [May 1823], wash drawing. Le Jeune "Voyage," folio 41.

vessels for pigs and knew "very well how to use." Firearms were evidently important Tahitian accessories. The crowds of people from Tahiti and neighboring islands who attended the annual general assembly of the mission were "almost all armed" with muskets, apparently as a defensive precaution against local rivals. Duperrey (1823b: 4–6) presented the king with an artillery saber but refused the hopeful request of his aunt, the regent, for "boats, cannons, guns, and blunderbusses." The king was escorted on his visit to the ship by a "royal guard," all "armed with guns."

These men, sneered Lesson (1823–1824, vol. 1: 478–479; vol. 2: 5), were "grotesquely decked out in old European costumes." Le Jeune's portrait has a hint of caricature made overt in his comment on local modes of dress (1822–1823: 22, 22v): "I

was much amused to see their costumes, some had only a shirt, others a ragged tailcoat, others a pair of trousers, the women wore a European skirt to their knees and had straw hats, but most were naked apart from the maro ['loincloth']." For the general assembly, most people donned European-style clothes and the chiefs proudly "dressed as gentlemen" but in garments "so tight they feared to move." Le Jeune opined that "this costume did not suit them as well as their own" and expressed the verdict visually in a watercolor of "Costumes of Tahiti": several superbly muscled, elegantly disposed, tattooed men in traditional dress are juxtaposed with three awkwardly posed women in a motley array of local cloth and imported garments. For Rolland (1993: 72), the indiscriminate wearing by men and women alike of ill-fitting European garments—like the waistcoat on Le Jeune's central woman—gave them an "air of caricature."

These French authors responded with varying degrees of incredulity, ambivalence, sarcasm, or contempt to the—to them—incongruous appearance and behavior of exotic Tahitian Christians. Le Jeune (1822–1823: 22) artlessly admitted that "we expected to see savage men entirely in the state of nature" but were "astounded" when the first two Tahitians to board the ship spoke "bad English" and dined in a "perfectly civilized" manner, though "naked except for a maro" and "covered in tattoo." In an ironic inversion of the demeaning cliché of the naïve savage gawking at the civilized, he reported—and Lesson (1823–1824, vol. 1: 474–475) confirmed—that the Europeans "followed their movements attentively and each of their actions made us cry out in astonishment." In contrast to Le Jeune's mild strictures on the eclecticism of Tahitian dress, Duperrey (1823b: 11) scathingly condemned and racialized the new modes; these

Le Jeune, "Taïti 20 mai 1823. Costumes de l'île Taïti. A bord de la Coquille," watercolor. Le Jeune, "Voyage," folio 29.

"incomplete" introduced costumes cost them "their distinctive character" and made them look like "large apes" trying clumsily to "mimic" Europeans, while the women's taste for homemade "English hats" instead of garlands of flowers produced the anomaly of "a strongly tanned face beneath an inherently ridiculous headgear." Lesson's journal (1823–1824, vol. 2: 19) pronounces a similarly unkind verdict: the women were transformed into "walking caricatures" by European dress.

As a patronizing romantic who thought it unwise to "multiply the needs of these peoples" rather than keep them in "their modest simplicity," Duperrey (1823b: 9–11) clearly took for granted that the aesthetic changes he deplored, like the moral and educational ones he condoned, were simply "prescribed" and enforced by the mission. Yet his reports and the journals and narratives of his crew bear repeated testimony to the complex intersections of convention or innovation, constraint or opportunity, conformity or desire, compulsion or choice, that limit or enable all human actions. Women, for example, evidently wore mission dresses and straw hats because they wanted to, for reasons of fashion, decorum, status, or perhaps as a sunscreen, and not just because prudish missionaries made them do so—Le Jeune (1822–1823: 22) remarked that they usually went bare-breasted for everyday wear, as in his depiction of "Costumes of Tahiti."

Disentangling agency with respect to *tatau*, "tattooing," is also problematic (see D'Alleva 2005: 91–98). Most of the missionaries condemned the practice as immoral and anti-Christian. They presumably encouraged its proscription in the codes of law they helped chiefs across the Society Islands to adopt in the wake of Pomare II's initiative in 1819 (Ellis 1831, vol. 3: 135–145, 175–214). The French supposed unproblematically that the laws were "imposed by the missionaries" and condemned several as "truly unjust and cruel," including those against tattooing. By contrast, the missionary historian Ellis (1831, vol. 3: 137) attributed the first code to Pomare II, with missionary "advice and direction" but without their entire approval because he used it to reinforce his despotism. The bans on *tatau* were widely resented, often contravened, and short-lived—though the practice eventually died out in any case (Lesson 1823–1824, vol. 1: 460, 467–468, 483; vol. 2: 30). Le Jeune's drawings depict an exuberant range of *tatau* motifs proudly displayed for the artist by Tahitians of both sexes. Lesson (1839, vol. 1: 239, 380–381, 443) stated that they loved tattoo "passionately." He elided the political agency of local elites by attributing the prohibition of *tatau*, under threat of "severe punishment," solely to "the missionaries," but his loathing of these English Evangelicals sensitized him to defiant or independent actions by some Tahitians, otherwise belittled as "big children." Young men, in particular, were so keen to add to their *tatau* that they fled to the woods for the purpose. And Lesson took sardonic pleasure in the desire to be tattooed expressed by several chiefs because it put the missionaries in an embarrassing double bind: they had either to oppose the wish (causing offense to a chief) or agree (breaking the law) (see also Gunson 1962).

Most of the French visitors were preoccupied with sex—craved, withheld, surreptitiously shared, or pruriently observed. Agency is always ambiguous in sexual relations, but Europeans typically attribute none or little to indigenous women (Douglas 2001: 37–64). Duperrey (1823b: 4) reported that the sailors were "much put out" to

be deprived of sexual partners by a régime of punitive control by middle-ranking men, *raʻatira*, who posted guards to keep the women in their houses at night. In published ethnological notes, Garnot (1827: 279–281) slotted such men into a conventional hierarchy of agency that gave all initiative to missionaries, made local men their dupes in policing female conduct, and objectified women as mere puppets. Lesson's early journal entries (1823–1824, vol. 1: 456, 470–471) also represent chiefs as the missionaries' "vassals" or "auxiliaries" and the chiefs' henchmen as sexual "spies." But Garnot complicated his scenario with an admission of surreptitious local male agency, accusing the guards of privately brokering "precious favors" for foreigners from women, including those of high rank. In his informal notes, Le Jeune (1822–1823: 22) reconfigured Garnot's charge of pimping into wry admission of a joke at French expense: though no women came on board the ship because of the missionary ban, some Tahitian men promised to arrange a tryst onshore at night, but when the time came, the men themselves turned up instead of women and were "much amused at our mistake." In contrast, Rolland (1993: 72) supposed that women acted independently to evade the new moral code; though mocking it, they nonetheless complied during the daytime but at night dodged their guards in order to meet their French lovers. Toward the end of the visit, Lesson (1823–1824, vol. 2: 61–63), too, noted the determination of many Tahitian women, including the "queen mother," to indulge their "taste" for illicit sex, often brokered by trusted male intermediaries. In the final days, several of the "prettiest girls" sneaked on board for the night. Such behavior prompted the snide comment that Tahitians had made great "progress in dissimulation" in the face of "missionary anathemas" and local "spies." Lesson's published narrative (1839, vol. 1: 250) extends this misogynist irony as rhetorical camouflage for countersigns of indigenous female agency; after the first frustrating days, Tahitian women showed the sailors that "their shrewdness did not need a civilized education to sin in secret and that they knew well how to wrap their actions in a thick and mysterious veil."

"Much good faith in the exchanges": New Ireland, August 1823

On August 12, 1823, after a difficult passage across the Pacific, Duperrey urgently sought supplies in the extreme south of New Ireland at Port Praslin (Lassim Bay), where the British navigator Carteret in 1767 and Bougainville in 1768 had found secure anchorage and ample wood and water. The area is one of the wettest places on earth and torrential rain fell during Bougainville's visit, as it did also at nearby Carteret Harbor (Lamassa Bay) when Entrecasteaux and Dumont d'Urville stayed there in 1792 and 1827 respectively (Bougainville 1977: 370–378; Dumont d'Urville 1830–1833, vol. 4: 531; La Billardière 1800, vol. 1: 235, 242). But in 1823, superb weather and plentiful supplies made Duperrey (1823b: 16–19; 1828: 598) "enchanted with this stopover." Equally, if unexpectedly, "admirable" was the "pacific and hospitable" conduct of the local people. There were no permanent nearby settlements and none of the earlier expeditions had had "the advantage of communicating with the inhabitants." But on the first morning, the ship was confidently approached by several dozen unarmed men who came from their village on the other side of the island and instigated peaceful trading

relations with the French. They camped in the bay, exchanging a "quite considerable" quantity of local produce, mainly for sharpened pieces of hoop iron which they knew and greatly valued—Lesson (1839, vol. 2: 61) thought it was "more precious" to them than gold. They also helped the sailors fish and the naturalists with their collecting, as depicted in Le Jeune's sketch. After five days, they took a friendly leave and departed because, Duperrey supposed, they had "nothing more to sell" and were "impatient to see their wives of whom they are very jealous" (see Lesson 1823–1824, vol. 2: 280–334; Lesson 1839, vol. 2: 12–66; Rolland 1993: 82–98).

A serendipitous balance of power, wariness, desire, and complaisance between the parties to this brief encounter underpinned their mutual gratification. But by all

Le Jeune, "Cascade du Port Praslin. N^lle Irlande" [August 1823], wash drawing. Le Jeune, "Voyage," folio 63.

accounts, the terms of the encounter were mostly set by the indigenous participants whose gestures (signs of "peace and friendship"), demeanor ("mild, cheerful, and obliging"), and actions ("not armed;" "probity;" "hospitality") were accurately read by the nervous French as signaling "good intentions" (Garnot 1827: 286). Their "conduct," said Lesson (1839, II: 14, 19–20), belied French "fears" and "precautions." Euphoric with relief, Duperrey (1823b: 17, 18) lyrically praised their "good faith in the exchanges." Rolland (1993: 82, 92–94) concluded from vulnerable experience, when treated kindly by eighteen men met unexpectedly in the jungle, that their reputation for cruelty and cannibalism was unfounded. Blosseville (1823: 303) emphasized the precedence of indigenous agency: "The conduct of the natives, from their first visit, determined ours and we carried no arms." Lesson, hard-nosed and contemptuous of all "savages," especially so-called "Negroes," was more guarded. In the immediacy of his journal (1823–1824, vol. 2: 284, 332–333), he allowed a degree of strategic local agency, surmising that after unpleasant past experience of the "immense superiority" conferred on Europeans by firearms, the New Irelanders had "taken the wisest course, that of living in good accord, and gaining every possible benefit from these fleeting relationships." But in the more distanced genre of the narrative (1839, vol. 2: 14, 19–20, 23, 61, 62), he took for granted that reflexive fear of French firearms and the "power" of the warship had alone restrained "the violence of their passions" and dictated "peaceful sentiments." Yet even Lesson allowed that French "relations" with these New Irelanders were "openly friendly"; he praised their "probity" in commerce and the "goodwill" of local guides toward the naturalists who were entirely "at their mercy" while wandering unarmed in the forests in search of natural history specimens.

Perhaps surprisingly, local agency in exchange is less ambiguous in French representations of their stay in Port Praslin than in relation to Tahiti, where the inhabitants, long experienced in trade with Europeans, managed it through emotional camouflage and modified customary strategies. Le Jeune (1822–1823: 22) noted wryly that the ingratiating conduct and "gentle character" of Tahitians had so delighted the French at the outset that they gave away many objects without expecting a return. Tahitians then sought to formalize such moral imperatives through the venerable institution of *taio*, "friendship," forged with individual sailors, who were expected to engage in disinterested mutual gift giving with their new "friends" (see also Rolland 1993: 72–74). More cynical and far less generous than the artist, Lesson and Garnot only negatively admitted Tahitian agency in exchanges. Lesson (1823–1824, vol. 1: 476, 480–483; vol. 2, 286; 1839, vol. 1: 394; vol. 2: 19, 20–21) railed against "shrewd" dealings by "clever" traders or moral coercion by "friends" who demanded much more in return gifts of clothing than they had given in "curiosities." He yearned instead for the impersonal "balance" and finality of one-off transactions. But when a "public market" was established in New Ireland in the "neutral ground" of the ship's chain-wale, he bemoaned the "exorbitant price" demanded for rare commodities such as pigs and poultry. Garnot (1827: 283–284) accused Tahitians of lacking "good faith in commercial relations" and of a "penchant for theft as much by skill as artifice." New Irelanders were similarly

maligned. Lesson (1823–1824, vol. 2: 297, 332–333) said they were "fundamentally thievish" but at first behaved "with the utmost circumspection" and only "raised the mask" late in the visit. Garnot (1827: 286) thought they were as "prone to theft" as other South Sea Islanders and "much more blameworthy" because they showed they knew it was wrong by "hiding behind trees to pilfer the sailors' washing."

In counterpoint to Tahiti, where women were publicly reticent but privately compliant, the French saw no females at all during their stay at Port Praslin, and sex figured in neither interactions nor representations. They blamed the "jealousy" of the men who deliberately misdirected the visitors away from their village. Only Blosseville (1823: 307), accompanied by a sailor, was permitted a brief tour of the village after showing extraordinary persistence to get there and scrupulously negotiating entry with the old men. But even then no women were in evidence—"not even little girls"—and Blosseville presumed they were shut away in their houses (Garnot 1827: 289; Lesson 1839, vol. 2: 34, 42, 55; Rolland 1993: 86–96).

Agency and Race

Le Jeune's manuscript notes (1822–1823) cease in Tahiti and his tolerant candor and enthusiasm are much missed from the textual corpus of *la Coquille's* visit to New Ireland. His Tahitian portfolio (1822–1825) contains more than fifty portraits of local women and men, many of them named. In contrast, there are extant drawings of only three anonymous New Ireland men. One has some of the naturalism and sensitivity to personal demeanor evident in many of Le Jeune's Tahitian works, but the other two figures are classicized ethnographic specimens prepared for engraving in the historical atlas of the voyage (see Duperrey 1826: plate 24). The reasons for the difference probably stemmed from both local conditions and European conventions. In Tahiti, Le Jeune exploited his *taio* relationship to recruit obliging subjects who were easy to draw because some approximated the classical physiques he was used to depicting; in New Ireland, a scarcity of willing subjects perhaps compounded his struggle to portray unfamiliar bodies.

The written texts considered here were more constrained by precedent and congealing racial presumptions than were equivalent eighteenth-century voyage materials, and indigenous countersigns are correspondingly more obscure (cf. Douglas 2009). By the nineteenth century, voyagers mostly reified races as literally true, but marked disjunctions still remain in the racialization of different groups of Oceanian people and between different genres or modes of representation. The less people seemed to meet European standards of physical appearance and lifestyle, the lower they were ranked racially. The less intimate and more schematic the genre or mode and the more scientific the author, the more sclerotic the assessments of racial differences and racial character, the less attribution of agency, and the fewer indigenous countersigns. In journals or reports written close to the event, the sailors Rolland, Blosseville, and Duperrey and the artist Le Jeune gave relatively unracialized accounts of friendly personal engagements with the "inhabitants" or "natives" of places visited—familiarity here bred the reverse of contempt and local agency figured significantly. Thus, following his village

Le Jeune, "N^lle Irlande" [August 1823], pen and wash drawing. Le Jeune, "Voyage," folio 20.

Le Jeune, "Guerriers de la N^lle Irlande" [August 1823], pen and wash drawings. Le Jeune, "Voyage," folio 64.

visit, Blosseville (1823: 308–309) hoped that "the magnanimous way in which the New Irelanders treated us, when entirely at their mercy," their "life style," and the "remarkable cleanliness" of their habitations (in contrast to those of Tahitians) would prove they were "much less distant from the first levels of civilization" than previously supposed.

In contrast, the naturalist Garnot (1827: 276–277, 284–285) marveled at the racial "difference" between "generally well built," "bronzed" Tahitians, whose facial angle was "as open as that of Europeans," and "black," "thin" New Irelanders whose facial angle was far more oblique and who were "less advanced in civilization." Both texts by his fellow naturalist Lesson are pervasively racialized, the narrative stringently so. His favorite noun for indigenous people is "savages," his first epithets for New Irelanders are "naked and black," and the narrative routinely calls them "Negroes." Yet even Lesson oscillated between particular historical and general ethnographic modes that parallel less and more acerbic racial judgments and show marked discrepancies in voice, tense, and vocabulary. Hence his descriptions of the actively "honest" trading, generous food sharing, and "good intentions" of individual New Ireland "natives" were phrased in the active voice and concretized in the past tense (1823–1824, vol. 2: 280, 284, 288; 1839, vol. 2: 14, 19, 23). Conversely, his invidious racial comparisons or vitriolic physical, aesthetic, and moral generalizations about "these Negroes" were often made in the passive voice and always eternalized by the ethnographic present: "their needs being purely animalistic, . . . all the Negro races find themselves more or less behind the rest of the human species," including "the Oceanians" (Lesson's modern Polynesians); the "singular" nose ornaments of the New Irelanders "stamp a hideous and ferocious quality on to their naturally repulsive and ugly physiognomy" (1823–1824, vol. 2: 313; 1839, vol. 2: 36–39, 54). Personality is involved as well as profession, genre, and mode because even Lesson's positive remarks often have a racialized edge, especially in the narrative. Though generally impressed by the "regular and gracious forms which characterize the Oceanians" (compared specifically to the New Irelanders), he was at once prurient, mysogynistic, and racialist about Tahitian women. Young women had well-shaped, "firm" breasts but ugly nipples compared with "the woman of Caucasian race," Tahitian women were "generally very ugly," and the old women were all "disgusting." Similarly, having praised two "young Negroes" who helped him collect and name specimens at Port Praslin, he described them as "clambering in the trees like apes" (1823–1824, vol. 2: 6, 19, 35, 44; 1839, vol. 1: 363–365; vol. 2: 23, 36).

Voyagers' representations of indigenous people are ambiguous precipitates of the lived tension between stereotype and personal experience. Relief at favorable indigenous conduct typically qualified negative depictions or generated positive ones, even in the face of prejudiced aversion to physical appearance, and it provoked rhetorical ploys to distance approved familiar people from analogy with the racial zero point of "the Negro." These textual elements are indigenous countersigns—oblique traces of indigenous demeanor as processed in European perceptions. Duperrey's (1823b: 18) exhilaration at the "admirable" conduct of the New Irelanders prefaced his praise for their "good faith," "hospitality," and "considerable intelligence." Lesson (1839,

vol. 2: 41–42) moved from acknowledging "good accord" with those New Irelanders the French saw often to asserting that their figures lacked "that emaciation exhibited in several other Negro races, and their limbs were agile and supple." Garnot (1827: 284–286) judged their color to be "less dark" than "the Negroes," their faces overall to be "far from agreeable" but their separate features "regular enough," their noses "not flat like the Negroes'," their bodies "well-proportioned," and their nature "cheerful."

Conclusion

This chapter has three interlocking aims: first, to identify indigenous countersigns embedded in voyagers' representations and evaluate their trajectory from the personal encounters that provoked them through varied media, genres, and modes of representations; second, to exploit such countersigns in an ethnohistory of encounters between European voyagers and Pacific Islanders; and finally, to relate indigenous agency in particular encounters to the uneven racialization of different representations.

I conclude that referents (things referred to) can inflect the signifiers (expressions) through which they are formulated. Indigenous presence pervades firsthand voyage materials and persistently disrupts the more remote, more racially charged genres of narrative and ethnography. The ambiguities and unpredictability of local agency in actual encounters regularly disconcerted, frightened, or infuriated voyagers, whether they acknowledged, demeaned, distorted, or repressed it. The threat of indigenous hostility, violence, or refusal to trade for supplies was ubiquitous during the age of sail in Oceania. This is why Tahitian "sociability" and the "sweet, pliant character of the inhabitants" so pleased the crew of *la Coquille,* like most of their predecessors (Le Jeune 1822–1823: 20). It is why praise for the "mild, cheerful, and obliging nature" of the New Irelanders qualified the racial ambivalence induced by their supposedly "Negro" features, nudity, and extravagant body decorations (Garnot 1827: 283–286; Lesson 1839, vol. 2: 14, 36–42). But voyagers usually failed to recognize the agency in friendly Tahitian demeanors, attributing them to lethargy induced by an undemanding lifestyle in a naturally favored environment and latterly to the enforced influence of Christianity, rather than to desire or intent (Lesson 1839, vol. 1: 361–362). Le Jeune's (1822–1823: 23v) fleeting historical insight that in 1767, following a lethal encounter with British guns, the Tahitians had chosen to abandon aggression in favor of "peaceable intentions" is an unusual but important allusion to the global strategy adopted and henceforth maintained by Tahitian leaders and people alike. In the immediate aftermath of encounters in New Ireland, the French acknowledged intent in friendly local behavior, perhaps because it so contradicted their ingrained belief in the "savagery" and "pure animality" of "Negro races." In retrospect, though, Lesson concluded that the New Irelanders' "circumspection" was not "habitual" but was "imposed" by fear of European firearms (Lesson 1839, vol. 2: 54, 61, 274). Complaisance and recalcitrance may equally be designed but the self-styled civilized tended to attribute both to reflex savagery rather than to indigenous agency or strategies.

Space limitations determined my historical method of juxtaposing disconnected

snapshots of particular encounters over a limited time span. Theoretically, I construe encounters in terms of qualified mutual agency and strategic interpersonal negotiations. Neither method nor theory lends itself to consideration of broad cultural transformations—the general theme of this volume. However, my interest in the intersections of indigenous actions and European ideas resonates strongly with the volume's focus on changing contexts and shifting meanings. The contexts addressed are long-contacted, newly Christian Tahiti and early contact New Ireland. In 1823, the French found Tahiti "much changed" from the "happy," "picturesque" depictions of Wallis, Cook, and Bougainville (Lesson 1823–1824, vol. 1: 423)—in dress, sexual conduct, bodily adornment, weaponry, gender relations, rituals, and so forth. Europeans then and since have usually attributed this behavioral transformation to simple mimicry or linear imposition by a superior culture; the LMS missionaries, wrote Duperrey (1823a), "have totally changed the direction of the morals and customs of this people." In contrast, I regard such altered behaviors as products of the ambiguous entanglement of old and new imperatives or desires with novel opportunities for choice. Thus, in the power vacuum following Pomare II's death, rival district chiefs—now mostly ardent Christians—endorsed his displacement of the waning contextual force of *tapu* by the universalist authority of law. However, they did so in pursuit of long-standing Tahitian goals: control of resources, control of people (especially women), and control of ritual access to a powerful new god in coalition with his missionaries. In New Ireland, conversely, not much seemed to have changed, but these very different settings shared a common denominator: the lust to appropriate selected aspects of European modernity—especially clothing and firearms in Tahiti and iron in New Ireland—to serve competing local interests.

I conclude with this reflection on the discursive implications of correlating the shifting signifieds of the European idea of race with voyagers' encounters with Pacific Islanders: that agency is a multifaceted human potential exercised by indigenous people as well as Europeans; and that a pluralized, de-exoticized, historicized conception of culture retains relevance for a postcolonial social science because Europeans have cultures as well as natives.

Notes

1. My use of the concept signifier is not strictly that of the Swiss linguist Ferdinand de Saussure (1974: 66) whose binary model of the sign paired a signifier ("sound pattern") with a signified ("concept"). Rather, I have appropriated the term, in the broad sense of "expression," to take account of the thing referred to, or referent—what the American philosopher Charles Peirce called the "object" of representation (Chandler 2002: 32). I do so in what might be called a radical empirical sense by arguing that existential referents may inflect the signifiers chosen to represent them. The signifieds, or meanings, of any signifier inhere, of course, as much in the reading as in the representation.

2. "Countersigns" are oblique traces of the imprint of local or subaltern agency on foreign or élite perceptions, reactions, and representations. They are manifest syntactically in word choice and arrangement, grammatically in tense, mood, and voice, and semantically in presence, emphasis, or absence.

3. The term "race" probably entered English from Italian via French in the fifteenth cen-

tury. It originally connoted common family, stock, or ancestry, expanded to mean humanity as a whole. By the eighteenth century, it was synonymous with "nation," "variety," or "kind" and applied to extensive populations. From the 1770s, initially in Germany and France, race was redefined as an innate biological characteristic. This usage percolated into English in the early nineteenth century and has since been naturalized globally. See Douglas 2005: 331–338; 2008: 34–44.

4. In 1815, the geographer Brué amended the regional name to Océanie, "Oceania" (Brué 1815: Carte 36). Both Océanique and Océanie encompassed the East Indies, New Guinea, New Holland, Van Diemen's Land, New Zealand, and the island groups of the Pacific Ocean, in contrast to the usual Anglophone restriction of "Oceania" to the Pacific Islands only. All translations are mine.

5. The Tahitian dignitaries included the three-year-old Pomare III, who had become king of Tahiti following the death of his father Pomare II in 1821; his mother Tere Moe-moe and her sister Pomare-vahine, the "regent"; his sister 'Aimatta, the future Pomare IV; and his brother-in-law Pomare-noho-rai'i. Tere Moe-moe, Pomare-vahine, and Pomare-noho-ra'i are portrayed by Le Jeune.

6. For other positive evaluations of aspects of Tahiti's "new face," see Anon. 1824; Garnot 1827: 276; Le Jeune 1822–1823: 21v; Rolland 1993: 68.

References

Anonymous. 1824. "Autre lettre sur le même sujet. Mes chers parens. A bord de *la Coquille*, Otaïti, 15 mai 1823." *Annales maritimes et coloniales* part 2, vol. 1: 313–314.

Blosseville, Jules-Alphonse-René Poret de. 1823. "[Narration de son voyage au village de Leukiliki, Nouvelle-Irlande, en août 1823]." In René-Primevère Lesson, [Voyage de la Coquille], vol. 2, 302–309. MS. MS1793. Paris: Muséum national d'Histoire naturelle.

Bougainville, Louis-Antoine de. 1977. "Journal de Bougainville commandant de la *Boudeuse*." In *Bougainville et ses compagnons autour du monde 1766–1769*, edited by Etienne Taillemite, vol. 1, 141–497. Paris: Imprimerie nationale.

Brué, Adrien-Hubert. 1815. *Grand atlas universel, ou collection de cartes encyprotypes, générales, particulières et détaillées, des cinq parties du monde*. Paris: Desray.

Chandler, Daniel. 2002. *Semiotics: The Basics*. London: Routledge.

D'Alleva, Anne. 2005. "Christian Skins: *Tatau* and the Evangelization of the Society Islands and Samoa." In *Tattoo: Bodies, Art and Exchange in the Pacific and the West*, edited by Nicholas Thomas, Anna Cole, and Bronwen Douglas, 90–108. London: Reaktion Books.

Davies, John. 1961. *The History of the Tahitian Mission 1799–1830*. Edited by C. W. Newbury. Cambridge: Hakluyt Society.

Douglas, Bronwen. 1999. "Science and the Art of Representing 'Savages': Reading 'Race' in Text and Image in South Seas Voyage Literature." *History and Anthropology* 11: 157–201.

———. 2001. "Encounters with the Enemy? Academic Readings of Missionary Narratives on Melanesians." *Comparative Studies in Society and History* 43: 37–64.

———. 2003. "Seaborne Ethnography and the Natural History of Man." *Journal of Pacific History* 38: 3–27.

———. 2005. "Notes on 'Race' and the Biologisation of Human Difference." *Journal of Pacific History* 40: 331–338.

———. 2006. "Slippery Word, Ambiguous Praxis: 'Race' and Late 18th-Century Voyagers in Oceania." *Journal of Pacific History* 41: 1–29.

———. 2008. "Climate to Crania: Science and the Racialization of Human Difference." In *Foreign Bodies: Oceania and the Science of Race 1750–1940*, edited by Bronwen Douglas and Chris Ballard, 33–96. Canberra: ANU E Press.

———. 2009. "In the Event: Indigenous Countersigns and the Ethnohistory of Voyaging." In

Oceanic Encounters: Exchange, Desire, Violence, edited by Margaret Jolly, Serge Tcherkézoff, and Darrell Tryon, 175–198. Canberra: ANU E Press.

Dumont d'Urville, Jules-Sébastien-César. [1825]. Notes relatives au roman des Nouveaux-Zélandais. 31 août 1825. MS. 7GG$_2$ 30. Vincennes, France: Service historique de la Défense, Archives centrales de la Marine.

——. 1830–1833. *Voyage de la corvette l'Astrolabe exécuté . . . pendant les années 1826–1827–1828–1829 . . . Histoire du voyage.* 5 vols. Paris: J. Tastu.

Duperrey, Louis-Isidore. 1823a. Lettre n°. 1 [Duperrey to Ministre de la Marine et des Colonies, Matavai Bay, Tahiti, 15 May 1823]. MS. Plaquette 3, BB4 1000. Vincennes, France: Service historique de la Défense, Archives centrales de la Marine.

——. 1823b. Relâche à l'ile de Tahiti et rapport de la traversée de la corvette La Coquille de Tahiti à Amboine, adressé à son Excellence Le Ministre de la Marine. Du 15 mai au 14 octobre 1823 [Ambon, October 14, 1823]. MS. Plaquette 3, BB4 1000. Vincennes, France: Service historique de la Défense, Archives centrales de la Marine.

——. 1826. *Voyage autour du monde, exécuté par ordre du roi, sur la corvette de sa majesté,* La Coquille, *pendant les années 1822, 1823, 1824 et 1825 . . . Histoire du voyage, Atlas.* Paris: Arthus Bertrand.

——. 1828. "Mémoire sur les opérations géographiques faites dans la campagne de la corvette de S.M. la *Coquille,* pendant les années 1822, 1823, 1824 et 1825." *Annales maritimes et coloniales,* part 2, vol. 1: 569–691.

Ellis, William. 1831 [1829]. *Polynesian Researches During a Residence of Nearly Eight Years in the Society and Sandwich Islands.* 4 vols., 2nd ed. London: Fisher, Son, & Jackson.

Forster, Johann Reinhold [John Reinold]. 1778. *Observations made during a Voyage Round the World, on Physical Geography, Natural History, and Ethic Philosophy.* London: G. Robinson.

Garnot, Prosper. 1827. "Notes sur quelques peuples de la mer du sud par M. le docteur Garnot, chirugien-major de la corvette *la Coquille.*" *Journal des voyages, découvertes et navigations modernes, ou archives géographiues du XIXe siècle* 33: 275–296.

Gunson, Niel. 1962. "An Account of the Mamaia or Visionary Heresy of Tahiti, 1826–1841." *Journal of the Polynesian Society* 71: 209–242.

La Billardière, Jacques Julien Houtou de. 1800. *Relation du voyage à la recherche de La Pérouse . . . pendant les années 1791, 1792, et pendant la 1ere. et la 2e. année de la République françoise. . . .* 2 vols. Paris: H. J. Jansen.

Le Jeune, Jules-Louis. 1822–1823. Journal de Mr· Le Jeune, dessinateur de l'expédition [11 August 1822–1823 May 1823]. MS. SH 355. Vincennes, France: Service historique de la Défense, Archives centrales de la Marine.

——. [1822–1825]. Voyage autour du monde sur la Corvette La Coquille. . . . Folio album of drawings. SH 356. Vincennes, France: Service historique de la Défense, Archives centrales de la Marine.

Lesson, René-Primevère. 1823–1824. [Voyage de la Coquille]. 2 vols. MS. MS1793. Paris: Muséum national d'Histoire naturelle.

——. 1839. *Voyage autour du monde entrepris par ordre du gouvernement sur la corvette la Coquille.* 2 vols. Paris: R. Pourrat frères.

Malte-Brun, Conrad. 1803. "Géographie genérale, mathématique et physique." In Edme. Mentelle and Conrad Malte Brun, *Géographie mathématique, physique et politique de toutes les parties du monde . . . ,* vol. 1, 151–552. Paris: Henry Tardieu and Laporte.

Mentelle, Edme., and Conrad Malte-Brun. 1804. *Géographie mathématique, physique et politique de toutes les parties du monde: rédigée d'après ce qui a été publié d'exact et de nouveau par les Géographes, les Naturalistes, les Voyageurs et les Auteurs de Statistique des nations les plus éclairées.* Vol. 12. Paris: Henry Tardieu and Laporte.

Rolland, Thomas Pierre. 1993. *Any Port in a Storm: From Provence to Australia: Rolland's Journal of the Voyage of* La Coquille *(1822–1825)*. Translated and edited by Marc Serge Rivière and Thuy Huynh Einam. Townsville, Qld.: James Cook University of North Queensland.

Saussure, Ferdinand de. 1974 [1916]. *Course in General Linguistics*. Translated by Roy Harris. Peru, Ill.: Open Court Publishing.

Staum, Martin S. 2003. *Labeling People: French Scholars on Society, Race, and Empire, 1815–1848*. Montreal and Kingston: McGill–Queen's University Press.

Aphrodite's Island
Sexual Mythologies in Early Contact Tahiti

Anne Salmond

In June 1767, the British ship *Dolphin* discovered Tahiti for Europe. Captain Wallis was on a voyage of exploration, searching for the Unknown Southern Continent. Although canoe travel linked this small Polynesian island to the archipelagoes around it, until that moment its people knew nothing of the wider world. Now this isolation was shattered as a succession of ships from France, Britain, and Spanish America began to anchor off the coast, and as the first vessel from each nation arrived, its officers landed and put up a flag or a cross, claiming Tahiti for their monarch. To these first Europeans the island seemed a paradise, with its volcanic mountains, encircling coral reefs, and luxuriant vegetation. For the sailors, much of its attraction lay with the island women, famed for their beauty, and Tahiti became a legendary haven.

Matavai Bay in Tahiti.
Credit: "A View of Matavai Bay in the Island of Otaheite" by William Hodges (Yale Center for British Art, New Haven, Conn.).

In the beginning, however, the strangers were not welcomed but greeted with deep suspicion. The islanders had been forewarned about their arrival, and the prophecy was ominous. In about 1760, when marauding warriors had attacked Taputapuatea, the sacred temple of the war god 'Oro, a priest named Vaita went into a trance and proclaimed that a new kind of people, coming on "a canoe without an outrigger," would take over the land and change their lives forever. Thus when the *Dolphin*, a "canoe without an outrigger" appeared above the horizon, the Tahitian men approached the vessel fearfully and in a ritual fashion. A hundred or so canoes surrounded the ship, and a priest made a long speech before throwing a plantain branch in the ocean.[1]

After much hesitation some of these men climbed on board the ship, where they gazed about in amazement. When they began to snatch at the iron stanchions, a nine-pound gun was fired, sending them scrambling overboard. The next day when the cutter was sounding the bay, a fleet of canoes attacked, pelting the crew with stones hurled from slingshots. In reprisal, the lieutenant fired at one of these men with buckshot, wounding him in the shoulder. Over the next few days there were further clashes, and a man was shot dead, to the amazement of his companions, indicating to the Tahitians that this strange vessel and its crew were imbued with 'Oro's power. Thunder and lightning were signs of the war god's presence, and red was his sacred color; the gun carriages and scuppers on the *Dolphin* were painted red, while her marines wore scarlet coats, just as the high chiefs of Tahiti wore the *maro 'ura* (red feather girdle).

On the third day when the *Dolphin*'s boats went to fetch fresh water, the islanders decided to try another ploy, bringing down to the beach a number of "fine young girls," who exposed themselves to the sailors. In times of war this was a hostile gesture, summoning up the power of the ancestor gods, but the British saw it differently. According to the ship's master Robertson, "This new sight Atract our men's fanc[y] a good dale, and the natives observed it, and made the Young Girls play a great many droll want[on] tricks, and the men made signs of friendship to entice our men ashoar, but they very prudently deferd going ashore, untill we turnd better acquainted with the temper of this people" (Robertson 1948: 148). This was wise, because as the boats put off, the women shouted loudly and pelted the sailors with Tahitian apples and bananas.

That night Wallis put his men on alert, posting sentries about the ship and ordering the guns to be primed and loaded.

The next morning while the *Dolphin* was being warped into Matavai Bay, the ship was surrounded by hundreds of canoes carrying about fifteen hundred people. Canoes packed with young women came alongside the *Dolphin*, and when they came close the women lined up in the prows naked, playing "wanton tricks" and exposing their genitals to the sailors. As Wilkinson, one of the sailors reported:

> At 10 the woman was Derected by the Men to Stand in the Prow of their Canoes & Expose their Bodys Naked to our View as our men is in good Health & Spirits and begin to feel the Good Effect of the fresh Pork It is Not to be wondred that their Attention Should be Drawn to A Sight so uncommon to them especially as their woman are so well Proportisned.[2]

Fleet of war canoes in Tahiti.
Credit: "The Fleet of Otaheite Assembled at Oparee"; engraving by Woollett after William Hodges.

As the crew crowded up on deck, riveted by this spectacle, the warriors let fly with their slingshots, hurling rocks at the strangers. In a fury, the sailors flew to their guns, loaded with grapeshot and round shot, and fired them into the canoes as they fled ashore, leaving a trail of bodies behind them. That night the corpse of a Tahitian woman floated past the ship, a shot through her belly.

During these confrontations, the British sailors understood the exposure of female genitals as a wanton provocation, but for the Tahitians, sexuality was associated with the ancestor gods, particularly the founder ancestor Ta'aroa and his son the war god 'Oro. According to their priests, at the beginning of the world:

> Ta'aroa saw that there were no inhabitants on earth. On looking down he saw Te papa raharaha, who turned her eyes toward him and smiled. Whereupon he said to her, "Here are Ta'aroa's genitals. Cast your eyes upon my Tumu. Stand up and gaze upon them. Insert them." From the union on these two were born; after them was born 'Oro, who became a god and lived in the sky.[3]

The *'arioi* were 'Oro's sacred followers, and in their dancing and rituals these origin myths were celebrated. Describing a dance performed after a ball game by two or three girls in which they exposed themselves, Morrison, one of the *Bounty* mutineers, made it plain that such performances said nothing about the sexual availability of these women:

> [These] Young Wantons, who stripping of their lower Garments Cover themselves with a loose piece of Cloth and at particular parts of the Song they throw Open their Cloth and dance with their fore part Naked to the Company making many

lewd gestures—however these are not merely the effects of Wantoness but Custom, and those who perform thus in Publick are Shy and Bashful in private, and seldom suffer any freedom to be taken by the Men on that account. (Rutter 1935: 225)

In ancient Polynesia this gesture was a ritual act, opening a pathway to Te Po, the realm of the ancestor gods, and channeling their power. In times of peace, their generative force was invoked, enhancing the fertility of plants, animals, and people. In times of war, the power of the female gods was directed in this way against enemy warriors, damaging their mana (see Reilly 2001). During these hostile confrontations, however, the British sailors took the gesture as a sexual enticement. Far from being a communication with the gods, in Georgian England genital exposure was associated with wanton women and orgiastic sex in popular festivals or brothels.

After another unsuccessful attack, envoys heaped the British with peace offerings while elders lined up fine young women on the beach, telling the sailors with graphic gestures to select their favorites. An 'arioi possessed by the war god had his pick of the young women, and Wallis' men were being treated as 'arioi conquerors. The sailors responded with gestures of their own and became "very merry," but according to the *Dolphin*'s master, Robertson, "the poor young Girls seemed a little afraid, but soon after turned better acquanted" (Robertson 1948: 166). As Tcherkézoff has noted, many of these girls were in their early teens and had no choice in the matter (see, for instance, Tcherkézoff 2004: 7–8). It was frightening to be handed over to these strange beings, whether ancestors, 'arioi, or some weird kind of person.

Over the following days, some of the sailors were so mad for sex that they copulated with the girls in front of their shipmates, who thrashed them for this lewd conduct. Mad for iron, some of the islanders offered girls to the sailors for nails, and many of these girls became infected with venereal diseases, which they took as a punishment from their gods, or those of the strangers. Robertson described these exchanges as the "old trade," likening these girls to the whores back home, paid with money for their services. In the Royal Navy at this time, most sailors were in their twenties or younger, and unmarried. Back in Britain, they often brought prostitutes on to the ships or met them in inns and brothels. Men took whores out in the open, on bridges or in parks, while in brothels, popular festivals, and below decks in port, orgiastic sex was not uncommon. Sex was spoken of in aggressive terms, and women as property to be owned or taken (see Henderson 1999; Rousseau and Porter 1988; Maccubbin 1985; Boucé 1982). Later, Tahitians would complain that the English had made their women shameless. As Wilson, one of the London Missionary Society missionaries, noted, "They lay the charge wholly at our door, and say that Englishmen are ashamed of nothing, and that we have led them to public acts of indecency never before practised among themselves. Iron here, more precious than gold, bears down every barrier of restraint; honesty and modesty yield to the force of temptation" (Wilson 1799: 142).

During this visit the price of sex soon escalated, and when spike nails began to vanish from the hull, threatening the safety of the ship, Wallis tried to stop the trade, flogging "mutinous" sailors, having his men searched before they went ashore, and

ordering women not to cross the river. The men were not amused, and when Wallis ordered one of the offenders to run the gauntlet, his shipmates hit him so gently that the punishment became a mockery. At the same time the sailors noted that in Tahiti, some women had considerable power, and few of the leading women would sleep with the sailors. Purea, a senior woman leader who forged a bond of friendship with Captain Wallis, was dubbed the "queen" of Tahiti and treated with considerable respect, although some of the sailors spoke of "petticoat government."

Few of Wallis' men were highly educated, and there is no high-flown language in their journals about their dealings with island women. They took female models from their own society—whores and queens—and transposed them to Tahiti. And when they sailed from Matavai Bay, they were comforted to see Purea and other islanders, including "one of the Beautiful woman" weeping on the beach, evidently very sorry to see them leave the island.

When he sailed from Tahiti on July 27, Wallis promised Purea that he would soon return. Nine months later in April 1768, when two more "canoes without outriggers" were seen off Hitia'a on the east coast, the local people thought he had kept his promise. These were, however, French ships, commanded by Louis de Bougainville, a diplomat and soldier on a scientific expedition. In a euphoric, intoxicated passage in his journal, Bougainville described the welcome his sea-weary crews received at Hitia'a.

Canoes crowded around the ships, many of them carrying fine young women, stripped naked by the old men and women who accompanied them:

> It was very difficult, amidst such a sight, to keep at their work four hundred young French sailors, who had seen no women for six months. In spite of all our precautions, a young girl came on board, and placed herself upon the quarter-deck, near one of the hatchways, which was open, in order to give air to those who were heaving at the capstern below it.
>
> The girl carelessly dropt a cloth, which covered her, and appeared to the eyes of all beholders, such as Venus shewed herself to the Phrygian shepherd, having, indeed, the celestial form of that goddess. Both sailors and soldiers endeavoured to come to the hatch-way; and the capstern was never hove with more alacrity than on this occasion. At last our cares succeeded in keeping these bewitched fellows in order, though it was no less difficult to keep the command of ourselves. (Bougainville 1772: 219)

Although the French sailors mistook this performance for sexual enticement, this high-born young woman was making a ceremonial offering of barkcloth to their commander. After they fondled her, she left the ship looking dismayed and affronted.

The next day when the crew went ashore, girls were presented to them, some of whom seemed frightened and reluctant, and wept afterwards. The prince of Nassau visited the chief's house, where he was presented with a beautiful young girl and urged to make love with her, surrounded by curious Tahitians. Distracted by this avid audience, he failed, although one of them tried "very singular means" to assist him. That night

Tahitian Woman.
Credit "A Portrait of Poedua," by John Webber, National Maritime Museum.

Reti, who had taken Bougainville and the prince of Nassau as his *taio* or bond brothers, sent one of his wives to sleep with them. This was a ceremonial gesture because *taio*, who exchanged names and gifts, gained overlapping identities, including access to each others' wives. The next day, escaping from a tropical downpour, the prince of Nassau enjoyed an idyllic dalliance in a hut with six young women who undressed him and examined his skin and body with ardent curiosity. While some of the officers described their experiences in salacious detail, Bougainville turned to the classics:

> These people breathe only rest and sensual pleasures. Venus is the goddess they worship. The mildness of the climate, the beauty of the scenery, the fertility of the soil everywhere watered by rivers and cascades, everything inspires sensual pleasure. And so I have named it New Cythera. (Bougainville 2002: 63)

In Greek mythology, Cythera was the island where the goddess of love, Aphrodite, first appeared from the ocean. During his education Bougainville had been immersed in the classics, studying both Latin and Greek at school and university. The sight of a young woman rising from the sea and stripping herself naked irresistibly reminded him of Aphrodite and her Roman counterpart Venus, often depicted in Renaissance art, goddesses who embodied the overwhelming power of sexual attraction. Later, describing a man singing to a flute as his sailors and the island women lay together, Bougainville quoted the text of the *Aeneid:* "O Venus, for they say it is you who grant rights to those who seek hospitality, may it be your pleasure to make this a happy day for those who set out from Troy and one our descendants may remember." [*Aeneid* I, 731–733].

In his shipboard journal, these Elysian images distracted Bougainville from the less idyllic aspects of his visit to Tahiti. By the end of their ten-day stay, more than thirty French sailors were showing symptoms of the venereal diseases left there by the British. In addition, some of the crew, already infected with syphilis, were transmitting this disease to local women. On shore it proved impossible to keep the sailors under tight control, and there was a shooting followed by other bloody clashes. Nevertheless, in addition to the classical references in his journal, Bougainville drew upon Christian mythology, describing Tahiti as a Garden of Eden where women living in a state of nature made love in all innocence. He also drew upon utopian literature. At this time in Europe, the South Sea was a favorite site for fables describing fantasy voyages and the island utopias they discovered. In a recent work, Cheek (2003; see also Fausett 1993) explores this tradition and its experiments with alternative sexualities, including Thomas More's *Utopia,* which featured the inspection of naked bodies before marriage; *L'isle des Hermaphrodites* by Arthus, describing a voyage to an island inhabited by hermaphrodites who worshipped Cupid, Bacchus, and Venus; Francis Bacon's *New Atlantis,* where explorers from Peru discovered a society dedicated to scientific enquiry whose laws of marriage were handed down from Solomon; and *La Terre Australe Connue* by Gabriel de Foigny, a lapsed Franciscan monk, recounting a shipwreck on another hermaphrodite island in the South Sea whose inhabitants procreated in a mysterious fashion. As he sailed from Tahiti, Bougainville invoked this tradition, writing that he had found the true Utopia. And in a letter sent from Mauritius, the expedition's botanist Commerson declared:

> This Island seems to me such that I have given it the name of Utopia or the Isle of Fortune, given by Thomas More to his Republican ideal. This is perhaps the only corner of the earth inhabited by men without vices, without prejudices, without needs and without dissension. They recognise no other God than Love [presumably Eros]. Every day is devoted to him, the whole island is his temple, all the women are

the altars, all the men the sacrificers. And what women, you ask me? The sisters of the Graces entirely nude. (Commerson 1977)

When Commerson's letter was published in the French newspaper *Mercure*, it created a sensation, because it seemed that this was no fantasy—a scientific expedition had found a real Utopia on a South Sea island. Tahiti became known as a paradise devoted to free love and was held up in contrast with contemporary life in France (by Diderot among others). Despite all contrary evidence, including Bougainville's official journal, this seductive image, celebrated in plays, poetry, art, and even wallpaper, still endures.[4]

In 1768, a year after Bougainville's departure, the *Endeavour*, commanded by James Cook, anchored in Matavai Bay on the north coast of the island. Cook would visit Tahiti on a number of occasions, but in this chapter I will pass over his famous voyages to discuss the lesser-known Spanish expeditions that arrived in Tahiti in 1772 and 1774, sent by the viceroy of Peru Manuel de Amat to discover whether the British had settled the island and, if so, to expel them. In his orders to the commander, Don Domingo Boenechea, Amat remarked that two Franciscan friars would accompany him because the Spanish Crown wished to rescue "the Indians from their miserable idolatry, and convert [them] by discreet and gentle means to a knowledge of the true God and the profession of our religion," and that his sailors should treat the local women with respect and "commit no rudeness nor least sign of impropriety, lest a bad example should serve as a hindrance that might retard and render difficult those natives' conversion" (Corney 1913–1919, vol. 1: 276).

The friars came from the missionary college of Ocopa in Peru, where friars from Europe were trained to take the gospel to the heathen; they had taken the vow of chastity and poverty and were devoted to the Virgin Mary (Arbesmann 1945: 393–417; Amich 1988). In South America, Mary had become a syncretic figure worshipped by the Indians and associated with the Earth Mother, the Chosen Women, mountains, birds, and flowers (Hall 2004). These hybrid elements in local Christianity aroused anxiety in the Catholic Church, and during this period an "Extirpation of Idolatry" was underway in which inquisitorial investigators were sent into local communities, seeking to abolish local beliefs and ritual practices. In Peru, where the Indians were subjected to forced labor in the silver mines, escalating taxes, and other injustices, this campaign had Andean communities in an uproar, and in 1767 all but one of the sixteen missionaries at Ocopa was killed by local Indians.

Among the tensions that provoked these conflicts were differing ideas about sex. For the Catholic Church, chastity was a virtue, monogamy was the rule, and premarital sex was a sin, whereas for the Indians, polygamy was a traditional practice and trial marriage was regarded as a sensible step before entering a permanent relationship. Priests used the confessional to get their congregations to adopt Catholic mores (for example, an early confessional manual in Peru included several hundred questions on sexual behavior), and bigamy was harshly punished. Yet at the same time, indigenous approaches to sexuality infiltrated many aspects of Peruvian life, to the despair of the Church hierarchy.[5] By the eighteenth century the grand convents in Lima were places of

pleasure where nuns dressed in silk and jewels received male visitors, while concubinage was so common that "it is considered a shame to live without a concubine" (Martin 1983: 152). Indeed Viceroy Amat himself (then in his sixties) was involved in a passionate affair with La Perricholi, a twenty-year-old opera singer, scandalizing the Church and Lima society.[6]

Although most of his officers were Spanish, Boenechea's sailors were recruited in Peru, and many of his men must have shared these attitudes. Nevertheless, because of the evangelical purposes of these voyages, sexuality was excluded as far as possible from their exchanges with the Tahitians. This prohibition evidently extended to their accounts, because compared with the British and the French, there is remarkably little discussion of sexuality in the Spanish journals. When they arrived at Vaitepiha Bay on the south coast in November 1772, Boenechea and his men received an enthusiastic welcome, but there was no mention of sexual displays on this occasion. The Tahitians took many of the officers and sailors as *taio* or bond brothers, but only Lieutenant Gayangos mentioned the sharing of wives that accompanied that relationship: "This arii intimated by signs that I should retire with one of his ladies, saying that he would remain in the launch with the other one. We thanked him civilly for his offer, and he seemed much surprised at my unwillingness to fall in with this proposal" (Corney 1913–1919, vol. 1: 323).

Throughout his journal Boenechea implies that his men did not sleep with local women, and he reports no punishments for sailors who had breached the viceroy's ruling. The relative silence about sex in the Spanish accounts is in striking contrast with the British and French journals, and it is ambiguous. Maybe the Spaniards saw no sexual displays on Tahiti, although this seems unlikely, because these are mentioned in the accounts from Boenechea's next visit. Perhaps his sailors were chaste during this brief visit, although given contemporary sexual mores in Peru, this also seems improbable. Still, unlike Wallis' and Bougainville's men, they had only been away from home for six weeks, and only during the Spanish voyages was sex with the local women strictly forbidden. Perhaps because of this prohibition, Boenechea and his companions kept quiet about any breaches. At this historical distance, it is impossible to be certain.

Toward the end of this visit an influenza-like illness broke out among the islanders, for which they blamed the Spaniards. Nevertheless, four young men volunteered to sail with them to South America. Upon arriving in Peru, two of the Tahitians died, and Viceroy Amat took the two survivors to lodge at his palace in Lima, where they must have met his infamous young consort, La Perricholi. During their two-year stay in Peru, Máximo Rodriguez, a young, native-born Peruvian marine who had traveled on the first expedition, was appointed to look after the islanders and learn to speak their language while teaching them some Spanish. In addition, intrigued by what the interpreter learned from these young men, Amat drafted a list of one hundred questions to be answered during the next expedition to the island—by far the most detailed set of ethnological instructions to be issued during this period of Pacific exploration.

When the second Spanish expedition left Callao in September 1774, the two young Tahitians were on board, accompanied by Máximo Rodriguez and two new friars from

Ocopa. During the voyage a cabin boy was given one hundred lashes over the cannon and put in a double iron collar for soliciting a page boy to commit sodomy. As they approached Tahiti on November 15, an edict was nailed to the masthead stating that any man who approached an island woman would be flogged over the cannon. As the anchors rattled down into Vaitepiha Bay, named "the Port of the Virgin" during Boenechea's previous visit, they received an ecstatic welcome.

Again, no sexual displays are mentioned on this occasion. The local chief, Vehiatua, who had adopted Boenechea as his *taio,* complained that the English had taken their women by force, and soon a seaman from the storeship was given fifty lashes over the cannon for sleeping with a local woman. And on December 27, however, when Vehiatua boarded the frigate, one of the sailors found him in the sergeants' mess coupling with his servant. To the Spaniards, this was a forbidden act, and the sailor punched the chief and beat his servant with a stick. In Tahiti, however, the *maahu,* men who slept with men and lived like women, played an accepted role, but punching a chief, the avatar of his ancestors, was an appalling insult.

Several days later Vehiatua and Boenechea made an uneasy peace, and the mission building was completed. On December 31 the friars slept ashore, and the next morning a boat came in bearing a large cross, accompanied by volleys of musket fire. While the ships were away on an excursion, canoe-loads of 'arioi arrived from Ra'aiatea for a *heiva* (or ritual celebration), and each night a tumultuous crowd surrounded the mission in which the two friars had barricaded themselves, mocking them mercilessly, the women exposing themselves and calling the monks fools, "old gaffers," and a term that meant "shellfish" but referred to private parts (Corney 1913–1919, vol. 3: 216–217). The friars, devoted to chastity and the Virgin Mary, found these graphic encounters traumatic, and when the frigate returned they complained that the islanders had "threatened to insult us and loaded us with shame" (Corney 1913–1919, vol. 3: 202) and begged that two sailors be left to protect them. Boenechea had fallen desperately ill, however, and several days later he died and was buried by the mission. Despite the presence of the fathers, during this visit it proved impossible to keep the sailors away from local women, and a number of them contracted venereal diseases left by the French and British (Pantoja y Arriaga 1992: 55).

When the ships sailed from Tahiti on January 28, the two friars, Máximo Rodriguez, and one sailor stayed on the island. As they departed, one of the officers remarked that the islanders did not much appreciate the restraint shown by the Spaniards; rather, because of the "stern and wanton" conduct of the British, they regarded them as more daring and respected them more highly. This comment was echoed by David Samwell, one of Cook's surgeons, who later talked with the islanders about the Spaniards. According to him, they particularly liked Máximo Rodriguez:

> Marteemo made the tour of the island & lived upon a very friendly footing with the Natives, conforming himself to their customs & manners, & indulging himself with those pleasures which the Island afforded, more particularly among the Girls, which last Circumstance was so agreeable to the Genius of these People that

they looked upon him on this account to be the best Fellow among his Countrymen, who preserved a haughty Distance in their Behaviour to the Indians. (Corney 1913–1919, vol. 3: xvii)

Even Máximo, however, stayed silent about sexual matters in his long journal, except for one indignant passage describing how the friars accused him of sleeping with a Tahitian girl.

The friars regarded the Tahitians as heathens and idolators, almost beyond redemption. In the Viceroyalty of Peru, where Indian men were expected to provide the Spanish with forced labor, congregations had to supply their priests with food and do their gardening and housekeeping. During their ten-month stay in Tahiti, the friars behaved as though they were back in Ocopa, demanding food from the local people, insisting that Máximo and the sailor cook and clean for them, deliberately desecrating local *marae*, and secluding themselves in the mission. The islanders found their chastity bizarre, their conduct ungenerous and sacrilegious, and their beliefs incomprehensible. When another epidemic broke out, striking Vehiatua, who died, and then the high chief Tu, the friars were held responsible. As soon as the frigate arrived with fresh supplies, they fled on board and refused to go back to the island.

Conclusion

From the accounts of the first British, French, and Spanish voyages to Tahiti, it is evident that for Europeans and Tahitians alike, sex was highly charged and imbued with mythic implications. It could not be experienced or talked about without these resonances helping to shape what happened or the descriptions of those experiences. The explorers reached for precedents from their own societies—whores and queens for the British; the Greek gods, the Garden of Eden, and literary utopias for the officers on Bougainville's ships. The Spaniards, with their evangelical intentions, censored sexual matters from their journals and experience as far as possible, while the Spanish friars, dedicated to chastity and the Virgin Mary, found the *'arioi*'s graphic sexual displays so appalling that they could not wait to leave the island. Equally, the Tahitians drew upon their own ancestral precedents to grasp and negotiate these exchanges with the explorers—the *'arioi* ceremonies and celebrations, the stories of Ta'aroa and 'Oro, and the prophecy of the priest at Taputapuatea.

These mythic scaffoldings shaped both the Tahitian and the European experience of their meetings. Yet the precedents drawn upon by different groups of explorers (including different individuals and subgroups within the various expeditions) and by the Tahitians were so distinct and various that sex became a potent, omnipresent source of misapprehension and confusion. And this was as true for the Europeans as it was for the islanders. In his work on such encounters, Marshall Sahlins (1985: xi) has drawn a contrast between the "mythopraxis of Polynesian peoples and . . . the disenchanted utilitarianism of our own historical consciousness," and only the myths of the Polynesians are analyzed. Yet in these meetings, variant myths from Europe and Tahiti tangled together, shaping different apprehensions of what happened and thus different conse-

quent courses of action—witness the Arcadian idylls of Bougainville and his men on the one hand and the hellish sufferings of the Spanish Franciscan friars on the other.

At the same time, history—in the sense of the sequence of events—as well as mythopraxis was potent in these meetings. The sexual delights experienced by Bougainville and his men, for instance, the source of an enduring European fantasy about island women, was contingent upon the Tahitians' prior experience with British muskets and cannons. Without the hail of shot from the *Dolphin*, scything through crowds of islanders on successive occasions, they would not have offered women in the way they did to successive groups of strangers. Once the islanders had learned the use of iron, too, they exchanged girls for it on every possible occasion. Sex on the island was transformed by the introduction of venereal diseases, both for islanders and later European visitors. In the wake of these early encounters, meanings and experiences of sex began to shift in both Tahiti and Europe in ways that transformed over time. And it is fair to speak of history here, because in Tahiti as well as Europe, events were ordered in sequence, although on the island, accounts of the past were structured not by dates but by genealogies and named battles. In trying to understand these encounters it is thus critical to recognize the orders in which they occurred, trying to grasp the implications of these successive meetings and the way they influenced subsequent events and understandings of them in Tahiti and in Europe.

Above all, the difficulty of grasping the sexual aspects of these encounters gives a powerful lesson in the opacity and frustration of historical reconstruction. The sources are such that one can only see past events through a haze of differing intentions. Only some of the protagonists in these events were literate, and only some accounts that were written survive to the present. Any accounts from the islanders come by indirection, for instance the distillation by missionaries of island histories. All the surviving accounts are filtered through memory and shaped by myth and historical expectation. All are dialogues with audiences, either with a later interested interlocutor (in the case of the island histories, for instance) or those for whom an account was written. The more those audiences are likely to be judgmental of what they read, the more the account is forged for their reception. The absence of discussion of sexual matters in the Spanish journals is only one extreme case of the intervention of imagined verdicts in these descriptions.

While acknowledging the irreducible entanglement of all these factors, however, the encounters themselves are not a myth, despite their mythic implications. They involved real people and occurred in real places, and the way they are recounted has powerful reverberations in the present. It has been too easy to suppose that cultures called "mythic" must give way to modernity, whether in conversion and the destruction of *marae*, the suppression of chiefly control, Christianity, and colonization. If only for this reason, it seems worthwhile to try to grasp these early encounters as far as possible from Tahitian as well as European vantage points. Scholarly interests are also at stake, and such an approach should yield more accurate, balanced understandings of past events rather than reproducing in ever more sophisticated versions old, one-eyed European mythologies about the "Other."

For among the stone temples at Taputapuatea, Vaita's prophecy still echoes:

Their body is different, our body is different
We are one species only from Te Tumu.
And this land will be taken by them
The old rules will be destroyed
And sacred birds of the land and the sea
Will also arrive here, will come and lament
Over that which this lopped tree has to teach
They are coming up on a canoe without an outrigger
 (Translated in Driessen 1982: 8–9).

Notes

1. For a description of the arrival of the *Dolphin* in Tahiti and the political and social context in the Society Islands at that time, see Salmond 2003: 39–46.

2. Francis Wilkinson, PRO Adm 51/4541/96, 48.

3. Lavaud, quoted in Oliver 1974, vol. 2: 883.

4. For other discussions of European imaginings of Tahitian sexuality, see Bolyanatz 2004; Sturma 1998; Jolly 1997.

5. For an account of many of these tensions, see Staving 1999 and Griffiths 1996.

6. For an account of La Perricholi and her affair with Manuel de Amat, see Villegas 1999.

References

Amich, Jose. 1988. *Historia de Las Misiones Del Convento de Santa Rosa de Ocopa*. Iquitos: CETA.

Arbesmann, Rudolph. 1945. "The Contribution of the Franciscan College of Ocopa in Peru to the Geographical Exploration of South America." *The Americas* 1 (4): 393–417.

Bolyanatz, Alexander. 2004. *Pacific Romanticism: Tahiti and the European Imagination*. Westport: Praeger.

Boucé, Paul-Gabriel, ed. 1982. *Sexuality in Eighteenth-Century Britain*. Manchester: Manchester University Press.

Bougainville, Louis de. 1772. *A Voyage Round the World, Performed by Order of His Most Christian Majesty, In the Years 1766, 1767, 1768, and 1769*. Translated by J. R. Forster. London: T. Davies.

———. 2002. *The Pacific Journal of Louis-Antoine de Bougainville 1767–1768*. Edited by John Dunmore. London: The Hakluyt Society.

Cheek, Pamela. 2003. *Sexual Antipodes: Enlightenment Globalisation and the Placing of Sex*. Stanford, Calif.: Stanford University Press.

Commerson, Philibert. 1977. "Post-Scriptum sur l'isle de la Nouvelle-Cythère ou Tayti par M. Commerson." In *Bougainville et ses compagnons autour du monde, 1766–1769: Journaux de navigation*, vol. 1, 2, edited by Étienne Taillemitte. Paris: Imprimerie Nationale. Translated in Cheek 2003: 139.

Corney, Bolton Glanvill, ed. 1913–1919. *The Quest and Occupation of Tahiti by Emissaries of Spain during the Years 1772–1776*. Vol. 1–3. London: The Hakluyt Society.

Driessen, Hank. 1982. "Outriggerless Canoes and Glorious Beings: Pre-Contact Prophecies in the Society Islands." *Journal of Pacific History* 17: 8–9.

Fausett, David. 1993. *Writing the New World: Imaginary Voyages and Utopias of the Great Southern Land*. New York: Syracuse University Press.

Griffiths, Nicholas. 1996. *The Cross and the Serpent: Religious Repression and Resurgence in Colonial Peru*. Norman: University of Oklahoma Press.

Hall, Linda B. 2004. *Mary, Mother and Warrior: The Virgin in Spain and the Americas*. Austin: University of Texas Press.

Henderson, Tony. 1999. *Disorderly Women in Eighteenth Century London: Prostitution and Control in the Metropolis 1730–1830*. London and New York: Longman.

Jolly, Margaret. 1997. "From Point Venus to Bali ha'i: Eroticism and Exoticism in Representations of the Pacific." In *Sites of Desire, Economies of Pleasure: Sexualities in Asia and the Pacific*, edited by Leonore Manderson and Margaret Jolly, 99–122. Chicago: University of Chicago Press.

Maccubbin, Robert Purks, ed. 1985. *Tis Nature's Fault: Unauthorized Sexuality during the Enlightenment*. Cambridge: Cambridge University Press.

Martin, Luis. 1983. *Daughters of the Conquistadores: Women of the Viceroy of Peru*. Dallas: Southern Methodist University Press.

Oliver, Douglas. 1974. *Ancient Tahitian Society*. 3 vols. Canberra: Australian University Press.

Pantoja y Arriaga, Juan. 1992. In *Un diario inédito sobre la presencia española en Tahiti (1774–1775)*, edited by Francisco Mellén Blanco. Translated by Gwyn Fox. Madrid: Revista Española del Pacifico.

Reilly, Michael. 2001. "Sex and War in Ancient Polynesia." *Journal of the Polynesian Society* 110 (1): 31–57.

Robertson, George. 1948. *The Discovery of Tahiti: A Journal of the Second Voyage of HMS* Dolphin *Round the World 1766–1768*. London: The Hakluyt Society.

Rousseau, G. S., and Roy Porter. 1988. *Sexual Underworlds of the Enlightenment*. Chapel Hill: University of North Carolina Press.

Rutter, Owen, ed. 1935. *The Journal of James Morrison Boatswain's Mate of the* Bounty. London: The Golden Cockerel Press.

Sahlins, Marshall. 1985. *Islands of History*. Chicago: University of Chicago Press.

Salmond, Anne. 2003. *The Trial of the Cannibal Dog: Captain Cook in the South Seas*. London: Penguin.

Staving, Ward. 1999. *The World of Tupac Amaru: Conflict, Community and Identity in Colonial Peru*. Lincoln: University of Nebraska Press.

Sturma, Michael. 1998. "Dressing, Undressing, and Early European Contact in Australia and Tahiti." *Pacific Studies* 21 (3): 87–104.

Tcherkézoff, Serge. 2004. *Tahiti—1768: Jeunes filles en pleurs*. Papeete: Au Vent des Iles.

Villegas, Bertrand. 1999. *La Perricholi*. Buenos Aires: Ed. Sudamericana.

Wilson, James. 1799. *A Missionary Voyage to the Southern Pacific Ocean, Performed in the Years 1796, 1797, 1798, in the Ship* Duff, *commanded by Captain James Wilson*. London: T. Chapman.

An Encounter with Violence in Paradise
Georg Forster's Reflections on War in Aotearoa, Tahiti, and Tonga (1772–1775)

Gundolf Krüger

During James Cook's second circumnavigation of the globe from 1772 through 1775, a certain young man's observations shed light on European encounters with foreign cultures from a perspective unlike that of any other European of his day. The young man was Georg Forster (1754–1794), a youth of only seventeen at the journey's start. Although in contrast to Cook—whom the public knows much more about today—his descriptions of their travel in the South Seas form in their distinctiveness a valuable contribution for today's cultural anthropology that is impressive in literary terms as well as being scientifically rich.

Together with his father Johann Reinhold Forster, Georg was charged with collecting, describing, and drawing objects of natural history. Father Forster admitted that it was the "thirst for knowledge," as well as the connected ideals of the Enlightenment and its encyclopedic scientific orientation, that compelled him to travel and in particular to discover new animal and plant species and categorize them (see Hoare 1982: 69, 72). In addition to this, the people inhabiting distant islands were topics of interest to the elder Forster, who saw himself not only as a natural scientist but also as an "independent anthropological philosopher" (Petermann 2004: 269).[1] The younger Forster, in contrast to his father and other contemporaries, illuminated much more comprehensively his cultural reflections about the Polynesians and their particular sociopolitical constitutions within the context of his encounters with them. With his comparative nature and analyses committed to subjectivity, Georg Forster succeeded—like no one else for a long time after him—in penetrating the conditions of ethnological observation and the problems of mediation involved. In a combination of systematic thought, linguistic talent, and social adroitness in communicating, he endeavored to overcome his own ingrained European thought processes and interpretive patterns in all of his descriptions and representations (see Heintze 1990: 69; Bödeker 1999: 230f).

Of particular lasting impression for Georg Forster were those encounters with the South Sea Islanders that accompanied conflicts, in addition to those that anticipated violence and the ones that caused him to think about the possibility of war. The discourse on the social causes of violence was reflected in his impressions of the French

Georg Forster. Engraving by Weger, after an oil painting by A. Graff. In Moleschott 1862, frontispiz.

Revolution, even in his later comprehensive literary works, which in this context gained a central significance when recalling his South Seas experience. As a German natural scientist and supporter of the French Revolution, Georg Forster in later times justified revolutionary violence because of the feudal authorities in former Europe, but, doubting at the same time the legitimacy of acting violent, the former South Seas traveler stayed torn on the question of who the actual rowdy barbarians in the South Seas were: the sailors from Europe penetrating Polynesia, or the resident island population with their respective social constitutions.

One does not do Forster justice by assuming in this context that his obvious criticism of civilization implied a secret idealization of the alleged naturalness and natural purity of Polynesian society. Influenced by Immanuel Kant, he did not follow that philosopher's anthropological basic assumptions about the mechanisms governing the development of human civilization, but he did accept and apply Kant's reflections on the comparison of cultures: Just as Kant did not make the mistake of "accepting the exotic as a reference to the natural state, and to see the natural paradises of the present . . . as the lost paradise of mankind" (Lepenies 1971: 101), Forster considered the encounter with the allegedly exotic to be merely one of two congeneric sides of the same coin. In this respect, he probably would have agreed with his contemporary, the revolutionary Saint-Jus: "One got used to believing that the savage life is the natural life. The corrupted nations regarded the brutal life of the barbarians to be Nature, whereas in fact the ones as well as the others were savage in their own way, and only differed with respect to the form of their barbarism" (Lepenies 1971: 111).

Whereas the conditions of encounters between European sailors and foreign societies, ever since the days of Greece and Rome, had been mostly tied to the conquest of empires, the search for gold, the creation of a slave trade, political and economic

interests, or the search for new trade routes and partners in commerce, the European entrance in the Pacific region added a new link to this chain of motives. Apart from purely scientific objectives, it was the longing for that earthly paradise the ancient Greeks had already spoken of and which was believed to have already been found in various places in the South Seas. In the reports from many South Seas travelers the immediate association was that of a Garden of Eden, the epitome of a conflict-free, simply constructed peasant society. Sometimes it was the Palau Islands, or Majuro Atoll in the middle of the Marshall Islands, both in Micronesia; sometimes it was Samoa; but mostly it was Tahiti in Polynesia—the island that to this day is considered the embodiment of the South Seas glorification.[2]

Since contact between the explorers and the South Sea Islanders was not always free of conflict, today we owe to Georg Forster those differentiated views that explain the various cultures' motives for power. In connection with such reflections, a philosophical debate intensified among Georg Forster's contemporaries that continually came into play in contemporary European discourse on the question of the causes of war and violence. This conflict concerns two opposing schools of thought in intellectual history, one going back to Thomas Hobbes' topos *Homo homini lupus* and the other to Jean-Jacques Rousseau's image of the noble savage.[3]

Rousseau's hypothetical construction appeared to become reality with Louis-Antoine de Bougainville's circumnavigation of the globe (1766–1769) and his visit to the Polynesian island of Tahiti. Bougainville (1771) portrayed the island as one with original human "naturalness"—with all the images projected from Europe, according to which even war served only for the rivalry of virtue and had no utilitarian purpose. There now was a person—Bougainville—who claimed to have encountered a paradisiacal primeval condition at the other end of the globe. It is true that Bougainville recognized Tahiti's corporate social structure with its strict and violence-enforced separation into nobility, commoners, and slaves. It is also true that he learned from his indigenous informant, Aotourou, that war, with all its cruelty, was something the Tahitians were quite familiar with. Bougainville represented this as well, but in Europe it was his ideal summary that in particular struck home. And in this presentation, it is nature that "dictates their laws to them. They follow it in peace and comprise the happiest society on this terrestrial globe" (Bougainville quoted in Kohl 1983: 216).

Thus Bougainville, with his depiction of Tahiti, established the South Seas myth in Europe. The "savages" living there were esteemed because their life provided the foil for criticism of one's own society (see Lepenies 1971: 98). And this interpretive pattern was taken along by Georg Forster when he accompanied Captain James Cook on the latter's second voyage.[4] Forster's two sojourns in Tahiti, in August 1773 and April and May of the following year, certainly constitute "the impressive pinnacle of the portrayal of the landscape and culture of the Pacific island world" (Akademie der Wissenschaften 1985: 684). However, an uncritical and lyrical acceptance of Bougainville's appraisal of the island's culture may by no means be ascribed to Forster (see Bitterli 1976: 382 ff.). Just as Denis Diderot, editor of the famous Encyclopédie, emphasizes in his supplement to Bougainville's account that the assumed social equality in the South

Seas is accompanied by stagnation and that progress is accompanied by inequality, Forster also did not believe that human bliss is founded in the natural original state (see Lepenies 1971: 102). In accordance with his father (an anti-Rousseauist), and congruent with the *progressum ad infinitum* idea of progress as developed mainly in Scottish Enlightenment, an idea that implies the moral teaching of the human pursuit of perfection as formulated by Adam Ferguson, a desire to return to the natural state is not mentioned or implied as a social option anywhere in Forster's works. In this respect, he concurs with Diderot's judgment that a just order for Europe could be found neither in the past nor in another geographic region, but in the future (see Kohl 1983: 237). Neither committed to Rousseau's reasoning nor leaning toward the leviathanic view of the world that Hobbes brings forward, Forster invariably saw the development of political institutions as determined by the particular social and economic conditions. He stood in the sociological and economic tradition of Adam Smith and his pupil John Millar, who both believed that man's boundaries are not set by any higher power, but by man himself.

Forster did not feel compelled to follow either Rousseau's figure of thought or the other. He attempted to capture and communicate the potential of his own self as the foreigner in his South Seas portrayals, and he succeeded in never seeing the foreigner as completely different; he discovered the foreigner to be a variety of the self in all his encounters, thereby creating for the reader of his South Seas diary a basis for comprehending the different not as a misunderstood exotic that is simply seen either as an expression of "raw barbarism" or the "high-minded character of a savage."

In order to more exactly envision Forster's self-critical perspective in his South Seas observations, his "ethnological perception instrument" must be seen in two different ways. Forster, on the one hand, follows the descriptive methods of the French natural historian Georges Buffon when documenting the "appearance" and "civilization" of a society in all its individual elements, conditioned by climate and topographic preconditions. Yet on the other hand—and seen from the vantage point of postmodern ethnology this is certainly an estimable approach—he avers that the judgment whether a collection of facts in the course of an observation is "complete" always depends on one's own interpretation. In this respect Forster followed the empirical approach already put forward by David Hume in which there is an epistemological distinction between "impressions" and "ideas." And, in writing, the subjective quality of these interpretations based on one's own experience with the foreigner must be made apparent to the reader: "sometimes I would follow my heart and let my sentiments speak [. . .]. Thus my reader had to know how the glass through which I saw is colored," wrote Forster (1989a: 13) in the foreword to his diary. In a letter to his publisher Spener, dated the 16th of September 1782, he noted that "the end purpose of life is [. . .] something other still than the smug grandeur of that polymath that is so highly cherished these days" (Steiner 1970: 166). Opposed to a one-sided piling up of facts aimed at gaining knowledge, he said of the armchair scholars of his age: "While they hunted facts to the point of nonsense, they lost attention to any other thing and became unable—even in a single sentence—to ascertain and to abstract" (Forster 1989a: 13).[5]

It is true that Forster repeatedly complained about the shortness of his stay on the island, noting that it did not allow him to study the foreign cultural institutions in greater detail, as linguistic mediation would have been required for a more exact understanding of them (Heintze 1976: 159). Still, even with a stay so much shorter than the usual duration of fieldwork today, he was able to look at his own observations in a cross-cultural way and to determine the reactions of the islanders as well as those of his fellow voyagers.

His combined achievement becomes quite clear when we consider what appears from a European view as a violent phenomenon: cannibalism among the Maori of Aotearoa ("Land of the White Cloud," New Zealand).

Extensively discussed in this time of great European expeditions, cannibalism, for many travelers, represented a form of violence that did not occur anymore in their own cultures and was regarded as an indicator of barbarian customs of strange peoples. While Europeans hypothesized about cannibalism with regard to the inhabitants of the South Seas, the following event was believed to confirm its existence among the Maori of Aotearoa. During a stay in Queen Charlotte Sound in November 1773, someone came upon human remains and assumed them to be the result of cannibalism. Among those remains was a completely preserved head, which the Englishmen acquired in exchange for a ship's nail. To be certain as to the question of cannibalism, they engaged the Maori, who after the trade showed "a great demand" for flesh from the head, in an "experiment." A piece from the cheek was cooked, which the natives then devoured "with all of us present . . . with the greatest greediness," as Forster (1989a: 403ff.) records in his diary—thus giving substance to the claims about cannibalism among the people of the South Seas.

Doubts remain, however, as to whether the above event delivered conclusive proof, since the consumption of the meat took place with almost grotesque pleasure. It remains an open question whether or not the Maori might have believed that cannibalism was expected of them by the Europeans, who, by their "experiment," had shown "such great interest in this topic," and whether the Maori, by their compliance, might have expected advantages in trade relations with the Europeans. Anne Salmond, a known expert in Maori history, believes after her thorough analysis of the case that the Maori, by their gesture of "finger licking" (Salmond 2004: 223; 1997), merely tried to imitate the Europeans and that the so-called experiment was a "spoof" (Obeyesekere 2005: 32). Anthropologist Gananath Obeyesekere, however, opines (just as does Marshall Sahlins, who gives reasons for the existence of cannibalism in the context of the Maori *papa/rangi*-mythology [1992: 65–69]) that an "experiment" indeed took place—albeit not in a modern sense of the term—and on the basis of the existing notes finds that to the European participants of the expedition this experiment was successful and conclusive proof of the existence of cannibalism. The European South Seas travelers could have found this proof merely by looking at their own European cultural history: European anthropophagy in the form of "shipwreck cannibalism" is attested to as early as the seventeenth century and thus could have been known to the seamen (Obeyesekere 2005: 36–43). With regard to the South Seas, the Spaniard Antonio Pigafetta, who took part in

the first European circumnavigation of the globe under Fernando Magellan, recorded the cannibalistic appetite of Europeans as early as 1520: Seamen who had fallen ill wished eagerly for the death of locals during violent encounters because they believed that the consumption of the slain opponents' intestines would quickly restore their health.

Whatever the truth may be, the categorization of the Maori as "man eaters" was established further because this stereotype offered practical advantages to the Europeans. It "served in the nineties in England as mission propaganda, as a dark background, against which the goals of conversion stood out brightly, giving a good conscience to the people's desire to colonize and expand" (Heintze 2005: 42–47)[6]—and this stereotype was not applied to New Zealand exclusively, but to many other regions in the South Seas as well.

Cook, as well as both Forsters, described the above case of cannibalism in detail; all three remained, however, equally reserved in their interpretations. On the one hand, Georg Forster registered—to a certain extent—the emotional consternation of one of his Tahitian companions, Maheine (O-Hedidi), who until then had voluntarily followed Cook's expedition but "averted his eyes from the abominable spectacle" and broke away "in tears" (Forster 1989a: 404) in light of this incident.

On the other hand, the younger Forster related the events in New Zealand to a contemporary case in his homeland, which, as he saw it, was even more despicable: "what is the New Zealander, who kills and eats his enemy in war, compared to the European who can tear a baby from her mother's chest and feed her to the dogs?" (Forster 1989a: 407).

Experiences of this very kind with the Maori, with whom the Europeans had had some conflict-laden encounters in other regions of New Zealand, were what led Georg Forster to the conclusion that despite the linguistic similarities with the other Polynesians and their common origin, certain Polynesian cultures could develop unique cultural peculiarities. In agreement with his father, Georg Forster attributed this to an interdependence of environment and education, as well as psychological factors. Both Forsters believed that there were several principles determining the biological development of mankind. They agreed with the philosopher Charles-Louis de Montesquieu that the manifold outer appearances of humans were influenced not only by natural environmental factors but also by climatic as well as historical and social conditions, that these circumstances as a whole contributed to the worldwide variations of the species "man" (see Mühlmann 1968: 54–56). But the Forsters attributed equal importance to education in the process of molding cultural habitus. Education not only created "the basis for the development of tradition, but also for its successful adaptation by following generations. When education is neglected, losses of culture are the result. This is the cause of the apparent cultural differences between the peoples of Tierra del Fuego, the South Seas, and Australia, differences which could not solely be attributed to different environments" (Petermann 2004: 270). In this respect it is interesting that Forster regarded the Maori as standing on a higher cultural level than the inhabitants of Tierra del Fuego—the Ona Indians in the southern part of modern Argentina, who had to live in a very rough and meagre environment—but he did not consider the Maori to be as culturally developed as the Polynesian Tongans, Marquesans, or even the Tahitians (see Urban 1994: 23).

Based on such reflections, then, for Forster the idea of a harmoniously stylized society with nature and humanity in balance had to disappear; the social structure he saw ran completely counter to that envisioned by Rousseau, as it was in fact a "picture of a society which is characterized by contradictions and polarities, i.e., of a state of internecine war" (Garber 1997: 20f). In a letter to his friend Friedrich Vollpracht, dated the 31st of December 1776, Forster indicated that it lies in "human nature" to "cultivate discord and hate against one another, and we simply cannot change that" (Steiner 1970: 4).[7]

Seen in this light, the Tahitians and the linguistically and culturally closely related people of Tonga were for Forster in no way representatives of "a primeval good natural humanity, [but] rather of an early phase of the development of society" (Heintze 1997: 55). For Forster, Tahiti was a non-European example of a model of society comparable to—but certainly not identical with—ancient Greece. The Greeks had not only allowed war and violence but had actually used them as agents for their own historical dynamic in order to justify the introduction of the new. Despite the virtues of its heroes, the political institutions of that age were ridden with violence, as Forster wrote to his friend Friedrich Heinrich Jacobi on the 20th of December 1783. In connection with this point and counting on the positive power in people, he continues in his statement:

Club *patu onewa*, basalt, plant fiber, Aotearoa. L. 35.5 cm, w. 9.5 cm. Inv. Oz 278. The Cook/Forster Collection of the Georg August University of Göttingen, Institute for Cultural and Social Anthropology. Photo: Harry Haase.

> "What costs blood is not worth blood" is true, . . . then I find in it one more reason to rely more on the internal improvement of the individual, and I find more to hope from that than from general political institutions, no matter how good they may be, that never can come about without violence. (Steiner 1970: 213)

Forster was never directly confronted with local wars during his South Seas journeys. On the one hand in Tahiti and in the other Society Islands, and on the other hand in Tonga, he came across two similar social systems that appeared to be similar to those found in the history of European cultures. In both of these distinctly stratified societies he studied the Polynesian conditions of governance and ruling, which, considering the huge war flotilla at Tahiti and the large amounts of weapons on the Tonga Islands, indicated to him that war and violence might indeed be known there. Throughout his Pacific travelogue, Forster generally preserves that philanthropic tenor of the Enlightenment that forbade him to justify "unwarranted violence" (Steiner 1970: 177), as he expressed in a letter to the scholar Jacobi on the 16th of November 1782. At no time in his descriptions of the South Seas does he succumb to "the fascination of evil"—at least if one discounts his admiration of the Tahitians for their adroitness in theft, much like admiring the Robin Hood myth. But similar to his later justification of revolutionary violence in response to feudal authority in Europe and his castigation of every attempt to maintain degenerated social structures, Forster at the same time questioned the principle behind the legitimacy of war and violence as well.

It is precisely in this constant change of perspective that Forster's productive side is to be found, especially concerning contemporary research. This ever-changing perspective makes Forster's eyewitness report a transparent document. A prime example of this quality is his report of what happened on Huahine, one of the Society Islands, in May of 1774. In spite of the readiness of the Europeans to exchange gifts peacefully, hostility arose. While Forster did see the necessity of a demonstration of superiority of arms, he qualified this critically: Cook, he wrote,

> had the crew shoot their guns into the ocean in series, and we amused ourselves at the amazement of the Indians, who had not guessed that a shot could reach so far, and that we could maintain a constant fire with our muskets. In this way, the expected war expedition went off without bloodshed, as all those among us who valued the lives of their fellow men as something other than a pittance of little worth had wished. Others, though, appeared to be totally dissatisfied that it hadn't come to people being struck dead. Used to the horrible appearance of war and the shedding of blood, they acted as if it were all the same to them to shoot at people as to shoot at a target. (Forster 1989b: 100f)

Shortly thereafter, Forster noted, admittedly with a not-to-be-missed European paternalistic tendency, that "our military crusade" brought no devastating consequences to the relations between the Europeans and the Tahitians, since "the next morning [. . .] we received various gifts from our acquaintances, showing that everything had been reconciled" (Forster 1989b: 101).[8]

On two separate occasions, Forster allotted many pages to the description of the Society Islands, while virtually at the same time making a cultural comparison with the Tahitian war flotilla, which, according to Rousseau's ideal picture, simply could not exist. At first, it is the preciseness of the details that he gives, in comparison to all the other reports, that is especially striking. Forster gives measurements for the construction of double-hulled boats, provides details concerning the diverse clothing of the various warrior grades, presents statistics on the warriors' relative numbers in the overall population, and describes the deployment of individual weapon types. His data concerning this complexity of material culture are to this day an indispensable component of ethnological documentation of objects from that region in museums and other collections.

However, in view of the fleet of 159 fully manned ships, Forster could not leave it at that. He looked for the causes of this martial appearance and discovered after some research that in fact "the entire armament is aimed at the island of Eimeo [Moorea], whose commander is a vassal of O-Thu [one of the leading chiefs of the entire Society Islands archipelago], but he has revolted" (Forster 1989b: 54).

What makes Forster's report so valuable as an ethnological source are his differentiated inferences with respect to the occurrence of cultural parallels—this despite his tendency to see parallels with the ancient Greeks, something he justifiably criticizes the landscape painter and South Seas scientific illustrator William Hodges for doing:

> The Greeks were doubtless better armed, having the use of metals; but it seemed plain, from the writings of Homer, in spite of poetical embellishment, that their mode of fighting was irregular, and their arms simple, like those of Taheitee. The united efforts of Greece against Troy, in remote antiquity, could not be much more considerable than the armament of O-Too against the isle of Eimeo; and the boasted

"Review of the War Galleys at Tahiti," by William Hodges, c. 1775–1776. National Maritime Museum, London.

> *mille carinae,* were probably not more formidable than a fleet of large canoes, which require from fifty to a hundred and twenty men to paddle them. The navigation of the Greeks in those days was not more extensive than that which is practiced by the Taheitians at present, being confined to short passages from island to island; and as the Stars at night directed the mariners through the Archipelago at that time, so they still continue to guide others in the Pacific Ocean. The Greeks were brave; but the numerous wounds of the Taheitian chiefs, are all proofs of their spirit and prowess. It seems to be certain, that in their battles they rouse themselves into a kind of phrenzy, and that their bravery is a violent fit of passion. From Homer's battles it is evident, that the heroism which produced the wonders he records, was exactly of the same nature. Let us for a moment be allowed to carry this comparison still farther. The heroes of Homer are presented to us as men of supernatural size and force. The Taheitian chiefs, compared to the common people, are so much superior in stature and elegance of form that they look like a different race. It requires a more than ordinary quantity of food to satisfy stomachs of unusual dimensions. Accordingly we find, that the mighty men at the siege of Troy, and the chiefs of Taheitee, are both famous for eating; and it appears that pork was a diet no less admired by the Greeks, than it is by the Taheitians at this day. Simplicity of manners is observable in both nations; and their domestic character alike is hospitable, affectionate and humane. There is even a similarity in their political constitution. The chiefs of districts at Taheitee are powerful princes, who have not more respect for O-Too, than the Greek heroes had for the "King of men"; and the common people are so little noticed in the Iliad, that they appear to have had no greater consequence, than the towtows in the South Sea. In short, I believe the similitude might be traced in many other instances; but it was my intention only to hint at it, and not to abuse the patience of my readers. What I have here said is sufficient to prove, that men in a similar state of civilisation resemble each other more than we are aware of, even in the most opposite extremes of the world. (Forster in Joppien and Smith 1985: 84 f)

Is it because of a desire to let the reader know of his extensive humanistic schooling, despite his young age, that he places this apparently exaggerated focus of the cultural comparison on ancient Greece?

This may indeed be the case, but besides this focus, Forster's approach generally follows a common tenor, namely, how strongly the cultural contexts of bellicose power and violence are bound to the social conditions of rule in each case. In other contexts too—not only in making comparisons with antiquity but also with the medieval European feudal system—this rationale or explanatory statement seems to him to be of significance. Examples of this can be found in the text when dealing with the interpretation of status and prestige and of particular insignia as visible expression of social heritage in Tahiti. Additionally, his comments about the cultivation of social etiquette as well as the taboo-regulated encounters between members of various social classes are characteristic of this approach as well. So is his discussion of the ritualized mock battles of rival chiefs and their guards in the sense of medieval jousting and tournaments.

Since Forster had been in Tahiti and had studied the social structure and its three classes—the Erihs (*ari'i*), the highest class, which in turn is divided into subclasses: the Manahaunas (*manahune*); and the Tautaus (*tautau*)—the following comparison is understandable. In castigating the feudal conduct of the Tahitian nobility as that of "lazy voluptuaries" and associating it with that of "privileged parasites" in Europe, he made clear what he later focuses on in the above-mentioned letter to his friend Vollpracht as being necessary for the existence of war and violence—as well as for the justification of revolution: "but in one's heart, it truly hurts when another's blood flows as rivers and even more when such a sinner as the Count of Hesse [a province in Germany] . . . profligately spends his gold in France—gold that his subjects had bought dearly with their blood and wounds" (Steiner 1970: 45).

Still, he does not see Tahiti "on the eve of destruction." Instead, he finds it in an auspicious transitional state. For Forster, the regent is more like a father to the people than a complete patriarch. The differences in class appear to him not yet to be so despotic that they will of necessity call forth a revolution by the people: "For O-Tahiti . . . the differences between the highest and the lowest taken as a whole are not even that which are found in England between the life-styles of a tradesman and a day laborer" (Forster 1989a: 299f).

While his two stays on the Society Islands lasted some two and a half months, his two visits to the Tonga Islands—during October 1773 and June and July of 1774—all in all lasted only four weeks. Despite the decidedly shorter period of contact with the people of Tonga, Forster correctly recognized in his continual comparisons a correspondence between the cultures and social structures of the Society Islands and Tonga. On the basis of linguistic correspondence and similarity of political forms, he established correctly that in terms of settlement history, the peoples on both archipelagoes must have sprung from a common original population, which simply gradually became different in cultural adaptations due to the differing natural settings and the resulting environmental conditions. He sees the poorer living conditions as the reason for the Tongans being more challenged in their daily and work lives than the Tahitians. He in turn considers this as the reason the latter population developed precisely the bourgeois European eighteenth-century virtues like discipline, industriousness, and orderliness—in the sense of conscientious material self-assertion and social emancipation—as well as products that in their quality and craftsmanship far exceeded anything else he had seen in Oceania.

Just as Abel Tasman in 1643 before him, Forster stresses the open-heartedness, the low level of mistrust in all areas, the great generosity, and the concomitant peaceful disposition of the people of the Tonga Islands, and he concurs with Cook that this archipelago had earned the right to be named the "Friendly Islands."

Although the authorities on Tonga—in contrast to those on Tahiti—hardly looked any different from the common people, Forster notices that in Tonga's social constitution, with its absolute central power in the form of a rule equivalent to a king, the latent power of social compulsion is much more strongly pronounced there than anywhere else in Polynesia: "the obedience and the loyalty to their rulers demonstrate to [my]

satisfaction that the constitution here, while not exactly completely despotic, still is quite far from being democratic" (Forster 1989a: 372). Forster describes in detail the conspicuous presence of weapons in the form of spears and clubs. And although the Tongans repeatedly assured Captain Cook that they had not conducted war for quite some time, and Forster opines "it is not easy to see for what purpose do these people have such a quantity of weapons" (Forster 1989b: 148), already during his first visit to Tonga he had penned the following:

> But the vast amount of weapons which we found among the locals was not consistent for me with the pacific disposition that they presented in all their behavior with us and their willingness to sell us their weapons. Accordingly, despite their peaceful-appearing character, they must have often dealt with one another, or waged war with neighboring islands. (Forster 1989a: 350)

Just how justified Forster was in being skeptical is expressed by the Viennese ethnologist Karl Wernhart in his own evaluation:

> The strongly centralized sacral state was repeatedly convulsed by internecine conflicts in the form of rivalry between the Tui Tonga royal line and other lines (Tui Takalaua and Tui Kanokupolu) that often broke out into civil war and power struggles. The designation Friendly Islands, that Captains Tasman and Cook used, isn't

Club 'akau-ta, wood, Tonga. L. 89 cm. Inv. Oz 124. The Cook/Forster Collection of the Georg August University of Göttingen, Institute for Cultural and Social Anthropology. Photo: Harry Haase.

really correct, and numerous clubs in ethnographic collections confirm the presence of bellicose activities. (Wernhart 1992: 84)[9]

What Forster did not learn, and what was recognized only in later research, was that in the eighteenth century the Tonga Islands—unlike the Society Islands—carried out heavy warfare for supremacy, not just within the archipelago but also for total hegemony of the Pacific Ocean. At that time, their dominion stretched across thousands of miles to Fiji and Tuvalu. They were master builders of the high seas double-hulled boats used for crossing these vast expanses, something Forster recognized but did not associate with warfare.[10]

So in the end, Forster remains cautious in his judgment—certainly mindful of the brevity of his stay—and, differentiated in the way already sketched at the beginning of the chapter, the foreigner is presented to his reader neither as simply a gentle creature nor a mere warlike barbarian. The Polynesians, Maori, Tahitians, and Tongans are as well not "exotics." On the contrary, in Forster's writings they become apparent to the reader as foreigners ("Others") with many characteristics he is familiar with in his own culture. The reports of his travels show, on the basis of their transparency and explanatory power, that they are historically believable and—more than that—unique among the travel descriptions in their ethnological interpretation of those cultural contexts.

Today we can say that Georg Forster's South Seas descriptions claim one's sympathies, but also call for critical consideration by every generation anew, since Forster as a subject of research is "something always contemporary and unfinished, that does not leave one in peace" (Sonnemann 1971: 8).[11] There can be no doubt that Georg Forster's South Seas diaries will be experiencing re-evaluations by future scientific analysis. There will also be new scientific questions concerning the numerous cultural documents that came to Europe from Cook's journeys (and are today located in various museums).[12] Conclusions drawn from the artifacts will change continuously,

> because each new age that we live in, and each new question that we pose of them, transforms not only the point of view of the observer, but also the act of seeing and the object seen. In this way they give us ever-changing answers, and new meanings become apparent against the background of shifting standpoints and questions. The view we get resembles a kaleidoscope—there is no one single, true picture, but several, existing side by side. These are always composed of the same basic elements, but are put together into fresh constellations with fresh messages. (Hauser-Schäublin 2006: 20f)

Thereby the "we" in this case has long since included the point of view of the Polynesians of today.[13] Their judgment not only contains expert and insider knowledge of the social contexts of the collected artifacts and new perspectives regarding the evaluation of European South Seas travelers like Georg Forster, but at the same time has messages that must be understood within the context of Pacific identity formations and efforts toward political autonomy.[14] The Tongan anthropologist and poet Epeli Hauʻofa

expressed in his words that the spirit of James Cook must be banished from the front stage of attention—and with it, once and for all, the one-sided European reception of Polynesian culture of that time. According to him, the Polynesians should stop believing that they and their institutions play only the minor roles or are only spectators (see Gizycki 2004: 2).

In this sense, the Polynesian look at Forster in connection with the interpretation of artifacts, which originate from a time when the Polynesian cultures were to a large extent still uninfluenced by European contact, could give new and perhaps completely different assessments.

Notes

1. In this chapter all quotes from German texts have been translated.

2. Cf. the counterworld projections in terms of a South Sea paradise by the novelist Robert Louis Stevenson and the painters Max Pechstein as well as Paul Gauguin.

3. The two viewpoints were used to either legitimize the violence-based authority of the state or (based on the assumption of the natural goodness of people, who have lost their noble character through the process of civilization) to rediscover man in his peaceful and egalitarian primeval state (see Bräunlein and Lauser 1995: VI–VII).

4. Forster not only had read the original French account of Bougainville's journey, he also was the translator of the work into English.

5. Moreover, Forster gave considered thought to the question of intersubjective verifiability, an issue of relevance to fieldwork: "What's more, two travelers seldom see the same object in the same way, rather each reports according to the measure of his own senses and way of thinking in a particular way" (Forster 1989a: 13).

6. A precise analysis of the issue of cannibalism exemplified by the encounters of Cook with the Maori during the third voyage (1777) was lately given by the New Zealand historian Anne Salmond (2004, see particularly pages 1–9).

7. Much later, in his inaugural address to the Jacobin Club in the German city of Mainz, Forster also gave the reasons as to why war and violence are invoked in Europe and elsewhere: he saw the causes as unambiguously tied to gross social inequalities within a given society.

8. Even with all the security the Europeans' superior weapons provided and the presence of which he appeared to rely on, Forster expounded later in his book on the inequality of the weaponry and saw in the Europeans' more advanced weapons technology a danger of the collapse of European culture: "More accurate is the observation that the Tahitians are brave . . . warriors, even when the Europeans make themselves formidable by means of their murderous weapons. Against gunpowder, all other weapons can be seen as nothing more than arrows of straw . . . it remains true . . . that the brave man is no safer from enemy bullets than the cowardly or weak, so that in Europe personal bravery and all the virtues that go with it will have to die out" (Akademie der Wissenschaften 1985: 67).

9. Tongan clubs were the object type most frequently collected on Cook's voyages: "nearly 100 can be identified today. Because they are so numerous, Tongan clubs are particularly useful for studying changes in carving styles during the short period between Cook's second and third voyages. These changes were due primarily to the introduction of metal tools, which made fine incising easier to carry out" (Kaeppler 1998: 216).

10. In this context Forster stated: "The second kind of canot was equipped for sailing; and people who understood seamanship had to acknowledge that they functioned exceedingly well . . . , [and] that the inhabitants of these islands must be far more experienced seamen than . . . [others]" (Forster 1989a: 366f).

11. Dawson emphasizes today's significance of the essayist Forster (1977: 125): "Whether he was analyzing Captain Cook's travels, passionately defending a poem about the ancient Greek gods, or attacking the despots of the German states, Forster's essays express a commitment to the present and curiosity about the future."

12. Today more than two thousand artifacts, which were collected during the three South Sea voyages of Cook, are distributed among more than forty museums and other institutions all over the world. The world's largest Cook-Forster collection, containing almost five hundred unique "cultural documents" (artifacts) from the South Seas and residing in the Institute of Cultural and Social Anthropology at Göttingen University, Germany, was shown to the local public in the course of two special exhibitions at the Honolulu Academy of Arts, Hawai'i, and at the National Museum of Australia in Canberra, Australia, in 2006. These two exhibitions were a unique and great opportunity for the people of the Pacific to see authentic artifacts originating from their ancestors. Dr. Stephen Little, director of the Academy of Arts in Honolulu, emphasizes the importance of such contemporary documents for today's inhabitants of the Pacific with these words: "They are remarkable for their inherent beauty and craftsmanship, and their condition is by and large pristine. The opportunity to stand before these original works and experience their visual and spiritual power is one that cannot be duplicated in a book or electronic image. These works directly connect us with the ancestors of the indigenous peoples of the Pacific, and impart to us something of their experience of the world" (Little 2006: VII).

13. In this context, I would like to point out the fruitful, helpful, and constructive cooperation with Patricia Wallace, New Zealand (concerning Maori artifacts), and Wendy Arbeit, Hawai'i (concerning Polynesian textile materials), during the exhibitions in Hawai'i and Canberra mentioned above.

14. Cf. Kaeppler 1994: 59–75.

References

Akademie der Wissenschaften der DDR. 1985. *Kleine Schriften zur Völker- und Länderkunde, Erläuterungen.* Edited by Horst Fiedler et al. Berlin: Akademie-Verlag.

Bitterli, Urs. 1976. *Die 'Wilden' und die 'Zivilisierten'. Grundzüge einer Geistes- und Kulturgeschichte der europäisch-überseeischen Begegnung.* Munich: Beck.

Bödeker, Hans Erich. 1999. "Aufklärerische ethnologische Praxis: Johann Reinhold Forster und Georg Forster." In *Wissenschaft als kulturelle Praxis, 1750–1900,* edited by Hans Erich Bödeker et al., 227–254. Göttingen: Vandenhoeck & Ruprecht.

Bougainville, Louis Antoine. 1771. *Voyage autour du Monde, par la Frégate du Roi la Bodeuse et la Flute l'Étoile, en 1766, 1767, 1768 et 1769.* Paris.

Bräunlein, Peter J., and Andrea Lauser. 1995. *Krieg und Frieden. Ethnologische Perspektiven.* Bremen: Kea.

Dawson, Ruth P. 1977. "Georg Forster, Essayist." *Jahrbuch für Internationale Germanistik* 9 (2): 112–125.

Forster, Georg. 1989a. *Reise um die Welt. Georg Forsters Werke. Sämtliche Schriften, Tagebücher, Briefe.* Vol. 2, 1. Berlin: Akademie-Verlag.

———. 1989b. *Reise um die Welt. Georg Forsters Werke. Sämtliche Schriften, Tagebücher, Briefe.* Vol. 3, 2. Berlin: Akademie-Verlag.

Garber, Jörn. 1997. "Reise nach Arkadien—Bougainville und Georg Forster auf Tahiti." *Georg-Forster-Studien* 1: 19–50.

Gizycki, Renate von. 2004. *Oceania—Our Sea of Islands. Begegnung mit Schriftstellern im Pazifik.* Neuendettelsau: Pazifik Informationsstelle (Dossier 69).

Hauser-Schäublin, Brigitta. 2006. "Witnesses of Encounters and Interactions." In *Life in the Pacific of the 1700s. The Cook/Forster Collection of the Georg August University of Göttingen,* vol. 2 (European Research, Traditions, and Perspectives), edited by Stephen Little, Peter

Ruthenberg, Brigitta Hauser-Schäublin, and Gundolf Krüger, 21–35. Honolulu: Honolulu Academy of Arts.
Heintze, Dieter. 1976. *Georg Forster. 1754–1794. Südseeforscher, Aufklärer, Revolutionär*. Roter Faden zur Ausstellung 3, edited by Dieter Heintze and Heinz Kelm. Frankfurt: Museum für Völkerkunde.
———. 1990. "Georg Forster (1754–1794)." In *Klassiker der Kulturanthropologie. Von Montaigne bis Margaret Mead*, edited by Wolfgang Marschall, 69–87. Munich: Beck.
———. 1997. "Dem Ethnologischen bei Forster nachspürend." *Georg-Forster-Studien* 1: 51–66.
———. 2005. "Mit Georg Forster in der Südsee." In *Ritual—Macht—Natur: europäisch-ozeanische Beziehungswelten in der Neuzeit*, edited by Johannes Paulmann, 35–56. Bremen: Übersee-Museum.
Hoare, Michael E. 1982. *The Resolution Journal of Johann Reinhold Forster 1772–1775*. London: The Hakluyt Society.
Joppien, Rüdiger, and Bernard Smith. 1985. *The Art of Captain Cook's Voyages*. Vol. 2 (The Voyage of the Resolution and Adventure 1772—1775). New Haven, Conn., and London: Yale University Press.
Kaeppler, Adrienne L. 1994. *Die ethnographische Sammlung der Forsters aus dem Südpazifik: klassische Empirie im Dienste der modernen Ethnologie*. Berlin: Akademie.
———. 1998. "Tonga—Entry into Complex Hierarchies." In *James Cook. Gifts and Treasures from the South Seas*, edited by Brigitta Hauser-Schäublin and Gundolf Krüger, 195–220. Munich; New York: Prestel.
Kohl, Karl-Heinz. 1983. *Entzauberter Blick. Das Bild vom Guten Wilden und die Erfahrung der Zivilisation*. Frankfurt/Main: Suhrkamp.
Lepenies, Wolf. 1971. *Soziologische Anthropologie. Materialien*. Regensburg: Carl Hanser Verlag.
Little, Stephen. 2006. "Foreword." In *Life in the Pacific of the 1700s. The Cook/Forster Collection of the Georg August University of Göttingen*, vol. 1 (Artifacts from the Life in the Pacific of the 1700s), edited by Stephen Little and Peter Ruthenberg, vii–viii. Honolulu: Honolulu Academy of Arts.
Moleschott, Jakob. 1862. *Georg Forster, der Naturforscher des Volks*. Berlin.
Mühlmann, Wilhelm E. 1968. *Geschichte der Anthropologie*. Frankfurt/Main, Bonn: Athenäum.
Obeyesekere, Gananath. 2005. *The Man-Eating Myth and Human Sacrifice in the South Seas*. Berkeley; Los Angeles; London: University of California Press.
Petermann, Werner. 2004. *Die Geschichte der Ethnologie*. Wuppertal: Peter Hammer.
Sahlins, Marshall. 1992. *Inseln der Geschichte*. Hamburg: Junius.
Salmond, Anne. 1997. *Between Worlds: Early Exchanges between Maori and Europeans, 1773–1815*. Auckland: Penguin Books.
———. 2004. *The Trial of the Cannibal Dog: Captain Cook in the South Seas*. London: Penguin Books.
Sonnemann, Ulrich. 1971. *Der kritische Wachtraum. Deutsche Revolutionsliteratur von den Jacobinern zu den Achtundvierzigern*. Munich: Kreißelmeier Verlag.
Steiner, Gerhard, ed. 1970. *Georg Forster. Werke in vier Bänden*. Vol. 4 (Briefe). Frankfurt/Main: Insel-Verlag.
Urban, Manfred. 1994. "Forster in der Südsee und die Entwicklung des ethnographischen Blicks." In *Weltbürger—Europäer—Deutscher—Franke. Georg Forster zum 200.Todestag*, edited by Rolf Reichardt and Geneviève Roche, 17–56. Mainz: Universitätsbibliothek.
Wernhart, Karl. 1992. "Aspekte der Kulturgeschichte Polynesiens." In *Polynesier. Vikinger der Südsee*, edited by Hanns Peter 53–90. Vienna: Museum für Völkerkunde.

Inventing Polynesia

Serge Tcherkézoff

It is usually assumed that the naming of the Pacific regions, at least for Melanesia, Micronesia, Polynesia, was invented by the French navigator Dumont d'Urville in the early nineteenth century, as the expanded knowledge of the Pacific, or Oceania as it began to be called at the same time in France, required more detailed maps and hence new names for subdividing a vast expanse that appeared to be composed of so many different islands.

Such a view, which one finds in most textbooks and school manuals, is oblivious to two historical dimensions. First, Dumont d'Urville's proposal was not so much a cartographic progress, a simple addition to universal geography with new maps, but was the outcome of a racial agenda. Second, the word "Polynesia" had already been in existence for seventy-five years, with a different geographical extension.

On the first issue, the racial agenda, I will not expand much in this direction, as other works are available (Tcherkézoff 2003, 2008). It is enough to know that Dumont d'Urville wrote in his private diary (kept in the City Library of Toulon, in the south of France), in the last days of December 1831, how he was eager to finish in time his "memoir about races" (*mémoire sur les races*), which he revealed in a lecture given at the Société de Géographie in Paris in early January 1832.[1] The 2003 special issue of the *Journal of Pacific History,* entirely devoted to Dumont d'Urville's division, also offers the first ever English translation of this foundational lecture given by Dumont d'Urville in January 1832 where he proposed this naming. Everyone can see clearly now that Dumont d'Urville's main purpose in this January 1832 lecture was to distinguish "two races" within the Pacific peoples. Indeed, Dumont d'Urville made no secret of this—since in those years attempts to distinguish "races" was seen as furthering "scientific knowledge"—as can be seen also from his introduction to his 1834 bestselling book *Voyage pittoresque* (which offered to the general public a compilation and summary of voyages in the Pacific):

> In the paper that I read to the Société de Géographie [in January 1832] . . . I suggested dividing all of Oceania [into] Polynesia, Micronesia, Malaysia, and Melanesia. . . . All travelers . . . [recognized] two separate races [in Oceania] . . . two varieties of the human spirit that are very different one from the other, and on the

basis of the many essential traits that characterize each of these two varieties, they separated them at once into two distinct races. (Dumont d'Urville 1834–1845: vi–vii) [2]

Let us note in passing that, in his fourfold division, Australia was just a part of his newly coined "Melanesia," and his global "Oceania" included what we call today Southeast Asia ("Malaysia"). But today, for a French audience, "Oceania" is understood as composed of the four divisions of Australia, Melanesia, Micronesia, Polynesia, not including Malaysia.

The two "races," Dumont d'Urville added in the same pages, are distinguished from one another by several "traits": skin color first of all, type of hair, proportions of the body, and also that the first "race" often forms nations, sometimes with monarchies, while the second one lives "in small tribes, almost never [forming] a nation"; "their condition is always close to barbarity" (Dumont d'Urville 1834–1835: vi). Dumont d'Urville then linked his fourfold regional division (Malaysia, Melanesia, Micronesia, Polynesia) to his binary racial division. The first "race" included the "copper-skinned people" present in Polynesia, Micronesia, and Malaysia. The second one included all the "black-skinned" people: "all the Oceanic peoples who have more or less black skin, curly and frizzy hair, and often frail, deformed limbs. We shall give [them] the name of Melanesia" (Dumont d'Urville 1834–1835: vii).

De Brosses' "Polynésie" (1756)

The other historical dimension usually forgotten is that the word "Polynésie" was already in use. I said I would not go further in discussing the unfortunate racial invention of "Melanesia" by Dumont d'Urville, but we have to keep it in mind, as it had a deep consequence on the history of the invention of "Polynesia." Indeed, if this latter name refers today only to the central and eastern part of the Pacific after Dumont d'Urville's racial mapping of 1832, it is because it had to concede some geographical space for the newcomer "Melanesia." This was not the case previously: the name applied then to the whole of the Pacific.

It had been coined in France in 1756 by a writer named Charles de Brosses to designate and encompass all the islands in the Pacific Ocean. De Brosses was a geographer, a jurist, a great reader of narratives of exploration, and he had the idea to offer to the French audience, and mainly to the royal court, a printed compilation of the existing narratives of voyages in the Pacific, translating them all into French. This was a premiere, as such a compilation had not been done. He titled it *History of the Navigations to the Austral Lands* (*Histoire des navigations aux Terres Australes*), and he wrote (de Brosses 1756, I: 13, 80):

> Our globe is made up of three large expanses of land, Asia, Africa and America, and three large expanses of sea, the Ethiopian or Indian Ocean, the Atlantic or Northern Ocean, the Pacific or Southern Ocean. In relation to this, we can even divide the unknown southern world into three parts, lying to the south of the three

mentioned above. One in the Indian Ocean to the south of Asia that I will call for that reason *Australasia*. Another, that I will name *Magellanic* after the man who discovered it. . . . I shall include in the third everything contained in the vast Pacific Ocean, and I shall give this part the name of *Polynesia* because of the many islands it encompasses (from 'polus' *multiplex* and 'nèsos' *insula*).[3]

It seems to me, when reading that book, that de Brosses was as much concerned with proposing a geographic nomenclature than he was in furthering strategic, political, or even colonial goals. He wanted to encourage the French court to send expeditions to this region. De Brosses wanted to give the impression with the word "Polynesia" that, apart from the famous southern continent that would surely be found one day, the Pacific was also likely to conceal "many" lucrative spice islands. He wrote:

> Apart from the Austral Lands [the proposed southern continent], it is impossible for there not to be, in the immense Pacific Ocean, between Japan and America, a large number of islands rich in spices. (de Brosses 1756: 4)

So the name "Polynesia" began its life in accordance with its etymology of "many islands," and it quite logically applied to the whole of the Pacific (but not including Australia, as can be seen from the maps included in de Brosses' book). But it also began its life with a potentially colonialist implicit agenda. Indeed, de Brosses' book will be quite instrumental in influencing the French and the British authorities to launch expeditions to that part of the world. It will then be the beginning of the era of voyages with which the exhibition Life in the Pacific of the 1700s: The Cook/Forster Collection of the Georg August University of Göttingen, presented at the Honolulu Academy of Arts, was concerned with.

Johann Reinhold Forster (1778)

Shortly after, Cook's expeditions will occur. We know how Johann Forster brought back from the second expedition a vast treatise, his *Observations* . . . (Forster 1996 [1778]). The expedition visited several archipelagoes of what we now call Polynesia, also with short visits—"discoveries" from the British point of view—to the New Hebrides (Vanuatu) and New Caledonia. Cook's previous voyage had already established the physical, cultural, and in particular linguistic similarities of the inhabitants of Tahiti, the Society Islands, the Tuamotus, the Austral Islands, and New Zealand. This had been discussed in England and France and became integrated into the specialized knowledge about the Pacific. The second voyage confirmed and broadened this similarity to the people living on Tonga, Easter Island, and the Marquesas. But this second voyage also encountered the land and people of Tanna and Malekula in Vanuatu, and of New Caledonia. Forster's observations were therefore based on (1) a set of islands whose human unity was already known, and (2) Vanuatu and New Caledonia, whose people were new to Europeans. He used skin color to highlight the difference. He wrote in his 1778 treatise (Forster 1996 [1778]: 153–154):

We chiefly observed two great varieties of people in the South Seas; the one more fair . . . the other blacker. . . . The first race inhabits O-Taheitee, and the Society Isles, the Marquesas, the Friendly Isles [Tonga], Easter-Island, and New-Zeeland. The second race peoples New-Caledonia, Tanna, and the New Hebrides, especially Mallicolo.

Forster added that each of the two "races" was divided:

> Each of the above two races of men, is again divided into several varieties, which form the gradation towards the other race; so that we find some of the first race almost as black and slender as some of the second; and in this second race are some strong athletic figures, which may almost vie with the first; however, as we have many good reasons for comprehending in one tribe all the islanders enumerated

(Facing page and above)

After the invention by de Brosses of the word "Polynesia" in 1756 to cover all the Pacific Islands, atlases will divide the Pacific into two regions: "Australasia" (Australia and part of Southeast Asia) and "Polynesia" (all the islands): see a U.S. example from the 1870s (facing page, top). This mapping will last in France only until D'Urville's lecture of 1832 (facing page, bottom), and French atlases will immediately integrate it (above), while it will last in English written atlases until the late nineteenth century.

under the first race, we could not help giving to all a general character, from which, on account of the extent and compass, wherein these nations are dispersed, the outskirts or extremes must deviate.

Thus, on the basis of what was known about a region yet unnamed but which will become with Dumont d'Urville the "Polynesia" that we know, Forster attempted to identify a second region. This was done using skin color since there was no linguistic unity or obvious shared cultural behavioral traits within this second region. The apparent unity of the "first race," combined with a contrast in skin color, led Forster to discard the model of a continuum and to conclude that there was an opposition between the two "races." The human "varieties" in the South Seas were now reduced to two races, and Forster had therefore marked out the route that eventually led to the distinction between Polynesia and Melanesia. In a way, fifty years later, Dumont d'Urville had only to give names to these two parts that Forster had discriminated, and indeed, in his 1832 lecture he paid homage to the "lucid system" proposed by Forster. We must remember of course that Forster was not preoccupied by any search for identifying "races" in the nineteenth-century sense of the word. But because he was aiming at writing a systematic treatise (about human "varieties"), he could not leave a part of the Pacific as a part about which nothing could be said. As the central-eastern part (the future Polynesia in the modern sense) was a unity, he decided, for the sake of balancing his model, that the western part should be considered as a unity, thus creating in advance a possibility of a naming of that part too; it will be "Melanesia" fifty years later.

"L'Océanique"

The word "Polynesia" as defined by de Brosses did not have a great career. Voyagers and geographers continued to talk mainly of the "Pacific," the "South Seas," or the "Grand Ocean." The first two terms would continue their existence, and the third one, "Grand Ocean," will gradually be replaced by the word "Oceania" (Océanie), which will appear in 1822 (although "Grand Ocean" continued to be used in parallel until the late 1830s).

A brief remark is useful to the story of this word "Oceania," a story that began in 1813. Malte-Brun, Danish by origin and living in Paris, the author of several works on geography and a founding member of the Société de Géographie in 1821, began publishing his *Précis de la géographie universelle* (Handbook of Universal Geography) in 1810. In volume 4, which was published in 1813, we find a "Description of the Oceanic, a new part of the world, comprising the lands situated in the Great Ocean, between Africa, Asia and America." He justified his usage of the term in this way:

> The fifth part of the world [. . .] is situated in the Great Ocean, in the archetypal Ocean [*l'Océan par excellence*]. It does not share this essential character with any other division of the globe. This character gives a particular aspect to its geography, its natural history, and its social history. This must therefore decide the name of the new part of the world. It will be called the Oceanic [*l'Océanique*].[4]

Malte-Brun extends his category of "the Oceanic" to include the islands of Sumatra, Java, and Borneo, now in Indonesia (Blais 2000: 59). De Rienzi, from 1831 to 1836, and Dumont d'Urville in 1832, would follow Malte-Brun and retain this large-scale conception of "Oceania." They simply named this Indonesian subdivision "Malaysia" (taking up a term that, as Dumont d'Urville said in his lecture, had been coined shortly before by René-Primevère Lesson).

But in 1813 Malte-Brun had not yet devised a terminology for the subdivisions. He simply spoke of the "western part" of the "Oceanic" for what would be called "Malaysia," the "central part" for everything from "New Holland" to New Zealand, and the "eastern part" for all the islands "from the Marianas to Easter Island" (Blais 2000: 60). This tripartite division is interesting. It is purely geometrical, merely straight lines drawn on a map. It took no account of differences and linguistic groupings that were already well known since Forster. It grouped together New Guinea and New Zealand (two quite distinct language areas, the "Papuan" and Polynesian), separating the latter from Easter Island (even though these were part of the same language area, the Polynesian language grouping), but joining Easter Island to the Marianas (again two distinct language areas, Micronesia and Polynesia). This is why people immediately paid attention to de Rienzi and Dumont d'Urville when both proposed a new definition of "Polynesia" (in the more restricted and present sense) and when they invented "Micronesia."

In French, "*l'Océanique*" sounded awkward, as if it were an adjectival form; in fact, it was the shortening of "the Oceanic part," "*la partie océanique*," which is why it quickly became nominalized into "Océanie." In December 1822, the same Malte-Brun titled one of the questions put up for a prize among the members of the Société de Géographie: "the origin and migrations of the people of Oceania" (*l'origine et les migrations des peuples de l'Océanie*), adopting a form that a cartographer, Brué, had used shortly before on one map. From then on, "Océanique" would not be seen anymore, only "Océanie."

From Malte-Brun and taken again by Dumont d'Urville in his 1832 proposal, the term "Oceania" will also include Australia. That is why today, in French Studies of Océanie, like in the Centre de Recherche et de Documentation sur l'Océanie, Australia is integral part of the domain, with Melanesia, Micronesia, and Polynesia, while usually English-speaking "Pacific Studies" do not include Australia—at least studies concerned with Aboriginal people's societies and cultures.

The First "Anthropological" Treatise: Blanchard 1854

Still, occasionally, the word "Polynesia" with reference to the whole of the Pacific islands will occur up to the mid-nineteenth century, as can be seen for instance in the first study—or, better, the first listing—of Pacific peoples presented under the title of "Anthropology," authored by a Dr. Blanchard in 1854. Curiously, this text seems to be unknown among scholars working around these topics. It is worth mentioning as the last occurrence of the original meaning of the word "Polynesia," but also because it is one of the nineteenth-century texts that presents in the most explicit way the new vision

of races that prevailed after the 1810s and the reasons for its opposition to eighteenth-century views.

This treatise is one of the volumes from the second voyage of Dumont d'Urville (1837–1840). It is quite representative of the "anthropology" of the nineteenth century. Let us remember that the word began in the sense of "(physical) anthropology": cranial measures, etc., in order to better distinguish "races." The title of that volume is "Anthropologie, par M. le Docteur Dumoutier," but it was written by Blanchard, who commented on the skulls collected or the imprints made in plaster by this Docteur Dumoutier who accompanied Dumont d'Urville.

It was the first time a volume from a voyage was called "Anthropologie." It reminds us that in Paris soon after, in 1859, would be founded the first "Société d'anthropologie" (Society of Anthropology), a new science that aimed at specializing in the study of the innate differences between human races and that explicitly rejected the universalistic trend of the naturalists of the eighteenth century, Buffon or Johann Forster. The introduction by Blanchard is explicit:

> To accept the specific unity of man and his variations purely as the result of external circumstances [climate, etc.] is in some way to annihilate the science of anthropology. If man is one, it is now only a matter of determining the causes which are of a kind to modify him, and since these causes must be imperceptibly graduated, then there is no longer even any reason to wish to characterise races or varieties which are necessarily mixed up together. By accepting on the contrary that each region has its own inhabitants as it has its particular plants and particular animals, anthropological science takes on vast dimensions. (Blanchard 1854: 52–53)

As a consequence, Blanchard is strongly opposed to any monogenist view. He says that a European individual, if he becomes tanned under the tropical sun, will never get the same pigmentation as the natives of those tropical regions. And, symmetrically:

> Who would dare to pretend that an inhabitant of say Guinea (Africa), transported into our country, would produce descendants who one day could become undifferentiated from the Gallic race?

What will be the method? Comparing the greatest possible number of individuals in the world.

> Are we going to follow Virey and say that the human genus is composed of two species, or Desmoulins who gives sixteen species, and several races, or Bory de St-Vincent, with fifteen species, or Mr Jacquinot with three species? Are we going to regard as species the races and varieties accepted by other anthropologists? Shall we say with Linnaeus that there are four of them, or with Hunter seven, with Blumenbach five, with Dr Pickering eleven, etc., etc.? (Blanchard 1854: 45)[5]

"No, a thousand times no!" answers Blanchard. "Anthropological science is still in infancy"; it is still necessary to gather together a large number of comparisons before reaching a "result" (Blanchard 1854: 46).

With this declaration Blanchard throws himself into the description of the different peoples encountered on the voyage. Chapter 4 of his treatise is an introduction to "Oceania":

> OCEANIA AND ITS DIVISIONS
>
> IV. Oceania
>
> For this part of the world, from the anthropological point of view, Mr Jacquinot [author of the volume "Zoology" for this voyage] accepts three major divisions: Australia, comprising New Holland and Tasmania; Polynesia, comprising all the islands of the Pacific Ocean, from America to the Moluccas; and Malaysia, comprising the archipelagos of the Moluccas, the Sunda Islands and the Philippines.
>
> We begin with the peoples of Polynesia, taking those who are nearest the American coast, and then proceeding further and further westwards, that is towards Malaysia and Australia.
>
> All of the Polynesians bear a great resemblance to each other and differ to no great extent in their general aspect from the indigenous inhabitants of America. Such is the impression gained by most of the navigators.
>
> We shall see what facts the materials brought back by Mr Dumoutier are going to provide us with in this respect.
>
> For Dr Jacquinot (Zoologie, t. II, p. 238), the Polynesians do not differ perceptibly from the Americans. They belong similarly to the Mongol *species,* but they are shown as forming the Polynesian race. For Blumenbach, for Desmoulins, for Dr Pickering, one of the most recent observers who has written about these peoples, etc., they belong to the *Malay* race." (Blanchard 1854: 62–63)[6]

Jacquinot was indeed still following the old model of de Brosses and had not yet incorporated Dumont d'Urville's new nomenclature: "Polynesia" was still all the islands of the Pacific. Blanchard, whose volume was published in 1854, begins by following this old tripartite division but makes a separate place for those he names "Melanians" at times, and at others, in reference to Dumont d'Urville, the "Melanesians." Because of this, the inhabitants of his "Polynesia," which stretches from the American coast to Southeast Asia, are entirely of "the Mongol species." In fact he uses the term "Polynesia" in a variable way. Sometimes he uses it in the old sense, as in the first lines of this preamble and again in the title of his sixth chapter: "POLYNESIA (MELANESIA)," where Melanesia is therefore presented as a part of Polynesia. At other times he will invoke its new and restricted sense, as in the following part of the preamble, when he speaks about the "Mongol" race, and in the title of his fifth chapter, "POLYNESIA."

And there of course, "Polynesia" is composed of examples from "Gambier ou

Pomotou," "Marquises," "Société," "Hawai" [sic], "Navigateurs ou Iles Samoa," and "Tonga ou des Amis." It corresponds to the new "Polynésie" of Dumont d'Urville. There is no need to say that the value judgments will be more or less positive, while of course they will be wholly negative for the description of the "Melanians" or "Melanesians" (similar to the variation regarding the definition of Polynesians, in these years scholars will use both "Melanians," the word coined in 1825, seven years before d'Urville's lecture, by the botanist Bory de Saint Vincent to designate the "black" people of the Pacific, and "Melanesians," the word proposed by Dumont d'Urville in 1832, the latter prevailing entirely from the 1840s onwards).

This text written by Blanchard is central for any study of the history of the notion of "races." But let us come back to our main theme: the word "Polynesia." Since the 1832 Dumont d'Urville lecture, or let us say since the early 1840s, when the new naming and mapping proposed by Dumont d'Urville went into all geography treatises and even schoolbooks, "Polynesia" is restricted to the region that we know as such. As Patrick Kirch has remarked, it is the only outcome of Dumont d'Urville's division that is worth retaining since it corresponds to a unitary region from an archeological and linguistic point of view, the history of the Polynesian migrations and languages:

> Although based on a superficial understanding of the Pacific islanders, Dumont d'Urville's tripartite classification stuck. Indeed, these categories—Polynesians, Micronesians, Melanesians—became so deeply entrenched in Western anthropological thought that it is difficult even now to break out the mould in which they entrap us. [. . .] Such labels provide handy geographical referents, yet they mislead us greatly if we take them to be meaningful segments of cultural history. Only Polynesia has stood the tests of time and increased knowledge, as a category with historical significance. (Kirch 2000: 5)

Still, between 1831 and 1840, there will be a certain fluctuation as to the limits of the new "Polynesia," as can be seen in the debate between Domeny de Rienzi and Dumont d'Urville concerning how far on the map the new entity coined "Micronesia" should extend. In it, we also find a few lines by de Rienzi that are the very first attempt to culturally define the Polynesian region.

De Rienzi (1836)

Grégoire-Louis Domeny de Rienzi, an obscure geographer and navigator who was familiar with Southeast Asia but not the Pacific, made a brief speech to the Société de Géographie on December 16, 1831. In 1836 he published a book titled *Oceania or the fifth part of the world . . . (Océanie ou cinquième partie du monde . . .)*, which is a compilation of voyage accounts displaying geographical and cartographical material at the same time. Remarks made by the author suggest that the introduction again takes up his speech of December 1831.

In his speech of 1831 de Rienzi seems to have proposed five geographical divisions for Oceania and devised the name "Micronesia." More precisely, de Rienzi would

have referred to "Micro-?," but we do not know what the ending of the word would have been ("Micronia" or something similar?). At least that is what we must infer if we are to account for the fact that in his own lecture of 1832 Dumont d'Urville says of this region: "I shall give it the name of *Micronesia,* which only differs from that proposed by Mr de Rienzi in terms of its ending"—before totally omitting any mention of his rival from 1834 onwards and giving himself sole credit for the invention of the word.[7]

De Rienzi took up these five divisions again in his book of 1836,[8] and in this same book he went on to give an exposition about the "four races" who inhabited these five divisions. In the course of this exposition he took it upon himself to define "Polynesia" by features we would see today as sociocultural. Thus, significantly, he proposed what in the history of European scholarly classifications was the first definition of the Polynesian culture area in its current sense.

The book published by de Rienzi included a map. The inscription denoting "Polynesia" extends from the north of New Guinea to Easter Island, thereby partly following de Brosses and including as well a part of what we now call Melanesia. But in his text, de Rienzi circumscribes Polynesia more narrowly than this (see below). As for "Melanesia," which appears on this 1836 map (after the coining of the word by Dumont d'Urville in January 1832), it extends only around Australia (to the west, southeast, and northeast).

The five divisions proposed by de Rienzi are, in order:

1. "Malaysia" to the west, with Borneo at its center.
2. "Micronesia" to the north. Made up of "very small islands" says the author (who leaves it to the reader to guess the reason for the choice of this term, from *micro,* "very small" and *nèsos,* "island").
3. "Polynesia which I proposed naming Tabooed Plethonesia [Plethonésie Tabouée], that is a multitude of islands under the sway of Taboo (a religious interdiction [. . .])." This division included the Carolines, the Gilbert Islands, and the Marshall Islands (which today are all part of Micronesia), as well as "the islands of the South Seas or of the Great Ocean," going from Hawaii to the north and Tikopia to the west up to the islands close to the American coast (and which are not Polynesian in the current sense). A part of present-day Melanesia is therefore still included under the designation "Polynesia."
4. The "Central Ocean": New Guinea "on which I conferred the name Papuasia [Papouasie],"[9] the Solomon Islands, New Ireland, and New Britain.
5. "Endamenia [Endaménie] or Southern Oceania [Océanie méridionale]": Australia, New Caledonia, and "Mallicolo."

The author adds: "I proposed, lastly, replacing the name *Oceania* by that of *Vulcanesia* [*Vulcanésie*] as volcanoes are present almost everywhere in this fifth part of the world."

Then de Rienzi adds this clarification about "Micronesia":

> In the session of 5 January 1832 the illustrious navigator Mr Dumont d'Urville read a memoir about the islands of the Great Ocean in which, after having adopted my second division of Micronesia, he extended it to the south.[10]

And indeed, Dumont d'Urville had placed the Caroline Islands in "Micronesia" in his memoir of 1832. In 1836 de Rienzi emphasizes his disagreement. We have just seen that he wanted to include the Carolines (together with the Gilbert Islands and the Marshall Islands) in his "Polynesia," which left "Micronesia" with only the other archipelagoes of this region (the Marianas, the "Pelew" group of islands, etc.).

De Rienzi obviously could not resist going one better than his colleagues and rivals. He wanted to rename Oceania "Vulcanesia" and invented "Endamenia." He also wanted to rename "Polynesia," and the term he proposed—"Tabooed Plethonesia"—is extraordinary. Where "Poly-nesia" already referred to "numerous islands," this would now become "a plethora of islands" (Pletho-nesie), of course "Tabooed" (where the populations live under the law of Taboo). More seriously though, it should be noted that the new terminology proposed by de Rienzi to refer to Polynesia includes a feature of the social system, namely "Taboo." When explaining why he could not accept situating the Caroline Islands in Micronesia, as Dumont d'Urville wanted to do, de Rienzi added this clarification:

> [The inhabitants of the Carolines are] true Polynesians among the majority of whom we find the Tahitian Trinity of the loathsome society of the Aritians [*aritois* in the French, in fact the Arioi], tattooing and even *Tapu*, under the name of *Penant* in the Carolines.

As to the extent of Micronesia, linguistics put Dumont d'Urville in the right over de Rienzi. The Caroline Islands, the Gilbert Islands, and the Marshall Islands are today definitely classified as Micronesian and not as Polynesian.

But there is another reason why we should pay attention to this passage. There is no doubt that it represents *the first Western construction of a definition of Polynesia as a culture area*. With the intervention of de Rienzi and Dumont d'Urville and the coinage of these new terms "Micronesia" and "Melanesia," the area denoted by the term "Polynesia" is no longer as extensive as de Brosses had made it. It begins to take on the dimensions we recognize today. We see that with this phrase de Rienzi is referring rather to the central and eastern islands and not to everything that the word "Polynesia" seems to cover in the map included with his book. Polynesia in the modern geographical and cultural sense has just come into being, and what do we observe? Its definition centers immediately on one island in particular, Tahiti, based on European prejudices about what the Tahitian way of life was supposed to be. The main elements of this construct are:

1. Sexual license: the "loathsome society" of the Arioi. This was a brotherhood cited by all the savants and voyagers from the time of the accounts of Cook's

expeditions. The Arioi were supposed to have held dances involving acts of sexual intercourse in public, and, most horrifying of all, the adepts were said to have smothered their children at birth in order to conduct their lives of sexual debauchery more freely.
2. Tattooing.
3. Taboo involving sacred prohibitions with all the ceremony and tradition-bound organization that this entailed.

In relation to the first of these, the "loathsome society of the Aritians," we can see the influence of the Western myth of Polynesian sexuality. This is not the place to debate the subject. Let me simply say that from the time of the publication in London in 1773 of the (reworked) narrative of Cook's first voyage, which included the description of the expedition's first stay in Tahiti, the rumors of sexual license are repeated by one and all but no one refers to any scene (of the Arioi dances) that they have actually observed. In fact, if we consult the ship's journals, which have now become accessible, Cook and Forster admit that no member of their expeditions had ever witnessed these rites.[11] In the case of infanticide, it was practiced, to a limited extent, but for reasons that had nothing to do with sexuality. Rather it was exclusively related to sacrificial rites for the god 'Oro expressing greater belonging to the god and seeking to better represent him on earth.[12] We can see that this passage from Domeny de Rienzi must now be added to the study of the evolution of the Western myth about Polynesian sexuality through the nineteenth century as another example in the history of the Western imagination and misrepresentation of Polynesian cultures that started with Bougainville in 1771 (the whole theme of the Garden of Eden).[13]

This is another discussion. But for our topic, de Rienzi's publication is the final text worthy of consideration. From these years of the 1830s through the 1850s, with de Rienzi, Dumont d'Urville, and Blanchard, the geographical extent (and the supposed cultural definition) of "Polynesia" will not vary any more in the Western literature.

Notes

1. These data are presented in Tcherkézoff (2008). For this chapter, Dr. Stephanie Anderson had kindly provided the English translations of my quotations from the French texts (de Brosses 1756; Blanchard 1854; de Rienzi 1836–1837; Dumont d'Urville 1834–1835; Malte-Brun 1813). Bronwen Douglas (see her paper in this volume) is one of the rare scholars to have also noted that aspect, in her publications dealing with the general topic of the emergence, at the beginning of the European nineteenth century, of a totally different and new notion of "race" in comparison with the use of this word in the eighteenth century (Douglas 1999a, 1999b, 2003, 2008a, 2008b).

2. This compilation is distinct from Dumont d'Urville's formal reports on his voyages.

3. The words "polus" and "nèsos" are printed in Greek letters in the book. For an article on de Brosses, see Ryan 2002.

4. I have drawn this quotation, as well as an indication of the significance of the role played by Malte-Brun, from Blais 2000, vol. 1: 52–53.

5. Blanchard is clearly blind to the fact that for the eighteenth-century authors he cites in his last sentence, the terms "races and varieties" by no means represented the same things as they did for Virey or Saint-Vincent.

6. The italics are the author's.

7. Given that de Rienzi's speech of 1831 was never published and that in his book of 1836—which was the first time he had committed his ideas to writing—he uses Dumont d'Urville's word "Micronesia," we can only conjecture about the word de Rienzi had proposed at that earlier time.

8. All the quotations from de Rienzi that follow are taken from pages 11 to 22 of de Rienzi 1836–1837.

9. Which is hardly new; reference had long been made to "the land of the Papuans" as well as to New Guinea.

10. The session took place on January 6. In 1836 de Rienzi simply said that in January 1832 Dumont d'Urville "adopted" his division (including the word "Micronesia") while modifying its field of application. He therefore seemed to be implying that he had proposed this word in this form in his speech of December 1831. Dumont d'Urville, for his part, said that he had changed the "ending." No doubt this is all we shall ever know on the matter.

11. See Tcherkézoff 2004a, ch. 14, for my review of what we know, or do not know, about the Arioi.

12. As to the last point, it has already been demonstrated by Alain Babadzan in his work on ancient Tahiti (Babadzan 1993).

13. See Tcherkézoff 2004a, 2004b, 2009.

References

Babadzan, Alain. 1993. *Les dépouilles des dieux. Essai sur la religion tahitienne à l'époque de la découverte*. Paris: Ed. de la Maison des Sciences de l'Homme.

Blais, Hélène. 2000. "Les voyages français dans le Pacifique. Pratique de l'espace, savoirs géographiques et expansion coloniale, 1815–1845." PhD thesis, École des Hautes Études en Sciences Sociales, Paris.

Blanchard, Emile. 1854. *Voyage au Pôle sud et dans l'Océanie, sur les corvettes l'Astrolabe et la Zélée, exécuté par ordre du roi pendant les années 1837 . . . 1840, sous le commandement de M. J. Dumont-d'Urville . . . Anthropologie, par M. Le Docteur Dumoutier. Texte de l'Anthropologie par Emile Blanchard*. Paris: Gide et Baudry.

Brosses, Charles de. 1756. *Histoire des navigations aux Terres Australes: contenant ce que l'on scait des moeurs et des productions des Contrées découvertes jusqu'à ce jour et où il est traité de l'utilité d'y faire de plus amples découvertes et des moyens d'y former un établissement*. Paris.

Douglas, Bronwen. 1999a. "Art as Ethno-Historical Text: Science, Representation and Indigenous Presence in Eighteenth and Nineteenth Century Oceanic Voyage Literature." In *Double Vision: Art Histories and Colonial Histories in the Pacific*, edited by Nicholas Thomas and Diane Losche, 65–99. Cambridge: Cambridge University Press.

———. 1999b. "Science and the Art of Representing 'Savages': Reading 'Race' in Text and Image in South Seas Voyage Literature." *History and Anthropology* 11 (2–3): 157–201.

———. 2003. "Seaborne Ethnography and the Natural History of Man." *Journal of Pacific History* 38: 3–27.

———. 2008a. "Climate to Crania: Science and the Racialization of Human Difference." In *Foreign Bodies: Oceania and the Science of Race 1750–1940*, edited by Bronwen Douglas and Chris Ballard, 33–96. Canberra: ANU E Press.

———. 2008b. "'*Novus Orbis Australis*': Oceania in the Science of Race, 1750–1850." In *Foreign Bodies: Oceania and the Science of Race 1750–1940*, edited by Bronwen Douglas and Chris Ballard, 99–155. Canberra: ANU E Press.

Dumont d'Urville, Jules Sébastien-César. 1834–1835. *Voyage pittoresque autour du monde:*

résumé général des voyages de découvertes de Mmoagellan, Tasman, Dampier . . . , publié sous la direction de M. Dumont d'Urville. Paris.

Forster, Johann Reinhold. 1996 [1778]. *Observations Made During a Voyage Round the World*. Edited by Nicholas Thomas, Harriet Guest, and Michael Dettelbach. Honolulu: University of Hawai'i Press.

Kirch, Patrick V. 2000. *On the Road of the Winds: An Archeological History of the Pacific Islands before European Contact*. Berkeley: University of California Press.

Malte-Brun, Conrad. 1813. *Précis de la géographie universelle*. Vol. 4. Paris.

Rienzi, Domeny de. 1836–1837. *Océanie ou cinquième partie du monde: revue géographique et ethnographique de la Malaisie, de la Micronésie, de la Polynésie et de la Mélanésie: offrant les résultats des voyages et des découvertes de l'auteur et de ses devanciers, ainsi que les nouvelles classifications et divisions de ces contrées*. Vols. 1–3. Series "L'Univers pittoresque. Histoire et description de tous les peuples." Paris: Didot Frères.

Ryan, Tom. 2002. "'Le Président des Terres Australes': Charles de Brosses and the French Enlightenment Beginnings of Oceanic Anthropology." *Journal of Pacific History* 37: 157–186.

Tcherkézoff, Serge. 2003. "A Long and Unfortunate Voyage Towards the 'Invention' of the Melanesia/Polynesia Distinction (1595–1832)." *Journal of Pacific History* 38 (2): 175–196.

———. 2004a. *Tahiti—1768*. Papeete: Au Vent des Iles.

———. 2004b. *'First Contacts' in Polynesia: The Samoan Case*. Journal of Pacific History Monograph. Canberra: Australian National University (republished 2008, Canberra: ANU E Press).

———. 2008. *Mélanésie/Polynésie: l'invention française des "races" et des régions de l'Océanie*. Papeete: Au Vent des Iles.

———. 2009. "A Reconsideration of the Role of Polynesian Women in Early Encounters with Europeans." In *Oceanic Encounters: Exchange, Desire, Violence*, edited by Margaret Jolly, Serge Tcherkézoff, and Darrell Tryon, 113–159. Canberra : ANU E Press.

PART II

Memories

Naming and Memory on Tanna, Vanuatu

Lamont Lindstrom

On August 5, 1774, James Cook's ship *Resolution* dropped anchor in what Cook was soon to name Port Resolution, a small bay on the eastern tip of Tanna Island (Cook 1777, vol. 2: 83–84). Cook had been sailing down the middle of an archipelago he had just renamed the New Hebrides, mapping and making observations. Attracted by the fire of Tanna's active volcano, and by a snug harbor located close by, Cook decided to land on the island to take on wood, water, ballast and, so he hoped, food.

While anchored at Port Resolution, Cook loaded up with water, shale ballast, and wood, but he acquired little food. He received, as a gift, only one small pig. This was August, what the Tannese call the "new time" (*nepwin vi*), and people were then busy clearing and burning fields to plant a new yam crop. They would have eaten much of the previous yam harvest except for their seed yams they soon would be planting. The *Resolution* remained anchored for a fortnight. On August 20, Cook sailed away toward neighboring Futuna, around the southern tip of Tanna, and then up the western coasts of the southern and central islands of the archipelago, working on his maps.

The Landing at Tanna, one of the New Hebrides (by William Hodges, in Cook 1777).

Port Resolution in the Isle of Tanna (Cook 1777).

Cook's stopover was Tanna's first contact with Europeans. Cook, however, had significant previous experience dealing with Pacific Islanders, and his journal and subsequent publications, along with those of Johann and Georg Forster, offer various comparisons between the Tannese and other peoples encountered elsewhere, such as the Malakulans, the Maori, and the Tahitians (Cook 1777; J. Forster 1996; G. Forster 2000). Cook applied his usual methods to manage a first contact. He fired cannon and warning shots, posted sentries, staked rope boundaries on the beach to separate islanders from his crew, engaged in promiscuous gift giving, and sought out but was ultimately disappointed not to identify Tanna's nonexistent chiefs. The Tannese were more puzzled. They quickly tried to help themselves to Cook's anchor buoys but retreated when Cook ordered his sharpshooters to shoot them with small diameter shot. They also succeeded in detouring Cook's landing parties' incursions, including an abortive trek to the volcano. In the main, however, Cook's visit passed peacefully until August 19, when an English sentry shot and killed a Tannese man (or perhaps a close bystander) who may or may not have made a move with a bow and arrow. The *Resolution* sailed away early in the morning of the following day.

Cook and the Forsters in their published accounts recorded the names of several men they had met on Tanna. Georg Forster was the better linguist: Fannòkko (Cook says Whā-ā-gou), Yogai (Cook has Georgy), Paw-yangom (Cook has Paowang), Yatta, and Oomb-yegan. This is an interesting list. My guess is that Fannòkko (Fanako?) was a young man from Futuna.[1] Alongside personal names, the Forsters collected terms from three different languages: the one spoken today around Port Resolution (Kwamera, or Nɨfe language), Nɨrak or White Sands language, spoken west of the volcano, and

Futunese spoken on Futuna, a Polynesian outlier located about eighty kilometers east of Tanna.[2] Either Port Resolution was already cosmopolitan when Cook arrived, or spectators, including Fanako, hurried in from afar, sailing over from Futuna to have a closer look at the British and the ship. The other names the explorers recorded are Tannese and three of these, at least, are still current on the island: Iata (Yatta), Pavegin (Paw-yangom, which means "shark"), and Koke or Iokai (Yogai).[3]

This chapter investigates notions of time and history on Tanna as these inform island-naming practices. Tannese people would not be surprised to find that Cook encountered namesakes of men living today. Continuity is embedded in island notions of time, space, and history. Tannese also insist that the fundamental structural contours and organization of place, like those of personality, have not much changed since Cook's visit. Tanna's personal and toponym systems are intimately connected. Each personal name cues some particular place, and vice versa. Recycled personal and place names suggest a static temporality, but there is a tension on Tanna between stasis and cycles, on the one hand, and change on the other—a tension between eternity and history. Enlightenment understandings of progressive time began to leach into Tanna from 1774 onwards, when Cook arrived with a ship's calendar. But one can also discern in island myth and cosmology other concepts of revolutionary time and social transformation that flank more static notions of timeless social reproduction. Expectations of historical transformation, therefore, are not necessarily exogenous to the island. On one level, the system pretends to eternal stasis and continual social reproduction—the same places, the same people, endure from century to century. On another level, however, history may rewrite eternity. People reinvent themselves and their island by inscribing new names (on their land and on themselves). These names remark and memorialize novel and unique historical events that themselves then become part of stereotypically reproduced island memory.

Static Time and Space

In societies without writing, history is commonly inscribed in landscape and is kept there through repetitive oral narration and naming. Swidden horticulturalists such as the Tannese, who are profoundly concerned with seasonality, often think of time in cycles, as many have noted (see, e.g., Davis 1991: 11). The Tannese, for example, arrange time by "nights" (*nipin*, that is by days), by "moons" (*makwa*, or months), and they have extended their word for yam (*nuk*) to refer also to "year"—each year that passes, or recycles, is yet another yam harvest. In the nineteenth century, Christian influence added a fourth time cycle to these original three—the *nafakiien*, or "week," derived from the word "to pray." By the late 1970s, European solar months had replaced the original lunar calendar and only scattered older people recalled some of the lunar month names that Presbyterian missionary William Gray (1892: 667–671) had recorded in the 1880s.

Alfred Gell (1992) has argued that temporal cycles are in actuality lineal spirals of progressive time. He was unable to locate anyone who presumes simple cyclic identity; one never swings back around to exactly the same moment twice. Gell concluded that

cultures everywhere must presume a progressive, mobile time that separates into the past, the present, and the future (1992: 315), although he does allow that people, subjectively, might often perceive and experience time as static, repetitive, and nonmetric. Although Tanna's time reckoning to us appears obviously cyclical, and if Gell is correct even spirally progressive, taking note of island nights, prayers, moons, and yams may once have centered time rather than measured its duration or movement. The island had no relentless ticking clocks or calendar pages of equal days and months, but rather remarkable, occasional yet recurrent events that marked points within the hours and the seasons.[4]

Carlos Mondragón, analyzing traditional calendars in northern Vanuatu, has similarly argued that Torres Islanders

> have no interest in "measuring" time on a scale of years, months or even days. This does not mean that they have no concept of the passage of time, but merely that

TABLE 1 Tannese Lunar Months (recorded 1979 and compared with Gray 1892)

No.	Nife name	Beginning date, 1886	Practical Associations
1	Kuramai [Gray: Kuramai]	July 31	Clear fields
2	Kurarurar [Gray: Kaneyau?]	August 29	Make yam mounds/hoe?
3	Kwakwsariakwsari [Gray: Kakuseriakuseri]	September 28	Tie up yam vines
4	Tamtamku [Gray: Kurarurar]	October 27	
5	Vertam [Gray: Tamtamuku]	November 26	[Gray: the end of "old time"]
6	Nahua [Gray: Veretam]	December 25	
7	Veru [Gray: Nahua]	January 24	Trees in fruit
8	? [Gray: Veru]	February 23	
9	? [Gray: Tamtamanen]	March 25	Yams ripen
10	Pikirpikir [Gray: Neuvsi]	April 23	
11	? [Gray: Pakerpaker]	May 23	
12	? [Gray: Kamneru]	June 21	Food scarce

they do not necessarily equate time with "measurement" or "duration." (2004: 300; see also Leenhardt 1979: 83)

Or, in other words, people are less interested in chaining up their nights, prayers, moons, or yams to measure time. Instead, they pay attention to specific time marks as spurs to practical activity—to clear fields, to plant, to hunt, to harvest, and so forth (see Damon 1982: 227). Most Tannese lunar month names, for example, were tied to practical tasks, for example, "moon of the fields" [i.e., clear the fields], "moon of the yam mounds," "moon of tying the yam vines," and so forth. In addition, a variety of tree and plant species today still mark time points around the annual cycle indicating upcoming garden and other events.

Other plant species mark time points within cyclical days. When photosensitive *rhigom* leaves fold, it is dusk and time for men to prepare and drink kava. The evening singing of cicadas likewise signals kava-drinking time.

One can find some linguistic routines of time measurement (which presume temporal motion) that work by way of plotting durations of time as lengths of space. Just as we might say "I'll see you in a bit," the Tannese say *kwopin ouihi takata ik*, "small space, I'll see you." However, island time reckoning exhibits strong elements of stasis and stillness.

Moving from "today" (*ipwet*) or "now" (*takwtakwnu*) into the future, one passes through "tomorrow" (*trakwakwi*). Moving back a day into the past is "yesterday"

TABLE 2 Cyclical Time Points

Nipin Vi ("new time"), October–March

Indian Coral tree flowers	=	clear new gardens
		crabs and crayfish ripe to eat
		whales appear
banyan leaves fall	=	plant yams
blue water tree leaves fall	=	yam vines sprout
almond tree (*Terminalia catappa*) leaves fall	=	plant sweet potatoes
nakur fruit sets	=	plant sweet potatoes
kapuapu and *napwesen* flowers	=	plant taro
nifua flowers	=	plant banana

Nipin Akwas ("old time"), April–September

nakur fruit ripens	=	harvest sweet potatoes
kapuapu and *napuesen* fruit ripens	=	harvest taro
wild cane flowers	=	harvest season

Static Time.

(*neiv*). But, then, the day after tomorrow (*neis*) is the same word as for the day before yesterday, and the word for indefinite future (*kwumwesin*) is the same for the indefinite past.

Like durative time mapped onto distance, this model of static time is even more easily spatialized. The present is a sort of island that, surrounded by the sea of future/past, is motionless in an ocean of time.[5] The word *kurira,* for example, means both "behind" and "next" and thus reflects a notion of the present as a center point, with past/future as its horizon. *Nari kurira* is something located behind me or is something following or next in line, for example, *nuk kurira* being the following (future) yam harvest/year. The Tannese, facing inwards toward the present, keep their backs to the future as they also keep their backs to the past (cf. Leenhardt 1979: 86; Salmond 1978: 10).

Talk of the present as some unmoving island within the encircling sea of time maps time onto space. Spatial models of time are widespread.[6] These spatial metaphors suppose an unmoving central time point—a pattern of center versus side, or center and periphery, or center and horizon. Now is at the center; future or past are off at the side. This center/periphery pattern also organizes island topology. Center is higher, and horizon lower. Tanna lies at the center of the universe surrounded by a horizon of other lands at increasing distance in all directions. Traveling out from Tanna, say to Vanuatu's capital town Port Vila, one "descends" (*-euaiu*). Traveling back home to Tanna, one "ascends" (*-uta*) back up to the center (cf. Hyslop 1999: 38–39). Similarly, Tanna lies at the center of the winds that blow inward from eight different directions.

The center/periphery model shapes island architecture and village layout as well

(Lindstrom 1996), patterning how people arrange themselves in space. The Tannese arrange their cultural landscape in terms of central kava-drinking clearings (*imwarim*) that are connected via a lattice of "roads" (*suatuk*) reaching out into the periphery to link clearing to clearing (see Guiart 1956: 104; Bonnemaison 1994: 117). Island kava-drinking clearings are the most prestigious spaces and are swept clean of all vegetation in counterpoint to surrounding field and forest. This same aesthetics of centered space governs events that take place on kava-drinking clearings themselves. Men meet here each evening to drink kava, and the community as a whole convenes at kava clearings to debate local issues and problems, to stage exchanges between families, and to dance. The deep structural pattern of center and periphery spatially organizes these events. Exchange occupies the center. Debaters likewise come into the center of a clearing as a mostly male audience collects around its edge, everyone sitting closest to the point where the particular road that leads back home intersects the central circle. Women and children, who do not ordinarily have the right to make public statements in debate, sit farther from the center around the outer edge of the perimeter where clearing fades into forest. The same spatial aesthetic governs how people dance. Dancing men clump in counterclockwise-rotating central groups surrounded by a periphery of skipping women. Finally, Tannese yam gardens, which are also circular clearings in the forest, exhibit this same structure: People plant prestigious, ritually male, yams in the center of a garden clearing and surround these yams with plantings of symbolically female taro and other crops (see also Bonnemaison 1994: 173–176).

Both time and space thus map into center/periphery. This spatializing of time into center and horizon works to prevent time from moving, and island agricultural time cycles also highlight important time points rather than serve as measurement systems of temporal progress. Nonetheless, the Tannese have sometimes also predicted sudden temporal disjunctions. And Western models of lineal, progressive time—just one more year after another—have today spread throughout. But original island discourses of static or static-cyclical time are still pervasive, and they sustain notions of timeless, stereotypically reproduced social persona and place.

Same Old Names

The Tannese say that their ancestors (*ris*—a term they use also for seed yams) long ago established a fixed system of personal and place names. Names flow on from generation to generation, although occasionally they might exist only in memory until enough children are born to shoulder temporarily unused names, or until people return to abandoned kava-drinking ground and village sites. This system is eternal, or potentially so. New names can neither be added nor subtracted, and prominent named stones and rocks fix the landscape even more permanently in time. These inspired mineral formations anchor both an unchanging landscape and an unchanging socioscape (see Mead 1973: 219).

Following anthropological usage, one might describe Tanna's localized, property-owning groups as "lineages." Instead, I previously proposed the term "name-set" for these groups (Lindstrom 1985). These are corporate groups that possess finite sets

of male and female personal names with which group members, recycling the same names over the generations, nominate their successors.[7] Although the Tannese entertain notions of patrilineal descent, which they symbolize by shared blood, local groups recruit new members through naming rather than by birth. A boy does not become a member of his father's corporate kin group unless he receives a name that belongs to that group. Adoption, in the form of naming another's child, is common as men bestow their names on variously available children.[8] Nomination, not descent, thus determines an individual's social persona and his or her membership in a local corporate group.

Unlike lineages elsewhere in Melanesia, Tannese name-sets never disappear or die away, at least in theory (Lindstrom 1985). Should all men of one name-set happen to expire, a second group (usually one of the others localized at the same kava-drinking ground) has rights to repeople the empty group by naming one or more young boys with its available names. Tannese local groups, defined and bounded by nomination, are thus impervious to the vicissitudes of historical event and accident. Groups are not only embodied in living members on the ground, but exist also as permanent sets of personal names in people's memories. Their existence is also grounded in place. If others wish to use the land of a defunct local group, they may legitimately do so only by reviving and repopulating that name-set, nominating their own sons with its available empty names. This reproduces the defunct group and maintains it within the island's social structure at large. Unlike descent, which only runs forward in time, nomination permits the Tannese to reproduce stereotypically structural detail in the face of historical and demographic events.

This keeps time centered. The same name-sets, and the same personal names, recycle from generation to generation—from Cook's visit in 1774 at least to the present. Shark met Cook back in 1774 but he very well might also be living now. Maurice Leenhardt suggested the term "social personality" to refer to the continual recycling of named persons, with associated rights and characters, in New Caledonia: "the ancestral name, periodically restored over the generations, actualizes the former personage by investing a new person in the society with his august personality . . . names return periodically, marking a rhythm of original personalities which are the group's strength" (1979: 156, 158; cf. Geertz 1966). These person-types, like Tannese namesakes, are very different from our notion of individualized persons who pop in and then pop out of lineal, progressive time.

Contemplating lines of namesakes, the Tannese further flatten time by conflating the current holder of a name with his predecessors. When speaking of ancestral namesakes and their remembered deeds, men often will use the present tense. They also use the first-person singular pronoun "I" (*iou*) when referring to these namesakes. Marshall Sahlins, who noted similar ancestral namesakes in Fiji, described this linguistic practice as the "heroic I"—the deployment by chiefs of the first-person singular pronoun to refer to the actions of their ancestral chiefly namesakes (1983: 523; see also Sahlins 1981: 13–14). On Tanna, all men may do likewise. Old Iaukarupwi in the 1980s, for example, when discussing his nineteenth-century namesakes who had dealings with various European visitors to the island (see Steel 1880: 456; Palmer 1871: 38, 46; Goodenough

1876: 275, for reports of several nineteenth-century namesake Iaukarupwis), spoke of their bygone acts as his own: *Iou* "I did it." Following this timeless logic, a man today might call out "father" or "grandfather" when summoning his son if the boy carries the name of his recent ancestor.

After Cook, other early visitors to Tanna also recorded names that men still carry on the island. Well-known Presbyterian missionary John G. Paton complained about a Soarim Naias, who in 1862 stole his bananas at Port Resolution (Adams 1984: 140; Paton 1890). This was a namesake of several Tannese men today. Paton also wrote of other men, his friends and his enemies, such as Nouar, Miake, Kwanwan, Kaiasi, and Iarisi, all of which are current namesakes of men in the environs of Port Resolution today.

In the 1920s, anthropologist Charles Humphreys (1926: 6–12) recorded the names of 187 Tannese men from whom he took anthropometric data, and the namesakes of many of these men, too, were my neighbors in the 1970s (e.g., Nouar, Iapwatu, Kwaniamuk, Kamti, Kauke, Iau, and more).

Names and name-sets are tied to place—a name-set is localized at a particular kava-drinking ground and each of its male personal names is attached (although often loosely and contentiously) to one or more plots of land (Lindstrom 1985). Perpetual social personalities, attached to land, anchor perpetual places. Just as the Tannese revivify empty name-sets, so they can repopulate long empty places. Toponyms, like personal names, are also sometimes referentially opaque and sometimes transparent. Iankahar ("At the three") names a kava-drinking ground once shaded by three banyans. Iatakwufweramrai ("At the yam mounds he cleared") is an old garden site. Kurukwiatikwapu ("One shot Tikwapu") names a place where someone shot and killed a man named Tikwapu. These last two names are examples of events that have been inscribed on landscape memory.

The island suffered drastic population decline between 1840 and 1930 following the introduction of European disease. After World War II, the island's population

Nouar (from M. Paton 1895: 52) Thomas Nouar, 1985.

rebounded from around 6,000 in 1940 to more than 28,000 today. Over the past fifty years, this demographic revival has sparked a rush of name retrievals and has also precipitated often fierce disputes over rights to names and associated lands as the growing island population expanded back onto deserted lands by reviving abandoned personal names and name-sets. Like temporarily unused personal names, place names have also persisted in memory. In the early 1980s, for example, some of my neighbors abandoned a local kava-drinking ground after a dispute. Since this clash was between people related by marriage, it could have made them a target of angry ancestors buried underfoot on that kava-drinking ground. Each party decamped to clear trees and brush off two other kava-drinking grounds, Isina and Iakanata, which had gone unused for several decades.

Listening to the Tannese, at least with one ear, one discovers changeless social personalities that are tied to fixed places that recur no matter the ebb and flow of history and event. The temporal center remains motionless despite swirls of past or future. The same names, the same groups, and the same places continuously recur—or rather merely occur, never disappearing even to recur. This perspective rejects moving time and its effects in favor of static temporality—time mapped spatially as an unmoving present surrounded by a future that blurs with the past. But, listening with the other ear, one hears Islanders also tell stories of temporal motion and change—of historical events serious enough to mark or even transform the island. Such change is reflected, and remembered, in new names for person and place that get written onto the landscape and inserted into name-sets. These nomenclatural augmentations and new toponyms themselves then begin to recur, also stereotypically reproduced in island memory.

New Same Names

Despite pervasive static and cyclical models of time, Tannese also presume and sometimes actively work to bring about sharp temporal disjunctions. Should such disjunctions occur, the present would jump into the future and the island would transform. This suggests no mechanical or steady evolutionary progress. Instead, this is a temporal Big Bang that one must work to bring about. Conceptions of disjunctive time are not incompatible with static spatial maps. If some timequake displaces the central island of the present, this then would leap off to a new situation. Themes of disjunctive time featured in island myth wherein an original Edenic period of peace and unity (*niprou*) collapsed in the face of emergent moieties and the appearance of named humans, name-sets, and places (Bonnemaison 1994: 141–142).[9] Disjunctive time appeared again in John Frum movement stories that promised an immediate spatiotemporal transformation upon John Frum's return (Lindstrom 1993). And they have turned up once again in more recent interest in evangelical Christian prophecies of Jesus Christ's second coming and the imminence of the "Last Day." Because time maps onto space, people expect temporal jumps to reshape their world. The island landscape reportedly reshuffled with the collapse of mythic *niprou* (Bonnemaison 1994: 137). Early John Frum prophecy similarly imagined transformation in landscape: Tanna and neighboring islands would merge, land would become sea, mountains would flatten and valleys would rise up, and so on (O'Reilly 1949).

Island temporal models presume occasional movement in time and thus also history and progressive memory. The Tannese may yet be disappointed in the failure of recently predicted temporal disjunctions to eventuate, but inspection of their stock of personal and place names reveals the effects of less cataclysmic historical events. They have remembered some passing event by revising and augmenting island nomenclature for person and place. The most obvious change in personal names has been the emergence of binominals sometime in late nineteenth or early twentieth century with the gradual acceptance of mission teaching on the island. Most male names today are linked with a second name typically derived from Christian sources. The event recorded, and subsequently reproduced in naming, was an ancestral experience of baptism. Young men and women may also add their father's, or namer's, or husband's name to their own in order to construct a binominal. Many European-derived names, now attached to a Tannese name, have since also been stereotypically reproduced as lines of subsequent namesakes have assumed the double-barreled name. My friends on Tanna, for example, include Rapi Timo (Timothy), Simon Vani, Philip Rosiau, Stephen Uahe, Kauke Phinias, Joshua Nakutan, Thomas Nouar, George Turiak, and many more.

The Tannese also borrowed names from passing Europeans, and some of these too have since been stereotypically reproduced. Today's Nariu Friman, for example, could be named after a copra trader named Freeman who lived on Tanna in the late nineteenth century (Rannie 1912: 118) or this may be the biblical Philemon. The Presbyterian missionary William Watt's two children, Thomas and Janet, born in the early 1900s at Port Resolution, have contemporary Tannese namesakes living near the site of their father's mission, along with their father's namesake William Usua. The Australian journalist Stanley James, who himself used several different names including Julian Thomas and "Vagabond," in 1883 met up with Koukare, leader of Christian converts at White Sands. Koukare asked James to name his recently born son. James wrote, "I christened him Vaga, and wrote it on my card, with the date, and a request to all white men to respect my godson" (Thomas 1886: 258). There are two men nowadays at White Sands, one named Thomas Vagabond and the other Julian. These names have become part of the nomenclatural archive of Koukare's name-set and have been continuously reproduced since James' act of naming 125 years ago. There is also, of course, a contemporary Koukare at White Sands, as there was in the 1920s when Humphreys arrived to measure Tannese noses, torsos, and arms (1926: 7). In addition to baptismal names, other men augmented their local name with a European appellative acquired in Queensland, where many Tannese worked in nineteenth-century sugar cane fields. Names such as Nase Sit (Shit) and Mangki (Monkey) may well record labor trade naming events, while other names such as Pailot (Pilot), Sotia (Soldier), and Kapten (Captain—Humphreys 1926: 8) likewise commemorate ancestral experiences abroad.[10] Historical events, notably the impact of Christianity and colonialism, have marked island memory by way of the transformation of personal nomenclature into a binary system.

As do personal names, Tannese toponymy also reflects historical imprint. Tanna's history began with James Cook's visit in 1774, which occasioned the renaming of the island itself. The story, which is probably a just-so story, is that either Johann or Georg

Forster, busy collecting local language terms, pointed at the ground and asked something like, "What's the name of this island?" (see, e.g., Adams 1984: 1; Cook 1777, vol. 2: 60; G. Forster 2000: 510; Gregory 2003: 67). A Tannese respondent (perhaps a man named Iasui as some local stories recount), thinking Forster was asking for the name for soil, replied *tina,* which means "dirt," "ground," or "earth." This name, first entered on European charts and then echoing back onto the island, replaced the original name Ipare which—reflecting local concern with center/horizon—means "inland" in a deictic opposition with *iperaha,* or "seaward." And Captain Cook himself is also now inscribed on the island, his name labeling rocky outcrops that jut from the coast off Port Resolution's eastern point—islanders conflate the name Cape Cook with Captain Cook.

Cook's novelty "Port Resolution," which has come to overlay local names for the bay such as Irupov and Uvea, was the first of many toponyms that outsiders bestowed on Tanna. Others are Green Point, Green Hill, White Sands, White Grass, Black Beach, Sulphur Bay, and Middle Bush, which rename island places that were salient to outsiders—passages, ports, beaches, and hills remarkable from ships. European renamings accelerated in the middle and late nineteenth century. Like many colonialist re-imaginings of alien space, these acts of renaming partly domesticated and secured those Tannese places that Europeans found conspicuous and important. But Islanders today have also adopted some of these foreign locatives and use them either in place of or alongside local toponyms.

Cape Cook (detail, map of Tanna, published by the Institut Géographique Nationale in Paris).

Christianity and colonialism thus shook and dislodged island memory, and their impact has been memorialized in toponymy alongside personal name. In the early twentieth century, Christian converts renamed their villages as they offered themselves up for baptism, and Tanna is dotted with biblical locatives including Samaria, Bethel, Nazareth, Bethany, Atenes (Athens), Macedonia, Tarsus, Antioch, Jericho, Galilee, and Jerusalem. Elsewhere, people renamed villages to reflect experiences in the colonial market for labor and manufactured goods. Renamed villages include Samoa (a Port Resolution place that might commemorate early Samoan mission teachers or might memorialize Tannese labor experience on Samoan plantations), Melbourne, and Isini (Sydney).

As with personal names, some of the more interesting renamings of place memorialize Tannese histories in Queensland. Ancestral namesakes of men from the Port Resolution area, for example, returned from Queensland to rename local places after Homebush, a plantation town south of Mackay, and also Iantina after Yandina, a small town a hundred kilometers north of Brisbane. Another Queensland returnee named his garden land Imwaisuka ("At the place of sugar," using Bislama *suka*). And, more recently, Jack Uiuai, who worked odd jobs for Canadian forces on Efate Island during the Pacific War, returned to Tanna to rename his village site Iakanata—"At Canada." Tanna's landscape, like its socioscape, has adjusted in memory of historical experience and events.

Memory through Naming

Historical memory is encoded in landscape throughout the Pacific and also beyond (Stewart and Strathern 2000), as on Tanna, where people memorialize important events and experiences in acts of renaming. Celebrating Tanna's powers of historical recuperation in landscape, cultural geographer Joël Bonnemaison figured Tanna to be "the last island":

> Together, magical powers, representations, and the history of old wars and, more recently, of white contact, are held in a web of places, paths, and boundaries–a web that keeps these events strangely alive and imparts to them the intense force of signs incarnated by land. . . . Here space does not prevent the flow of history from taking place, but influences it in such a way that the spirit of conservation wins over that of rupture. (1994: 325)

People in Vanuatu often speak of Tanna as the home of "full *kastom*" given its rich cultural heritage of ritual and everyday practice. Yet the island has also experienced more than two centuries of compelling historical events: Much of its male population decamped for Queensland sugar fields in the late nineteenth century, again to work for Allied military forces in the 1940s, and again today to work in Port Vila; the majority of the island converted to Christianity and many families moved down to coastal mission villages; the majority of the island again left the churches in 1941 and joined the John Frum movement; and more.

How might Tanna thus enjoy both full *kastom* alongside a very full history? A

landscape of inspirited places and ageless stones, which change slowly and only incrementally, provides a solid canvas for memory—each island generation lives among the same named rocks, beaches, mountains, and forests. And within this landscape, Tanna's stereotypically reproduced name-sets and personal names are as solid and enduring as places for purposes of encoding memory. The same social personalities persist on the island, like its stones, mountains, and harbors, from one century to the next.

Personal and place names encode an island archaeology. One can peel back a layer of names, and then the next layer, to discover previous inscriptions of historical event and personal experience. Remarkably, island affirmations of static time, and unchanging landscape and socioscape, make possible this progressive historical perspective. Novel historical events and experiences sink down into the centered, unmoving present to be stereotypically reproduced, long remembered, and even recuperated if once forgotten. If cyclical time, rationally, is ultimately lineal time, progress on Tanna reshapes local memory only insofar as island time is centered and still. Captain Cook, for example, is not some distant or half-forgotten historical personage. Instead, he has become a Port Resolution rocky projection who has always already been recalled in this landscape of memory.

Notes

1. Janet Keller, personal communication.

2. Kwamera or Nɨfe language features in this chapter (Lindstrom 1986). The symbol "ɨ" represents a mid-central vowel similar to "ə".

3. These personal names today, however, are found in places beyond Port Resolution. There was considerable population movement in and out of the port region in the mid-nineteenth century following the introduction of firearms, which probably escalated the effects of local feuding, and the introduction of Western disease (Adams 1984).

4. Gell borrowed from Bourdieu's descriptions of the Kabyle for an example of a nonmetric sort of time-marking system: The Kabyle mark punctual time indicators "which are recognized as they loom up, occur and are done with, in the flux of practical existence, as a series of passing 'guide-marks' as to the progress of the year, but which never undergo *totalization*, to form a coherent schematization of homogeneous duration" (1992: 295–296).

5. Or, as Gell put this for the Umeda, "today is always Wednesday" (1992: 88).

6. See Jolly 1999 for another Vanuatu example.

7. See Eyre 1992, who describes a similar system of name-sets in Papua New Guinea; also cf. Leach 2003.

8. In the late 1970s, for example, 41 percent of men with rights to live at Iankahar kava ground had received names from someone other than their fathers (Lindstrom 1985: 38).

9. For other accounts of episodic or disjunctive time in Melanesia, see McDowell 1988: 124; Errington 1974: 257; Kahn 1983: 110; Guidieri 1988: 183–185; Kempf 1992.

10. More than do the Tannese, Pacific Islanders elsewhere also transform history and experience into personal name—see Turner 1991 and Arno 1994 for Fiji; Kuschel 1988 for Bellona.

References

Adams, Ron. 1984. *In the Land of Strangers: A Century of European Contact with Tanna, 1774–1874*. Pacific Research Monograph No. 9. Canberra: Australian National University.

Arno, Andrew. 1994. "Personal Names as Narrative in Fiji: Politics of the Lauan Onomasticon." *Ethnology* 33: 21–35.

Bonnemaison, Joël. 1994. *The Tree and the Canoe: History and Ethnogeography of Tanna.* Honolulu: University of Hawai'i Press.

Cook, James. 1777. *A Voyage towards the South Pole, and round the World, Performed in His Majesty's Ships the Resolution and Adventure, in the Years 1772, 1773, 1774, and 1775.* London: W. Strahan and T. Cadell.

Damon, Frederick H. 1982. "Calendars and Calendrical Rites on the Northern Side of the Kula Ring." *Oceania* 52: 221–239.

Davis, J. 1991. *Times and Identities.* Oxford: Clarendon Press.

Errington, Fred. 1974. "Indigenous Ideas of Order, Time, and Transition in a New Guinea Cargo Movement." *American Ethnologist* 1: 255–267.

Eyre, Stephen L. 1992. "Alliance through the Circulation of Men: A System of Name-Assigned Residence." *Ethnology* 31: 277–290.

Forster, Georg. 2000. *A Voyage round the World.* Edited by Nicholas Thomas and Oliver Berghof. Honolulu: University of Hawai'i Press.

Forster, Johann Reinhold. 1996. *Observations Made during a Voyage round the World.* Edited by Nicholas Thomas, Harriet Guest, and Michael Dettelbach. Honolulu: University of Hawai'i Press.

Geertz, Clifford. 1966. *Person, Time and Conduct in Bali: An Essay in Cultural Analysis.* Southeast Asia Program Cultural Report Series, No. 14. New Haven, Conn.: Yale University Press.

Gell, Alfred. 1992. *The Anthropology of Time: Cultural Constructions of Temporal Maps and Images.* Oxford: Berg.

Goodenough, James. 1876. *Journal of Commodore Goodenough during his Last Command as Senior Officer on the Australian Station, 1873–1875.* London: Henry S. King.

Gray, William. 1892. "Some Notes on the Tannese." Report of the 4th Meeting of the Australasian Association for the Advancement of Science, Hobart, Tasmania. Vol. 4, Section G: 645–680.

Gregory, Robert J. 2003. "An Early History of Land on Tanna, Vanuatu." *Anthropologist* 5 (2): 67–74.

Guiart, Jean. 1956. *Un siècle et demi de contacts culturels à Tanna, Nouvelles Hébrides.* Publications de la Société des Océanistes, No. 5. Paris: Musée de l'Homme.

Guidieri, Remo. 1988. "Two Millenaristic Responses in Oceania." In *Ethnicities and Nations: Processes of Interethnic Relations in Latin America, Southeast Asia and the Pacific,* edited by Remo Guidieri et al., 172–198. Houston: Rothko Chapel Press.

Humphreys, C. B. 1926. *The Southern New Hebrides: An Ethnological Record.* Cambridge: Cambridge University Press.

Hyslop, Catriona. 1999. "The Linguistics of Inhabiting Space: Spatial Reference in the North-East Ambae Language." *Oceania* 70: 25–42.

Jolly, Margaret. 1999. "Another Time, Another Place." *Oceania* 69: 282–299.

Kahn, Miriam. 1983. "Sunday Christians, Monday Sorcerers: Selective Adaptation to Missionisation in Wamira." *Journal of Pacific History* 18: 96–112.

Kempf, Wolfgang. 1992. "'The Second Coming of the Lord': Early Christianization, Episodic Time, and the Cultural Construction of Continuity in Sibog." *Oceania* 63: 72–86.

Kuschel, Rolf. 1988. "Cultural Reflections in Bellonese Personal Names." *Journal of the Polynesian Society* 97: 49–70.

Leach, James. 2003. *Creative Land: Place and Procreation on the Rai Coast of Papua New Guinea.* New York: Berghahn Books.

Leenhardt, Maurice. 1979. *Do Kamo.* Chicago: University of Chicago Press.

Lindstrom, Lamont. 1985. "Personal Names and Social Reproduction on Tanna, Vanuatu." *Journal of the Polynesian Society* 94: 27–45.

———. 1986. *Kwamera Dictionary/Nìukua sai Nagkiariien Nìinife.* Pacific Linguistics Series

C: 95. Canberra: Dept. of Linguistics, School of Pacific Studies, Australian National University.

———. 1993. *Cargo Cult: Strange Stories of Desire from Melanesia and Beyond*. Honolulu: University of Hawai'i Press.

———. 1996. "Arts of Language and Space, South-east Tanna." In *Arts of Vanuatu*, edited by Joël Bonnemaison, Kirk Huffman, Christian Kaufmann, and Darrell Tryon, 123–128. Bathurst, N.S.W.: Crawford House Publishing.

McDowell, Nancy. 1988. "A Note on Cargo Cults and Cultural Constructions of Change." *Pacific Studies* 11: 121–134.

Mead, Sidney H. 1973. "Folklore and Place Names in Santa Ana, Solomon Islands." *Oceania* 43: 215–237.

Mondragón, Carlos. 2004. "Of Winds, Worms and Mana: The Traditional Calendar of the Torres Islands, Vanuatu." *Oceania* 74: 289–308.

O'Reilly, Patrick. 1949. "Prophétisme aux Nouvelles-Hébrides: Le mouvement John Frum à Tanna 1940–1947." *Le Monde Non-Chrétien* 10: 192–208.

Palmer, George. 1871. *Kidnapping in the South Seas: Being a Narrative of a Three Months' Cruise of H.M. Ship Rosario*. Edinburgh: Edmonston and Douglas.

Paton, John G. 1890. *John G. Paton, Missionary to the New Hebrides, an Autobiography Edited by His Brother*. London: Hodder and Stoughton.

Rannie, Douglas. 1912. *My Adventures among South Sea Cannibals: An Account of Experiences and Adventures of a Government Official among the Natives of Oceania*. London: Seeley Service and Co.

Sahlins, Marshall. 1981. *Historical Metaphors and Mythical Realities: Structure in the Early History of the Sandwich Islands Kingdom*. ASAO Special Publication No. 1. Ann Arbor: University of Michigan Press.

———. 1983. "Other Times, Other Customs: The Anthropology of History." *American Anthropologist* 85: 517–544.

Salmond, Anne. 1978 "Te Ao Tawhito: A Semantic Approach to the Traditional Maori Cosmos." *Journal of the Polynesian Society* 87: 5–28.

Steel, Robert. 1880. *The New Hebrides and the Christian Missions with a Sketch of the Labour Traffic, and Notes of a Cruise through the Group in the Mission Vessel*. London: James Nisbet.

Stewart, Pamela J., and Andrew Strathern. 2000. "Naming Places: Duna Evocations of Landscape in Papua New Guinea." *People and Culture in Oceania* 16: 87–107.

Thomas, Julian. 1886. *Cannibals and Convicts: Notes of Personal Experiences in the Western Pacific*. London: Cassell.

Turner, James West. 1991. "Some Reflections on the Significance of Names in Matailobau, Fiji." *Journal of the Polynesian Society* 100: 7–24.

Inventing Traditions and Remembering the Past in Manus

Ton Otto

Societies remember the past in many different ways. There are historical narratives of various kinds, which keep track of past events that are relevant for the keepers of the histories (for example, descent groups, church groups, religious movements, political units). The past is also remembered in the passing on of ritual practices, social customs, practical knowledge, and material products. Traditions are forms of historical knowledge that elaborate on social practices and that are consciously orchestrated (e.g., as ceremonies or learning situations). A special kind of traditions put weight on an assumed continuity with the past. In Melanesia these traditions are often referred to as *kastam* or *kastamwok*.

The regional focus of my presentation is Manus, in Papua New Guinea, where *kastam* ceremonies have become an important arena for social action, during which historical memory is negotiated. I will argue that *kastam* as an indigenous field of

Manus Province in Papua New Guinea.

Baluan Island in Manus Province.

action with reference to the past first originated in the 1960s as a result of "inventions" by a number of local leaders. This invention of tradition has to be seen against the background of the massive abolishment of indigenous ceremonies by the Paliau Movement in the 1950s, which thereby introduced the concept of tradition (as a negative category). The reintroduction of "traditional" ceremonies raises questions about social agency and the use of various forms of historical memories in the context of colonial and postcolonial modernity.

Kastam Today on Baluan

Baluan is a small island lying south of Manus, the largest island in the homonymous province in Papua New Guinea. When I began my field research among Baluan's ca. 1,000 inhabitants in 1986, I soon found that the Papua New Guinea pidgin word *kastam*—which I gloss as "tradition"—referred to an important social category. For example, in all the island's six villages a discussion went on about traditional leadership. This discussion was initiated by the Provincial Cultural Council, which had suggested that all villages should identify their traditional leaders—or *lapans* as they are called in Manus. On Baluan this led to many meetings and even more informal discussions during which a lot of historical knowledge was presented, contested, and negotiated. This collective remembering has produced an interesting body of knowledge on leadership titles, hierarchies, *lapan* feasts, warfare, and *lapan* prerogatives (Otto 1994, 2006). Even more conspicuous were the great number of ceremonial exchanges organized at the occasions of birth, marriage, and death, which collectively were called *kastamwok*, that is "tradition work" (Otto 1991). The gloss "work" is appropriate as the exchanges cost a lot of energy and also caused stress for the organizers. Some people even compared *kastamwok* with warfare, as did the old Molean Pokasau, who after having completed a large ceremonial exchange visited me in a military outfit and claimed that he had won a battle. The belief that *kastam* could produce illness, and even death, was widespread. Why would people engage in these exchanges that were so demanding when, as I soon found out, there were alternatives? Not all people approved of *kastamwok* and some, especially members of the Seventh-Day Adventist Church, were strongly opposed to it.

The most important motives for engaging in *kastamwok* can be summarized as competition for status, confirmation of land rights, maintenance of support networks, and excitement or entertainment. To start with the last point, for many participants, part of the attraction of *kastam* exchanges was that they could be compared to a game where one had to make a contribution in money or kind and could be lucky enough to get a higher return. In addition there normally was an abundance of cooked food, drumming, dancing, and the delivery of speeches in which people tried to impress and challenge each other. As the positions and obligations in the exchanges were determined by kin relations, the performance of *kastamwok* validated these relations, and distant relatives often made a contribution in order to refresh the memory of their common descent.[1] Furthermore, *kastam* exchanges following a death could have an impact on claims to land; if a descent group did not carry them out or if they did it poorly, this would weaken their hold on their land property. The memory of past performances was an important factor in asserting or rejecting claims. Finally, *kastamwok* was an important way to build up social esteem and status. The exchanges concerning marriage and death were especially seen as highly competitive. This competition concerned the amounts of food and goods collected and distributed as well as the way the ceremonies were executed. The exchanges were public and often attracted an audience that was larger than the people directly involved. As part of the ceremony it was free for anyone to address the people present and to comment on the event, both positively and nega-

tively. Often commentaries were explicitly invited, especially from those considered knowledgeable about traditions and the past. Therefore *kastamwok* was an arena for historical remembering in which it was important to be able to defend elements of the ceremony as right with reference to the past; this could concern the use of a specific dance, a specific body decoration, or a specific ceremonial action. Both knowledge of the details of a performance and knowledge of who had the rights to execute them were important assets, which were put to the test when engaging in *kastamwok*.

Tradition and Agency

In this chapter I argue that the categories of *kastam* and *kastamwok* are relatively recent on Baluan and that their origins can be found in the past sixty years. This is not to deny that there are important cultural continuities in the exchanges that go on and in the kind of sociality they establish. What is new, though, is that *kastam* and *kastamwok* explicitly refer to the past as an important criterion for the validation of the ideas and actions involved. In that way they differ not only from exchanges and leadership forms of the past but also from alternative social arenas in the present, for example those constituted by modern politics and church organizations (Otto 1992c). Whereas the discussions about traditional leadership could be seen as an exercise in oral history, the remembering that was occasioned by *kastamwok* was not primarily verbal, even though it was accompanied by oral commentary. I soon found that it was nearly impossible to get a complete description of a traditional exchange ceremony by interviewing alone. Once I began to participate—partly because I was invited to do so and partly as a research strategy—I discovered that appropriate actions were often remembered by doing and that they would become the object of verbal approval or rejection only after their performance.

The processes that I will describe can be seen as an example of "the invention of tradition" (Hobsbawm and Ranger 1983; Keesing and Tonkinson 1982), with the added specification that it was the idea of tradition itself that was invented in the first place. Like similar developments recorded elsewhere in the Pacific, Africa, and many other places, the overall context was the impact of colonialism. But in this chapter I am not primarily interested in the actions and ideas of political leaders, trained in a Western context and working toward independence and the establishment of national identities. I want to zoom in on processes at the village level, where I pay attention to local actors and their intentions and motivations. Of course they partake in chains of events that are set in motion by the arrival of white colonizers, but colonial histories are multiple and the contingencies of local actions and decisions establish different cultural patterns. The theoretical framework I will use here is more fully developed in Otto and Pedersen (2005).

Inspired by the invention-of-tradition literature and the dialectical phenomenology of Berger and Luckmann (1967), we see traditions as "second-order" objectifications that support and legitimize the "first-order" objectifications that comprise all socially established customs and institutions. Traditions are more explicit forms of cultural performance that require conscious orchestration in contrast to daily routines. Traditions

are organized and performed at selected occasions and often function to reconfirm social arrangements. They do this by means of their repetition but also by providing a reflexive space for articulating motivations, intentions, and interpretations. But traditions can also be used to introduce new social arrangements, and this is what "invented traditions" are about. As Hobsbawm (1983) observes, invented traditions normally evoke an explicit link with a specific past, even though this link often is more imagined than real. Important for my argument, however, is not that the claimed historical continuity is often factitious but rather that the past has become the most relevant point of reference. At the risk of laboring the obvious point, I stress the crucial distinction between an emic concept of tradition and our analytic use of the term. Traditions in our analytic definition do not necessarily refer to the past as the central criterion of their legitimation; they may imply or refer explicitly to nature, God, morality, or progress without giving a special status to the past. If the past becomes the primary referent we may speak of traditionalism, and *kastamwok* on Baluan is a tradition of this type.

In order to conceptualize the link between traditions and individual action I find it useful to reproduce a diagram from Barth (1993: 159) with some minor adaptations (see Otto 2005).

In the first place the model highlights the Weberian distinction between behavior and actions. Human behavior underlies the laws of material causality and unfolds as a series of events. At the same time human behavior needs to be seen from the perspective of actors who transform events into acts through their capacity of signification; that

Cultural premises of human action
(adapted from Barth 1993:159)

Barth 1993: 159.

is, they give meaning to their lived-in worlds. In the column "actions" Barth divides the process of meaning giving into two different components, namely "intentions," which are the meanings attached to an act by the actor himself or herself, and "interpretations," which are the meanings conferred on the act by others (this includes the interpretation of what was intended and what was effected). This process of signification is based on cultural "premises." Interpretations are transformed and accumulated into "experience," which engenders "concerns." These concerns provide orientation to people's intentions and interpretations at an implicit level. More explicitly people relate the intentions and interpretations of their actions to values and norms. These are closely connected with and derived from bodies of ideas that Barth calls "traditions" (or "traditions of knowledge"), discursive spaces that are maintained by actors, often with special functions and expertise, in concrete social organizations. It is thus with regard to the more explicit expression of intentions that traditions play a major role. In the following I will describe the development of such a discursive space, which allows actors to express their intentions in relation to a valued past—a traditionalist tradition.

Paliau's Negation of Tradition

To be able to describe the origin of *kastam* as a tradition in Baluan and the whole of southern and eastern Manus, I first have to give some background on a major movement that created the historical conditions conducive to its development. The Paliau Movement is well known in anthropological literature thanks to the work of Margaret Mead (1956), Theodore Schwartz (1962), and Peter Worsley (1968). More recently Berit Gustafsson (1992, 1995), Ton Otto (1992a, 1992b, 1998, 2004), and Alexander Wanek (1996) have contributed to our knowledge of this movement, which aimed at a total reorganization of indigenous society in order to establish equality with the colonizers. The roots of the movement can be found in the 1920s and 1930s when a lot of Manus men were employed as contract laborers and were away from their societies for many years. In these years they learned about the customs of other indigenous groups as well as about the institutions and organization of Western colonial society. Some of these men returned to their villages not only with money and goods but also with a strong desire for change. They did not want to accept the existing relations of obligation and power that would keep them in a position of dependence for many years. Paliau Maloat from Baluan had worked in the native police in different regions and had gradually come to the insight that the traditional exchanges and feasts were wasteful of wealth and human life. They would often lead to temporary poverty, disease, and even death, and they prevented the indigenous population from building up wealth and strength to match the white colonizers. The rejection of traditional ceremonies with large distributions of food and wealth, as well as the pooling of goods and money acquired through contract labor, became central elements of Paliau's program. Why he, rather than other enterprising young men, got a regional influence that far exceeded previous leaders is an interesting question. No doubt his intelligence, charisma, and political insight played an important part, as well as his high status in the native police. But both for him and other innovating leaders, the Second World War, with the pres-

ence of enormous American wealth and manpower, was an event of such impact that it created the opportunity for radical change that would have been unthinkable before.

Paliau and his many followers—at its height the movement included thirty-three villages—were able to realize a major restructuring of their society that affected its core institutions and principles of social organization. All major ceremonial exchanges were abolished: the great *lapan* feasts to commemorate a deceased leader and establish the reputation of his successor; *pailou*, the compulsory distribution of wealth at the occasion of death; and the competitive bride-price payments (*mossap*) that would indebt the married men for many years, as it was their fathers, uncles, or elder brothers who organized the ceremonies. The movement experimented with new forms to mark and establish social relations and statuses. For example a marriage was performed through the payment of a modest sum of Western money in the presence of the appointed village leader. And adultery was to be solved by paying a fine to the woman involved (who would then give it to her husband). Central to these reforms was a break with the past; the ways of the ancestors were seen as inhibiting and even damaging because they caused poverty and illness. They had to be replaced by new ways (*nupela pasin*) that were derived from an experience with colonial society. Most villages in the movement were newly built, often involving two formerly separated ethnic groups. Houses were built on poles and placed in straight lines. Village life was no longer organized along traditional kin networks but more in the style of a labor camp on a plantation. Villagers would meet in a "line," and the appointed or elected village leader would divide the work of the day. Exploitation of land and sea resources was done in a communal spirit,

Paliau Maloat and his wife Teresia in 1986.

which overrode traditional claims to ownership. Explicit markers of "modernity" or Western culture were introduced, such as a meeting or council house and the use of Western clothes at ceremonial occasions. Importantly, a new sense of historical agency had developed that understood the present as a period of historic change and that created an interest in the recording of events and dates.

Without doubt there was also much cultural continuity underlying the massive and overwhelming transformations introduced by the Paliau Movement in a relatively short time, about six to eight years (Schwartz 1973). As examples, one could point to conceptions of knowledge and efficacy, to the role of predictions in validating knowledge, to aspects of leadership such as the capacity for oratory and for organizing large social events. Often traditional concepts were used in a new context. For instance it was important for Paliau that a large meeting house was built, and this can be understood against the cultural background that the material house was a symbol for the traditional descent group, which was at the center of the old society;[2] the new meeting house was therefore to mark the start of a new society. This symbol thus combined traditional and Western connotations. Important, though, for the present argument is that explicit culture in the movement was focused on new institutions and traditions: council meetings, village leadership, collective organization of work in the "line," schools, Western clothing, etc. (Schwartz 1993). Paliau and the other local leaders asserted their own agency with a new sense of historicity that challenged both the Western mission and the colonial government. They were going to be the authors of their own future!

Polpolot, or the Affirmation of Tradition

The negative attitude toward traditional institutions and ceremonies was apparently pervasive in the villages that followed the Paliau Movement.[3] This does not mean that all forms of traditional exchanges had completely disappeared. According to my informants some traditional activities continued, in particular ceremonies concerning death, as many still considered it opportune to placate the spirits of the dead. But these activities were performed mostly clandestinely or in any case not publicly, as the new doctrine condemned them. The focus was on creating a new world, and traditional ceremonies were considered an obstacle to achieving that goal. Paradoxically, this negation of tradition created the discursive space necessary for the development of a new sphere of meaningful action that explicitly referred to the past for its legitimation.

The establishment of this new traditionalist sphere on Baluan can be traced back to the actions of three known individuals.[4] Of course they reacted to context and circumstance, but their decisions were decisive for initiating a process that continues to the present day. The first person to openly organize a ceremony that clearly involved traditional elements was Ninou Solok of the Sauka clan. The year was presumably 1958, twelve years after the start of the Paliau Movement on Baluan. According to the principles of traditional succession, Ninou Solok could have established himself as the leader of the large Sauka clan, because the senior lineage did not have a man able to assume this role. On Baluan there were undoubtedly more men in a similar position who nevertheless abstained from engaging in traditional ventures, but according to

my informants Ninou decided to make a feast after he was nearly fatally hit by a large branch that fell from a tree.[5] Acutely aware of his mortality, he wished to establish his reputation—and that of his lineage—through a big traditional feast before it was too late. The ceremony he organized was called *polpolot*—at least retrospectively—after the name for a particular type of song. A *polpolot* is sung in two-voice harmony and it typically describes memorable deeds of the ancestors, such as wars, large feasts, migrations, etc. The language used in these songs is different from daily speech, and at the time of my fieldwork few people could still understand this language. Both the singing of these songs and the actual exchanges organized made a strong statement concerning the value of the ways of the ancestors, in stark contrast with the ethos of the Paliau Movement.

Ninou Solok had died when I did my first fieldwork on Baluan (1986–1988), but I was able to interview the second man who organized a *polpolot*, Kelu Salikioi of the Poipoi clan, presumably in 1960 or soon thereafter. He made a large garden with only the primary ceremonial food, namely yams, and his clan brothers also made gardens. When the yams were harvested he collected all the food in front of his house and invited his *narumpein*. This Baluan word refers to the descendants of the women of his own clan who, as was Baluan custom, had married men from other clans. *Narumpein* stands in opposition to *narumwen*, and these categories are conceived as the descendants of a sister and a brother pair (*narumpein* means son of the woman and *narumwen* means son of the man). The *narumwen* are the primary guardians of the clan properties, but the *narumpein* retain secondary rights to these properties and are believed to have power over the clan's success and fertility. In traditional Baluan understanding it is imperative to keep good relationships between the *narumpein* and the *narumwen* in order to secure prosperity as well as to reconfirm obligations to assist with major enterprises including feasting and warfare. In the New Way established by the Paliau Movement it was not really possible to acknowledge these relations, at least not in larger public events. Kelu purposely invited his *narumpein* to a party where he entertained them with *polpolot* songs and cooked food. At the end he divided the noncooked garden food between the different *narumpein* groups. Later these groups returned with a gift of predominantly Western money but also some traditional valuables, namely dogs' teeth and shell beads, even though the latter had become scarce on Baluan. Kelu divided the money between the people who had helped him produce the food. Half the money went to his affines, the family of his wife, and the other half to a man who was his *narumwen*.

The third man to organize a *polpolot* was Kisokau Aiwai from the Munukut clan. Like Kelu Salikioi he was the traditional leader of a clan of some status. The New Way did not allow them to assert their leadership with regard to potential competitors nor to reconfirm the relative status of their group. Their staging of a *polpolot* did not directly challenge the political authority of the movement's leaders but rather established a different field of competitive action. Of course the performance of such "recidivist" activities clearly challenged the hegemony of the New Way and opened the way for more heterodox developments. Apparently there was sufficient support for this. Asked for the reason for the introduction of *polpolot* ceremonies, most informants pointed to the

Kelu Salikioi chewing betel nut (1987).

wish "to show the family." Clearly it had been felt that the old networks of kin relations needed to be maintained or re-established in spite of the community-based organization of the New Way. The new social bonds could not fully replace the old ones. Interestingly, even though the *polpolot* ceremony referred to the past and the ways of the ancestors, it was in fact a new cultural form. On the basis of my oral history material, I am certain that no such ceremony existed in prewar Baluan. In the past, all ceremonies were connected with critical life events such as birth, marriage, and death. The *polpolot* was perhaps most similar in its intention to the old *lapan* feasts, where a new clan leader established his reputation by honoring his deceased predecessor. But concerning the scale of these events as well as the particulars of their execution, these ceremonies

Kisokau Aiwai with his wife Nakop (1987).

were in fact quite dissimilar.[6] The most conspicuous continuity with premovement culture was in the public staging of exchange activities involving relevant kin groups and the singing of traditional songs.

The *polpolot* ceremonies, even though popular at the time, did not have a long life. I have records only of the three I have mentioned here. They were superseded by ceremonies that were more similar to those of the past, especially those relating to marriage and death. These ceremonies were reintroduced slowly and with many changes and adaptations to the new circumstances, including the use of Western money. One informant assessed this revival as follows: "They did not do it right. Like a tree that was cut in pieces; some parts were taken, while other parts were left to rot." But even

though this criticism is correct from a traditionalist point of view, *kastam* has become an important part of contemporary Baluan life. The three *polpolot* organizers used the possibility of the discursive space created by the Paliau Movement, namely to express their intention to use "traditional" means to establish their name and to reconfirm their relations. By so doing they stand at the beginning of a new sphere of action that explicitly uses the past as its point of reference. They started the explicit remembering that continues in present day *kastam* ceremonies.

Kastam as a Tradition

Developments similar to those on Baluan also occurred elsewhere in Manus. Schwartz (1962: 316) reports the occurrence of a tradition-like activity as early as 1953. It was called *pilei* and was an exchange "in which cross-cousins challenged one another to match the goods (mostly European) that one could give against the money the other could pay." He mentions that initially there was embarrassment about these kinds of exchanges as they were against the movement's ideology, but by 1963 they were celebrated with older style dancing and drumming and the use of traditional costumes (Schwartz 1976: 225). Apparently Manus people were not prepared to give up the excitement that accompanied these events, and they also continued to rely on the networking that was the key to the exchanges. But in significant ways the situation was different from prewar Manus culture. First, the exchanges were explicitly considered as continuous with an older past, even though people were well aware of changes, adaptations, and even new inventions. They were presented as *pasin bilong tumbuna* (ways of the ancestors), that is, as a traditionalist tradition. Second, these exchanges were an option next to other possibilities, not something one simply had to do. People could choose to be more or less involved in them or, alternatively, to focus more on modern political institutions or church ceremonies. Therefore, "tradition" began to have the contours of a separate sphere of social action in which continuity with the past was an important criterion.

This trend was reinforced by other developments that directly stemmed from initiatives taken by the colonial government. One important field was that of titles to land. Sack (1987, 1990) has shown that Australian colonial policy concerning law was characterized by a two-spheres approach, which aimed at keeping the indigenous population under the rule of custom as far as necessary and possible until people were sufficiently advanced to be completely absorbed by Western law. The aim was gradually to replace the sphere of custom by the sphere of law, not to achieve a kind of synthesis. Custom would only be preserved as long as it was functional in controlling local communities. The land laws of 1962–1963 were to facilitate the conversion of customary land tenure into individual ownership—that is from custom into law—in order to stimulate economic development. To this end demarcation committees were instituted, staffed with indigenous people, who would implement this transition. The unintended result was, though, that the whole discussion about traditional ownership received much more space and attention than had been the case previously, when solely Western patrol officers were in charge of land courts. The committees conducted their

work often in the vernacular, thereby excluding white patrol officers from access to the local knowledge. Their sessions heightened local interest in traditional principles of ownership and in fact developed this as a field of dispute in which historical knowledge of genealogies, ceremonies, and land transfers was crucial. The Paliau Movement had suppressed the assertion of ownership, but the new colonial laws encouraged people to test their claims in court. As the arguments that could be used in the courts explicitly had to refer to past claims and practices, the demarcation committees, in spite of being Western institutions aiming at modernization, strengthened the sphere of tradition as relevant for contemporary concerns. It is perhaps not surprising that the committees completely failed to establish individual titles to land, as the traditional systems comprised a complex variety of collective rights, primary as well as secondary, that needed to be asserted via traditional exchanges.

A second colonial initiative came from the Education Department around 1970. Here the awareness had grown that it was necessary to maintain at least some elements of traditional culture. This was considered important in order to prevent schoolchildren from being completely cut off from their social roots, but it was also already envisaged that there should be space for the development of national culture and identity.[7] Therefore teachers were encouraged to reserve two hours per week for cultural activities to instruct children in traditional arts. The first indigenous headmaster on Baluan told me that he found it important to inform the schoolchildren about both traditional and Western ways. In the classroom he taught the children Western music, while he invited village elders to come and instruct the pupils in traditional handcraft, drumming and singing in the school's courtyard. Paradoxically, this generation of children did not learn these traditional skills from their parents, who had not acquired them themselves because they had been disregarded during the Paliau Movement; the skills were transmitted from grandparents to grandchildren. As a result it was the younger generation that could assist the elders when they required drumming and dancing as part of the ceremonial exchanges that gradually came in vogue again. The attention for past knowledge and skills in schools and land courts strengthened a growing conviction that the old ways still had value, in contrast to the beliefs of the early Paliau Movement. But at the same time these developments reinforced the creation of a separate sphere of tradition that was distinct from other forms of knowledge and practice.

The introduction of the word *kastam* to refer to traditional activities I date around the middle of the 1970s (see also Schwartz 1993: 1). Before that date I have not found the word in government reports and minutes, where instead the phrase *wok* (or *pasin*) *bilong tumbuna* was used. In 1978 the Paliau Movement clearly announced its changed view on tradition by taking on a new name: Manus Kastam Kansol (shortened as Makasol). Young Manusians who had been part of the discussions surrounding independence and Papua New Guinea ways had returned to Manus with ideas about national identity and tradition, which became incorporated in a new doctrine for the movement. Global and national political developments became thus transferred to local realities and contributed to a further development of the sphere of tradition on Manus, which became more conspicuous but also more diverse (Otto 2002). The

sphere became stronger because more people had an interest in it, for various reasons, and therefore contributed to its development through their actions and stated intentions. Here I refer to Barth's model of social action discussed above. Different actors, such as local leaders wishing to establish their reputation, schoolteachers carrying out a new policy, land owners claiming their property, and leaders of the Paliau Movement trying to regain political support, were all able to formulate their motivation in terms of *kastam*, thus making it visible as a tradition of knowledge with its own concepts, rules, and organizational forms.

There was a final and strong motivation for the flourishing of the traditional sphere, which on Baluan really took place only in the 1980s and 1990s. This motivation was first identified by James and Achsah Carrier (1989). To explain this I have to give some additional background on socioeconomic developments, starting roughly in the late 1960s. Partly in response to the impact of the Paliau Movement, the colonial government made a strong effort to establish schools in Manus. As a result, Manus provided a disproportionately large percentage of young educated people who were needed in the developing national administration, school system, and private economy of Papua New Guinea. These people living in the major towns had good salaries but also strong ties to their home communities. They would send remittances home for specific purposes, such as school fees for their younger siblings or an outboard motor for their own transport home. At the occasion of ceremonial exchanges, these rich urbanites felt under pressure to contribute according to their means. I have met a number of them who tried to escape from this pressure, but as most migrant workers planned to return home and as quite a few also aspired to leadership roles, they constituted an important economic resource for the village people. Even though in principle one could expect to receive as much from traditional exchanges as one contributed (counted over a period of time), *kastamwok* on Baluan and Manus resulted in a considerable stream of money from urban centers to the villages. It therefore functioned as a siphon that connected the villages to the Western money economy.

Conclusion

In this chapter I have analyzed the origin of a new cultural tradition on Baluan called *kastam*, in which the past is a central sign of value and criterion of validation. I have shown how changing colonial and postcolonial contexts have given shape to this cultural tradition, first by creating conditions for its invention and later for its rise to prominence.

An important precondition for the start of this new tradition was the rejection of traditional culture in the Paliau Movement, which established a new sense of historical agency, a belief that society could and should be changed. The Paliau Movement focused in particular on the abolition of large ceremonial exchanges, which were seen as wasteful and blocking the much-desired development. The reintroduction of some form of ceremonial exchange by three Baluan individuals not only challenged the social philosophy of the movement but also established continuity with the past as a positive referent for contemporary action. This process has similarities with "the invention of tradition" as described in Hobsbawm and Ranger's celebrated anthology. An obvious

difference, though, is that this local process of invention and revival was not initiated by a colonial government or by local leaders educated and trained in Western administrative structures. It happened as the result of actions by local actors who wanted to reassert a sense of identity, status, and sociality in opposition to the social models defined by the local reform movement. Of course, these events cannot be understood without taking into account the wider context of colonialism, which set in motion local reactions and revaluations. But the specific ways these events developed were not only determined by different histories of colonial impact and control, but also by local histories of interpretation, resistance, and negotiation. Therefore one can find quite different histories of "tradition" elsewhere in Melanesia, for example in the Tanga Islands in Papua New Guinea (Foster 1995), in the Marovo Lagoon in the Solomon Islands (Hviding 1996), or among the Kwaio of the Malaita highlands, also in the Solomons (Keesing 1992).

Common in all these places is though that "tradition" has been established as a separate sphere of social action in which the past has a special status as a criterion of legitimation and validation. Even though there are obvious cultural continuities in the performance of ceremonial exchanges and practices of resource use and leadership, the context of these traditions has changed fundamentally. They have become a knowledge tradition that people can draw upon in competition with or as an alternative to other traditions. The tradition of *kastam* and *kastamwok* gives special status to a presumed continuity with the past and promotes the kind of remembering and referring to past practices that is part of traditionalism. Therefore it is a tradition that can be identified as part of a process of modernization, since traditionalism typically plays a role in times of change. Like other traditions, *kastam* is a tradition that provides a discursive or symbolic space for articulating intentions and interpretations, in other words for acting out agency. Equally like other traditions, *kastam* is dependent upon the conscious action of human agents for its maintenance and development; its relative strength in relation to other traditions is conditioned by the number of agents that choose to "bear it." In contemporary Manus and Melanesia more generally, *kastam* obviously provides a space for a variety of interests as briefly discussed above (see also Otto 2002). Therefore it has become a strong cultural tradition that has put its mark on life in Melanesian villages, not only at special occasions that celebrate national and regional identities but also and particularly in daily practice.

Acknowledgment

I thank the participants and discussants of the "Changing Contexts—Shifting Meanings" symposium in Honolulu for their comments, especially Paul van der Grijp, Aletta Biersack, and Peter Hempenstall, as well as the participants and discussant Nils Bubandt at the staff seminar of the Department of Anthropology, University of Aarhus. I am particularly grateful to the late Paliau Maloat, Kelu Salikioi, and Kisokau Aiwai as well as members of the Sauka clan for their collaboration in providing information relevant for this chapter. As always I thank the people of Baluan for their kind hospitality and interest.

Notes

1. When I began to participate in *kastamwok* myself after I had received a name and family position, people used the exchanges to show me the kin relationships that I could draw on whenever I would need them.

2. A patrilineage is typically called the house of a particular ancestor; for example *um tan Paliau* is "the house of Paliau," referring to Paliau's patrilineal descendants.

3. Tradition was also rejected in villages that followed the missions, most strongly in those adhering to the Seventh-day Adventist Church.

4. There is wide consensus about this among my Baluan informants.

5. The story specifies that it was a nut tree. Therefore the accident probably happened when people were harvesting nuts, which they often do by cutting down branches.

6. Traditional *lapan* feasts were very large events, which often involved many years of preparation. Contrary to the *polpolot*, the leader of a *lapan* feast did not get a return for his gifts in the form of valuables or food. The pattern of distribution was also different.

7. See the Commonwealth of Australia report for 1969–1970 to the United Nations, where the second general objective of educational policy was formulated as follows: "an understanding and an appreciation of traditional indigenous culture and the cultures of other societies and the growth of a distinctive national cultural identity appropriate to the present." Further on in the same report we can read, "Change as an ever present factor creates many difficulties for the individual. To avoid these difficulties it is important that the cultural heritage of the community be preserved by close attention being given to the social customs, the traditions, beliefs, art, music and dancing of the communities to ensure that the school has an organic link with the world of the children" (Commonwealth of Australia 1971).

References

Barth, Fredrik. 1993. *Balinese Worlds*. Chicago: University of Chicago Press.
Berger, Peter L., and Thomas Luckmann. 1967. *The Social Construction of Reality: A Treatise in the Sociology of Knowledge*. Harmondsworth: Penguin Books.
Carrier, James, and Achsah Carrier. 1989. *Wage, Trade, and Exchange*. Berkeley: University of California Press.
Commonwealth of Australia. 1971. *Report to the General Assembly of the United Nations on the Administration of the Territory of New Guinea, 1969–70*.
Foster, Robert J. 1995. *Social Reproduction and History in Melanesia: Mortuary Ritual, Gift Exchange, and Custom in the Tanga Islands*. Cambridge: Cambridge University Press.
Gustafsson, Berit. 1992. "Houses and Ancestors." PhD, Göteborg University.
———. 1995. "From God to Win: The Rise of a Melanesian Religious Movement Based on Christianity." In *Syncretism and the Commerce of Symbols*, edited by G. Aijmer, 60–83. Gothenburg: The Institute for Advanced Studies in Social Anthropology.
Hobsbawm, Eric. 1983. "Introduction: Inventing Traditions." In *The Invention of Tradition*, edited by E. Hobsbawm and T. Ranger, 1–14. Cambridge: Cambridge University Press.
Hobsbawm, Eric, and Terence Ranger, eds. 1983. *The Invention of Tradition*. Cambridge: Cambridge University Press.
Hviding, Edvard. 1996. *Guardians of Marovo Lagoon: Practice, Place, and Politics in Maritime Melanesia*. Honolulu: University of Hawai'i Press.
Keesing, Roger M. 1992. *Custom and Confrontation: The Kwaio Struggle for Cultural Autonomy*. Chicago: The University of Chicago Press.
Keesing, Roger M., and Robert Tonkinson, eds. 1982. "Reinventing Traditional Culture: The Politics of Kastom in Island Melanesia." Special Issue. *Mankind* 13 (4): 297–399.
Mead, Margaret. 1956. *New Lives for Old*. London: Victor Gollancz Ltd.

Otto, Ton. 1991. *The Politics of Tradition in Baluan: Social Change and the Construction of the Past in a Manus Society*. Nijmegen: Centre for Pacific Studies.

———. 1992a. "From Paliau Movement to Makasol: The Politics of Representation." *Canberra Anthropology* 15: 49–68.

———. 1992b. "The Paliau Movement in Manus and the Objectification of Tradition." *History and Anthropology* 5: 427–454.

———. 1992c. "The Ways of Kastam: Tradition as Category and Practice in a Manus Village." *Oceania* 62: 264–283.

———. 1994. "Feasting and Fighting: Rank and Power in Pre-Colonial Baluan." *History and Anthropology* 7: 223–240.

———. 1998. "Paliau's Stories: Autobiography and Automythography of a Melanesian Prophet." *Focaal* 32: 71–87.

———. 2002. "Chefs, Big Men et Bureaucrates. Weber et les Politiques de la Tradition à Baluan (Papouasie-Nouvelle-Guinée)." In *La Tradition et l'État*, edited by C. Hamelin and E. Wittersheim, 103–129. Paris: Harmattan.

———. 2004. "Work, Wealth, and Knowledge: Enigmas of Cargoist Identifications." In *Cargo, Cult, and Culture Critique*, edited by H. Jebens, 209–226. Honolulu: University of Hawai'i Press.

———. 2005. "Concerns, Norms and Social Action: Notes on Fredrik Barth's Analytical Model." *Folk: Journal of the Danish Ethnographic Society* 46/47: 143–157.

———. 2006. "Warfare and Exchange in a Melanesian Society before Colonial Pacification: The Case of Manus, Papua New Guinea." In *Warfare and Society: Archaeological and Social Anthropological Perspectives*, edited by T. Otto, H. Thrane, and H. Vandkilde, 187–199. Aarhus: Aarhus University Press.

Otto, Ton, and P. Pedersen. 2005. "Disentangling Traditions: Culture, Agency and Power." In *Tradition and Agency: Tracing Cultural Continuity and Invention*, edited by T. Otto and P. Pedersen, 11–49. Aarhus: Aarhus University Press.

Sack, Peter. 1987. "'Law' and 'Custom' in Papua New Guinea: Separation, Unification or Corporation?" *Verfassung und Recht in Übersee* 20 (3): 329–342.

———. 1990. "'Law' and 'Custom' in Papua New Guinea." *Transactions of the Jean Bodin Society* 51, Pt. 1: 249–274.

Schwartz, Theodore. 1962. "The Paliau Movement in the Admiralty Islands, 1946–54." *Anthropological Papers of the American Museum of Natural History* 49: 207–421.

———. 1973. "Cult and Context: The Paranoid Ethos in Melanesia." *Ethos* 1: 153–174.

———. 1976. "Relations among Generations in Time-Limited Cultures." In *Socialization as Cultural Communication*, edited by T. Schwartz, 217–230. Berkeley: University of California Press.

———. 1993. "Kastom, 'Custom,' and Culture: Conspicuous Culture and Culture-Constructs." *Anthropological Forum* 6: 515–540.

Wanek, Alexander. 1996. *The State and Its Enemies in Papua New Guinea*. Nordic Institute of Asian Studies Monograph Series, vol. 64. London: Curzon Press.

Worsley, Peter. 1968. *The Trumpet Shall Sound. A Study of 'Cargo' Cults in Melanesia*, 2nd augmented edition. New York: Schocken Books.

Social Mimesis, Commemoration, and Ethnic Performance

Fiji Banaban Representations of the Past

Wolfgang Kempf

In this chapter I will show that mimetic practice in a society is a key element in creating and handing down binding representations of a collective past. "Social mimesis," in the sense used here, derives primarily from the philosophical works of Gebauer and Wulf (1995, 1998, 2003). These authors have taken a concept normally associated with aesthetics and usefully extended it to the social and cultural sciences. Following Gebauer and Wulf, I conceive mimesis as embracing in like measure acquisition and articulation, imitation and change. Corporeality and practice function as fundamental elements of the social process. Thus it is chiefly the performative aspects of human action that unfold their social agency via mimetic processes. So social mimesis is eminently compatible with the results of studies on the performative character of embodied memory, ritual practice, and place making (Casey 1998; Connerton 1989; Gupta and Ferguson 1997; Hughes-Freeland 1998; Hughes-Freeland and Crain 1998). The concept allows us to construe social interaction as a field of relations in which the actors incorporate historically and culturally preformed discourses and practices, interpreting and re-enacting them as they do so. "Mimesis" stresses that social actors align themselves to models, exemplars, or ideal representations, yet without neglecting the creative aspect of autonomous action. Gebauer and Wulf speak of the subject's ability to incorporate the outer into the inner world, thereby generating references and identifications that are then expressed in social performances (Gebauer and Wulf 1995: 2–4; 2003: 102–126). It is via such mimetic processes of referencing and performing that certainties are created, attachments generated, and realities constructed. Thus past and tradition are the consequence of a society's mimetic practice. The process-linked performative nature of social mimesis accounts for the fluid character of cultural constructions of past and tradition. Embodied practice in the form of interaction, incorporation, interpretation, and re-enactment enables members of a culture to model their perspective on the past and on tradition, negotiating and aligning these with the historical, socioeconomic, and political contexts of a given time.

The Banabans

In what follows, I will focus on mimetic practice among the Banabans on Rabi Island in northeastern Fiji. This group hails originally from Banaba (also known as Ocean Island), an island in the central Pacific and since 1979 part of the state of Kiribati. Extensive phosphate mining on Banaba, commencing at the start of the twentieth century and making ever-deeper inroads into the fundaments of Banaban existence, caused the British colonial administration in 1945 to resettle the group in Fiji. The current state of affairs is one where Banabans recognize two home islands, separated by more than

Section of map of Oceania showing the islands of Banaba (Kiribati) and Rabi (Fiji).

two thousand kilometers of open sea and belonging to different Pacific nation-states. Banaba, now part of Kiribati, represents for Banabans their ancestral homeland, the island that is constitutive of their identity, the place they feel bound to through their forebears and traditions and by the fact of land ownership. Thus the Rabi Council of Leaders (the body elected to represent the Banabans' political interests) signals this sense of closeness to Banaba through the blue signet inscribed in its letterhead, offering a bird's eye view of that island.

The overwhelming majority of today's Banabans see Rabi Island in Fiji as their second homeland.[1] In the decades since relocation, the diaspora community has turned the island into a political and cultural enclave, with the express aim of guaranteeing the community's survival as an independent ethnic minority living in Fiji.[2] An important step in this direction was taken, only a few years after arriving, by the settler generation with the establishment of four villages named after the four traditional villages on Banaba: Tabwewa, Buakonikai, Uma, and Tabiang (cf. Silverman 1971: 210–220). In this way, they inscribed in Rabi's landscape the community's continuing sense of linkage with its island of origin. Mimetic reference to remembered village formations on Banaba has welded Rabi and Banaba into a single spatial interface of Banaban identity, one that has now become a core component of the group's social practice on its new island in Fiji. Primary membership of one of the four villages is essential to the everyday life of each and every member of the Banaban community, determining where someone stands vis-à-vis those from other villages. Later generations of Banabans who have grown up on Rabi, who identify with one village or another and can therefore position themselves with regard to others, participate therefore in this ongoing process of emplacement on Rabi, a process that simultaneously keeps alive the collective memory of their earlier island home.

The four villages on Rabi Island are not only constitutive of everyday life among the Banabans. They also supply the structural basis for the community's primary collective ritual: the commemorative festival held each year on December 15, marking the day when the Banabans first set foot on Rabi Island in 1945. The festival testifies to the community's efforts to preserve, in its collective memory, the cultural traditions and historical events associated with the first home island. Ritual performances of this kind are based on processes of social mimesis, permitting younger generations of Banabans especially to incorporate culturally binding narratives, imaginings, and codes of conduct into their own discourses and practices (cf. Gebauer and Wulf 2003: 126–129). At the same time, these performances renew the social power of the older generation, which is able to exert control over collective memory in matters relating to the Banabans' origins, their tradition, and the past. This commemorative festival is used by the Banaban community on Rabi Island to ritually orchestrate their view of the past, with each year representing a fresh departure.

The Commemorative Festival

What began as a divine service held to mark the anniversary of the Banabans' arrival on Rabi Island has evolved, across intervening decades, into an official commemora-

tive festival lasting a whole week. The festival centers around a historic site, which the Banabans call *te marae* ("public place"). Here stood the provisional tent camp into which the new arrivals moved upon reaching Rabi on December 15, 1945. Today *te marae* is used by the community as a sports ground and festival square in one. The small, roofed-over rostrum (in local parlance "the pavilion"), the flag mast, and the open square are key sites in this annual commemorative festival. That the spatial layout reflects the local power structures is made clear in the opening ceremony. Seated in the pavilion are members of the Rabi Council of Leaders, invited guests (usually representatives of the governments of Fiji and/or Kiribati), local church leaders, as well as surviving members of the generation that first settled Rabi Island. The celebrations commence with representatives of kindergartens, schools, dance groups, church groups, and sports clubs marching into the festival square carrying flags and banners; they then take up assigned places facing the pavilion. The marchers are mostly youngsters; their presence on the open field is an integral part of the opening ceremony that follows.

The commemorative festival is usually opened by a church dignitary, who concludes his remarks by offering up a prayer. He thanks God for having protected the Banaban community in difficult times and asks his blessing for the coming days of celebration. Depending on the order of proceedings, this ritual act may be supplemented by a choral performance or by a lengthy sermon. Then a policeman hoists the Fijian flag as a brass band plays the national anthem, after which the Banaban community sings its own anthem, which actually is a hymn: *Te Atua Buokara* (God our help). Then the chairman of the Rabi Council of Leaders gets up to speak, stressing again the signal importance of the day and why it is being celebrated, adding his voice to what the church dignitary had said earlier. The theme that will run through the coming days of festivities is clearly

Opening ceremony of the commemorative festival of December 15, 1997, held on the Banaban community's festival square, Rabi Island, Fiji (Photo: Wolfgang Kempf).

enunciated at this point: that the Banabans are grateful to God for protecting their community in the dark days of the war and the subsequent resettlement in Fiji, thus ensuring their survival as a collectivity. In the main part of his speech, the chairman passes review of what the government has accomplished on their behalf in the past year. In the further course of the opening celebrations, the guest of honor is given the opportunity to address the assembled Banabans.

In 2004 and 2005 the Banabans revived their earlier practice of asking members of the pioneering generation from each of the four villages to speak publicly of how he or she had experienced the war and the subsequent dislocation of resettlement. On the sixtieth anniversary of Banaban resettlement on Rabi, which was marked on December 15, 2005, in the presence of invited representatives of Fiji's government (including the Tui Cakau, Naiqama Lalabalavu), these members were Ten ("Mr.") Uoue (for the village of Tabwewa), Ten Tete (for Uma), Nei ("Mrs.") Naomi (for Tabiang), and Nei Mereba (for Buakonikai). The general tenor of such narratives is that the Banabans, faced with the threats of hunger, death, and deracination, were able to surmount these by God's grace. By thus publicly performing their embodied memories, the older generation is able to explicitly generate (and hand down) continuity between past and present, between Banaba and Rabi. The mimetic practice the speakers resort to establishes temporal and spatial bearings that are core domains of Banaban identity. In like manner, the various groups that then line up in formation and march past the pavilion, filling the square with vibrant movement, attest to the remembered space-time of Banaba and its articulation with Rabi Island.

Underlying the commemorative festival—and this is something I would like to pick up on—is a core structuring principle, namely that the Banabans' four villages are all represented and, if you will, assembled on the festival square. I have already mentioned the four older persons, each representing a particular village, who are called on to reminisce about the past and how they experienced it at the time. In the Rabi Council of Leaders too, its members following the celebrations from the pavilion, each of the villages is represented by two counselors. Yet another example is the rugby, volleyball, or netball teams, each representing a particular village, that compete on the festival square. Thus the four villages are pitted against each other in a variety of combinations: Buakonikai versus Uma, Tabwewa versus Tabiang, Uma versus Tabwewa, and so on and so forth. As part of the festivities, the villages send their own dancing (*batere* or *maie ni kawa*) or singing groups (*kuaia*), which vie publicly for the honors on the festival square (cf. Silverman 1971: 212).

During the entire week that is given over to celebrations, the villages in various groupings compete in one event or another. On the final day, the total number of points scored by each village is tallied up and the winner declared for that year. If the four villages feature so prominently in the order of proceedings, it is chiefly because they orchestrate, by means of this relational constellation, Banaba as the point of reference for all Banabans assembled on Rabi Island's festival square, recalling their ancestral home and evoking it in a celebratory spirit.

Some of the dance groups within the Banaban community—and these regularly

feature in the second part of the program for the opening ceremony—establish on the *marae* this shared linkage with Banaba. These dance groups, either associated with schools on Rabi or set up by local composers, bring their old homeland back to life through songs, dances, and dance theater spectacles. Performing art is something the Banabans of Rabi Island see as a valuable instrument for representing—re-presenting, one might say—their past and traditions.

Ethnic Performances

For present purposes, I shall confine my remarks to one of the oldest of Rabi Island's dance groups, the Banaban Dancing Group, whose creation at the beginning of the 1970s was closely linked to the struggle being waged at the time for financial compensation and political independence. Reverend Tebuke Rotan, a local politician who had used his influence to set up the dance group, declared that an ensemble with songs of its own and an unmistakable dancing style would greatly assist the Banabans in their attempts to mark themselves off ethnically from the Gilbertese (today known as the I-Kiribati). Thus the dances and songs created for the group by the composer and choreographer Ten Tawaka Tekenimatang primarily served the cause of publicly enacting difference. It was the European organizers of the First South Pacific Festival of Arts (1972) who first put in place a process of reconstructing tradition with their rigid "back to the roots" politics of authenticity and exclusion of modern elements (see Kempf 2007). The Banabans not only designed a traditionizing dance costume but also revitalized their ancient stick dance (*Te Karanga*). Nei Makin Corrie Tekenimatang, a female schoolteacher, also set about orchestrating a dance theater piece modeled on an ancient Banaban legend. And so it was that at the First South Pacific Festival of Arts, held in the Main Civic Auditorium of Suva, two performances were given of the first dramatic piece *Kunean te Ran* (The finding of water). The story tells of a heroic local figure who with the help of the gods finds precious fresh water inside the caves on Banaba. Songs by the composer Nei Tebwebwe Beniamina, the woman who succeeded the first director of the dance troupe, later supplied the foundation for further dramatic pieces. In deciding what direction the dance theater should take, Ten Maraki Kokoria, who headed the Banaban Dancing Group in the 1990s, played a leading role. He choreographed the new pieces and arranged them in chronological sequence. Thanks to his efforts, the repertoire now ranges from enactments of precolonial traditions to events in early colonial history to the resettlement of the Banabans on Rabi Island (see graphic). A typical performance of the group's entire program might begin with the stick dance *Te Karanga*, which the Banabans think of as their most ancient tradition, followed then by the Banaban Dancing Group's first piece, *Kunean te Ran* (The finding of water). The next three pieces—*Te Itiran* (The fetching of water), *Te Riena* (The catching of the flying fish), and *Te Kunikun* (The almonds)—portray traditional, gender-specific activities on Banaba.[3] Then comes *Rokon te Aro* (The arrival of Christianity), marking the transition to the colonial era. The ensuing pieces track the chronology of historical events on Banaba: *Rokon te Kambana* (The arrival of the company)[4] treats the onset of phosphate mining on the island; *Rokon te Buaka* (The arrival of the war)[5] is

a piece dealing with the Japanese occupation during World War II; *Te Katanoata* (The announcement) enacts the occasion when word of their impending resettlement first reached the Banabans; *Te Mananga* (The voyage) takes up the story of the Banabans' voyage to Fiji, while *Te Bwimanimaua n Ritemba* (The 15th of December)[6] revisits the difficult conditions awaiting the Banaban community in its new island home.

If I have chosen these dance theater pieces, which today have a firm place in the Banabans' politics of identity, it is in order to designate ethnic performance. With Bovin (1998: 94, 97, 108) I take this as meaning, in this context, that the Banabans present a public image of themselves, one clearly differentiated from everyday reality, through an ethnic ensemble using a configuration of music, dance, and dance theater to strategic effect, namely to evoke in the audience insights into what is specific to Banaban existence. The actors conjure up on stage vanished time-spaces from the past, such as are associated in the Banaban community itself with their origins, traditions, and history (cf. Connerton 1989: 69; Hastrup 1998: 34, 41). The power of such performances derives from the actors' ability to involve their audience, sensuously and emotionally, in the ongoing process of constructing a past reality, reminding them of Banaban presence and also of Banaban difference as an ethnic group (cf. Hastrup 1998: 41–42; Schieffelin 1998: 194, 204–205).

The Banaban Dancing Group, which gives concrete expression on stage to the cultural and historical memory of the Banaban community, has made a point of recruiting young unmarried Banaban men and women, who are then guided by still active older members. Having to learn the various movements and songs, having to coordinate bodies with narratives, permits the successor generations to deepen and act out the knowledge they have of their origins and traditions as well as the historical events that shaped them. Thanks to this mimetic practice, dance group members are able to adopt a collective view of the past, enacting it and preserving it as embodied memory (see Gebauer and Wulf 1995: 2–5; 1998: 11–12, 152–153; Bottomley 1991: 306–307; Connerton 1989: 72–73). And an integral part of such embodied memory is the ancestral island of Banaba.

Rokon te Aro

For analytic purposes, let me now select from the dance group's repertoire a piece situated at the interface of precolonial and colonial pasts: *Rokon te Aro* (The arrival of Christianity). My remarks are based on a performance I witnessed during the festivities for December 15, 1997. In *Rokon te Aro*, the Banaban Dancing Group enacts the first encounter between Banabans and Christian missionaries on ancestral Banaba; it depicts how their ancestors reacted to this event and portrays the process of their conversion. Greg Dening's metaphor of the beach as a place of transformation and transition seems particularly apt here (Dening 1980: 3, 20; 2004: 16–17). In *Rokon te Aro* the Banaban Dancing Group portrays the beach of ancestral Banaba from the indigenous perspective. *Rokon te Aro* is a reflection on the historical process of transformation of their religion. What this piece makes clear is how the Banabans see, through the prism of hindsight, their ancestors' conversion to Christianity. The dramatic enactment of

Precolonial Time

- **Te Karanga** — The Stick Dance
- **Kunean Te Ran** — The Finding of Water
 - **Te Itiran** — The Fetching of Water
 - **Te Riena** — The Catching of the Flying Fish
 - **Te Kunikun** — The Almonds

Rokon Te Aro — Arrival of Christianity

Colonial Time

- **Rokon Te Kambana** — The Arrival of the Company
- **Rokon Te Buaka** — The Arrival of the War
- **Te Katanoata** — The Announcement
- **Te Mananga** — The Voyage
- **Te Bwimanimaua n Ritemba** — The 15th of December

Sequence of dance theater pieces by the Banaban Dancing Group enacting the culture and history of the Banaban community.

this act of conversion provides an insight into how this reading of the transformation of their traditional religion has impacted on contemporary constructions of tradition, crucial as these are for the Banabans' self-perception as an ethnic group.

The dramatic sequence relating how the Banabans converted to Christianity at the end of the nineteenth century is based on a narrative circulating within the community as oral history. This narrative has now turned up inter alia in diverse seminar papers or dissertations written by theology students from the Banaban community (see Benaia 1991: 23; Hedstrom 1995: 10–11). As these sources tell it, Nei Tituabine, an important goddess in the traditional Banaban pantheon, appears before a family living on Banaba. Her message: A fire will soon approach the island from the sea. This fire, she tells them, will herald the arrival of a new god, mightier than all the traditional local deities. Nei Tituabine then advises the family, and through it the wider community, to turn away from these local deities (and all other spirits) and open themselves up to this new and mightier god, or God, to whom the Banabans should now give allegiance and extend recognition. Looking back, many of today's Banabans interpret the fire of Nei Tituabine's prophecy as having indeed been the light that let their ancestors finally break with the archaic world of darkness, thereby entering upon a new age.[7]

In the opening scene of *Rokon te Aro,* a Banaban woman informs her compatriots that she had received in a dream a message from "the old lady," as Nei Tituabine is sometimes called:

> First Banaban woman: *Mane, ongora! I matu ngkebong ao i mii. E roko te unaine ao e tuangai ba ti nang kaki antira aio ba e nang roko riki te Atua ae maaka.*
>
> Men, listen! When I was asleep last night, I had a dream. The old lady came and told me we should leave our present gods, for another God is about to come who is more powerful.
>
> *Ao kaotina ai aron te ai ae ura mai marawa. E uara anne?*
>
> And the way he'll appear is like a fire lighting up at sea. How about that?

But the bystanders are not impressed by the woman's dream-message and turn away from her:

> People: *Tiaki kan ongo!*
> We don't want to hear you!
> First Banaban woman: *Ao e tau e nang tamaroa.*
> Well, it's all going to turn out for the best.

At the same time, two male dancers from the back of the group work their way forward in measured, coordinated steps. One is the American missionary Captain A. C. Walkup, the other his assistant, Kinta, from the Gilbert island of Tabiteuea, both of whom had sailed to Banaba.[8] These personages first describe a great circle, then move toward the group of Banabans, then go ashore. The Banaban woman who had begun by telling her

dream points to the strangers and cries out that what she predicted has now come true. The Banabans come running to see. Kinta—who is there to translate for the Reverend Walkup, who speaks only English—turns to the assembled group:

Kinta: *Kam na mauri kaain Banaba!*
 Greetings be with you, people of Banaba!
Banaban people: *Mauri o!*
 Greetings!
Kinta: *Ngaira bon mitinare ae ti kamanangaki mai Kiribati n te aro ni kamatu ba ti nako mai ba ti taekina Uean te Atua nako abami.*
 We are missionaries sent from Kiribati who practice the religion of the Congregational Church.[9] We have come to talk of and spread the Kingdom of God to your people.
 Uotara aran te Atua ni kamaiu ba kam na kaki antimi kaain Banaba.
 We bring the name of God the Savior so that you may leave your gods, people of Banaba.
People: *Tiaki kaan ongo!*
 We don't want to hear you!
Kinta: [*To Rev. Walkup*] They say they want to follow their own God. Speak to them about our God.

While Kinta is talking to missionary Walkup, the Banabans divide into three groups. The women of each group sit on the ground. Behind them stand one or two men, mimicking magical practices by their gestures. Now Walkup addresses the first group:

Rev. Walkup: We come to bring the word of God to you!
First Banaban woman: *Nao taiaoka tera ae taku teuaio?*
 Man, please what is this man saying?
Kinta: *Aran te Atua ae ti uotia nakomai ba kam na kaki antimi.*
 We bring the name of God so you'll have to leave your gods.
First Banaban woman: *Oh ti nang nanokawaki ti a bon aki kona ni kaki antira aio.*
 Well, we are very sorry but we really cannot leave our gods.
 Antira aio ma ngkoa, ma ngkoa ao ngkai kam nang roko n tuangira ba ti nang kaki antira aio.
 The gods we have are from before, from before and now you come and tell us that we should leave our gods.
Kinta: [*To Rev. Walkup*] They say this is their true God.
Rev. Walkup: [*Kneeling down and raising his right arm skyward*] God is power!
First Banaban woman: *Tera ae taku teuaio?*
 What is he saying?
Kinta: *Te Atua are i karawa e maka riki nakon antimi.*
 The God in Heaven is more powerful than your god.

FIRST BANABAN WOMAN: *I aki kona n ataia ae maaka riki te atua are i karawa ma e maaka riki antira ngaira.*

I don't know whether he is more powerful, the God [that is] in Heaven but I know that our gods are very powerful.

REV. WALKUP: I beg you! Leave your idol gods! Please! [*Loud laughter from the audience*]

KINTA: *Kam na ongo ao kam na kamaiuaki roro ma roro n aran te Atua ni kamaiu.*

You must listen and you'll be saved, one generation after the other, all in the name of the God who saves.

REV. WALKUP: Please! Please! This is the wrong God! Come! [*Stretching his arms out to the Banabans in an inviting gesture—the audience laughs*]

FIRST BANABAN WOMAN: [*To Kinta*] *Bon te koaua anne?*

Is that really the truth?

KINTA: *Te koaua.*

[It is] the truth.

FIRST BANABAN WOMAN: [*To her compatriots*] *Ao euara mane, tia rairaki?*

So what do you think, men, shall we repent?

Those in the first group now abandon their resistance. Up till now, they have been sitting on the ground. Now they get up in a decisive movement, signaling their willingness to embrace the new religion. Missionary Walkup and his assistant Kinta thank the converts and move on to the next group of Banabans. The American missionary again comes straight to the point:

REV. WALKUP: God gave his son Jesus Christ and it is for you that He died on the cross!

SECOND BANABAN WOMAN: *Tera ae taku?*

What is he saying?

KINTA: *Te Atua ae maaka ae tine n te kaibangaki ba kam na kamaiuaki i bukin ami bure. Kam riai ni kaki antimi kaain Banaba.*

The God who is powerful hangs on the cross so you can be saved from your sins. You should leave your gods, people of Banaba.

SECOND BANABAN WOMAN: *Tiaki kaan ongo ba Atuara aio e bon maaka.*

We don't want to hear this, because the God we have is very powerful.

KINTA: [*To Rev. Walkup*] Say something more about our God. They say their idol God is power.

Again the missionaries have to dip deep into their persuasive skills; finally, however, those in the second group are won over to the new religion.

At which point the pair move on to the third and last group. Curious, Reverend Walkup gets one of the men to hand him a ritual object. The missionary sniffs it briefly, then denounces it without further ado as evil-smelling. In so doing, he expresses his

After the first group of Banabans (standing on the right) are converted to Christianity, the missionaries move on to the second group (sitting on the left). Mission assistant Kinta (center left) translates while Rev. A. C. Walkup (center right) listens (Photo: Elfriede Hermann).

The two missionaries move on to the third and last group of Banabans, intending to convert them as well to Christianity (Photo: Elfriede Hermann).

misgivings about the local magical practices. Then he talks of his mission to bring the Word of God to the Banabans. In this, he adheres to the same pattern of interactions between missionary and local population as was established earlier: Kinta acts as interpreter and mediator between the Banabans and Reverend Walkup; the local group, as represented by a female speaker, is initially little inclined to turn its back on the local gods, but the promises the missionaries make finally induce a change of heart. The last group now abandons its resistance and stands up; the two missionaries shake hands and congratulate each other on a successful mission.

In the final scene of *Rokon te Aro,* all the dancers line up in a semicircle. With the dancer playing the Reverend Walkup standing at the right end of the semicircle, the chair of the dance group, Ten Maraki Kokoria, who is playing Walkup's assistant Kinta, raises his voice from the other end of the semicircle:

KINTA: *Kaain Banaba!*
 People of Banaba!
BANABANS: Oh!
KINTA: *Ti a nang kakatonga ngkai kam a tia n tuea ba kam na kaaki antimi.*
 Today we are very grateful that you've promised to leave your gods.
 Ao kam bon kakoaua ba kam nang toro iroun te Atua?
 And now do you swear that you will serve God?
BANABANS: *Ti kakoaua.*
 We swear.
KINTA: *Ti na anene. Katorobubua ba ti na anene neboa te Atua.*
 Let us sing. Kneel down, so we can sing praise to the Lord.

The dancers now kneel, fold their hands, and sing a verse from the hymn *Baa ni Koa* ("Rock of Ages"). Thus they signal that the Banaban community has been converted now and forever to Christianity.

Let me pick up on three aspects of *Rokon te Aro* that are central to how the Banabans retrospectively view their change of religion. First, their identification with Banaba, which, as we have seen, is kept alive on Rabi Island by recourse to mimetic practices, includes their own version of how they were won over to the new religion. This version—and this is my second point—has little in common with "auto-orientalism," such as we know it from comparable accounts of the arrival of Christianity in Melanesia (see Errington and Gewertz 1994: 104; Kulick and Willson 1992; Neumann 1992; White 1991). The Banabans do not represent their ancestors as benighted savages having little or no culture. In their re-enactment of the beach on Banaba as a place of transformation, what we are given, instead, are self-assured ancestors who declare themselves ready, though only after thoroughly discussing the issues with the missionaries, to turn away from the magical practices of old and embrace the new religion of Christianity. What so amuses the audiences is how hard it is for both the American missionary and his assistant to make any headway against their forebears' obstinacy. And when they *are* won over, the credit rests not with the outsiders but with Nei Tituabine

Final scene of *Rokon te Aro*. The Banabans, all of whom have now switched to Christianity, sing the hymn *Baa ni Ngkoa*. Mission assistant Kinta (left) is conducting (Photo: Elfriede Hermann).

and the agency she unfolds. It is this evident will to self-determination that constitutes my third point. The narrative of Nei Tituabine's prophecy clearly signals to audiences the Banabans' claim to have anticipated their incorporation into the Christian community. At the same time, they can actively pinpoint where their traditional goddess stands in relation to Christianity, ensuring that Nei Tituabine will continue, as she has always done, to protect their community and homeland. Despite the break with the precolonial past marked by the conversion to Christianity, the Banabans have managed to preserve a sense of ongoing linkage to the ancestral world of Banaba. At bottom, the relation the Banabans have built through Nei Tituabine to Banaba *as well as* to Christianity forms a central plank in their ethnic identity.

Conclusion

Associating the ancestral island with Christianity is an integral part of the Banaban discourse of survival, as conducted at the annual commemorative festival on December 15. Central to the celebrations recalling the intermediary space of arrival on Rabi Island is the effort Banabans have made to connect the two islands, Banaba and Rabi. The reference to Christianity underlying the festivities lets the Banabans depict the continuity of their existence as an ethnic group within a context of dispersion and resettlement. The Banabans deploy mimetic practices to reclaim for themselves the past as a place of ruptures and continuities. Their selective approach to these historical ruptures and continuities may be said to create the prerequisite for constituting an ethnic identity based on identification with two islands in two nation-states.

A dance formation of the Banaban Dancing Group depicts in outline the ancestral island of Banaba. The occasion is the commemorative festival of December 15, 2005, held on Rabi Island's festival square. The map of Banaba was digitally inserted (Photo: Wolfgang Kempf).

The Banabans use their public representations of the past and of tradition as political resources (cf. Kempf and Hermann 2005). In a Fiji marred by a succession of coups and rewritten constitutions, by the rise of ethnic-nationalist discourses and acts of violence, the Banabans have had to take on board, with growing concern, the fact that their status and rights of ownership over Rabi Island may well be challenged or even reversed. Through their annual commemorative festival, the Banabans demonstrate their loyalty to Fiji as a Christian nation. Thus, Christianity represents important shared ground between Banabans and ethnic Fijians. The Banaban discourse that it was God who led them to Rabi Island, and by doing so preserved them from disappearing without a trace, can be read as an appeal to the selfsame Christian ethic espoused by ethnic Fijians, namely that the Fijians should respect them as having found a refuge, a place of survival, in Fiji.

In this last picture—and I show it here by way of conclusion—a dance formation from the Banaban Dancing Group can be seen. The picture was taken on the festival square of Rabi on December 15, 2005, and shows youthful dancers depicting the ancestral island of Banaba in outline. Banaban commemorative festivals and ethnic performances show the relevance of mimetic processes for a resettled society, one which is striving to articulate its new island and concomitant identity with how it construes the past and past tradition. Mimesis refers to the shaping power of interaction, incorporation, interpretation, and performance, such as can coordinate lived-out representations of the past and tradition with demands posed by the present. The Banabans deploy such mimetic processes to guarantee their survival as an ethnic group. What their case also shows is that we must learn to see constructions of the past and tradition among Pacific societies in terms of their historically specific experiences and narratives, and ask if these turn on rootedness, mobility, or displacement.

Notes

1. Rabi Island is some sixty-eight square kilometers in size (cf. Maude 1946: 11; Derrick 1951: 252). In August 1998, according to information supplied by the Rabi Council of Leaders, there were 3,898 members of the Banaban community living on the island, with another 250 Banabans staying on Banaba. Also, a sizeable number of Banabans have settled in recent years in Fiji's urban centers (especially Suva, Lautoka, and Labasa) and in Kiribati (especially on Tarawa); a smaller number have moved to Nauru or even afield, to Australia or New Zealand. The total size of the Banaban diaspora is now somewhere in the order of 6,000 persons.

2. Prior to the Banabans' arrival, Rabi Island had been owned by Europeans for many decades. The island's history is complex. King George Tupou I of Tonga conquered Rabi in 1855; some fifteen years later, he sold it to Captain John Hill and the Dawson brothers in Sydney. It was this same Captain Hill who turned Rabi into a plantation island. Hill initially used hired hands from what is now Vanuatu, from the Solomon Islands, but also from the present-day state of Kiribati (some of whom were Banabans); after 1879, he also brought in Indian indentured labor. In June 1890, Captain Hill sold Rabi Island to the English silk manufacturer Josiah Smale, who leased it to various parties such as the Pacific Islands Co. Ltd. and Lever's Pacific Plantations Ltd. After Josiah Smale's death in 1911, ownership of Rabi Island passed to his daughter, Helen Gertrude Smale. Twelve years later, she sold it to a British firm, Lever's Pacific Plantations Ltd. Finally, in 1942, the Western Pacific High Commission bought out this firm with the intention of resettling the dislocated Banaban community on the island (see Kempf 2011).

3. The cyclical character of activities like these stemming from precolonial times is indicated in the graphic by a circle. The dance theater pieces follow the usual order of performance of the Banaban Dancing Group. My many thanks to Steffen Herrmann for preparing this table and the photos for publication.

4. See Hermann 2004.

5. See Kempf 2004.

6. See Kempf and Hermann 2005.

7. A remarkable parallel to this narrative of a woman who prophesied the coming of Christianity can be found in the biography of Pastor Elekana, a Cook Islander who was active as a missionary on Tuvalu (see Goldsmith and Munro 2002: 3–4, 6–7).

8. For the history of the early missionization of Ocean Island, see Silverman 1971: 88–94 and Binder 1977: 23–27.

9. This particular missionary, Captain A. C. Walkup, was a member of the American Board of Commissioners for Foreign Missions (ABCFM), a missionary society set up by the Congregational Church at the start of the nineteenth century. For the history of the activities of the ABCFM in the Gilbert and Ellice Islands, see Macdonald 1982, ch. 3.

References

Benaia, Temaka. 1991. "The Story of the Protestant Church on Banaba and Rabi." BD thesis, Pacific Theological College.

Binder, Pearl. 1977. *Treasure Islands: The Trials of the Ocean Islanders.* London: Blond and Briggs.

Bottomley, Gillian. 1991. "Culture, Ethnicity, and the Politics/Poetics of Representation." *Diaspora* 1 (3): 303–320.

Bovin, Mette. 1998. "Nomadic Performance—Peculiar Culture? 'Exotic' Ethnic Performances of WoDaaBe Nomads of Niger." In *Recasting Ritual. Performance, Media, Identity,* edited by F. Hughes Freeland and M. M. Crain, 93–112. London and New York: Routledge.

Casey, Edward S. 1996. "How to Get from Space to Place in a Fairly Short Stretch of Time: Phe-

nomenological Prolegomena." In *Senses of Place,* edited by S. Feld and K. H. Basso, 13–52. Santa Fe, N.M.: School of American Research Press.
Connerton, Paul. 1989. *How Societies Remember.* Cambridge: Cambridge University Press.
Dening, Greg. 1980. *Islands and Beaches: Discourse on a Silent Land: Marquesas 1774—1880.* Melbourne: Melbourne University Press.
———. 2004. *Beach Crossings: Voyaging across Times, Cultures and Self.* Melbourne and Philadelphia: University of Pennsylvania Press.
Derrick, R. A. 1951. *The Fiji Islands: A Geographical Handbook.* Suva: Government Printing Department.
Errington, Frederick, and Deborah Gewertz. 1994. "From Darkness to Light in the George Brown Jubilee: The Invention of Nontradition and the Inscription of a National History in East New Britain." *American Ethnologist* 21 (1): 104–122.
Gebauer, Gunter, and Christoph Wulf. 1995. *Mimesis: Culture—Art—Society.* Berkeley: University of California Press.
———. 1998. *Spiel—Ritual—Geste. Mimetisches Handeln in der sozialen Welt.* Hamburg: Rowohlt.
———. 2003. *Mimetische Weltzugänge. Soziales Handeln—Rituale und Spiele—ästhetische Produktion.* Stuttgart: Kohlhammer.
Goldsmith, Michael, and Doug Munro. 2002. *The Accidental Missionary: Tales of Elekana.* Christchurch: Macmillan Brown Centre for Pacific Studies, University of Canterbury.
Gupta, Akhil, and James Ferguson. 1997. "Beyond 'Culture': Space, Identity, and the Politics of Difference." In *Culture, Power, Place: Explorations in Critical Anthropology,* edited by Akhil Gupta and James Ferguson, 33–51. Durham, N.C., and London: Duke University Press.
Hastrup, Kirsten. 1998. "Theatre as a Site of Passage." In *Ritual, Performance, Media,* edited by Felicia Hughes-Freeland, 29–45. London and New York: Routledge.
Hedstrom, Allan T. 1995. "Faith Community: Buakonikai Village, Rabi Island." Davuilevu Methodist Theological College.
Hermann, Elfriede. 2004. "Emotions, Agency and the Dis/placed Self of the Banabans in Fiji." In *Shifting Images of Identity in the Pacific,* edited by Toon van Meijl and Jelle Miedema, 191–217. Leiden: KITLV Press.
Hughes-Freeland, Felicia. 1998. "Introduction." In *Ritual, Performance, Media,* edited by Felicia Hughes-Freeland, 1–28. London and New York: Routledge.
Hughes-Freeland, Felicia, and Mary M. Crain, eds. 1998. *Recasting Ritual: Performance, Media, Identity.* London and New York. Routledge.
Kempf, Wolfgang. 2004. "The Drama of Death as Narrative of Survival: Dance Theatre, Travelling and Thirdspace among the Banabans of Fiji." In *Shifting Images of Identity in the Pacific,* edited by Toon van Meijl and Jelle Miedema, 159–189. Leiden: KITLV Press.
———. 2007. "Le premier festival des Arts du Pacifique Sud revisité: Fabriquer de l'authenticité et le cas des Banabans." In *Le défi indigène: Entre spectacle et politique,* edited by Barbara Glowczewski and Rosita Henry, 221–233. Courbevoie/Paris: Editions Aux Lieux d'Etre.
———. 2011 *Translocal Entwinements: Toward a History of Rabi as a Plantation Island in Colonial Fiji.* PURL: http://resolver.sub.uni-goettingen.de/purl/?webdoc-2923.
Kempf, Wolfgang, and Elfriede Hermann. 2005. "Reconfigurations of Place and Ethnicity: Positionings, Performances, and Politics of Relocated Banabans in Fiji." In *Relations in Multicultural Fiji: Transformations, Positionings and Articulations,* edited by Elfriede Hermann and Wolfgang Kempf. Special Issue of *Oceania* 75 (4): 368–386.
Kulick, Don, and Margaret Willson. 1992. "Echoing Images: The Construction of Savagery Among Papua New Guinea Villagers." *Visual Anthropology* 5: 143–152.

Neumann, Klaus. 1992. *Not the Way It Really Was: Constructing the Tolai Past*. Honolulu: University of Hawai'i Press.

Macdonald, Barrie. 1982. *Cinderellas of the Empire: Towards a History of Kiribati and Tuvalu*. Canberra: Australian National University Press.

Maude, Henry E. 1946. *Memorandum on the Future of the Banaban Population of Ocean Island; With Special Relation to their Lands and Funds*. Auckland: Gilbert and Ellice Islands Colony.

Schieffelin, E. L. 1998. "Problematizing Performance." In *Ritual, Performance, Media*, edited by Felicia Hughes-Freeland, 194–207. London and New York: Routledge.

Silverman, Martin G. 1971. *Disconcerting Issue: Meaning and Struggle in a Resettled Pacific Community*. Chicago and London: University of Chicago Press.

White, Geoffrey M. 1991. *Identity through History: Living Stories in a Solomon Islands Society*. Cambridge: Cambridge University Press.

PART III

Global and (Trans)local Processes

Moving onto the Stage

Tourism and the Transformation of Tahitian Dance

Miriam Kahn

While living in France in February of 2002, I visited the annual Salon Mondial du Tourisme (tradeshow of global tourism) in Paris. It was packed with thousands of people browsing among some two hundred booths advertising every tourist destination imaginable. While looking at a display about farm stays in Tuscany, I suddenly heard the unmistakable sounds of Tahitian drumming reverberating throughout the hall, announcing that the next cultural performance—one of several that occurred at regular intervals throughout the tradeshow—was about to begin. As if on cue, crowds of people began to push their way toward the thunderous sounds at the end of the hall. By the time I arrived at the makeshift stage fronted by a dozen rows of metal folding chairs, the performance had begun. The only space left was standing room on the perimeter, so I joined the crowd and, like everyone else, strained my neck for a better view. Sensing how intensely focused everyone was, I realized that for this particular Parisian audience the drumming and dancing were spellbindingly exotic—like nothing they would encounter during an afternoon stroll on the Champs Élysées. From my vantage point, the performance looked like simply another version of what I had often seen in hotels in French Polynesia. Except here, under the harsh fluorescent light and encircled by people carrying shopping bags with tradeshow giveaways, the performance seemed more blatantly commercialized. Indeed, the star of the show—an elaborately tattooed male dancer—told me in a post-performance conversation that he was employed full-time by Tahiti's Office of Tourism and spent his days traveling internationally from tradeshow to tradeshow, dancing to advertise Tahiti.

Travel between Europe and Tahiti (in both directions) in search of the foreign is nothing new. Ever since 1767, when Samuel Wallis' ship appeared on Tahiti's horizon (and soon thereafter the ships of Louis-Antoine de Bougainville and James Cook), Tahitians have participated in an increasingly globalized world in which people, ideas, fashions, money, images—and dance styles—move across the oceans as dependably as the moon pulls the tides (of course, interisland exchanges within the Pacific had been going on for centuries prior to that time). Not only did British and French explorers travel to Tahiti in the late 1760s, but Tahitians also traveled to Europe. When Bougainville

returned to Paris in 1769 he took along nineteen-year-old Aotourou, who became the first Tahitian to visit Europe. In 1774, Cook transported a second Tahitian, Omai, to England, where for three years he participated in various British customs such as going to dances, concerts, the theater, and the opera.

In this chapter I look at some of the transformations that occurred in Tahitian dance from the eighteenth century (when European explorers first landed in Tahiti and two Tahitian men sailed back with them to Europe) to the twenty-first century (when Tahitians travel around the world and dance at tradeshows to entice tourists to visit Tahiti). I explore how cross-cultural exchanges, shifting historical contexts, and especially the growth in tourism after the 1960s have impacted Tahitian dance. Over the centuries Tahitians have always developed new dances, songs, and costumes in creative ways. Tourism, however, has encouraged Tahitians to also choreograph dances that directly respond to tourists' expectations of experiencing a predictable, spectacular, photogenic show.

When European missionaries first encountered Tahitian dance in the early nineteenth century, they banned the practice because of what they perceived to be its erotic qualities. Ironically, these same qualities have encouraged the Office of Tourism to choose dance as the main attraction for advertising Tahiti to the contemporary world. Since the emergence of organized mass tourism in the 1960s, Tahitian dance has been transformed into the main cultural element that represents "Tahiti" to outsiders and entertains tourists once they arrive in French Polynesia. Dance has evolved from a culturally meaningful, and passionately practiced, local pursuit—which it continues to be for Tahitians—into an internationally performed, commercial spectacle that involves innovative, dazzling elements, often borrowed and recontextualized to create photogenic appeal and to signify "Tahiti" to outsiders (see Lawrence 1992 and Moulin 1994, 1996, both of whom have written about the adaptive borrowing, both interisland and international, that occurs in Tahitian dance). Today Tahitians dance in numerous settings and for many different audiences. Dancing occurs at village school and church functions, for the arrival of dignitaries, at holiday celebrations, on cruise ships and in hotels, at regional contests, at the annual month-long Heiva competition every July, and at the Festival of Pacific Arts held every four years. Increasingly, it is also taught and performed at the Conservatoire Artistique Territorial (Moulin 2001).

Within the tourist setting, however, dance has become *the* cultural icon performed for outsiders and adapted to their expectations. In these settings dance is, above all, a visual emblem that offers tourists something they can predict, witness, record, and narrate to others. Tahitians embrace hotel performances both creatively and pragmatically—as a way to earn money, travel, and have fun. Tourists, of course, see these performances very differently. Although they are watching a culturally grounded aesthetic, their focus is on the visual and recordable aspect of it. Because tourists see dance mainly as an anticipated, advertised "show," they fail to see the dancers and musicians as individual people with a complex culture. Unless Tahitians are performing on the dance stage, they tend to disappear from tourists' views.

Dance at the Time of First Contact with Europeans

The history of early contact between Europeans and Tahitians—and how it impacted dance—is fairly typical of most colonial situations in the Pacific. A period of initial interest shown in dance (by explorers) was followed by efforts to ban the practice (by missionaries). At first, Tahitians and Europeans displayed great interest in one another's customs. As described by the Tahitian historian Teuira Henry, Tahitians and members of Captain Cook's crew reciprocally entertained one another with dance.

> Sometimes entertainments were given on shore at which Tahitian men and women exhibited the dance called *heiva* (amusement), accompanied with drum and flute and comic songs, in which they improvised suitable words for their foreign company, frequently mentioning the name Tute (Cook). In return the English seamen sang lively airs and danced to the horn and bagpipe, which the native men soon imitated fairly well. (Henry 1928: 21)

For Tahitians, however, dance was more than a source of entertainment. We know from early accounts that it was a way of expressing beauty, harmony, and excitement. It accompanied all celebratory occasions, including community activities, rites of passage, politics, war, and religion (Moulin 1979: 8). Although some dances were performed in elaborate costumes of up to forty yards of barkcloth, others were with limited clothing, and still others were performed completely nude (Moulin 1979: 10). In short, there was much variety.

Several decades after Tahitians' relatively fleeting contacts with European explorers, missionaries came to Tahiti. Some of them, like William Ellis, who settled in Tahiti in the early 1800s, recorded general descriptions of dance costumes, movements, songs, instruments, and settings.

> Their dances were numerous and diversified; the *heiva* was performed by the men and women—in many the parties did not dance together. The dress of the women was remarkably curious, and not inelegant; their heads were decorated with fillets of *tamau*, or plaited human hair, and adorned with wreaths of the white sweet-scented *tiare* flower. The arms and neck were uncovered, the breasts ornamented with shells or coverings of curiously wrought net-work and feathers. The native cloth they wore was always white, sometimes edged with a scarlet border. Their movements were generally slow, but remarkably regular and exact; the arms, during their dances, were exercised as much as their feet. The drum and the flute were the music by which they were led; and the dance was usually accompanied by songs and ballads. There were other kinds of dances, in which smaller parties engaged; and, although sometimes held in the open air, they were more frequently performed under the cover of the spacious houses, erected in most of the districts for public entertainments . . . the dances ensued in the evening, and were often continued till

the dawn of the following morning. There were gods supposed to preside over the dances. (Ellis 1829: 298–299)

In general, missionaries suppressed traditional dances and instruments and instead taught Tahitians how to perform European dance steps and play European musical instruments (Kaeppler 2001). Ellis noted not only that "dancing appears to have been their favorite and most frequent performance" (Ellis 1829: 318), but also that music and dance had become "blended" with European styles.

By the 1820s dance was prohibited by law, and there is evidence that people did, indeed, refuse to perform in public (Stillman 1988: 152–153). Yet, as in other colonial settings in the Pacific, dance continued to quietly flourish on the side (Hort 1891). In the 1920s and the 1930s Gerrard witnessed Tahitian dance that "set the blood in turmoil" (Gerrard 1932: 59), Jackson saw men dancing "unchecked by restraint" (Jackson 1938: 113), and Emory described how Tahitians were giving dance lessons to visiting archaeologists (Krauss 1988: 373). Even with dance being "banned," it was clear that a particular type of dance performance already "stood out in the world of dance as being uniquely and beautifully Tahitian" (Moulin 1979: 11).

Beating Drums and Exploding Bombs

The 1950s and 1960s was a time of reinvigoration for Tahitian dance. Madeleine Mou'a has been credited with its revival. After visiting France in 1955 and seeing folkloric dance performances, she returned to Tahiti with a desire to bring Tahitian dance back to life. A year later, she formed Tahiti's first professional dance group of thirty to forty dancers, which she named Heiva.

Around the same time Paulette Viénot, a woman of Tahitian-French descent and known in Tahiti as the "Queen of Tahitian Tourism," created another dance group, Tahiti Nui, specifically in response to the fledgling tourism industry. Viénot recalled the details:

> In the 1960s, when there were only a few tourists, there weren't a lot of things for them to do like there are today. They stayed on the island of Tahiti, usually for about two weeks. They loved this beautiful island. So we realized we had to do things for them. They wanted to have canoes so I got canoes for them to paddle. And they wanted to go around the island so I got buses for them. I had a dancer go along. On the bus everyone got a flower garland, and we had champagne and cashews too. When we got to Tautira on the south side of Tahiti we took a canoe and went across to a small island, where I always sent my dancers ahead. That way when the tourists stepped onto the island they were very surprised. They heard dancing and drumming as they arrived. It was a very popular form of entertainment. (Viénot, personal communication, 2001)

Viénot had explicit ideas about how Tahitian dance should look in order to appeal to tourists; she wanted to combine the athleticism of Cook Islander male dancing with

the grace of Tahitian female dancing. To accomplish that goal she asked Turepu Turepu, a prominent Cook Islander dancer and choreographer, to come to Tahiti with his dancers and teach Tahitians the drumming patterns, dances, and songs from the Cook Islands (Moulin 1996: 136–137).

Before long, dance had become not only the most popular form of tourist entertainment within Tahiti, but also the main element of Tahitian culture chosen to represent and promote Tahiti in other countries. Once again, Viénot was at the forefront when dance was first used to promote tourism overseas.

> In the late 50s I had a beautiful house on the beach with a lovely garden. I hosted a lot of events for tourism in my home. One day TAI Airlines [Transports Aériens Intercontinentaux] wanted a big party because a lot of tour operators had arrived from the United States. I put together a group of dancers for them and they loved it. After that the group stayed together for thirty-five years. They began touring the United States, each time staying for four months and going to about thirty cities. This was how we promoted Tahiti. In every city where they danced, I had one night where I invited all the travel agents to the show. That's how the dance group Tahiti Nui was started and how it was used to promote tourism. (Viénot, personal communication, 2001)

The growth of tourism in French Polynesia—which occurred at the same time as the advent of tourism throughout the Pacific—also coincided with events of a much more political nature, namely France's commencement of what would become more than thirty years of nuclear testing in the territory. In the mid-1950s, anticipating that Algeria would soon gain independence, the French government began preparing to transfer its nuclear test site from Algeria to French Polynesia. In 1963, a year after Algeria became independent, President Charles de Gaulle established the Centre d'Expérimentations du Pacifique (CEP) and officially announced that Moruroa and Fangataufa, two uninhabited atolls in the Tuamotu Archipelago of French Polynesia, would be the new test sites. In addition, headquarters and support facilities were established in the capital city of Pape'ete, on the island of Tahiti, where a large area of the lagoon was reclaimed for the construction of new docks to shelter and service the numerous ships required to support and monitor the nuclear tests.

One of the most significant aspects of the preparations was the construction of an international airport at Faa'a, a few kilometers down the road from Pape'ete, which opened in 1960 and served as a hub for multiple activities. Nuclear supplies and military personnel were channeled through the airport and harbor en route to the outer islands of Moruroa and Fangataufa. In addition, dance groups were moving through the airport on their way to Europe and the United States to drum up interest in a "pristine" paradise, in a manner similar to what has been described for Hawai'i, where hula troupes were put in service of, and used to disguise the activity of, military troops (Imada 2004: 142). At the same time, tourists were also arriving on international flights in record numbers. Whereas fewer than 1,500 tourists had come to Tahiti in

1959, a year later, when the airport was in operation, 4,000 arrived, and by the following year there were more than 8,500. By 1965 the number had grown to 15,000 (Covit 1968: 113). Each succeeding year witnessed dramatic increases in the number of tourists, as well as in the number of hotels that sprang up. In 1966, L'Office de Développement du Tourisme was created and for the first time an official guidebook, *Official Directory and Guide Book: Tahiti*, was produced. "From that time on, a tourist policy was progressively elaborated and tourism was promoted to the rank of great pillars on which the Territory's economy was to repose" (Robineau 1975: 63). To this day, tourism, which is by far the most prominent and lucrative industry in French Polynesia, is the main avenue through which non-French money is introduced into the territory.

The nuclear testing program totally transformed French Polynesia. In addition to pumping money into the territory for the testing program, the French government injected extra funds and goods to encourage local acquiescence, generating a colonial dependency relationship and artificial prosperity. For example, between 1960 and 1966 military spending in the territory rose from 4 percent of the gross domestic product to 80 percent. During that same period returns on exports dropped from 90 percent of the cost of imports to 10 percent (Henningham 1992: 127–128). Government welfare allocations began in the 1960s, with the amounts given and the categories of who qualified steadily increasing over the years. Television was also introduced in 1966, the same year that the first atmospheric explosion occurred. Prior to CEP, most of French Polynesia's population had fed itself by subsistence agriculture and fishing, but within a decade the territory was importing most of its food. In the space of a single generation, Tahitians were transformed into a working-class population that had become almost completely dependent on the money and goods brought into the territory by France. Land, too, slipped increasingly out of Tahitians' control. Some people took advantage of opportunities to sell titles to their land in order to earn income. The purchasers, who were often real estate agents, then sold the land to French, Chinese, and other nonindigenous buyers (Tetiarahi 1987: 54). The greatest change was on the island of Tahiti, and especially the urban area of Pape'ete, to which people migrated from the outer islands, attracted by construction and service work in the budding tourism industry. Like many towns on Pacific islands, Pape'ete was transformed from a sleepy colonial port town to a cosmopolitan city, almost doubling its population between 1960 and 1970.

Not only did tourism generate jobs and income—all necessary to sustain the CEP-induced artificial economy—but it also became a picturesque distraction from the environmental hazards and health risks caused by the testing program (see Kahn 2000, 2003, 2011). Images in tourist brochures of gracefully tilting coconut palms on sandy beaches distracted attention from the fact that on Moruroa workers were forbidden from eating coconuts (and other food) for fear of radiation sickness. And hotel performances of lively drumming and dancing made tourists forget that bombs were exploding eight hundred miles away. Dance became the ultimate antithesis of testing and a colorful icon of "paradise." As Moulin stated about Tahitian dance, "it has come to stand as almost a symbol of the South Seas; indeed, part of that very image of blue water and

coconut palms includes the vision of grass-skirted girls shaking their hips in an ecstasy of wild, pulsating movement" (Moulin 1979: 6).

Inside the Tourism Cocoon

Because dance is an essential aspect of Tahitian life, it is an activity where spontaneous Tahitian behavior meshes well with tourists' expectations. In the words of Amy Stillman, the fact that Tahitians "could be promoted as an attraction, while entertaining themselves, was a fortuitous coincidence of image and tradition, of consumer— and producer—happiness" (Stillman 1988: 155). As one dancer told me, "We like to dance. It's our passion, our culture." This love of dance is clearly evident. All major village festivities, including school or church functions, the arrival of political figures, or celebrations like Bastille Day, always include dance performances. In Pape'ete, where the residents originally come from all over French Polynesia, large dance contests are common where dance groups from different islands, each with unique costumes and dance choreography, compete for monetary prizes awarded for various "bests," such as costume, performance, etc. And the Heiva festival in Pape'ete every July, while also enjoyed by tourists, is still first and foremost the biggest and most lively spectacle by and for the local population. All over French Polynesia, even older people dance. For example, my husband and I were invited to join one hundred elders from Huahine for a trip to another island for a three-day gathering of hundreds of elders from the Society Island archipelago. The main highlight of the trip was a dance competition, which even included waltz-style dances that were originally introduced by Europeans (of which the elders were especially fond because these dances reminded them of their youth).

A particular type of dance has also blossomed within the tourism industry, both within French Polynesia and overseas. Hotel floorshows have become *the* main occasions for tourists to "see" the Tahiti (and Tahitians) of their imaginations—to experience for themselves postcard and brochure images, web site animations, and friends' videos as they come to life. In discussing strategies for the production of publicity material, Christel Bole (the marketing manager for GIE Tahiti Tourisme in 2001) told me, "We choose images of dancers specifically to represent Tahitian 'culture.'"

When Tahitians perform in a hotel or on a cruise ship, dance becomes an additional avenue for them to do what they otherwise enjoy, while offering them several personal opportunities. For example, dancers can earn extra money (dancers say this is the main reason they dance for tourists—their earnings are usually about $15 US per person per performance), exploit travel opportunities (even less popular dance groups have performed overseas), express themselves creatively, and have fun. To be a member of a successful dance group involves hard work, some business acumen, and collegial commitment. Dancers work tirelessly, practicing several times a week to ensure that their performances are outstanding. Costume designers devote endless hours to searching for prized materials and creating stunning regalia. Dance elements are combined into a marketable mélange, always with the aim of keeping the performance dazzling and the tourists happy. Although Tahitian dance is always seen (by Tahitians) as a visual

spectacle (Kaeppler 1987: 166; Stevenson 1999), in the tourist setting it is seen (by the tourists) as primarily only that. For tourists, it has become the anticipated and unrivaled *visual* experience.

By encouraging a particular type of dance to flourish, tourism has altered the character of that dance in fundamental ways. Marietta Tefaataumarama, the former dance leader of Huahine's dance group Tamari'i Mata'ire'a Nui, described these changing contexts and shifting meanings.

> Hotels sprang up and needed dance groups to entertain tourists. Hotel dancers get paid so money entered the picture. When dance became a hotel show everything changed. The songs and dances began to lose their meaning. Normally music, words, and special hand gestures go with every song. Tahitians know these details because they live inside the dance. It's their culture. But, in a hotel performance, these details no longer communicate any real meaning because dancers combine different elements to create a spectacle. They borrow elements from everywhere, especially from other shows they've seen. Today dancers chase after spectacles to create shows that are visually appealing to tourists. The girls hike up their *pareus*. They smile and show their teeth. They do some hand gestures. Tourists like that because it's an attractive show to watch. It's pleasing to the eye. It makes a good video. But the meaning is gone. Plus, the hotel tells you to dance for thirty minutes and that's all. After half an hour you're finished. You can't dance about your culture and your history in half an hour. But there are some things for which there is great respect and these will never appear in a hotel show. The *'ote'a mau* [an old warrior dance] will never be performed in a hotel. (Marietta Tefaataumarama, personal communication, 2001)

Ironies Behind the Camera Lens

According to the French philosopher Henri Lefebvre, spaces exhibit an "increasingly pronounced visual character. They are made with the visible in mind. . . . The predominance of visualization . . . serves to conceal repetitiveness. People look, and take sight, take seeing, for life itself" (Lefebvre 1991: 75–76). Tahitian dance—because it can be colorful, animated, flashy, and seemingly exotic—serves this need for visual character in Tahiti where tourists "take seeing for life itself." Dance brings tourists into contact with local Tahitians in a temporally defined (half an hour) and spatially contained (on the stage) setting that is anticipated, picturesque, and reproducible (thus allowing it to be further anticipated by others). In such spaces the visual dominates, with tourists' main experiences being the decoding of messages by the eye. The eye relegates people and objects to a safe distance and turns them into a visual spectacle (Lefebvre 1991: 286).

Conflicting perceptions and multiple ironies are embedded in the interactions between tourists and dancers. For members of a dance group, the transition from living their daily lives to performing in a hotel can seem commonplace. After all, for them it's a job. Yet for tourists it's the height of exoticism, of experiencing an "other" culture. I

was able to observe these different perceptions and ironies when I occasionally accompanied members of the Tamariʻi Mataʻireʻa Nui dance group on the island of Huahine.

On one occasion I spent time with the dancers while they were getting ready to perform at one of Huahine's most luxurious hotels. This particular hotel is located on the shore of a secluded bay—a tourist "cocoon" so isolated that it is accessible only via the hotel transfer boat, which ferries the guests between the main town and the hotel. The dozen or so dancers had arrived about an hour before their performance and were getting ready in the hotel's main lounge area and its adjoining corridor (both of which were empty because the hotel guests were in the dining room eating dinner). Sitting in small groups on the wooden floor, the dancers were surrounded by their dance paraphernalia, as well as by plastic bags containing fresh leaves and flowers that they were skillfully adding to their costumes, all of which they did amidst jovial chatting and joking with one another.

Five male musicians, with their drums, guitars, and ukuleles, were already seated on their stools at the far end of the dining room providing music for the guests as they dined. When the musicians received word that the dancers were ready, the drummers began to beat their drums more forcefully to announce the dancers' arrival (see Moulin 2004 on the power dynamics of cueing up). The performers appeared, flowing gracefully through the dining room and into its central area to the rhythm of the thundering drums. They began dancing with their headdresses bobbing, shredded-leaf skirts swaying, and, most important of all, torsos steady and hips gyrating. Songs varied, as always, between wild, rhythmic *ʻoteʻa* (drum dances), which were accompanied by the pulsating sounds of the drums, and gentler, graceful *ʻaparima* (storytelling dances with words and hand gestures) accompanied by more melodic music that included guitars and ukuleles.

The audience was mesmerized. The men, especially, focused intently. Many abandoned their dinner as they watched with rapt attention. With video cameras poised, many dinner guests watched much of the performance through their camera lenses. Even through the loud music I could hear the constant click of camera shutters. Toward the end of the performance, as is the custom, the dancers went into the audience, inviting individuals—whether eager or reluctant—to be their partners. Dancers were mindful to create memorable experiences and photographic moments for the tourists, and they took care to invite as many guests as possible. As Susan Sontag has said about contemporary culture:

> Needing to have reality confirmed and experience enhanced by photographs is an aesthetic consumerism to which everyone is now addicted. . . . Ultimately, having an experience becomes identical with taking a photograph of it, and participating in a public event comes more and more to be equivalent to looking at it in photographed form. . . . Today everything exists to end in a photograph. (Sontag 1979: 24)

As Jean Yves Teriʻitapunui, one of the dancers, told me, "tourists like to get invited to dance. They can try out their dancing. And their spouse can take a picture of them.

It becomes a nice souvenir." It is precisely this type of souvenir that later, supplemented by narrative, connects the memento back to its origins and in doing so continues to perpetuate the myth. "We do not need or desire souvenirs of events that are repeatable. Rather we need and desire souvenirs of events that are reportable, events whose materiality has escaped us, events that thereby exist only through the invention of narrative" (Stewart 1993:135).

Once the tourists were invited to dance and their photos were taken, it meant that the standard thirty minutes of animated performance had come to an end. At this time the lead dancer announced that one of the men would perform a fire dance outdoors on the dock (to be safely close to water), and several guests moved outside to watch. While he was rapidly twirling his flaming baton and handling and swallowing fire, a skill he had perfected over many years, the rest of the dancers quickly retired to the lounge area to change back into their regular clothing and gather up their belongings for their departure. The timing was carefully planned. As soon as the fire dancer was finished and the guests had retired back inside the hotel, the captain of the hotel boat started the engine to take the dancers and musicians back to town.

Loaded down with various bags and bundles, instruments, and musicians' stools, we all climbed into the boat and off we went. As the boat sped across the water through the dark night, the dancers talked about the performance, expressing general satisfaction with how they danced, but saying that they could have performed still better if they hadn't been so exhausted. Most of them were tired, even before dancing, because it was a Friday—a workday and the end of the workweek for most of them. Jean Yves had spent the day waiting on customers at the fabric store in town. Huguette had been performing custodial services at the bank. Théophile had been hanging onto the back of a garbage truck, jumping off at each house to unload the contents of people's heavy garbage cans. And Willy, one of the musicians, had been driving the van for one of the hotels, shuttling tourists to and from the airport. Others had been working as well. Yet, tired as they were, they now relaxed among themselves. They picked up their guitars and ukuleles and continued to play and sing for the fifteen minutes it took for the boat to race across the water and arrive back in town.

Listening to them play and sing, I thought, as I often did in such spontaneous, post-performance, musical moments, about the differences between performing for others (within the tourist setting) and making music for themselves (outside of it). For them it was a seamless, practical transition—between a staged performance of a rehearsed, photogenic notion of "culture" presented within a tourist setting, and a fluid, spontaneous living of culture outside it.

Jamaica Kincaid, the Caribbean author who has written about tourism, has commented on the irony that exists in countries that on the one hand appoint a minister of culture to orchestrate the performance of culture for tourists, and on the other hand have inhabitants who live their culture daily, but in ways that go unnoticed by tourists.

> Have you ever heard of any culture springing up under the umbrella of a Minister of Culture? . . . In countries that have no culture or are afraid they may have no

culture, there is a Minister of Culture. And what is culture, anyway? In some places, it's the way they play drums; in other places, it's the way you behave out in public; and in still other places, it's just the way a person cooks food. And so what is there to preserve about these things? For is it not . . . that people make them up as they go along, make them up as they need them? (Kincaid 1988: 49–50)

As Kincaid indicates, culture exists in the flexible, fluid, and animated details of everyday life and is generated and utilized as needed. Culture cannot be photogenically staged in a dance performance in a hotel. Nor can it be captured in an image of dancers on a tourist brochure or postcard. Culture is, as Kincaid said, what people construct and use as the need arises. Moulin has commented in particular about Tahitians, who she feels "view culture as something that is constantly created from materials at hand, a replenishable resource" (Moulin 1996: 146). Even though the Office of Tourism has chosen dance as the vehicle through which to share Tahitian "culture" with tourists, tourists could also understand "culture"—and perhaps even more insightfully—if they had access to other dance-related areas of Tahitian life. For example, tourists could learn a lot if, in addition to watching the floor show, they could see the social aspects of preparing and practicing prior to the dance performances, understand what the dancers and musicians do during the day that makes them exhausted even before they begin dancing, know about the dancers' attempts to save money from tourist performances and how they plan to spend it, or witness the spontaneous music and conversation in the transfer boat after the staged performance is done. There is a difference between imagining, viewing, capturing, and reproducing a visual image of a part of culture on the one hand, and living inside a culture on the other. But, as one of Tahiti's postcard producers told me, "tourists want to stay inside the postcard" (Diane Commons, personal communication, 2001).

Within the hotel setting, dance plays an extremely critical role—perhaps the most crucial—by providing tourists with the ultimate, most picturesque, and most advertised, "cultural" encounter they hope to have. Dance is such a prominent and repeated feature of the tourist experience that, as tourists typically move from island to island on a packaged tour, they see similar dance performances at each of their hotels. Because of this repetitive fare, there are always some tourists who, possibly at their third or fourth hotel, only glance up casually as they continue to eat their dinner. After all, they have already captured "culture" on video at the first hotel.

This sense of the repetitiveness of touristic performance can also exist for dancers. At one performance, which took place in the lounge of a cruise ship, I was sitting among the tourists as they watched the dancers. I noticed an unusually disengaged expression on the faces of most of the dancers, who were staring blankly up at the wall behind my head while they danced. When I later asked them about their atypical detachment, one dancer explained, "Oh, didn't you see? There was a television on the wall above your head and we were watching it." Each dance setting has its own cultural rules. Just as one would never see Tahitians perform the *'ote'a mau* in a hotel or on a cruise ship, one would never see them watching television while performing at an important event like Heiva.

While ironies abound, perhaps the greatest irony of all is that in the process of bringing the brochure images to life, dance erases the complexity of Tahitians and their culture from tourists' views. For a hotel to showcase Tahitians only as they appear on stage, dancing in their costumes of shredded leaves and feathers and with coconut shell brassieres, is highly misleading. Within the context of the hotel setting, guests only see Tahitians in limited ways—either as they energetically and exotically dance on stage or as they competently and quietly provide the backbone of the hotel's operation by driving vans, registering guests, carrying suitcases, making beds, serving food, or maintaining the grounds. For tourists to watch Tahitians dance in colorful costumes validates marketing images and tourists' own senses of experiencing "Tahiti." But for tourists to stroll on the hotel grounds and pass a Tahitian weeding a flowerbed in his shorts and T-shirt does not. Tourists are not prepared to encounter the groundskeeper (and, in fact, don't usually "see" him) any more than they are prepared to find rain or mosquitoes during their vacation. The van drivers, food servers, and groundskeepers (like the rain and mosquitoes) are absent in brochures, guidebooks, and postcard images and do not appear in tourists' snapshots or videos (at least not in their shorts and T-shirts, although the irony is that the groundskeeper may also be one of the dancers). Yet when drums beat wildly and dancers flow onto the hotel stage, tourists grab their cameras and feel elated, realizing that they are witnessing—in front of their own dinner table—the scene they have hoped, and are prepared, to experience. In today's visually oriented culture, the video cameras often sit poised by the guests' dinner plates as the tourists wait for the dancers to begin. Through the use of vision, the brochure images come to life. Through the use of photography, the images are reproduced and circulated. In these moments, images of the fantasized place and the material place are brought into line with one another. During the hotel dance performance, expectation and experience, dream and reality, are immediately and vividly united. I once overheard a tourist tell her husband as the dancers began, "Oh, my gosh, can you believe what we're seeing! It's just like those pictures we saw in the brochure. This is incredible!" Click.

Acknowledgments

I conducted research in French Polynesia for a total of fifteen months during five different trips (in 1994, 1995, 1996, 2001, and 2010). I thank the Fulbright Program, the Max and Lotte Heine Philanthropic Fund, the American Philosophical Society, and the Royalty Research Fund at the University of Washington for making the research financially possible. In French Polynesia many friends facilitated my work, most notably Edouard and Kim Tai Piha, Poema and Billy, Rachelle and Philippe, Kiki and Moana, Marietta and Atea Tefaataumarama, Théophile and Huguette Ihorai, Marty and Moe Temahahe, Heitiare and Willy Tereua, Kiki and Bianca Taupu, Jean Yves Teri'itapunui, Georges Matauteute and Pauline Barff, Paul and Vatiana Atallah, Hiti and Turia Gooding, Peto and Mariette Firuu, Bruno Saura, Yoshi Sinoto, Dorothy Levy, Siki Teururai, Mama Rere, and Sabrina Birk. I also benefited greatly from conversations with Paulette Viénot, Karine Villa, Christel Bole, Brigitte Vanizette, Laurent Bessou, Louise Peltzer, Teva Sylvain, Diane Commons, Gilles Fuller, Jan Prince, Richard Shamel, Etienne

Faaeva, Henriette Colombanie, Jean-Pierre Amo, Etienne Ragivaru, and Jean-Merry Delarue. I am particularly grateful to Jane Freeman Moulin, who took a sincere interest in this chapter and provided me with much useful feedback. My husband, Richard L. Taylor, not only accompanied me to the field (as did our daughter Rachel), but also helped in the gathering of data and with the formulation of my ideas.

References

Covit, Bernard. 1968. *Official Directory and Guide Book: Tahiti*. Papeʻete.
Ellis, William. 1829. *Polynesian Researches, During a Residence of Nearly Six Years in the South Sea Islands*. London: Fisher, Son, and Jackson.
Gerrard, Bassigny. 1932. *Island Girls I Have Loved*. New York: Harcourt, Brace and Co.
Henningham, Stephen. 1992. *France and the South Pacific: A Contemporary History*. Honolulu: University of Hawaiʻi Press.
Henry, Teuira. 1928. *Ancient Tahiti*. Bernice P. Bishop Museum Bulletin 48. Honolulu: Bishop Museum Press.
Hort, Dora. 1891. *Tahiti: The Garden of the Pacific*. London: T. Fisher Unwin.
Imada, Adria. 2004. "Hawaiians on Tour: Hula Circuits through the American Empire." *American Quarterly* 56 (1): 111–149.
Jackson, William Chapin. 1938. *You'll Dance in Tahiti*. New York: Putnam.
Kaeppler, Adrienne. 1987. "Pacific Festivals and Ethnic Identity." In *Time Out of Time: Essays on the Festival*, edited by Alessandro Falassi, 162–170. Albuquerque: University of New Mexico Press.
———. 2001. "Accordions in Tahiti—an Enigma." In *Traditionalism and Modernity in the Music and Dance of Oceania*, edited by Helen Lawrence and Don Niles, 45–66. Oceania Monographs, No. 52. Sydney: University of Sydney Press.
Kahn, Miriam. 2000. "Tahiti Intertwined: Ancestral Land, Tourist Postcard, and Nuclear Test Site." *American Anthropologist* 102 (1): 7–26.
———. 2003. "Tahiti: The Ripples of a Myth on the Shores of the Imagination." *History and Anthropology* 14 (4): 307–326.
———. 2011. *Tahiti Beyond the Postcard: Power, Place and Everyday Life*. Seattle: University of Washington Press.
Kincaid, Jamaica. 1988. *A Small Place*. New York: Farrar, Straus and Giroux.
Krauss, Bob. 1988. *Keneti: South Seas Adventures of Kenneth Emory*. Honolulu: University of Hawaiʻi Press.
Lawrence, Helen Reeves. 1992. "Is the 'Tahitian' Drum Dance Really Tahitian? Re-Evaluating the Evidence for the Origins of Contemporary Polynesian Drum Dance." *Yearbook for Traditional Music* 24: 126–137.
Lefebvre, Henri. 1991. *The Production of Space*. Translated by Donald Nicholson-Smith. Oxford: Blackwell. Originally published in French in 1974.
Moulin, Jane Freeman. 1979. *The Dance of Tahiti*. Christian Gleizal: Les éditions du pacifique.
———. 1994. "Chants of Power: Countering Hegemony in the Marquesas Islands." *Yearbook for Traditional Music* 26: 1–19.
———. 1996. "What's Mine Is Yours? Cultural Borrowing in a Pacific Context." *The Contemporary Pacific* 1: 128–153.
———. 2001. "From Quinn's Bar to the Conservatory: Redefining the Traditions of Tahitian Dance." In *Traditionalism and Modernity in the Music and Dance of Oceania*, edited by Helen Lawrence and Don Niles, 233–250. Oceania Monographs, No. 52. Sydney: University of Sydney Press.

———. 2004. "Cueing Up: Situating Power on the Tahitian Stage." *Yearbook for Traditional Music* 36: 109–127.
Robineau, Claude. 1975. "The Tahitian Economy and Tourism." In *A New Kind of Sugar: Tourism in the Pacific*, edited by Ben Finney and K. Watson, 61–76. Honolulu: East-West Center.
Sontag, Susan. 1979. *On Photography*. New York: Picador.
Stevenson, Karen. 1999. "Festivals, Identity and Performance: Tahiti and the 6th Pacific Arts Festival." In *Art and Performance in Oceania*, edited by Barry Craig, Bernie Kernot, and Christoph Anderson, 29–36. Honolulu: University of Hawai'i Press.
Stewart, Susan. 1993. *On Longing: Narratives of the Miniature, the Gigantic, the Souvenir, the Collection*. Durham, N.C.: Duke University Press.
Stillman, Amy Ku'uleialoha. 1988. "Images and Realities: Visitors' Responses to Tahitian Music and Dance." In *Come Mek Me Hol' Yu Han': The Impact of Tourism on Traditional Music*, edited by Adrienne Kaeppler and Olive Lewin, 145–166. Jamaica: Jamaica Memory Bank.
Tetiarahi, Gabriel. 1987. "The Society Islands: Squeezing Out the Polynesians." In *Land Tenure in the Pacific*, edited by Ron Crocombe, 45–58. Suva: University of the South Pacific.

Producing Inalienable Objects in a Global Market

The Solien Besena in Contemporary Australia

Jacquelyn A. Lewis-Harris

The Solien Besena are a unique cultural group originating from the Motu-Koita and Tatana people of the Papua New Guinea south coast region, between Tatana Island and the Brown River. Numerous clan members migrated to eastern Australia in the 1970s up until the late 1990s. The Solien Besena now hold a distinctive ethnic marginality in both Papua New Guinea and Australia and consequently they aggressively promote their culture despite societal pressures from the dominant Australian population and other Papua New Guinean groups. They are recognized for their exemplary cultural development work in Brisbane and Sydney, having been invited to two Asia-Pacific Triennial of Contemporary Art exhibits and numerous art festivals along the east coast of Australia.

Solien Besena secular dance performances are performed in Australia during national holiday celebrations and local events. The Roroipe dance cycle, part of the larger Guma Roho funerary ceremony, is performed on rare occasions. It marks the end of mourning and completes outstanding reciprocity claims (Seligmann 1910; Choulai 1997). Central to this discussion is the management of dance components by contemporary Solien Besena artist Wendi Choulai and her clan members in preparation for the 1996 Roroipe performance at the Second Asia-Pacific Triennial of Contemporary Art in Brisbane.

This chapter examines the economic cost of maintaining Solien Besena culture in Australia within an atmosphere of shifting cultural meanings and values. This will be examined by way of two examples, the first being the unusually dominant role of women as cultural knowledge brokers within a customary patrilineal group and the evolution of a secondary economy, encompassing the concept of inalienable wealth and possessions, that has evolved; it is based upon a cultural currency of scarce dance components—specific choreography, chants, and costume items. These components gain their value through the trader's manipulation of the contexts in which they are used and exchanged.

When discussing dance, Solien Besena women often declare, "*Aina asi a mavaru kavamu,*" meaning "We don't dance for no meaning" or "We don't dance for nothing."

The frequent use of this phrase reinforces for those among the group, as well as for the casual listener, that there is a monetary value placed upon their dance activities. They are quick to explain that all their dances are "called" or arranged with an initial exchange of betel nut or cash; therefore, the performance itself is an article of trade. As C. A. Gregory observed in his Papua New Guinea research: "Economic activity is not a natural form of activity. It is a social act and its meaning must be understood with reference to the social relationships between people in historically specific settings" (Gregory 1982: 115). Economic activity lies at the core of Solien Besena dance culture and it is an essential part of their historical and social relationships. Women's conversations are laced with accounts relating to the intricacies and burdens of financial survival while "keeping the culture" and supporting the dance groups in Australia.

Through my interviews and conversations I observed that personal power, contestable values, and commodification all play a part in the dancer's interchange and group trade of costume materials, lyrics, and choreography. The ownership and knowledge of the dance unit, as well as the consequent gifting of costume material, reinforces the status of the dance group leaders and performing artists. There was an ongoing rivalry between the Australian-based groups revolving around the rights to the most traditional items, choreography, and lyrics. The majority of the tension and disagreements among dancers and dance troupes primarily arose from the recognition of the material's monetary and cultural value and its relationship to power. A similar dynamic was discussed in Harrison's article "The Commerce of Cultures in Melanesia" (Harrison 1993) and described by Thomas: "the artifact is not simply a valuable object of exchange or even a gift that creates relations of one sort or another but also a crucial index of the extent to which those relations are sustained or disfigured" (Thomas 1991: 19). The continual search for female dance skirts and the maintenance of good relationships with those close or distant relatives who supply crucial costume materials illustrate how dance relations rotate around the exchange of important cultural items and sustain relationships among the groups. This activity relates not only to Thomas' and Harrison's research but also to one of Mauss' major components in "The Gift," namely the use of object exchange to form and maintain social and spiritual ties (1967: 22, 31, 66). The women's trade activities not only involve international negotiations, creative cash management, and the maintenance of far-reaching reciprocal ties but also display their negotiation skills within ever-changing contexts of the Australian market and environment.

Shifting Meanings—the "Gift" among the Solien Besena

In an effort to comprehend the numerous contemporary exchange systems, multiple levels of object value, and the role of specific items and individuals in the maintenance of Solien Besena identity, status, and power, I surveyed the works of Marcel Mauss and several contemporary scholars who have reanalyzed his theories. Solien Besena negotiations emulate the gift economy theories posed by Mauss. He discussed the principle of the gift exchange as "characteristic of societies which have passed the phase of 'total prestation' . . . but have not yet reached the stage of pure individual contract, the money

market, sale proper, fixed price, and weighted and coined money" (1967: 45). This statement aptly describes the premigration generation of the Solien Besena and helps one interpret their contemporary exchange activities, as these groups operate within the shifting contexts of the global market economy but still participate in the spirit of the gift exchange.

Solien Besena trade of dance components and the resultant effect upon societal relations encapsulate Mauss' definition of total prestation. The precept of an "obligation to give and the obligation to receive" is still a part of their social interactions and remains especially strong within intergenerational family exchanges. "In all these instances there is a series of rights and duties about consuming and repaying existing side by side with rights and duties about giving and receiving" (Mauss 1967: 11). The relationship of Theresa Barlow and Wendi Choulai to their maternal aunt, Helen Chan, offers a good example of this. Both women discussed their "clan obligation" to provide dance skirts or textiles to their aunt upon request; this action was not debatable. Chan, in turn, was very conscious of their obligatory role, maintaining the reciprocal balance by being circumspect in her requests. In our informal conversations she debated whether or not to ask Barlow to choreograph an informal dance for her bowls club. Chan knew that Barlow held two jobs in addition to managing her dance group and that she would feel obliged to do as Chan had asked.

"Total prestation" was applicable to the Australian-based groups' broader cultural exchanges, where items would be used to bind a contract of exchanged services, such as calling a dance or presenting a dancer with a special headdress to ensure that he or she showed allegiance to a specific dance group. Mauss acknowledged that there were possibilities for mixed economic exchanges in his concluding chapter: "It is a complex notion that inspires the economic actions we have described, a notion neither of purely free and gratuitous prestations, nor of purely interested and utilitarian production and exchange; it is a kind of hybrid" (1967: 70). This closely parallels the Solien Besena–Australian economic activities with feather headdresses and costume items, being key prestation objects exchanged solely between clan members, and by utilitarian production mixed with gratuitous prestations being carried out intergenerationally and between dance group members.

Since the term "gift" plays such as pivotal role in understanding the exchange activities of the Solien Besena women, it is important to examine contemporary theories relating to this term. Both Laidlaw and Thomas complained that the definition and interpretation of the gift was often inflated or overextended. "A gift is indeed both a thing and a kind of act, but the emphasis upon the social relation has been almost to the exclusion of the nature of the object" (Thomas 1991: 17). Laidlaw, while expounding upon the idea of the free gift, posed, "What is the basic, irreducible idea of a gift? One party makes over something of theirs to another. There is no 'price', and there is no recompense. It is given, and that is that" (Laidlaw 2000: 22). Their versions of the gift apply to this study, primarily in regard to the individual trade relationships between dance members. Annette Weiner has observed, with some cynicism, "The label 'gift' reinforced the old, inaccurate assumption that material culture in 'primitive' societies is devoid

of particular ownership, thereby making other people's cultural property more easily transferable into the hands of Western collectors or national trusts" (1992: 393). While geared toward people in their indigenous context, Weiner's comments also relate to the Australian Solien Besena, as their discussions would concur that a gift would not be ownerless even if it were used in reciprocity. The women constantly transformed cultural commodities into gifts and thus the item was owned before it was used in exchange.

Gell's and Gregory's view of the gift reflects Mauss' theory but extends the discussion: "Neither flesh nor fowl nor good red herring, the gift is admirably calculated to divert attention and conceal motives while certain crucial rearrangements of social relationships occur" (Gell 1992: 143). Gregory in turn examines the gift from a Marxist perspective, counterpoising gift and commodity as a binary pair. His analysis of the commodities and gift transaction is abstracted from Marx's analysis of capitalism. "Gifts belong to, and reproduce, 'the social conditions of the reproduction of people' within a clan or kinship-based social order; commodities to 'the social conditions of reproduction of things' in a class-based division of labour" (Gregory 1980: 641). The environment, cultural context, or economic system in which the gift might be exchanged seems superfluous in his discussion. What's important is the intent and interaction of those involved in the exchange and how the gift interfaces in that situation. Weiner's, Gell's, and Gregory's definitions of the gift can be observed and applied to the Solien Besena context, as clan members employ gifts in reciprocity exchanges within their system while participating fully in the commodity market to obtain items to be used in future exchange.

Shifting Meanings of Solien Besena Inalienable Objects

To understand the importance of dance skirts, feather headdresses, tapa (barkcloth), and shell jewelry in the development of power and status among the dance group members, one needs to discuss the concept of inalienable objects and wealth. The processing of these objects best illustrates changing contexts–shifting meanings in the Solien Besena milieu.

There are contestable definitions of inalienable objects, all based upon Mauss' study but reshaped and defined by the scholars' philosophical bent. Gregory's Marxist economic approach revolves around class-based and clan-based societies:

> In a class-based society the objects of exchange tend to assume the alienated form of a commodity and, as a consequence, reproduction in general assumes the particular form of commodity reproduction. In a clan-based society the objects of exchange tend to assume the non-alienated form of a gift. (Gregory 1982: 41)

The Solien Besena dance members navigate trade in two arenas: the traditional clan-based form, which involves barter, reciprocity, and gifting, and the Australian class-based economy, where items bought with currency are transformed into important cultural trading objects. These objects, in turn, are used to build and sustain societal ties as well as reinforce identity and cultural understanding among the young Australian-

born. The majority of the ephemeral material, such as choreography, music, and lyrics, generally fall into the inalienable possessions category, as described by Annette Weiner:

> Inalienable possessions are embedded with culturally authenticating Ideologies associated with mana, ancestors and gods that give shape and drive to potential processes. They are imbued with history composed of their own exceptional trajectories and the beliefs and stories that surround their existence. (Weiner 1992: 150)

Inalienable possessions are used as a form of cultural currency, traded and bartered between the Australian and Papua New Guinean clan groups. Costume items such as skirts, older feather headdresses, and tapa cloth have a double value, being both inalienable wealth within the Australian Solien Besena cultural community and an expensive commodity in the broader Australian and Papua New Guinean community. Gregory argues that Weiner's notion of inalienable possessions is based upon special objects being exchanged and shared. He stresses that this muddies the true understanding of the role of goods and gifts:

> These objects must be *kept* not *given;* they are *goods* not *gifts*. This important distinction is missing from Weiner's work, with the result that she confuses *inalienable keepsakes* (goods) with *inalienable detachables* (gifts). The former are valued because, among other things, they store memory of ancestors; the latter are valued because they are the sign of contemporary alliances such as those created between men of renown. Furthermore, we must speak of *guardians,* rather than *donors* or *owners* when talking of goods. (Gregory 2000: 79)

While the lyrics, music, and choreography fit Weiner's description of inalienable possessions as well as Gregory's inalienable keepsakes, the costumes are better described in Gregory's concept of inalienable detachables. The Solien Besena frequently make reference to the guardians or custodians of the dance, meaning those people who owned the dance and had the responsibility of retaining all the choreography and lyrics in memory. The issue of inalienable keepsake guardianship played an important role in shaping the Solien Besena dance groups in Australia. Even though two first cousins had limited rights to certain Solien Besena choreography and lyrics, they chose to form dance groups that featured dance from indigenous groups related to the Solien Besena or their affines. This decision helped them avoid the numerous problems related to obtaining dance rights from the Papua New Guinean guardians and reduced interclan friction in Australia. Although they perform dance sanctioned through their affine connections, they often had to contend with close scrutiny by local custodians. Other dancers, such as Kari Thomas, of Motu-Koita lineage, could dance with Theresa Barlow when performing Solien Besena dance, but she could not use the dance in her own group's repertoire. Even in Australia, the custodian's power of censure and the restricted use of dance components illustrate the viability of Gregory's theory of inalienable keepsakes and the role of the guardian.

The scarcity and marketability of special costume items within the class-based Australian communities reinforces the items' position as goods while helping to establish them as highly valued inalienable detachables within the local clan-based society. Discussions by Mauss and Weiner reinforce the relevance of these inalienable detachables within the clan-based exchanges (Mauss 1967; Weiner 1992). These objects are exchanged with family members for services or gifted to the younger and new dance group members for their commitment to the group. Weiner observed, "The possessions are kept within the family and passed among generations. The loss of the item diminishes the self or the group by extension. It represents the power of cosmological authentication" (Weiner 1992: 6). Inalienable detachables, in the form of older costume pieces and special new items, are circulated among the clan members, thus reinforcing their connection to the clan and their collective identity as Solien Besena. The clan's authentication is a work in progress, revolving around dance, key female players, inalienable keepsakes, and the next generation who receives them.

Wendi Choulai was instrumental in creating essential inalienable wealth through the production and circulation of her contemporary dance costumes. These items became the most important and contestable, inalienable keepsakes to enter circulation within the Solien Besena clans. In 1986, Choulai endeavored to design and construct a woman's dance skirt as part of her senior project at the Papua New Guinea National Art School. Prior to this time, males acquired all Solien Besena skirts through trade, so she had to obtain her clan's permission to construct the skirt and incorporate clan designs. Upon completion, she used her status as the first female college graduate to negotiate the acceptance of the skirt into the clan dances. Her exchange experience was reflected in the research of Fajans (1993), Gregory (1982), and Strathern (1971), in which "the potential of gift exchange—the exchange of like-for-like—establishes an unequal relationship of domination between the transactors" (Gregory 1982: 48). The skirt, called Guma Rami, was a compilation of a customary Motu-Koita fiber skirt and her handmade fabrics. Choulai reflected on the complexity of this project and the role of reciprocity:

> As the making of grass skirts is a traditional trading activity made by certain villages, my first consideration was to acquire this knowledge. This involved contact through in-laws to the village that makes and trades the skirts. It also involved a payment of food and cash that totaled 500 Kina. This was for the construction of a skirt to be made on my own property with control of the color repeats in the skirt. (Choulai 1997: 30)

Choulai reconstructed the Motu-Koita skirt to fit her design concept, taking care to preserve the panels that held the original clan's motif. Choulai stated, "I retained the checked markings as acknowledgement to her (the skirt maker) for being part of the process which [sic] could see me making another payment if the skirt is sold" (1997: 30). In acquiring the skirt, she had to balance status and the power of ownership between the suppliers and herself. Her gift-exchange process was not without difficulties, as the

skirt suppliers saw this situation as a possible financial loss and a situation through which she would potentially profit. In total, she paid an estimated $1,500 US in money and trade items for skirt construction and acceptance into the dance (Choulai, personal communication, 2000). She became the cocreator and guardian of an inalienable keepsake through her redesign of the skirt and presentation of the Guma Rami in ceremony. The Guma Rami skirt was accepted by the elders and community for several reasons. Choulai and her family were highly respected, financially well off, and full participants in the interclan reciprocity exchanges. The Guma Rami and subsequent contemporary skirts eventually became inalienable keepsakes, transforming cultural traditions and playing a pivotal role in the establishment of Solien Besena authenticity in Australia.

Gregory recognizes that contemporary Papua New Guineans traverse both the historic clan-based exchange systems with gift exchange as well as the contemporary class-based systems with market exchange. His theory of gifts (relations between nonaliens by means of inalienable things) on the one hand, and commodities (relations between aliens by means of alienable things) on the other, succinctly encapsulates the exchange activity within the Solien Besena groups. His categorizing framework of exchange-value and surplus-value under commodity, or equal and unequal items under gift (Gregory 2000: 52), are all descriptive groupings of item use undertaken by the women. Outside of Choulai's activities, other members were also actively engaged in transforming objects into gifts and inalienable objects. Several of the women discussed this issue with me, as they worried that they were becoming more dependent on transforming objects from the global economy into costume components that would become gifts. For example, when Barlow could not acquire traditional feathers for headdresses, she visited chicken farms outside of Brisbane to negotiate a bulk price for feathers. These items, in turn, were dyed, trimmed, and woven into feather tiaras that became fledgling gifts, entrusted and bestowed upon the younger dancers who had demonstrated a commitment to staying in the dance group.

Changing Contexts, Slightly Shifting Meanings

In 1995 Choulai called a Guma Roho for the Brisbane Asia-Pacific Triennial of Contemporary Art. Her activities served multiple purposes: it helped Choulai's family complete an overdue funerary cycle for her grandmother Agnes Dahanai, and it repaid clan exchange partners for past reciprocity. The Roroipi performance in the Guma Roho also premiered the Solien Besena culture at an international art exhibit and provided a showcase for her Guma Rami and other contemporary skirts. The calling of the dance ceremony was a complicated operation in which the art and performance took a back seat to the whole process of establishing and sorting out custodianship of inalienable keepsakes. Choulai's experience was encapsulated in Harrison's observation on the exchange of property rights "in return for the kinds of material goods that functioned as prestige items in these societies. It was an exchange of dissimilar goods. Those conferring rights in their rituals were converting their symbolic capital into economic capital, and the recipients were doing the reverse" (1993: 147). Jealousies and misunderstandings arose during the planning, since the ceremony was a commodity and

was viewed as a status-raising opportunity for the clan and the person who called the dance. According to Solien Besena beliefs, it was also a means by which the clan could spiritually and physically establish a claim upon Australian soil (Choulai and Helen Chan, personal communication, 2000).

Animosities first arose when Choulai contacted her extended family to enlist their help for the performance. They questioned her right to call such an important dance and conduct the proper reciprocity, as she was relatively young and had not been raised in the village. As Harrison has clarified in both his 1993 and 2002 articles on the commence of cultures and the shared cultural symbolism, Choulai's difficulties were typical, as traditional copyright, status, power, and ownership was at the heart of the disagreement. Choulai was a respected member of the clan, but not yet a senior member. She remarked about the situation:

> To call dancers to perform ritual is a public statement that goes something like this: "I am now ready to take full responsibility as a mature member of our clan with full regard to our traditions and obligation to ensure their proper continuation." In other words you are saying that you are a "big man". The responsibility is serious and irreverent acts have dire consequences. (Choulai 1997: 23)

In addition to calling the ceremony, Choulai was using an unorthodox source of funding from outside the clan-based system: the Australian government. In the past, the securing of reciprocity-free, outside funds would have been viewed as a positive attribute—stressing the person's status, power, and persuasive ability to obtain outsider's goods to support the clan's activities. To perform the ceremony correctly, she had to engage in two different spheres of exchange, the traditional clan-based exchange and the commodity-driven class-based exchange. She was in a liminal state: a "big man" in the making, partially inside and accepted by her Australian-based clan while still establishing her status among the elders in the Papua New Guinean–based clan. Gregory's discussion of value and rank encapsulated Choulai's conundrum:

> The distinction between value and rank epitomizes the difference between commodity exchange relations and gift exchange relations. The former emphasizes quantity, objects and equivalence; the latter emphasizes quality, subjects and superiority. (Gregory 1982: 50–51)

She was a cautious gift transactor who maintained that she was generating rank for her clan as opposed to rank for herself. As the first Solien Besena to be given a $5,000 AU grant and venue in the Asia-Pacific Triennial of Contemporary Art, she used the funds in reciprocal interactions with the clan and the Papua New Guinean–based dancers. From her clan's perspective, Choulai's status as an artist with political connections in the Australian art world helped her call the Guma Roho and enhance her status. I contend that clan jealousy was connected to Choulai's inherent power to create inalienable objects and have them accepted in both the Papua New Guinea village and Solien

Besena clan-based economy, while maneuvering in the Australian cash economy to pay for the ceremony.

As Harrison has noted in his article on shared cultural symbolism, the transformation of cultural traditions is costly for a reason: "I see these disputes as being analogous to conflicts over the ownership of trademarks, and as drawing on the same underlying conceptions of proprietary identity" (Harrison 2002: 229). Choulai's activities had such a disquieting effect upon both the Papua New Guinean and Australian-based Solien Besena societies that reciprocal negotiations had to be conducted. Several meetings and feasts were held under the advice of the senior members of the Australian-based clan to settle any potential disputes and custodial claims. Choulai noted that "political infighting amongst the clan, had mainly to do with who should be invited to dance and who has authority within the clan. . . . There was also a fear that the (Australian) family group performing the Roroipe would appropriate the dance" (Choulai 1997: 18). Her activities illustrated the contemporary use of gift transaction and the importance of inalienable possessions in the lives of both Australian-based and Papua New Guinean–based Solien Besena. The exhibit and performance were the end result of skillful reciprocity negotiations within both clan-based and class-based economies, resulting in the successful acceptance of new inalienable keepsakes in the clan trade circuit. Through their participation, the youngest members of the Solien Besena–Australian clan were inducted into cultural exchanges and a historic event that encouraged positive attitudes toward their culture and sparked their commitment to their cultural traditions (Chan 2000; Theresa Barlow, personal communication, 2003). Finally, the Solien Besena achieved what was most important to the elders: completion of the funerary ceremonial cycle and the reciprocal transactions.

Both the gift-reciprocity equation posed by Mauss and the market-exchange equation supplied by Gregory (1982) and Gell (1992) are applicable to the Solien Besena's activities. The performance activities demonstrate the Solien Besena's participation in multiple trade systems, traditional and contemporaneous ceremony, and the construction and preservation of inalienable possessions. The Guma Roho episode and Barlow's and Choulai's exchange activities also illustrate the active transformation of cultural traditions within an environment of shifting meanings. Outside of the extraordinary examples such as the Guma Roho funerary ceremony, there are more commonplace examples of inalienable keepsakes creation. Tapa cloth was customarily used for breech clothes and decorative panels on the Solien Besena men's dance costumes. In the past, the groups obtained the material through trading partners, but in contemporary times, mulberry tapa was obtained from a commercial retailer like the Girl Guides Shop or the crafts markets in Port Moresby, Papua New Guinea. This material was manufactured exclusively in the Collingwood Bay area of Oro Province and shipped out to Port Moresby for sale. John Barker documented the contemporary commodification of tapa, noting that by the early 1980s, the Maisin had developed a specialty in the national artifact market, with Papua New Guineans being the major purchasers (2001: 368). In 1994 a threat to the Collingwood Bay rain forests by international forestry conglomerates resulted in Maisin village partnerships with nongovernmental organizations such

as World Wildlife Fund and Conservation Melanesia (Barker 2004). The Maisin Tapa Business Group, in conjunction with Greenpeace, the Peace Corps, and other NGOs was responsible for international tapa sales promotion and exportation. Maisin tapa became the symbol for "an environmentally friendly product that serves the purpose . . . of providing an economic alternative to logging" (Barker 2001: 369).

The Maisin's good fortune produced negative effects in the local market. According to Theresa Barlow and Alma Adamson, pre-1994, a three-foot-by-two-foot piece of mulberry bark tapa sold locally for $25 to $35 AU (personal communication, 1999). In their opinion, the NGO enterprise killed the local market for mulberry barkcloth. By 1999, the same sized tapa sold in Port Moresby for $65 AU, thus making the tapa unobtainable for most Papua New Guineans. Maneuvering between class-based and clan-based exchange, Barlow and Adamson now buy cheaper, Samoan-made, breadfruit bark tapa in the Australian crafts markets. This is a direct commodity purchase; they have no personal trade relations with the Samoan sellers and no cultural connection to breadfruit tapa. This material, with its coarser texture and Samoan designs, is viewed as a poor replacement for the pale, soft mulberry tapa, but the Solien Besena dancers cut and shape it, using the plain reverse side for their decorations. The artificial price spike in the Maisin tapa has now created two classes of tapa wealth among the Solien Besena—one that encompasses the older, well-preserved mulberry tapa pieces that are forms of inalienable wealth and the newer, less valued, breadfruit tapa bought as a commodity in Australia. As the tapa example illustrates, the women have a history of dealing in class-based societies, using commodified alien wealth to construct important items that in turn are used to strengthen their clan-based society and add to their collection of inalienable wealth.

The average Solien Besena female dance costume can cost up to $585 AU, as it consists of several dance skirts, feather headdresses, and shell and other traditional jewelry. Outside of the skirts and jewelry originally brought from the dance leader's villages, most of the items were former commodities from the Port Moresby and Brisbane crafts markets. A contemporary dance costume can easily be seen as an exercise in the transformation of commodities into inalienable possessions. The multicolored palm fiber skirts worn by each female dancer originate in the South Central Province Motu-Koita villages immediately west and east of Port Moresby. The skirts, costing $35 to $55 AU, are either commissioned by Australian-based dancers or obtained from the local markets. As seen in this instance, the majority of the skirts begin as a commodity, being purchased in the open market with no exchange ties, whereas their ultimate distribution and use within the Australian Solien Besena groups redefine their value and role, transforming them from commodity to gift status to inalienable wealth.

The skirts are used as a nonalienated form of a gift, within a clan-based societal situation (grandmother's gift to granddaughters), and later enter the transformation process from commodity to clan wealth upon incorporation into the dance wardrobe. Group leaders or female relatives give new skirts and necklaces to the youngest or most recent dance group members in return for their participation. The young dancers are trained in the care of the items, taught the historic relevance of the item, and entrusted

with their maintenance. The older dancers treat the dance costumes as inalienable keepsakes in the making, knowing that the items escalate in value as they are incorporated into the clan-based dance groups and ceremonial dance. In contrast, most of the younger dancers first view these items as merchandise, like gym clothing or a ballet costume; as Australians, they are engaged in a class-based society, which considers these pieces to be ethnic commodities. In this scenario of changing contexts–shifting meanings, young people—the next Solien Besena generation—gradually begin to understand the value of the inalienable gift as they become culturally aware of a new frame of reference within their clan society.

Conclusion

Changing contexts and shifting cultural meanings are persistently evident in Solien Besena cultural activities in both Australia and Papua New Guinea. Their gift reciprocity and cultural development endeavors would not exist without their active involvement in global and local commodity exchange, thus the common use of the saying "We don't dance for nothing." The women continually manipulate the commodities, exchange values, and venues to maintain and strengthen their cultural activities. Due to their socioeconomic and liminal cultural positions within Australian society, the womens' commodity exchange becomes the economic bedrock of their cultural interactions and the most expedient means through which ordinary items are transformed into inalienable objects in their gift-based economy. As travel between Papua New Guinea and Australia becomes more prohibitive in cost and substitute materials from the global market become cheaper to incorporate into their dance costumes, more instances of commodity transformation will be found within the Solien Besena Australian culture. The dance leaders are very adaptive entrepreneurs and use whatever resources they have to ensure the continuation of their traditions through their dance groups and cultural gatherings.

References

Barker, John. 2001. "Dangerous Objects: Changing Indigenous Perceptions of Material Culture in Papua New Guinea Society." *Pacific Science* 55 (4): 359–375.
———. 2004. "Films and Other Trials: Reflections on Fieldwork among the Maisin, Papua New Guinea." *Pacific Studies* 27 (3/4): 81–106.
Choulai, Wendi. 1997. "Indigenous Oceanic Design in Today's Market: A Personal Perspective." Master's thesis, Royal Melbourne Institute of Technology.
Fajans, Jane, ed. 1993. *Exchanging Products: Producing Exchange*. Oceania Monograph 43. Sydney: University of Sydney.
Gell, Alfred. 1992. "Inter-tribal Commodity Barter and Reproductive Gift-exchange in Old Melanesia." In *Barter, Exchange and Value: An Anthropological Approach,* edited by Caroline S. Humphrey and S. Hugh-Jones, 142–168. Cambridge: Cambridge University Press.
Gregory, Christopher A. 1980. "Gifts to Men and Gifts to God: Gift Exchange and Capital Accumulation in Contemporary Papua." *Man* 15 (4): 626–652.
———. 1982. *Gifts and Commodities*. London: Academic Press.
———. 2000. *Savage Money: The Anthropology and Politics of Commodity Exchange*. Amsterdam: Harwood Academic Publishers.

Harrison, Simon. 1993. "The Commerce of Cultures in Melanesia." *Man* 28 (1): 139–158.
———. 2002. "The Politics of Resemblance: Ethnicity, Trademarks, Head-Hunting." *Journal of the Royal Anthropological Institute* 8 (2): 211–232.
Laidlaw, James. 2000. "A Free Gift Makes No Friends." *The Journal of the Royal Anthropological Institute* 6 (4): 617–634.
Mauss, Marcel. 1967. *The Gift*. New York: Norton and Company.
Seligmann, Charles. 1910. *The Melanesians of British New Guinea*. Cambridge: Cambridge University Press.
Strathern, Andrew. 1971. *The Rope of Moka: Big-men and Ceremonial Exchange in Mount Hagen, New Guinea*. Cambridge: Cambridge University Press.
Thomas, Nicholas. 1991. *Entangled Objects: Exchange, Material Culture, and Colonialism in the Pacific*. Cambridge, Mass.: Harvard University Press.
Weiner, Annette B. 1992. *Inalienable Possessions: The Paradox of Keeping-while-giving*. Berkeley: University of California Press.

Alienation and Appropriation

Fijian Water and the Pacific Romance in Fiji and New York

Martha Kaplan

In changing contexts through time and across the globe, certain Fijian water has shifted in meaning. It has emerged unnamed from springs, free-flowing and uncommoditized in the foothills of the Kauvadra mountain. It has been put in a coconut shell cup and named "*wai ni tuka*" (water of immortality) by prophet-leader Navosavakadua, drunk to induce warrior invulnerability by the Vatukaloko people, and sent to potential allies for consumption. And some recently has become another kind of transacted object, pumped into square plastic bottles with hibiscuses on them and sold in U.S. upscale places like Adams Fairacre Farms, on Route 44–55, in Poughkeepsie, in the Hudson Valley of northern New York State, for US$2.29 for 1.5 liters. Since 1997, Natural Waters of Viti Ltd., founded by Canadian David Gilmour, has pumped water from an aquifer in Ra province, Viti Levu, bottled it, and exported it. It currently has sales of millions of dollars per year in the United States.[1] The bottling plant is located on land owned by the government of Fiji, which can be leased for ninety-nine years, unlike other lands in Fiji, such as those owned by ethnic Fijian kin groups. The local Vatukaloko people have a long-standing claim to the land where the bottling plant is located. How are we to understand the history of shifting cultural meanings of Fijian water and the implicit and explicit discourses of romance and exchange that are its contexts in Fiji and the United States today?

Connecting literature on the politics of the transformation of cultural traditions (especially Sahlins 1996 and Cohn 1983) to literature on the social life of commodities in global contexts (e.g., Appadurai 1986; Mintz 1985), this essay focuses on the curious Pacific romance of U.S. consumers, and on the Pacific romance of Fijian cultural nationalism. On the one hand, why do capitalist U.S. Americans buy Fijian water? Is this a continuation of long-standing Western colonial cultural traditions of conquest, seizure, objectification, and commodification? What U.S. cultural traditions of commodity fetishism and of imagined Pacific romance fill that bottle (pricey for water but cheap for an exotic experience) at US$2.29? How is a peculiarly effective and novel form of global power enacted in U.S. consumption and assimilation of exotic, "indigenous" luxuries? On the other hand, what ethnic Fijian cultural traditions impel a Pacific romance of indigenous rights, nonalienation, and ownership in Fiji? How do concep-

tions of the nature of "people of the land" and "life in the way of *loloma* (kindly love)" shape assertions of land and water rights? How have ethnic Fijians found in forms and processes set up by colonizers forms and processes for defining their own entitlements? Local and national ethnic Fijian projects have had an impact on the Fiji Water bottling company as well as vice versa (see Kaplan 2004, 2005, 2007).

Fijian Water in New York: Corporate Strategies and a U.S. Pacific Romance

What does Fijian water mean to an American consumer?[2] Why would U.S. Americans buy Fijian water? Certainly Americans buy Fijian water in part as a consequence of recent transformations in U.S. water consumption more generally. Americans bought 6.8 billion gallons of bottled water in 2004 (Korolishin 2005). Corporate strategies to persuade consumers to buy bottled water influence its seeming necessity, and in a complex interaction with consumer desires, corporate marketing endows all purchasable water with meaning. Within the panoply of water choices, Fiji Water inhabits a niche. Reading Fiji Water's own labels and talking to consumers, it seems that Americans buy Fijian water as a token of an imagined Pacific of luxury, natural purity, and health. Juxtaposing it with Fidji perfume, an earlier bottled "essence of Fiji," Fiji Water could also be read as satisfying a long-standing European voyeurism. Does it enable some kind of consummation of a Pacific romance?

Fijian water is just one instance of the startling rise of U.S. bottled water consumption: In 1976 U.S. per capita consumption of any kind of bottled water was 1.6 gallons. In 2006 it was 27.63 gallons (http://www.ers.usda.gov/Data/FoodConsumption/FoodAvailSpreadsheets.htm#beverage, accessed October 16, 2008; Korolishin 2005: 14). In 2007 U.S. Americans as a whole bought 8.8 billion gallons of bottled water. Wholesale dollar sales approached US$12 billion (http://www.bottledwater.org/public/statistics_main.htm, accessed October 16, 2008). In 2004 Aquafina was the top seller at 15 percent of the market, followed by 13 percent private label (e.g., supermarket brands) versions, Dasani 12 percent. (Aquafina is bottled by Pepsi, Dasani by Coke. Both are tap water.) Poland Spring accounted for 7 percent of sales, Propel 6 percent, Dannon 6 percent, Arrowhead 5 percent, Deer Park 4 percent, Crystal Geyser 3 percent, Evian 3 percent. In that year Fiji Water was in competition with Evian to become the largest selling imported water in the United States (www.bevnet.com/news/200411–29–2004-fiji_water_aquired_roll_international). Imported water is about 6 percent of the U.S. bottled water market. While imported water is a very small portion of a big industry, it is such a big industry in the United States that even imported water is significant economically, as well as culturally and politically (see also Kaplan n.d., Royte 2008; Wilk 2006).

Corporate Marketing Contexts

Fijian water did not come to supermarket shelves in New York in response to grassroots demand. In the 1980s, transnational corporations made bottled water an element in their future strategies. Political economists Frederick Clairmonte and John Cavanagh (1988) identified the "big fifty" transnational corporations that in 1985 each had

beverage sales of more than US$500 million. All are conglomerates, most marketing a range of foods, beverages, and other products. The late Constance Hayes (2004), a *New York Times* business reporter, describes how Coke, in a schismogenetic relation with Pepsi in the late 1990s, began to distribute Naya (Canadian spring water) and Evian (French spring water), then, in 1999, Dasani (tap plus Coke's mineral salt addition [2004: 247]). Hayes describes the shift Coke planners had to make and did make in envisioning water as part of their long-term marketing plan. Marketing Fiji Water, Gilmour and his company skillfully interacted with this much wider context and found a successful niche for Fijian water.

Corporate distribution tactics create meanings for consumers. The sudden omnipresence of bottled water, via the beverage distribution systems so intricately set up by soft drink bottlers, enables bottled water to seem an obvious alternative, a reasonable choice, to be preferred to tap or drinking fountains (Robert Foster 2002 and personal communication 2006). In the cafés in Barnes & Noble, Fiji Water is the bottled water for sale. Thus, via supply, it becomes an almost inevitable choice. Otherwise, if you want a drink you have to drink something caloric, or less "natural," or a hot beverage, or you have to leave the café and go out to the water fountain, near the bathroom. So availability makes the water seem obvious, not a peculiar or novel choice. But of course there is more to the meaning of bottled water, and Fiji Water in particular, than availability.

There is also fomented fear about public water, from mistrust of drinking fountains to public water supplies. An industry analyst, Kitty Kevin, began a 2004 article about bottled water remarkably frankly, stating that people worry about water safety, and "worry sells." Interestingly, there is a confluence between leftist environmental concerns about water pollution (a long-standing concern in areas of New York State adjacent the Hudson River), right-wing conspiracy theories about fluoridation, and beverage industry interest in encouraging water purchase (see Kaplan n.d.). Clairmonte and Cavanagh see this as part and parcel of privatization, an attack by corporate capital and its political associates on public-sector enterprises (1988: 127), where "consumers are being molded by multibillion dollar advertising campaigns to repudiate public sector tap water" (1988: 127). Industry planners both respond to and create consumer desires, especially when it comes to products that can connote health or wellness, a major American preoccupation.

On the one hand, a long history of health, body, and agency practices provides some of the context. Certainly Fiji Water taps into long-standing European and U.S. interest in health and specialty waters, encountered at spas or in rural resorts (see Chapelle 2005). (Including, in New York State, Saratoga Springs.) This deep history of water-related body practices articulates with a recent trend of the past two decades in the United States that involves a complex, at least three-sided interaction of consumer agency with professional and public institutions and with corporations. The meteoric rise of bottled water in the United States is simultaneous with the rise of nutritional "supplements" as a major industry and as an increasing U.S. "body practice." In both cases, individual people often choose to buy something they believe is good for them.

People find bottled water is virtuous compared to soft drinks or alcohol ("no calories, no chemicals"). Relatively small amounts of money spent allow people to treat their own bodies through supplements—unhindered by medical authority and/or the insurance industry. With purchased water, one can address the "need" often quoted to me by informants that "you are supposed to drink eight glasses a day" to be "hydrated." Further, it is felt that you can control what you drink.

But what is also interesting is the way that bottled, purchased, nonshared water has come to connote health and purity. Just as with supplements, new cultural meanings emerge in the creation of a sense of agency, health, and purity through purchase and individual ownership and consumption of bottled water. Especially when it is Fiji Water.

Semiotics of Fiji Water: Pacific Romance, Luxury, Nature, Health, and Agency

Guy Laroche's 1966 Fidji perfume—which has no ingredients originating in Fiji—was probably the first globally transacted bottling of essence of Fiji. It cost US$44.99 for 1.7 oz. on Amazon.com in the fall of 2005. In contrast, on the web on February 17, 2006, you could order twenty-four 16.9 oz. plastic bottles of Fiji Water for US$34. The price of Fiji Water signals luxury, and an exotic luxury, like the perfume, but far less expensive. And there are some fancy, pricey add-ons available, like metallic foil "sleeves" you can order on the Fiji Water website for gift bottles or restaurant serving. But most of the Fiji Water ad copy, and the bottle labels, evoke nature ("Natural Waters"), health, purity, and a remote, indigenous origin, far from "continents." In this section I briefly introduce a reading of Fiji Water's own ads and intentions.

The original packaging and website up through 2005 emphasized pristine, natural, tropical beauty: "The Origin of Fiji Natural Artesian Water is rainfall, which over decades filters into an aquifer deep beneath volcanic highlands and pristine tropical forests on the main island of Viti Levu in Fiji. Separated by over 1,500 miles of the open Pacific from the nearest continent, this virgin ecosystem protects one of the purest waters in the world. Fiji Natural Artesian Water has a soft, refreshing taste."

One of the interesting things about the Fiji Water label is that it goes straight to nature for its imagery. While one could mobilize a romantic "gift economy" image to sell a product associated with Fiji (it has been a part of Fiji tourism promotions) it is not being used to sell Fiji Water. There are no people (not even indigenous, exotic, friendly "others") pictured on the Fiji Water bottle. The bottle has a life of its own as a desirable object. Now, when U.S. Americans partake of the ritual meal of turkey at Thanksgiving, one consumes the indigenous product (turkey is the indigenous bird) and thereby remakes oneself as American. Thanksgiving is a softly scripted ritual that commemoratively, viscerally traduces and synthesizes a complex reality of conquest, people, politics, and history. But who or what do you become when drinking Fiji Water?

Are you a voyeur, the Western explorer, trader, tourist, peering through the hibiscus flowers to watch a beautiful Pacific maiden bathe in a waterfall? That is what the first version of the Fiji Water bottle brought to mind for a group of Americans I spoke with in the fall of 2005. For them, Fiji Water's packaging evoked Hollywood images. They

spoke of 1950s movie and stage practices of gazing, picturing, and desiring a sensual, virginal, but accessible "other" (see also Said 1978; Lutz and Collins 1993; Wilson 2000). So, in drinking Fiji Water, does one become a satisfied voyeur?

There were changes in Fiji Water's labeling that can help us pursue this further. In 2004 Gilmour sold the company, reportedly for US$50 million (*The Review,* December 16, 2004, p. 3), to Roll International, a privately held company owned by a wealthy California couple who also own Paramount Citrus and Paramount Farms, the world's largest growers and processors of citrus, almonds, and pistachios, as well as the Franklin Mint, which markets collectibles. They also own a line of exotic fruit drinks, including Pom pomegranate drink. The company has made some changes to the Fiji Water label. Since the water is pumped from an aquifer, they have stopped using the waterfall image and replaced it with text that explains how pure the water is, untouched by air or hands (see Fall 2005 Fiji Water press release).

The 2006 website copy begins "Untouched by Man. Until you drink it" (Fiji Water Website, http:// fijiwater.com, accessed Feb 17, 2006). It would seem that this ad copy makes the voyeuristic experience almost palpable, offering the viewer/consumer/drinker the chance to be the first "Man" [*sic*] to touch.

Fijian Water from Vatukaloko Lands in Fiji: A Pacific Romance and the Refusal of Alienation

In Fiji itself, Fijian water from Vatukaloko lands has had different meanings in changing political contexts. During Fiji's colonial and postcolonial history, different ethnic Fijians have mobilized their own romantic vision or self-understanding as indigenes or "people of the land," and water has played a part in these projects. More than a century ago, water from springs at the foothills of Nakauvadra was a token of anticoastal and anticolonial hinterland divine power; now Fijian water's new global desirability infuses new meanings as do changing local and national contexts. A history of colonial separation of colonized peoples and colonial preference for ethnic Fijians was shaped in part by a Western Pacific romance and resulted, dialogically, in special standing for Fiji's indigenous "landowners" (and water owners too). Articulating with diverse ethnic Fijian constructions of the power and rights of indigenous peoples, a romance of indigenous ownership has come to shape contemporary ethnic Fijian mobilization as special shareholders in the nation. Thus, as we shall see, Vatukaloko understandings of Fijian water begin with the question of whose land, whose water Fiji Water is, and the question of what the nature of ownership might be.

It is important to note that complex interconnections are not new or recent for Fiji. In the 1700s, the islands now called Fiji were, for the kingdom of Tonga to the east, a source of husbands for sisters of kings of Tonga, also of mats, canoes, and political systems. Circa 1800, Fiji, like other Pacific islands, was a source for the China trade of *bêche-de-mer* and sandalwood. From the 1840s on, white settlers tried growing cotton, vanilla, and ginger for export. From the 1870s on, with cession to England in 1874, Fiji was a classic British sugar colony, producing the sugar that, Sidney Mintz (1985) shows us, provided the calories for the tea of England's proletariat. Fiji's sugar indus-

try did not turn the indigenous people into plantation laborers, but rather employed Asian indentured laborers, in the case of Fiji, from India (see Kelly 1991; Lal 1992). Until recently, including following independence in 1970, sugar was the backbone of the economy. This has changed. In 2004 Fiji's main businesses and exports earned slightly more than F$1 billion. Tourism accounted for around F$500 million a year, garment exports grew from almost nothing in 1988 to a record F$313.9 million last year. Plantation pine is a F$35 million industry, and plantation mahogany is destined to become a larger one. Exports of fresh tuna are running at F$50 million and other fish exports make for a total approaching F$100 million. Gold and sugar each earn significant incomes, but less than in years past, and then there is mineral water, a sector with essentially one company: F$24.7 million (Keith-Reed 2005).

Speaking very locally, the water sold as Fiji Water comes from an aquifer below the lands of the Vatukaloko people who live in Ra province in the north of Fiji's largest island. They are well known in Pacific history, and in literature on anticolonial movements, for their late nineteenth-century anticolonial political religious movement against British colonizers and Christianity, led by a man called Navosavakadua. Among the Vatukaloko, in the nineteenth century, this water was distributed to make political alliances, had special powers, and more recently—ironically for water—has been claimed as a special possession of "*land*owners," or indigenes (the ethnic Fijian word is *taukei*) (Kaplan 1995, 2004, 2005).

Beginning in the 1860s Vatukaloko people asserted their autonomy and their ritual position, in opposition to eastern coastal Fijian kingdoms and in opposition to Christianity and British colonialism. The Vatukaloko asserted their autonomy by claiming they were ritually prior, more authentically indigenous than other more powerful chiefly lines and polities, because they were linked to the gods of the Kauvadra range. In the 1870s, most of the Vatukaloko people followed Navosavakadua, an oracle priest and member of an installing lineage, who sought to establish a new kind of polity. Rather than being authorized by the "foreign" *mana* (effective power) of a chief's *lewa* (rule), it was made powerful by its connection to the center of autochthony, or indigenousness, which were the gods of the Kauvadra range. Rather than a kingdom led by a "stranger king," it was a land-centered polity, led by an oracle priest, a member of the kin group that installs the chiefs and embodies autochthonous power.

Navosavakadua skillfully gave meaning to foreign and indigenous powers and then re-aligned them. Where Cakobau and other eastern chiefs adopted Christian gods and British forms of rule as powerful foreign forms, Navosavakadua preached that what was powerful was powerful because it was autochthonous and Fijian. Thus Jesus and Jehovah were Fijian gods. Water was an important token in Navosavakadua's polity; he and later followers sent out clay and coconut vessels filled with *wai ni tuka*, "water of immortality," to those who wished to join his mobilization against coastal chiefs and colonizers. It is not incidental to his claims to special power that he sent his allies water whose source was not foreign or coastal, but which sprang from the foothills of this sacred mountain range.

Fiji's people of the land were in many cases also landowners in new colonial terms.

Governor Sir Arthur Gordon's romantic visions of Fijian social evolutionary simplicity articulated with his governorial intent to plan and control Fiji's economy from an ordering center (France 1969; Kaplan 1989, 1995; Kelly 2004). Gordon was one of the great colonial voyeurs. His colonial project was an elaborate playing out of his fantasy, openly nostalgic, of being a lord among a brave, rustic people whose unspoiled simplicity and demonstrated capacity for improvement rivaled the Scottish highlanders of days past. For many ethnic Fijians, chiefly leadership was preserved, lands were legally allotted to them, and "custom" was extolled. But the Vatukaloko colonial experience was different. Criminalized and deported by the colonial British because of Navosavakadua's anticolonial movement, the Vatukaloko were not living on their lands when the Colonial Commissions traveled the islands to register kin groups and their traditional landholdings. Eventually 83 percent of Fiji's land was allotted to kin groups and their descendants, owned communally and inalienably. But almost none went to the Vatukaloko. Their lands fell into the hands of white settlers and by 1926 were sold to the Colonial Sugar Refining Corporation (CSR), the colonial-era sugar refining monopsony, as a cattle ranch. At independence in 1970 the new Fiji government bought the land from the departing CSR and in 1973 established a private company 100 percent owned by the Fiji government; the lands were used to ranch cattle. In the 1990s, the post-coup Rabuka government leased part of this land to David Gilmour's corporation, "Natural Waters of Viti."

In the 1990s, Gilmour, a Canadian who owns a very expensive resort called the Wakaya Club on another Fiji island, Taveuni, had gotten interested in the water under the Yaqara land. From a Fiji perspective, the stories are that Gilmour was friends with Ratu Mara, Fiji's prime minister from independence in 1970 till 1987. One story goes that at his resort Gilmour or his guests noted that they were drinking *imported* bottled water while surrounded by pristine natural beauty. Perhaps Gilmour, entrepreneurially brilliantly, wanted to "bottle" the resort experience and sell it en masse, one could say "democratize" it. Gilmour might not have known Ra and might never have tasted this water. He was not known to the Vatukaloko. He had interests in gold mining in various parts of the world, and he "borrowed geologists from his gold business to tap the Fiji source" (*Newsweek*, July 30, 2001). But he and/or industry advisers knew both the Fiji political and land tenure scene and the global market potential well enough to know that he needed some rentable land in Fiji with a ninety-nine-year lease where he could bottle water that could be sold as Fijian water. And that meant that it couldn't be 83 percent of Fiji's land, owned inalienably by Fijian kin groups, leaseable on agricultural leases only for up to thirty years at a time to Fiji's other half, the landless Indo-Fijians. But Crown land, since independence it was "national" land, could be leased for a stretch that would satisfy an investor. A bottling plant is now located at Yaqara, with pipes sunk deep into the aquifer. The distinctive square bottles are made on site from imported plastic; the water goes directly into them. Cartons are produced locally.

Since Gilmour built the bottling plant in 1998, Vatukaloko people have had differing responses. Some people have worked at the plant and are satisfied. The Vatukaloko people set up their own corporation, the Vatukaloko Investment Company, Ltd., headed

by Vatukaloko chiefs, to provide security, maintenance and groundskeeping, and laundry and meal service to the bottling company. In ensuing years, however, some of the nearby *mataqalis* (kin groups) were disillusioned with the Fiji Water company. Villagers from Naseyani sought to open their own bottling project, using springs at Nananu. A culminating moment of dissatisfaction came on July 12, 2000, during the turmoil following the 2000 coup. The *Daily Post* reported, "Over 80 villagers armed with spear guns, knives and sticks seized the Natural Waters of Viti Ltd. factory" (Seema Sharma, "Water Plant Seized," *Fiji Times,* July 14, 2000). The takeover ended with arrest of the occupiers, and charges against them were eventually dropped. The company continued to contract for services with Vatukaloko people and has sponsored a number of initiatives for local development, including building kindergartens in local villages and settlements.

The Vatukaloko refuse alienation from their land. Beginning with Navosavakadua, they phrased their autonomy in terms of their ritual priority, their indigenous or autochthonous status. The remarkable conviction of many of the Vatukaloko people that land they had not held title to or owned during the 130 years of legislated private property in Fiji was indeed inalienably "theirs" made the takeover action legitimate and moral. This tenacious sense of ownership, of being vested and entitled to the returns on that ownership, has endured through more than a century. Strikingly, they have found in the colonial forms and processes set up by colonizers, and carried forward by colonial chiefly Fijian bureaucrats, forms and processes for defining their own entitlements.

Elsewhere I have described in greater detail how the concepts and practices of being *"itaukei"* owners of the land, for the Vatukaloko, articulate with wider Fijian ethnonationalist postcolonial politics (Kaplan 2004, 2005). Despite the atypical history of the Vatukaloko, their takeover in 2000 mirrored the actions of many other ethnic Fijians who "took over" hydroelectric stations, dams, roads, and resorts following the 2000 coup. Moreover, the most recent takeovers illuminate recent shifting meanings of *"itaukei"* ownership and being people of the land.

It is most likely that in the early nineteenth century the status and meaning of *"itaukei"* was particularly important in the ritual politics of chiefly leadership. Land people were warriors, farmers, priests, and installers of chiefs. Owners of the land variously mobilized their power to install, support, or constrain chiefs. In a shift in meaning it was the British who insisted on the codification of land ownership and explicitly linked it to corporate kin group ownership of land. Throughout the twentieth century, ethnic Fijians variously and creatively construed landownership as being people of *loloma*. Translated as "kindly love" or "compassion," *loloma* has connoted Christ's grace (Kaplan 1990), reciprocity (Sahlins 1972, 1985), hospitality, and a fundamental interconnection of individuals, their kin groups, ancestors, and their ancestral lands. Most pointedly, in much of the twentieth century many ethnic Fijians, including chiefs, colonial and postcolonial political leaders, and commoner Fijians, contrasted their generous and hospitable "life in the way of *loloma*" with an imagined and despised "life in the way of money." "Life in the way of money" was held to be the cultural attribute of Europeans, but also especially of Fiji citizens of South Asian descent, and I have also

heard ethnic Fijians call it "life in the way of the devil," a conflation of the capitalist entanglements and non-Christian religion of Indo-Fijians. Ethnic Fijian refusal of alienation went hand in hand with a refusal to understand the situation of the Indo-Fijians whose colonial experience was highly different from that of ethnic Fijian landowners (Kelly 1991, 1992, 1999; Lal 1992). Indo-Fijians emerged from plantations owning no lands and had recourse only to wage labor or entrepreneurship to make a living.

But at the turn of the millennium, cultural meanings of being an ethnic Fijian "*itaukei*" again shifted. The takeover goals of the Vatukaloko were not to dispossess the water-bottling factory, and the takeover goals of other ethnic Fijians were not to drain the Monasavu dam waters and end hydroelectric power, nor to close resorts. No one seems to want to leave the *yavutu* (origin lands) empty for the ancestors to inhabit. The goal is to receive payments (trust funds, higher rents, scholarships) and employment. However, this is not simply seen as a matter of rental or leasing. The insistence on the trust funds and on the acknowledgment of the contribution as essential to the endeavor emphasizes a different emerging cultural meaning. Use of ethnic Fijian land is now explicitly seen as the ethnic Fijian capital contribution to businesses, the national economy, and the nation-state more generally. In the view of coup leaders at the national level, Fijians are seen as permanently deserving of political leadership because of their contribution of capital in the form of land—and now water. The capital of other investing corporations is discounted (and there are sound politics to this sense of entitlement to the fruits of the investments of colonial capitalists or North American water bottlers, who after all took and take fine profits from Fiji). But unfortunately, the poorly compensated labor of Indo-Fijian plantation workers from 1879 to 1920, and the work of Indo-Fijians since then, is also seen as secondary. So too, if ethnic Fijians are seen as specially vested citizens, then the political rights of a multiethnic citizenry are in question. In the context of indigenous continuity and rights, Fiji Water comes from the lands of the Vatukaloko people, and the corporation that profits from it owes them profits. In the context of a multiethnic nation-state, rent paid for national land is owed to the multiethnic citizenry. The ethnic Fijian Pacific romance holds tenaciously to a nonalienated way of life, but allows less compassion for "others." What of the consumers of this water of the land? Ironically, the success of the water company relies less on the success of Fiji's indigenes or their actual political plans than it does on global consumers' hopes for (or fantasies about) Fiji and the nature of being an indigene.

A U.S. Pacific Romance: Assimilating the Indigene

In Fiji in the 1870s, Sir Arthur Gordon, colonial governor and a consummate political voyeur, imagined ethnic Fijians as simpler people, evolutionarily enmeshed in precapitalist, communal, kin-based life. Unusually routinized in Fiji's colonial land tenure system, this imagination is also the stuff of voyeuristic romantic fantasies. Do U.S. consumers' imaginations continue the British colonial categories of Fijians as savage rather than civilized? And do drinkers of Fijian water want to colonize the "other" or to emulate the "other"? Does purchase of an exotic commodity like Fijian water signify a U.S. anticapitalist desire for a vacation land, a holiday from first world cares, from

civilization? In the U.S. American imagination, are Fiji and Fijian water also tokens of generosity, noncapitalist exchange, hospitable peoples, langorous sensuality? Or, in the current U.S. does Fiji Water evoke a postcolonial recognition of obligation? Might Fiji Water purchase be imagined as a gesture across the globe of aid and assistance from a first-world to a third-world people, the sort of consumption urged by purveyors of "Fair Trade" products?

Based on my research so far, I find no attempt on the part of U.S. drinkers of Fiji Water to aid or even acknowledge the existence of actual indigenes, neither ethnic Fijians nor Fiji citizens, by drinking the water. In all the versions of the Fiji Water website I have seen, there is no mention of local ethnic Fijian social or political history. There is certainly no discussion of rents or land ownership issues! There are also no Fijian people portrayed. This is a very different marketing and consuming situation from "Fair Trade" branding, which often addresses in packaging copy or advertisements the human, social conditions of production. Recollect the recent 2006 website copy:

> Untouched by Man. Until you drink it.
> Please do not touch the water: it's our number one rule.
> You see, FIJI Water's state-of-the-art bottling facility was designed to protect the purity and quality of our water every step of the way. It literally sits right on top of an aquifer, and the water is drawn into the plant using a completely sealed delivery system, designed to prevent any possibility of human contact.
> So, until you unscrew the cap, FIJI Water never meets the compromised air of the 21st century. No other natural waters can make that statement.
> The nature of water. (From the Fiji Water website, accessed February 17, 2006)

Note that instead of fair trade, civilizing mission, or a fulfilled romance, Fiji Water's 2006 bottle labels and website copy promises instead, if I may recontextualize the phrases, "a completely sealed delivery system, designed to prevent any possibility of human contact."[3] It promises an experience of fulfillment through commodity fetishism.

Conclusions

A reading of this labeling and advertising copy for Fiji Water shows that the U.S. consumer is not a voyeur and participant in a Pacific romance—romance as human relationship—but an initial, first encounterer, not of people but of pristine nature itself. The first "Man" to touch the water is not, I would argue, a fulfilled voyeur. Rather, he is the U.S. American self-named "discoverer" of a land that is in reality full of people but is asserted to be empty nature. Picturing no Fijian people, ultimately Fiji Water's self-presentation does not invite you to meet, to aid, or to ravish an indigenous person. The water is marketed through skilled product placement, placing it directly in the hands of U.S. actors and celebrities and directly in the obvious "natural" spots for purchase of a drink in the café of a Barnes & Noble. Bottle in hand, commodity fetishized, the

promise, the hope, for the U.S. consumer, is to be the indigene, to restore health like an imagined indigene.

The cultural meanings of Fiji Water for U.S. consumers are both similar to and different from British imperial iterations of the Pacific romance. The colonial British recognized, extolled, and theorized their "civilization" and their colonial relationship. The commodities of empire were conceived as luxurious products of industry or conquest. Bernard Cohn (1983) showed how it was the British who loved the luxury, the ceremonial they attributed to those they ruled. James Walvin (1997) has shown how the British valued "fruits of empire" that added luxury to everyday consumption. In the English view, white bread, as E. P. Thompson (1971) showed, or refined sugar, as Sidney Mintz (1985) showed, were held to have a purity derived from their entire processing, and therefore were better. Marshall Sahlins (1996), reflecting on the sadness of sweetness, connects Americans to a wider Western Judeo-Christian history of a needful self, making these luxuries not only high culture but solutions to a strongly felt problem, the body corrupted by human history and agency. But like Bernard Cohn, Sahlins also points us to consider U.S. cultural specificity. Is there an alternative American solution to the problem of the corrupted, needful body? I would argue that just as the nature of U.S. power and depredation is different, so also here is an American approach to saving the body from its history. Even in their exotica American desires are distinguishable from the imperial British love of finery and the refined. The British desired augmentation, the U.S. Americans want discovery and inner simplicity. It is not surprising to me that the big seller of bottled essence of Fiji in the United States is not expensive French perfume, but water. For U.S. Americans Fijian water is a "democratized" luxury that promises purity and an authentic first contact with nature.

U.S. Americans have a long cultural tradition of political symbolism in which white Americans claim identity as indigenes and consume indigenous products. White colonists, protesting British taxation without representation, disguised themselves as "Indians" when they threw tea in Boston Harbor, claiming autochthony in the face of the "foreign" British. The post–Civil War origins of the yearly national holiday of Thanksgiving are known to few, but the practice of consuming turkey, the indigenous bird, at the yearly ritual is omnipresent. Generations of U.S. American "boy scouts" and summer campers have mastered imagined Indian lore, making and remaking selves.[4] Surely it is an open question whether the desire is to "be native" or to make the self through reflection on others. But in U.S. consumption, human relationships are devalued in favor of the paramount relationship of consumer and desired product. And U.S. Americans currently long for tokens of nature. Radically uninterested in history, U.S. consumers of Fijian water seek pleasure, fulfillment, and health, indeed nonalienation, through being the imagined "first" to touch this natural water (see also Kaplan 2007).

Across the globe, Fijian water has brought together complex desires, practices, and meanings. Strikingly, its success in the U.S. market seems to depend on its remarkably effective denial of connection to actual origins, colonial history, U.S. power, and real people. "It really is from Fiji" the website insists, but perhaps the real success of the product is that buyers do not believe there really is a serious, multiethnic postcolonial

Fiji out there, imagining instead an original, natural, empty Paradise. Fiji Water speaks to U.S. cultural desires for naturalness, not just with any pure natural spring water, but native nature, from a native, natural nation. In Fiji, the history of water from the foothills of the Kauvadra range has engaged the cultural politics and meaning of "land-" (and water) "owning" in highly consequential ways. In the context of the global intricacies of the flow of this water, the Pacific romances of U.S. consumers and of Fijian cultural nationalism have intensified and transformed.

Acknowledgments

I thank the government of Fiji for research permission in 2002, 1991, 1996, and 1984–1985. I appreciate research funding from the Vassar College Faculty Committee on Research and the Mellon Faculty Research Enhancement Fund, Vassar College. Warm thanks to Elfriede Hermann and the sponsors of the conference at which this chapter was initially presented.

The first version of this chapter was written in 2006, and in general the present tense refers to 2006–2007. The economic crisis of 2008 is likely to strongly affect bottled water sales in the United States and globally. Since this chapter was written a number of important works on water by scholars and journalists have been published, only some of which could be noted.

Notes

1. Natural Waters of Viti is a privately owned company and therefore sales and earnings figures are not publicly available. (It was sold by Gilmour to Roll International Corporation in 2006.) Thus I don't have local figures for sales in the Hudson Valley region of New York State, where this research is carried out, but the water is available at local upscale stores and restaurants and at Barnes & Noble cafés.

2. This section addresses some issues also raised in Kaplan 2007. On issues of environment, health, and water, see also Royte 2008 and Szasz 2007, both of which were published after this chapter was completed. See also Wilk 2006.

3. In the fall of 2007 a number of bottled water companies began to emphasize environmental goals, with strategies such as reducing the plastic content in bottles or reducing emissions in manufacturing or transporting bottled water. On Fiji Water's "green goals," announced in November 2007, see Deutsch 2007: C3. For an analysis that focuses on bottled water as a strategy of "quarantine" see Szasz 2007. On U.S. bottled water use and conceptualizations of nature, see Wilk 2006. On American self-imagery as encounterers of pristine nature, see Kaplan 2007.

4. There is an extensive literature on white U.S. American appropriation and self-identification as Indian, which considers in detail histories and varying motives for "playing Indian" (see for example, Deloria 1998; Green 1988; on the "Boston Tea Party," see also Young 1999).

References

Appadurai, Arjun. 1986. *The Social Life of Things: Commodities in Cultural Perspective*. Cambridge: Cambridge University Press.

Chapelle, Francis H. 2005. *Wellsprings: A Natural History of Bottled Spring Waters*. New Brunswick, N.J.: Rutgers University Press.

Clairmonte, Frederick, and John Cavanagh. 1988. *Merchants of Drink, Transnational Control of World Beverages*. Penang, Malaysia: Third World Network.

Cohn, Bernard. 1983. "Representing Authority in Victorian India." In *The Invention of Tradition*, edited by Eric Hobsbawm and Terence Ranger, 165–210. Cambridge: Cambridge University Press.
Deloria, Philip. 1998. *Playing Indian*. New Haven, Conn.: Yale University Press.
Deutsch, Claudia. 2007. "For Fiji Water, a Big List of Green Goals." *New York Times*, Wednesday, November 7: C4.
Foster, Robert. 2002. *Materializing the Nation: Commodities, Consumption and Media in Papua New Guinea*. Bloomington: Indiana University Press.
France, Peter. 1969. *The Charter of the Land: Custom and Colonization in Fiji*. London: Oxford University Press.
Green, Rayna D. 1988. "The Tribe Called Wannabee: Playing Indian in America and Europe." *Folklore* 99 (1): 30–55.
Hayes, Constance. 2004. *The Real Thing: Truth and Power at the Coca-Cola Company*. New York: Random House.
Kaplan, Martha. 1989. "The 'Dangerous and Disaffected Native' in Fiji: British Colonial Constructions of the *Tuka* Movement." *Social Analysis* 26: 20–43.
———. 1990. "Christianity, People of the Land, and Chiefs, in Fiji." In *Christianity in Oceania*, edited by John Barker, 189–207. Association for Social Anthropology in Oceania Monograph XII. Lanham, Md.: University Press of America.
———. 1995. *Neither Cargo nor Cult: Ritual Politics and the Colonial Imagination in Fiji*. Durham, N.C.: Duke University Press.
———. 2004. "Promised Lands: From Colonial Law-giving to Postcolonial Takeovers in Fiji." In *Law and Empire in the Pacific: Fiji and Hawai'i*, edited by Sally Engle Merry and Donald Brenneis, 153–186. Santa Fe, N.M.: School of American Research.
———. 2005. "The *Hau* of Other Peoples' Gifts." *Ethnohistory* 52: 1.
———. 2007. "Local Politics and a Global Commodity: Fijian Water in Fiji and New York." *Cultural Anthropology* 22 (4): 685–706.
———. N.d. "Lonely Drinking Fountains and Comforting Coolers: Paradoxes of Water Value and Ironies of Water Use." Forthcoming in *Cultural Anthropology*.
Keith-Reed, Robert. 2005. "Fiji Focus: Fiji Water Creating Waves in the United States: Entrepreneurs Optimistic about Future." *Pacific Magazine*, October 2005.
Kelly, John D. 1991. *A Politics of Virtue: Hinduism, Sexuality and Countercolonial Discourse in Fiji*. Chicago: University of Chicago Press.
———. 1992. "Fiji Indians and 'Commoditization of Labor.'" *American Ethnologist* 19: 97–120.
———. 1999. "The Other Leviathans: Corporate Investment and the Construction of a Sugar Colony." In *White and Deadly: Sugar and Colonialism*, edited by Pal Ahluwadia, Bill Ashcroft, and Roger Knight, 95–134. Commack, N.Y.: Nova Science Publishers.
———. 2004. "Gordon Was No Amateur: Imperial Legal Strategies in the Colonization of Fiji." In *Law and Empire in the Pacific: Fiji and Hawai'i*, edited by Sally Engle Merry and Donald Brenneis, 61–100. Santa Fe, N.M.: School of American Research.
Kevin, Kitty. 2004. "Water Log, 2004." *Beverage Industry*, August. Edgell Communications, Inc.
Korolishin, Jennifer. 2005. "Water, Water Everywhere: Bottled Water Category Exhibits Continued Growth." *Beverage Industry*, August. Edgell Communications, Inc.
Lal, Brij V. 1992. *Broken Waves: A History of Fiji in the Twentieth Century*. Pacific Islands Monograph Series No. 11. Honolulu: University of Hawai'i Press.
Lutz, Catherine, and Jane Collins. 1993. *Reading National Geographic*. Chicago: University of Chicago Press.
Mintz, Sidney. 1985. *Sweetness and Power: The Place of Sugar in Modern History*. New York/London: Penguin.

Royte, Elizabeth. 2008. *Bottlemania: How Water Went on Sale and Why We Bought It*. New York: Bloomsbury.

Sahlins, Marshall. 1972. *Stone Age Economics*. Chicago: Aldine.

———. 1985. *Islands of History*. Chicago: University of Chicago Press.

———. 1996. "The Sadness of Sweetness; or, The Native Anthropology of Western Cosmology." Reprinted (2000) in *Culture in Practice: Selected Essays*. New York: Zone Books.

Said, Edward. 1978. *Orientalism*. New York: Vintage.

Szasz, Andrew. 2007. *Shopping Our Way to Safety: How We Changed from Protecting the Environment to Protecting Ourselves*. Minneapolis: University of Minnesota Press.

Thompson, E. P. 1971. "The Moral Economy of the English Crowd in the Eighteenth Century." *Past and Present* 50: 76–136.

Walvin, James. 1997. *Fruits of Empire: Exotic Produce and British Taste, 1660–1800*. New York: New York University Press.

Wilk, Richard. 2006. "Bottled Water: The Pure Commodity in the Age of Branding." *Journal of Consumer Culture* 6: 303–325.

Wilson, Rob. 2000. *Reimagining the American Pacific: From South Pacific to Bamboo Ridge and Beyond*. Durham, N.C.: Duke University Press.

Young, Alfred F. 1999. *The Shoemaker and the Tea Party: Memory and the American Revolution*. Boston: Beacon Press.

Shanti and *Mana*

The Loss and Recovery of Culture under Postcolonial Conditions in Fiji

John D. Kelly

In *The Intimate Enemy: Loss and Recovery of Self under Colonialism,* Ashis Nandy (1983) argued that the British, in India, hypermasculinized themselves while denying adult manhood in subtle and not-so-subtle ways to the colonized men in India. Kipling is his prime example. Nandy argued that the Gandhians responded most effectively: they abandoned efforts to outmasculine the British and instead valorized an androgynous ethic of nonviolent and spiritual superiority. Nandy's thematic of loss and recovery is certainly relevant to the anxieties and ideologies one finds in Fiji in recent decades, most obviously among ethnic Fijians justifying military coups, but more subtly, and quite possibly as profoundly, among Fiji citizenry appalled by its domestic military aggressions. Under postcolonial conditions, the question is not dialogue between colonizer and colonized but, especially in Fiji, dialogue among the ex-colonized. Yet in Fiji that dialogue retained the form it had had in the colonial end game, hypermasculinity confronted by an opposing ideology it cannot measure, an enemy to patriarchal claims of right-and-ready violence that insists with ethical passive aggression, calm reason, and peace. In Fiji, the chiefs of the Great Council, above all, took over the role of masculine paramounts, hypermasculinized agents of power—and thereby kept alive an extreme colonial gender dialogue for decades longer than it lasted in most sites in South Asia or the Indian diaspora. In Fiji, the cultures of ethnic Fijians and Indo-Fijians, despite the great diversity of both and especially the latter, are also locked together structurally in ways that no group expects or welcomes, in a gendered political dialogue. In their resolution to overcome the influence of the other they change in connected, contrastive ways, and sustain or even ramify a late colonial gender structure. Unlike in Africa (cf. Mbembe 1992), chiefly rule in Fiji is not about the banality of power but its masculinity, and the strange political tactics of nonviolent protest and withdrawal, aggressive pacifism, find ample targets and extend themselves. The result is a sequence of impasses that dangerously illegitimize the state, yet the impasses are extraordinary for the infrequency of actual political violence despite the extremes of feeling.

Shanti and Mana

Shanti and *mana* are both important in Fiji. Neither is simply a local phenomenon. *Mana* is of pan-Pacific importance in Islander ritual and politics. Via anthropological literature, starting at least with Codrington (1891), Durkheim (1915), Malinowski (1922), Mauss (1924), and Hocart (1936), the idea of *mana* has also gained an academic life. While anthropologists focused on the Pacific continue to contribute to its interpretation and fame—in recent decades, notably Valerio Valeri (1985), Marshall Sahlins (1985), Roger Keesing (1984), and Bradd Shore (1989)—the term has also spread to new usage especially in the United States and Europe. It has become a recognizable term for political charisma, capacity, and force, and has even become a staple in fantasy literature. *Mana* is a Pacific contribution to transnational, cosmopolitan culture, in ways (as is typical) not intended by and not even reasonable from the perspectives at its origins. But if *mana* has in its strange vicissitudes become a global token,[1] it has not thereby lost its local vitality nor stagnated in its social career in specific Pacific locales. Quite the contrary: My thesis is that its social life has taken quite an unexpected turn in recent decades in its social career in Fiji. It has become the opposite of *shanti*.

Shanti means peace, which is roughly as adequate as saying that *mana* means power. *Shanti* is a conception of religious peace and well-being, the calm after the storm and the experience of grace, particularly important in the *bhakti* devotional traditions within the universe of discourse that is commonly glossed "Hinduism." *Bhakti* means devotion, devotion to God, and the many *bhakti* traditions in Hinduism over the past millennium recentered religious practices away from ritual, austerities, meditation, and study as ends in themselves and toward devotion to God and quest for reunion with God. In most *bhakti* traditions, intense longing and despair make *shanti,* peace, both a goal and a means of religious commitment. In Fiji, Hindu devotional movements as varied as the Kabir Panth, the International Society for Krishna Consciousness (ISKCON), and the Sathya Sai Samiti brought their views of *shanti* to Fiji,[2] and *shanti* was and is particularly important to the branch of Hindu theology and practice that has established itself as mainstream in Fiji, the self-titled Sanatan Dharm. Sanatan Dharm means "eternal" and "true" *dharma, dharma* meaning truth and natural law. The Sanatan Dharm movement successfully portrayed itself as orthodox, in religious contest with a deliberately reform Hindu movement, the Arya Samaj, but in fact the Sanatan Dharm followed a particular, focalizing religious logic of its own. It taught a religion focused on a particular version of the Ramayana, the Ramcaritmanas, of Tulsi Das. Sanatan Dharmi missionaries to Fiji, from the early decades in the twentieth century, successfully taught that the Tulsi Das version of Ram-centered devotionalism was the fifth Veda for overseas, indentured Indians, their perfect shelter from the storms of colonial pollution and injustice. The Sanatan Dharm, in Fiji and elsewhere among the indenture colonies, developed a Ramayan-centered Hinduism that taught grace in alienation and exile and that emphasized the peace of *shanti* as its realization. Ramayan *mandalis,* circles of recitation and study of the Tulsi Das text, can be found everywhere Hindus have settled in Fiji, especially though not exclusively Hindus of North Indian descent,

and their form of Hindu practice is above all a quest for the peace of mind and experience that comes from realization of the real pains of existence in separation from divine reality. The suffering, exploitations, and even the atrocities of this-worldly existence are transmuted into evidence of larger truths only accessible via calm recognition and love.

My scandalous thesis, in this essay and a prior one (Kelly 2005), is that *shanti* and *mana* have become dialogically entwined in postcolonial Fiji. I see in Fiji a postcolonial permutation of the gender dialogic Ashis Nandy (1983) identified for colonial South Asia in his classic *The Intimate Enemy*. *Mana* is swept into the nexus of hypermasculine self-justification, a late-colonial British fantasy of self that Fijian chiefship has uniquely successfully been able to trump and replace, but at great cost to itself. I see *shanti* as Nandy also sees it, embracive of the androgyny that the Gandhians, the Tagores and Nehrus, and other characters of implacable ethical nonviolent extremism used to escape a colonial patriarchal chronotope of civilization, an androgyny that denies that the civil is made, protected, and owned by wielders of martial force and that insists it exists, where and when it exists at all, centered on the truths and structures of feeling that are beyond violence. But what I see in Fiji is not merely the recurrence of the colonial dualism. In Nandy's India, Kipling and Churchill were confronted by Gandhi and the rest of the Congress, the colonial illusion of permanence was finally understood and denied, and colonial claims to unique power were unmasked and parochialized as postcolonial visionaries sculpted an alternative world. In Fiji's hereditary chiefs and tender egalitarian *bhaktas*, there is a specifically postcolonial form of intimate enemies. In Fiji, ethnic Fijian chauvinist insistence on the truth of power cohabits with this different citizenry, committed to the power of truth. For the ethnic Fijians and especially the chiefs, these Indo-Fijians have become a citizenry not actually, simply alien but, my point, increasingly, specifically, extremely different, even opposite, in their ethical and emotional resignation. The chiefly truth of power can metamorphose readily into fear of loss, but is less prepared for this opposed presence, insistence on the power of truth.[3] Fiji thus becomes a very specific instance of what Kumkum Sangari (1999) finds basic to postcoloniality generally: history irrevocably different but also irrevocably shared. *Mana* and *shanti* have locked in to a dialogical antithesis that no one anticipated, promoted, or welcomed. *Shanti* and *mana* capture and polarize ways of political, religious, and ethical being, frustrating deliberate efforts to move "toward a common future," as the deliberately hopeful report of the 1997 constitutional commission was titled.[4]

Coups, Takeovers, and *Mana*

In the concluding pages of *The Intimate Enemy*, Ashis Nandy declares, "My concerns here are unheroic rather than heroic and empirical rather than philosophical" (1983: 113). Yet he begins this final section of his text with something quite heroic-sounding, a quotation from Amilcar Cabral, "national liberation is necessarily an act of *culture*" (Nandy 1983: 112, quoting Cabral 1973: 43, italics originally in Cabral). Nandy's point is that he is empirically tracking a story of national political liberation, especially in the campaigns of Gandhi. There is at its core, in Nandy's view, a precedent, powerful, psychological, and cultural liberation, a recovery of lost self via the discovery

of the power of the androgynous alternative to colonial insistence of possession and valorization of a masculine superiority. Gandhi finds a new center for ethical historical narrative, spiritual universals of service, suffering, and grace that parochialize stories of masculine pioneering, conquest, husbandry, and mastery. Gandhi's *satyagraha* tactics, "holding to the truth" or "insistence on the truth," also poetically glossed as "soul-force," used public campaigns to render visible claims of right. In 1930 Gandhi marched hundreds of miles to the sea to make salt, publicly demonstrating his intention to violate the terms of a colonial tax and monopoly. Gandhi rejected the term "passive resistance" for his ostentatiously nonviolent, truth-focused tactics. Gandhi denied that his tactics were passive and pointed out that they insisted on things rather than resisting things. They took initiative, requiring the British to respond with force or resignation.

What "acts of culture" inform or characterize projects of liberation in Fiji? As already noted, this essay is my second on *shanti* and *mana* in Fiji; the first is already an extended answer to this question, from its title onward (see Kelly 2005). It is about boycotts and coups. The late-colonial British, especially when still ensconced within their illusion of permanence, were more irritated and worried about Fiji's Indians than about the ethnic Fijians.[5] It was Indo-Fijian leadership that pushed for independence and ethnic Fijians and especially their chiefs who received multiple layers of privilege and protection in the independence constitution. But precisely the forces felt most loyal and trustworthy by the one-time empire, the army and the Great Council of Chiefs, engineered the coups that overturned the British-written constitution and led Fiji out of the British Commonwealth. And the coups since (there have been three or four coups, depending on how you count) were all designed to restore Fiji's chiefly political leadership. The wonderful thing about the coups, from a certain point of view, is that they were acts of *mana*, self-validating usurpations in line with a much longer tradition in the establishment of right. And here my analysis breaks from Nandy's, with an interest in culture over self and in shared, public, repeated endeavors over the solitary works and recognitions of genius. Plainly Nandy's interests were also social, and all among the colonized felt some form of the intimate enemy dialogic he described, not only the luminaries like Gandhi or Dayanand Sarasvati (the Arya Samaj leader who attempted to restore a lost Hindu masculinity to match up with the British). But his analysis is still both psychoanalytic and luminary in its logic; the great men led and felt and taught the deepest realizations. Not only Nandy but even subalternists like Ranajit Guha (2002) and Partha Chatterjee (1986) are capable of this Joycean logic, in which the smithies of great souls are the forge of national culture.[6] You might think that coups, by their logic, could not become the replicated quotidian experience of a large population. By their logic they are antidemocratic, hierarchical acts that destroy existing institutions to replace them, albeit usually with a logic of restoration, with a new top-down authority certified first of all by its force. You might think that such things could only be the vehicle for one person or at best one movement at a time. But in the case of Fiji, as anyone will attest who can remember the year 2000, you would be underestimating the possibilities of the logic of the takeover. The year 2000 saw the true efflorescence of this particular logic of liberation.

First, in Fiji's capital, at least two coups unfolded at once. On May 19th, a minor ethnic Fijian political figure, George Speight, took over Fiji's parliament with the help of much of the Fiji army's elite Counter Revolutionary Warfare Unit, including that group's leader Ilisoni Ligairi. With thirty parliamentarians including Prime Minister Mahendra Chaudhry hostage, the Speight group declared themselves the new government and declared the 1997 constitution revoked. Shortly thereafter, the rest of the army surrounded the parliament, and in the days that followed, complex negotiations led to at least two more rejections of the 1997 constitution. The surrounding military helped Fiji's president dismiss the hostage prime minister on flimsy legalities, then prorogued the parliament as a whole, removed the president from office, declared martial law, and revoked the 1997 constitution by military decree. It has become conventional in Fiji not to notice that this also was a military coup, a second one going on at the same time as the first. In the same days, the Great Council of Chiefs, an institution granted much power under the 1997 constitution, but not this much, also declared that the 1997 constitution required massive revisions; its president, the two-time 1987 coup leader Sitiveni Rabuka, condemned the 1997 constitution (which he had helped draft and adopt, in the wake of his coups) as the "document that brought about this situation." This Great Council of Chiefs, mysteriously still in existence and in session though the laws that defined it were allegedly dissolved, sought a constitution in which political paramountcy would become impossible for any coalition of parties primarily supported by Indo-Fijian votes. Thus the situation was complicated; it took fifty-five days for the Great Council, various parts of the army and navy, the Speight group, and others to coordinate plans for a new government and political system. The problem was not only that there had been a coup, but, observers claimed, the wrong one. One observer, then minister of agriculture Poseci Bune, reported that when the Speight group stormed parliament and took the Chaudhry government hostage, the opposition MPs looked "aghast," not because they were against a coup but because their plans "were pipped" (Kelly and Kaplan 2001: 218).

Okay, but there was more going on than multiple overturnings of the 1997 constitution, amidst at least two coups. By July 2000, as the deals were struck and the Speight group was finally dislodged from the capital, Fiji's countryside was seething with quotidian, local takeovers. Roads, resorts, factories, even police stations and a military base were taken over by supporters of the Speight group and others wishing to dramatize their concern for ethnic Fijian political entitlements. It is hard to get this form of political action into focus. These takeovers bear some resemblance to the "ethnonationalist" election rioting in South Asia discussed by Tambiah in *Leveling Crowds* (1996). Like the crowds that endemically riot before, and not merely after, elections in South Asia, these takeover movements responded to a sense of social grievance and urgently sought an ethnic redress. But unlike rioters, these movements claimed and took possession of things, often big things, and unlike the South Asian crowds, which Tambiah persuasively argues are an outcome of democracy under conditions of continuing frustration, the ethnic Fijian takeovers were absolutely not exercises in "leveling." Attacks on others viewed as unfairly privileged, yes, but not toward a common level: In Fiji,

in the midst of a coup against a popular, elected government, the violence was not on behalf of the hostages but on behalf of the hostage takers. In 1999, for the second time in Fiji's history, Indo-Fijian voters (47 percent of Fiji's population) had substantially elected a government. In 2000, for the second time, the Indo-Fijian–supported government was removed by coup, and the constitution with it. But it was not Indo-Fijians rioting, taking up weaponry, taking over other civil, economic, political, or religious institutions. In the wake of the 1987 coups, it was mosques and Hindu temples, not Christian churches, getting torched and desecrated. But in 2000, as the Speight group made its final deals toward amnesty and a continuing role in government, it was the Speight supporters and other ethnic Fijian advocates who took over things, not leveling but demanding ownership and prerogative.

We will move on, soon, to the boycotts in response and to the rest of the other side of this astonishing cultural dialogue in Fiji, to more fully understand the actual collective forging, in the smithy of political liberations, of the uncreated conscience of this nation-state. Or perhaps, to move farther from James Joyce's language and back toward Kumkum Sangari's, it is simply the melting and reworking of the complex cultural manifold of one place with many histories, irrevocably different but now irrevocably welded together. And I will mainly leave to others more expert the interpretation of nuances in the connections and tensions between *vanua* (the land), *loloma* (kindly love), and *mana* (power). We exit via the obvious: the underlying significance of Fiji's land tenure system, and the sense of license it engenders for some ethnic Fijians, in Fiji's postcolonial illusion of permanence.

Fiji is rare in the postcolonial world for the degree of success it has afforded the group attempting to rival and supplant the colonizers in their patriarchal establishment. In many postcolonies, there was an effort at patriarchal succession, a new elite claiming the spaces and styles of the colonizers, at least for a while. Usually it did not go well. In Africa the banality of power emerged as its own excuse, its own grotesque realism out of the deficiencies of succession (cf. Mbembe 1992). In India a nostalgically partriarchal Hindutva is bombastically self-parodic in its quests for a lost precolonial golden age of Hindu manliness, in the wake of the attenuation of the charisma of Gandhi's ethical, androgynous congress. But even as its rules change, Fiji's chiefship entails a coherent and centered assemblage of established (and increasing) patriarchal rights and claims to right. The land is really ethnic Fijian property, and in lease politics and even Crown land conversions this is increasingly, incessantly insisted upon, Lockean logic be damned. Far from a historical and quietist grace in alienation, the ethnic Fijians can conjoin their political sensibility to inalienable land, and with it the apparently unending privilege of being indigenous. Rights out of time, to which history and a larger world can only threaten, but *mana* can ever restore, as long as *mana e dina, mana* is the truth. But is it only a partial truth?

Boycotts, Strikes, and *Shanti*

The oft-killed 1997 constitution came back into force in 2001 in the aftermath of a stunning victory in a civil rights case in the courts, probably much negotiated, definitely

mediated by Australian expatriate judges (thus decidedly not blind to the world at large), and certainly not final until, strangely, the Great Council of Chiefs was consulted by the illegal administration and concurred in the reinstitution and call for new elections. The story that a normalizing neoliberal (or, really, Pax Americana) global order insisted upon it has its own partial truth—see also Kelly and Kaplan (2001) and Kelly (2005). But absolutely crucial to this outcome was the failure of another enterprise. The "Civilian Government" installed by the Fiji military in the wake of the 2000 coups attempted to organize a new constitution-writing commission. And this commission was boycotted, with near complete solidarity, by the supporters of the Chaudhry government and the 1997 constitution. It was boycotted until it shriveled and died.

If coups and takeovers have emerged as modalities of *mana* and the truth of power, boycotts have long stood in Fiji as the primary modality of the politics of *shanti*, and even of *satyagraha*, the power of truth, under Pacific conditions in Fiji. Remembering the colonial end game, the colonizers were perhaps unwise not to worry about the possibility of military takeover when they planned the postcolonial would-be nation-state. But they were paranoids with real enemies when it came to Indo-Fijian civil, economic, and political claims of right and the politics of boycott. Even in the midst of the negotiation of Fiji's independence in 1967, there was a major boycott of Fiji's Legislative Council by members of the National Federation Party (NFP), a party built out of labor unions, whose candidates were elected mostly by Indo-Fijian votes. That boycott was entirely misapprehended by the hopeful, insider-led Alliance Party, who thought their members on the Indian side had driven weaker opponents from the field and did not understand that their derision of this boycott doomed them for a generation at least. By-elections returned the NFP members with greater majorities and Fiji thereafter saw fewer Indo-Fijian Alliance votes in successive elections.

And by 1967, the boycott was an old and familiar tactic on the interface between "European" colonizers and the Fiji Indians in Fiji.[7] The strikes in 1920 and 1921 marked the emergence of collective Fiji Indian politics; the boycott of a governor's commission inquiring into the strikes shut it down in 1921 and prompted the government of India to send its own inquiry instead; the boycott of the Indian seats on Fiji's Legislative Council, from 1929 to 1933 by the short-lived Fiji Indian National Congress, tragically failed to win the principle of "common roll," nonracialized voting. The Fiji Indians even, famously and infamously, boycotted military service in World War II, a boycott that actually began in the late 1930s, before the fall of Poland, in the period of "phony war," as a boycott not of military service but of receiving military pay.[8]

Indo-Fijian political history is, actually, almost entirely a story of strikes and boycotts, often followed, in 1932 and 1944 as well as 1968, by electoral victories that ratify the leaders of withdrawal to the consternation of their powerful enemies. There is much more jeopardy in Indo-Fijian political history in making a public compromise with power. Jai Ram Reddy, leader of the NFP in the 1990s, seems to have killed his party when he shook hands with Rabuka over the 1997 constitution and addressed the Great Council of Chiefs, calling them "my chiefs." To the shock of Rabuka and most of Fiji's journalists, who expected the 1999 elections to ratify Rabuka's government and bring

Reddy's NFP in as its coalition partner, the NFP won no seats at all in that election. It has shown few signs of life since.

As Donald Brenneis (1983) has documented elegantly, the egalitarianism of the Indo-Fijians is, as he puts it, "tender." Devotional, *bhakti* movements in South Asia were not all anticaste, but they frequently were. *Bhakti* movements were particularly popular among the low castes, and in fact theologically depict all human beings as low before god—thus, for example, the Caitanya *bhakta*s of ISKCON often adopt the surname Das or Dasa, "servant," the classic Shudra surname; we are all servants before god. But despite, and along with, this grandiloquent valorization of lowness, the emergent and highly successful *bhakti* groups, especially in Fiji, put much emphasis on the importance of good company. Ironically, while the Indo-Fijians largely abandoned caste, they never abandoned outcasting. To spend time in company that was *satsang*, morally good and uplifting, is basic to living appropriately. Thus the tenderness; the humblest man is also morally vigilant, not out to overcome evil, but definitely to withdraw from it.

The Fiji Indians did not come to Fiji always already nonviolent; the Fiji Hindus did not arrive already as *bhakta*s dedicated to Tulsi Das and egalitarian to the point of abandoning caste. The vast majority of Fiji's Indians came between 1879 and 1916 as indentured labor for sugar plantations. Those lines were famously violent, with extraordinary crime rates, especially on gendered lines. From the 1930s on, rumors circulated in Fiji that the Fiji Indians were not military sorts of men. But in fact, recent research on the history of labor markets in South Asia, especially Kolff (1990), indicates exactly the opposite. The indenture recruiting in Uttar Pradesh, the source of the majority of Fiji's Indian plantation labor, picked up free laborers in districts, even in market towns, where young men had a long history of traveling for employment. Before the 1820s it was a very different kind of employment: caravan military service called *naukari*. Evidence of at least some cultural continuity between indentured labor in Fiji and earlier *naukari* military labor migration is the massive popularity of wrestling, for centuries the sport of choice among South Asia's mercenary soldiers, on and between Fiji's plantations. This makes the religious and social transformations of the Fiji Indians in the twentieth century all the more remarkable, coordinate with changes in marriage system, away from caste distinctions, and also away from bride-price to dowry, in religion toward the quietist forms of *bhakti* and similar turns in Islam, and in politics embracing the Gandhian synthesis of a religious, nonviolent politics from the 1910s onward. Their gender system changed massively, and despite an Arya Samaj effort to sustain a masculinism, the main shift was very much toward the androgynous quietism of *shanti*. Since Fiji's independence this cultural vector has been sustained, if anything with even greater intensity, despite very different trends in South Asia itself.

After Nandy: The Intimate Enemy, Colonial and Postcolonial

It's time to observe some real complexities, both in fairness to Nandy and to the complexity of Fiji and the transnational forces that transcourse through it. Nandy insists correctly that there are multiple masculinist, feminine, and androgynous possibilities in any real social field; the point is dominance. In Fiji, among ethnic Fijians, there is

loloma (kindly love) as well as *mana,* a feminine and sometimes androgynous force (as with Jesus). But it is *mana e dina* (*mana* is the truth), not *loloma e dina* (kindly love is the truth), at the core (and chorus) of ethnic Fijian ritual. And it is also worth noting, in passing, the interesting impasse separating *loloma* and the complex devotional forms of love in the *bhakti* movements. *Loloma,* kindly love, is pre-eminently a family as well as a churchly value. Ethnic Fijian *loloma* tends therefore to attenuate as it extends in social scale, from family to *mataqali* (kin group) to village to *vanua* (chiefdom) to race to nation. *Loloma*'s capillary action complements and fleshes out the top-down hierarchies that substantiate *mana; bhakti* and *shanti,* like the early Christianity as Edward Gibbon (1994) saw it in Rome, undermines the significance of any worldly rank. Fijian Christianity is thus, in the vocabulary of Gibbon and Weber (1993), highly this-worldly; here Christian devotionalism offers little bridge to Hindu *bhakti,* even its most evangelical forms. The seekers of Christian amazing grace are (a) expectant that God sustains worldly rank for his major purposes and (b) hopeful of top-down help in God's hierarchical universe. Hindu *bhakti* traditions diverge on the prospects for this-worldly help, with Sai Baba, for example, at a charitable, playful extreme. *Bhakti* traditions diverge even on the ontological status of this world, the degree to which it is illusion, and its reasons for being; the Krishna *bhakti* traditions tend to see the world as a grand *lila,* play, while the Ram-centered traditions, more dominant in Fiji, tend to emphasize duty and a less comic, more tragic universal theater. But in all cases the truths of god and love dissolve and rebuild, rather than build upon, human relationships, stations, and hierarchies. Quietist, universalistic, monist *bhakti* traditions are neither capillary nor arboreal in their vision and practice of power.

To review then, I am arguing that *mana* and *shanti* have changed and are changing each other as they interlock increasingly in charged cultural politics in Fiji. There was, originally, no relationship in particular. Fiji was the scene of two largely separate, simultaneously running, and very different versions of the "intimate enemy" dialogics, one between ethnic Fijians and British colonizers and the other between Fiji Indians and the British. Both were well-developed by the era of World War II and utterly uncommensurated then; while the Fiji Indians' boycott of the war had a local pattern and content, it was also consonant with the Indian National Congress's advice and practice in India, and part of the emerging "half-naked fakir" androgyny that was confounding British colonial masculinism on the eve of the collapse of the Raj. In the South Asian press, which was read and reproduced in Indian Fiji, there was growing contempt for British colonial ideology, well-grounded in colonial history. And all of this appalled the leadership of ethnic Fijians, who were by World War II already ensconced as Fiji's aristocracy. The anxious desire of ethnic Fijian leadership to send soldiers into harm's way during World War II was as marked as the withdrawal from the war of the Fiji Indians. Many ethnic Fijians felt an anxiety not to miss the perfect opportunity to demonstrate vigor, competence, and loyalty.[9] Ethnic Fijian leadership was hard to convince, blind indeed to the world at large, about the virtues of decolonization because they saw so clearly the uniquely sustainable prospects for hierarchy and increasing patriarchy that their place within a British Empire was providing. The British, in the colonial end game, began to

connect the dots. When Fiji Indians demanded common roll voting in the late 1920s and 1930s, the British ramified chiefly privilege and publicly worried over threats to the indigenes. They used ethnic Fijian needs and paramountcy as a justification even for a late 1930s rollback of democracy itself, when many legislative council seats reverted from elected to appointed. Fiji became, in British hands, perhaps the most racist and racialized of colonies outside of South Africa.

But in conclusion, I am not trying here to describe a continuing plural society, some kind of Furnivall (1944) fatality, despite Fiji's census voting. To be clear, I am also not following Nandy, either, into the smithies of actual psychoanalytic selfhood. Apart from my skepticism of analysis by luminary, I am also, here, not willing to try to open the doors of depth psychology. (An example from Nandy: "Orwell grew up in an essentially women's world with imageries of men as dirty, violent and inferior." 1983: 41.) No doubt the matters I address also go beyond conscious calculations of practical reason. They are matters of culture, the modes shared in and enabling of collective experience. Thus like Gaston Bachelard (1964) I seek a psychoanalysis of the important things just beneath the surface, not the deepest depths. My interest is the prospects for the dialogical reconstruction of complex, globally connected cultural materials under postcolonial conditions.[10] For considerations concerning the significance of law and the virtues of Weber's approach to it, versus more contemporary and too totalizing theories of liberal subjectivity, see the companion essay to this one (Kelly 2005). Here I want to finish with: How far has this recurrent political complex of coups and boycotts driven Fiji toward creation of a national culture via efforts at cultural renewal and political liberation? Have the politics of postcolonial self-determination in Fiji had unintended cultural consequences? Have these most challenging and least accepting of local political movements, strikes and boycotts, coups and takeovers, generated anything like a new national self-fashioning?

It really is stunning what recurs and appears even to accelerate in Fiji's politics. Some observers were encouraged that the restoration of electoral democracy, even restoration of a couped-out constitution, happened so much more quickly after the 2000 coups than after the 1987 coups. But the efflorescence of takeovers in 2000 points in another direction and makes the cycle seem more like a trap and even a downward spiral. A new coup was threatened early in 2006, and by the end of that year, after confrontations between the army and the police, the army again removed an elected government. The coups themselves grow more unstable, appearing to be more focused on rivalries between particular ethnic Fijian personalities. In the 2006 coup, the leader of the second coup in 2000, Commodore Frank Bainimarama, deposed elected prime minister Laisenia Qarase, the very man he had originally installed as prime minister in 2006, in part because Qarase was allowing legislation that might have released from prison George Speight, the other 2000 coup leader. Such contests over power are increasingly an ethnic Fijian elite intramurals; neither side in 2006 is deeply affiliated with any Indo-Fijian leaders or organizations. And the instabilities in 2006 and 2007 have taken on a new dimension as an unprecedented public rivalry and struggle has emerged between the army and the Great Council of Chiefs, the two ethnic Fijian monopoly organiza-

tions that have survived all other anticonstitutional uprisings as close and needed allies. Meanwhile, the extreme form of Indo-Fijian withdrawal in pursuit of *satsang* is still emigration, up to the quota limits, with significant continuing effects.

There is also much to be said on the positive side. Many brave voices have been raised in calm but determined protest against "coup culture" in Fiji, among Indo-Fijians and also from ethnic Fijians citing Christian, secular cosmopolitan and, n.b., Gandhian precedents. More generally, I still have no doubt that Fiji's politics only look catastrophic if one ignores the rest of the world. The single most important thing about Fiji's political conflicts and hatreds is the lack of deaths, which I attribute almost entirely to the valorization of *shanti*, the extraordinary grace in exile of a highly ethically determined social congeries, that is to say, to the value placed on peace in Fiji by so many Indo-Fijians and others there. Finally, committed to the duty to be empirical, not heroic, we will finish with a set of questions about a cultural system only halfway formed, a Fijian national field of recognitions, tactics and countertactics, values and countervalues, that are only partly commensurate: What would it mean to be liberated from that complexity? Nandy's anticolonial story is after all from the heyday of the Saidian reassessment of colonial tales of good and evil in the history of civilization, a Manichean reversal, the colonizers rendered parochial and the colonized more universal and triumphant. I suppose I can accept that national liberation, if such a thing can actually happen, would be an act of culture. But is a national culture best forged in the smithy of liberation? Or would that always be a project of self-damaging usurpation, a violent forgetting of a real past that included irrevocable difference, however irrevocably shared history has also made it?

The cultures of ethnic Fijians and Indo-Fijians are increasingly locking together in a political schismogenesis that is calibrating diverse elements at the same time that it sweeps them into oppositions. This political and cultural dialogic was neither sought nor welcomed on either side, but it is an ineluctable part of the nation-state under local historical and demographic conditions. The result has been a sequence of impasses, recurrently illegitimizing the state, serially but unevenly for various audiences, yet the impasses have been extraordinary for the infrequency of actual political violence despite extremes of feeling. Things do not come together; notably the celeritas of usurpation cannot be reconciled with any sustainable gravitas. But neither do things fall apart, as in more dysfunctional ex-colonies. At some point, this inventive recovery, elaboration, and inhabitance of an opposition built from and against the gendered fantasies of long-gone colonizers will seem more nostalgic than sustainable to Fiji citizenry. But at present, not only does the predominant nonviolence among Indo-Fijians circuit-break the descent into anarchy of recurrent efforts to militarize *mana*, but the politics of *mana* sustain also their inverse, renewing the attractiveness of nonviolent insistence on the truth. History elsewhere (see, e.g., Adams 1998 on Nepal's democratic revolution) suggests that the charisma of Gandhian movements attenuates most quickly when and where they gain the most executive power. In Fiji, a highly ethical cultural politics remains extremely popular, long after its demise in South Asia, perhaps precisely because of the measure of its necessity and limits of its success.

Notes

1. In fact, tokens of *mana* are literally traded and spent globally, especially among young men in fantasy games in English-speaking virtual reality.

2. The Kabir Panth actually synthesizes, via the devotional poetry of Kabir (fifteenth century), Islamic and Hindu quests for God and peace. Pursuit of peace is also, on separate grounds, a goal of many Muslim traditions of study, prayer, and practice, important enough to be codified in the standard greeting in phatic communion between Muslims, which in Fiji and most places is "*assalam alaikum*" "peace be with you," with the response "*alaikum assalam*" "with you be peace" (Arabic original). This is culturally related in turn to the Hebrew greeting "*shalom.*"

3. It is a basic point of Piercian semiotics: extreme opposition is a far less radical form of distinction than uncalibrated alienness of form. As Sahlins (1985) notes, opposites are alike in all ways but one. While such a characterization clearly goes too far regarding the egalitarian questors for *shanti* compared to the defenders and wielders of *mana*, the point is that cultural dialogue, precisely, can fashion oppositions out of more basic, less calibrated differences, and thereby fashion culture out of encounter and conjuncture.

4. My experience with this argument is that it is hard to get some scholars to understand that I am making it. Fiji's historiography is rich with controversies about cultural genealogy. Did Gordon or Thurston, the elite Whig or the antipodean homeboy, invent Fiji's uniquely early form of indirect rule, and was it a form more or less in keeping with prior forms of government? Is Fijian chiefship a refraction of colonial fantasy or an organic continuation of Polynesian (or is it Melanesian, or what?) forms of ritual-political order? For the record, I am with Martha Kaplan (1995) and Marshall Sahlins (1985) when these are the questions; the place to start is a Polynesian history of chiefship, though as Martha also argues, not as much in the interior. But the point here is that these are questions, predominant questions for Fiji's historiography, about precedent Fijian culture and then a long conversation between Islanders and Europeans. The literature on Indo-Fijians, much thinner to start with on cultural historical questions, also generally focuses on questions of European imperial and colonial dynamics and their consequences. Capitalism is generally more front and center, kind of hard to miss in the nitty-gritty of the stories. But discussions of the consequences of ethnic Fijian and Indo-Fijian cultural interactions generally look back to colonial mediations if they want to get somewhere. My story here is also, in the most important sense, a story of colonial mediation: the postcolonial intimate enemies are successors to versions of the gendered dilemmas of the colonial intimate enemy pretty much as Nandy's model would anticipate, as I will explain. But the main point is, colonial past notwithstanding, and notwithstanding the U.S. mediating of the postcolonial order, the issues engaged now in the conjuncture of *shanti* and *mana* owe little, and peripherally, to any European, American, or for that matter any continuing South Asian cultural mediation. I am well aware of how superficial at best, and more often how embarrassing many scholarly claims of specific historic relationships between Indo-Fijian and ethnic Fijian culture have been. I want nothing to do with stories of a Pacific way loosening up caste strictures, or stories of an Indian sexual conservatism teaching shame to native prodigals. But the story of *shanti* and *mana*, I think, is real. Ethnic Fijian *mana*, valorizing hierarchy, paramountcy for chiefs, and permanence for *taukei* (landowners), informs and valorizes by contrast the Indo-Fijians' "tender egalitarianism" or "enclave egalitarianism," which in turn leads the Fiji Hindus to appreciate the virtues of *bhakti* and *shanti*, finding perfect ethical expression in Tulsi Das's duty-oriented tale of Ram's exile, service, and triumph. And devotional Hindu values have fundamentally challenged and are altering the practices and significances of ethnic Fijian *mana*; here lies the truest scandal, if it is true. The soi-disant autochthones and their advocates much prefer the images of simple difference, or resistance to encroaching modernity or capitalism, some version of the classic Pacific romance. But isn't it worth looking, for a few minutes more at least, at the possibility that something else is going on?

5. On this illusion of permanence see the elegant, astonishingly early book by American political scientist and Gandhi watcher Francis Hutchins (1967). The book is early in the sense that it long preceded the rise of postmodern theories of ideology and postcolonial critiques of colonialism. Its resources for probing insight and radical critique of British colonial policy and even British colonial culture were instead those of a self-confident New Deal–period American intellectual. One wonders what we will finally learn about American culture, and from whom, at and after the end of Pax Americana.

6. James Joyce's famous image is from *Portrait of the Artist as a Young Man* (1980): "Welcome, O life! I go to encounter for the millionth time the reality of experience and to forge in the smithy of my soul the uncreated conscience of my race."

7. A word on nomenclature: I follow the convention of reference that finds "Fiji Indians" in the British Empire electing to become "Indo-Fijians" in the push to make Fiji into an independent commonwealth and their unambiguous home.

8. When war was declared, the Fiji military considered disbanding its Indian platoon, which had originally been organized to enable a more colorful royal visit earlier in the 1930s. The planter-colony force was quite nervous about providing Indians with modern weaponry and military training—see comments below on actual history of violence—and sought to establish a stricter racial protocol throughout the army as war planning began. Before the war, capitation grants paid part-time soldiers a fraction of their ordinary wages, varying according to the individual soldier. After the declaration, rates of pay by race were declared. After much internal and some public debate among the Indian platoon members and in Fiji's Hindi-language press, the Fiji Indian soldiers decided to stay in the army but refuse the racially discriminatory pay level (their weekly pay was to be one-half white soldiers' pay). Instead they would serve in the army for no wages at all. However, catching wind of this, the commandant of Fiji's defense force determined to use it as his excuse to disband his Indian regiment, declaring it an act of insubordination for a soldier to refuse to accept his pay. In a dramatic parade-ground confrontation, the members of the Indian platoon refused, one by one, to accept their pay packets and were dishonorably discharged from the force. Later in the war, things only got worse. The governor refused to receive petitions from the Central Indian War Committee, a planning council of prominent Indo-Fijians, but asked the committee to constitute an Indian labor battalion for Allied, actually American, use. The committee voted not to obstruct government labor recruiting efforts, but not to promote them either, and to disband. Later in the war, in 1943, Fiji's governor refused an offer from London to raise the price of cane in light of 100 percent wartime inflation, and an impasse over price between the (almost entirely Indo-Fijian) growers and the monopsony company led to the loss of most of a season's cane crop. See Kelly and Kaplan 2001, ch. 4; and Lal 1992, ch. 3.

9. On ethnic Fijians and World War II, see Ravuvu 1988 and Lal 1992.

10. On "postcolonial conditions" more generally, see Ashcroft, Griffiths, and Tiffin 1995. On "dialogue" and "dialogical" analysis, see Bakhtin, especially Bakhtin 1981. There are some cultural phenomena—in fact, Martha Kaplan and I think, almost everything complex and interesting—that are only fully comprehensible from a dialogical point of view. For example, the Buddhist canon can give clear reasons, fully adequate within Buddhist ontology and cosmology, for mandating Buddhist monks to beg for food and eat everything donated, and for Buddhist tonsure. However, one gets richer insight into both when one realizes that Brahmans, with hair in a top-knot, tightly restrict the foods they are willing to accept from non-Brahmans. As Romila Thapar (1979: 83) has pointed out, a "contrapuntal pattern" organized Buddhist and Brahman forms of asceticism, and many subdivisions and other divisions in South Asian religious specialization as well. Religious forms that manifested distinction and opposition as well as their own positive logic need to be read dialogically as well as immanently for their full significance to become clear. To restate the problem, then, if Buddhism is an example of a religious and cultural

system self-constituting in antithesis to another, that is, what some now call Brahmanism, with *shanti* and *mana* we have an additional problem. *Shanti* and *mana* have vastly different cultural roots; clearly neither was originally conceived or elaborated in practices in any opposition to the other. (Okay, I am oversimplifying a little here if I portray Buddhism as simply an offshoot of a Brahman religion. See, e.g., Jaini 1970 for a better history. Buddhism also has *sramana* roots, which go way back—but always in cultural dialogue and intertwining with *brahmana* traditions.) To observe the forging of antithesis between *shanti* and *mana*, then, is to observe dialogical forces constituting cultural structures out of colonial transcourse.

References

Adams, Vincanne. 1998. *Doctors for Democracy: Health Professionals in the Nepal Revolution.* Cambridge: Cambridge University Press.
Ashcroft, Bill, Gareth Griffiths, and Helen Tiffin, eds. 1995. *The Postcolonial Studies Reader.* London: Routledge.
Bachelard, Gaston. 1964. *The Psychoanalysis of Fire.* Boston: Beacon Press.
Bakhtin, M. M. 1981. *The Dialogic Imagination.* Austin: University of Texas Press.
Brenneis, Donald. 1983. "The Emerging Soloist: Kavvali in Bhatgaon." *Asian Folklore Studies* 42: 63–76.
Cabral, Amilcar. 1973. "National Liberation and Culture." In *Return to the Source: Selected Speeches.* New York: Monthly Review Press.
Chatterjee, Partha. 1986. *Nationalist Thought and the Colonial World: A Derivative Discourse?* London: Zed Books.
Codrington, Robert Henry. 1891. *The Melanesians.* Oxford: Clarendon Press.
Durkheim, Emile. 1965 [1915]. *The Elementary Forms of the Religious Life.* New York: The Free Press.
Furnivall, J. S. 1944. *Netherlands India: A Study of Plural Economy.* New York: Macmillan.
Gibbon, Edward. 1994. *The History of the Decline and Fall of the Roman Empire.* New York: Penguin.
Guha, Ranajit. 2002. *History at the Limit of World-History.* New York: Columbia University Press.
Hocart, Arthur Maurice. 1970 [1936]. *Kings and Councillors.* Chicago: University of Chicago Press.
Hutchins, Francis G. 1967. *The Illusion of Permanence: British Imperialism in India.* Princeton, N.J.: Princeton University Press.
Jaini, Padmanabh S. 1970. "Sramanas—Their Conflict with Brahmanical Society." In *Chapters in Indian Civilization,* edited by Joseph Elder, vol. 1, 39–82. Dubuque, Iowa: Kendall-Hunt.
Joyce, James. 1980. *A Portrait of the Artist as a Young Man.* New York: Penguin Books.
Kaplan, Martha. 1995. *Neither Cargo Nor Cult: Ritual Politics and the Colonial Imagination in Fiji.* Durham, N.C.: Duke University Press.
Keesing, Roger. 1984. "Rethinking Mana." *Journal of Anthropological Research* 40: 137–156.
Kelly, John D. 2005. "Boycotts and Coups, Shanti and Mana in Fiji." *Ethnohistory* 52 (1): 13–28.
Kelly, John D., and Martha Kaplan. 2001. *Represented Communities: Fiji and World Decolonization.* Chicago: University of Chicago Press.
Kolff, Dirk H. A. 1990. *Naukar, Rajput and Sepoy: The Ethnohistory of the Military Labour Market of Hindustan.* Cambridge: Cambridge University Press.
Lal, Brij V. 1992. *Broken Waves: A History of the Fiji Islands in the Twentieth Century.* Honolulu: University of Hawai'i Press.
Malinowski, Bronislaw. 1950 [1922]. *The Argonauts of the Western Pacific.* New York: E. II. Dutton.

Mauss, Marcel. 1967 [1924]. *The Gift: Forms and Functions of Exchange in Archaic Societies.* Translated by Ian Cunnison. New York: Norton.
Mbembe, Achille. 1992. "The Banality of Power and the Aesthetics of Vulgarity in the Postcolony." *Public Culture* 4 (2): 1–30.
Nandy, Ashis. 1983. *The Intimate Enemy: Loss and Recovery of Self Under Colonialism.* Delhi: Oxford University Press.
Ravuvu, Asesela. 1988. *Fijians at War.* Suva: Institute of Pacific Studies, University of the South Pacific.
Sahlins, Marshall. 1985. *Islands of History.* Chicago: University of Chicago Press.
Sangari, Kumkum. 1999. *Politics of the Possible.* New Delhi: Tulika.
Shore, Bradd. 1989. "Mana and Tapu: A New Synthesis." In *Developments in Polynesian Ethnology,* edited by Alan Howard and Robert Borofsky, 137–173. Honolulu: University of Hawai'i Press.
Tambiah, Stanley J. 1996. *Leveling Crowds: Ethnonationalist Conflicts and Collective Violence in South Asia.* Berkeley: University of California Press.
Thapar, Romila. 1979. *Ancient Indian Social History: Some Interpretations.* Delhi: Orient Longmans.
Valeri, Valerio. 1985. *Kingship and Sacrifice: Ritual and Society in Ancient Hawaii.* Chicago: University of Chicago Press.
Weber, Max. 1993. *The Sociology of Religion.* Boston: Beacon Press.

Justice in Wallis-'Uvea
Customary Rights and Republican Law in a French Overseas Territory

Françoise Douaire-Marsaudon

On the Polynesian island of Wallis-'Uvea, which is part of the French overseas territory referred to as Wallis-and-Futuna, several "affairs" occurred between 2001 and the present, whose legal and political dimensions provoked much turmoil in the territory. These affairs illustrate particularly well the difficulties that arise from the interaction between two different legal systems, one of which is the local system, considered "customary" by Wallisians, and the other is the French system, referred to as "Les lois de la République."[1]

In 2001, four notions were widely used by the people when speaking about social life in Wallis: *la coutume* (custom/*kastom*), *la mission* (the Catholic church and mission), *la politique* (politics), and *la jeunesse* (youth). Although these key concepts are still in use, a new word, rarely heard in the 1990s, has now become particularly recurrent in Wallisian discourse: the word "justice." Here I propose to explain the current meaning of the word "justice" in Wallis-'Uvea, and as an example I will take a close look at the Kalomaka case, one of the affairs that has caused trouble on Wallis. The analysis of the case presented here shows how the traditional system, which—prior to the arrival of Westerners—ensured that the law was respected, punished lawbreakers, and regulated conflicts, was gradually transformed by the growing implication of Wallisian society in the modern world. This process, which began with the introduction of a code of laws based on the Western model brought from outside, was followed by the coexistence and later confrontation of two different, even contradictory, ways of making and administering law. It is proposed here that beyond the confrontation of the two judicial systems, there is a truly "societal choice" made by the population concerned, and that the notion of "justice" now widely used by Wallisians is the consequence of it, being an encompassing value that is able to overcome the fragmentation of their sociopolitical life.

Wallisian Society through the Key Concepts of Custom, Mission, Politics, and Youth

The notion of custom (*la coutume*) encompasses three aspects of Wallisian society. First, it refers to the global set of rules Wallisians consider to organize their "traditional" way

of life, even though today this is largely based on a set of Christian ideas. Second, in a more restricted sense, "*faire la coutume*" refers to a ritualized gift exchange, still central to Wallisian social organization. Third, it refers to the chieftaincy, the "*chefferie*," in other words to the functioning of the customary chiefs. The Wallisian chieftaincy is a typical Polynesian hierarchy, with six *aliki* chiefs, that is, sacred high chiefs who are believed to have a special relationship with the supernatural (an idea that has remained important in this society since the middle of the nineteenth century, although they have been Christianized). At the head of this class of chiefs is the *hau*, translated as "king" by the missionaries but which signifies "the champion," "the winner," a chief of high rank who is addressed by his title, Lavelua. The *hau* is supposed to descend from a *hau*, on either his mother's or his father's side, which implies that the *hau* title is preserved within the same extended family.[2]

There are also three district chiefs (one for each district: Hihifo, Hahake, Mua), headed by the *puluiuvea*, who has the role of "chief of police." These latter functions were created at the end of the nineteenth century. Finally, there are twenty village chiefs, *pule kolo*, who, while still considered chiefs of lesser rank, are commoner chiefs as opposed to *aliki* chiefs. As in many other Polynesian societies, all these titles are, like the *hau*, inherited through the same lineage (*kainga*), on either the male or the female side. Any chief, even the *hau*, could be deposed by the people, and until the reign of Tomasi Kulimoetoke, the *hau* was generally deposed after some years. The (recently deceased) *hau* Tomasi Kulimoetoke took office in 1959 and remained in charge until his death in 2007—even though he was nearly deposed some months beforehand—which was an entirely uncommon situation.

The mission refers in general to the Roman Catholic clergy (the priests and the bishop, most of whom are Wallisian), but also to the whole institution of the Catholic Church, which today has a large overlap with the chieftaincy. In any celebration, the priests sit beside the chiefs and receive their share of gifts, for example, the offering of first fruits. Catholic religious feasts are numerous and considered to be native (customary) feasts. From the time of Christian conversion, the chiefs have been required to support the priests, and, consequently, the people under the chiefs' authority have been required to cultivate the mission plantations. Until the law of 1961, which transformed the French protectorate of Wallis-and-Futuna into an overseas territory, all schools were run by the Catholic Church and many Wallisian political leaders were trained in Catholic seminaries, both in Wallis and in New Caledonia.

Politics, for Wallisians, refers to all the questions pertaining to the new territorial institutions. The territory is administrated by a prefect, who represents the French government, just as in all French departments. The prefect is charged with executive powers, assisted by the Conseil territorial. This Territorial Council is composed of the three "kings" in the territory (the *hau* of Wallis and the two *sau* of Futuna), three individuals named by the prefect, and the prefect himself. The prefect has veto power, except for development programs and issues concerning "custom," in particular questions pertaining to land. Legislative power is held by the Assemblée territoriale, composed of twenty councilors (thirteen for Wallis and seven for Futuna) elected by the people for

five years. The territory is represented in metropolitan France by a "député," a member of Parliament elected by the people for five years, and a "sénateur" elected for nine years by the Assemblée territoriale and the deputy.

The term "youth" refers to young people less than twenty years of age, who currently represent about 58 percent of the population. In the 1990s the same term was used, in a more restricted sense, for men about forty years of age who were very active in the political sphere but who were considered, at that time, "young" by the traditional *aliki* chiefs (a person was considered to be young as long as he did not have white hair!). Today, this group of strong-minded people are now over fifty, and many of them are still involved in either the chieftaincy or politics ("*la politique*"). Today, the new generation of Wallisians in their thirties and forties complains that it is granted neither responsibilities nor government jobs (many of them have received a secondary education and some have received a higher education in New Caledonia or in French universities).

The Kalomaka Case

The story begins in 1998, when the Conseil territorial des femmes, the Women's Territorial Council, instigated legal action against a council member. This council includes nearly all women involved in business or community activities, such as the sale of women's handicrafts, fund raising, etc. The council is also involved in social and cultural issues related to women's affairs, such as women's rights, violence against women, promotion of health and education. It is an important institution today and is active and well respected. The council was created around 1970 by leading women in the community, including Kalomaka. It is funded through the Assemblée territoriale. Kalomaka had been president of the council for a long time until legal action was brought against her. In 1998, some of the council women noticed that there were anomalies in the accounts and that five million French Pacific Francs (about 42,000 Euros) had disappeared. This amount corresponded to the subsidy provided by the Assemblée territoriale. Although Kalomaka provided the council with an explanation, the board was not satisfied, and the council finally sought legal action. The affair was adjudicated by the Procureur de la Republique (the attorney general), a Wallisian woman. With the help of the council secretary, Cecilia, the attorney general was able to find papers and bills that proved that the council's accounts had been mismanaged and that the money had disappeared without justification.

From that point, the attorney general was certain that the affair would become problematic. Kalomaka was a prominent woman. She had created the Women's Council. She had been elected to the Assemblée territoriale (only the third woman to have been so honored), was from an *aliki* family, and was a close friend of the king's daughter. Besides that, she also worked as an accountant for one of the biggest supermarkets on Wallis, and it was a public secret that from time to time she furnished the royal household with goods, although nobody could prove it.

At the beginning of the legal action, a number of people, mostly women, spoke to the judge, who had Kalomaka's house searched. During the search, important documents were found, and the national police finally came from Nouméa to collect evidence.

A major problem for the judiciary authorities was the pressure exercised by the chiefs, which started soon after Kalomaka's house was searched. In the beginning, the chiefs' interventions were courteous and polite, as they sought some kind of mutually acceptable arrangement. However, the attorney general explained that once legal action, with evidence, had been initiated, it was impossible to stop the process. Under customary law, all affairs ended with a *fakalele* ritual, which means "to do the right thing," during which the "offender" pleads with the "offended" for forgiveness and offers him a gift (food and traditional valuables).

The judge and the attorney general asked Kalomaka several times to come to the trial and provide them with her explanations, but she never appeared. By and by, the Kalomaka case was referred to the king. One day, the six *aliki* chiefs, acting as official representatives of the king, went to the attorney general and proclaimed, "Stop now, it is finished for you, this woman Kalomaka will not come to provide you with any explanation, you have to put an end to this affair." The attorney general explained the implications of French republican law to the chiefs. She told them that if Kalomaka came to the tribunal herself, she would receive only a symbolic punishment. The attorney general was certain that Kalomaka had not kept the money for herself, but for the royal palace. However, Kalomaka never appeared and was finally judged (in absentia) by a court in Nouméa. The sanction was severe: she received the maximum sentence, two years in prison and five years' suspension of her civil rights.

She could have appealed for a new judgment, but she did nothing. The king's daughter came to see the attorney general and begged to have Kalomaka released. The king's son also came and proposed to go to jail instead of Kalomaka. Of course, neither of these solutions was acceptable to the court in Nouméa. Finally, Kalomaka took refuge in the royal palace, which caused a strange situation because the police did not dare arrest Kalomaka in the king's palace against his will. The Wallisian population was split into two groups: those supporting Kalomaka and those against her. The "sénateur," because he defended the king's honor, was in favour of Kalomaka, but the deputy advocated republican law. The Assemblée territoriale was also split into two. The prime minister or Kivalu, a powerful political chief, made a courageous televised speech, declaring that republican law must be respected. Some days later, he was deposed by the other chiefs and the king. Fortunately for the king, the fortieth anniversary of his reign occurred not long afterwards, and a councilor was sent by the French president, Jacques Chirac, to mark the occasion. The councilor advised the king to ask Kalomaka to appeal for presidential amnesty. She finally did so, and from that time forward she was free, and legal proceedings were put on hold while the judicial process waited for the presidential decision. And the matter rested there. Of course, President Chirac could not subvert French law, but neither did he want to create a conflict with the principal customary chief of the island. The presidential amnesty remained suspended until the time of the king's death.

The Legal System and Its History

In order to understand the legal system in Wallis, we have to return to the time of the arrival of the first missionary in 1837. He was Father Bataillon, a Roman Catholic

priest and a member of the Marist order (La Société de Marie), directly under the pope's authority. He had a strong personality and soon became advisor of the reigning Wallisian *hau*, Queen Amelia. In 1842, following the murder of Father Chanel, the French Catholic missionary on Futuna, the inhabitants of Wallis were almost completely converted. Bataillon persuaded Amelia to change Wallis into a French protectorate, a decision that was ratified in 1887. Father Bataillon drew up a code of rules in 1870, still known as the "Code Bataillon." It is primarily a collection of moral prohibitions and rules of social behavior. It not only institutionalized the customary organization of powers but also reinforced the centralization of these powers.[3] Bataillon also created law courts, although it seems that these courts tried to find a compromise between the ancient and the new rules. It is interesting to note that everybody living on Wallis at the time, whatever their origin, was subject to this elementary legal system, which remained entirely under the control of customary chiefs. This situation lasted from 1870 until 1933.

It is worthy of note that the Code Bataillon prohibited any sale of land, a measure that has since been adopted into (French) territorial law.[4]

By government decree, French law (*justice de paix*) was officially installed in Wallis (and Futuna) in 1933, for the first time. This French law concerned only French citizens, French "protégés" (people who had a special status with respect to France or her colonies, for example Kanaks), and foreigners of whatever nationality. The people—"les indigènes"—continued to be judged under the Code Bataillon, considered to be the local, customary law. However, the *justice de paix* could, in certain cases, be applied to "indigenes." For example, if a person of one of the above-mentioned statuses (French, protégé, foreigner) was involved in litigation concerning the natives, the entire affair would fall under French law. As will be seen, this new French justice, which regulated affairs between local people, French residents, and foreigners, actually created two different legal statuses: one governed by French republican law and another governed by the local, customary law. (It should be noted that customary or local law, sometimes called *droit particulier* at that time, concerned the entire population with the exception of about sixty people who came under French republican common law or *droit commun*.)

In 1961, with the creation of the overseas territory, a new legal system was installed. The *loi fondamentale* stipulates that all indigenous people have French nationality and enjoy the rights, prerogatives, freedoms, and obligations associated with French citizenship. Those inhabitants who do not have the status of *droit commun*—that is, who still remain under the status of *droit particulier*—maintain their original status unless they intentionally renounce it. The *loi fondamentale* also specifies the jurisdiction for the adjudication of customary law: (1) for disputes between citizens under the status of local law and for affairs relating to the application of this status: if the affair involves locals in a case against metropolitan French, or against foreigners, it thus falls under the jurisdiction of French common law; (2) for disputes involving property held according to custom (customary property includes all land owned by Wallisian people).

However, although the *loi fondamentale* confirms the existence of both statuses,

it also stipulates that the common law (*droit commun*) is the only law pertinent to the judgment of *penal* matters (and this stipulation, of course, enforces French common penal law throughout the territory).

To summarize, from 1870 to 1933, the administration of legal proceedings lay entirely in the hands of the customary authorities, who were partly reorganized by a French missionary. Between 1933 and 1961, although the administration of justice was shared between the French authorities and the customary authorities, the largest share of such matters, that concerning indigenous people, was still devolved to the latter. From 1961 to the present, although the customary authorities were deprived of their judiciary power in all penal matters, they still controlled customary law related to civil affairs and in particular to issues linked to the land tenure system. Today, 98 percent of the territorial population is still considered to remain under the status of local law, but in the case of penal matters, or if an explicit request is made, the people are judged under French common law (*droit commun*).

Wallisians and "Justice"

Following the Kalomaka case, many Wallisians discovered not only the discrepancies of their legal system, but more simply, how it actually worked. The Kalomaka case clearly shows that at the time (2001) most of the chiefs, and nearly the entire population, were simply not familiar with the law of 1961. It should be pointed out that among the Wallisian chiefs, who between 1959 and 1961 participated in the drafting of this law, only two of them understood French. It is probable that most of the chiefs were not at all aware that this law deprived them of the control over penal law, which they had exercised since 1870. In other words, for at least thirty years, Wallisian judicial practices did not correspond to the real legal system.[5]

There was a huge discussion in Wallis about this dualistic legal system and the disparity between the principles and the practices of the law. It was in this context that the word "justice" appeared. In fact, this term "justice" appears almost systematically in three specific types of situation.

The first concerns contradictions between the principles and the practice of law. As we have seen, according to the *loi fondamentale* (French republican or common law) all affairs concerning land must be judged by the customary chiefs. But if a conflict over land—and they are numerous—involves injuries, the present legal system disassociates judgment of the conflict from judgment of the injury. The chiefs resolve the conflict but cannot punish the person responsible for the injury, a fact that is misunderstood by most Wallisians. In fact, most injuries *are* punished by the chiefs using the ceremony called *fakalele*, during which whoever is found guilty by the customary authorities must beg pardon from the victim during the course of a ritual. Beyond the request for pardon, this ritual also involves feeding the chiefs and the people present during a customary meal of pork and vegetables. In other words, for most Wallisians, once the *fakalele* ritual has been performed, there is no need for any further punishment.

The second type of situation concerns the transformation of the relationship between society and the chiefs. Nowadays, "custom" is still treated as an important institution.

For Wallisians, it is the chief's duty to ensure that everyone respects civil peace. For the peoples' sake, they are supposed to manage the customary rules in order to resolve disputes between themselves and/or related to land. However, in an attempt to adapt to modern life, the chieftaincy has, more and more frequently, chosen "young" (about forty years of age) chiefs, sometimes because they are successful businessmen. But these new-styled chiefs are sometimes accused of ignoring custom and even of betraying its most important rules. For instance, in 2001 one such "young" chief, a businessman, was accused of taking advantage of his function as chief to gain a contract, and when he was asked to resign he refused—an act that was simply unbelievable for most of the people. Today, it is becoming more and more common for people to use French common law against chiefs who take advantage of their status.

The third type of situation concerns money, something that was central to the Kalomaka affair. Even though there is not sufficient space to fully develop this subject here, the reader should be aware that traditional Wallisian life is still punctuated by the exchange of gifts. These gifts are exchanged either between family members on the occasion of rites of passage, during rituals between the people and their chiefs, on occasions of title acquisition, and during feasts involving the chiefdom, or between the population and representatives of the Catholic Church during religious festivals. The majority of gifts consist of food—pigs and root crops—produced and presented by the men, and "traditional wealth"—mats, barkcloth, and coconut oil—produced and presented by the women. Since the arrival of Catholic missionaries in the nineteenth century, money has also entered into the realm of gifts, and it circulates in a manner similar to other offerings. That is to say, when money enters into ritual gift exchange, it is invested with a function and a value identical to that of traditional ceremonial gift-exchange items (see Douaire-Marsaudon 2005: 222). However, alongside this exchange system—which has always punctuated the economic, social, and religious life of the Wallisians—since acquiring the status of overseas territory in 1961, a regularly employed section of the population has developed. At first, this was reserved for (state) civil servants, expatriated from metropolitan France, but has since come to include native residents.[6] However, civil servants from France receive about twice the normal salary (and are exempt from taxes) as local civil servants doing the same job. Since 1993, there have been numerous strikes in Wallis, with local civil servants demanding the same salaries as their metropolitan colleagues. Some categories of civil servants—but not all—have won their claims. Chiefs, including the king, receive an allowance from the French government, which is however far less than the salary of certain categories of civil servants. In Wallis, this kind of consideration is included under the notion of "justice." Wallisian society, like many others that have a colonial history, has seen its cultural traditions transformed under the pressure of numerous external factors. In the context of an affair such as that of Kalomaka, one must first recognize that the transformations affecting an institution can have repercussions extending well beyond the judicial domain. The Kalomaka case also shows how two judicial systems of different origins and conceptions, one local and traditional, the other imposed from outside according to the modern Western model, can suddenly find themselves in confrontation after having coexisted without interac-

tion for many years. It is therefore important for anthropologists to try to comprehend not only how and why this confrontation occurred, but also to evaluate the implications for the people involved.

From the outset, the Kalomaka case offers numerous levels of analysis, in particular at the *judicial level*, with the confrontation of two competing systems, the traditional Wallisian system and French law. The conflict that arose between the two systems can be attributed to the fact that certain social actors, here the women of the association, had recourse to French law, whereas others, such as Kalomaka, relied on traditional justice. The case can also be analyzed at the *political level*, which provides the underlying context in the sense that this affair unleashed a true crisis within all the institutions, those considered relevant to tradition, such as the chiefdom, as well as those related to modern life, such as the French administration. There is also the *socio-psychological* level, the level relevant to the actors, which concerns both the individuals (Kalomaka, the king's daughter, the king) and the groups involved (representatives of tradition, the chiefs and men of the church, the youth, the elders, the Women's Association, etc.). Correct understanding of this affair requires anthropological analysis at each of these levels.[7] Or, to put it another way, in a case such as this one, it is important to take the resulting changes into consideration *in their entirety:* those related to the topic of research itself—transformations within the traditional legal system—as well as those affecting the largest possible framework, the entire society. Otherwise, in the case studied here, the analysis runs into a series of additional specific difficulties, those that characterize a conflict when it results in the confrontation of two competing legal systems operating in the same society over the same people. In discussions between Wallisians, the topic that aroused the most vehemence was that of trying to agree on who the persecutor and the persecuted were in this affair. For some, the problem began with the complaint raised by the women's association regarding a conflict between the association and its director, Kalomaka; both the persecutor and the persecuted were clearly identified, since Kalomaka had stolen from the women of the association. For others, Kalomaka's "gesture" should have been appreciated and seen in the perspective of custom, as her pious effort to come to the aid of the highest representative of traditional authority, the king, unjustly treated (financially speaking) by the French administration. For some Wallisians, in embezzling money from the state for the benefit of the supreme chief, the king, Kalomaka did nothing more than follow tradition by re-establishing a small degree of equilibrium in the unjust remunerations instituted by the French government: In this view, the person of Kalomaka becomes the victim, persecuted by the "new" judicial powers.

As Luc Boltanski has clearly demonstrated, in all litigations and judicial acts, it is important from the outset to "qualify" the social actors and to have the greatest possible number of people accept these "qualifications" (Boltanski 1990: 59). This is not easy, even in the context of a single legal framework. In the case presented here, it can be seen that depending on whether one takes the defense of custom (considered local and traditional) or republican law (considered modern and international), the qualification of the social actors is not only different but completely contradictory: Depend-

ing on one's point of view, the same person could be considered either the author of a crime or the victim of an unjust punishment. One can observe here the first type of fragmentation, which implicates not only the two judicial systems but also the two "states of society" for which they serve as references, public institutions that position themselves beyond individual interests: on one hand a group living under traditional precepts, whose interpreters are the chiefdomship and the church, and on the other hand a group in step with modernity, whose recognized interpreters are the agents of the state, above all the prefect, and the attorney general. Note, however, that today it is a rare individual whose activities fall entirely within only one of these groups to the exclusion of the other.[8]

As we have seen, the Kalomaka affair divided society at all levels, even within families. Nevertheless, each Wallisian, whatever his or her opinion on the question and therefore the stance he or she has taken, is perfectly conscious of the possibility that the reasoning of the other group may in fact be correct, and this helps to explain why so much passion was invested in the debate.[9]

The sociologist Boltanski, who has studied disputes and conflicts in Western societies, has brilliantly shown that "actualizing the requirement for justice cannot occur without reference to a scale of values" (Boltanski 1990: 79). To move beyond violent disputes and to arrive at this other form of nonviolent dispute referred to as "justice," all parties must recognize "a general equivalence, treated as universal" (Boltanski 1990: 138). When Wallisians today speak of "justice," one should understand that what they are seeking is not only more "justice" in their daily lives, but also the application of a unique principle of equivalence, which Boltanski, after Rousseau, referred to as the shared superior principles, "*les principes supérieurs communs*" (1990: 79). In other words, a value that is able to transcend all the levels of fragmentation of their society. When contemporary Wallisians speak about "justice," it is not only to undermine the discrepancies of their legal system, that curious hybrid of local customary law and imported French republican law, nor the existing contradictions between judiciary principles and practices. For them, the notion of "justice" also represents an encompassing value able to evoke not only those things that should not occur, but also the ideal society to which they aspire.

Acknowledgments

I am grateful to Sioli Pilioko, Atonia Trouillet, Ivoni Halisi, and Pipiena Keletanoa for their precious help and advice.

Notes

1. At the time of the 1996 census, the population of Wallis was 9,528, according to the National Institute of Statistics and Economics Sciences (INSEE).
2. For the organization of the chiefdoms on Wallis, see Bataillon 1841; Burrows 1937; Douaire-Marsaudon 1998; Chave 2000.
3. The Code Bataillon has been published by K. H. Rensch under its Uvean title, *Tohi Fono o Uvea* (Rensch 1981).
4. The Code Bataillon also stipulated that "there is only one religion in Wallis, the Roman

Catholic Religion; and neither the king or his chiefs have the power to establish another church; that would bring misfortune into the country" (art. 9). This provision has also been maintained in territorial law but is expressed a little more ambiguously: "The Republic guarantees the population of the Territory the free exercise of their religion together with the respect of their beliefs and their customs as long as they are not contrary to the general principles of the right and dispositions of the present law" (art. 3).

5. In 1989, when the author first visited Wallis, the people as well as the chiefs considered that *all offenses* except murder would be judged under customary law.

6. In 2000 there were about a thousand salaried employees in the territory, including both Wallis and Futuna. About eight hundred of them were state employees (*fonctionnaires d'Etat*) and the majority of these positions were held by local residents. Even though there are a few small to medium-size private businesses on Wallis (see van der Grijp 2003 and 2005), the greatest number of salaried employees work for the state.

7. Which cannot be done in such a short chapter as this.

8. For example, even the most traditional Wallisians recognize the importance of school for their children or grandchildren, use the post, or buy products in the shops.

9. Some Wallisians have also expressed the idea that after a century and a half of transformations to their lives, the people will finally comprehend the true judicial framework under which they live, and that the phrase "no one should be ignorant of the law" (*nul n'est censé ignorer la loi*) will finally have some truth for them.

References

Bataillon, Pierre. 1841. "Notice sur l'île et la mission de Wallis, adressée au R. P. Colin, supérieur-général de la Société de Marie." *Annales de la Propagation de la Foi* 13: 5–34.

Boltanski, Luc. 1990. *L'amour et la justice comme compétences. Trois essais de sociologie de l'action*. Paris: Editions Métailié.

Burrows, Edwin G. 1937. *Ethnology of Uvea*. Bernice P. Bishop Museum Bulletin 145. Honolulu: Bishop Museum Press.

Chave, Sophie. 2000. "'Uvea (Wallis), une société de Polynésie occidentale. Étude et comparaison." PhD thesis, École des Hautes Études en Sciences Sociales.

Douaire-Marsaudon, Françoise. 1998. *Les Premiers fruits. Parenté, identité sexuelle et pouvoirs en Polynésie occidentale (Tonga, Wallis et Futuna)*. Paris: CNRS-Editions, Éditions de la Maison des Sciences de l'Homme.

———. 2005. "Food and Wealth. Ceremonial Objects as Signs of Identity in Tonga and in Wallis." In *The Changing South Pacific. Identities and Transformations*, edited by Serge Tcherkézoff and Françoise Douaire-Marsaudon, 207–229. Canberra: Pandanus Books, RSPAS, ANU.

Rensch, Karl H. 1981. *Tohi Fono o Uvea. Code de Wallis: Articles des lois promulgués à Wallis par la reine du pays et ses chefs en l'année du jubilé 1870*. Canberra: Archipelago Press.

van der Grijp, Paul. 2003. "Between Gift and Commodities: Commercial Enterprise and the Trader's Dilemma on Wallis ('Uvea)." *The Contemporary Pacific* 15: 277–307.

———. 2005. "Development Polynesian Style: Contemporary Futunan Social Economy and its Cultural Features." *Journal of the Polynesian Society* 114 (4): 311–338.

PART IV

Cultural Exchange and Identities

Maori Traditions in Analogy with the Past

Toon van Meijl

> [A]ssertions of indigenous difference from "the West" . . . often do not account for *changes* in indigenous ways of knowing. . . . [C]hange in the Pacific gets collapsed with previously formed ways of knowing.
>
> —Teresia K. Teaiwa, "On Analogies: Rethinking the Pacific in a Global Context."

During the late 1980s and early 1990s a whole generation of scholars examined and discussed the reconstruction of traditions and their politicization in the Pacific. This debate about the revival of traditions came gradually to an end during the mid-1990s. Some ten years later, however, it may be concluded that the implications of this discussion for anthropological theory have barely been made explicit. The aim of this chapter is therefore to revisit the debate about the politics of traditions and consider the consequences for anthropological thinking about traditions and particularly their role in processes of cultural change. I will suggest that traditions may be revived and reconstructed in analogy with similar practices in the past in order to come to terms with changes that have taken place in the interim.

When reviewing the debate about the revival of traditions in the Pacific, it is striking that few people have undertaken a comparative analysis of the discourse (e.g., Norton 1993; Otto and Pedersen 2005), while even fewer have been brave enough to make an effort to develop some kind of theoretical synthesis (e.g., Linnekin 1992). This is unfortunate since initially it seemed as though the debate about the cultural renaissance would have some radical implications for improving our understanding of the relationship between cultural innovation and cultural continuity. Refining anthropological insights into cultural change is desirable to move at long last beyond the dichotomy between tradition and modernity. The origin of the gap between the old and the new in Western thinking about change dates back to the Enlightenment yet remains deeply embedded in the social sciences. Even the anthropological champions of cultural variation willy-nilly have severe difficulties discarding the assumption that change occurs in one direction only and invariably involves declining traditionality and rising modernity (Bendix 1966: 307–308). This appeared in particular in some early contributions to the debate about the "invention" of tradition, notably by Allan Hanson (1989) and Roger

Keesing (1989). Indeed, these were criticized by indigenous people for raising the question of the authenticity of revived traditions (Nissen 1990; Trask 1991). In retrospect, however, it could also be argued that these publications raised the issue of authenticity not only because of their references to the misleading concept of "invention," as it was argued in those years (Linnekin 1991), but also because they failed to understand the changing meanings of Pacific representations of traditions, as their analyses remained rooted within the trap of the ancient dichotomy between tradition and modernity.

The controversy about the authenticity of Pacific traditions sparked off some sophisticated contributions about the contextual constructions and negotiations of authenticity (e.g., Jolly 1992), which concept, as a consequence, has become inherently ambiguous in the social sciences. At the same time, however, it must be concluded that the wider issue from which the controversy around the authenticity of revived traditions emerged, the deeply rooted dichotomy between tradition and modernity, remains theoretically largely unresolved. Although studies of sociocultural change in colonial and postcolonial societies might be impossible without some sort of model in which the arrival of Europeans marks a crucial turning point, notions of tradition and modernity remain too often at the root of anthropological analysis. To illustrate this point it may be useful to recall some earlier contributions to the debate.

In his overview of the debate published in the first issue of *The Contemporary Pacific,* Roger Keesing (1989) focused mainly on the lack of continuity in the revival of traditions in the Pacific, in spite of his observation that the representation and reproduction of culture had always been imbued with politics, even in the precolonial past. A few years later a similar contention was put forward by Nicholas Thomas (1992), who argued that the dynamics of colonialism influenced the reconstitution of tradition insofar as only those elements were selected for revival that could serve the differentiation of Pacific peoples from European settlers. In a critique of these publications, Marshall Sahlins (1993) argued that both Thomas and Keesing failed to acknowledge that the imposition of the colonial state is always culturally mediated by indigenous people or that modernity is indigenized, as he phrased it. Later he elaborated on this argument by pointing out that the inclusion of the periphery into a global society is being adapted by indigenous peoples for the reproduction of what remain their own cultures and traditions (Sahlins 1999).

Although the approach of Keesing and Thomas on the one hand and Sahlins on the other might at first sight seem radically different, Francesca Merlan (1998, 2005) has recently argued that these seemingly opposed views share the assumption that indigenous cultural production is autonomous, either drawing resources from or in opposition to a domain of nonindigenous otherness. She takes issue with this point of departure and contends that the revival of cultural traditions among indigenous peoples cannot be understood in that manner since in her view the indigenous scene is not autonomous but rather what she labels intercultural, as it engages elements from both indigenous and nonindigenous sources.

Merlan first launched this idea in her book *Caging the Rainbow* (1998), but in a recent paper she has elaborated on the notion of the intercultural with reference to

the concept of dialogue derived from the Russian scholar Mikhail Bakhtin (Merlan 2005). Bakhtin was trying to come to terms with the dichotomy between objectivism and subjectivism and with the gap between synchrony and diachrony. He responded to these dilemmas with the concept of dialogue, which he developed to do justice to the interplay between social codes of communication and individual speech, as well as between the reproduction of language codes and the transformation of language brought about by individual variations in speech patterns. This view makes a reconsideration of structuralist structures necessary since their elements of social meaning and ordering only persist as the products of interaction, rather than as elements of relatively closed systems that function in separation from the world (Merlan 2005: 177). Thus it can be argued that an intercultural account transcends the boundedness of cultures and their transformation by focusing on the interchanges between both their sociocultural similarities and their differences with other cultures with which they interact.

In my view the suggestion that in colonial circumstances changes in indigenous societies do not normally take place autonomously but in the form of an interactive dialogue with colonizing societies has far-reaching implications for anthropological understandings of cultural change. Merlan points out that indigenous societies do not simply borrow self-directed cultural elements from their colonial rivals or purely reconstitute their culture in opposition to their adversaries. Instead, she suggests, they draw analogies between their own and other practices that allow them either to make the most of both worlds or to discard foreign influences and highlight indigenous sources. In both cases changes in indigenous practices result from interactions between various value systems, either focusing on the similarities or on the differences between colonized and colonizer. Cultural changes, therefore, take place interculturally in a process of dialogue between practices that are compared positively or negatively.

The focus on intercultural interaction and the process of drawing analogies between similar or different practices is not only useful for the analysis of intercultural change, but also for intracultural changes. After all, in the cultural renaissance in recent years analogies are not only drawn with other societies, but also with traditional practices in one's own society in the past. Analogies between past and present enable people to focus on cultural continuities in indigenous practices or values without drawing attention to possible discontinuities, thus accounting for minor and major changes in their society. Indeed, the concept of analogy seems crucial in indigenous accounts of historical transformations of significant cultural practices, yet it remains largely undeveloped as an analytical term in anthropology. Hence a brief excursion into the etymology and broader meaning of the concept of analogy in other academia is in order.

The lack of clarity about the precise meaning of the concept of analogy in the social sciences is in marked contrast with linguistics and also with the natural sciences, particularly mathematics, physics, and biology, in which it is a key concept. As Archimedes discovered the law of communicating vessels when playing with some toys in his bathtub, scientific discovery frequently consists in seeing an analogy where nobody has seen one before. In scientific thinking analogies or resemblances may be used to suggest hypotheses or the existence of some law or principle, especially if a comparison can be

made between the functions of elements in two systems (Lorenz 1974). This is in line with the term's etymological meaning as it has been derived from the greek *ana* and *logon*, literally "according to a ratio," which in contraction referred to a similarity in proportional relationships. This original meaning was later adjusted by philosophers such as Aristotle and Plato, who used the term to explain relationships not yet understood in analogy with relationships already familiar.

In the Middle Ages it was believed that the universe forms an ordered structure such that the macrocosmic pattern of the whole is reproduced in the microcosmic pattern of the parts so that it is possible to draw inferences by analogy from the one to the other (Foucault 1966). Such parallels were held to constitute arguments and not merely allegorical illustrations. For that reason, too, the word "analogical" soon became linked with the word ambiguous, and this meaning became later standard in both logic and theology. As a consequence, functional resemblances are generally more fundamental than proportional ones, simply because they do not require complicated methodological procedures of verification. Instead, they elucidate some unfamiliar point in terms of what is more familiar. Nevertheless, such analogies are often misleading insofar as they overlook differences between the notions that are compared. When the method of analogy is employed, it is not uncommon that the resemblances noted bear relevantly on the point to be established, but the remaining differences are deemed irrelevant and therefore downplayed. Analogies, in other words, usually involve only superficial resemblances of structures that have different origins, but still they are crucial to process new types of information. In cognitive sciences, too, it is widely accepted that analogies are common devices for teaching and learning cognitive information with which individual subjects are yet unfamiliar (Gentner, Holyoak, and Kokinov 2001).

In view of these insights it may be productive to examine to what extent analogies are used in indigenous accounts of social and cultural changes. When doing ethnographic field research in New Zealand it always struck me that Maori people frequently draw analogies between the old and the new in order to de-emphasize changes, and these analogies are typically situated out of time. The so-called timelessness of Maori analogies convey that these comparisons function to defy change, not to deny changes, since the changes are presupposed in the act of comparison on which the analogy itself is based. Since nowadays the dynamics of the process of drawing analogies are often simultaneously influenced by a stereotypical opposition between Maori and Pakeha culture, the aim of the process of comparison is often clearly related to the politics of Maori identity formation in contemporary New Zealand. Maori draw analogies between the old and the new in contrast to a stereotype of a non-Maori counterpart, with the ultimate aim of boosting their own traditions and values. Let me illustrate these points with two case studies of the various meanings of the concept of *iwi*, often glossed as "tribe," and related notions of *aroha* or "love" in a broad sense.

The Widening Meaning of *Iwi*

In the 1970s the traditional structure of the tribal organization of Maori society was formally still intact, although its impact on social practices had diminished over the

years. Dispossession of tribal lands in the course of colonial history and a wave of urbanization after the Second World War had entailed a change in modes of self-identification among the Maori population. Some statistical data may clarify this.

By the end of the previous century the Maori made up about 15 percent of the total New Zealand population of four million. More than 80 percent of all Maori are living in urban areas, and less than 20 percent are fluent in the Maori language. In addition, it is significant that even Maori academics argue that unofficially at least 50 percent of all Maori cannot or will not identify with any tribal organization, *iwi*, or *hapuu* (Durie 1998; Walker 1996).

These statistics notwithstanding, the tribal organization of Maori society re-emerged powerfully in the political arena during the second half of the 1980s. The reinforcement of tribes partly resulted from a new government policy of decentralization. The Labour government reorganized the Department of Maori Affairs, which was completely devolved to tribal organizations or *iwi* authorities. *Iwi* or tribes were recognized under the Runanga Iwi Act of 1990 and became responsible for economic development programs and social services. As a result, tribal organizations regained recognition at a time when Maori society was becoming increasingly pan-tribal following the urbanization process (van Meijl 1997).

Although the Runanga Iwi Act was repealed by the national government immediately after re-election in 1990, it left a legacy of a strong, centralized structure of tribal organizations that had a far-reaching influence on the debate about treaty claims and settlements. This appeared in particular in the dispute about the distribution of the fisheries settlement, about which the government reached agreement with a representation of Maori tribes in 1992 (van Meijl 2006). The struggle about the distribution of the fisheries became a continuation of the struggle to qualify as *iwi* brought about by the introduction of the Runanga Iwi Act. Here it is important to point out that *iwi* is generally translated as "tribe," whereas the literal meaning is "bone" or "people." Against this background a profound controversy emerged regarding whether the fisheries should be distributed among tribal organizations or among "all Maori," including pan-tribal organizations.

Initially the terms of the debate were formulated by the Treaty of Waitangi Fisheries Commission (or Te Ohu Kai Moana, "The Seafood Group"), in which only Maori tribal organizations were represented. Their viewpoint was rather straightforward: The fisheries have been dispossessed from Maori tribes and should therefore be returned to tribal ownership. There was no discussion about the meaning of the term *iwi*, which in the opinion of the fisheries commission referred exclusively to traditional tribes. The main characteristics of *iwi* were summed up as sharing descent from ancestors and comprising a number of *hapuu* or subtribes. This definition of *iwi* has recently been deconstructed by the New Zealand anthropologist Steven Webster (2002: 350–352), who has argued compellingly that *iwi* and *hapuu* are not nearly as stable as the Maori representatives of the Te Ohu Kai Moana, all tribal chiefs, would like to establish. Maori society has traditionally had an extremely flexible kinship system, which also explains the waxing and waning of tribes over time (Ballara 1998; Poata-Smith 2004). The

Carved ancestor in the front post of an ancestral meeting house.

recent redoubling of *iwi* also illustrates that *iwi* may rise and decline opportunistically in response to changing sociopolitical and economic conditions (Webster 2002: 358).

The irony of the influential position of Te Ohu Kai Moana, too, is that its model of the structure of Maori sociopolitical organization is rooted in anthropological accounts drawn up in the beginning of the twentieth century, notably by Raymond Firth (1959 [1929]), who in turn based his interpretations on the corpus of ethnographic data collected by Elsdon Best toward the end of the nineteenth century (e.g., Best 1941 [1924]). In consequence, it may be argued that the proposal of the fisheries commission to allocate the fisheries assets exclusively to so-called traditional *iwi* is not primarily grounded in a vision of tribes as survivals of the past. Te Ohu Kai Moana is no longer concerned with a representation of the historic past, but on the basis of the work by Firth they draw an analogy with the past as a result of which the concept of tribe has become a stereotypical representation of contemporary ideas about the precolonial past. In their worldview, *iwi* have become a simulacrum of the past, a copy of a copy, or a reconstructed simulation of the past as it was imagined by the informants of Elsdon Best (Barcham 2000: 147).

The most interesting aspect of the debate about the central position of tribes in contemporary Maori society, however, is that in spite of the critique of tribes, the traditional Maori concept of *iwi* has been co-opted by urban Maori groupings to demonstrate that the differences between traditional tribes and nontraditional groupings are effectively negligible. They simply draw an analogy between the two forms of organization and thus emphasize the similarities while downplaying the differences. Let me illustrate this second type of analogy in more detail.

Although urban Maori groupings lost the dispute about the distribution of fishing quota in court, pan-tribal authorities in New Zealand cities did book a small political victory as it became recognized that they represent large sections of the Maori population. This political progression was endorsed by a landmark ruling of the Waitangi Tribunal in 1998 giving one of the main urban Maori groups, Te Whanau o Waipareira Trust, negotiating status with the government as "*iwi*" (Waitangi Tribunal 1998). In their claim to the tribunal the group from west Auckland had argued that "Waipareira is not an *iwi* but is *iwi*" (Waitangi Tribunal 1998: 6), and the tribunal accepted that "(t)oday, '*iwi*' can mean either the people of a place or a large tribe composed of several dispersed groups" (Waitangi Tribunal 1998: 18). This report of the Waitangi Tribunal resulted in some social welfare programs for pan-tribal Maori communities, while in the fisheries debate it necessitated a new proposal acknowledging pan-tribal interests as well.

The conclusion to be drawn from these debates about the meaning of the Maori concept of *iwi* is that nowadays it is used, on the one hand, as a marker of cultural distinction between Maori and non-Maori, but on the other hand, it is paradoxically also used to emphasize the similarities between two distinct types of social organization in Maori society, that is, tribal *iwi* and pan-tribal *iwi*. Traditional *iwi* have re-emerged, not primarily to denote Maori forms of social organization, but to assert cultural difference and, concurrently, to justify the settlement of their long-standing grievances about

violations of the Treaty of Waitangi. The settlement process, in turn, has generated a movement among urban groupings to share in the redistribution of resources dispossessed in the nineteenth century. Thus it might be argued that, in the terminology of the French semiologist Roland Barthes (1957), a discrepancy has emerged between the denotation of the concept of tribe and its diverging connotations in different contexts.

First, traditional tribes have re-emerged as corporate organizations since the government is devolving substantial amounts of resources to Maori ownership in order to redress Maori colonial grievances (Rata 2000). Although their impact on social relationships is relatively limited, in the discourse of tradition they continue to be represented as immutable remnants of the past. In order to defy and resist the historic transformations of the value of *iwi*, tribal conceptions are detemporalized to enable *iwi* to be represented as timeless and unaltered. In that sense, the signifier *iwi* is lagging behind current practice. Second, the change in meaning of the concept of *iwi* appears from its application in reference to groups and organizations that are set up on a regional or urban basis. Pan-tribal organizations in cities increasingly authorize their status by identifying their organization as "*iwi*" and even use traditional Maori terminology to indicate that, for example, Ngati Poneke, literally "the descendants of Wellington," or Te Whanau o Waipareira, the "extended family of Waipareira." These new labels are appealing as they continue to evoke the connotation of traditional Maori kinship groupings.

What traditional *iwi* and pan-tribal organizations share is that both justify their contemporary forms in analogy with historic forms of Maori sociopolitical organization. It is this form of analogy that in my view is crucial to understanding how social and cultural changes are accounted for. This use of analogy is also evident in another comparison that is often made between tribes, on the one hand, and gangs or motorbike associations of Maori youngsters, on the other hand. The analogy between tribes and gangs also aims at constructing continuity by linking the past (tribes) with the present (gangs). In this case, the differences between tribes and gangs are neglected so that the comparison functions primarily to re-establish relationships between tribal and non-tribal groupings of Maori people. This became particularly clear to me at the funeral of a Maori "bikie," when a gang leader referred to his bike as a "canoe" (*waka*), an ancestral vehicle but as concept also used metaphorically for all descendants of their crew (in contemporary anthropology now considered as a "confederation of tribes"). The gang leader unquestionably aspired to recommitting Maori affiliations and allegiances: "Just like our ancestors traveled in their canoes, so we drive our bikes to go out to meet people and have a good time."

Pointing to his leather jacket with the gang's patch at the back, the gang leader simultaneously resolved one of the salient differences in the similarities between tribal ancestors and themselves: "We may be wearing a different style of clothes you fellas don't like, but we are still people! We all have mothers and fathers and brothers and sisters. We only don't have a job and that's why we stick together."

At the end of his speech he carried the analogy between gang and tribe through by referring to the "pad" of the gang as a *marae*: "as a *marae* is always open to anybody,

our pad is always open too. And we like to invite yous all to drop in sometime when you pass by."

This striking analogy between gangs and tribes brings to the fore the similarities in sociality and the functions both groups accomplish, while differences in historical origin and social organization are defied. The Maori concepts of *waka, iwi,* and *marae* are detemporalized to facilitate analogies between past and present forms of social organization in order to emphasize continuity and downplay historic differences to render the contemporary state of reality as normal. In this manner, traditional concepts play a central role in Maori accounts of social change. The metaphoric use of *waka* and *iwi*, and even *marae*, is typical for the discourse of modern Maori organizations, which are not based on descent or kinship connection, but which aspire to rehabilitate the political and economic role of tribes and the quality of group life associated with them (Metge 1995).

Naturally, all Maori people realize that gangs are a recent innovation of group formation and therefore different from ancient tribes. In contradistinction to European forms of organization, however, the similarities between tribes and gangs outweigh the differences and therefore assist in justifying claims to a united and sovereign Maori nation on the basis of radical alterity between Maori and Europeans. The central role of tribal notions in the Maori discourse of tradition, however, is not derived from a mere opposition to European domination. Their reconstitution is the result, in the first place, of indigenous attempts at coping with the disintegration of tribal organizations following colonization and urbanization. In the discourse of Maori tradition, historical transformations in tribal organizations are disguised to expose the continuing rel-

Motor bikes forming a guard of honor at the *marae* funeral of a Maori gang member.

evance of pan-tribal expressions of relatedness among all Maori people. At present, the contemporary extensions of classificatory "kinship" bonds are most conspicuously articulated in terms of emotional concepts such as hospitality, caring and sharing, and *aroha.*

Aroha or "Love for Kin"

Nowadays *aroha* is usually translated as "love" in a broad sense. Originally, however, *aroha* implied "love for kin" (Metge 1976: 66), and not only in the sense of affections, but also in relation to its practical consequences. In modern Maori society the traditional connotations of *aroha* have been replaced by associations with strongly felt communal bonds and affection. Analogous to the countercultural hippie movement of the 1960s that used love as a rallying symbol of protest against war and the establishment, *aroha* has become a central concept in counter colonial Maori discourse. Ideologies of love are appealing as they defy any validation of its political connotations in a language other than the ecstatic.

Aroha has become an ethnic marker in Maori society and is applied to create a collective consciousness of Maori as distinct from Europeans. As such, it reinforces unity among all Maori people regardless of tribal affiliations (compare Kaplan and Kelly's discussions of the Fijian equivalent of *aroha*, i.e., *loloma*, this volume). In addition, it complements and sustains the sheer unlimited extensions of classificatory kinship to all Maori people, as was expressed, for example, at a conference that aimed at enhancing Maori unity: "We need funding as a boat needs oil and petrol to keep going, but the mechanics of Maoridom are formed by *aroha*" (representative of Ratana church).

This speaker implied that the unique Maori feeling of *aroha* outweighs European perishable goods in importance. At the same time, contemporary uses of *aroha* often hint at the uniqueness of the feeling to Maori people. Once I was even told, "You fellas [European people, TvM] don't have *aroha*. You've got nothing. We beat you."

In this context, *aroha* has emerged as a concept unique to Maori and is said to import a warmth of feeling, while European New Zealanders are generally associated with "cold" by contrast. Thus parallel features of European society are inverted in ideology and boosted for ethnopolitical reasons. In contemporary Maori discourse, however, *aroha* is a powerful concept not simply as the indigenous counterpart of European coldness, but primarily because it facilitates an analogy between traditional notions of "love for kin" and the new inclusive ideology of pan-tribal relatedness among urban Maori communities. *Aroha* enables Maori people to phrase their ethnic unity in terms of traditional Maori kinship by drawing an analogy between their common ethnicity and their common descent from a mythological homeland called Hawaiki. The semantics of *aroha* have gradually shifted from communal kinship in the past to communal affection in the present, but by continuing to attribute a central role to *aroha* in Maori political discourses, this subtle mutation in meaning is discounted. The signifier *aroha* remains unchanged to enable *aroha* to be represented as everlasting. From a Maori point of view it can thus be argued that nothing has changed after all.

Careful analysis, however, shows that the content of the timeless notion of *aroha* has

Expressing *aroha* during a *marae* welcome.

clearly been accommodated to modern-day living. In some circumstances, for example, representations of *aroha* indicate a process of commodification, particularly in the context of Maori tourism enterprises, in which Maori attempt to capitalize on their reputed hospitality (compare Kahn's discussion of the commodification of Tahitian dance, this volume). *Marae* tours, for example, are sometimes advertised as offering *aroha:* "We offer tourists plenty of *aroha* and whatever else they would like to buy." This commodification of *aroha* discloses the ideological value of the concept. *Aroha* is redefined for strategic purposes to draw a strict ethnic boundary between Maori and European New Zealanders as well as to enhance, occasionally, commercial gain.

Aroha has become an emotionally charged concept in interethnic discourse, but equally so in intra-Maori discourse. For some people argue that *aroha* has lost its traditional meaning, not only because of the tendency to commodification, but because the younger generations of Maori people appear ignorant of it. In a discussion about the disarray in which many young people find themselves, a youth leader only twenty-five years old said, "Our young people don't want to hear about development. Their real guts of the matter is bread and butter, not the cream on top of it. They don't know about *aroha*. Let's face it. It might sound harsh, but it is the truth."

Significant also in the reflections on the loss of *aroha* is the distinction made between *aroha* in discourse and *aroha* in practice: "We talk a lot about *aroha,* but it's bloody shit *aroha* if you see how people get on with one another these days."

"They talk about *arohanui* ("lots of love") and *rangimaarie* ("peace[ful]"), but the next day they stab you in the back."

Implicit and explicit references to violence in Maori society disclose an internal contestation of predominantly interethnic representations of *aroha*. At the same time, the moving statements quoted above elucidate why emotional concepts have retained

a central position in Maori ideology. *Aroha* continues to be a central concept in the Maori discourse of tradition since it provides a charter for the re-establishment of a traditional society based on "love for kin." Since the realization of Maori sovereignty depends on the dismantling of colonial control, however, *aroha* is also reconstructed to distinguish Maori culture from European culture. For that reason, too, *aroha* is chiefly reformulated in opposition to the stereotype of European society as harsh and individualist. This antithetical articulation is, in turn, highlighted by differences in meaning between *aroha* in the public discourse of tradition and the way it is contested within predominantly Maori settings.

Concluding Remarks

In this chapter I have argued that the significance of central concepts of the Maori discourse of tradition, such as *iwi* or "tribe" and *aroha*, is not simply determined by the oppositional dynamics of interethnic politics in New Zealand. Both *iwi* and *aroha* are powerful symbols in Maori ideology because they allow people to draw analogies between the old and the new, and as such they play a crucial role in indigenous accounts of social change. This also explains why only values and practices that are still relevant in contemporary society are being reconstructed in traditional terms. It shows that we are not dealing with inventions or reinventions of lost traditions, but with continuously changing traditions.

Changes in indigenous traditions are accounted for by conflating distinctions between the past and the present in analogies between, for example, traditional tribes and pan-tribal groupings in cities, between tribes and gangs, and between conceptions of "love for kin" and "love for all Maori." Timeless representations of traditional concepts in analogies between distinctly past and distinctly present phenomena do not necessarily foreclose change since a transformation is presupposed in the resemblance evoked by the analogies. By being rendered as everlasting, changes therefore are not denied, but only defied and resisted, both to come to terms with and to divert the contemporary dislocation of Maori society as well as to validate the demand for changes in political directions.

In spite of their timeless representation in ideology, the analysis of two central concepts of the Maori discourse of tradition shows that tradition is far from static. The dynamics of tradition is particularly obvious in the contrast between contextual connotations in interethnic and intra-Maori discourse. While the signifiers *iwi* and *aroha* remain seemingly unchanged in interethnic ideology, they have acquired new signifieds and have come to evoke different connotations in Maori social practice. The new countercolonial ideology of tradition is formulated, as it were, in terms of old signifiers of which the "traditional" signifieds are lagging behind present practices. The colonial history of New Zealand has transformed the valuation of historical Maori signs, a process in which Maori people are now attempting to intervene by resisting change in ideology. Consequently, tradition is represented as timeless, as continuous, but with the paradoxical aim of re-acquiring control of the direction and pace of change in New Zealand society.

This argument takes issue with the focus on the countercolonial dynamics of the so-called "invention" of tradition by Keesing and Thomas, but also with the emphasis on cultural continuity in the work by Marshall Sahlins. Although the latter made a useful critique of the perspective on oppositional change, there can be no doubt about the impact of colonial resistance on the manner in which the discourse of tradition is shaped. The notion of the intercultural suggested by Merlan is an interesting attempt to bridge the gap between exclusive foci on internal or external constructions of culture, on continuity or discontinuity. A focus on the intercultural dynamics in the transformation of traditions is also useful since it draws attention to the role of functional analogies between old and new meanings of traditions. The analysis of these analogies has demonstrated that they are invariably invoked to highlight structural differences between Maori and non-Maori in order to downplay changes and differences within Maori society. Thus, the Maori discourse of tradition exemplifies unambiguously that the dichotomy between tradition and modernity is not an indigenous problem.

References

Ballara, Angela. 1998. *Iwi: The Dynamics of Māori Tribal Organisation from c. 1769 to c. 1945*. Wellington: Victoria University Press.

Barcham, Manuhuia. 2000. "(De)Constructing the Politics of Indigeneity." In *Political Theory and the Rights of Indigenous Peoples*, edited by Duncan Ivison, Paul Patton, and Will Sanders, 137–151. Cambridge: Cambridge University Press.

Barthes, Roland. 1957. *Mythologies*. Paris: Éditions du Seuil.

Bendix, Reinhard. 1966. "Tradition and Modernity Reconsidered." *Comparative Studies in Society and History* 9: 292–346.

Best, Elsdon. 1941 [1924]. *The Maori*, vols. 1, 2. Wellington: The Polynesian Society.

Durie, Mason. 1998. *Te Mana, Te Kāwanatanga: The Politics of Māori Self-Determination*. Auckland: Oxford University Press.

Firth, Raymond. 1959 [1929]. *Economics of the New Zealand Maori*. Wellington: Government Printer, Shearer.

Foucault, Michel. 1966. *Les mots et les choses; Une archéologie des sciences humaines*. Paris: Gallimard.

Gentner, Dedre, Keith J. Holyoak, and Boicho N. Kokinov, eds. 2001. *The Analogical Mind: Perspectives from Cognitive Science*. Cambridge, Mass.: Massachusetts Institute of Technology.

Hanson, F. Allan. 1989. "The Making of the Maori: Culture Invention and its Logic." *American Anthropologist* 91 (4): 890–902.

Jolly, Margaret. 1992. "Specters of Inauthenticity." *The Contemporary Pacific* 4 (1): 49–72.

Keesing, Roger M. 1989. "Creating the Past: Custom and Identity in the Contemporary Pacific." *Contemporary Pacific* 1 (1–2): 19–42.

Linnekin, Jocelyn. 1991. "Cultural Invention and the Dilemma of Authenticity." *American Anthropologist* 93 (2): 446–449.

———. 1992. "On the Theory and Politics of Cultural Construction in the Pacific." *Oceania* 62 (4): 249–263.

Lorenz, Konrad Z. 1974. "Analogy as a Source of Knowledge." *Science* 185 (147): 229–234.

Merlan, Francesca. 1998. *Caging the Rainbow: Places, Politics and Aborigines in a North Australian Town*. Honolulu: University of Hawai'i Press.

———. 2005. "Explorations towards Intercultural Accounts of Socio-Cultural Reproduction and Change." *Oceania* 75 (3): 167–182.

Metge, Joan. 1976 [1967]. *The Maoris of New Zealand; Rautahi.* London: Routledge & Kegan Paul.
———. 1995. *New Growth from Old: The Whaanau in the Modern World.* Wellington: Victoria University Press.
Nissen, Wendyl. 1990. "Academics to Stand Up for Maoritanga." *New Zealand Herald,* March 1, 1990.
Norton, Robert. 1993. "Culture and Identity in the South Pacific: A Comparative Analysis." *Man* (N.S.): 28: 741–759.
Otto, Ton, and Poul Pedersen. 2005. "Disentangling Traditions: Culture, Agency and Power." In *Tradition and Agency: Tracing Cultural Continuity and Invention,* edited by Ton Otto and Poul Pedersen, 11–49. Aarhus: Aarhus University Press.
Poata-Smith, E. S. Te Ahu. 2004. "The Changing Contours of Maori Identity and the Treaty Settlement Process." In *The Waitangi Tribunal: Te Roopu Whakama i te Tiriti o Waitangi,* edited by Janine Hayward and Nicola R. Wheen, 168–183. Wellington: Bridget Williams Books.
Rata, Elizabeth. 2000. *A Political Economy of Neotribal Capitalism.* Lanham, Md.: Lexington.
Sahlins, Marshall. 1993. "Goodbye to *Tristes Tropes:* Ethnography in the Context of Modern World History." *Journal of Modern History* 65 (1): 1–25.
———. 1999. "Two or Three Things That I Know About Culture." *The Journal of the Royal Anthropological Institute* 5 (3): 399–421.
Teaiwa, Teresia K. 2006. "On Analogies: Rethinking the Pacific in a Global Context." *The Contemporary Pacific* 18 (1): 71–87.
Thomas, Nicholas. 1992. "The Inversion of Tradition." *American Ethnologist* 19 (2): 213–232.
Trask, Haunani-Kay. 1991. "Natives and Anthropologists: The Colonial Struggle." *The Contemporary Pacific* 3 (1): 159–167.
van Meijl, Toon. 1997. "The Re-emergence of Maori Chiefs: 'Devolution' as a Strategy to Maintain Tribal Authority." In *Chiefs Today: Traditional Pacific Leadership and the Postcolonial State,* edited by Geoffrey M. White and Lamont Lindstrom, 84–107. Stanford, Calif.: Stanford University Press.
———. 2006. "Who Owns the Fisheries? Changing Views of Property and its Redistribution in Post-colonial Maori Society." In *Changing Properties of Property,* edited by Franz von Benda-Beckmann, Keebet von Benda-Beckmann, and Melanie G. Wiber, 170–193. New York/Oxford: Berghahn.
Waitangi Tribunal. 1998. *Te Whanau o Waipareira Report* (Wai 414). Wellington: GP Publications.
Walker, Ranginui. 1996. *Ngaa Pepa a Ranginui: The Walker Papers.* Auckland: Penguin.
Webster, Steven. 2002. "Maaori Retribalization and Treaty Rights to the New Zealand Fisheries." *The Contemporary Pacific* 14 (2): 341–376.

Contemporary Tongan Artists and the Reshaping of Oceanic Identity

Paul van der Grijp

According to Epeli Hauʻofa, "in cultural creativity we can carve out our own spaces, in which we set the rules, the standards that are ours, fashioned to suit our circumstances, and to give us the necessary freedom to act in order to bring out the best in us. The realization of this potential can unleash an enormous creative energy that could help to transform and reshape the face of contemporary Oceania in our own image" (2005: 11–12). Here, the crucial message is the claim of freedom to explore and represent one's own identity in an artistic way. Epeli Hauʻofa makes this claim against limitations imposed by both indigenous authorities (the chiefs, the churches, or the family) as well as foreign (European) artistic standards (Suva, personal communication, 2006). The ethnographic material analyzed in this chapter may illustrate what this claim entails.

Material culture studies in "folklore or ethnology" have, to quote another relevant author in this context, been preoccupied for a long time with "handmade objects created by makers who are members of what are perceived to be isolated groups, uncorrupted by the outside forces of industrialization and [Western] popular culture" (Pocius 1997: 6). The ethnology concerned dealt with "folk craft" and "folk art," that is, with "the products of pre-industrial or semi-industrial cultures not yet caught up in the main stream of mass culture" (ibid.). In this, the notion of authenticity was crucial, and the objects concerned reflected this. In recent decades the emphasis in these kinds of studies has shifted from the creation of objects to their functions, from design as an expression of "an individual's aesthetics" to economic considerations. The focus too has been redirected to the notions of tradition and authenticity—cultural constructs indeed. More generally, the rise of material culture and folklore studies may be considered as an academic preoccupation with authenticity, and in this research more attention should be paid to the backgrounds of the makers of these kinds of products. As an anthropologist I do not limit my research interests simply to "ethnology" in Pocius' perspective, although I do feel it worthwhile to follow his advice (see in this respect also Marcus and Myers 1995; Phillips and Steiner 1999; and Myers 2002). This is what I will do here by taking a close look at five Tongan artists and vendors of art and craft, including their biographical backgrounds, the social organization of their enterprises, projects for the future, and the artists' ideas about the relation between art and craft.

The Polynesian Kingdom of Tonga is situated in the southern hemisphere, east of

Female Tongan wood carver (Tonga, 2006).
Photo: Paul van der Grijp.

Fiji, west of Samoa and north of New Zealand. Tonga consists of some 150 tropical islands and has a predominantly Polynesian population of about 100,000 people within its borders, with an additional 50,000 Tongans living overseas. Tonga is an independent nation-state that has never been colonized, but it was a British protectorate between 1900 and 1970.[1] The changing context of Tongan artists is an increasingly monetarized economy and mobility of persons, ideas, goods, and money. The shifting meanings concern wood and bone carvings, which are now produced for a tourist market inside the country that consists not only of foreign tourists, but also of emigrated Tongans visiting their home country. It is my aim to show some of the daily preoccupations of these Polynesian artists and, in so doing, to make them less exotic, with the words of Condominas (1965) in mind: *L'exotique est quotidien:* the exotic is a daily matter.

Business Strategies of Tongan Artists

Lopati, our first example, was born on Tongatapu, the main island of Tonga, sixty-three years ago.[2] Since his early youth, he has been keen on drawing. His parents sent him to a technical school in Honolulu, Hawai'i, but he was not really interested in mechanics, and he asked to be allowed to go to the Honolulu Academy of Arts, where he obtained a scholarship. So when Lopati was nineteen years old, he studied fine arts there. Returning to Tonga, Lopati was unemployed and, moreover, had no money to buy materials for oil painting as he had had in Honolulu. Nevertheless, he did manage to make a few oil paintings, but found it hard to sell them in Tonga; he sighs: "there is no market for painting here" (Maofanga, personal communication, 2006). There was, however, plenty of wood available for free. He started working with it, carving the kinds of things he thought would be easy to sell. He never studied sculpture, but he said to himself, "What I can do on paper or canvas, I can do that on wood too" (ibid.). Thus he became a carver and intends to remain a carver. In Tonga, Lopati tried to find out what potential customers would like to buy and made several remarkable carvings. One of these was a sculpture of the fictive, sacred paramount chief of Tonga, a legendary Tu'i Tonga, named Nui Tamatou. Lopati gives the following explanation:

> The eleventh Tu'i Tonga was Tu'itātui, who had two sons. The eldest was Talatama and the second Tala-'i-Ha'apepe. Talatama died childless. Tala-'i-Ha'apepe wanted to become the Tu'i Tonga [the sacred paramount chief], but the other chiefs disagreed because he was a brother of the preceding Tu'i Tonga. Tala-'i-Ha'apepe then carved a wooden human image (*tiki*)[3] and stated, "This is Nui Tamatou, the son of Talatama and the legitimate new Tu'i Tonga." Tala-'i-Ha'apepe organized a wedding party for that *tiki*, the fictive Tu'i Tonga Nui Tamatou, and claimed to be the son of Nui Tamatou. Next, he declared that Nui Tamatou had died, and he had him ceremonially buried in the royal cemetery in Mua, and he took the Tu'i Tonga title himself since he was the son of the previous Tu'i Tonga. I made a carving of Nui Tamatou, a large *tiki*-like sculpture, three feet high, and also carved a woman leaning on him, very realistic. My brother who lives in America bought it from me with the words: "This sculpture will become very valuable when you die!" It is still with him in America. (Ibid.)[4]

Lopati's first carving in Tonga was an eagle holding a snake, a typical North American image; his second was a Tongan rider holding his horse by its mane—Tongans do not use saddles or reins. His third carving was the aforementioned Nui Tamatou, and his fourth was a Tongan man drinking kava.[5] Lopati made all this to test what people would buy. He took drawings of sculpture projects around to potential European (*pālangi*) buyers such as the bank director and owners of large shops and had them place their orders, which he then executed. Lopati worked slowly; his colleagues, who were mass-producing *tiki,* were much faster. Some of them also made cow bone carvings and the tourists appeared to prefer them to woodcarvings. Bone carvers were

able to make a better living, and Lopati too almost switched to bone carving but finally stuck to woodcarving because, as he emphasizes, "I still liked to do my artwork" (ibid.).

Ofa, our second example, was born fifty-six years ago on the island of Uiha in Tonga's central Ha'apai Group (see also van der Grijp 2006b: ch. 8). As a child, Ofa used to make small wooden boats to play with in puddles during the rainy season, and sometimes he took them out to sea. He also remembers modeling small animals from clay. In primary school, he had to make a walking stick and a wooden tapa beater.[6] He asked his adoptive father, who taught construction and carpentry in a high school on Tongatapu, how to proceed, but the latter told him, "You can work it out yourself." His father showed him an old tapa beater and said, "Have a look how this one is made." Ofa made a copy of it. Later he worked in the Black Coral Factory (*falengaue toa tahi*, which in Tongan means "the factory of ironwood from the sea") in the Small Industries Center in Maofanga on Tongatapu (van der Grijp 2006a). At school, he also learned how to build a house and how to be a plumber and a mechanic. In the Black Coral Factory, however, he got the idea that he could earn more money working on his own (*ngaue a'aku*). Today, Ofa presents himself as an artist, carver, and draftsman on his business card, but it also reads in bold letters: Dealer in Ancient Tongan Artifacts.

Ofa makes replicas of ancient artifacts from St Cartmail's book *The Art of Tonga* (1997) and realizes that sometimes errors or poor work are depicted in the book. Other carvings, however, may approach perfection: "I touch it, hold it, and feel it, and it's really, really perfect" (personal communication, 2006). Simultaneously, Ofa thinks about the man who made the object in ancient times: "I know that I get the same feeling as he had" (ibid.). When Ofa feels that a war club is in balance, he knows he could have survived a battle had he been living in those days. He keeps this in mind when he makes a carving himself:

> When I make a drawing, or carve a piece of wood, the only thing to force me to carve is the knowledge that someone wants a fish, or a horse. But for me, I want to see that piece of wood in the meantime. If I want to carve a piece of wood, I look at it, turn it around and look at it many times and, finally, I see the figure that will come out from that piece, and know then: that's the thing I want to carve. And I carve accordingly to what I saw coming out from the wood previously. (Ibid.)

For Ofa, one occasion to make something special was for the author of the book *The Night of the Tiki*. Two other Tongan carvers had sold him wooden *tiki*, but they were crooked. The author of *The Night of the Tiki* was surprised to find St Cartmail's book *The Art of Tonga* (1997) in Ofa's market stall and asked him whether he could copy a sculpture in it (ibid.: 58) of a girl sitting with both legs at one side: *fāite* (i.e., to sit on the floor with the legs bent in the way that women do). Ofa said he would be able to carve such a sculpture and advised him to come back in three days. On seeing the result, the man gave him four hundred Tongan dollars (*pa'anga*), although they had not even discussed the price at all. Ofa asked him why he wanted to have that *tiki* in

particular, and he was given the reply: "Because this is the best *tiki* I have ever seen. I want to publish another book on *tiki* with a picture of your sculpture in it."

Most buyers of Ofa's products are Tongans living overseas. In 2003, for example, I witnessed a transaction with a Tongan man living on the big island of Hawai'i who bought fifty small wooden turtles and the same number of shark's tooth pendants, with the aim of selling them for a profit on his new home island. Ofa himself drills the line holes in the upper part of the shark's teeth, and his daughters string them along some black coral beads. Ofa spends most of his time in the market selling other people's products, instead of producing them in his own workshop at home, because he has no one to take care of the market stand. His wife is busy at home caring for the young granddaughter they recently adopted—or rather, had to adopt. Their daughters are all married and have jobs. Ofa's dilemma is that he feels that only close family members could look after his stall if he were to work at home: "It would be all right if my daughters did not give me the money from the things they sell. It would be wrong, however, when someone from outside my family would do that" (Nuku'alofa, personal communication, 2003). Since Ofa started carving, prices have fallen considerably:

> Some of my colleagues say that we are with too many now, but I don't believe this. If we would sell for the same price now as fifteen years ago, only Tevita and I would still sell, and not the others. This is why they dropped the prices. Maybe it's only my own problem: I can't mass produce things. However, I still sell the mass products of others. I only make unique pieces myself and ask a price for them that seems reasonable to me. This piece [a pendant in cow bone], for example, costs 45 [Tongan] dollar, which is not too expensive, but people have heard prices like three dollar for similar pieces—though of inferior quality—and say to me that I'm too expensive. I remember very well that, when I started carving, prices were still good." (ibid.)

Tevita, our third example, was born forty-seven years ago on the island of Ha'ano, also in the Ha'apai Group. Tevita descends from a line of canoe builders, *tufunga vaka*, in distinction to the *tufunga fale*, house builders. Tevita's father's house on Ha'ano was *vaka lau tala,* which implied that in the past, Tongan boats on their way to Samoa or Fiji would stop there so that his father or grandfather could indicate the necessary modifications to the rigging, sails, outriggers, and the like. This was the hereditary task of this lineage, as Tevita says: "We are the *fa'ahinga* [lineage] of boat builders" (Popoa, personal communication, 2005). His father made the transition from carving outrigger canoes (from tree trunks) to building European or "English" boats (from wooden planks), and besides boats sometimes made decorative carvings that later became popular among American Peace Corps volunteers and visiting yachties. He was, however, not really a Western-style entrepreneur, unlike his son Tevita. Tevita says he was the first in his family to really commercialize art.[7] As a young man, after quitting his job in an office in Nuku'alofa, Tevita took his last wages of fifty-seven Tongan dollars and bought a saw, a drill, and a file. Afterwards he had twenty dollars left to buy a stock of black coral from some fishermen, and he carried all this in a handbag to the park

at the ocean front, where he met with the older woodcarvers. They were about fifteen artists working in the park at the time, twelve men and three women. Tevita learned many things from Lopati (our first example), one of the senior carvers, just by working side by side and by looking at how the other was going about it. According to Lopati, some of Tevita's work is better than his own: "Tevita is the only one about whom I now think: If I can't do a job, I leave it to him" (Maofanga, personal communication, 2006). Meanwhile, Tevita has become the most successful art entrepreneur of the islands.

Tevita estimates that 30 percent of his work is bought by Tongans and 70 percent by Western foreigners (*pālangi*). He sees this as a progress because in the past his only clients were *pālangi*. Among his merchandise are masks and small *tiki*, clearly inspired by contemporary Tahitian and Hawaiian "tourist" art. Other pieces are inspired by New Zealand Maori art. Tevita, however, sees his mix of styles as typically Tongan. The only really Tongan-style pieces are small sculptures of the ancient god Tangaloa. Tevita claims to be responsible for re-introducing this sacred sculpture to Tonga in the 1980s. Initially, he made mainly pendants, but now most of his pendants are made by his five apprentices in the workshop behind his house, and Tevita is able to concentrate on his larger sculptures. In 2005, I observed someone buying a small, seaworthy outrigger canoe, several meters long, for 1,200 Tongan dollars.[8] Tevita sailed one of his canoes from Nuku'alofa to his shop at the seafront in Maofanga. One of his trademarks is huge wooden sculptures of whales. An example of this, a mother and baby whale about six meters long, can be seen in the dining room of the Paradise Hotel, the largest hotel in Vava'u. Tevita's colleague Lopati roughed out the outlines of this sculpture for him with a chainsaw.

Feleti, our fourth example, is forty-five years old and was born in the village of Ha'alaufuli on Tonga's northern island of 'Uta Vava'u. In 1988, after working as a carpenter in American Samoa and California, Feleti married Seine and returned with her to Tonga. They lived in Seine's home village of Pea on Tongatapu, and Feleti became friends with Ofa, who suggested that he make sea jewelry. Feleti bought some second-hand tools at the flea market and started working black coral and cow bone. Both Tevita and Ofa taught him how to carve. Feleti also sold many of Ofa's products because, as he says, Ofa's work was so much better than his own. Feleti employed some boys, and his wife Seine (our fifth example) knows how to work with sandpaper and the polishing machine. They carved wood, cow bone, black coral, and scrimshawed seashell. Fifteen years later, Feleti is still modest about the quality of his products:

> This morning, I made seven pairs of scrimshawed seashell earrings. They are far from perfect, but I try it over and over every day. Now, I make some ten pieces a day (pendants, earrings, etc.), like my wife Seine. And in the evenings, we carve black coral, whalebone, cow bone, and wood in the workshop in the back. That would produce too much dust here in the shop. (Neiafu, personal communication, 2003)

From the beginning, Seine and Feleti carved together every evening and she increasingly liked it, including the financial results: "I like to work, not to be lazy (*faka-

pikopiko)" (ibid.). Since 2002, Seine has sold her own products as well as Feleti's in the new municipal market in Neiafu, the central harbor town of Vava'u. She explains:

> Many people don't know about our shop in front of the Paradise Hotel. In the market I can make publicity for it. And when they come to Feleti in his shop and say that "a woman in the market" has recommended his shop, he says, "Of course, choose whatever you like, and I will give you a good price." (Ibid.)

Feleti and Seine also sell Tongan antiquities. In her market stall, Seine displays an old tapa beater (*'ike*). This is mainly there as a sign to people who are looking for old things to lure them to the shop in front of the hotel, where Feleti has more of the like: ancient headrests, kava bowls, stone adzes, old whale teeth, and a war club. The best-selling products among their handicrafts, which Seine sells in the Neiafu market, are

Female Tongan wood carver (Tonga, 2006).
Photo: Paul van der Grijp.

necklaces and earrings. Many market vendors are women, because the men usually work in their gardens in the bush, although selling in the market (*fakatau*) is neither typically female (*fakafefine*) nor typically male (*fakatangata*). Seine also sells basketwork and wood carvings from other producers such as Feleti's sister and the latter's husband. In the market she works with her stepmother. She also sells some of her own products to other craft workers.[9] Feleti passed away in 2004, but Seine continues running the art and handicraft business in Vava'u.

The Search for Good Selling Outlets

A major problem for all these artists is to find a good outlet for their products. It is indeed a fine ideal, as formulated by Hau'ofa (and quoted above), to "set the rules, the standards that are ours, fashioned to suit our circumstances, and to give us the necessary freedom to act in order to bring out the best in us." However, these Tongan artists also have to earn a living via their artistic production. How do they cope with this problem? In the late 1970s and early 1980s, many cruise ships visited Tonga, and Lopati (our first example) was able to sell a lot of his work to the passengers and crews. Foreign navy ships were also excellent markets. In the 1980s, the artists began selling in the park.[10] Later they moved to the new market hall, the Talamahu Maketi, in the center of Nuku'alofa town. Lopati, however, has neither shop nor market stall. He sells his carvings through the handicraft cooperative Langa Fenua (see below). For most of his working life, Lopati has made his living from woodcarving. He is also a carpenter and built, for example, his own house.

After resigning from the Black Coral Factory, Ofa (our second example) went to work as a carver in the park, where he built a small booth that served as both workshop and selling place. He was a member of a small group varying from four to seven carvers who worked on what they called sea jewelry, made from black coral, seashell, cow bone, whalebone, shark teeth, and whale teeth.[11] This was in 1982, when I met him and the other carvers for the first time. In 2003, Ofa had a stall on the second floor of the market, where he sold handicrafts made from black coral, whalebone, cow bone, fish bone, pig tusks, hardwood, and seashell. He made his handicrafts in his workshop at home late in the evening and early in the morning. In the market he only sold, spending his time in intense discussions with colleagues and friends, including his foreign customers. In 2002, he made a turnover of about thirty thousand Tongan dollars, but his monthly income varied from one thousand to seven thousand dollars. Previously, when he was still selling in the park, his annual revenues were much higher. His stall on the second floor of the market was clearly not the best location.[12] Ofa would like to have a shop on the seafront, like some of his colleagues. He has access to a plot of land along the road in the village where he lives, on the route between the capital and the international airport. He could open a shop there, he said, but the capital is obviously a better selling place. He spent the two years between 2003 and 2005 in New Zealand. Upon his return he obtained one of the better places on the ground floor of the market hall opposite the entrance closest to Nuku'alofa's main street. Here he exhibits some remarkable pieces: a heavy stone adze, an antique kava bowl (from 'Uvea or Wallis

Wooden swordfish (Tonga, 2006).
Photo: Paul van der Grijp.

Island), and a weatherbeaten, life-size wooden sculpture of a man with a wound in his belly, which refers to an old legend.

For seven years, Tevita (our third example) has had a small wooden shop at the seafront where he sells his own work and that of the men working in his small factory. He has a young saleswoman on the payroll. During the incidental visits of cruise ships, about twice a month, Tevita sets up a stand on the main wharf. His seafront shop is strategically situated between this wharf and Nukuʻalofa. At present, the number of visiting cruise ships seems to be on the increase. His turnover per cruise ship varies between three thousand and four thousand Tongan dollars. He also has two stalls in the market hall, one on the ground floor looked after by his twin sister, and another one on the first floor managed by one of his daughters. He has yet another stall in the new shopping center on Nukuʻalofa's main street, staffed by another daughter. He sells his most expensive pieces in the latter, because the location is excellent but the rent is high. By selling several expensive artworks per week, he is able to pay the rent, other expenses, and still make a profit. Tevita, assisted by the team of young carvers in his workshop, has to work hard to supply all his shops with high-quality material. He also travels frequently to Hawaiʻi and New Zealand to sell his most expensive works. He has thus developed into an entrepreneur who has the bulk of his products produced

by five male apprentices in his small factory and has these products sold by women, mainly close kinsfolk, keeping his own hands free to work on important projects, such as canoes and his huge whales, and to further extend his flourishing enterprise. Tevita says that the Tongan government should pay more attention to this kind of art. The artists were chased from the park where they had been working and selling for many years. Tevita was finally able to obtain a shop on the waterfront. When an artist produces high-quality products and has a good location to sell them, he can earn good money, according to Tevita, but this is not possible in the municipal market.

In 1988, when Feleti and Seine (our fourth and fifth examples) started making sea jewelry, they were in a group with six men and four women. The women, Seine, Luisa, Tai, and Tina, were all spouses of the men in the group and sold mainly basketry as well as the products of their husbands, who remained at home to carve, since they needed electricity for their machines. There were three stalls on each side of the park entrance, as well as some extra tables in the park. Feleti and Seine also had a second stall behind the old vegetable market (where the Development Bank is located today), where they worked in the evenings and slept at night. During the day, they sold their products in the park. Tevita would approach *pālangi* tourists passing by for down payments on work still to be realized, which he would then carve at home. In 1994, Feleti was able to lease a plot of land in front of the Paradise Hotel on Vava'u.[13] They moved to Vava'u because cruise ships stopped there much more often than in Nuku'alofa, and also because it was the site for the frequent conferences of the Methodist Church. The large numbers of participants coming from overseas resulted in a good local market. Moreover, in Nuku'alofa competitors would try to take away their customers by standing in front of Feleti's and Seine's stall and offering lower prices. When they were still working in the park, some of their colleagues tried approaching customers assertively, as is done in Fiji: "Hey, my friend, come and have a look in my stall." Seine does not like this behavior: "We call this *fakamālohi*; it isn't very Tongan, and in Vava'u it hardly ever happens" (Neiafu, personal communication, 2003). In Neiafu, they sell more to *pālangi* than to Tongans, and this too is different from Nuku'alofa, according to Seine. The tourist season, when they sell the most, lasts from May till September. In 1998, Feleti built his commercial premises where he has his own shop and workshop, as well as several other shops he leases out.[14]

In Tonga, it is not just individuals or families who are engaged in the production and sale of arts and crafts, but also collectivities or cooperatives. In the 1950s, for example, the cooperative Langa Fenua (literally "uplifting the land") was founded by Queen Salote, the mother of the late King Taufa'ahau Tupou IV, with the aim of improving family revenues through the marketing of women's craftwork (*ngaue fakafefine*) such as tapa making (*toulanganga*) and mat weaving (*toulalanga*).[15] The initiative was later taken up by wives of some of the nobles, by village chiefs, and by church ministers. In 2002, there were 212 inscriptions in this handicraft cooperative: 121 individuals and 91 groups.[16] Members fix the selling price of their products in consultation with the cooperative.[17] For the past ten years, the emphasis has no longer been exclusively on women, but on the nuclear family as a whole, and not only on the products of women's work, but also those of men and children. The fabrication and selling of handicrafts are only

Sawing cow bone to make fishhooks (Tonga, 2008).
Photo: Paul van der Grijp.

part of its activities, with another part being, for example, small business training. In the cooperative's building there is a separate showroom where previously two Tongan painters exhibited their work, but they have since left for New Zealand to find a better market for their art.

Aspects of Globalization

In this section, I will analyze some of the international dimensions of the production and sale of Tongan arts and crafts.

In 1987, Tevita (our third example) went for the first time to artists' conferences in New Zealand and the Cook Islands. Later, he gave courses to young prospective artists in Samoa and Fiji. He also spent a month in Hawai'i to study and make drawings of bone fishhooks. He has participated in large exhibitions in Hawai'i, New Zealand, and Portugal, and in 2005 he displayed several outrigger canoes (with sails made from mats) at a large canoe festival in Hawai'i. He sent fifteen canoe models, up to several meters long, to the festival by container, and he also carved a canoe on the spot.

In 2003, Ofa (our second example) had several market outlets outside Tonga. An

Tongan artist making a cow bone fishhook (Tonga, 2006).
Photo: Paul van der Grijp.

Englishman had a shop called Afro Asian Art in Port-Vila, Vanuatu, and he asked Ofa to produce carvings for him and send them to him four times a year. Sometimes he forwarded seven thousand Tongan dollars, other times five thousand. This was good money for Ofa, who worked for him for nine years until the Englishman moved to the Cook Islands, where he opened a new shop selling only gold jewelry. Recently, someone from Alaska came to Ofa proposing an arrangement similar to the one he had with the Englishman.

During the Pre-Olympic Games in Australia, the Ministry of Foreign Affairs organized an exhibition called Sculpture-by-the-Sea with 102 artists: 90 from Australia and New Zealand and 12 from overseas countries such as Japan, Germany, and Sweden. They worked with all kinds of material from bronze to wood. The South Pacific islands were represented only by Lopati from Tonga (our first example) and another carver from the Solomon Islands. Lopati sent a wooden whale seven feet long, which he finished on the spot. He gained fifth place among the 102 participating artists. Lopati's comment: "I was so happy to bring the news back to our islands that Tonga came in number five" (Maofanga, personal comment, 2006).[18]

Perspectives for the Next Generation

Here we will look at the transmission of carving skills to the younger generations, still with Hau'ofa's cultural project in mind (quoted in the opening section of this chapter): "to transform and reshape the face of contemporary Oceania in our own image." Lopati, for example, has twelve children, eight girls and four boys. All the boys and five of the girls have learned how to carve: "In Tonga, you don't see any girl carvers, but my girls like to carve. And two sons-in-law are carvers too" (Maofanga, personal comment, 2006). In Lopati's house, I observed one of his daughters carving, and I think she did a good job. She may become, like Seine (in our fifth example), one of the women who is changing the strict sexual division of labor concerning Tongan arts and crafts. Lopati's third and fourth sons, twenty-five and twenty-three years old, have become professional carvers like their father.

Ofa (our second example) spent two years in New Zealand between 2003 and 2005. His wife had gone there to look after her aged parents and, finally, he went there too. In New Zealand, Ofa counseled young adults (between eighteen and thirty years old) from the Tongan Mormon community in how to find jobs. His prestige in the Mormon community back home in Tonga, however, was threatened by one of his sons, who had remained behind and was using drugs. Ofa returned to Tonga in 2005, because he felt it was more important to help his own son rather than other people's children. Ofa has two adult daughters, both employed in Tonga by foreign firms, while their husbands work for the government. Yet these daughters continue to ask their father for money for a car or for other purchases. Ofa advises them to do the same work he does, because the pay is good. Had the pay not been good, he would have left for the United States long ago. His adoptive parents live in Utah and never stop asking him to immigrate, saying, "You buy your own ticket and, when you're here in America, we'll look for a place where you can live." However, as Ofa observes,

"Here in Tonga, I've everything I need, and I can do what I want and when: rise early and play tennis or in the evening, attend informal kava parties (*faikava*) and talk with friends. Here, I have my own house for free" (Nuku'alofa, personal communication, 2006).

Ofa's younger colleague Tevita (our third example) has two sons, six and ten years old, and five daughters, one of whom is married. Two daughters work in his shops and market stalls, selling his products. Another daughter takes literature courses at the high school. Tevita stimulates her by saying that she should pay close attention to these courses so that later she can write his story and the history of the older wood carvers who worked in the park at the oceanfront when he started carving. All the young men Tevita has trained as artists received their own tools when they left him and went into business for themselves. Tevita is not in competition with them, since he has shifted from making bone and black coral pendants to carving large objects. At present, Tevita has five young men working for him producing carvings for his sales outlets. On average, they work for him for four to six years, for a fixed wage of between seventy and two hundred Tongan dollars a week. Tevita has set his maximum wage at two hundred dollars a week, which is what he pays his oldest employee, who has been working with him for nine years: "I can't give him more. By the time he will say, 'Tevita, can I get more wages?' I will say no, I will give you everything, tools and the like, so that you can do your own work" (Popoa, personal communication, 2005). Tevita:

> The work I teach them is not the same as in construction. It is easier to become a bricklayer or carpenter. Art is different. You have to really train them for that. These boys were failures at school. They ran away from school and have nobody to rely on. Their future was very cloudy. I'll never use a boy who is well educated. In that case I'd say, "You better go and find your own way. You're smart enough to find work elsewhere." (Ibid.)

Tevita teaches them the basics of carving wood, bone, and coral. He has been teaching for a long time now and does not feel that he is creating his own competitors because, as he says, "I've been improving my art business, both money-wise and concerning quality. I'm always creating new ideas and can't rely on my old style of several years ago. I don't think that my students will be able to overtake me" (ibid.).

Ideas about Art and Craft

What are the artists' ideas about the difference—if any—between art and craft? Here, I will once more reflect on Hau'ofa's idea (quoted above) that "we [Pacific Islanders] can carve out our own spaces, in which we set the rules, the standards that are ours, fashioned to suit our circumstances." Today, Lopati, our first Tongan example, insists he is making art, not handicraft, and says that it feels good when he finishes a carving, especially when he takes his time and does a good job. Lopati does not believe in mass products. He tried to make them but did not like it. For him, carving is art, and should remain so:

I want that every piece is different; I don't like copies. The wood too is different every time. I carve billfish and whales, but my favorite is octopus. I also liked to make mermaids. A difficulty with mermaids is what you do with their hands. The most natural is that she combs her hair and looks in a mirror. My daughters, however, do not appreciate me carving naked women. They don't think in terms of art, but accuse me of being a dirty old man. This is why I don't make mermaids anymore. (Maofanga, personal communication, 2006)

Under the dominating influence of the churches, Tonga has become very puritanical about nudity. Exposing women's breasts and even men's torsos is considered immoral and is even illegal. Under such circumstances, especially when close family members bring pressure to bear on them, it can indeed be difficult for artists to represent the human body. Interestingly, in the Western art world, erotic representations have served as important critiques of the cultural establishment (see Mahon 2005).

Lopati's colleague Ofa has this opinion:

Handicraft is part of art, like music and dancing. I think they are all part of art. I want to make replicas of ancient Tongan artifacts. Anyone with the talent to make something new in handicraft should make it according to how it comes to his mind. But as far as I know, most carvers don't, they just copy. (Nuku'alofa, personal communication, 2003)

Tevita, Ofa's younger colleague and a successful art entrepreneur, claims not to see any difference between art and handicraft, although he does not himself want to be considered a maker of handicraft:

I'm an artist, a *tufunga*. Many of my fellow artists don't have a creative eye. I travel a lot, and read books on art and religion. This is part of my character. I can't sleep without having read something first. My art is innovative because I read about so many things. This makes me different from other [Tongan] artists. I make contemporary art, but also realistic sculptures. I know artists who are unable to carve a whale or a dolphin. They're able to make an abstract form of it that looks like a whale or a dolphin from a distance, but they don't look real. I can also make abstract sculptures. Most artists don't do that. They make the same *tiki* [anthropomorphous carvings] again and again. (Popoa, personal communication, 2005)

In Tonga today, according to Tevita, people are starting to recognize what art is. Previously, this was not so. In 1990, for example, he was commissioned to make a sculpture for a Tongan government department. He made a fine sculpture of the legendary Polynesian demi-goddess Hina, for which he asked eight hundred Tongan dollars. They thought, however, that it was too expensive. Tevita replied, "When you think it is too expensive, I will take it back home. If you buy a sculpture from me, you also buy my artistic interpretation of that legend. This is my art, I don't sell just a piece of

Whale ivory food hook with two Tongan goddess figures (Tonga, 2006).
Photo: Paul van der Grijp.

wood" (ibid.). Ten years later, he received another commission from the same government department. He again made a fine sculpture that this time was well appreciated. According to Tevita, Tongans are beginning to learn what art is all about:

> Some Tongans have a good income, but will not spend this on art very quickly, because they don't know what it is. Certain visitors from Europe or the United States, however, immediately recognize the artistic value of my work and buy several pieces at once because the price is good. (Ibid.)

Although these remarks seem to be part of Tevita's marketing discourse, I think they also reflect a real change in Tongans' mentality toward art today.

Feleti, Tevita's colleague in Vava'u, also does not see any difference between art and handicraft, although he is conscious of the distinction in Western eyes. Feleti says he does not conceive of himself as an artist, a point of view based on his background as a carpenter. According to Seine, Feleti's wife and business partner, art and handicraft are the same. Even when she copies the same necklace over and over again, for her this would still qualify as art because she made the original design in the first place.

I hope this brief but detailed ethnographic review of artists, their daily activities, and their thoughts on handicraft and art in these so-called exotic societies—Tonga, for example, is proud to call itself the last Polynesian kingdom—results in a de-exoticization of such artists, in the sense that we feel closer to them. The ambivalences and ambiguities in their respective definitions of art and craft, including their personal and cultural search for new standards fashioned to suit their own circumstances, and thus reshape the face of Oceanic identity, are integral to this closer look.

Notes

1. The ethnographic material presented here is from three recent periods of fieldwork (2003–2006) in Tonga, where I have worked for the past twenty-seven years (e.g., van der Grijp 1993, 2004, 2007).

2. Here I follow the Tongan custom of calling people by their first name. Most names are pseudonyms. Prices are given in Tongan dollars (*pa'anga*).

3. *Tiki* are anthropomorphous sculptures.

4. The historical—or "mythological"—part of this explanation corresponds to the account given in Bott 1982: 94.

5. Kava is the social and ceremonial drink, used throughout Polynesia, made from the dried and pulverized roots (mixed with water) from the *Piper methysticum*.

6. Tapa is barkcloth made from the paper mulberry tree (*Broussonetia papyrifera*, or *hiapo* in Tongan; see Whistler 1991: 42–45).

7. Tevita has five brothers and two sisters, including a twin sister. Three brothers live in New Zealand and make Maori-style greenstone carvings. Another brother has become a *tufunga vaka* and has a boat construction enterprise in the village of Nukunuku on Tongatapu. In 1977, Tevita's elder brother, Viliami, built a sailboat in New Zealand and became well known in yachting circles for sailing around the world single-handed.

8. The buyer also had to pay another four hundred dollars for transportation costs.

9. In 2003, for example, I saw her making large numbers of small unfinished discs of mother-

of-pearl, which were sent to New Zealand, where they were further worked into finished products such as earrings and other "natural" jewelry.

10. The park was situated on the oceanfront in Nuku'alofa, between the International Date Line Hotel and the residence of the Prince Tu'i Pelehake (the younger brother of the late King Taufa'ahau Tupou IV).

11. Cow bone of course does not come from the sea, but it is included in "sea jewelry" because of the fishhooks and little dolphins made from it. In east Polynesia, mammal (human, dog, pig) bone and even dog teeth were widely used for fishhooks in ancient times.

12. According to Ofa (in 2003), a local market survey showed that only 30 percent of market visitors go to the second floor. Many people do not even know that the market has a second floor.

13. This was a plot ('*api uta*) of thirty square rods (about 0.1 *ha*) for which he paid three thousand dollars, after which he still had to wait three years before receiving the official conveyance from the local authorities.

14. To a tourist shop, a café, and a travel agency specializing in whale watching.

15. See van der Grijp (1995) and Kaeppler (1999). The prefix *tou* means to work together, and help each other.

16. Individual members pay a two-dollar membership fee per year and a three-dollar inscription fee. Group members pay the same inscription fee and a membership fee according to the size of the group: five dollars for 5 to 10 persons, ten dollars for 10 to 49 persons, twenty dollars for groups of 50 persons or more, the latter usually concerning entire villages.

17. The organization asks a 15 percent commission on the sales and employs one saleswoman and two assistants, and also has two volunteers. Langa Fenua's average monthly receipts are 7,500 dollars (vice president Tonu, Nuku'alofa, personal communication, 2003), from which we might deduce that the declared monthly sales of its members are about 50,000 dollars.

18. This was only the second time in his life that Lopati had participated in a carving competition. During his stay in the United States as a young man, Lopati worked for Pan American Airlines in San Francisco for six years, loading and unloading airplanes. For a small art show organized by the company, Lopati carved a model 747 airplane and a canoe and received a second prize for the canoe.

References

Bott, Elizabeth. 1982. *Tongan Society at the Time of Captain Cook's Visits*. Wellington: The Polynesian Society.
Condominas, Georges. 1965. *L'exotique est quotidien: Sar Luk, Vietnam central*. Paris: Plon.
Hau'ofa, Epeli. 2005. "The Development of Contemporary Oceanic Arts." *People and Culture in Oceania* 20: 5–12.
Kaeppler, Adrienne L. 1999. *From the Stone Age to the Space Age in 200 Years: Tongan Art and Society on the Eve of the Millennium*. Tofoa: Tongan National Museum.
Mahon, Alyce. 2005. *Eroticism and Art*. Oxford: Oxford University Press.
Marcus, George E., and Fred R. Myers, eds. 1995. *The Traffic in Culture: Refiguring Art and Anthropology*. Berkeley: University of California Press.
Myers, Fred R. 2002. *Painting Culture: The Making of an Aboriginal High Art*. Durham, N.C., and London: Duke University Press.
Phillips, Ruth B., and Christopher B. Steiner, eds. 1999. *Unpacking Culture: Art and Commodity in Colonial and Postcolonial Worlds*. Berkeley: University of California Press.
Pocius, Gerald L. 1997. "Material Culture Research: Authentic Things, Authentic Values." *Material History Review* 45: 5–15.
St Cartmail, Keith. 1997. *The Art of Tonga: Ko e Ngaahi 'Aati 'o Tonga*. Honolulu: University of Hawai'i Press.

van der Grijp, Paul. 1993. *Islanders of the South: Production, Kinship and Ideology in the Polynesian Kingdom of Tonga.* Leiden: KITLV Press.

———. 1995. "Made in Tonga: Manufacture and Art Objects from Leaves, Bark and Wood." In *Pacific Material Culture,* edited by Dirk Smidt, Pieter ter Keurs, and Albert Trouwborst, 200–218. Leiden: National Museum of Ethnology.

———. 2004. *Identity and Development: Tongan Culture, Agriculture, and the Perenniality of the Gift.* Leiden: KITLV Press.

———. 2006a. "Precious Objects with a Natural Touch: Endangered Species and the Predilection for the Exotic." In *The Frontiers of Southeast-Asia and Pacific Studies,* edited by Hsin-Huang Michael Hsiao, 267–295. Taipei: Center for Asia-Pacific Area Studies, Academia Sinica.

———. 2006b. *Passion and Profit: Towards an Anthropology of Collecting.* Berlin: Lit Verlag.

———. 2007. "*Tabua* Business: Re-Circulation of Whale Teeth and Bone Valuables in the Central Pacific." *Journal of the Polynesian Society* 116: 341–356.

Whistler, W. Arthur. 1991. *The Ethnobotany of Tonga: The Plants, their Tongan Names, and their Uses.* Bishop Museum Bulletin in Botany 2. Honolulu: Bishop Museum Press.

A Tale of Three Time Travelers
Maintaining Relationships, Exploring Visual Technologies

Karen L. Nero

This chapter traces the stories of three late eighteenth-century Palauan treasures that are now held in the British Museum[1]—a large shell-inlaid bird-shaped wooden bowl, a shell-inlaid canoe, and an oil painting of three Palauans. These pieces were given, transferred, or commissioned during Honourable East India Company ship visits—Captain Henry Wilson's first extended visit to Palau in 1783 and Captain John McCluer's return visits in 1791–1795. Occurring within decades of the Cook Pacific voyages and collections, the stories of these pieces both parallel and diverge from those of objects held in the Cook/Forster Collection at the Georg August University of Göttingen displayed in the Life in the Pacific of the 1700s exhibition—the occasion of the conference at which these chapters were presented. British Museum trustee Sir Joseph Banks was involved in both collections and was a friend and colleague of Professor Johann Friedrich Blumenbach of Göttingen, to whom he sent a second oil painting of the three Palauans in 1792.

I have called these three "time travelers." Not only were they transported across the world, but they are still materially present (in Britain) today for museum visitors and researchers to view. They are vital connections to the past, carrying knowledge through to the present, representing ancestral prestige and power (Tapsell 2006: 17). It is highly unlikely that they would have survived the rigors of Palau's hot, humid environment and typhoons, or local and global wars. To my knowledge in Palau no other such treasures remain from that period. With the exception of the physical signs of history (the bead monies and stone pavements of the meeting houses and their associated oral histories, chants, and dance) (Parmentier 1987; Nero 1987, 1992), Palauans focus less upon objects than the relationships whose exchange they signify. These treasures too serve as "beads of history" that evoke and sediment historical knowledge.

For this analysis we must move beyond mundane analyses of political and economic globalization. True, a defining characteristic of the Palau Islands is their strategic position on the borderline of the world divided between the Portuguese and Spanish by the Treaty of Tordesillas in 1494 and between Asia and the Pacific today. In the 1780s Britain was looking for way stations as it attempted to wrest the Spice Islands trade from the Dutch (see Nero 2002), and in the late twentieth century the United States'

interest in Palau was based on its strategic position bordering Asia. However if we are to understand the deeper meanings of the interchanges that occurred between the British and the Palauans, then and now, we must seek indigenous perspectives of the meanings of cultural treasures that were given beyond their homes. Tapsell's (1997, 2006) groundbreaking work tracing the metaphoric pathways of Maori *taonga* serves as a foundation to understand the pathways of these time travelers through time and space and to consider their implications and extensions as applied to another Oceanic society. Both Maori and Palauans recognize the ancestral power that may be held by cultural treasures today.

Analyzing the individual stories of three treasures from Palau using the "Changing Contexts—Shifting Meanings" theme of the conference helps identify the close relationships and partnerships established in the late eighteenth century between Koror/Palau and the British that are kept alive to this day. The pieces are embroiled in the complex continuum of the histories of acquisition and representation relevant in current international discussions surrounding the exhibition and repatriation of cultural treasures. There is a long theoretical development of the concepts of gifts and the obligations such transfers might entail (i.e., Mauss 1967 [1925]; Godelier 1999; Strathern 1988, 1992). While this concept of the gift is the correct context for discussing Koror chief Ibedul's transfer of the bird-shaped bowl to Captain Wilson, there is deep dissonance between the meanings of the word "gift" in English and in Palauan, discussed below. The reason behind the transfer would be better translated by the Palauan term *bltikerreng*, which refers to deep affection or love, reminding us of the importance of the transfers of such key embodiments of cultural knowledge and power, and the continuing relationships for which they stand. This recognition opens possibilities of new partnerships for their management and exhibition. We are aided by new visual technologies that may bridge time and space to reconnect these time travelers to their original culture and descendants.

The Honourable East India Company and Palau

In 1780, as Dutch mercantile and naval power waned while that of Britain grew, the two nations engaged in the fourth of their wars, opening the possibility that England might capture the spice trade. In 1783 the Honourable East India Company (H.E.I.C.) sent a packet under Captain Henry Wilson on a mission out of Macao to scout eastern approaches, but Wilson's ship, the *Antelope*, was wrecked on the reefs of Koror in Palau.

Captain Wilson's three-month stay in Koror was unusual in that there were Malay speakers in both parties who could translate at meetings between Captain Wilson and his representatives and the Ibedul of Koror, who held one of two paramount chiefly titles of Palau, and his representatives. The relationships established were unusually close, connecting siblings and sons on both sides. Two of Ibedul's brothers were on the first canoe to meet Wilson and his men. Wilson's brother Matthias and son Henry Jr. were on the voyage, and Wilson first sent Matthias with one of Ibedul's brothers to meet with Ibedul. Ibedul's brother, Rechucher, or "the general," stayed with Wilson and

remained one of his key negotiators. At this first meeting Matthias brought gifts that were reciprocated by Ibedul's welcoming offer of provisions and permission to build a vessel under his protection. After an eventful but generally friendly stay the British were able to build a small ship, the *Oroolong,* which reached Macao and Canton in December 1783, where they found passage back to England. Lebuu, the young adopted son of Ibedul, and gifts including the bird-shaped bowl, accompanied Captain Wilson to England; Lebuu was treated as a son and friend of Henry Jr. In 1788 *An Account of the Pelew Islands* by Keate (1803) was first published, based on Wilson's journals. The fifth edition in 1803[2] included in full the rare supplement J. P. Hockin published describing the H.E.I.C. return voyage in 1791. The number of editions, translations (French, Dutch, German, Spanish, Italian), and adapted volumes made it perhaps second only to the Cook voyages in eighteenth-century popularity (Thomas 2002). Lebuu was one of the early Pacific visitors to England who influenced English society; a ship was named for him, and poetry, a child's puzzle, and at least two London plays were composed.[3] Editions of the popular schoolboy primer based on Lebuu's life (Anonymous 1789) remained in print until 1844.

Captain Wilson visited Palau only briefly in 1783, although he remained involved through his support of Lebuu and later negotiations for a return voyage. Lebuu died tragically of smallpox in late 1784 and was buried in the Wilson family tomb. In 1788 the H.E.I.C. began actions for a return visit to Palau, and an order was finally signed in 1790 for the return visit on the *Panther* and *Endeavour* under hydrographer Captain John McCluer, presumably when strategic concerns again balanced the considerable risk and costs involved. Wedgeborough and White from the first voyage accompanied McCluer to advise Ibedul of the death of his son. Despite his loss, in January 1791 Ibedul welcomed the British with another round of feasts, singing, and dancing, and the British landed livestock, arms, tools, and gifts to such excess that Ibedul protested he could not provide an adequate return (Hockin in Keate 1803: 16).

The relationships between Britain, the H.E.I.C., and Koror became even closer during McCluer's extended visit. After a brief visit in mid-February he set off on the *Panther* on a supply trip to China accompanied by three Palauan youths and commissioned oil paintings of them by Spoilum. He also carried a small royal canoe. In March 1791 he sent the *Panther* journal to England with the China fleet (Hockin in Keate 1803: 35), and the small canoe and at least one of the oil paintings were left with Freeman to be sent on the next season's ships (McCluer 1790–1792: 27; Peacock 1987; British Library MS Department BL ADD MS 33982 252). A portrait was delivered by H.E.I.C. Captain James Urmston to Sir Joseph Banks on August 22, 1792.[4] McCluer returned to Palau in early June but again set sail in late June 1791 to survey New Guinea, finally returning to Koror in January 1793. He decided to resign from H.E.I.C. and stay in Palau to establish a settlement, and he sent the *Endeavour* and *Panther* back to China with a letter advising the H.E.I.C. directors of his intentions (McCluer 1790–1792: 75). McCluer married into Ibedul's matriline and a son, George, was born in December 1793, welcomed by Koror, as "they would now have an English Abba Thulle" (Hockin in Keate 1803: 54).

Peacock (1987: 147–151) researched the denouement. Disillusioned by island life in April 1794, McCluer set out for Ternate in a small boat, arriving Macao in ill health nineteen days later. After recovering his health he purchased a vessel and returned to Palau to fetch his family, attendants, and property, apparently to resettle in Bombay. En route via Bencoolen he sent six attendants on to Bombay. After departing Calcutta in August 1795 McCluer, his family, and crew were apparently lost at sea. In July 1797 on his arrival in Bombay, Captain Wilson was informed that three Palauan women still remained there under Wedgeborough's and Snook's care. Wilson brought them to Macao, where the company's supercargoes authorized Snook to purchase a small boat to return the women and their goods to Palau. The women were finally returned home in early 1798. Captain Wilson then commissioned his son-in-law, the Rev. John Pearce Hockin of Exeter College of Oxford, to write *A Supplement to the Account of the Pelew Islands compiled from The Journals of the Panther and Endeavour*, which was published separately in 1803 and also appended to the fifth edition of the Keate *Account* (1803).

Just as the British were seeking new lands to support their mercantile endeavors, the Ibedul and Palauans were very aware of the benefits to be gained by relations with the British, an ascendant power in the 1780s. Shortly after Captain Wilson demonstrated the turnout of the guards and their use of firearms, the Palauan chiefs recognized the importance of harnessing this power for their local battles. In what would turn into a battle of wills Ibedul insisted upon Wilson's support in battles.[5] Ibedul and his brothers were eager during Wilson's visit to learn of the relationships among European nations (Keate 1803: 33–41), and again during McCluer's return. Both the British and the Palauans were aware that their close relationship could provide access to new opportunities and power. Koror and the British and the East India Company engaged in long-term meaningful reciprocal relationships, mutually honored through hospitality and responsibility to those under their care.

Bltikerreng—Love or Deep Affection

Throughout the visit of the British to Koror, they were paired with Palauan friends, in the process creating Palauan kin-like relationships. Ibedul's and Wilson's brothers and sons were so linked. Ibedul entrusted his son Lebuu to Captain Wilson upon his departure for the dangerous trip to England. He also gave Wilson the treasured bird bowl and a dugong bracelet that signified Wilson's rank, and provisions for the journey and gifts too numerous to mention or to accept in the interests of safety. The concept that best captures the meanings of such transfers of persons, food, and objects is expressed by *bltikerreng* in Palauan. The word is so difficult to translate simply into English that when speaking English Palauans often use the word "gift." *Bltikerreng* is translated as "love; affection" (Josephs 1990: 25) and is based upon the core term *reng* ("heart; spirit; feeling; soul; seat of emotions") (ibid.: 289) that forms the linguistic base to all such related concepts. A quick review of translations of the term "gift" into Palauan translated back into English demonstrates the deeply different practices and obligations the term "gift" in Palauan entails. The Palauan dictionary translation of "gift"

as *"bleblel"→blebaol* ("the severed head of enemy; present; gift") (ibid.: 22), *omiange* [(Jp. omiyage), "gift; souvenir" (ibid.: 256)]. The definition of gift lists four culturally specific types of gifts (Josephs 1990: 405–406). A full analysis of the Palauan epistemology of gifts, in comparison with its meanings in English, must be reserved for development elsewhere. We are again reminded that cross-cultural analyses must begin by examining the meanings of such transfers within each culture.

Three Palauan Treasures in the British Museum

The Bird-Shaped Bowl

The first treasure selected for our consideration is the famous bird-shaped wooden bowl entirely decorated by shell inlay that is shown as plate 1 in Keate (1803: preceding p. 69). This bowl and seven other treasures make up the Wilson collection at the British Museum and are the earliest and best documented of all found in Palauan collections from this earlier period. The bowl is impressive, at a length of three feet and height of one foot nine inches.

Since their departure in November 1783, the stories of the treasures are predominantly held and written by the English and European researchers. The bird-shaped bowl featured prominently in the account of Captain Wilson's first arrival in Koror.

> Before the King[6] appeared, some of the natives were sent down with refreshments; they first brought a large tureen, made of wood, in the shape of a bird, and inlaid with shell, this was full of sweet drink. (Keate 1803: 68)

The British were then offered sweetmeats with Seville oranges on a painted stand, as well as boiled yams (taro) and young coconuts. Captain Wilson in turn offered small

Bird-shaped bowl with Shell Inlay. Palau. Plate 1, Keate 1788 and 1803.

gifts of iron hoops, gold and silver lace necklaces, and some files. Gifts and countergifts between the Palauans and British were the norm from the beginning.

The bowl was a state item owned by and given by Ibedul to Captain Wilson at his departure on the newly built *Oroolong*. The treasure's high value and singularity was noted:

> On days of public festivity, there was usually brought out the vessel . . . representing a bird, the top of which was lifted off, forming its back. It contained about thirty six English quarts; and was filled with sweet drink for the King and the rupacks.[7] This was Abba Thulle's property; and when one considers it as the work of so much time and patience (and the more estimable, as being the only vessel of the kind in their country), the King's giving it to Captain Wilson on his departure . . . was an additional proof of the liberality of these people, who were ready to divest themselves even of what they most valued, to give to their friends. (Keate 1803: 209)

A number of these early gifts were retained by Captain Wilson, his brother Matthias Wilson, and son Henry Wilson and were passed on within the family for a century. Captain Wilson retired to Devonshire to a house he named Oroolong. His daughter Christiana married the Rev. J. P. Hockin, who wrote the 1803 supplement to the Keate *Account,* and Henry Jr.'s daughter married the Rev. W. Willis. The British Museum retains correspondence from 1870–1875 from Edward B. Tylor to A. W. Franks of the British Museum concerning Tylor's negotiations with the Rev. W. Wills, who "was inclined to leave these to the nation." Tylor noted that by then "the great bird bowl is

Bird-shaped bowl. The British Museum 1875.10–2.1.

sadly knocked about." Wills' niece Miss Salter assisted in the transfer of this collection to the British Museum in 1875. The bowl illustrated by Edge-Partington and Heape (1890: 181) shows the damage referred to by Tylor.

We are still researching documentation of earlier exhibitions of the pieces of the Wilson collection in the then Museum of Mankind, but the bowl would have been on public display at least part of the time. The bowl is currently in storage at the British Museum.

Bicentennial events held in England and Palau honored the first recorded contact between the British and Palau in 1783. Once again the strategic position of Palau and its international relationships came to prominence and connected directly back to the early relationships established between Ibedul and Palau with the British through Captain Wilson. Complaining of the lack of development by its U.S. trustee, Palauans turned to Britain for support, and a British firm, IPSECO (International Power Systems Company, Ltd.), negotiated to build a large power plant in Palau. IPSECO officials courted Palauan officials, including the two paramount chiefs, and presented the current Ibedul with a first edition of the Keate *Account* during one visit to London. IPSECO also agreed to fund part of the binational bicentennial exhibition and celebrations, but as these international negotiations eventually soured the exhibition plans had to be curtailed.

The 1983 Museum of Mankind exhibition A Pattern of Islands: Micronesia Yesterday and Today was curated by Dorota Starzecka and included the Wilson collection and an oil painting of the three Palauan youths. In preparation, Starzecka corresponded with Belau National Museum and Palauan officials, including the Ibedul. The current Ibedul of Koror was present to honor the opening after accepting the Right Livelihood Award in Sweden for his efforts supporting Palau's nuclear-free constitutional status.

Within Palauan oral histories and memory, two centuries is a short time. The stories of Captain Wilson's visit and Lebuu are held not only in Koror, but throughout Palau. The hosting of Wilson and his men, McCluer and his men, and distribution of their gifts included not only the people of Koror and its allies but also then enemies of Peleliu and Melekeok, described by Keate and Hockin (1803).

When McCluer returned to Palau in 1791, he brought a copy of the Keate 1788 edition that included the plate 1 drawing of the bird-shaped bowl of Koror. We do not know how long that book survived in Palau, but original and reprinted versions are today available in Palauan libraries, along with historical studies of the islands written in English and those of successive academics and colonizers in Spanish, German, and Japanese. During the past century islanders' travel was controlled. When air service was opened in the 1960s and travel restrictions relaxed in the 1970s, more Palauans traveled for education. Over the years many Palauans have recounted their visits to London and their joy that they were able to visit the collections at the British Museum and the grave of Lebuu. The current Ibedul contributes to the care of Lebuu's grave in Rotherhithe, London.

Relationships between Palau and the British Museum remain strong. In 2002, as

the Belau National Museum was planning simultaneously for the construction of a new museum facility and hosting the 2004 Pacific Festival of Arts, Director Faustina Rehuher and I were in communication with Lissant Bolton, head of the Oceania Section at the British Museum, and her staff concerning possible loans for a historical exhibition. By then Jenny Newell, assistant editor of our Keate republication (Nero and Thomas 2002), was curator, Oceania. Despite their support in accessing documentation on the collections, it was not possible to mount this historical exhibition due both to construction delays and the need to keep large exhibition areas available to the visiting national delegations.

Official, private individual, and collegial museum relationships between Palauans and British have been renewed over the past two centuries. The visibility and knowledge of the treasures at the British Museum and the Lebuu grave as the outward signs of these relationships have contributed to keeping these ties alive, in keeping with their ancestral powers. The two treasures associated with Captain McCluer are also highly valued but are far less well documented or known to Palauans. These two pieces are more typical of the limited documentation generally available for Micronesian pieces in overseas collections, and they raise important comparative considerations.

The 1791 Canoe

The second time traveler is a very rare early canoe described by the British Museum as a war canoe made of wood, inlaid with pearl shell, collected by Capt. John McCluer in Palau and donated by Sir Joseph Banks in 1792. The British Library MS Department holds documents showing that this highly decorated royal canoe had been the Ibedul's:

> Mr. Morrison the Chief Supercargo at Canton has given me leave to offer you the King of the Pellews Proa, which was brought to China by Captain McCluer last year. She is hewn out of one tree like the Southsea Cannoes about forty foot long and has paddles spears &c &c belonging to her. Britannia in the Downs April 22–92. Captain Cummings. (BL ADD MS 33979 153–154)

By May Cummings advised Banks that the canoe had been delivered to the India Warehouse and that "Captain Wilson's brother has offered to rig her" (ibid.: 252). The canoe was made from one log and in most documents has been identified as a *kabekl* (war paddling canoe), although at 35.5 feet it is smaller than normal and must be considered a *kaeb* (large sailing canoe). One side of the canoe is beautifully decorated with a shell-inlay stripe along the full length, above which are depicted eight long-necked birds facing away from a central warrior/dancer in profile. On both sides of the canoe's bows the long stripe is joined by three rows of shell inlay. The canoe had been decorated with suspended white cowrie shells—several shells and some of the lashings remain. Only a few fittings of the outrigger and sail are still present.

There is surprisingly little mention of the canoe or the circumstances of its collection, either in the McCluer journal or *The Banks Letters* compiled by Warren Dawson (1958) on the correspondence of Sir Joseph Banks.

As McCluer left for Macao on February 12, 1791, with the adopted son Kokiuaki[8] and daughter of Ibedul and another young girl, he stated, "The King ordering his own brother Arrakoker with his State canoe to go and fetch them on board" (McCluer 1790–1792: 21). In his journal McCluer identified a whole list of gifts he made to Ibedul, his men, and the son of Rechucher, then renamed Harry for his friend Henry Wilson Jr. He did not identify specific return gifts other than food and the Ibedul's repeated offer of a dugong bracelet. For a description of the canoes and their use I have quoted from the general discussion based on the journals of the first voyage (Keate 1803: 211):

> TR CANOES
>
> They were, like most other canoes, made from the trunk of a tree dubbed out; but our people, who had often seen vessels of this sort in many other countries, thought those of Pelew surpassed in neatness and beauty any they had ever met with elsewhere; the tree out of which they were formed grew to a very considerable height, and resembled much the English Ash.—They were painted red, both within and without, and inlaid with shells in different forms.—When they went out in state, the heads and sterns were adorned with a variety of shells strung on a cord, and hung in festoons.—The smallest vessel that they built could hold four or five people, the largest were able to contain about twenty-five to thirty.—They carried an outrigger, but only on one side; and used latine sailes made of matting.

Details of the decoration of the canoe were drawn by Edge-Partington (1780: 180), identified only as depicting a canoe of 35'5" at the British Museum. Haddon and Hornell (1975: 429) included a drawing of details of the 1791 canoe as Figure 309a, with the notation: "Palau *kabekl* and *kaep*. A, side view of *kabekl* hull (British Museum) ornamented with pearl shell inlay in five (sic) narrow bands on bow, with a lateral line on which a row of long-necked birds are spaced at regular intervals."

Two metal braces inserted into the canoe indicate the canoe might have been suspended along the wall for exhibitions, but this history has not yet been traced. Much of what is known of the 1791 canoe and the eighteenth-century relationship between England and Palau is based on the careful research conducted by Mr. Nevil Dickin and Daniel Peacock and published in Peacock's (1987) *Lee Boo of Belau,* including to my knowledge the first published photograph of the 1791 canoe.

We have not yet discovered Palauan oral histories about the canoe. Few Palauans are aware it is in the British Museum, and few visitors have seen it in deep storage. At the time of the 1983 exhibition it was not possible to display the 1791 canoe from McCluer. In 2002, as we corresponded with museum curators, the canoe again began attracting greater interest and visibility.

PORTRAIT OF THREE PALAUANS

The third treasure is another of the oil paintings of the three Palauan youths, which according to British Museum documents was possibly from the William Blackmore

Museum, Salisbury, Wiltshire. It was included in The Human Image exhibit and published in *The Human Image* (King 2000: 49) under the title "Portrait of three Micronesians," 100 x 65 cm, with the further description "Kokiuaki and his sisters, executed in the style of New England portraiture by the Chinese artist known in the West as Spoilum (*fl.* 1770–1810) China 1791." The image was again published by Kaeppler (2008: 44).

Any oral histories of the visit of the three youths to Macao in 1791 have not yet been traced. McCluer (1790–1792: 27) reported:

> The famous painter Spoilem came down to Macao at my request, his terms were to be ensured 50 Dollars for his trip, this sum I gave him for a picture of myself and the three Pelew people in a groupe, this piece I hope is already in your possession, which I left with Mr. Freeman [at Macao] to be sent home by the ships next season. This piece was judged to be a striking likeness of everyone in the groupe, and the Palau people were much pleased with their own resemblance. Dr. Harrison and several of the Gentlemen had a copy of the three people.

In the supplement, Hockin (in Keate 1803: 35–36) reported on the youths' exciting visit to Macao and sight of an English warship, tales the young man embellished on his return to Palau. Hockin reported that the *Panther*'s journal was transmitted to England on the *Leopard* and *Thames*, but no mention was made either of the paintings to be sent or of the canoe that had been dispatched on these China fleet ships. In his journal, McCluer (1790–1792: 32) stated that he gave Ibedul "a present of a dozen China paintings," which may have included paintings of the three youths.

The portrait held by the British Museum's Ethnography Library, Pictorial Collection, reminds us of the wealth of visual materials held in national archives and collections around the world. For years it was displayed in the Student's Room at the Museum of Mankind, visible to countless researchers but less known to Palauans. This image was not among those sent to Ibedul in 1983. A small black and white image of the painting was published by Peacock (1987: 160). After its 2000 publication by King, the Belau National Museum purchased the rights for a digital image for exhibition.

The painting of the three Palauans that Banks sent to Blumenbach in Göttingen is very similar to the one depicted above, but the nudity of the young man was covered by an inlaid covered container held by one of the young women (Plischke 1955).

Unfortunately, in 2001 the image of the three Palauans held in Britain was used as the cover image for *Body Trade: Captivity, Cannibalism and Colonialism in the Pacific* (Creed and Hoorn 2001). The Palauans were not captives or cannibals, nor were they colonized at the time of the painting. The book's only reference to Palau was in the editors' misinformed and fanciful introduction. It was clear that the editors had not used the knowledge held by Prasaud, the library curator, nor had they consulted the standard reference on early Palau, Keate (1803). Palauans were understandably affronted by the book's misstatements and misleading use of this striking image in an academic publication. Given the fast international communications now available to twenty-first-century researchers and institutions, it is time for depositories of cultural treasures to reconsider

A 1792 canoe in storage at the British Museum, with detail. Photo: Karen L. Nero, 2007.

Portrait of three Micronesians. Oil painting, 100 x 65 cm. The British Museum.

their standardized protocols and ways these might be adjusted to involve the institutions of the cultures of origin in the management, exhibition, or publication of cultural treasures.

Changing Meanings: Stars and Comets

These early treasures from Captain Wilson's and McCluer's sojourns in Palau are highly valued by Palauans. Still present in museums, collections, and various libraries and archives overseas, these time travelers can release ancestral knowledge, their presence evoking awe and pleasure. I have chosen the cosmological metaphors of stars and comets to represent the treasures traced in this study, building upon Tapsell's 1997 metaphor of overseas Maori *taonga* (treasures) as comets, poignantly capturing the awe and consternation that often accompanies their unexpected reappearance. The comet metaphor is useful to consider the slow re-entry of the 1791 canoe and oil painting into the awareness of their descendants, as these are gaining illumination as they approach. While the narratives that once accompanied them are still not visible, knowledge of their existence is beginning to reach contemporary Palauans.

The Bird Bowl—A Star

However not all the Palauan treasures that traveled overseas have been lost from the knowledge of their descendants. The relationships between Captain Wilson and his family, and the Ibedul of Koror and his son Lebuu were between the families and the polities they represented. Captain Wilson was a representative of the powerful Honourable East India Company, and a century later his descendants transferred the pieces to the British Museum in recognition of their national importance. I suggest that the meanings of the bird-shaped bowl, then and now, might be better understood using another metaphor of time and space—that of a star. Just like a star the knowledge and image of this important icon, and the relationships established by its transfer, have remained visible to Palauans and its successive British custodians throughout the intervening centuries. The ongoing presence of Lebuu's grave and the bird-shaped bowl in London continue to underpin relationships enacted today between Palauans and British. Connecting British meanings of gifting and its obligations with the Palauan concept of *bltikerreng*, the British Museum and Rotherhithe church graveyard are the custodians of these symbols of the timeless feeling of *bltikerreng* that enabled these time treasures to travel like stars and comets. We must also ask: Why are these treasures again visible? How can they kindle and rebuild tighter collaboration, friendship, and collective efforts between Belau National Museum and British Museum scholars and staff?

New Directions

The visual and Internet technologies and international air travel of the twenty-first century provide new opportunities to develop these relationships and to expand the ways in which the knowledge condensed in the treasures may be made available to their descendants. Faustina Rehuher, director of the Belau National Museum, was invited as a Pacific Scholar in Residence to Cambridge in 2007, researching and further building

relationships with British institutions to honor the Palauan collections in their care. As part of current research, color digital images of the British Museum's Palauan collection have been made to augment the museum's written and archival records. New digital technology is being used to compile a composite image of the 1791 canoe that we hope can be projected full-size at the Belau National Museum. 3D technologies provide even more exciting possibilities than 360-degree images of objects; we are experimenting with ways to use not only their "textural" or surface images, but also the structural knowledge on which these 3D images are based. Such images of the cross-sections of the 1791 canoe (and others in museum collections) may offer new ways to access the knowledge of their construction.

Recent edited volumes address issues of relationships between museums and their home and source communities (Peers and Brown, 2003; Karp, Kreamer, and Lavine 2010). For examples of work on the interfaces of museums and digital media, see Cameron and Kenderdine 2007 and Eklund et al. 2009. Taylor et al. 2002 document a decade of Canadian 3D technology. At present, work is underway by many scholars to provide color images and electronic documentation of visual images and written and archival materials in ways appropriately accessible to libraries and museums (see Rowley et al. 2010; Eklund 2009).

The Belau National Museum, established by traditional and civic leaders in 1955, contributes to nation building. Opportunities for Palauans to view their own and their ancestors' creativity housed through virtual exhibitions, images, and documentation assists in the museum's vital work with its own communities. The descendants can then develop the implications and applications of such knowledge as they reclaim their sense of place, pride, and hope for future generations.

Acknowledgments

To Brigitta Hauser-Schäublin and Elfriede Hermann, who insisted on the framework of contexts and meanings; Dorota Starzecka, Lissant Bolton, Harry Prasaud, Jill Hasell, Jenny Newell, John Osborn, and James Hamill of the British Museum; Paul Tapsell, Merata Kawharu, and Roger Neich, cocreators of our *Bringing Together Academic and Museum Knowledge and Practices* project; colleagues Faustina Rehuher, director of the Belau National Museum, and Fermina Brel Murray, representing my many Palauan mentors; readers Peter Hempenstall and J. Kehaulani Kauanui; and Nelson Graburn, who first directed my work through his insightful questions.

Notes

1. Used to refer to the British Museum including earlier names, i.e., Museum of Mankind.
2. Pagination is based on Keate's 5th edition including the Hockin Supplement.
3. See Peacock 1987: 193–194 and 230–231.
4. It appears that the portrait received by Banks was not given to the British Museum. In 1797 Professor Blumenbach thanked Banks for sending him a picture of the Pelew Islanders for his anthropological collections (Dawson 1958: 837 and 114 respectively).
5. The experiences of Koror's enemies, in particular Melekeok and Peleliu, substantially differ.

6. A later clarification noted that Abba Thulle was not sovereign over the entire archipelago (Keate 1803: 194).

7. Rupacks [*Rubak*] (male titleholders).

8. Quotations from the McCluer Journal 1790–1792 are from the Nevil Dickin transcription of the British Library manuscript.

References

Anonymous. 1789. *The Interesting and Affecting History of Prince Lee Boo*. London: E. Newbery.

Cameron, Fiona, and Sarah Kenderdine, eds. 2007. *Theorizing Digital Cultural Heritage: A Critical Discourse*. Cambridge, Mass.: The MIT Press.

Creed, Barbara, and Jeanette Hoorn, eds. 2001. *Body Trade: Captivity, Cannibalism and Colonialism in the Pacific*. New York: Routledge.

Dawson, Warren R., ed. 1958. *The Banks Letters*. London: The British Museum.

Edge-Partington, James, and Charles Heape. 1890. *An Album of the Weapons, Tools, Ornaments, Articles of Dress of the Natives of the Pacific Islands*. Manchester: Issued for private circulation by J. Edge-Partington & Charles Heape.

Eklund, Peter. 2009. "The Virtual Museum of the Pacific." Video, 10 minutes. Centre for Digital Ecosystems, University of Wollongong. Published December 8, 2009. Consulted November 8, 2010. http://www.youtube.com/watch?v=YbSgKvWauP8.

Eklund, Peter, Peter J. Goodall, Tim Wray, Vinod Daniel, and Melanie Van Olffen. 2009. "Folksonomy with Practical Taxonomy, a Design for Social Metadata of the Virtual Museum of the Pacific." Conference Paper. 6th International Conference on Information Technology and Applications (ICITA 2009). http://www.icita.org/papers/04-au-Eklund-136.pdf.

Godelier, Maurice. 1999. *The Enigma of the Gift*. Chicago: University of Chicago Press.

Haddon, A. C., and J. Hornell. 1975 [1936–1938]. *Canoes of Oceania*. Bernice P. Bishop Museum Reprint of Special Publications 27–29. Honolulu: Bishop Museum Press.

Josephs, Lewis S. 1990. New Palauan-English Dictionary. Based on the *Palauan-English Dictionary* by Fr. Edwin G. McManus, S.J. Honolulu: University of Hawai'i Press.

Kaeppler, Adrienne L. 2008. *The Pacific Arts of Polynesia and Micronesia*. Oxford: Oxford University Press.

Karp, Ivan, Christine Mullen Kreamer, and Steven D. Lavine, eds. 2010. *Museums and Communities: The Politics of Public Culture*. Washington D.C.: Smithsonian Institution Press.

Keate, George. 1803. *An Account of the Pelew Islands . . . To which is added, A Supplement by J. P. Hockin*. 5th ed. London: G. and W. Nicol.

King, J. C. H., ed. 2000. *The Human Image*. London: The British Museum.

Mauss, Marcel. 1967 [1925]. *The Gift: Forms and Functions of Exchange in Archaic Societies*. Translated by I. Cunnison. New York: W. W. Norton & Co.

McCluer, John. [1790–1792]. "Journal of a Voyage to the Pelew Islands in the H.C. 'Endeavour.'" In British Library Manuscript Department, Additional MS19301. London.

Nero, Karen L. 1987. "*A cherechar a lokelii*: Beads of History of Koror, Palau, 1783–1983." PhD diss. University of California, Berkeley.

———. 1992. "The Breadfruit Tree Story: Mythological Transformations in Palauan Politics." *Pacific Studies* 15 (4): 199–209.

———. 2002. "Keate's *Account of the Pelew Islands:* A View of Koror and Palau." In *An Account of the Pelew Islands: George Keate,* edited by K. L. Nero and N. Thomas. London and New York: Leicester University Press.

Nero, Karen L., and Nicholas Thomas, eds. 2002. *An Account of the Pelew Islands: George Keate*. London and New York: Leicester University Press.

Parmentier, Richard J. 1987. *The Sacred Remains: Myth, History, and Polity in Belau*. Chicago: University of Chicago Press.

Peacock, Daniel J. 1987. *Lee Boo of Belau: A Prince in London*. Honolulu: University of Hawai'i Press.

Peers, Laura, and Alison K. Brown. 2003. *Museums and Source Communities: A Routledge Reader*. London: Routledge.

Plischke, Hans. 1955. Über die Palau-Inseln um 1790. *Zeitschrift für Ethnologie* 80: 165–169.

Rowley, Susan et al. 2010. "Building an On-Line Research Community: The Reciprocal Research Network." In *Museums and the Web 2010: Proceedings*, edited by Jennifer Trant and David Bearman. Toronto: Archives & Museum Informatics. Published March 31, 2010. Consulted November 8, 2010. http://www.archimuse.com/mw2010/papers/rowley/rowley.html.

Strathern, Marilyn. 1988. *The Gender of the Gift: Problems with Women and Problems with Society in Melanesia*. Berkeley: University of California Press.

———. 1992. "Qualified Value: The Perspective of Gift Exchange." In *Barter, Exchange, and Value: An Anthropological Approach*, edited by C. Humphrey and S. Hugh-Jones. Cambridge: Cambridge University Press.

Tapsell, Paul. 1997. "The Flight of Pareraututu: An Investigation of *Taonga* from a Tribal Perspective." *Journal of the Polynesian Society* 106 (4): 323–374.

———. 2006. *Ko Tawa: Maori Treasures of New Zealand: The Gilbert Mair Collection, Auckland War Memorial Museum Tamaki Paenga Hira*. Auckland: David Bateman in association with Auckland War Memorial Museum Tamaki Paenga Hira.

Taylor, J., J.-A. Beraldin, G. Godin, R. Baribeau, L. Cournoyer, F. Blais, S. El-Hakim, M. Picard, J. Rioux, and J. Domey. 2002. NRC-CNRC: Culture as a Driving Force for Research and Technology Development. Paper read at Proceedings of the EVA 2002 July, at London.

Thomas, Nicholas. 2002. "'The Pelew Islands' in British Culture." In *The Account of the Pelew Islands: George Keate*, edited by K. L. Nero and N. Thomas. London and New York: Leicester University Press.

Cultural Change in Oceania
Remembering the Historical Questions

Peter Hempenstall

Ordinarily a historian among anthropologists is a nervous creature. The Malinowskian tradition of European anthropology condemned the historian to the status of inferior cousin in a family devoted to studying the functional regularities of social structure in "other cultures." History was regarded as an oversimplified project, a fact-grubbing chronicle or speculative flight of fantasy incapable of connecting with the reality of past societies. Historical anthropology was a weaker variety of the real anthropology, in which "social change" might be studied by comparing the start and end points of a particular society and evaluating the amount of change that occurred between. But anthropology has been thoroughly "historicized" since then (Biersack 1991). Temporality as a process has been incorporated into explanations of cultural shifts, and anthropologists have become adept at exploring how time is differently conceptualized, represented, symbolized, and constructed by social groups (Hastrup 1992: 124). Today, historians of the Pacific Islands will often turn first to the anthropologist, not just for an understanding of the social structure with which they are dealing, but for a sophisticated exploration of the dynamic of change occurring among a historical island population.

So this Pacific historian feels reasonably comfortable that he is among friends, friends whose studies of moments of cultural transformation in Oceania have provided a richly woven and suggestive tapestry of events, customs, signs, and practices encompassing the multiple regions in which the Pacific Islands lie. The breathtaking objects in the Cook/Forster Collection of artifacts from the University of Göttingen link us to a series of historical moments in eighteenth-century Europe. And they join us to the overarching theme of the conference, the process of ever-changing answers that these artifacts give to the questions raised by each age that observes them—their shifting meanings as contexts change. The historian would perhaps emphasize the context before studying the shift in meaning, a point Brigitta Hauser-Schäublin highlighted in her opening address on the collecting habits of the eighteenth century and the way the University of Göttingen's treasures came into its hands. Hauser-Schäublin from the beginning emphasized the point that a historian would make in observing these stunning objects: they are not a direct window onto a past that is 230 years old. They are signals we must interpret from our present standpoint as professional observers with

all the scholarly apparatus at our command, but with imagination as well: imagination to understand the meaning these still-living objects had for their contemporary creators and users, as well as for the native Hawaiians and other Pacific Islanders who, during the exhibition at the Honolulu Academy of Arts, came to venerate the objects that linked them to their ancestors.

It is in that space of scholarly craft combined with historical imagination that historians work. In the spirit of that enterprise I would venture to gather the myriad cases presented during the conference, with their thoughtful analyses, into some kind of order that makes personal sense and to highlight the themes of historical importance and explanatory value that the historian might gently encourage his colleagues to remember.

The first is the importance of making identifiable persons, subjective presences, part of the evaluation of structural changes as well as elements in the story of transformative events. A concentration on cultural structures, on the genealogies of ideas, on the process of transformation of traditions, can mask the personal agency through which such processes are enacted. "Agency" has become a cult word in the lexicon of critical theory, though it has been around within the literary genre of biography for a hundred years as the recognition of an individual's constrained autonomy of action. Biography itself has been made to bear an increasing weight of relevance in the twenty-first century as it encompasses the "lives" of cities, institutions, and ideas, as well as having to cover the sins of the person. At a variety of levels the analyses of cultural change during the conference recognized these notions of "biography." The lives of persons were implicit in Elfriede Hermann's stress on traditions as the product of interactions among social actors in particular contexts, who were the agents for transforming cultural traditions. "Biography" was implicit too in Martha Kaplan's playfully serious analysis of the "life" and "career" of Fijian bottled water in the United States, and in Deborah Waite's "cultural biography" of the image of 'A'a of the Austral Islands. Objects were given invented lives in the tales Brigitta Hauser-Schäublin and Adrienne Kaeppler told of the movement of museum artifacts from age to age and market to market. Stephen Little, director of the Honolulu Academy of Arts, spoke of the objects on display as "ancestors" communicating between past and present. Even the tour of the Honolulu Academy of Arts, with its intimate rooms of chronologically arranged art pieces, was presented by Little as a kind of biography of the human species in our quest for cultural meaning and aesthetic expression.

But words like "agency," "*wokim kastom,*" "enacting," "binding," "enabling," that implied the actions of individuals and groups, too frequently were abstract proxies for real people acting in historical circumstances. A sense of individual lives and their influence on the contexts and meanings of transformative events were often absent in the cast of characters enacting social processes.

The historical biographer would make a plea for inserting a more humane dimension into our understanding of cultural transformation and the contexts in which they occur. Though the social sciences have developed a serious literature on "life narratives" and the methods by which they might be captured for research, there remains a strong case

in anthropology for being more alert to the genre of biography as explanation, despite its old-fashioned penchant for "great figures." Biography is a genre now conscious of its own complex history and problematics, especially when dealing with non-Western senses of the person and how to represent this (Lal and Hempenstall 2001; see also Tridgell 2004). The representation of the contexted life—in the sense of situating a theorized self within a matrix of its own chronological and structural contexts—has shown a transdisciplinary energy and an explanatory value that is part of the equation for explaining cultural transformation. It can take without strain the form of the modernist unified self or the postmodern sense of multiple, changing identities and fragmented selves. It can analyze the complexities in personal "becoming," determine the central importance of choice by individuals, and demonstrate the crucial ambiguity of "agency." Elfriede Hermann's sense of "context bound articulations" can apply as easily to the biographical project as to the concept of tradition and can illuminate shifting meanings within cultures in the hands of individual persons.[1]

The classic case hovering at the center of discussions about cultural transformation in the Pacific is of course that of Captain James Cook. Cook's reputation has inscribed a trajectory from admiration and veneration to vilification and blame, all the more poignant for the presence in Hawai'i at the time of the conference of the magnificent cloaks, helmets, cloth, and implements that were the fruit of his three voyages. He has been elevated—reduced perhaps—to the position of an icon in theoretical discourse about the violence of the encounter between Enlightenment Europe and unreconstructed "native" society. He is an example of the reification of solid individuals into a fulcrum of cultural transformation. Interesting, therefore, were Gundolf Krüger's observations on someone close to Cook on his second voyage—Georg, the younger Forster with his self-awareness of his own changing contexts as he moved between collecting in the islands as the voyage proceeded and writing up the voyage at a distant remove in Europe. Here was a young man, "always contemporary and unfinished, that does not leave one in peace" (Sonnemann, quoted in Krüger, this volume). Contexts, meaning, and transformation—of self and culture—are all linked in such a life and the ideal outcome of the biographical impulse.

A particular problem for biography has been to treat differently and to represent the quality of the personal non-Western life, and this conference was a good example. Pacific Islanders who were also part of the fulcrum of transformative events were named and their significance was outlined—Mai, Tupaia, Purea, Vehiatua, Paliau, and Kalomaka of Wallis Island. But as Amy Stillman remarked, we register their lives largely second hand, our voices drowning out theirs in academic symposia. Jolly reminded us we have many images of Mai but have paid too little attention to his "becomings." We commemorate, with a variety of interpretations, the Europeans who engaged in beach crossings, but we have captured precious little knowledge of the inner curiosity of those individual Pacific Islanders who shared the world of Europeans on their ships or in Europe itself. Wolfgang Kempf gave an intriguing insight into the process of a new "becoming" for Banabans reshaping their memories of a Banaban past on the island of

Rabi in Fiji. Kempf made a valiant effort to disaggregate named individuals from his Banaban dancing group, but the focus of his analysis, understandably, remained the process of mimesis by which an ethnic group remakes its past into a charter for the present. Sometimes the people at the center of vast cultural shifts are ignored altogether, as Kaplan reminded us. Her Fijian bottled water has become a talisman for the American drinker seeking regenerative powers, but the existence of Fijians themselves as people is not acknowledged in the consumption of the water.

This dealing with lives in an islands context is partly a problem of evidence, partly an issue of crossing into new terrains of the self, whether the "partible self" of Marilyn Strathern's Melanesia-oriented conception (1988: 321) or some other projection of self that flows from familiarity with a people and their culture. I have written elsewhere of the costs and benefits of experimenting with such projections (Hempenstall 2001). The impediments to articulating another's culture and histories using our logic are substantial but not insuperable if we are to give the process of transformation a human face.

A second reason for giving individuals a higher profile in the analysis of changing traditions is their occasional role as *the* context for change, through their capacity to creatively invent new categories of meaning for old practices. James Cook is the singular example in this regard, though Ton Otto introduced us to a Pacific Islander at the other end of the Pacific, Paliau Maloat of Manus, Papua New Guinea, who crossed a cultural threshold to abandon ceremonial exchanges and provoked others—Ninou Solok, Kelu Salikioi, and Kisokau Aiwai—to remake tradition-seeking ceremonies. Naming and describing such individuals is an important affirmation of their historical agency, even if one has little evidence to decide why they chose their singular paths. Such transformative agents came infrequently before us during the conference, which may have something to do with cultural analyses that draw productively on the structural history of transformative cultural events à la Marshall Sahlins (1981, 1985).

Sahlins was an interesting ghost at the banquet of the Hawai'i conference. Elfriede Hermann's opening offering of "traditions as context-bound articulations," constantly open to reshaping by the interaction of social actors in specific contexts suggested a Sahlinesque model of explanation. He was invoked at other points by various speakers: by Anne Salmond in her reminder that we must pay more attention to the intersection of Polynesian with European myths in understanding early contact encounters, and indirectly by Margaret Jolly, who alluded to Sahlins' jousting with Gananath Obeyesekere over Hawaiian cultural logic and the death of Cook. Sahlins remains a beacon for anthropologists and historians alike in his theorization of the "returning event" (Sahlins 1991), which marries cultural structures with the unintended consequences of events, which in turn imbue the culture with new categories of meaning. But his theory has been criticized for underestimating the force of the creative individual whose actions have ambiguous effects and who can act outside cultural templates to invent new categories (Sewell 2005: 197–224). This is an area where a readiness to "do biography" can net one a more complete and persuasive picture of cultural transformations.

The conference shifted continually among a number of such explanatory orienta-

tions in examining the contexts in which cultural traditions shifted meaning. Representational analysis predominated, via the metaphors of "beach crossings" and "evanescent footprints" of encounter, the invention of tradition by social theorists, and the bringing into being of a place called Polynesia by European armchair travelers. The analysis of representations of their past re-enacted by the Banabans on Rabi, or recrafted by Tannese cueing personal names to places of historical significance down through the generations, were particularly sophisticated examples. But just as the concentration on cultural structures and their meanings masks the role of individual lives, so too can representational analysis make us underestimate the intrusion of outside structures of power and their effects. In the context of recounting the way transformed dance forms on Tahiti represent the fullness with which the islands of French Polynesia have been drawn into global flows of tourism, Kahn argues that dance is the ultimate distraction for the West from real engagement with Pacific culture. Kahn reminds us that France's policy of building a nuclear testing infrastructure in French Polynesia has had naked imperial effects through the hollowing out of social classes produced by two decades of tourist growth. Martha Kaplan too shows that there is nothing subtle in the plans of transnational corporations to drown the world in bottled water by tapping into the alleged regenerative powers of "native" spring water in the Fijian islands. Consumers ignore, or are never exposed to, the intricate multiethnic, colonial, and globalizing vectors that deliver Fiji Water to them. Amy Stillman was equally blunt in her reflection on the homogenizing effects of the West's music industry on Hawaiian hula's forms and expressions. More complex perhaps were the material elements of the British imperium in Fiji, which, as John Kelly showed, privileged chiefs with layers of power that they have continued to project upon their own people.

Recognizing the force of radical material changes to island societies over a succession of colonial periods and within global economic frameworks is not the same as arguing that Pacific Islanders have been helpless in the face of such onslaughts. The historical reality has been a series of "messy entanglements" (Talu and Quanchi 1995). Stillman's story was actually about hula's ability to sustain a culturally Hawaiian aesthetic logic by reproducing itself underneath the shield of twentieth-century tourist entertainment. Kaplan's bottled water empires were still founded on historically created dialogic processes between producers (Fijian and European) and consumers, while the Fijian Indian citizens in Kelly's Fiji have been able to apply a culture of nonviolence and "grace in exile" as a kind of circuit breaker that keeps Fiji from falling apart amid coups and countercoups. Hybridized societies emerge from the encounter between Pacific Island cultural traditions and the "modernizing" traditions of the West, as Françoise Douaire-Marsaudon showed in her study of Wallis-'Uvea, where the system of traditional laws underwent an interesting mutation with the imposition of a Western legal code. Lewis-Harris provides a particularly "modern" example of the Solien Besena culture that straddles southern Papua and mainland Australian communities, in which the inalienable treasure of traditional dance forms is traded and transformed within the modern Australian economy. Another example is Manus Island in Papua

New Guinea. Ton Otto argues that colonial structures of government and law, along with the education received in national and global developments by young Manus change agents, are all embedded in the hybrid *kastom* movement trying to shift Manus into a modern world.

The continuation of colonial structures of direct and indirect rule, the institutional power of Western lawmaking to reconfigure cultural traditions, the strengthening of privilege over material resources by certain classes within modernizing island societies—all of these examples from case studies presented here signal what we might call the political economy of cultural transformation. By this I mean the transformative potency of material conditions of power imposed upon Pacific Island cultures, largely from outside, but also from within through the disparities of power and resources within Oceanic communities. Foreign imperial regimes, transnational corporate strategies, new class formations—these are the forces that the historian would want to include in any examination of context for cultural change. The point of Margaret Jolly's essay is well made: the exchange metaphor can be too soft in dealing with the power relations enacted in beach crossings, not just by European to Islander but by Islander to Islander. These essays remind us of the need to maintain a historical focus on the material realities of power—wielded by foreigners and their privileged island clients—for ordinary Pacific Islanders.

What made this range of presentations special within the setting of the Honolulu Academy of Arts was the integration of the politics of present-day museums into the framework for evaluating transformations of culture. Museums have been memorably dubbed the capillaries of empire to denote their role as the conduits through which the export of ethnic objects and the debate about the hierarchy of cultural meanings were transmitted from the periphery to the center (Richards 1993: 15). The Honolulu essays amply demonstrate the continuing relevance of that description and the immersion—in some respects the collusion—of museums in the political economy that reshapes Oceanic cultures. Brigitta Hauser-Schäublin's and Adrienne Kaeppler's stories during the conference about disappearing and reappearing helmets and cloaks are contemporary evidence of a globalized market economy that continues to commodify Oceanic cultural objects—often themselves conduits to the ancestors—after fifty years of decolonization. They raise the question of whether, as territorial empires die, they are simply replaced by empires of trade and commodification consonant with the market imperatives of the twenty-first century. Museums and art galleries are both shopwindows onto other cultures and a marketplace where fair trade jostles with uncertain provenances, disguised identities, and complaisant auction houses in an at times ambiguous exercise in intercultural education.

We see a growing tension in the twenty-first century between the academic priority for communicating the complexity and contemporaneity of cultures, the public fascination with the exotic and the bizarre, and the pressure on institutions to justify their "mission" in an age of "user pays" cultural financing. This enlarged threat of the decontextualization of cultural knowledge sits alongside another created by what has been

called the second great museum age (Lunnon 2005). Artifacts have become charged with the weight of the relationships between the developed and undeveloped world. Discussions in Honolulu acknowledged the "decollecting" pressures mounting on some institutions in Germany, pressures to rid themselves by sale or exchange of objects that for reasons of space or political embarrassment cannot be displayed. On the other hand there is room for optimism in the development of new digitized images of artifacts held at a great distance from their origins in the Pacific. The example of the virtual repatriation of Micronesian objects held presently in New Zealand museums suggests a future of new exhibitions of objects "projected" through the Internet, which descendants from the original society might contextualize with their contemporary knowledge (see Nero, this volume). What effect this might have on destroying or masking the ritual value, or mana, of such objects in their original space was a caution voiced by the art historian Anne D'Alleva. Discussion also raised the possibility that these digitized forms might constitute the warrant of a new kind of colonialism whereby institutions could resist legitimate requests for the physical repatriation of objects to their cultural homelands. Another example, perhaps, of the tenacity of empires, though Nero's point was partly that the generosity of Pacific Islanders in gifting treasures to early Western travelers is being repaid through time: many of these treasures would no longer exist were it not for their (sometimes hidden) lives within museums.

This was merely one issue of contemporary relevance among several that were implicit in the largely historical analyses of cultural change in Oceanic societies. The spread of globalizing networks of finance capital and knowledge and the continuing diaspora of Pacific peoples adds a new matrix in which to consider the contexts and shifts of meaning for cultural traditions. The eighteenth century can still bleed into the twenty-first through artifacts such as the Cook/Forster Collection of the University of Göttingen. As Hauser-Schäublin points out, they continue to transmit ever-changing signals to new generations living and interpreting in new contexts. The ways in which James Cook stories have been recirculated, and still recirculate in Hawai'i, New Zealand, Vanuatu, and Australia according to the political and moral concerns of both indigenous and settler communities, are one example. Another are the physical remains of the Micronesian sites Nan Madol and Lelu, which, as David Hanlon points out, tend to get banished to "prehistory" through privileging the documented history of colonial ages as the key to cultural transformation. His is an elegant plea for "the ways in which archaeology might again be history"; museums are the signal boxes where this "deep time" can be transmitted to present generations.

But what are the implications today for local cultural forms and practice as the population and profiles of Oceanic culture shift under our feet? Eighty-three percent of Cook Islanders now live either in New Zealand or other rim societies. Three times as many American Samoans live in the United States as in the home islands. The same can be said for Samoans in New Zealand and Australia, for Wallis Islanders and Niueans. Only 14 percent of the more than two million Polynesians live in independent Polynesian nations; most are on the west coast of the United States or in New Zealand, Australia,

and a hundred other countries (Crocombe 2001: 66–67; Crocombe 1999). The very concept of Polynesia shifts, as Serge Tcherkézoff made plain, depending on where one stands to observe this migrant flow; kinship and language become highly diffuse categories in an expanding set of communities. New Zealand, the world's largest Polynesian society, is undergoing a thoroughgoing "Pacification." Maori numbers rose from 12.9 percent in 1991 to 15.1 percent in 2001, while 643,977 Maori (17.7 percent) claimed Maori ancestry in the 2006 census; other Pacific Islanders will make up more than 9 percent of the population by 2021. Overall, Maori and Pacific Islanders will account for more than a quarter of the population in that year and around 30 percent of the work force between 2030 and 2035. The implications for the economy are obvious, no less so for the sense of identity of the white settler population and for the nation-state overall, in which Asian ethnicity will also double to 14 percent of the population in 2021 (James 2005; Statistics New Zealand: 2006 census).

In New Zealand one sees emerging projections of a new, positive Oceanic identity mediated through sports like rugby and netball, through the reshaping of popular music culture in Pacific hip-hop and rap, and through the enlarging, if contested, vision held out by the Treaty of Waitangi and the history of land settlements (Ward 1999; Belgrave 2005). Along the way, Pacific Island culture itself takes on contours very different from the village setting in the islands as young people shape new communities of practice (Macpherson, Spoonley, and Anae 2001). Toon van Meijl explores the way Maori wrestle with their contemporary social formations as one example of this process. Another is Paul van der Grijp's account of young Tongan artists literally reshaping artistic formats and practices. They are at once responding to globalizing market demand and refashioning a sense of self in a modernizing Tongan world.

The material factors of transnational media and corporate investment strategy pointed up in several essays are facilitating and accelerating these cultural changes, which reinforces their importance as key points of focus for our understanding of contemporary cultural transformations. Such present-day processes, through people of many Oceanic societies enabling a set of as-yet unseen futures, must be as open as the eighteenth century to our critique as social scientists.[2]

Yet in the final analysis historicity is embedded in all such processes. In the face of those who preferred to argue around "strategic deployments of culture" rather than engage in a conversation with the past—a theme that attracted some heat at a point in the conference dealing with the "invention of tradition"—the richest analyses belonged to those moments provided by Anne Salmond, who connected the potency of the mythopraxis of Polynesians with the history of Europeans, equally ruled by myth, in a common historical moment, opaque perhaps to the historian reading back, but powerful in its reverberations through to the present. Lamont Lindstrom's account of the people of Tanna, who reinvent themselves and their island by inscribing new names on land and people that then become part of eternal island memory, was another invocation of the historical moment. "History can trump eternity" was Lindstrom's reminder that Pacific peoples are not just people of the land or of the ocean but history people too.[3]

Notes

1. Being aware of one's own place in the scholarship that produces our understanding of cultural changes is also important as a factor in explanation—a well-recognized trend in reflexive anthropology today, even if it was singularly underplayed during the presentations. Two commentators on the essays—Anne D'Alleva and Christian Feest—drew attention to the need to register our looking at ourselves looking at the eighteenth century, while Alan Howard described proceedings as our imagining of their imaginings. A few essays alluded to "beach crossings" as the paradigmatic metaphor for encounters between Islanders and outsiders in the spirit of Greg Dening's work (see Jolly and Hanlon, this volume; Dening 2004). None indulged in a personalized account of such crossings in their own work.

2. A most important process in today's Oceania, conspicuously absent in any systematic examination during the Honolulu gathering, is the transformation or set of transformations being wrought by religion, specifically Christianity and its myriad forms. Johannes Fabian's plea in respect of African religions, that we need a "history and political economy of religion in an age of planetary embourgeoisement" (Fabian 1991: 124) is the more relevant as the re-enchantment of the world through new religious movements proceeds and as Islam and Christianity increasingly face off across and within nations; Oceania is the most Christianized area on earth. Part of such examination must be the shaping of language as an instrument by institutions of authority to control the message and its use by believer communities for their own purposes, which include forging wider connections. A good example from the Pacific of all these aspects of religious transformations of and in culture is Don Tuzin's study (1997) of his own unwitting involvement in the social revolution that destroyed the *tambaran* rituals among the Ilahita Arapesh.

3. A point made by John Pocock (1992) in speaking about New Zealand Maori as *tangata whenua* (people of the land).

References

Belgrave, Michael. 2005. *Historical Frictions: Maori Claims and Reinvented Histories*. Auckland: Auckland University Press.

Biersack, Aletta, ed. 1991. *Clio in Oceania: Toward a Historical Anthropology*. Washington, D.C.: Smithsonian Institution Press.

Crocombe, Ron. 1999. "Bases of Belonging." *Anthropological Journal of European Culture* 8 (1): 31–60.

———. 2001. *The South Pacific*. Suva: Institute of Pacific Studies USP.

Dening, Greg. 2004. *Beach Crossings: Voyaging across Times, Cultures and Self*. Melbourne: Miegunyah Press.

Fabian, Johannes, ed. 1991. *Time and the Work of Anthropology. Critical Essays*. Chur: Harwood Academic Press.

Hastrup, Kirsten, ed. 1992. *Other Histories*. European Association of Social Anthropologists. London: Routledge.

Hempenstall, Peter. 2001. "Sniffing the Person: Writing Lives in Pacific History." In *Pacific Lives, Pacific Places: Bursting Boundaries in Pacific History*, edited by Brij Lal and Peter Hempenstall, 34–47. Canberra: The Journal of Pacific History.

James, Colin. 2005. "The Pacific Dimension in New Zealand Demographics." Paper prepared for the Australia–New Zealand Leadership Forum, Melbourne, April 29–30, 2005. In author's possession.

Lal, Brij, and Peter Hempenstall, eds. 2001. *Pacific Lives, Pacific Places: Bursting Boundaries in Pacific History*. Canberra: The Journal of Pacific History.

Lunnon, Jenny. 2005. "People Watching." *Oxford Today*, Michaelmas Issue (October): 24–26.

Macpherson, Cluny, Paul Spoonley, and Melani Anae. 2001. *Tangata o te Moana Nui: The*

Evolving Identities of Pacific Peoples in Aotearoa/New Zealand. Palmerston North: Dunmore Press.

Pocock, J. G. A. 1992. "Tangata Whenua and Enlightenment Anthropology." *New Zealand Journal of History* 26 (1): 28–53.

Richards, Thomas. 1993. *The Imperial Archive. Knowledge and the Fantasy of Empire.* London: Verso.

Sahlins, Marshall. 1981. *Historical Metaphors and Mythical Realities. Structure in the Early History of the Sandwich Islands Kingdom.* Ann Arbor: University of Michigan Press.

———. 1985. *Islands of History.* Chicago: University of Chicago Press.

———. 1991. "The Return of the Event, again: With Reflections on the Beginnings of the Great Fijian War of 1843 to 1855 between the Kingdoms of Bau and Rewa." In *Clio in Oceania: Toward a Historical Anthropology,* edited by Aletta Biersack, 37–100. Washington, D.C.: Smithsonian Institution Press.

Sewell, William H., Jr. 2005. *Logics of History. Social Theory and Social Transformation.* Chicago: University of Chicago Press.

Statistics New Zealand: 2006 Census Data: Quick Stats about Māori. http://www.stats.govt.nz/census/2006censushomepage/quickstats/quickstats-about-a-subject/maori.aspx.

Strathern, Marilyn. 1988. *The Gender of the Gift. Problems with Women and Problems with Society in Melanesia.* Berkeley: University of California Press.

Talu, Alaima, and Max Quanchi, eds. 1995. *Messy Entanglements. The Papers of the 10th Pacific History Association Conference Tarawa, Kiribati.* Brisbane: Pacific History Assocation.

Tridgell, Susan. 2004. *Understanding Ourselves: The Dangerous Art of Biography.* New York: Peter Lang.

Tuzin, Don. 1997. *The Cassowary's Revenge: The Life and Death of Masculinity in a New Guinean Society.* Chicago: University of Chicago Press.

Ward, Alan. 1999. *An Unsettled History. Treaty Claims in New Zealand Today.* Wellington: Bridget Williams Books.

Epilogue

Aletta Biersack

This volume comes out of a symposium staged in conjunction with an exhibit at the Honolulu Academy of Arts: Life in the Pacific of the 1700s: The Cook/Forster Collection of the George August University of Göttingen. Displayed in that exhibit were some five hundred items of ethnological interest from New Zealand, Tonga, Tahiti, the Marquesas, New Hebrides, New Caledonia, Hawai'i, and the northwest coast of America, all collected during the second and third voyages of Captain James Cook (Little 2006; see Hauser-Schäublin 1998 and this volume; Kaeppler 1998; Urban 1998a).[1] The exhibit was a major event in the annals of Euro-American museology and ethnology. Cook was not the first European to voyage in the Pacific, nor would he be the last (Meleisea and Schoeffel 1997), but Cook had a major impact on the European worldview and directed European curiosity (Kaeppler 1978) toward the Pacific. Cook's voyages generated a wealth of knowledge, inspiring the scientific and not just the popular imagination to conjure distant others. His "expeditions were immediately famous among mariners, artists, writers and the wider public; it is no exaggeration to claim that they captured the attention of the epoch" (Thomas 2005: 13).

To the extent that Europe was central to the nascent globalizations of the eighteenth and nineteenth centuries, to the extent, too, that the greater Europe (including America) has now entered an era of political and representational decolonization, Oceanic encounters, yesterday and today, become central to a world history that requires careful narration and theorization. The various contributions to this volume constitute forays into that narration and theorization. Taken together, they begin to map the terrain of a history of Oceania's globalization. This epilogue summarizes what in my reading are the highlights of the conference. Pacific Island history has inspired some of the most important writings in historical anthropology. At the close, I use the conference to assess the new directions in that rich and ever-burgeoning field for this, an era of postcolonial dialogue and research.

Encounters, Mythologizations, Racializations

The contributions of Salmond, Douglas, and Krüger help us understand the knowledge generated by the voyages of Cook and others in the second half of the eighteenth century and the first half of the nineteenth century, the preconceptions that guided their

"discoveries," and the impact of their findings on Enlightenment philosophy, so critical to European and American intellectual history.

In his voyage around the world from 1766 to 1769, the Frenchman Louis-Antoine de Bougainville found in Tahiti the realization of the Rousseauian ideal of a "noble" savagery living peacefully and harmoniously with nature. Hobbes had dismally posited that the "natural state" of "man" was the abject state of a war of all against all (Salmond, this volume), but Bougainville concluded that Tahiti was "the happiest society on this terrestrial globe" (quoted in Krüger, this volume) and "the true Utopia" (quoted in Salmond 2003: 53). Of Tahiti and Tahitians, Bougainville wrote, "I thought I was transported into the garden of Eden . . . everywhere we found hospitality, ease, innocent joy, and every appearance of happiness amongst them" (quoted in B. Smith 1985: 42).

Tahiti had been discovered for Europe just months earlier by Captain Samuel Wallis, commander of HMS *Dolphin*. As in so many encounters between Europeans and Islanders in the Age of Discovery, the crew of the *Dolphin* resorted to violence. As conquerors, the British were seen by Tahitians as imbued with the power of the war god 'Oro and considered *arioi:* priest-navigators or warrior-navigators devoted to the worship of 'Oro (Salmond, this volume; see also Salmond 2003: 35–39). "An *'arioi* possessed by the war god [as Wallis' victory suggested that he and his seamen were] had his pick of the young women" (Salmond, this volume). Tahitian women would be traded for iron, the price of a liaison being as little as a nail or two.

The traffic in Tahitian women did not stop there. When Bougainville arrived in 1768, just nine months after Wallis' visit, women were again made available, sometimes in the context of creating *taio* relationships or "ceremonial friendships" (Salmond 2003: 48) across the cultural divide. *Taio* bondsmen exchanged names, gifts, and wives, possibly as a kind of peacemaking diplomacy (Mauss 1967). Little wonder that Tahiti was designated "Aphrodite's Island," where the spirit of Venus and Aphrodite are alive and well, where "people breathe only rest and sensual pleasures," as Bougainville put the matter (quoted in Salmond, this volume; see also Denoon 1997a: 130–131; Kahn 2003; Salmond 2010; B. Smith 1985: 47; Tcherkézoff 2008: ch. 8; Tcherkézoff 2009).

Such ruminations reflected a broader trend at the time, one that Krüger touches upon in his discussion of "the noble savage": the use of the South Seas as "a favorite site for fables describing fantasy voyages and . . . island utopias" (Salmond, this volume; cf. Campbell 1980; Kahn 2000a: 11–13; B. Smith 1985: ch. 11). British encounters with Tahitians were "highly charged and imbued with mythic implications" (Salmond, this volume), implications that verified the very assumptions framing "European vision" (B. Smith 1985), making it a matter of seeing what was already believed. Salmond tells us that Bougainville's "tales of an island Eden in the South Pacific created a sensation upon his return to Europe" (2003: 53) and that texts concerning Tahitian life fueled "philosophical speculations about 'the state of nature', including . . . Jean Jacques Rousseau's dream of the 'noble savage'" (ibid.). The Tahitians, meanwhile, mistaking the British for 'Oro priests, saw only what a culturally and historically specific fantasy of their own prepared them to see.[2]

In light of Wallis' and Bougainville's visits, Cook's ship the *Endeavour* headed for Tahiti, where it landed in 1769. Cook would return to Tahiti on his second voyage, taking along Johann Reinhold Forster, the naturalist, and Georg, his precocious son, who would assist his father in his scientific investigations. As already indicated, the upbeat Rousseauian view of a "state of nature" in which "noble savages" lived peacefully and in harmony with nature put forth in *The Social Contract* was at the time opposed by the more pessimistic Hobbesian view that the "natural state" of man was a state of a war of all against all (Salmond, this volume). Krüger's chapter on the impressions of the younger Forster must be read against the backdrop of this tension between Rousseauian and Hobbesian views. The younger Forster would subscribe to neither view. Just seventeen years old when he embarked with his father on Cook's second voyage, Georg Forster concluded that Oceanic people were neither gentle creatures nor warlike barbarians (Krüger, this volume) but "a variety of the self" (ibid.), with many familiar characteristics.[3] Together with his father (Thomas 1996), Georg Forster supported a universalist view that envisioned humanity as unified in aptitude and potential, even though not all types or groups had actualized that potential and attained the culminating level of "civilization" (see also Jolly 2007: 516–510; note Ryan's [2004: 182–183 and 183: n. 97] disagreement with Thomas' interpretation of J. R. Forster's view).

These views of the Forsters partake of a much broader history of "race," a history that encompasses the history of European encounters in the Pacific and that has been chronicled most recently and extensively in Bronwen Douglas' exquisite contributions to *Foreign Bodies: Oceania and the Science of Race 1750–1940*. The term "race" emerged in early eighteenth-century Europe and became biologized in part through scientific voyaging in Oceania. Early speculations that climate determined skin color would eventually give way to the proposition that skin color reflected inherent biological differences. "Eighteenth-century discourses on man were often scurrilous about non-Christians, 'Negroes', and other nonwhites, and yet racial taxonomy was still embryonic while most savants allowed all human beings the innate capacity to become 'civilized'" (this volume). Race would become far less benign in the nineteenth century, as white skin color came to be seen as a sign of superiority, Europeans trumping all non-Caucasian races by virtue of their alleged natural endowments (see also Douglas 2008a; Tcherkézoff, this volume; Thomas 1997: ch. 5). "Encountering Agency" focuses upon a single voyage—the voyage of the *Coquille*, under the command of the Frenchman Louis Isidore Duperrey from 1822 to 1825—at sufficient temporal remove from Wallis', Bougainville's, and Cook's voyages to allow for a rethinking of the anthropological aspects of scientific voyaging. Indeed, the engravings published in the Atlas of the *Voyage of the Coquille* reduced Pacific Islanders to dehumanized racial types, contributing to the hardening European perception of biological differences among hierarchically ordered "races" (Douglas, this volume).

Dumont d'Urville was the first officer on the *Coquille*, and he would head up his own expedition to the Pacific several years later. Dumont d'Urville's major conclusion, expressed in a report he made to the French Société de Géographie in December 1831–

January 1832 (now translated into English [2003]), was that "all travelers, without exception" (Dumont d'Urville 2003: 164) to the Pacific Islands agreed that Islanders could be divided between "two separate races" (ibid.). One was "copper-skinned" (ibid.), had "more or less strong leaning towards civilized practices" (ibid.)—Hawai'i, Tonga, and Tahiti being the most advanced (ibid.: 166)—and "often organized into nations and sometimes powerful monarchies" (ibid.). The other, a "black race" (ibid.), "degraded and wretched" (ibid.: 170), was "organized into tribes or clans of varying size, but very seldom into nations" (ibid.), and whose various societies were in a relatively "barbaric state" (ibid.: 169; see also Douglas 2008b: 123–124; Tcherkézoff 2007; Thomas 1997: 144–151; Thomas 2002). The first and superior race claimed Polynesia, distinctive for its use of the sacralizing *tapu*, Micronesia, which lacked *tapu* but which was stratified like Polynesia, and Malaysia (see Tcherkézoff, this volume). The second and inferior race claimed Australia, New Caledonia, Vanuatu, and Fiji. Dumont d'Urville speculated that Polynesia and Micronesia originated from what is now called Southeast Asia, while Melanesians came from the Andaman Islands, Sri Lanka, or Madagascar (2003: 171–172). This taxonomy encapsulates the two positions scholars of the eighteenth and nineteenth (Euro-American) centuries distinguish: the one allowing that all human beings, regardless of skin color, are capable of achieving civilization, skin color demarcating mere "varieties" of humanity, and the other claiming that this capacity seizes up as skin pigmentation darkens. One could argue, as does Tcherkézoff (2003), that Dumont d'Urville's dualistic model marked a shift from an earlier period (1730–1790), when "the unity and uniqueness of humankind [over against animals] was asserted" (ibid.: 183) and "races" were "varieties" within an encompassing unity, and a later period, beginning in 1830, when the "human unity and its elevated position . . . was broken up and scattered along a 'zoological' axis bearing all living species, human and animal, with the unfortunate consequence that some 'savages' were regarded as being more animal than human" (ibid.; see also Tcherkézoff 2004: 31–104).

Dumont d'Urville's regional dyad of copper/black was ultimately elaborated as a global triad. The Polynesian-Micronesian-Malaysian race, "copper" or "yellow" in hue, originated in the central plateau of Asia, spreading thence to Oceania and across the Bering Strait to America (Dumont d'Urville 2003: 173). The Melanesian race originated in Africa and spread to the southern coastlines of Asia, the Indian Ocean, Malaysia, and Oceania (ibid.). The Caucasian race ("white or pinkish" [ibid.]) originated in the Caucasus (ibid.). The color spectrum marked a hierarchy of "intellectual capacities" (ibid.) and "moral qualities" (ibid.; see also Douglas 1999: 65), with whites at the apex, blacks at the bottom, and the yellow race falling in between (Dumont d'Urville 2003: 173).[4] The term "Melanesia," which Tcherkézoff credits Dumont d'Urville with inventing (this volume), marked the nadir of all known human variation within a naturalized and stratified racial taxonomy tied to specific geographical coordinates (see Tcherkézoff 2003: 182–187; Tcherkézoff 2007). Oceanic peoples thus assumed their respective positions within a pernicious zoology of physical variation, a zoology scientific voyaging in the Pacific helped shape (see also Douglas 2008b: 123–124).

Pacific Islander Agency

The exhibit Life in the Pacific of the 1700s displayed the artifacts Captain Cook collected on his second and third voyages, setting a Eurocentric tone for the symposium. Offsetting this tone is the effort in a number of essays in this volume to find evidence of subaltern lives and purposes in the sources. While Salmond is interested in the sexual fantasies and liaisons of British shipmen, for example, her account also suggests Tahitian efforts to mollify a perceived war god, to establish pacific exchange (*taio*) relations with volatile and dangerous strangers, and to trade "curiosities" and women for European goods. Such trade and the Islander objectives motivating it are crucial to the story that Hauser-Schäublin tells in her contribution to this volume of how the Cook/Forster Collection came to be in the first place (see also Salmond 2003; Thomas 1991: ch. 3).

Agency as much as race is the theme of Douglas' contribution. Her term "countersign" refers to "oblique traces of the imprint of local or subaltern agency on foreign or élite perceptions, reactions, and representations" (this volume, note 1), and she finds these traces in the written record of explorations (this volume) as well as in artwork (Douglas 1999: 73–83). The persistence of tattooing, despite missionary attempts to suppress it, provides one such countersign. The popularity of tattooing remained unabated among Tahitian males, and Tahitian chiefs' desire to be tattooed put the missionaries in the difficult position of either allowing it and breaking their own law or prohibiting it and offending the very leaders upon whom they relied for effective overrule (this volume; see also Douglas 2005). Similarly, Tahitian women exploited the cover of night to rendezvous with their French lovers, trysts that Tahitian males sometimes arranged despite the interdiction of interracial intercourse (cf. Stoler 2008 [1989]; Stoler and Cooper 1997: 24–29; Tcherkézoff 2008: 26, 106, 164–166; cf. Linnekin 1990a: 186; Sahlins 1981: 37–43 [but see Merry 2000: 242–244]; Tcherkézoff 2009; Wallace 2003: ch. 2).

While Douglas' methodology involves reading between the lines or against the grain of a narrative, evidence of Pacific Islander agency may be on the surface of European accounts. Jolly's "Beyond the Beach?" discusses two remarkable Islanders and their respective involvements with the British: Mai (aka Omai) and (the more important for present purposes) Tupaia (aka Tupaya, Tupia). Tupaia was a prominent *arioi* or servant of the "great war-god" 'Oro (Salmond 2003: 35; see also Salmond, this volume; Salmond 2010). Tupaia had his first brush with the British when the *Dolphin* arrived in Tahiti in 1767. Cook would bring him on board the *Endeavour* and use him as an indispensable go-between, greatly facilitating Cook's exploration of New Zealand—as a Maori speaker, for example. He was, as Jolly (this volume) puts it, "the valued guide and translator" on Cook's first voyage.[5] As importantly, Tupaia provided Cook with invaluable information about Pacific navigation (Dening 2004: 174–176; Jolly, this volume; Salmond 2003: 110–111; Thomas 1997: 1–4; Turnbull 1998; Turnbull 2004: 64–72), information that no doubt stemmed from his own experience as a navigator-priest in the cult of the war god 'Oro. He was credited with having brought the cult of 'Oro from Ra'iatea (lying 340 miles northwest of Tahiti [see Turnbull 1998]) to Tahiti

(ibid.: 38–39; Dening 2004: 171–172; Salmond 2003: 38–39).[6] To the extent that the voyages of discovery were world-historical in import, exciting "European imaginations, stimulating missionary drives, kindling commercial aspirations and whetting imperial appetites" (Ballantyne 2004: xviii), Tupaia was a world-historical actor.

Beyond Encounter: Toward "Oceanic History"?

In his epilogue to *Remembrance of Pacific Pasts* (edited by Robert Borofsky 2000), Epeli Hauʻofa makes the point Dening made in *Beach Crossings* (see Hanlon, this volume): that "first contact" is not the "ground zero" of Pacific Island history, the prelude to which is aptly described as "prehistory" (2000: 454–455), that there is an Oceanic history, or histories, to which Pacific Islanders themselves and not Europeans are central. This history chronicles the interactions of islands—interisland exchanges, marriages, warfare, peacemaking, and overseas voyaging in general (Hauʻofa 1994)—and utilizes oral traditions and oral histories in producing "legitimate histories apart from mainline [European, Eurocentric] history" (Hauʻofa 2000: 458; see also Falgout, Poyer, and Carucci 2008; White 1991b; White and Lindstrom 1989; Waiko 1986, 1991). In this light, the Pacific must be understood in *transinsular* terms: not as an aggregate of "*islands* of history" (Sahlins' trope [1985]) but as an *ocean* of history,[7] to which the voyages of Captain Cook and others constitute mere footnotes. Oceanic history could in fact be said to mediate Age of Discovery voyaging. Tupaia's famous map, summarizing geographical information he presumably gained in his own extensive travels as an *arioi* or priest-navigator for the god ʻOro but guiding Cook on his first voyage, is a prime example of such mediations. Similarly, as Salmond (2003: 38) shows, the reception of Wallis' *Dolphin* or Cook's *Endeavour* was "shaped" by the maritime practice of long-distance journeys and intercultural articulations if not the alliances that were already in place. *Taio* ceremonial friendships no doubt created and maintained interisland linkages in true Maussian fashion (1967), a social organizational stratagem that received novel application in the "first contact" moments of the Age of Discovery. A history centered on Pacific Island voyaging, with its technologies and knowledges, would be a source of regional pride (see Feinberg 1988; Finney 1976, 1979, 2003; Howe 2007, 2008), a way "of attaining and maintaining cultural autonomy and resisting the continuing encroachments on and domination of our lives by global forces" (Hauʻofa 2000: 456).

To clear a space for Oceanic history, Hauʻofa (ibid.: 458) calls for a laying to rest of the ghost of Captain Cook, a condition that the symposium, convened against the backdrop of an exhibit of the artifacts Cook collected on his second and third voyages into the Pacific, obviously could not meet. Nevertheless, the arguments of two symposium contributions strongly resonate with Hauʻofa's call for a non-Eurocentric history of the Pacific Islands. In her contribution to this volume, Margaret Jolly asks a key question: Why is it that we emphasize the boundary (or, in Dening's well-known metaphor, the beach [1980; Pratt's "contact zone" (1992)]) between Islanders and Europeans, ignoring the "parallel histories, other beach crossings, encounters *between* Islanders" (Jolly, this volume) that are as pertinent to the history of the Pacific Islands, if not more so (see also Jolly 2007: 514–515)?

As if in response, David Hanlon's "Histories of the Before" uses two famous Pacific archaeological sites, Lelu on Kosrae and Nan Madol on Pohnpei, generally considered high cultural achievements, to argue for the importance in Pacific Island history of *precontact regional* limens. Against the view expressed by the British anthropologist F. W. Christian that the ruins of Nan Madol and Lelu are attributable to the ingenuity of Japanese immigrants, Hanlon argues (on the basis of the work of the archaeologist Ross Cordy) that the two sites are evidence of an indigenous ingenuity—in fact, of the way these two islands influenced each other. Instead of being vestiges of a prior, glorious age in which foreign populations elevated Kosrae and Pohnpei, albeit momentarily, Lelu and Nan Madol bear witness to the impact of a *regional* circulation of ideas and technologies through the sporadic historical contact of the two islands.

A third contribution approaches the possibility of a Pacific Island–centered history from a different direction, through an exploration of indigenous notions of time, a topic Hauʻofa also broaches (picking up on the dissertation of a fellow Tongan scholar, ʻOkusitino Mahina [1992]) (2000: 459–461). In this volume, Lamont Lindstrom argues that for the Tannese of Vanuatu, time is inseparable from space. "Now is at the center; future or past are off to the side" (this volume). (Alternatively, in Fiji and Tonga, the future is "behind" while the past is "in the front" [Hauʻofa 2000: 459–460].) This practice of spatializing time renders it static or "static-cyclical" (Lindstrom, this volume), precluding a notion of historical time in the Euro-American sense (cf. Falgout, Poyer, and Carruci 2008: 20–22; Gell 1992). Even the events of the last 235 years, beginning with the first-contact event of Captain Cook's arrival at the place he would name Port Resolution after his ship *Resolution*, are stripped of their temporality by virtue of their association with place and its stasis. Lindstrom's subtle analysis of Tannese notions of time and space suggests how critical a hermeneutic of time, or time-space, is to the writing of Oceanic history, a history that is ideally informed by the perspectives and rhythms of Pacific Islanders themselves.

Memory and Invention

The word "history" has at least two referents: actual past events and their recollection. Wolfgang Kempf's "Social Mimesis, Commemoration, and Ethnic Performance" treats the difficult but important topic of the politics of history in this second sense. In 1945, Banabans left Banaba (or Ocean) Island, their homeland in Micronesia, and resettled on Rabi Island in the Fijian archipelago. To what use do diasporic Banabans put their past? As elsewhere (2004), Kempf answers this question with an analysis of performances of the Banaban Dancing Group, a group that formed in anticipation of the first South Pacific Festival of Arts in Suva in 1972. The highlights of the Suva performance were the revived war dance *Te Karanga* and the dance-theater play *Kunean te Ran* (The finding of water), which was based on an old Banaban legend (ibid.: 166). The dance and the play were deployed strategically to secure compensation for the effects of phosphate mining on Banaban Island and to establish their distinctiveness from Gilbert Islanders, the ethnic majority of I-Kiribati, into which Banaba Island was absorbed in 1979.

In the 1997 performance of the Banaban Dancing Group Kempf studies in his

contribution to this volume, the goals were different. Designed to commemorate the resettlement of Banabans in Fiji, the performance implicitly asserted autonomy from, but also affiliation with, ethnic Fijians, Fiji's ethnic majority (see also Kelly, this volume). The set piece of greatest significance in this 1997 performance was *Rokon te Aro* (Arrival of Christianity), which depicted the conversion of Banabans to Christianity at the end of the nineteenth century. Ethnic Fijians are Christian, and the subtext of the story about Banaban conversion to Christianity was the kinship Banabans enjoyed with ethnic Fijians through their shared religion. Yet Banabans narrated the conversion in such a way as to blur the boundary between Christianity and Banaban indigenous religion, making Banaban Christianity a marker of ethnic difference. As *Christians,* Banabans were similar to ethnic Fijians, but as *Banaban* Christians, they were distinctive from ethnic Fijians.

Kempf's sensitivity to the politics of the performances of the Banaban Dancing Group is reminiscent of an extensive Oceanic literature on the cultural politics of tradition. The literature has proven tendentious, provoking sharp debate among anthropologists and between white anthropologists and Pacific Islander scholars and activists. Kempf's contribution is implicitly in conversation with that literature, a point to which I will soon return. I begin, though, with an all-too-brief review of this literature.

For the Pacific Islands, the foundational text remains Roger Keesing and Robert Tonkinson's anthology *Reinventing Traditional Culture: The Politics of Kastom in Island Melanesia,* which was published as a special issue of *Mankind* in 1982. In this anthology, the word "reinvention" was applied to top-down nation-building efforts to impose a generic, impressionistic cultural uniformity upon disparate societies within the emerging postcolonial states of island Melanesia (Keesing 1982; Tonkinson 1982a, 1982b), especially in Vanuatu and the Solomon Islands. Foisting a contrived uniformity upon culturally diverse populations met with an entirely expectable resistance from below, a phenomenon that the several contributions to the collection chronicle (see, for example, Lindstrom 1982).

Eric Hobsbawm and Terence Ranger's edited collection appeared a year later (1983) and gave us the phrase we have been discussing ever since: not the reinvention but the "*invention* of tradition" (emphasis added). Whereas Keesing and Tonkinson were interested in postcolonial nationalism and the secessionist sentiment it fomented, Hobsbawm and Ranger focused more on colonial strategies of incorporation in times of imperial expansion using European and African materials. What, then, did Hobsbawm and Ranger mean by the term "invention of tradition"? In his introduction to *The Invention of Tradition,* Hobsbawm characterized tradition as invariant and connected with the past. But he noted that not all tradition is actually connected to the past; some tradition is invented. *Invented* traditions "attempt to establish continuity with a suitable historic past" (ibid.: 1), but this continuity is "largely factitious" (ibid.: 2). For all the appearance of continuity with a past, invented traditions constitute a break with the past: "they are responses to novel situations which take the form of reference to old situations" (ibid.). They are, then, faux ("inauthentic" [Jolly 1991]) traditions.

Over against tradition, invented or not, Hobsbawm placed "custom," which "dom-

inates so-called 'traditional' societies" (1983: 2) and which is both dynamic *and* precedented. If tradition is (at least notionally) static, "custom does not preclude innovation and change up to a point, though evidently the requirement that it must appear compatible or even identical with precedent imposes substantial limitations on it. What it does is to give any desired change (or resistance to innovation) the sanction of precedent" (ibid.).[8]

Although continuity with the past is what distinguishes Hobsbawm's "custom" from his "invented tradition," significant discontinuity is not always required by inventionists, the term I will here use to signify those inspired by Hobsbawm and Ranger's book.[9] Jocelyn Linnekin (1990b, 1992), whose writings have been crucial to the articulation of an inventionist stance in Pacific Island research, asserts, for example: "However creative, representations of collective identity are never invented in the sense of fictions created ex nihilo. There is always a prior collective context of cultural meanings and significance" (Linnekin 2004: 246). She continues: "I know of no writer in the symbolic constructionist [that is, inventionist; see note 9] vein who has argued otherwise" (ibid.). That being the case—and given the controversial nature of the term (Hanson 1991; Jolly and Thomas 1992: 242–243)—do we need the category "invention of tradition" at all?[10] After all, tradition is always invented—how else could it come into existence?—and is thus inherently historical. Any reinvention, change, or transformation partakes of the same historicity that summoned tradition (or the anthropologist's culture [Wagner 1981]) into existence in the first place.

In all the hoopla about "invention of tradition," Hobsbawm's second category, "custom"—rooted but dynamic, precedented but responsive to "changing contexts" (see Hermann's introduction)—has received little explicit attention. Might not "custom" serve as a term of compromise and moderation, one that directs us toward rejecting *both* the "primordialist" position (Linnekin 1990b), premising an essentialized, changeless culture, *and* the inventionist position, which has too often been understood to maintain (disclaimers notwithstanding) that the past is opportunistically fabricated and that history enters into the equation only in the contemporary period, as the global impinges upon the local? In the extreme, the inventionist position denies difference (cf. Dirks 1996: 39), undermining the human rights and sovereignty claims of indigenous peoples.[11] The variability and flexibility of Hobsbawm's "custom" accords it the historicity that immutable "tradition" lacks and renders it the better descriptor of practices that are precedented but *not fixed* for all time, practices that are then *doubly* motivated, by *both* the past *and* the present, convention *and* circumstance (see Jolly 2000; Tonkinson 2000).

Kempf's essay "The Drama of Death as Narrative of Survival" (2004) provides a perfect example of what I mean. The centerpiece of the 1972 Suva performance Kempf features in this article is the war dance *Te Karanga*. The dance was described in 1910 in *Blackwood's Magazine* (ibid.: 165–166) and in 1932 by anthropologists who judged the dance to be "authentic Banaban tradition" (quoted from Maude and Maude 1932: 287, in ibid.: 165). In the 1972 Suva performance, the dance was coupled with the play *Kunean te Ran,* which was based on "surviving textual sources on Rabi Island, as

well as from memories of how performances were staged in the post-war era" (Kempf 2004: 166). The dance and the play were both precedented, therefore. But in being remembered and re-enacted in a particular moment, the performance articulated with the present no less than with the past. Precedented, it was *also* recontextualized. *It accommodated circumstances but without being reducible to them* (see also Thomas 2002). In short, the 1972 Suva performance involved "actively self-shaped reconstructions of an authentic tradition" (Kempf 2004: 166). Clearly the term *invented tradition* would be inappropriate, and Kempf, whose analysis allows for the double impact of precedence *and* situation, makes no use of it.

Similarly for van Meijl's interesting discussion of how Maori culture is transposed from rural to urban settings. Writing very much in the aftermath of the altercation between Alan Hanson and his New Zealand interlocutors (see Hanson 1989, 1991; see also Linnekin 1991a; see note 10), van Meijl examines how urban Maoris use analogies to articulate with the past even as they accommodate change. Urban gang members may refer to themselves as *iwi* or "tribe" and their "pad" as a *marae* or tribal ceremonial ground, and they may embrace the ethos of *aroha* or "love" in affirmation of Maori lifeways, implicitly denigrating those of the white, Pakeha majority of New Zealand. By the same token, Maori tradition (custom, culture) persists in modernized form, as a renovation of a past that is *ipso facto* a "*living* tradition" (Sahlins 1999: 409, emphasis added), not a relic of the past but vibrantly responsive to the challenges of contemporary life. Pakeha may prefer the illusion of a monocultural society. Yet it is in the interest of Maoris to promote biculturalism (see discussion in Hanson 1991), countering Pakeha assimilationism with an assertion of irreconcilable difference. The Maori project is fundamentally "countercolonial" (van Meijl, this volume; see also Keesing 1982; Tonkinson 1982a, 1982b), but it also references the precontact past: "we are not dealing with inventions or reinventions of lost traditions" (van Meijl, this volume), "but with *continuously* changing traditions" (ibid., emphasis added), traditions that are being made relevant to an urbanized and colonial present. In this understanding, tradition is inventive rather than invented (Sahlins 1999: 408), a matter of modifying "older forms and relationships" (ibid.: 408–409) to accommodate or respond to changing circumstances—a matter of *persisting through change*.

Relevant to this discussion is the remarkable paper Amy Kuʻuleialoha Stillman gave at the symposium, "Changing Contexts—Shifting Meanings." "Modern Hula: A Crucible of Hawaiian Tradition" argues that the modern hula, including hula performed for tourists, constitute the repository of hula tradition. Traditional hula dances and songs oscillate between *leʻa* and *nanea*, an ebb and flow that now excites, now soothes, listeners. The aesthetic of *leʻa* and *nanea* did not disappear; rather, it was incorporated into modern hula, enabling (by virtue of a veneer of Westernization) the perpetuation of ancient hula. Stillman closes by noting ironically that the greatest threat to the preservation of hula traditions has been the effort since the 1970s to revive what are believed to be more authentic hula forms and the concomitant disavowal of modern hula, which, according to Stillman, is the actual repository of an ancient aesthetic logic. As with Trobriand cricket (Kildea and Leach 1979), a deft response to missionary efforts to

suppress aspects of Trobriand culture, the appearance of Westernization serves to camouflage cultural continuities, shielding difference against its detractors (see also Sahlins 1994: 381–384).

The final essay to be discussed in this cluster is Ton Otto's "Inventing Traditions and Remembering the Past in Manus." Together with his coauthor Poul Pedersen, Ton Otto (2000, 2005) has written some of the most nuanced recent discussions of the inventionist literature, and his contribution to this volume is no exception. Here Otto focuses on *kastam* ("custom") and *kastamwok* ("the work of custom"), referring to ceremonial exchanges organized on the occasions of birth, marriage, and death. These exchanges are "relatively recent" (Otto, this volume), about sixty years old. *Kastam* and *kastamwok* depart from the practices of the more distant past, which according to Otto did not invoke antiquity for their legitimation. Why, then, do *kastam* and *kastamwok* appeal to the past for their legitimation? Otto answers: to render that which is Baluan antiquarian, setting it off from "modern politics and church organizations" (ibid.). *Kastam* and *kastamwok* are thus shown to be oppositional and presentist rather than traditional in their nature. While Otto concludes that *kastam* and *kastamwok* conform to Hobsbawm's "invented traditions" in invoking "an explicit link with a specific past, even though this link often is more imagined than real" (ibid.), he does state that "there are important cultural continuities in the exchanges that go on and in the kind of sociality they [*kastam* and *kastamwok*] establish" (ibid.), posing once again the question of whether custom (in Hobsbawm's sense of that word) is not the better analytical category.

Globalization

The contributions just discussed are symptomatic of the fact that the Pacific is no longer a "sea of islands" linked through voyaging (Hauʻofa 1994) but the site of significant globalization, whether globalization takes the form of colonialism and missionization, the development of postcolonial nations, or the penetration of capitalist industries and markets. The contributions of van Meijl and Otto constitute somewhat contrasting meditations on the history of culture in globalizing contexts.

Several other contributions concern the effects of globalization in the late twentieth and early twenty-first centuries. Globalization is most obviously the backdrop for van der Grijp's "Contemporary Tongan Artists and the Reshaping of Oceanic Identity" and Lewis-Harris' "Producing Inalienable Objects in a Global Market." Van der Grijp discusses a handful of living Tongan artists, all of whom rely to one degree or another on international markets for their living. Three have attended conferences, given courses, and sold and/or exhibited elsewhere in the Pacific. A fourth spent two years living in New Zealand and has Mormon adoptive parents in the United States, although he prefers to live in Tonga.

In "Producing Inalienable Objects in a Global Market," Lewis-Harris examines the exchange activities of Solien Besena, a people who migrated from the south coast of Papua New Guinea to eastern Australia. A minority in both PNG and Australia, Solien Besena have "aggressively" promoted their culture and achieved recognition in Bris-

bane and Sydney "for their exemplary cultural development work" (Lewis-Harris, this volume), and it is upon this exemplary work and the transactions undergirding it that Lewis-Harris focuses. In brief, Solien Besena dance groups use the objects they buy to decorate the costumes they wear, gifting relatives with these costumes. As with all Pacific Island diasporic groups, then, Solien Besena participate in two different economies, the one a "commodity economy" and the other a "gift economy" (Gregory 1982; see also Appadurai 1986; Thomas 1991). Lewis-Harris takes this one step further, showing that diasporic Solien Besena convert commodities into gifts, buying desired commodities abroad so that they might gift relatives when they return home, a practice pursued in other Pacific Island diasporas as well (see, for example, Small 1997).

Miriam Kahn's "Moving onto the Stage" adds another chapter to Anne Salmond's tale of European fascination with Tahiti. Shocked by the "erotic qualities" (Kahn, this volume) of Tahitian dance, the missionaries banned it in the 1820s (although Tahitian dance "continued to quietly flourish" [ibid.; cf. Stillman 2006]). Ironically, the "erotic qualities" that caused the missionaries to ban Tahitian dance inspire the Tahitian Office of Tourism to promote it as "*the* cultural icon" (Kahn, this volume). Mass tourism did not develop until the 1960s, when Tahitian dance was being revived and France, now interested in French Polynesia for nuclear testing purposes, built an international airport. With France's new interest in Tahiti, Tahiti experienced rapid monetization. The development of mass tourism and the promotion of a newly revived dance tradition were related aspects of that transformation. In the touristic context, Tahitian dance has "evolved from a culturally meaningful, and passionately practiced, local pursuit—which it continues to be for Tahitians—to an internationally performed, commercial spectacle that involves innovative, dazzling elements, often borrowed and recontextualized to create photogenic appeal and to signify 'Tahiti' to outsiders . . ." (ibid.). Through the eye of the camera, "Tahiti" is discursively *re*constructed as a tropical paradise and put into global circulation, recent developments resonating with the eighteenth-century developments upon which Salmond's contribution dwells.

Martha Kaplan's "Alienation and Appropriation" also resonates with Salmond's contribution. In the eighteenth century, visitors to the Pacific Islands such as Bougainville tended to see in them the mythic space of a paradise or Garden of Eden, as a place where Rousseau's "noble savage," living close to and in harmony with nature, dwelled (see also Krüger, this volume; Salmond 2003: 53). Centuries later, Fijian water is marketed as "Untouched by Man." The fantasy here is perhaps not unlike the fantasies of eighteenth-century explorers and their seamen: a fantasy of being liberated from civilization and its many malaises. The promotional material for the Fijian water goes on to note that Fiji is spatially remote, 1,500 miles away "from the nearest continent" (this volume), in a "virgin ecosystem" with "one of the purest waters in the world" (ibid.). Indeed, the waters of Fiji are arguably not of this world at all but, rather, extra- and infraterrestrial: rainwater that has been filtered naturally "deep beneath volcanic highlands" (ibid.). And so Kaplan's explanation of the demand for Fijian water: In appropriating Fijian water, American consumers appropriate the indigenous, which is to say pristine nature, much as they appropriate the indigenous in consuming the indigenous

bird, the turkey, at Thanksgiving. Kaplan's contribution is a surprising confirmation of Salmond's thesis that if "mythopraxis" is anywhere, it is everywhere, at home as well as abroad.

John Kelly tells yet another story of Fiji and globalization, one concerning the relationship between ethnic Fijians and the descendants of those South Asians who were brought to Fiji in the late nineteenth and early twentieth centuries as indentured plantation workers (Denoon 1997a: 230) and who today constitute a minority in a postcolonial nation-state dominated by ethnic Fijians. Kelly is interested in the "dialogics" of this relationship, which turn on the contrast between a masculinized *mana* (roughly "power") on the ethnic Fijian side and a feminized *shanti* (roughly "peace") on the Indo-Fijian side. In true Batesonian (1958) schismogenic fashion, these values are played out in a recurring struggle between "coups and boycotts" (Kelly, this volume), coups being the "primary modality of the politics" (this volume) of *mana* and boycotts being the principal expression of *shanti*. Only the entire history of British colonialism and the development of a plantation system in Fiji can account for these dynamics, the pernicious legacy of Fijian globalization.

Douaire-Marsaudon's "Justice in Wallis-'Uvea" also concerns the legacy of colonialism and its dynamics on Wallis-'Uvea. When a woman named Kalomaka stole money from a woman's association, the association attempted to prosecute her through French law. Undaunted, Kalomaka defended herself through customary law. This conundrum of French law versus customary law divides communities and allows no easy resolution. All other things being equal, a decision based on customary law would garner the support of chiefs and the church, while agents of the state, specifically the prefect and the attorney general, would accept a decision based on French common law. The legal situation Douaire-Marsaudon describes exists at the juncture of two contradictory systems, the one Pacific and the other European, the precarious by-product of globalization.

Toward a History of Globalization

The collection eschews historical anthropology's earlier focus on structure and event or structure and action, developed under Sahlins as "structural history" (1981, 1985 [intro. and ch. 5 especially], 1991; see also Sahlins 2000b) and under Ortner as "practice theory" (1989) (see also Sewell 2005). The task at hand was to understand events as "a *relation* between a happening and a structure (or structures)" (Sahlins 1985: xiv). In and of themselves, happenings lack significance. They acquire significance semiotically, through a system of categories or meanings. In classifying Cook as Lono, the god of peace and fertility, as Sahlins maintains Hawaiians did (1981: ch. 1; 1985: ch. 5 especially; 1995), Cook acquired the significance the Lono category conferred upon him. Thus his arrival was no longer a happening but an *event*, a unit within what is always already a cultural (or structural) history. While several chapters dwell upon moments of first contact, their preoccupation is not with the interplay of structure and action but with European constructions of Pacific Islanders, Said's *Orientalism* serving as the tacit muse. Have we entered a new era of Pacific Island historical anthropology, then, an era inaugurated in part by Obeyesekere's *The Apotheosis of Captain Cook* (1992/1997),

which took Sahlins to task on the grounds that his argument about the deification of Cook smacked of neocolonial arrogance (see Borofsky 1997; cf. Obeyesekere 2005)?

The answer, I would hope, is both yes and no.

Yes, there is no doubt that the topic of "race" has been extremely productive in today's Pacific Island historiography, as the several contributions devoted to it demonstrate. It is also arguably *the* postcolonial topic of choice (see Gates Jr. 1985). In interrogating the racial categories of European explorers, colonial administrators, missionaries, and settlers, scholars interrogate the colonial project itself (see especially Thomas 1994), enabling the postcolonial critique of colonialism. Narratives of "race" are necessarily Eurocentric (since "race" is a European construct, motivated by the desire to subordinate the darker-skinned to white overrule), however, limiting the contribution they make to our understanding of the complexities of Pacific Island history in an era of globalization. Indeed, the Eurocentric nature of white Pacific Island historiography has been one of the thorns in the sides of native scholars, determined as they are to narrate history on their own terms and from their own perspectives (Hauʻofa 2000; Kameʻeleihiwa 1992; Silva 2004; L. Smith 2005; and Trask 1999, to name some).

The inventionist argument that indirectly "the peoples and cultures of Oceania are inventions of imperialism," as Hauʻofa has put it (2000: 456), has provoked Pacific Islanders to write a Pacific history that is at once recuperative (relying on oral and other vernacular sources [Silva 2004; Stillman 2002, among others]) and critical of white historiography. Postcolonialist critiques of the orientalist and racist strands within this historiography are clearly important, but it is also important (lest the inventionist argument stand) to tease out the ways Pacific Island cultures have persisted (albeit to varying degrees) despite the cultural disruptions of the last two centuries. While first contact was not the "ground zero" of Pacific Island history (Dening 2004; Hanlon, this volume; Hauʻofa 2000), it *was* the ground zero of globalization in the sense of articulations and circulations between North and South, Euro-America and the rest (Inda and Rosaldo 2008), and the changes that would ensue (see Hermann's introduction).[12] Life in the Pacific of the 1700s, the exhibit that served as the backdrop for the symposium, was the by-product of such articulations and circulations. On display were objects collected by Cook and the Forsters and transferred to the University of Göttingen, all in the "northern" eighteenth century, but exhibited in 2006 in a sector of "Polynesia" that now falls within the bounds of the United States of America and whose time and calendar are similarly "northern." The "social life" of these things (Appadurai 1986), from valuable to "artificial curiosity" (Kaeppler 1978) and from object of the northern scientific gaze to ephemerally repatriated valuable—this social life is a *globalized* social life, one beginning with Euro-American exploration and scientific voyaging and culminating in gestures of decolonization. This volume provides glimpses into the kind of history that is required, one that is cognizant and critical of the orientalist dimensions of those articulations and circulations, but one that also examines the process of globalization as a *cultural* process, a cultural process that leaves in its wake (for example) Hawaiians who are capable of demanding the repatriation of exhibited objects and a voice in the narration of any exhibition of Pacific Island artifacts (Andrade 2007: 342; cf. Kahn 2000b).

In this regard, the effort of the structure and event literature—to show culture in motion over a history of exogenous influences the impact of which, even when devastating, is *not* "fatal"—bears revisiting. The history I have in mind welds the deconstructions and critiques of the literature on Euro-American imaginings of the Pacific Islands from first contact onward to a postinventionist methodology of deploying ethnographic insights to ferret out the history of difference over the course of those North-South articulations, entanglements, intertwinings, exchanges, and mutual influences that go by the name of globalization (see Gewertz and Errington 1991; Hermann's introduction). Identity is one place to start (e.g., White 1991a; Besnier 1994; Mageo 1992, 1996; Wallace 2003 on the history of Polynesian sex/gender identities), but there are obvious societal level transformations and their consequences—transformations and consequences that words such as *colonial* and *postcolonial* direct us toward—that require theorization.

What lessons, then, have we learned from the contributions to this volume about the history of globalization in the Pacific Islands?

1. It is a history of conjunctures in which two or more cultures, semantic fields, projects, and historicities meet, intertwine, engage, and exchange. Whatever the power differential, the complexity of the interaction can only be captured through what Thomas has called "double vision" (1999) and with respect to which Dening's own *Islands and Beaches* and Salmond's *Two Worlds* serve as early exemplars. To understand the impact of society A, we must understand society B, and vice versa. Eurocentric narratives are necessarily partial (Thomas 1997: ch. 1), blind in one eye, as it were. To surpass the provinciality (Chakrabarty 2007) of Eurocentric narratives, as so many Pacific Islander scholars have argued (Hauʻofa 2000; Kameʻeleihiwa 1992; Silva 2004; L. Smith 2005; Trask 1991, 1999), indigenous perspectives must be brought to bear. But a history of globalization must go further, toward a history, or histories, of complex encounters, rooted in the logics and practices of both Euro-Americans and Pacific Islanders as these engage, understanding and misunderstanding (see Tcherkézoff 2008) each other.
2. Double vision requires that we know the actors, their consciousness, goals, contexts, and strategies. Identifying and understanding Islander agency is crucial, a matter Douglas tackles directly in her contribution to this volume. But a history narrated under the sign of encounter requires equal mastery of the consciousness, agency, contexts, and strategies of Euro-American actors. Without being Eurocentric, the history of globalization in the Pacific Islands must understand Euro-Americans and not just Pacific Islanders. It must understand each in the presence of the other, through their interactions and the by-products of these (Biersack 2005, Foster 2005).
3. In this history of globalization in the Pacific Islands, mythopraxis operates on both sides of the global threshold (Salmond, this volume; Tcherkézoff 2004, 2008). There is never just a single "romance," to use Martha Kaplan's term. Each party to globalized interaction conjures the other in terms that are meaningful to

themselves, however wide of the mark they actually are. That Islanders mythologized and divinized Euro-Americans is well documented (Sahlins 1981, 1985, 1995; see Salmond 2003: 383, 394–408; Tcherkézoff 2008: 5–6, 113–116, 127–128; Thomas 2003: 442–444; see Valeri 1985b: 31–36 on Hawaiian notions of *akua* or the "gods"; see rebuttal of Sahlins in Obeyesekere 1992/1997) and is documented again in Salmond's contribution to this volume, which argues that Wallis and his seamen were understood to be priest-navigators of the war god 'Oro and treated accordingly. But the volume also demonstrates the persisting mythopraxis of Europeans. Tahiti is paradise, a Garden of Eden where the "noble savage" lives. Bottled Fijian water is "Untouched by Man." Understanding the dialogues or conversations, however broken, that unfold across a global threshold requires a complex hermeneutics.

4. An important debate within globalization theory concerns globalization's outcome. Are differences eliminated—is globalization tantamount to Americanization or McDonaldization?—or do differences proliferate through the "alchemy" (Fox and Starn 1997: 10) of "intercultural" (Merlan 2005) processes—Christianity becoming Banaban Christianity (Kempf, this volume), for example? Appadurai has suggested that globalization is best thought of in terms of this "tension between cultural homogenization and cultural heterogenization" (Appadurai 1996: 2). Debates spurred by Hobsbawm's "invention of tradition" ultimately concern this debate. If the "invention of tradition" is an "inversion of tradition" (Thomas 1992), difference is merely a reflex of the hegemony of Euro-America—homogeneity by other means (see comments in Thomas 1997: 12–13). If, instead, tradition is "living" (Sahlins 1999: 409), rooted in the past but responsive to the present, the process of globalization conserves a flexible, residual, and ineradicable difference, alterity. In this context, the question of change and how it is to be theorized (Hermann, this volume) becomes paramount. There is no contribution that argues that this history is one of unequivocal rupture. There are discontinuities, but there are also continuities. In analyzing change, the task at hand, then, is to understand the relationship between the two. Toon van Meijl's "analogy," Kempf's "mimesis," and Kelly's "dialogical" approach to intrasocietal, schizmogenetic tensions all provide conceptual tools for capturing this relationship. So do the Comaroffs' emphasis upon the "dialectics" of colonialism (1991, 1997) and Sahlins' notion of a "structure of the conjuncture" (1981, 1985, 1991, 1992).[13]

5. While a history of Europe is not the main goal of this history, this history is as foundational to the history of the greater Europe (including America) as it is to Pacific Islanders. The chapters on the early history of colonialism in the Pacific suggest what has been suggested more generally: that colonialism is a two-way street, involving reciprocal impacts, metropole upon colony but colony upon metropole (John and Jean Comaroff 1997: 22; Stoler 1995; Stoler and Cooper 1997: 1; Wallace 2003). Experience in the Pacific was foundational to European self-fashioning, establishing for all times, it would seem, a racial hierarchy

that favored whiteness. As Bronwen Douglas has written, "the flow of empirical data back to the metropole, especially from the Pacific, contributed significantly to the decline of neoclassical idealism in art and science—including a nascent anthropology—presaging the triumph of romantic sensibility in art and literature, the 'biologization' of the human sciences, and, eventually, an evolutionist cosmology" (Douglas 1999: 69).

6. Scientific explorations into the Pacific took as their ambition (as Johann Forster put the matter) the study of "the Earth, the Sea, the Air, the Organic and Animated Creation, and more particularly that class of Beings to which we ourselves belong" (quoted from Forster's *Observations*, p. 11, in B. Smith 1985: 7), "nature to its greatest extent" (ibid.; see also Salmond 1991: 114). Life in the Pacific of the 1700s, the exhibit that framed the symposium out of which this collection emerged, provided tangible evidence that the "science of man" was among the sciences stimulated by eighteenth-century scientific voyaging. The exhibit came to us from the University of Göttingen, where the German comparative anatomist Johann Friedrich Blumenbach started the museum that would eventually attract the artifacts on display in the exhibit (Hauser-Schäublin, this volume; see also Hauser-Schäublin 1998; Little 2006; Urban 1998b). In a carefully substantiated history of the race concept, Douglas designates Blumenbach "a pivotal figure" (2008a: 37) in the fatal shift from a notion of human variation as "externally induced" (ibid.: 33)—by climate, for example—to a "science of race that reified human difference as permanent, hereditary, and innately somatic" (ibid.; see also Douglas 2008b: 106–109, 110). The museum Blumenbach started at Göttingen was "the first-known ethnographic museum in the world" (Little 2006), and it was at Göttingen that the terms *Völkerkunde*, "ethnology" or "anthropology," and *Ethnographie*, "ethnography," were coined (Hauser-Schäublin, this volume). Ethnology can hardly be disentangled from the racialized worldviews that emerged alongside it, especially given the exotic nature of the information that fed its imagination (see Ballard 2008). This point has been made most forcefully in critiques of the categories Melanesia and Polynesia, which originated in the racialized schemes of Dumont d'Urville and others (Tcherkézoff 2003) and which, in the hands of some anthropologists, have been stratified in cultural evolutionary terms, Polynesia marking a pinnacle of achievement in the Pacific and Melanesia representing a more primitive stage of a Pacific evolutionary trajectory (see Jolly 2007: 521; Tcherkézoff 2004: 31–104; 2007, this volume; Thomas 1997: 133–155). Anthropology must be placed under suspicion as a result (cf. Ballard 2008: 341–342; Douglas 2008a: 3; Tcherkézoff 2001; 2007: ch. 11; 2009; this volume [on Blanchard's 1854 treatise]; see also note 5).

7. Double vision requires collaboration. The exhibit and the symposium were mounted at a time when Euro-American ethnographic and historical authority was under attack (see Clifford 1988 for an early contribution to these discussions). Double vision requires a democratic, "decolonized" methodology—real

(and not just token) collaboration (fraught with difficulty as that might be; see Kahn 2000b). The deconstructive bent of several of the contributions as well as recent publications by white scholars seeking to expose the racism and the misunderstandings (van der Grijp 1994 and Tcherkézoff 2008, among others) in Euro-American representations of Pacific Islanders suggests that now is the time for a vigorous, productive dialogue between Pacific Islander and other scholars.

8. Finally, there is the issue of heritage and its ownership. The exhibit brought the five hundred items of Göttingen's Cook/Forster Collection back to the Pacific (Little 2006), if only momentarily. Karen Nero's chapter concerns the repatriation of artifacts—in this case, artifacts collected in the 1780s and 1790s in Belau. While these artifacts remain in the British Museum, they also exist in the virtual space of the three-dimensional projection of the Belau National Museum. More than the momentary repatriation of artifacts collected in the eighteenth century by Cook and the Forsters, more even than the virtual repatriation of artifacts collected in Belau around the same time, the actual repatriation of artifacts would help close the circle in the history of globalization the symposium ultimately addressed. Artifacts displayed in museums are emblematic of the knowledge, or knowledges, that such museums represent; unrepatriated artifacts signify persisting inequalities between the knower and the known, those who inscribe and those who are inscribed, inequalities of representation (Clifford 1988; Marcus and Fischer 1986; Said 1978, 1989). The history of globalization that begins with Enlightenment-inspired scientific voyaging can only end, or be redirected, once authority and the power to know, or represent, ceases to be a Euro-American monopoly.

Notes

1. According to the eminent Pacific anthropologist-historian and museum curator Adrienne Kaeppler, the Göttingen Cook/Forster Collection comprises one-quarter of all ethnographic items acquired on Cook's voyages that are presently in museum collections around the world (1998: 8) and is second in importance only to the subcollection housed in the Pitt Rivers Museum in Oxford.

2. In the lengthy account of the arrival of the *Dolphin* that Anne Salmond provides in *The Trial of the Cannibal Dog*, we learn that the arrival had been prophesied by one of the priests of 'Oro named Vaita, who predicted that a new kind of people, different in body, would come in a canoe that lacked an outrigger (2003: 39–40). A demonstration of the power of firearms convinced some Tahitians that the *Dolphin* was indeed this forecast ship and that it had "burst through their sky from [the cosmogonic space of] Te Po. Others thought that this was a sacred island, drifting along their coastline" (ibid.: 42).

3. Thomas comments on Georg's father's typifications of South Sea Islanders. Making the point that J. R. Forster did not "orientalize" South Sea Islanders—that is, define them in sharp and denigrating contrast to the self—he writes of him: "Forster's ethnology was not a discourse exclusively of the 'other' but one that encompassed a hierarchy of races in the unity of the species, that took Europeans of various classes and nations as well as 'savages' and 'barbarians' to be susceptible to the same processes, to common causes of improvement and degeneracy" (1996: xxxv).

4. At the close of his crucial 1831/1832 lecture, Dumont d'Urville acknowledges that it was only after completing the lecture that he realized that one well-known physiologist, Cuvier, had also concluded that there were three "varieties in the human species" (2003: 174)—Caucasian, Mongolian or yellow, and Ethiopian or Negroid—but that he hadn't known how to classify the Malays, the Americans, and the Papuans. Dumont d'Urville quickly assigns the Malays and Americans (the Indians) to the "yellow race" and Papuans to the "black race" (ibid.).

5. Dening's claim that "[e]very encounter of the *Endeavour* with indigenous peoples" (Dening 2004: 173), from the time that Tupaia entered the picture until the time he died of scurvy and its complications in 1770 in Batavia, the East Indies, "was mediated by Tupaia" (ibid.) is surely an exaggeration (see Salmond 2003: 162 on Tupaia's uselessness in Australia). It is clear nonetheless that to the extent Cook was successful in his diplomatic mission, it was because Tupaia proved a knowledgeable, respected, and trustworthy intermediary. Tupaia achieved fame "throughout New Zealand. Among the Maori he was remembered for generations longer than Cook. The Maori named a cave for him where he slept, a well that he dug. They [gave] their children his name" (ibid).

6. Salmond writes that there was a "great voyaging network" (2003: 36) that centered on 'Oro's temple on the southeastern coast of Ra'iatea (ibid.: 36) and that included the Marquesas, the Cook and Austral islands, the Tuamotus, and, through the efforts of Tupaia himself, Tahiti, to which Tupaia had brought the worship of 'Oro (ibid.: 38).

7. According to Epeli Hau'ofa,

> Fiji, Samoa, Tonga, Niue, Rotuma, Tokelau, Tuvalu, Futuna, and Uvea formed a large exchange community in which wealth and people with their skills and arts circulated endlessly. From this community people ventured to the north and west, into Kiribati, the Solomon Islands, Vanuatu, and New Caledonia, which formed an outer arc of less intensive exchange. . . . The Cook Islands and French Polynesia formed a community similar to that of their cousins to the west; hardy spirits from this community ventured southward and founded settlements in Aotearoa, while others went in the opposite direction to discover and inhabit the islands of Hawai'i. Also north of the equator is the community that was centered on Yap. [See also note 6.]
>
> Melanesia is supposedly the most fragmented world of all: tiny communities isolated by terrain and at least one thousand languages. The truth is that large regions of Melanesia were integrated by trading and cultural exchange systems that were even more complex than those of Polynesia and Micronesia. Lingua francas and the fact that most Melanesians were and are multilingual . . . make utter nonsense of the notion that they were and still are babblers of Babel. . . . Nineteenth-century imperialism erected boundaries that led to the contraction of Oceania, transforming a once boundless world into the Pacific Island states and territories that we know today. People were confined to their tiny spaces, isolated from each other. No longer could they travel freely to do what they had done for centuries. (Hau'ofa 1994: 154–155; cf. Biersack 1995)

8. Hobsbawm's typology actually rests on three terms, not two. The term "custom" is unbifurcated, but the term "tradition" breaks down into "invented tradition" and the unmarked tradition (a "genuine" [Hobsbawm 1983: 8] tradition, which is presumably invariant and actually connected to the past).

9. Linnekin prefers the terms "constructionism," "symbolic constructionism," and "postmodernism" (1992, 2004).

10. As many of my readers will be aware, some inventionists have ultimately retreated from the word "invention." Alan Hanson, for example, responding to criticism he received in New Zealand of his journal article "The Making of the Maori: Cultural Invention and Its Logic," wrote just two years after his article appeared that "invention when applied to culture and tradi-

tion is a systematically misleading expression that should not be perpetuated" (1991: 450), and he apologized for having used the word.

11. Oceanists will be aware of the backlash by those Pacific Islanders who are deeply offended by the inventionist argument, which subverts indigenous claims to peoplehood, resting as they often do upon a rooted (albeit not timeless) culture. See Keesing 1989, 1991; Linnekin 1991b; Trask 1991 for a key exchange. See Jolly and Thomas 1992: 242–243 for a discussion of the pros and cons of the term.

12. Indeed there is already a vast body of materials bearing upon that history, from the literature on exploration and scientific voyaging in the Pacific to accounts of colonization and missionization to histories of the Pacific theater in World War II to studies of international migration and the remittance-based economies of the late twentieth century and continuing into the twenty-first century. Texts such as Campbell's *World's Apart* (2003), Denoon's *The Cambridge History of the Pacific Islanders* (1997b), Denoon, Mein-Smith, and Wyndham's *A History of Australia, New Zealand, and the Pacific* (2000), Fischer's *A History of the Pacific Islands* (2002), Howe's *Where the Waves Fall* (1984) and *Tides of History* (1994), Quanchi and Adams' *Culture Contact in the Pacific* (1993), and Scarr's *The History of the Pacific Islands: Passages through Tropical Time* (2001) provide useful overviews, spanning centuries of Pacific Islander engagement with Euro-American worlds.

13. Other texts that examine, sometimes only implicitly, the relationship between structure (or culture) and history include Biersack 2006; Bott 1982; Sahlins 1981, 1985, 1991, 1992, 1994, 2000a, 2004; Valeri 1972, 1985a, 1985b, 1990, 2008; and Wood-Ellem 1999.

References

Andrade, Ivy Hali'imaile. 2007. "Review of Life in the Pacific of the 1700s: The Cook/Forster Collection of the George August University of Gottingen." *The Contemporary Pacific* 19 (1): 341–342.

Appadurai, Arjun, ed. 1986. *The Social Life of Things: Commodities in Cultural Perspective.* Cambridge and New York: Cambridge University Press.

———. 1996. *Modernity at Large.* Minneapolis: University of Minnesota Press.

Ballantyne, Tony. 2004. "Introduction." In *Science, Empire and the European Exploration of the Pacific,* edited by Tony Ballantyne, xv–xxxv. Aldershot, Hants, UK, and Burlington, Vt.: Ashgate.

Ballard, Chris. 2008. "The Cultivation of Difference in Oceania." In *Foreign Bodies: Oceania and the Science of Race 1750–1940,* edited by Bronwen Douglas and Chris Ballard, 339–344. Canberra: Australian National University E Press.

Bateson, Gregory. 1958. *Naven. A Survey of the Problems Suggested by a Composite Picture of the Culture of a New Guinea Tribe Drawn from Three Points of View.* Stanford, Calif.: Stanford University Press.

Besnier, Niko. 1994. "Polynesian Gender Liminality through Time and Space." In *Third Sex, Third Gender: Beyond Sexual Dimorphism in Culture and History,* edited by Gilbert Herdt, 285–328. New York: Zone Books.

Biersack, Aletta. 1995. "Introduction: Huli, Duna, and Ipili Perspectives on the Papua New Guinea Highlands." In *Papuan Borderlands: Huli, Duna, and Ipili Perspectives on the Papua New Guinea Highlands,* edited by A. Biersack, 1–54. Washington, D.C.: Smithsonian Institution Press.

———. 2005. "On the Life and Times of the Ipili Imagination." In *The Making of Global and Local Modernities in Melanesia: Humiliation, Transformation and the Nature of Cultural Change,* edited by Joel Robbins and Holly Wardlow, 135–162. Burlington, Vt.: Ashgate.

———. 2006. "Rivals and Wives: Affinal Politics and the Tongan Ramage." In *Origins, Ancestry*

and Alliance, edited by James Fox and Clifford Sather, 241–282. Reissue. Canberra: Australian National University E Press.

Borofsky, Robert. 1997. "Cook, Lono, Obeyesekere, and Sahlins." *Current Anthropology* 38 (2): 255–282.

———. ed. 2000. *Remembrance of Pacific Pasts: An Invitation to Remake History.* Honolulu: University of Hawai'i Press.

Bott, Elizabeth. 1982. *Tongan Society at the Time of Captain Cook's Visits: Discussions with Her Majesty Queen Salote*. Memoir no. 44. Wellington: The Polynesian Society.

Campbell, I. C. 1980. "Savages Noble and Ignoble: The Preconceptions of Early European Voyages in Polynesia." *Pacific Studies* 4 (1): 45–59.

———. 2003. *Worlds Apart: A History of the Pacific Islands*. Christchurch, New Zealand: Canterbury University Press.

Chakrabarty, Dipesh. 2007. *Provincializing Europe: Postcolonial Thought and Historical Difference*. Reissue with a new preface. Princeton, N.J.: Princeton University Press.

Clifford, James. 1988. *The Predicament of Culture*. Berkeley: University of California Press.

Comaroff, John L., and Jean Comaroff. 1991. "Introduction." In *Of Revelation and Revolution: Christianity, Colonialism, and Consciousness in South Africa*, 1–48. Chicago: University of Chicago Press.

———. 1997. "Introduction." In *Of Revelation and Revolution: The Dialectics of Modernity on a South African Frontier*, 1–62. Chicago: University of Chicago Press.

Dening, Greg. 1980. *Islands and Beaches: Discourse on a Silent Land, Marquesas 1774–1880*. Honolulu: University of Hawai'i Press.

———. 2004. *Beach Crossings: Voyaging across Times, Cultures, and Self*. Philadelphia: University of Pennsylvania Press.

Denoon, Donald. 1997a. "New Economic Orders: Land, Labour and Dependency." In *The Cambridge History of the Pacific Islanders*, edited by Donald Denoon, 218–288. Cambridge: Cambridge University Press.

———, ed., with Stewart Firth, Jocelyn Linnekin, Malama Meleisea, and Karen Nero. 1997b. *The Cambridge History of the Pacific Islanders*. Cambridge and New York: Cambridge University Press.

Denoon, Donald, Philippa Mein-Smith, and Marivic Wyndham. 2000. *A History of Australia, New Zealand, and the Pacific*. Oxford and Malden, Mass.: Blackwell.

Dirks, Nicholas. 1996. "Is Vice Versa? Historical Anthropologies and Anthropological Histories." In *The Historic Turn in the Human Sciences*, edited by Terrence J. McDonald, 17–51. Ann Arbor: University of Michigan Press.

Douglas, Bronwen. 1999. "Art as Ethno-historical Text: Science, Representation and Indigenous Presence in Eighteenth and Nineteenth Century Oceanic Voyage Literature." In *Double Vision: Art Histories and Colonial Histories in the Pacific*, edited by Nicholas Thomas and Diane Losche, 65–99. Cambridge: Cambridge University Press.

———. 2005. "Notes on 'Race' and the Biologisation of Human Difference." *The Journal of Pacific History* 40 (3): 331–338.

———. 2008a. "Climate to Crania: Science and the Racialization of Human Difference." In *Foreign Bodies: Oceania and the Science of Race 1750–1940*, edited by Bronwen Douglas and Chris Ballard, 33–98. Canberra: Australian National University E Press.

———. 2008b. "'Novus Orbis Australis': Oceania in the Science of Race, 1750–1850." In *Foreign Bodies: Oceania and the Science of Race 1750–1940*, edited by Bronwen Douglas and Chris Ballard, 99–155. Canberra: Australian National University E Press.

Dumont d'Urville, Jules-Sébastien-Cesar. 2003. "On the Islands of the Great Ocean." Translated from the French by Isabel Ollivier, Antoine de Biran, and Geoffrey Clark. *The Journal of*

Pacific History 38 (2):163–174. First published as "Sur les îles du Grand Océan," *Bulletin de la Société de Géographie* 17 (1832): 1–21.

Falgout, Suzanne, Lin Poyer, and Laurence M. Carucci. 2008. *Memories of War: Micronesians in the Pacific War.* Honolulu: University of Hawai'i Press.

Feinberg, Richard. 1988. *Polynesian Seafaring and Navigation: Ocean Travel in Anutan Culture and Society.* Kent, Ohio, and London: Kent State University Press.

Finney, Ben R., ed. 1976. *Pacific Navigation and Voyaging.* Memoir no. 39. Wellington, N.Z.: The Polynesian Society.

———. 1979. *Hokule'a: The Way to Tahiti.* New York: Dodd, Mead.

———. 2003. *Sailing in the Wake of the Ancestors: Reviving Polynesian Voyaging.* Honolulu: Bishop Museum Press.

Fischer, Steven Roger. 2002. *A History of the Pacific Islands.* Hampshire, England, and New York: Palgrave.

Foster, Robert J. 2005. "Afterword: Frustrating Modernity in Melanesia." In *The Making of Global and Local Modernities in Melanesia,* edited by Joel Robbins and Holly Wardlow, 207–216. Burlington, Vt.: Ashgate.

Fox, Richard G., and Orin Starn. 1997. "Introduction." In *Between Resistance and Revolution: Cultural Politics and Social Protest,* 1–16. New Brunswick, N.J.: Rutgers University Press.

Gates, Henry Louis Jr., ed. 1985. *"Race," Writing, and Difference.* Chicago: University of Chicago Press.

Gell, Alfred. 1992. *The Anthropology of Time: Cultural Constructions of Temporal Maps and Images.* Oxford: Berg.

Gewertz, Deborah, and Frederick Errington. 1991. *Twisted Histories, Altered Contexts: Representing the Chambri in a World System.* Cambridge and New York: Cambridge University Press.

Gregory, Christopher. 1982. *Gifts and Commodities.* London: Academic.

Grijp, Paul van der. 1994. "A History of Misunderstandings: Early European Encounters with Tongans." In *European Imagery and Colonial History in the Pacific,* edited by Toon van Meijl and Paul van der Grijp, 32–48. Nijmegen Studies in Development and Cultural Change, vol. 19. Saarbrücken: Verlag für Entwicklungspolitik Breitenbach.

Hanson, Allan. 1989. "The Making of the Maori: Culture Invention and Its Logic." *American Anthropologist* 91 (4): 890–902.

———. 1991. "Reply to Langdon, Levine, and Linnekin." *American Anthropologist* 93 (2): 449–450.

Hau'ofa, Epeli. 1994. "Our Sea of Islands." *The Contemporary Pacific* 6 (1): 148–161. Reprinted in *We Are the Ocean: Selected Works.* Honolulu: University of Hawai'i Press, 2008.

———. 2000. "Pasts to Remember." In *Remembrance of Pacific Pasts: An Invitation to Remake History,* edited by Robert Borofsky, 453–471. Honolulu: University of Hawai'i Press. Reprinted in Hau'ofa, *We Are the Ocean: Selected Works.* Honolulu: University of Hawai'i Press, 2008.

Hauser-Schäublin, Brigitta. 1998. "Exchanged Value: The Winding Paths of the Objects." In *James Cook: Gifts and Treasures from the South Seas. The Cook/Forster Collection, Göttingen,* edited by Brigitta Hauser-Schäublin and Gundolf Krüger, 11–29. Munich and New York: Prestel.

Hobsbawm, Eric. 1983. "Introduction: Inventing Traditions." In *The Invention of Tradition,* edited by Eric Hobsbawm and Terence Ranger, 1–14. New York: Cambridge University Press.

Hobsbawm, Eric, and Terence Ranger, eds. 1983. *The Invention of Tradition.* New York: Cambridge University Press.

Howe, K. R. 1984. *Where the Waves Fall: A New South Sea Islands History from First Settlement to Colonial Rule.* Honolulu: University of Hawai'i Press.

———. 1994. *Tides of History: The Pacific Islands in the 20th Century*. Honolulu: University of Hawai'i Press.

———. 2007. *Vaka Moana: Voyages of the Ancestors: The Discovery and Settlement of the Pacific*. Honolulu: University of Hawai'i Press.

———. 2008. *The Quest for Origins: Who First Discovered and Settled New Zealand and the Pacific Islands*. New York: Penguin Books.

Inda, Jonathan, and Renato Rosaldo. 2008. "Tracking Global Flows." In *The Anthropology of Globalization: A Reader*, 2nd ed., edited by Jonathan Inda and Renato Rosaldo, 3–46. Malden, Mass.: Blackwell.

Jolly, Margaret. 1991. "Spectres of Inauthenticity." *The Contemporary Pacific* 4 (1): 49–72.

———. 2000. "Custom and the Way of the Land: Past and Present in Vanuatu and Fiji." In *Remembrance of Pacific Pasts: An Invitation to Remake History*, edited by Robert Borofsky, 340–357. Honolulu: University of Hawai'i Press.

———. 2007. "Imagining Oceania: Indigenous and Foreign Representations of a Sea of Islands." *The Contemporary Pacific* 19 (2): 508–545.

Jolly, Margaret, and Nicholas Thomas. 1992. "Introduction." In *The Politics of Tradition in the Pacific*, edited by Margaret Jolly and Nicholas Thomas. Special Issue. *Oceania* 62 (4): 241–248.

Kaeppler, Adrienne L. 1978. *"Artificial Curiosities": Being an Exposition of Native Manufactures Collected in the Three Pacific Voyages of Captain James Cook, R. N., at the Bernice Pauahi Bishop Museum, January 18, 1978—August 31, 1978, on the Occasion of the Bicentennial of the European Discovery of the Hawaiian Islands by Captain Cook, January 18, 1778*. Honolulu: Bishop Museum Press.

———. 1998. "The Göttingen Collection in an International Context." In *James Cook: Gifts and Treasures from the South Seas. The Cook/Forster Collection, Göttingen*, edited by Brigitta Hauser-Schäublin and Gundolf Krüger, 86–93. Munich and New York: Prestel.

Kahn, Miriam. 2000a. "Tahiti Intertwined: Ancestral Land, Tourist Postcard, and Nuclear Test Site." *American Anthropologist* 102 (1): 7–26.

———. 2000b. "Not Really Pacific Voices; Politics of Representation in Collaborative Museum Exhibits." *Museum Anthropology* 24 (1): 57–74.

———. 2003. "Tahiti: The Ripples of a Myth on the Shores of the Imagination." *History and Anthropology* 14 (4): 307–326.

Kameʻeleihiwa, Lilikalā. 1992. *Native Land and Foreign Desires*. Honolulu: Bishop Museum Press.

Keesing, Roger M. 1982. "Kastom in Melanesia: An Overview." In *Reinventing Traditional Culture: The Politics of Kastom in Island Melanesia*, edited by Roger M. Keesing and Robert Tonkinson. Special Issue. *Mankind* 13 (4): 297–305.

———. 1989. "Creating the Past: Custom and Identity in the Contemporary Pacific." *The Contemporary Pacific* 1 (1 and 2): 19–42.

———. 1991. "Reply to Trask." *The Contemporary Pacific* 3 (1): 168–171.

Keesing, Roger, and Robert Tonkinson, eds. 1982. *Reinventing Traditional Culture: The Politics of Kastom in Island Melanesia*. Special Issue. *Mankind* 13 (4).

Kempf, Wolfgang. 2004. "The Drama of Death as Narrative of Survival: Dance Theatre, Travelling and Thirdspace among the Banabans of Fiji." In *Shifting Images of Identity in the Pacific*, edited by Toon van Meijl and Jelle Miedema, 159–189. Leiden: KITLV Press.

Kildea, Gary, and Jerry Leach. 1979. *Trobriand Cricket: An Ingenious Response to Colonialism*. Ronin Films.

Lindstrom, Lamont. 1982. "Leftamap Kastom: The Political History of Tradition on Tanna, Vanuatu." In *Reinventing Traditional Culture: The Politics of Kastom in Island Melanesia*, edited by Roger M. Keesing and Robert Tonkinson. Special Issue. *Mankind* 13 (4): 316–329.

Linnekin, Jocelyn. 1990a. *Sacred Queens and Women of Consequence.* Ann Arbor: University of Michigan Press.

———. 1990b. "The Politics of Culture in the Pacific." In *Cultural Identity and Ethnicity,* edited by Jocelyn Linnekin and Lin Poyer, 149–173. Honolulu: University of Hawai'i Press.

———. 1991a. "Cultural Invention and the Dilemma of Authenticity." *American Anthropologist* 91: 446–449.

———. 1991b. "Text Bites and the R-Word: The Politics of Representing Scholarship. *The Contemporary Pacific* 3 (1): 172–177.

———. 1992. "On the Theory and Politics of Cultural Construction in the Pacific." In *The Politics of Tradition in the Pacific,* edited by Margaret Jolly and Nicholas Thomas, 249–263. Special Issue. *Oceania* 62 (4): 241–354.

———. 2004. "Epilogue: Is 'Cultural Identity' an Anachronism in a Transnational World?" In *Shifting Images of Identity in the Pacific,* edited by Toon van Meijl and Jelle Miedema, 237–256. Leiden: KITLV Press.

Little, Stephen. 2006. "Life in the Pacific of the 1700s: The Cook/Forster Collection of the George August University of Göttingen." *Calendar News* (Honolulu Academy of Arts) 78 (1): 4–5.

Mageo, Jeannette. 1992. "Male Transvestism and Cultural Change in Samoa." *American Ethnologist* 19 (3): 443–459.

———. 1996. "Samoa, a Walk on the Wilde Side." *Ethos* 24 (4): 588–627.

Mahina, 'Okusitino. 1992. "The Tongan Traditional History: *Tala-e-Fonua.*" PhD diss. Australian National University.

Marcus, George E., and Michael Fischer, eds. 1986. *Writing Culture: The Poetics and Politics of Ethnography.* Berkeley: University of California Press.

Maude, H. C., and H. E. Maude. 1932. "The Social Organization of Banaba or Ocean Island, Central Pacific." *Journal of the Polynesian Society* 76 (4): 415–425.

Mauss, Marcel. 1967. *The Gift: Forms and Functions of Exchange in Archaic Societies.* Translated by Ian Cunnison. New York: Norton.

Meleisea, Malama, and Penelope Schoeffel. 1997. "Discovering Outsiders." In *The Cambridge History of the Pacific Islanders,* edited by Donald Denoon, 119–151. Cambridge: Cambridge University Press.

Merlan, Francesca. 2005. "Explorations towards Intercultural Accounts of Socio-Cultural Reproduction and Change." *Oceania* 75 (1): 167–182.

Merry, Sally Engle. 2000. *Colonizing Hawai'i: The Cultural Power of Law.* Princeton, N.J.: Princeton University Press.

Obeyesekere, Ganath. 1992/1997. *The Apotheosis of Captain Cook: European Mythmaking in the Pacific.* With a new preface and afterword. Princeton, N.J.: Princeton University Press.

———. 2005. *The Man-Eating Myth and Human Sacrifice in the South Seas.* Berkeley: University of California Press.

Ortner, Sherry B. 1989. *High Religion.* Princeton, N.J.: Princeton University Press.

Otto, Ton, and Poul Pedersen. 2000. "Tradition Between Continuity and Invention: An Introduction." In *Anthropology and the Revival of Tradition: Between Cultural Continuity and Invention,* edited by Ton Otto and Poul Pedersen. Special Issue. *Folk* 42.

———. 2005. "Disentangling Traditions: Culture, Agency and Power." In *Tradition and Agency: Tracing Cultural Continuity and Invention,* edited by Ton Otto and Poul Pedersen, 11–50. Aarhus: Aarhus University Press.

Pratt, Mary Louise. 1992. *Imperial Eyes: Travel Writing and Transculturation.* New York: Routledge.

Quanchi, Max, and Ron Adams, eds. 1993. *Culture Contact in the Pacific.* Cambridge and New York: Cambridge University Press.

Ryan, Tom. 2004. "'Le President des Terres Australes': Charles de Brosses and the French Enlightenment Beginnings of Oceanic Anthropology." In *Science, Empire and the European Exploration of the Pacific. The Pacific World: Lands, Peoples and History of the Pacific, 1500–1900*, vol. 6, edited by Tony Ballantyne, 225–246. Aldershot, Hampshire, UK, and Burlington, Vt.: Ashgate.

Sahlins, Marshall. 1981. *Historical Metaphors and Mythical Realities: Structure in the Early History of the Sandwich Island Kingdom*. ASAO monograph no. 1. Ann Arbor: University of Michigan Press.

———. 1985. *Islands of History*. Chicago: University of Chicago Press.

———. 1991. "The Return of the Event, Again: With Reflections on the Beginnings of the Great Fijian War of 1843 to 1855 between the Kingdoms of Bau and Rewa." In *Clio in Oceania: Toward a Historical Anthropology*, edited by A. Biersack, 37–99. Washington, D.C.: Smithsonian Institution Press.

———. 1992. *Anahulu: The Anthropology of History in the Kingdom of Hawai'i*. Vol. 1: *Historical Ethnography*. Chicago: University of Chicago Press.

———. 1994. "Goodbye to Tristes Tropes: Ethnography in the Context of Modern World History." In *Assessing Cultural Anthropology*, edited by Robert Borofsky, 377–395. New York: McGraw-Hill.

———. 1995. *How "Natives" Think: About Captain Cook, For Example*. Chicago: University of Chicago Press.

———. 1999. "Two or Three Things that I Know about Culture." Huxley Lecture 1998. *Journal of the Royal Anthropological Institute* (N.S.) 5: 399–421.

———. 2000a. "Hawai'i in the Early Nineteenth Century: The Kingdom and the Kingship." In *Remembrance of Pacific Pasts: An Invitation to Remake History*, edited by Robert Borofsky, 189–211. Honolulu: University of Hawai'i Press.

———. 2000b. "Individual Experience and Cultural Order." In *Culture in Practice: Selected Essays*, 277–291. New York: Zone Books.

———. 2004. *Apologies to Thucydides: Understanding History as Culture and Vice Versa*. Chicago: University of Chicago Press.

Said, Edward W. 1978. *Orientalism*. New York: Pantheon Books.

———. 1989. "Representing the Colonized: Anthropology's Interlocutors." *Critical Inquiry* 15 (2): 205–225.

Salmond, Anne. 1991. *Two Worlds: First Meeting Between Maori and Europeans 1642–1772*. Auckland: Viking.

———. 2003. *The Trial of the Cannibal Dog: Captain Cook in the South Seas*. London: Penguin.

———. 2010. *Aphrodite's Island: The European Discovery of Tahiti*. Berkeley: University of California Press.

Scarr, Deryck. 2001. *The History of the Pacific Islands: Passages through Tropical Time*. Richmond, Surrey, UK: Curzon.

Sewell, William H., Jr. 2005. *Logics of History: Social Theory and Social Transformation*. Chicago: University of Chicago Press.

Silva, Noenoe. 2004. *Aloha Betrayed: Native Hawaiian Resistance to American Colonialism*. Durham, N.C.: Duke University Press.

Small, Cathy. 1997. *Voyages: From Tongan Villages to American Suburbs*. Ithaca, N.Y.: Cornell University Press.

Smith, Bernard. 1985. *European Vision and the South Pacific*, 2nd ed. Melbourne and Oxford: Oxford University Press.

Smith, Linda Tuhiwai. 2005. "Imperialism, History, Writing, and Theory." In *Postcolonialisms: An Anthology of Cultural Theory and Criticism*, edited by Gaurav Gajanan Desai and Supriya Nair, 94–115. New Brunswick, N.J.: Rutgers University Press.

Stillman, Amy Kuʻuleilaloha. 2002. "Of the People Who Love the Land: Vernacular History in the Poetry of Modern Hawaiian Hula." *Amerasia* 28 (3): 85–108.

———. 2006. "Modern Hula: A Crucible of Hawaiian Tradition." Paper presented at the conference "Changing Context—Shifting Meanings: Transformations of Cultural Traditions in Oceania." Honolulu Academy of Arts, February 23–26, 2006.

Stoler, Ann Laura. 2008 [1989]. "Making Empire Respectable: The Politics of Race and Sexual Morality in Twentieth-Century Colonial Cultures." Reprinted in *Anthropological Theory: An Introductory History*, 4th ed., edited by R. Jon McGee and Richard L. Warms, 459–481. Boston: McGraw Hill.

———. 1995. *Race and the Education of Desire: Foucault's History of Sexuality and the Colonial Order of Things*. Durham, N.C.: Duke University Press.

Stoler, Ann Laura, and Frederick Cooper. 1997. "Between Metropole and Colony." In *Tensions of Empire*, edited by Frederick Cooper and Ann Stoler, 1–56. Berkeley: University of California Press.

Tcherkézoff, Serge. 2001. *Le myth occidental de la sexualité polynésienne: Margaret Mead, Derek Freeman et Samoa*. Paris: Press universitaires de France.

———. 2003. "A Long and Unfortunate Voyage Towards the 'Invention' of the Melanesia/Polynesia Distinction 1595–1832." *The Journal of Pacific History* 38 (2): 175–196.

———. 2004. *Tahiti 1768: jeunes filles en pleurs. La face cachée des premiers contacts et la naissance du mythe occidental (1595–1928)*. Papeete, Tahiti: Au Vent des Iles.

———. 2007. *Mélanésie/Polynésie: l'invention française des "races" et des régions de l'Océanie (1595–1985)*. Paris: Société des Océanistes, publication 50.

———. 2008. *"First Contacts" in Polynesia: The Samoan Case (1722–1848); Western Misunderstandings about Sexuality and Divinity*. Canberra: ANU E Press.

———. 2009. "A Reconsideration of the Role of Polynesian Women in Early Encounters with Europeans: Supplement to Marshall Sahlins' Voyage around the Islands of History." In *Oceanic Encounters: Exchange, Desire, Violence*, edited by Margaret Jolly, Serge Tcherkézoff, and Darrell Tryon, 113–159. Canberra: ANU E Press.

Thomas, Nicholas. 1991. *Entangled Objects: Exchange, Material Culture, and Colonialism in the Pacific*. Cambridge, Mass.: Harvard University Press.

———. 1992. "The Inversion of Tradition." *American Ethnologist* 19 (2): 213–232.

———. 1994. *Colonialism's Culture: Anthropology, Travel and Government*. Cambridge: Polity Press.

———. 1996. "'On the Varieties of the Human Species': Forster's Comparative Ethnology." In *Observations Made during a Voyage round the World, by Johann Reinhold Forster*, edited by Nicholas Thomas et al., xxiii–xl. Honolulu: University of Hawaiʻi Press.

———. 1997. *In Oceania: Visions, Artifacts, Histories*. Durham, N.C., and London: Duke University Press.

———. 1999. "Introduction." In *Double Vision: Art Histories and Colonial Histories in the Pacific*, edited by Nicholas Thomas and Diane Losche, 1–20. Cambridge: Cambridge University Press.

———. 2002. "Colonizing Cloth: Interpreting the Material Culture of Nineteenth-Century Oceania." In *The Archaeology of Colonialism*, edited by Claire L. Lyons and John K. Papadopo, 182–198. Los Angeles: Getty Research Institute.

———. 2003. *Discoveries: The Voyages of Captain Cook*. London: Allen Lane; New York: Penguin Putnam.

———. 2005. "Introduction." In *Tattoo: Bodies, Art and Exchange in the Pacific and the West*, edited by Nicholas Thomas, Anna Cole, and Bronwen Douglas, 7–29. London: Reaktion Books.

Tonkinson, Robert. 1982a. "Kastom in Melanesia: Introduction." In *Reinventing Traditional*

Culture: The Politics of Kastom in Island Melanesia, edited by Roger M. Keesing and Robert Tonkinson. Special Issue. *Mankind* 13 (4): 302–305.

———. 1982b. "National Identity and the Problem of Kastom in Vanuatu." In *Reinventing Traditional Culture: The Politics of Kastom in Island Melanesia,* edited by Roger M. Keesing and Robert Tonkinson. Special Issue. *Mankind* 13 (4): 306–315.

———. 2000. "'Tradition' in Oceania, and Its Relevance in a Fourth World Context (Australia)." In *Anthropology and the Revival of Tradition: Between Cultural Continuity and Invention,* edited by Ton Otto and Poul Pedersen. Special Issue. *Folk* 42.

Trask, Haunani-Kay. 1991. "Natives and Anthropologists: The Colonial Struggle." *The Contemporary Pacific* 3 (1): 159–167.

———. 1999. *From a Native Daughter: Colonialism and Sovereignty in Hawai'i.* Honolulu: University of Hawai'i Press.

Turnbull, David. 1998. "Cook and Tupaia, a Tale of Cartographic *Meconnaissance?*" In *Science and Exploration in the Pacific: European Voyages to the Southern Oceans in the Eighteenth Century,* edited by Margarette Lincoln, 117–134. Woodbridge, Suffolk, UK: The Boydell Press, in association with the National Maritime Museum.

———. 2004. "(En)-Countering Knowledge Traditions: The Story of Cook and Tupaia." In *Science, Empire and the European Exploration of the Pacific, The Pacific World: Lands, Peoples and History of the Pacific, 1500–1900,* vol. 6, edited by Tony Ballantyne, 225–246. Aldershot, Hampshire, Great Britain, and Burlington, Vt.: Ashgate.

Urban, Manfred. 1998a. "Cook's Voyages and the European Discovery of the South Seas." In *James Cook: Gifts and Treasures from the South Seas. The Cook/Forster Collection, Göttingen,* edited by Brigitta Hauser-Schäublin and Gundolf Krüger, 30–55. Munich and New York: Prestel.

———. 1998b. "The Acquisition History of the Göttingen Collection." In *James Cook: Gifts and Treasures from the South Seas. The Cook/Forster Collection, Göttingen,* edited by Brigitta Hauser-Schäublin and Gundolf Krüger, 56–85. Munich and New York: Prestel.

Valeri, Valerio. 1972. "Le fonctionnement du système des rangs à Hawaii." *L'Homme* 15: 83–107.

———. 1985a. "The Conqueror Becomes King: A Political Analysis of the Hawaiian Legend of 'Umi." In *Transformations of Polynesian Culture,* edited by A. Hooper and J. Huntsman. Memoir no. 45. Auckland: The Polynesian Society.

———. 1985b. *Kingship and Sacrifice: Ritual and Society in Ancient Hawaii.* Translated by Paula Wissing. Chicago: University of Chicago Press.

———. 1990. "Constitutive History: Genealogy and Narrative in the Legitimation of Hawaiian Kingship." In *Culture through Time: Anthropological Approaches,* edited by Emiko Ohnuki-Tierney. Stanford, Calif.: Stanford University Press.

———. 2008. "Marriage, Rank, and Politics in Hawaii." Expanded version of "Le fonctionnement du système des rangs à Hawaii," originally published in *L'Homme,* 1972. Translated by Aletta Biersack and Janet Hoskins. In *Hierarchy: Persistence and Transformation in Social Formations,* edited by Knut Rio and Olaf H. Smedal, 211–244. Oxford and New York: Berghahn Books.

Wagner, Roy. 1981. *The Invention of Culture,* 2nd ed. Chicago: University of Chicago Press.

Waiko, John. 1986. "Oral Traditions among the Binandere: Problems of Method in a Melanesian Society." *Journal of Pacific History* 21 (1): 21–38.

———. 1991. "Oral History and the War: The View from Papua New Guinea." In *Remembering the Pacific War,* edited by Geoffrey M. White, 3–16. Occasional Paper 36. Honolulu: Center for Pacific Islands Studies, University of Hawai'i at Mānoa.

Wallace, Lee. 2003. *Sexual Encounters: Pacific Texts, Modern Sexualities.* Ithaca, N.Y., and London: Cornell University Press.

White, Geoffrey M. 1991a. *Identity through History: Living Stories in a Solomon Island Society.* Cambridge: Cambridge University Press.

———, ed. 1991b. "Remembering the Pacific War." Occasional Paper 36. Honolulu: Center for Pacific Island Studies, University of Hawai'i at Mānoa.

White, Geoffrey M., and Lamont Lindstrom, eds. 1989. *The Pacific Theater: Island Representations of World War II.* Honolulu: University of Hawai'i Press.

Wood-Ellem, Elizabeth. 1999. *Queen Salote and Tungi: The Story of an Era 1900–1965.* Auckland: Auckland University Press.

Contributors

Aletta Biersack has conducted long-term research on the Ipili speakers of Enga Province, Papua New Guinea. Her foci have been reproduction and its social organization, the gendering of work, indigenous rituals and worldview and the relationship of these to Christianity, and, most recently, gold mining and its dynamics. The question of how to conceptualize change and transformational processes has become central to her research and writings, and she has written theoretical and ethnographic texts on this topic, the most recent being "The Sun and the Shakers, Again," forthcoming in *Oceania*. She is editor of *Clio in Oceania, Papuan Borderlands,* and *Ecology for Tomorrow* and co-editor of *Reimagining Political Ecology*.

Françoise Douaire-Marsaudon is an anthropologist, a director of research (emeritus) at the National Center of Scientific Research (CNRS) in France, and a member of CREDO. Her research interests include the formation and transformation of political systems in Polynesia (Tonga, Wallis, and Futuna) and their relationships with the construction of the person (self, body, gender, and sexuality). Among her publications are "The Kava Ritual and the Reproduction of Male Identity in Polynesia" in *People and Things: Social Mediations in Oceania,* ed. Monique Jeudy-Ballini and Bernard Juillerat (Durham, N.C.: Carolina Academic Press, 2002), and *The Changing South Pacific: Identities and Transformations,* co-edited with Serge Tcherkézoff (Canberra: Pandanus Publications, 2005).

Bronwen Douglas is senior fellow in the College of Asia and the Pacific at the Australian National University. Her major research interests are the history of the idea of race globally and in Oceania, the history and theory of agency in cross-cultural encounters and colonial representations, and Christianity, gender, and community in Melanesia. She is the author of *Across the Great Divide: Journeys in History and Anthropology* (Amsterdam, 1998) and more than fifty refereed articles or book chapters. She is the co-editor of *Foreign Bodies: Oceania and the Science of Race 1750–1940* (Canberra, 2008) and *Tattoo: Bodies, Art and Exchange in the Pacific and the West* (London, 2005).

David Hanlon teaches history at the University of Hawai'i, Mānoa. He is a former director of that university's Center for Pacific Islands Studies and a past editor of both the Pacific Islands Monograph Series (PIMS) and *The Contemporary Pacific: A Journal of Island Affairs*. He currently serves on the editorial boards of the University of Hawai'i Press and the *Journal of Pacific History*. Hanlon's geographical area of interest is Micronesia. He has authored a history of the island of Pohnpei, a more general study on development issues in Micronesia, and numerous articles on Pacific Islands history and its practice. With Geoffrey M. White, Hanlon co-edited *Voyaging through the Contemporary Pacific*. His interests include cross-cultural encounters, missionization, colonialism, development, and an ethnographic approach to the study of the past.

Brigitta Hauser-Schäublin is senior professor of anthropology at the Institute of Cultural and Social Anthropology, University of Göttingen (Germany). She was educated at the University of

Basel (PhD, 1975; Habilitation, 1985). She was curator at the Ethnographic Museum in Basel and has taught at the University of Basel and the University of Cologne before she moved to Göttingen in 1992. She held visiting professorships at Columbia University (1993), the New School for Social Research (1994), Dartmouth College (1996), and L'École des Hautes Études en Sciences Sociales in Paris (2006). Her research interests are Southeast Asia and Oceania (mainly Melanesia), the anthropology of space and ritual, material culture, and the anthropology of the body/gender.

Peter Hempenstall is emeritus professor at the University of Canterbury. His work has been largely in tracing processes of social and political change in colonial contexts in the Pacific, with special reference to Samoa, Papua New Guinea, and the Germans as colonial rulers. He is also a biographer, with a special interest in the development and nature of the genre in both Western and non-Western contexts. His publications include *Pacific Islanders under German Rule*, *Protest and Dissent in the Colonial Pacific* (with N. Rutherford), *The Meddlesome Priest: A Life of E. H. Burgmann*, *The Lost Man: Wilhelm Solf in German History* (with Paula Mochida), and *Remaking the Tasman World* (with Philippa Mein Smith and Shaun Goldfinch). He is currently working on a book about the anthropologist Derek Freeman.

Margaret Jolly is an Australian Research Council Laureate Fellow and professor in Gender and Cultural Studies and Pacific Studies in the School of Culture, History and Language, College of Asia and the Pacific at the Australian National University. She is a historical anthropologist who has written extensively on gender in the Pacific, on exploratory voyages and travel writing, missions and contemporary Christianity, maternity and sexuality, cinema, and art. Her most recent book, co-edited with Serge Tcherkézoff and Darrell Tryon, is *Oceanic Encounters: Exchange, Desire, Violence* (ANU E Press, 2009).

Miriam Kahn is a professor in the Department of Anthropology at the University of Washington. Her research interests include the anthropology of place, colonial and postcolonial politics, nuclear testing, tourism and travel, and cultural representations. She has done fieldwork in Papua New Guinea (1976–1995) and French Polynesia (1993–present). In the past she has had a joint appointment between the Department of Anthropology and the Burke Museum of Natural History and Culture, where she was curator of Pacific ethnology and lead curator for the Pacific Voices exhibit. She is the author of *Always Hungry, Never Greedy: Food and the Expression of Gender in a Melanesian Society* (Cambridge University Press, 1986; Waveland, 1994), co-author of *Pacific Voices: Keeping Our Cultures Alive* (University of Washington Press, 2005), and *Tahiti Beyond the Postcard: Power, Place and Everyday Life* (University of Washington Press, 2011).

Martha Kaplan is a professor of anthropology at Vassar College. Her research interests include ritual and historical anthropology, colonial societies and decolonization, and global commodities and local politics. Since 1982, she has been pursuing research in Fiji, especially concerning a nineteenth-century anticolonial ritual political movement and its aftermath. She is the author of *Neither Cargo Nor Cult: Ritual Politics and the Colonial Imagination in Fiji* (Duke University Press, 1995), and, with John D. Kelly, of *Represented Communities: Fiji and World Decolonization* (University of Chicago Press, 2001). She guest edited a special issue of *Ethnohistory* (52 [1] [2005]) titled *Outside Gods and Foreign Powers: Making Local History with Global Means in the Pacific*. She is currently working on a project titled *Decolonizing Rituals,* a study of the naturalization of the nation-state through new political rituals of the post–World War II, United Nations era. Her recent work on drinking water as a global commodity (published in *Cultural Anthropology* in 2007 and forthcoming 2011) includes studies of water use and water value in Fiji, New York, and Singapore.

John D. Kelly is a professor of anthropology at the University of Chicago. Since 1982 he has been pursuing research in Fiji and has published numerous articles on a wide range of topics, especially concerning Indo-Fijian culture and history and Fiji's colonial and postcolonial politics. (His other research interests include decolonization and U.S. power, semiotic technologies, and knowledge and power in early historic South Asia.) He is the author, together with Martha Kaplan, of *Represented Communities: Fiji and World Decolonization* (University of Chicago Press, 2001), and of *A Politics of Virtue: Hinduism, Sexuality and Countercolonial Discourse in Fiji* (University of Chicago Press, 1991). Also in 1991, he and Uttra Singh published a translation, from Hindi to English, of Totaram Sanadhya's *My Twenty-One Years in the Fiji Islands*. His most recent books are *The American Game: Capitalism, Decolonization, World Domination, and Baseball* (Prickly Paradigm Press, 2007) and *Anthropology and Global Counterinsurgency* (edited, together with Beatrice Jauregui, Sean Mitchell, and Jeremy Walton, University of Chicago Press, 2010).

Wolfgang Kempf gained his PhD in cultural anthropology at the University of Tübingen. In his extensive fieldwork with the Ngaing of Madang Province, Papua New Guinea, and among the Banabans of Fiji and Kiribati, he has made a point of balancing an on-the-ground presence with archival work on the recent history of these groups. His research interests are colonialism, displacement, biography, religious transformation, and, most recently, Oceania in an age of climate change. He taught cultural anthropology at the Universities of Tübingen and Heidelberg; and he also held a guest professorship in Vienna. Currently he combines teaching and research at the Institute of Cultural and Social Anthropology, University of Göttingen. He was guest co-editor (with Elfriede Hermann) of "Relations in Multicultural Fiji: Transformations, Positionings and Articulations," a special section in *Oceania* 75 (4) (2005). His recent publications include "Mobility, Modernisation and Agency: The Life Story of John Kikang from Papua New Guinea," in *Telling Pacific Lives: Prisms of Process*, ed. Brij V. Lal and Vicki Luker (Canberra: ANU E Press, 2008); and "A Sea of Environmental Refugees? Oceania in an Age of Climate Change," in *Form, Macht, Differenz: Motive und Felder ethnologischen Forschens*, ed. Elfriede Hermann, Karin Klenke, and Michael Dickhardt (Göttingen: Universitätsverlag Göttingen, 2009).

Gundolf Krüger, PhD, has been curator of the Ethnographic Collection, Institute of Cultural and Social Anthropology, University of Göttingen, Germany, for twenty years. He was previously assistant at the Oceania Department, Ethnological Museum in Berlin, and head of the Department of Public Relations, Linden-Museum (Ethnographic State Museum) in Stuttgart. His research subjects include museology, material culture of Polynesia, and sports in non-European societies.

Jacquelyn Lewis-Harris, PhD, is the director of the Connecting Human Origin and Cultural Diversity program and assistant professor at the University of Missouri–St. Louis. She has lived and worked extensively in the Pacific for twenty-seven years. Her long association with the Pacific began in Papua New Guinea, where she worked for six years as a government art and handcraft advisor and officer in charge of arts promotion. In her former position as assistant curator at the St. Louis Art Museum, she reinstalled the Oceanic galleries and curated more than fifteen exhibits related to Oceanic, African, and Native American art. She has served as an advisor to several Oceanic gallery reinstallations and exhibits, including the Museum of Art and Archaeology at the University of Missouri, the McNider Museum, the Honolulu Academy of Arts, and the Nijmeegs Volkerkundig Museum. She currently consults for several national and international museums and boards. Her publications include monographs of contemporary Pacific artists, numerous articles on Papua New Guinea culture and art, Pacific identity and expression, as well as the influence of globalization and world markets upon traditional arts and copyright.

Lamont Lindstrom earned his PhD at the University of California at Berkeley. Professor Lindstrom has taught courses in anthropology and sociolinguistics at the University of Tulsa; Rhodes College, Memphis; the University of Papua New Guinea; and the University of California at Berkeley. He is the author of *Cargo Cult: Strange Stories of Desire from Melanesia and Beyond* (University of Hawai'i Press, 1993), *Knowledge and Power in a South Pacific Society* (Smithsonian, 1990), and *Kwamera Dictionary* (Australian National University, 1987), co-author of *Kwamera* (Lincom Europa, 1994), *Kava: The Pacific Drug* (Yale University Press, 1992), and *Island Encounters: Black and White Memories of the Pacific War* (Smithsonian, 1990), editor of *Drugs in Western Pacific Societies: Relations of Substance* (University Press of America, 1987), and co-editor of *Chiefs Today: Traditional Pacific Leadership and the Postcolonial State* (Stanford University Press, 1997), *Culture, Kastom, Tradition: Developing Cultural Policy in Melanesia* (University of the South Pacific, 1994), and *The Pacific Theater: Island Representations of World War Two* (University of Hawai'i Press, 1989). He has had visiting fellowships at the East-West Center, the Center for Pacific Islands Studies (University of Hawai'i), the Macmillan Brown Centre for Pacific Studies (University of Canterbury, Christchurch, New Zealand), and the Kagoshima University Research Center for the South Pacific in Kyushu, Japan.

Karen Nero is professor of the Macmillan Brown Centre for Pacific Studies at the University of Canterbury. A cultural anthropologist, she has been working in Palau and other Micronesian island nations for more than two decades. She studied the Anthropology of Art, Museums, and Tourism with Nelson Graburn at the University of California at Berkeley; her doctoral thesis on the Koror paramount chieftaincy drew upon oral histories and archival sources. She worked with the Trobriand and Pacific Collections at the Phoebe A. Hearst Museum at Berkeley, curating the Wealth of the Pacific: Contemporary Pacific Exchange in 1993, 1996. She was field director of Micronesian Studies at the University of California at Irvine prior to moving to New Zealand in late 1993. Her current research focuses on bringing together indigenous and academic/museum knowledge and practices.

Ton Otto is professor and research leader (*People and Societies of the Tropics*) at the Cairns Institute, James Cook University, Australia, and professor of anthropology and ethnography at the University of Aarhus, Denmark. He has conducted long-term fieldwork in Manus and shorter fieldwork in Lavongai (both in Papua New Guinea). He is especially interested in social and cultural change, which includes religious and political movements, political leadership, warfare, tradition and identity, and the management of resources. He also writes about methodological and epistemological questions and engages with material and visual culture through exhibitions and films. His recent publications include the co-edited (with Nils Bubandt) volume *Experiments in Holism: Theory and Practice in Contemporary Anthropology* (Wiley-Blackwell, 2010) and a co-directed (with Christian Suhr Nielsen and Steffen Dalsgaard) film *Ngat Is Dead – Studying Mortuary Traditions. Manus, Papua New Guinea* (DER, 2009).

Anne Salmond is a distinguished professor in Maori Studies and anthropology at the University of Auckland and the author of seven award-winning books and many articles on Maori life and early contact between Europeans and Islanders in Polynesia. She is a corresponding Fellow of the British Academy, a Foreign Associate of the National Academy of Sciences, a Dame Commander of the British Empire, chairman of the New Zealand Historic Places Trust, and was recently honored with a Prime Minister's Award for Literary Achievement. Her most recent work, *Aphrodite's Island: The European Discovery of Tahiti,* is published by the University of California Press.

Serge Tcherkézoff is professor of anthropology (Directeur d'études) at L'École des Hautes Études en Sciences Sociales (a founding member and, until 2008, the director of CREDO), adjunct professor of anthropology and Pacific Studies at Canterbury University, New Zealand (since

2000), recently ARC Linkage Fellow at the Australian National University, and now (since 2011) adjunct professor at the Australian National University, College of Asia and Pacific, and director of the Centre EHESS-Canberra. His works bring together the results of his field studies in Samoa during the 1980s and 1990s with an ethnohistorical critique of European narratives about Polynesia. He has published extensively concerning contemporary Samoan society (and Western misconceptions) in the domains of economy, politics, and gender relations: *Le mythe de la sexualité polynésienne* (Paris, Presses Universitaires de France, 2001), *FaaSamoa, une identité polynésienne* (Paris, l'Harmattan, 2003), *The Changing South Pacific* (Canberra, ANU E Press, 2009). Other books discuss "first encounters" between Polynesians and Europeans: *Tahiti 1768* (Papeete: Au Vent des Iles, 2004); *First Contacts: The Samoan Case, 1722–1848* (Canberra: ANU E Press, 2008); *Oceanic Encounters: Exchange, Desire, Violence*, co-edited with Margaret Jolly and Darrell Tryon (Canberra: ANU E Press, 2009).

Paul van der Grijp is professor of anthropology at the Université Lumière in Lyon, France, and is also a member of the Center for Anthropological Research and Studies (CREA) in Lyon. Previously, he worked at the Universities of Nijmegen and Utrecht in the Netherlands and in Marseille and Lille in France. His research interests include economic and political anthropology, the anthropology of art and collecting, history and theory of anthropology, West Polynesia, and Europe. Apart from articles in *The Contemporary Pacific, Oceania, Pacific Studies*, the *Journal of the Polynesian Society*, the *Journal de la Societé des Océanistes*, and other specialized and more general anthropological journals, he edited several volumes on the Pacific, also including a special issue of the Taiwanese journal *Asia-Pacific Forum* with an introduction on prospects for research in the Pacific (2006). Among his books are *Identity and Development: Tongan Culture, Agriculture, and the Perenniality of the Gift* (Leiden, 2004); *Passion and Profit: Towards an Anthropology of Collecting* (Berlin, 2006); and *Art and Exoticism: An Anthropology of the Yearning for Authenticity* (Berlin, 2009).

Toon van Meijl studied social anthropology and philosophy at the University of Nijmegen and at the Australian National University in Canberra, where he completed his PhD in 1991. Since 1982 he has conducted thirty months of ethnographic fieldwork among the Tainui Maori in New Zealand. Currently he is associate professor in the Department of Anthropology and Development Studies at the University of Nijmegen in the Netherlands. He is also academic secretary of the interdisciplinary Centre for Pacific and Asian Studies at Nijmegen. He is mainly interested in issues of cultural identity and the self and in sociopolitical questions emerging from the debate about property rights of indigenous peoples. Major publications include the co-edited volumes *Property Rights and Economic Development; Land and Natural Resources in Southeast Asia and Oceania* (1999) and *Shifting Images of Identity in the Pacific* (2004). In 2009 he was guest editor of the *International Journal of Cultural Property* for a special issue on Pacific discourses about the protection of cultural heritage.

Index

Page numbers in **boldface** type refer to illustrations.

Academic Museum of Göttingen University, 20, 29, 34–35
adoption, of ideas, 4
agency, 2, 14n4, 74, 171, 187, 223, 224, 231, 314, 315, 327; in encounters between European voyagers and Pacific Islanders, 68, 88–89; of Europeans, 82, 89, 337; historical, 164, 170, 316; of indigenous actors, 6, 11, 74, 82, 84, 88, 89, 187; individual and collective, 8, 13; of Pacific Islanders, 63, 327, 337; personal, 314; political, 81; and race, 85, 88; social, 158, 174; and tradition, 6, 160
Age of Discovery, 324, 328
alienation: grace in, 236, 240; refusal of, 228–229
analogy, 269–271, 274–275, 332; concept of, 13, 263, 265–266, 338
androgyny, 12, 235–243 passim
anthropology, historical, 2, 57, 313, 323, 335
anthropology, history of, 2, 5, 29–30, 130, 313, 339
Aotearoa New Zealand, vii, 58, 64, 66, 68, 111, 112, 125, 129, 266–267, 274, 278, 282, 284–285, 287–289, 319, 320, 323, 327, 332, 333
'*aparima* (storytelling dances), 203
Appadurai, Arjun, 221, 334, 336, 338
appropriation, 42, 54, 89, 217, 221–232, 232n4, 334
arioi (Tahitian traveling association of god 'Oro), 63–64, 66, 95–96, 102–103, 134–135, 136n11, 324, 327–328; Tupaia as a member of, 64, 66, 71n17, 327–328
aroha (love), 13, 266, 272–274, 332
art, 10, 13, 99–100, 209, 215, 277, 281–293 passim, 314, 339; and handicraft, 290–293. *See also* artist(s); Hodges, William; Le Jeune, Jules-Louis; *Portrait of three Micronesians* (Spoilum); Tupaia's paintings
art dealers, 22, 31
articulation, 1, 3, 4–5, 9–11, 60, 161, 171, 174, 223 passim, 274, 316, 328; concept of, 3, 7; context-bound, 1, 3, 7–8, 12–13, 315, 316; in the context of globalization, 336–337; of identity with tradition, 13, 188; of islands, 178; politics of, 7; of relations between past and present, 7, 56, 332; of systems, 3, 7, 11. *See also* re-articulation
artist(s), 13, 20, 24, 64, 75–88 passim, 209–210, 216, 277–293, 305, 320, 323, 333; selling outlets of, 284–287. *See also* Hodges, William; Le Jeune, Jules-Louis; *Portrait of three Micronesians* (Spoilum); Tupaia's paintings
Arya Samaj, 236, 238, 242
Asian indentured laborers. *See* Indo-Fijians
authenticity, 12, 20, 179, 215, 264, 277
auto-orientalism, 186

Bakhtin, Mikhail, 247n10, 265. *See also* dialogical analysis
Baluan (island), 157–172, 333
Baluan Islanders, 11, 157–172
Banaba (Ocean Island), 11, 175–188, **175**, **188**, 329
Banaban Dancing Group, 179–188, **185**, **187–188**, 316, 329–330
Banabans, 11, 175–188, 315–317, 329–331, 338
Banks, Sir Joseph, 29, 59, **61**, 63, 69n5, 70n13, 70n17, 296, 298, 303, 305
barter, 25–27, 213; by seamen, 25–26
Barth, Fredrik, 161–162, 170
beach: concept of, 9, 56–57, 180; material and metaphysical, 56; as metaphor, 56–59, 68–69, 186, 328

beach crossings, 56–59, 63, 66–69, 315, 317–318, 328
Belau. *See* Palau
Belau National Museum, 13, 302–303, 308–309, 340
bhakti (devotion), 236, 242–243
biography, 13, 189n7, 314, 315, 316; as explanation, 315; of objects, 314; role of agency, 314. *See also* history: and biography
Blanchard, Emile, 129–132, 135
Blosseville, Jules-Alphonse-René Poret de, 75, 84–85, 87
bltikerreng (love; affection), 297, 299–300, 308
Blumenbach, Johann Friedrich, 29, 30–32, **30**, 35, 130, 131, 296, 305, 309n4, 339
body practices, history of, 223, 231
Boenechea, Don Domingo, 100–102
Bonnemaison, Joel, 147, 150, 153
borrowing: cultural, 13, 196, 202, 334; names, 151
Bougainville, Louis-Antoine de, 64, 75–76, 89, 135, 325; Act of Possession by, 59; and Aotourou (Ahutoru), 59, 109, 195–196; in New Ireland, 82; and sexual encounters, 10, 97–99, 104; as *taio*, 98, 324; and Utopia, 99–100, 103, 109, 135, 324, 334
bowl: bird-shaped, 296–303, **300**, **301**, 308
boycott, 238, 240–241, 243–244; politics of, 241
Brenneis, Donald, 242
British Museum, 13, 296, 300–309

canoe(s), 93, 95, **115**; building of, 281, 282; Palauan, 298, 303–304, **306**, 309; "without outrigger," 93, 105, 340n2. *See also* outrigger canoe(s); *waka* (canoe)
carving, 277–293; black coral, 280–282, 290; bone, 278–279, 282, 284, **287–288**, 290; as business, 279–289 passim; of replicas, 280, 291; styles of Tongan clubs, 120n9; teaching of, 290; wood, 278–284, **278**, **283**, **285**, 289–293
Centre de Recherche et de Documentation sur l'Océanie (CREDO): and research of Australia, 129
chief(s), 277; battles of, 116; clothing of, 80, 94; and commoners, 44, 116, 256; and Europeans, 27, 97, 102, 104, 299; Fijian, 226–228, 235, 237–241, 317 (*see also* Great Council of Chiefs); and "heroic I," 148; and law, 89, 254–258, 335; Maori, 267; and missionaries, 81–82, 89, 327; sculpture of Tongan, 279; Wallisian, 251–258
chiefly hierarchy, 44–51 passim
Choulai, Wendi, 209, 211, 214–217
Christian, F. W., 41–42, 329
Christianity, 88, 104, 179, 187–188; Banaban, 330, 338; and colonialism, 151, 153, 226; conversion to, 11, 153, 180, 182, 185–187, 251, 329; Evangelical, 76; Fijian, 243, 329; local, 100
citizenship, 254
civil rights, 240–241
Cohn, Bernard, 221, 231
collecting, 22, 25–27, 71n18, 83, 107, 152, 313, 315
colonialism, 12, 20, 42, 53, 68, 160, 171, 264, 319, 335, 338; academic, 5; conquest and, 23; labor trade and, 11; postcolonial critique of, 247n5, 336. *See also* Christianity: and colonialism
commemoration, 10, 58–59, 68, 174, 176–177, 329. *See also* memory
commodification, 210, 221, 273; of cultural objects, 318; of tapa, 217
commodity, 213, 215, 218, 229; and gift, 212–213, 215, 218, 334; global, 224–225, 231–232
commodity exchange, 212, 216, 219
commodity fetishism, 221, 230
conflicts, 100, 107, 109, 112, 118, 245, 255, 257
constitution(s): of Fiji, 188, 238–241, 244
consumption: colonial, 231; United States, 12, 221–222, 224, 230–231, 316
continuity, cultural, 2, 6, 11, 164, 242, 263, 275; symbolic construction of, 6
Cook, Captain. *See* Cook, James
Cook/Forster Collection at the Georg August University of Göttingen, vii–x, 1, 8, 121n12, 296, 322, 327, 340; changing contexts, shifting meanings of, 1, 20–35, 313, 319; exhibited at Honolulu Academy of Arts (*see* Life in the Pacific of the 1700s); exhibited at National Museum of Australia (*see* Cook's Pacific Encounters)
Cook, James, vii, 35, 59, 71n18, 89, 100, 152, 154, 315–316, 319, 323; apotheosis of, 62, 335; on *arioi*, 135; as beach crosser, 58–59, 68; copy of Tupaia's map by, 64; encounters with Pacific Islanders, 8, 11, 27, 70n8, 112, 114, 142–143, 197; ghost of, to be laid to

rest, 120, 328; and Mai, 59, 62–63, 186; in OMAI (pantomime), 62; trade with Pacific Islanders, 25–27; and Tupaia, 63–67, 70n14, 327–328; voyages of, vii, 20, 31, 59, 100, 107, 121n12, 135, 141, 323–324, 328
Cook's Pacific Encounters (exhibition at National Museum of Australia, Canberra), 35, 69, 71n18, 121n12
countersigns, indigenous, 74, 82, 85, 87–88
coups: in Fiji, 188, 235, 237–241, 244, 317, 335
coutume. See *faire la coutume*
creativity, 5, 63, 277, 309
critique, postcolonial, 247n5, 336
cultural nationalism, 221, 232. See also ethnonationalism
cultural persistence, 327
culture: and history, 10, 13, 132, 181, 202, 221, 315, 333, 342n13
culture areas. See Melanesia: naming of; Micronesia: naming of; Oceania: naming of; Polynesia: naming of
curiosities, 32; artificial and natural, 22, 25–27, 29, 32–34
custom, 4, 7, 157, 160, 168, 227, 250–251, 255, 257, 313, 330–333. See also *faire la coutume*; *kastom*

Dance, Nathaniel, 60
dance(s), 10, 180, 296; of *arioi*, 135; as article of trade, 210; and British sailors, 95–96, 197–198; at commemorative festival on Rabi Island, 177, 179, 180–188; as cultural icon, 196, 200, 334; European style, 197–198, 201; and missionaries, 197–198, 334; ownership of, 210, 213, 216; prohibition of, 198; reinvigoration of Tahitian, 198; right to execute, 160; of Solien Besena, 209–219, 317; spatial aesthetic of, 147; Tahitian, 195–206, 317, 334; and tourism, 195–196, 198–199, 201–206, 317, 332, 334, transformations in, 196–198. See also *'aparima* (storytelling dances); hula; *'ote'a* (drum dances); stick dance
dance competition, 196, 201
dance costume(s), 12, 179, 196–197, 201, 206, 210–215, 217–219, 334; financial costs of, 218
dance group, 177–188, 198, 201–204, 210–213, 218–219. See also Banaban Dancing Group; Tahiti Nui
dance performance(s): of Banaban Dancing Group, 179–180, 180–188, 329–332; and British sailors, 95–96; at the Honolulu Academy of Arts, **ix**; of Solien Besena, 209, 215; Tahitian, 195, 201, 203–204, 205; taking pictures of, 203–204
dance show, 195, 201–202, 203–204
dance theater, 11, 179–187, 329
dance tradition(s), 11–12; revived, 334
De Brosses, Charles, 124–125, 128, 131, 133–134
decolonization, 243, 318, 323, 336
deep time, 42, 52–53, 58, 319
Deleur, 45, 51
Deloria, Philip, 232n4
Dening, Greg: and beach crossings, 9, 56–59, 68, 180, 321n1, 328, 337; and deep time, 42, 52–53, 58; and Mai, 63; and Tupaia, 63, 66–67, 341n5
De Rienzi, Gabriel Domeny, 129, 132–135
dialogical analysis, 244, 265, 338
dialogical exchanges, 58
dialogicality, 225, 237–238, 243–245, 317
dialogical relationships, 3, 335
dialogue(s), 235, 323, 338, 340; with audiences, 104; concept of, 265; political, 12, 235; transforming, 57, 68
diaspora, 176, 189n1, 235, 319, 334
difference, history of, 337
discontinuity, cultural, 2, 5, 52, 265, 275, 331, 338
double vision, 57, 337, 339
drama, 180–186
dream, 65, 182, 183
dress: local modes of, 31–32, 79–81, 197. See also dance costume(s)
Dumont d'Urville, Jules-Sébastien-César, 76, 82; naming of Pacific regions by, 10, 123–124, 128–135, 325–326, 339
Duperrey, Louis-Isidore, 10, 45, 75–76, 79–89 passim, 325

early contact, history of, 197
Ellis, William, 81, 197–198
embodiment, 56, 65, 66, 69, 99, 109, 174, 226, 297. See also memory: embodied
emotions, 2–3, 5, 84, 112, 180, 237; concepts of, 272–273. See also *aroha* (love); *bltikerreng* (love, affection); *loloma* (kindly love)
encounters, 8, 9, 42, 54, 56, 58, 69, 74, 75, 89, 110, 112, 323, 325, 337; cross-cultural, 57, 59; early, 53, 104, 316; among Pacific Islanders, 9, 58, 67, 328; between Pacific

Islanders and European voyagers, 2, 8, 10, 12, 58, 74, 88, 107, 108, 321n1, 324; sexual, 10, 81–82, 104, 327; transcultural, 56
Enlightenment, 23, 65, 107, 114, 263, 315, 324, 340; ideas of, 10, 28, 74, 143; Scottish, 110
entanglement, 43, 89, 104, 229, 317, 337
ethnohistory, 74, 88
ethnonationalism, 12, 228, 239. *See also* cultural nationalism
exchange, 9, 12, 13, 26, 54, 56 passim, 75, 78, 96, 101, 103, 111, 147, 230, 296, 318, 319, 324, 327, 337; ceremonial, 159–160, 162–164, 168–171, 256, 316, 333; clan-based, 214, 215, 216, 218; class-based, 216; contact and, 50, 53; cross-cultural, 196; cultural, 8, 12, 13, 211, 217; intercultural, xii, 11, 12; interisland, 195, 328; local agency in, 84; mutuality of, 68
exchange relations, 327
exchange systems, contemporary, 210–211
exchange value, 219

faire la coutume, 250–251
fakalele ritual, 253, 255
festival, 176–179, 187–188, 256, 288, 303. *See also* Festival of Pacific Arts; Heiva (festival)
Festival of Pacific Arts, 179, 196, 303, 329
Fiji, 7, 11, 12, 64, 119, 148, 175, 188, 221, 224, 225, 227, 229, 231–232, 235–245 passim, 278, 281, 286, 288, 316–317, 326, 329–330, 334–335, 337
Fijians, ethnic, 12, 188, 222, 225, 227–230 passim, 235, 237, 238, 240, 242–243, 245, 330, 335
Fiji Indians. *See* Indo-Fijians
Fiji Water. *See* water
fisheries: of Maori, 267, 269
Forster, Georg, 23–33 passim, **24**, 64, **108**, 315; 325; and Tannese, 142–143; and violence, 10, 107–119
Forster, Johann Reinhold, 23–33 passim, **24**, 107, 110, 112, 130, 325, 339; and Arioi dances, 135; and classification of Oceanian people, 75, 125–129; and Tannese, 142
Forster collection, vii, 31–32. *See also* Cook/Forster Collection
Francke collection: Franckesche Stiftungen Halle, 32–33
French Polynesia, 12, 195, 196, 199–210, 317, 334

French Revolution, 107–108
Friendly Islands, 117–118. *See also* Tonga

Gandhi, Mohandas K., 237–238, 240, 242, 245
gangs: of Maori youngsters, 270–271
Garden of Eden, 99, 103, 109, 135, 324, 334, 338
Garnot, Prosper, 75–76, 82, 84–85, 87–88
Gell, Alfred: and gift, 212, 217; and navigation, 65; and time, 143–144, 154nn4–5
gift(s), 24, 141, 218, 251; artifact as, 31–32, 210; categories of, 256; commodity as, 334; and Cook, vii; costume components as, 215, 218, 334; exchange of, 27, 75, 98, 301; inalienable, 219; indigenous concept of, 299–300; money as, 165, 256; objects as, 68, 298; reciprocity, 217, 219; as reconciliation, 114, 253; theoretical concept of, 210–217, 297, 334; transaction, 217; transactor, 216
gift economy, 210, 219; romantic image of, 224
gift exchange, 27, 75, 84, 98, 114, 210–219, 251, 256, 297, 301, 324; money in, 256
gift giving, 25, 31–32, 84, 142, 298, 302, 304, 319
gifting, 210, 212, 319; British meanings of, 308
globalization, 59, 287, 296, 323, 333, 335, 336–338; as cultural process, 336; history of, 323, 335, 337–340 passim
global market, 12, 211, 219, 227
goddess: figures of Tongan, **292**; indigenous, 11, 182, 187; sculpture of Hina, 291; Venus, 97, 99
Great Council of Chiefs, 238–239, 241, 244
Greek mythology, 99, 103
Greek society: ancient, 109, 113, 115–116
Guha, Ranajit, 238

handicraft: and art, 290–293
handicrafts: exchange of, 25; mass production of, 279, 281, 290; selling of, 252, 279–286. *See also* Langa Fenua
hau (head of class of chiefs), 251, 254
Hau'ofa, Epeli, 7, 42, 53, 69n3, 119–120, 277, 284, 289–290, 328–340 passim
Hawai'i, vii, viii, 14n3, 21, 58, 68, 132, 133, 199, 279, 281, 285, 288, 315, 316, 319, 323, 326
Hawaiian hula, history of, 10

Hawaiians, viii, 2, 5, 20, 62, 314, 335, 336
Hawaiki, 272
heiva (dance, ritual celebration), 102, 197
Heiva (festival), 196, 201, 205
Hereniko, Vilsoni, 10
Hinduism, 12, 236–237, 240, 242–243
Hinüber, Christian Heinrich von, 31
historicity, 3, 5, 11, 164, 320, 331; concept of, 3
history, 2, 5, 6, 41–42, 53, 104, 224, 313, 320, 323, 325, 331; and biography, 290, 314–315; colonial, 179, 225, 231, 243, 256, 267, 274, 319, 334, 335; Eurocentric, 57, 327, 336; indigenous notions of, 143, 151; natural, 23, 25, 32, 35, 74, 84, 107, 128; non-Eurocentric, 328; political, 10, 230, 241; politics of, 232, 329; postcolonial, 225; prehistory and, 42, 52, 53, 54, 319; representation of, 317; structural, 2, 316, 335
Hobbes, Thomas, 109–110, 324–325
Hobsbawm, Eric, 5, 160–161, 170, 330–331, 333, 338
Hodges, William, 115; engraving after, 60, **95**; works of, **93**
Honolulu Academy of Arts: exhibition Life in the Pacific of the 1700s at, vii–x, 8, 20–21, 35, 68–69, 71n18, 121n12, 125, 296–297, 314, 318, 323, 327, 336, 339; scholarship at, 279; symposium at, vii, x, 69, 323, 327–328, 332, 339–340
Honourable East India Company, 296, 297–298, 308
Huahine, 62, 114, 201–203
hula, 10, 199, 317, 332; history of, 10
Humphrey, George (art dealer), 31
hypermasculinity. *See* masculinity

Ibedul, 297–299, 301–305, 308
identification, 13, 50, 174, 186, 187, 267
identity, 42, 119, 143, 171, 176, 210, 212, 231, 277, 320, 337; collective, 13, 214, 331; ethnic, 187, 266; national, 169; Oceanic, 293, 320; politics of, 13, 180. *See also* sex/gender identity, Polynesian
I-Kiribati, 179, 329
inalienable objects, 12, 209, 212–219
indigenes: appropriation of, and self-identification as Indian, 231; assimilation of, 221, 229
indigenous Australians, 63, 66
Indo-Fijians, 12, 226, 227, 228–229, 235, 237–243 passim, 245–246, 335

interactions, 1, 8–12, 85, 314, 328, 337; analytical, 8–12; intercultural, 2–4, 11; political, 1, 12; social, 1, 8, 9, 13, 211, 216; structural, 1, 2, 8, 11; transcultural, 1, 8, 13, 25, 27, 186, 202, 219, 264, 265
Isohkelekel, 50–52
itaukei (people of the land), 222, 225–226, 228–229. *See also* Fijians, ethnic
iwi (tribe), 13, 266–267, 269–271, 274, 332

John Frum movement, 150, 153
justice, 12, 250, 254–258, 335

kastam, 11, 157, 159, 160, 162, 168, 170, 171, 333. See also *kastom*
kastamwok, 157, 159, 160, 161, 170, 171, 333
kastom, 4, 7, 153, 250, 314, 330; movement, 318
Katau, 50–51
Katau Peidi, 46
kava-drinking clearings, 147–150
kava-drinking time, 145
kava pounding stones, 50
Kincaid, Jamaica, 204–205
King George II, 30
King George III, vii, 30–31
Kinta (mission helper), 182–187
Kinyeir Fulat, 42–43, 48
Kiribati, 13, 133, 134, 175, 176, 177, 183, 189nn1–2
Kosrae, 9, 41–54, 329; contact between Pohnpei and, 42–43, 45, 50, 52
Krishna, 243
Kūkāʻilimoku (god), feathered image of, **viii**, 27, **28**

labor trade, 11, 151
land: as economic resource, 229; ownership of (*see* ownership: of land); use of, 148
land tenure, 168, 227, 229, 240, 255
Langa Fenua (Tongan handicraft cooperative), 284, 286–287
lapan (political leader), 159, 163, 166
law, 12, 81, 89, 198, 244, 327; customary, 250–258, 317, 335; French, 250–258, 335; Western, 168–169, 317–318
Lebuu, 298–299, 302–303, 308
Lefebvre, Henri, 202
legal system. *See* law
Le Jeune, Jules-Louis, 75–88; drawings and paintings of, 77–80, **80**, 83, **86**
Lelu (Leluh), 9, 41–46, **44**, 48–53

Lesson, René-Primevère, 75–89, 129
liberation, 237–238, 240, 244–245
Life in the Pacific of the 1700s (exhibition at Honolulu Academy of Arts, Hawai'i), vii–x, 8, 20–21, 35, 68–69, 71n18, 121n12, 125, 296–297, 314, 318, 323, 327, 336, 339
limen, 56–69 passim; between Europeans and Islanders, 58–59, 68; between Islanders, 58–59, 329
loi fondamentale (French republican or common law), 254–255
loloma (kindly love), 222, 228, 240, 243, 272
Lower Saxon State Museum in Hanover, vii
Lurun, 43, **49**

Magritte, René, 21
Mai (Omai), 9, 58–63, **60–61**, 196, 315, 327
Makasol. *See* Manus Kastam Kansol
Malte-Brun, Conrad, 75, 128–129
mana (charismatic power): concept of, 12, 236–241, 243, 245, 335; in cosmopolitan culture, 246n1; damaging of, 96, 319; "foreign," 226; of inalienable possessions, 213; of Oceanic objects, vii, 71, 319
mankind, history of, 35
Manus Island (Papua New Guinea), 11, 157–171, **157**, 316, 317–318, 333
Manus Kastam Kansol, 169
Maori: art, 282; club, **ix, x**; dance group, **ix**; of New Zealand, 13, 66–68, 111–112, 142, 266–274, 320, 332, 341n5; *taonga* (treasures), 297, 308
marae (ceremonial ground), 63, 103–104, 270–271, 332
market exchange, 215, 217
marketing: of art, 286, 293; tourism, 201, 206; of water, 222–223, 230
Marquesas, 57–58, 125, 127, 323
masculinity, 235, 237–238, 242–243
Mauss, Marcel, 210–212, 214, 217, 236, 297, 328
Mbembe, Achilles, 235, 240
McCluer, Captain John, 296, 298–299, 302–304, 308
Melanesia, 20, 68, 75, 128, 129, 133, 171, 330; naming of, 123–124, 128, 134, 326, 339; as part of Polynesia, 131
memory, 8, 10–11, 50, 58, 68, 104, 143, 147–154, 159, 213, 315, 320, 329, 332; collective, 32, 176; embodied, 174, 180; historical, 153, 157, 158, 180; intragroup, 10; oral history and, 302. *See also* commemoration
Merlan, Francesca, 3, 264–265, 275, 338
Micronesia, 9, 43, 53, 68, 75, 109, 124, 129, 303, 319, 326; naming of, 123, 132–134
mimesis, social, 11, 174, 176, 188, 316, 329, 338
mining: of gold, 227; of phosphate, 175, 179, 329
Mintz, Sidney, 221, 225, 231
mission, 4, 81, 164
mission archives, 58
missionaries, 4, 34, 75–76 passim, 81–82, 180, 182, 183–186 passim, 196, 197, 198, 327, 333, 336; of London Missionary Society, 57, 76, 89, 96; Presbyterian, 143, 149, 151; reports of, 46; Roman Catholic, 251, 253, 254, 256; Sanatan Dharmi, 236
mission dresses, 81
missionization, 151, 189n8, 333
mission plantations, 251
mission propaganda, 112
mission teacher, Samoan, 153
modernity, 23, 89, 104, 158, 164, 250, 256–258, 315, 317–318, 320, 332–333; aspects of, 78, 89; colonial and postcolonial, 158; exclusion of, 179; tradition and, 5, 263–264, 271–275
modernization, 169, 171
money economy, 170
Moorea, 115
Motu-Koita, 209, 213–214, 218
Mou'a, Madeleine, 198
museums: academic, 23, 33–35; 3D technology in, 309
mythology, 10, 99, 111; sexual, 10, 93, 103, 135
mythopraxis, 103–104, 320, 335, 337–338

names, 51, 98, 324; personal, 10, 65, 142, 143, 147–151, 153–154, 317, 320; of places, 10, 65, 70n15, 123, 143, 147, 149–151, 153–154, 317, 320
namesake, 143, 149, 151, 153
naming, 10, 141, 148, 152; oral narration and, 143; of Pacific regions, 123
Nan Dauwas, 41, 46, **47**
Nandy, Ashis, 235, 237–238, 242, 244–245
Nan Madol, 9, 41–53, 319, 329
natural history, 23, 25, 32, 35, 74, 84, 107, 128

naturalness, 108–109, 232
nature, 29, 32, 75, 108–110, 113, 161, 224, 230–232, 334, 339; American longing for, 230–231; state of, 80, 99, 110, 324–325; tokens of, 231
Navosavakadua, 221, 226–228
Nei Tituabine (goddess), 182, 186–187
New Ireland, 10, 75, 78, 82, 84–85, 87–89, 133
New Irelanders, 84, 87, 88
New Zealand. *See* Aotearoa New Zealand
Ngaing, 4
Ni-Vanuatu, 69n6, 141–154
"noble savage," 59, 109, 324–325, 334, 338
nonviolence, 245, 317
nuclear testing, 12, 199–200, 317, 334
Nui Tamatou, 279

objectification, 160, 221
occupation: of property, 239
Oceania: naming of, 75, 90n4, 123, 124, 128, 129, 131, 133, 134; studies of, 8–13, 56–57, 85, 131, 132, 313, 323, 326, 336
Oceanic history, 328, 329. *See also* Pacific Island history
Omai. *See* Mai
OMAI (pantomime), 60–64
oral history, 160, 166, 182
'Oro (Tahitian war god), 53, 63–64, 94–95, 103, 135, 324, 338; Tupaia as a priest of, 59, 63–64, 66, 327–328
Otaheite, 60–61, 64–65, 93, 95, 115. *See also* Tahiti
'ote'a (drum dances), 202–203, 205
outrigger canoe(s), 281–282, 288, 303–304
ownership: assumption of lack of, 211–212; of dance unit, 210; of fisheries, 267; of heritage, 340; of land, 163–164, 168–169, 225, 228, 230; and power, 214, 216; of Rabi Island, 188, 189n2; of water, 224–225

Pacific Island history, 226, 323, 328, 329, 336. *See also* Oceanic history
Pacific romance, 221–232; in advertising, 229–230
Pacific Studies: and research of Australia, 129
Pahn Kadira, 41, 46
Palau, 13, 109, 296–309
Palauans, 13, 296–299, 301–305, 308–309
Palauans, portrait of three, 298, 304–305, **307**
Paliau movement, 11, 158, 162–165, 168–170, 316

pantomime, 60–64
Pape'ete (Tahiti), 199–201
Papua New Guinea, 4, 11–12, 157–171, 209–210, 213–219, 316, 333
Papua New Guineans, 4, 11–12, 157–172, 209–219, 317, 333–334
paradise, 108, 232; earthly, longing for, 109; Tahiti as, 12, 93, 100, 199–200, 334, 338
peace, 84, 96, 102, 109, 119, 150, 235–237, 245, 256, 273, 315, 335
Pensa, **48**
performance. *See* dance performance(s)
performance (as analytical category). *See* mimesis, social
Pohnpei, 9, 41–54, 329; contact between Kosrae and, 42–43, 45, 50, 52
political economy of cultural transformation, 11, 318
polpolot (ceremony), 164–168
Polynesia, 9, 10, 20, 53, 66, 68, 75, 93, 96, 108–109, 119, 123–136, 250, 277, 317, 319, 320, 326, 336, 339; naming of, 124–125, 127, 128, 133–134
Pomare II of Tahiti, 76, 81, 89, 90n5
Pomare III of Tahiti, 90n5
Portrait of three Micronesians (Spoilum), 298, 304–305, **307**
Port Resolution (Tanna), 141–143, **142**, 149, 151–154, **152**, 329
positioning, 7
postcolonialism, 58, 68
prestation, 210–211
prophecy, 94, 103, 105, 150, 182, 187
protocols, indigenous, x, 66
purity, 108, 222, 224, 230–231

Qalo, Ropate, 11
quietism, 12, 242

Rabi Council of Leaders, 176–178
Rabi Island, 175, 176–179, 186, 187, 188, 189nn1–2, 329, 331
"race," history of, 74, 132, 325, 336, 339; scientific discourse of, 10, 41, 74–75, 123, 325–326, 336, 338–340
Ram, 236, 243
re-articulation, 56, 66, 68–69
religion, 34, 197, 291; ancestral, 4; Christian (*see* Christianity); conversion to Christianity (*see* Christianity: conversion to); indigenous, 63, 330; Indo-Fijian, 229, 236, 242;

Polynesian, 53; transformation of, 11, 180, 182, 186
relocation, 176
remittances, 170, 342n12
Renaissance cabinets, 32–34
renaming, 152, 153
repatriation, 297, 319, 336, 340; virtual, 14, 319, 340
representation, 4, 21–22, 59–60, 63, 66, 74 passim, 107, 153, 174, 188, 264, 267, 269, 273–274, 315, 327, 340; analysis of, 317; indigenous, 5, 6
Rokon te Aro, 179–187, **185, 187,** 330
Rolland, Thomas Pierre, 75–76, 80, 82–85
Roman Catholic mission, 251, 253–254
Rousseau, Jean-Jacques, 109–110, 113, 258, 324–325, 334

Sahlins, Marshall, 2, 70n8, 111, 148, 228, 231, 236, 246n3; on cultural continuity, 2, 275; on cultural transformation, 2, 221, 316; on indigenization of modernity, 264; on mythopraxis of Polynesians, 103, 338; and structural history, 2, 316, 335, 338; on tradition, 6, 332, 338
Said, Edward, 225, 245, 335, 340
Sanatan Dharm, 236
satyagraha (insistence on truth campaigns), 238, 241
Saudeleur (ruler of Nan Madol), 46, 50–51
Schwartz, Theodore, 162, 164, 168–169
scientific voyaging, 75, 325–326, 336, 339–340
scrimshaw, 282
sculpture, 279–282, 285, 291, 293
sea jewelry, 282, 284, 286
Selbasr, 50–51
settlement, history of, 41, 43, 65, 117, 320
sex, 78, 81, 85, 96, 100, 103, 104; experience of, 10, 104; meanings of, 10, 104
sex/gender identity, Polynesian, 337
sexuality, 62, 95, 100, 101, 135; Western myth of Polynesian, 135
shanti (peace), 12, 235–238, 241–245, 335
social action, 157; model of, 161–162, 170; sphere of, 168, 171
social personality, 148–150, 154
Society Islands, 63, 81, 114–119 passim, 125. *See also* Tahiti
Solien Besena (cultural group), 12, 209–219, 317, 333–334
Solomon Islands, 4, 5, 133, 171, 289, 330

song, 10, 165, 179–180, 197, 202, 332
South Asians, descendants of. *See* Indo-Fijians
Southeast Asia, 25, 124, 127, 131–132, 326
South Pacific Festival of Arts, 179, 196, 303, 329
South Seas Project, 8
souvenir: picture as, 203–204
space, notions of, 143, 146–147
stick dance, 179
Stillman, Amy Ku'uleialoha, 10, 201, 315, 317, 332, 334, 336
structural history, 2, 316, 335

Tahiti, vii, 10, 57, 59, 60, 63–64, 67, 75–89, 93–105, 107, 109, 113–117, 134–135, 195–206, 317, 323–327, 334, 338
Tahitians, 9, 10, 12, 63–65, 76–88, 94–104, 109, 112, 114, 117, 119, 125, 142, 195–206, 323–327, 334
Tahiti Nui (dance group), 198–199
taio (ceremonial friends), 64, 84–85, 98, 101–102, 324, 327–328
Tambiah, Stanley, 239
Tanna (island), 10, 125, 127, 141–154, 320
Tannese, 10, 141–154, 317, 329
tapa (barkcloth), 60, 64, 66, 212–213, 286, commodification of, 217–218; exchange of, 63; as gift, 31–32
tapa beater: wooden, 280, 283
tapu (taboo), 89, 134, 326
tatau (tattooing), 81
tattoo, 57, 60, 64, 76, 80–81, 134–135, 195, 327
Te Ohu Kai Moana (Treaty of Waitangi Fisheries Commission), 267, 269
Thanksgiving, 224, 231, 335
theater, 10, 196. *See also* dance theater
Thomas, Nicholas, 8, 63, 66, 210–211, 264, 275, 323–338 passim
tiki (sculptures), 279–282, 291
time, notions of, 42, 143, 329
timelessness, 143, 147, 149, 266, 270, 272, 274, 342n11
Tonga, vii, 10, 21, 26, 64, 107, 113–114, 117–120, 125, 127, 132, 189n2, 225, 277–295, 323, 326, 329, 333
Tongans, 112, 117–119, 227–293
tourism, 12, 195–196, 198–206, 226, 273, 278–279, 317, 332, 334
tourist entertainment, 199, 317
tourist market, 278
trade, of dance components, 209–218, 317;

between Europeans and Pacific Islanders, vii, 26–27, 111, 324; between Pacific Islanders and Europeans, 78–79, 84, 88, 327. *See also* labor trade
trade networks, in Oceania, 53
tradeshow, 195–196
tradition: and analogies, 272; anthropological concepts of, 1, 3, 5; as context-bound articulation, 1, 3, 7–8, 12, 13, 316; as discourse, 6; dynamics of, 274; imagined, 6; invention of, 5, 158, 160, 170, 274, 275, 317, 320, 330, 331, 332, 333, 338; inversion of, 338; of knowledge, 162, 170; negation of, 162, 164; as political symbol, 5; politics of, 6, 176, 263, 330; popular concepts of, 3; as resource, 6; revival of, 263, 264; symbolic construction of, 6; transformation of, 42, 217. See also *kastam*
traditionalism, 161, 171. See also *kastam*
transculturation, 4, 8–9, 11, 13, 56, 59, 63, 179, 212, 297; definition of, 4
transfer, cultural. *See* transculturation
transformation, political economy of, 11, 318
Trask, Haunani-Kay, 5–6, 336–337, 342n11
Tuka movement. *See* Navosavakadua
Tulsi Das, 236, 242
Tupaia, 9, 59, 63–68, 315, 327–328
Tupaia's map, 63–66, 328
Tupaia's paintings, 63, 66
Turnbull, Paul, 8, 70n10
Tuvalu, 13, 119, 189n7
Tuvaluans, 13

Utopia, 99–100, 103, 324

Vanuatu, 4–5, 7, 10, 68, 125, 141–154, 329–330
Vatukaloko, 221, 225–229
Vehiatua (Tahitian chief), 102–103, 315
"Venice of the Pacific," 43
Viénot, Paulette, 198–199
violence, 4, 10, 59, 88, 107, 188, 240, 315, 324; in Maori society, 273; political, 235, 245; against women, 252
Vulcanesia, 133–134

wai ni tuka (water of immortality), 221, 226
waka (canoe), 270–271
Walkup, A. C. Reverend Captain, 182–186
Wallis, Samuel, 59, 64, 93–97, 195, 324–325, 328, 338
Wallis-and-Futuna, 12, 250–251, 254, 259n6
Wallis-'Uvea, 250–258, 284, 317, 335
warfare, 119, 159, 165, 328
water, 12; bottled, 221–224, 227, 230–232, 314, 316–317, 334, 338; and health, 222–224, 231; of immortality, 221, 226; marketing of, 222–223, 230; as natural, 223–224, 230–232; public, 223
Weber, Max, 161, 243–244
Wilson, Captain Henry, 296–302, 308
women: as carvers, **278**, **283**, 289; and informal trade systems, 210–212, 218
Women's Territorial Council, 252
World War II, 153, 162, 180, 241, 243, 342n12

Yali Movement, 4
yams, 141, 144–145, 147, 165

About the Editor

Elfriede Hermann is a cultural and social anthropologist at the University of Göttingen, Germany, and also a research fellow at the Honolulu Academy of Arts, Hawai'i. Since earning her PhD from the University of Tübingen in 1995, she has been with the University of Göttingen's Institute of Cultural and Social Anthropology, where she gained her *venia legendi* and currently has the responsibilities of a professor. In her research at the Honolulu Academy of Arts, she has worked since 2005 with a group of twenty noted Oceanists on an interdisciplinary project: "Changing Contexts—Shifting Meanings: Transformations of Cultural Traditions in Oceania," which is the topic of the present book. She has a long research track of engaging with indigenous historicity and agency in connection with cultural transformation but also with constitutings of self and ethnicity, working in both instances with the Ngaing of Papua New Guinea and the Banabans of Rabi Island (Fiji) and of Banaba Island (Kiribati). Among her publications are *Emotionen und Historizität: Der emotionale Diskurs über die Yali-Bewegung in einer Dorfgemeinschaft der Ngaing, Papua New Guinea* (the conclusion is in English) (Berlin: Reimer, 1995); "Emotions and the Relevance of the Past: Historicity and Ethnicity among the Banabans of Fiji," *History and Anthropology* 16 (3) (2005): 275–291; and (as guest co-editor with Wolfgang Kempf) "Relations in Multicultural Fiji: Transformations, Positionings and Articulations," a special section in *Oceania* 75 (4) (2005).

HAWAI

Production Notes for
HERMANN / CHANGING CONTEXTS, SHIFTING MEANINGS

Design and composition by Josie Herr
with text in Sabon and display in Gill Sans

Printing and binding by Sheridan Books, Inc.

Printed on 60 lb. House White Web Matte, 556 ppi